NEW YORK DADA 1915-23

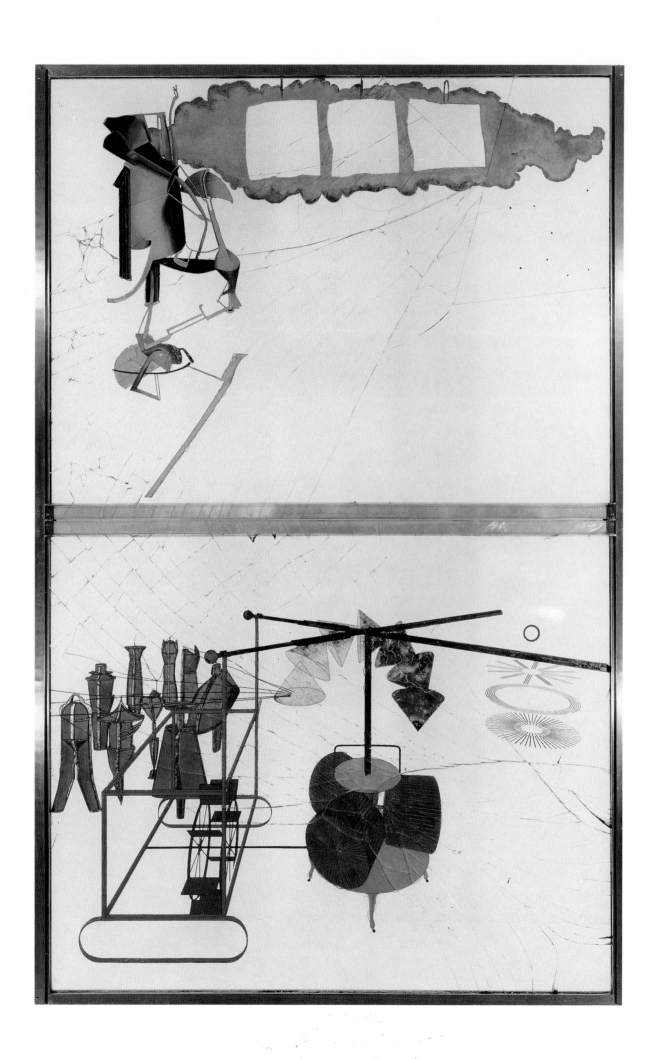

NEW YORK

DADA

1915 - 23

FRANCIS M. NAUMANN

HARRY N. ABRAMS, INC., PUBLISHERS

For:

GABRIELLE BUFFET-PICABIA

(1881–1985)

LOUISE NORTON VARÈSE

(1890–1988)

BEATRICE WOOD

(1893–)

Three wonderful women of Dada

whose recollections made

this period come alive

Editor: Phyllis Freeman
Designer: Bob McKee
Photo Editor: J. Susan Sherman

Library of Congress Cataloging-in-Publication Data

Naumann, Francis M.
New York Dada: 1915–23 / Francis M. Naumann.
p. cm.
Includes bibliographical references and index.
ISBN 0–8109–3676–3
1. Dadaism—New York (N.Y.) 2. Arts, Modern—20th century—
New York (N.Y.) 3. Arts, American. I. Title.
NX511.N4N38 1994
709'. 747'109041—dc20 93–34280
 CIP

Text copyright © 1994 Francis M. Naumann
Illustrations © 1994 Harry N. Abrams, Inc.

Published in 1994 by Harry N. Abrams, Incorporated, New York
A Times Mirror Company

Printed and bound in Japan

Title page: Marcel Duchamp. The Bride Stripped Bare by Her
Bachelors, Even, *or* Large Glass. *1915–23. See p. 38.*

CONTENTS

P REFACE

A N D

A CKNOWLEDGMENTS

My interest in the subject of this book can be pinpointed to the summer of 1970, when I read Barbara Rose's *American Art Since 1900*, a survey text that had appeared a few years earlier. In reading the book one evening, I was struck by a passage where the author describes the critical role played in the history of American modernism by the collector Walter Arensberg, who, she reported, during the second decade of this century, "opened his living room on Sixty-seventh Street to a lively group that included Duchamp, Picabia, Man Ray, Marsden Hartley, Joseph Stella, Charles Demuth, Charles Sheeler, Isadora Duncan, William Carlos Williams, Edgard Varèse, and miscellaneous other figures from the artistic and musical avant-garde."[1]

In an era when parties were a way of life, all I could think of was: "Too bad I missed this one." My only consolation was to dream, and hope that someday I would learn more about the events I missed, due, if to no other reason, to regrettably fixed factors of time and place.

The opportunity to write about the Arensbergs and New York Dada came only years later in response to a proposal I received from the publishers of the present volume, who had known about my interest in this topic and were aware of the fact that, other than for an anthology of writings, the subject of New York Dada had never been accorded monographic treatment. It was not long after accepting their proposal that I decided the text for this book should be organized in such a way as to isolate the major protagonists of this period and their accomplishments. Since there were four figures that fit into that category—Walter Arensberg, Marcel Duchamp, Francis Picabia, and Man Ray—the resultant structure coincidentally mirrors the approach used in two books that were intended to characterize other, tangentially related periods in history: Roger Shattuck's *The Banquet Years* (Henri Rousseau, Erik Satie, Alfred Jarry, Guillaume Apollinaire), and Calvin Tomkins's *The Bride and the Bachelors* (Duchamp, John Cage, Jean Tinguely, Robert Rauschenberg).[2]

I am honored to single out the three women to whom this book is dedicated: Gabrielle Buffet-Picabia, who died in Paris in 1985 at the age of one hundred and four; Louise Varèse, who died in 1988 at the age of ninety-eight; and Beatrice Wood, who, having passed her one-hundred-first birthday, continues an intense and productive daily work schedule out of her home and studio in Ojai, California. In numerous interviews, all three of these women gave tirelessly of their time and energies to relay their memories of the Arensbergs and their circle of friends. Beatrice Wood was especially helpful and informative, for it was her vivid memory that best made this period come alive, and resulted in leaving me with the distinct impression that I had not entirely missed the party after all.

Finally, I am all too painfully aware of the fact that few art books are actually read (pictures, after all, are perfectly qualified to speak for themselves). I am, therefore, especially indebted to Marie Keller, who patiently read through my manuscript as it was being produced, and at an early stage caught many errors that would, if they had remained, have caused considerable embarrassment. I am also grateful to Phyllis Freeman, who served as my principal editor at Abrams; in the process of reading my manuscript, she offered many helpful suggestions, several of which have improved the sense of flow that I strive—with some difficulty—to attain. Thanks to her editorial skills, there is a better chance that some readers will actually make it to the end, a journey that, hopefully, will be made ever the more pleasurable and rewarding by means of the accompanying illustrations.

One of the primary goals of this book is not only to provide an accurate and reliable text on the historical contributions of the artists who participated in the New York Dada enterprise, but also to illustrate their achievements with the highest quality of reproductions currently available. After a careful examination of the works produced in this period, one must inevitably conclude that—contrary to popular belief—the Dada movement was not dedicated exclusively to promoting the concept of anti-art. The Dadaists certainly shared a distaste for artists and writers who relied heavily on the accomplishments of the past, as well as a general lack of respect for those who adhered exclusively to bourgeois taste. As a perusal of the works of art reproduced in this book will confirm, however, they certainly allowed for their own personal expression, while still remaining faithful to the basic ideologies and principles of Dada. For these reasons I should like to especially acknowledge the assistance of J. Susan Sherman, who, from sources both private and public, painstakingly assembled the photographs contained in this volume.

A number of friends and colleagues were generous enough with their time to accept my request to read my entire manuscript or portions of it before publication: Barbara Bloemink, Gisi Baronin Freytag von Loringhoven, Carolyn Burke, William Camfield, Roger Conover, Linda Henderson, Robert Rosenblum, Robert Pincus-Witten, Calvin Tomkins, Charles Stuckey, Steven Watson, and Beatrice Wood. Their careful reading caught many errors that might otherwise have gone unnoticed. I thank them for their valuable corrections and suggestions.

So many other people have helped with this project over the years that it would be difficult to establish a hierarchy of their importance; therefore, I hope to be forgiven for listing in alphabetical order the following names of colleagues and professional associates who have—in varying capacities—lent their assistance: Lawrence Adamo, Craig Adcock, William Agee, Paul Avrich, Sherry Barbier-Thévenot, Theresa Bernstein, Ruth Bohan, John Chilton, Chantal Combes, Marc Dachy, Anne d'Harnoncourt, Max Harrison, Billy Klüver, Elske Kosta, Lisa Kurzner, Patrice Lefrançois, Richard Lilly, Rose-Carol Washton Long, Garnett McCoy, Julie Martin, Olivia Mattis, Chris Moreton, Fifi Oscard, Robert Reiss, Daniel Robbins, Naomi Sawelson-Gorse, Michel Sanouillet, D. O. Spettigue, Marino Vismara, Chou Wen-chung, Judith Zilczer.

There are yet others who provided assistance in securing valuable reproductions, and/or provided permission to publish materials in their possession (the specific institutions these people represent are individually acknowledged in the captions): Arakawa, Charles C. Arensberg, Timothy Baum, Ecke Bonk, Elisa Breton, François Chapon, Roger Conover, Alexina Duchamp, Blanche T. Ebeling-Koning, Jacques Fajour, Jerome Gold, Mrs. John D. Gordon, Maria Morris Hambourg, Carl Hultberg, Mark Kelman, Marjorie Klein, Frank Kolodny, Carlton Lake, Jean-Jacques Lebel, Don Luck, Juliet Man Ray, Giorgio Marconi, James Maroney, Stephen Mazoh, Olga Mohler, Jacqueline Monnier, Anthony Penrose, Nils Rahm, Arturo Schwarz, Michael Senft, Robert Shapazian, Katherine Sharp, William Kelly Simpson, Matt Singer, Charles Stuckey, Alan Tarica, Lucien Treillard, Henry Weinberg, Elizabeth Wrigley, Virginia Zabriskie.

Lastly, I should also like to take this opportunity to thank a number of friends and relatives, many of whom were inconvenienced by my insistence that the completion of this book take precedence over my social life: Larry Becker and Heidi Nivling, Mike Bidlo, Mathilda S. Bing, Ecke Bonk and Marlene Greussing, John Cauman, Jan Ceuleers, Roger and Anna Conover, Hester Diamond and Ralph Kaminsky, Stephanie Dragovitch, Jack Flam and Bonnie Burnham, Philippe and Paul Gaucherand and Anne de Rochas, Steve Gianakos, Susan Ginsburg, Charles Goldsmith, Gaylyn Grace and George Herms, Nancy Grove, Stanley Jernow, Tom, Charlotte, and Megan Keller, Amelia Keller-Nass, Pat Kogan, Tom Lawson and Susan Morgan, William Leh, David Letterman, Albert and Alicia Lorenzoni, Just Moller, Tom Murphy, Otto, Tristan, Ambrose, and Siena Naumann, Rose Naumann, Brian O'Leary, Pawlie, Bob, Totor, and Widl, John Rewald, Sabine Rewald, Archie, Jane; Robert, Sophie, and Theo Rosenblum, Naomi and David Savage, Martica Sawin, Paolo Serra, Heidi Shafranek, R. P. Singh, Leo Steinberg, Marion Tyler, Girolamo DeVanna, Ronny and Jessy van de Velde, Mark and Carol Willis, Rob Wynne and Charles Ruas.

INTRODUCTION

Early one afternoon in 1913, a young New York debutante named Mary Phelps Jacob sat quietly in her boudoir trying to decide which dress she would wear to a dance that evening. Exasperated at the thought of once again being harnessed into her stiff, heavily starched whalebone corset, she decided to give some consideration to a more comfortable alternative. Apparently, like her renowned distant relative—Robert Fulton of steamboat fame—she understood the important role necessity plays in the process of invention and set about devising a replacement for this constricting undergarment. With two handkerchiefs, some baby ribbon, and the assistance of her French maid, Miss Jacob invented the prototype of today's modern brassiere.[1]

This new method of support not only left the midriff free for the important requirement of breathing, but also eliminated the rounded, artificial look of the bow-fronted bosom, popular since Edwardian times, and gave the breasts a more natural separation.[2] The new Backless Bra, as Miss Jacob called her invention, was an overnight success. Friends and even strangers wrote to her for samples, and in November 1914, she was granted a patent.[3]

Although the invention of the bra was a single isolated event, its immediate acceptance and use was indicative of the quest for liberation that motivated an entire generation of free-thinking individuals: both men *and* women. These people were eager to rid themselves of the inhibitions and restraints imposed on their lives by the conservative ideals of their forefathers, restraints that were not

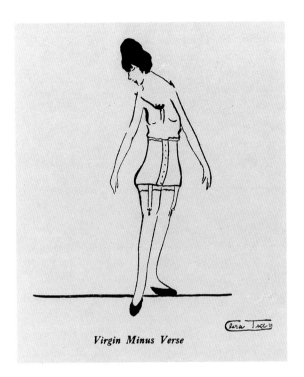

Virgin Minus Verse

only physical, but moral, intellectual, and aesthetic as well. Indeed, as early as 1915, in an article for *The New York Call,* a critic by the name of Emanuel Julius asserted that the elimination of corsets was a stylistic innovation that found a direct equivalent in the new poetry, or "versifying," as he preferred to call it. Indeed, he regarded the poems of Robert Carlton Brown as being so totally free from convention that he termed them "corsetless."[4]

Ironically, just as the elimination of the corset can be seen to have reflected the spirit of liberation in the prewar era, it

was burning the bra some fifty years later that symbolized the spirit of rebellion in a totally new generation of American youth who wished to separate themselves from the conservative ideals of their parents. It is also perhaps no coincidence that in the 1960s artists and historians began to reinvestigate the art of the teens, finding within it the first important precedent to their own aesthetic preoccupations. Just as the youth of the latter period were fueled by their intense hatred for an unjust war, American liberals in the second decade of this

century were forced to ponder the implications of an even more devastating conflict, one which would claim the lives of over five million Europeans and, before it was over, some 115,000 Americans.

In order to avoid any involvement with the First World War, in 1914 and 1915 a group of young European artists and writers fled to neutral Switzerland, where in February 1916, they assembled for common purposes in a small cabaret in Zurich. These artists not only shared a mutual hatred for the atrocities of war, they possessed collectively an innate

nihilistic, anarchic, and revolutionary spirit, dedicated to destroying bourgeois notions of meaning and order. Within weeks, they staged poetry readings and held performances designed to express their defiance, and they would soon organize art exhibitions with the same goals in mind.

It would not be long before these artists decided to issue a new magazine to publicize their common interests. The proposed publication was to be an international review, presenting literary and artistic works of a highly unconventional nature. But they had not yet established a name for their new venture. They looked for a title that would reflect the originality of each contributor and also encompass the revolutionary ideals of their own newly formed group. No ordinary word would suffice. Seeking inspiration in the pages of a German-French dictionary, they came upon the following entry:

DADA. Noun, masculine. Linguistics. Funny or childish term, used to describe a horse. Plural: des dadas.—Figurative: obsessive idea, leaning, project one endlessly toys with, and always comes back to.

Reaction was unanimous: the word "Dada" was perfect. It was a child's utterance, exactly the kind of word they were looking for. It expressed the primitive and newborn qualities of their artistic innovations.[5]

Through their publications and correspondence with other artists in Europe, the Dadaists soon established new centers in Berlin, Cologne, Hanover, and Paris—and, eventually, New York, where, as we shall see, Dada-style activities took place even before the official foundation of the movement in Zurich in 1916.

Whereas the European Dada movement has been the focus of many detailed studies, with few exceptions, New York Dada has been analyzed only within the framework of general survey texts, where Dada is usually treated as little more than a mere prelude to Surrealism.[6] The reason for this neglect can be traced to the artists themselves, particularly to Man Ray and Marcel

Duchamp, who maintained that although their activities in New York were motivated by a similar spirit to that which fired their European counterparts, they were in no way directly inspired by them. In fact, in interviews conducted late in his life, Man Ray went so far as to contend that there was no such thing as New York Dada.[7]

Despite such disclaimers, recent evidence has demonstrated that a select group of artists in New York were aware of the Dada movement in Europe shortly after the word first appeared in print (see chapter 8). Moreover, it is now clear that by the time they first learned of the Dada movement in Europe, a number of American artists had already embraced and employed the basic principles and ideologies that inspired their European colleagues, causing modern historians to classify their activities as pre- or proto-Dada.

One incident demonstrates how certain Dada sensitivities were transported to New York in the years immediately preceding America's entry into the war. On April 4, 1916 (coincidentally, just a few weeks before the word Dada was discovered in Zurich), an exhibition of modern art opened at the Montross Gallery on Fifth Avenue at Forty-fifth Street in Manhattan. The show featured the work of four French painters: Jean Crotti (actually a Swiss living in Paris) and Marcel Duchamp, who had left Paris shortly after the outbreak of war, and Albert Gleizes and Jean Metzinger, two well-known painters who were then generally thought to be among the most articulate and authoritative representatives of the new Cubist style, for by that time, their pioneering book on the movement had appeared in both French and English.[8]

Because the exhibition consisted entirely of the works of four expatriate French modern artists, the press dubbed it a show of "Four Musketeers." However, these four exponents of modernism were not as compatible or as friendly with one another as the appellation might suggest; in fact, a few days before the show opened, Gleizes and Crotti got into a rather heated argument over the titles Crotti had chosen for his works.

Apparently, Gleizes—who took his Cubism quite seriously—thought that some of the titles were too provocative, and in his opinion, served only to invite "potentially damaging criticism." Proclaiming that he was speaking both for himself and for Metzinger (who remained in Paris), he wrote a carefully phrased letter to Crotti, explaining that he objected to these titles because he felt their lack of seriousness might reflect upon everyone in the group—by which we can assume he meant not only those exhibiting at the Montross Gallery, but all Cubist painters.[9] On at least one other occasion, we know that Gleizes had accepted a similar role as Cubism's moral defender, when a few years earlier in Paris, he and a number of his Cubist colleagues tried to persuade Duchamp to alter the title of a painting he had submitted to the Salon des Indépendants (this, of course, was the Nude Descending a Staircase [see p. 16], which Duchamp eventually withdrew). In the case of the Montross exhibition, Gleizes wanted his actions to be clearly understood, so in his letter to Crotti, he explained that he objected to the titles not because he doubted Crotti's commitment to his artistry, but most of all because he wanted to avoid "waging a battle of the avant-garde."

It is worth pausing for a moment to reflect upon Gleizes's choice of words. In aesthetic terms, by the late nineteenth century, the term avant-garde—borrowed from French military usage—had come to identify those artists who were thought to be ahead of their time, painters and sculptors who voluntarily marched into the front line of a battle for more progressive art. In 1916, of course, this military metaphor would have been especially poignant, for at that very moment, the French were physically engaged in a struggle for political freedom. But more specifically, in the case of the Montross exhibition, in having warned Crotti against the potential of creating a "battle of the avant-garde," Gleizes automatically included himself and Metzinger as exponents of the "avant-garde," while at the same time recognizing the fact that Duchamp and

Crotti represented challenging factions within this same group.

At least one intelligent collector—the poet and Baconian scholar Walter Arensberg—was not only aware of the activities of these Europeans, but fully endorsed and promoted their friendly rivalry. Arensberg often delighted in showing guests the more unusual works he collected, not because he thought they would recognize their inherent value, but for precisely the opposite reasons: because he knew some would fail to comprehend their aesthetic significance. On one occasion, for example, he proudly showed the critic Henry McBride a gift he had received from Duchamp: a small glass ampule that was broken open, emptied, and resealed, trapping 50 cc of Paris air (see p. 50). Upon seeing it, the critic joined his host in an outburst of laughter. But an uninformed visitor—whom McBride had brought along for the tour—was not so easily amused, and quickly pointed out that the item probably no longer contained air from Paris, for it was his understanding that science had proved that the properties of air change over a period of time.[10]

The ever-perceptive McBride later noted that Arensberg seemed to play up to the man's ignorance, a conscious act, he thought, "to épater le bourgeois." The idea of "shocking" or "dumbfounding" the benighted bourgeois runs throughout the entire Dada period, beginning with its foundation in Zurich in 1916, to its eventual dissolution and demise in Paris some five to six years later. We can be sure that those who embraced the tenets of Dada in New York wholeheartedly accepted and applied these principles, but—as suggested by the Gleizes/Crotti affair at the Montross Gallery—a number of these artists took this idea one step further: rather than simply befuddle the bourgeois, they might have reasoned, why not also try to confound those who claimed to be in the know: namely, artists and critics who already considered themselves at the forefront of the avant-garde?

It was nothing short of these sentiments that prompted Arensberg to tell Picabia in 1920 that "the cubist artist is, after all, a casserole, so shit to them all."[11] If it was Arensberg's intention to épater le bourgeois, then the grandest form of épater-ing would be to acknowledge the fallacy of his own pretensions, which is probably what motivated Arensberg to send one of the founders of Dada a telegram in 1920 referring to Dada as "le mouvement KaKa."[12] Scatological inferences of this type abound throughout the literature of Dada, for any form of self-deprecation (or, in this context, what might be called "self-defecation") was perfectly in keeping with the humor and nihilistic spirit that formed the basis of Dada's intentionally shocking public persona.

There can be little doubt that Duchamp and his colleagues in New York were aware of their advanced position within the avant-garde. Knowledge of the European Dada movement would only have added fuel to the fires of their discontent, making them aware that artists in other parts of the world were also united in their disregard for traditional artistic practice. But among those who would go on to embrace the basic principles of Dada in New York, most were equally skeptical of the critical acceptance of most contemporary art. Because his *Nude* had caused such a furor when it was exhibited in New York, Duchamp was often asked to provide his opinion of the most recent manifestations of the avant-garde, and to speculate on its future. Rather than defend Cubism, as might have been expected, he preferred to take the opportunity to correct public preconceptions, while at the same time dismissing most of the Cubists as little more than second-rate imitators of Cézanne and Seurat. Of course, he was well aware of the fact that these were two artists from the past who—in the context of an avant-garde—could be recognized for the importance of their historical contribution. Others, however, could not accept anything that came after Cézanne or Seurat (if they got that far), limitations that would in no way encumber the thinking of Duchamp or any of his Dada friends in New York. Years later, when referring to discussions he had had with Picabia about Dada, Duchamp underscored the fact that their understanding of modern art differed from that of the Cubists. For everyone else, "There was no thought of anything beyond the physical side of painting," he said. They were all "either for or against Cézanne."[13]

If it can be established that certain artists, collectors, and critics were aware of divisions within the avant-garde, then it is logical to question exactly how this situation affected the development of a modernist aesthetic, and whether or not a similar situation continues to affect our understanding and appreciation of the works produced in this period. It is only through a detailed examination of the works themselves—seen not only through the events that inspired their making, but also through the reactions they served to inspire (contemporaneously and in the future)—that we can establish with certainty not only that the Dada movement existed in New York, but that the works its artists produced are among the most important and influential creations of this century.

1 • PROTO-DADA

The pioneering American photographer and gallery owner Alfred Stieglitz was—unquestionably—the individual most responsible for the introduction of modern art to America. He was, as a friend asserted, a "John the Baptist in the American desert of modern art."[1]

The advancement and promotion of modern art was not, however, his original objective. In 1902, he founded the Photo-Secession group, an organization of photographers dedicated to fostering the acceptance of photography as a mode of artistic expression. The aesthetic credo of this group was articulated throughout the pages of *Camera Work*, a sumptuous, large-format periodical that carried magnificent black and white reproductions of photographic images. Stieglitz himself personally edited and published the magazine, beginning with the first number, in 1903 (followed by some fifty issues, which appeared, intermittently, through 1917). In 1905, with help from the photographer Edward Steichen, Stieglitz opened The Little Galleries of the Photo-Secession, which, as its name indicates, was designed to showcase the work of Photo-Secession members. Within a few years, however, he and Steichen became convinced that the only way photography could be accepted within the context of modern art would be to present it literally in such a milieu, so in January 1908, they opened the gallery to a showing of fifty-eight

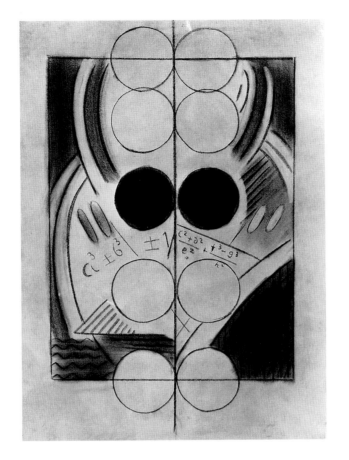

drawings by the noted French sculptor
Auguste Rodin. This show represented
the first in a series of important exhibi-
tions of modern art held at the gallery,
which soon became known simply as
"291" (from its street address on Fifth
Avenue). Between 1908 and 1917, some
of the most important and influential
sculptors and painters on both sides of
the Atlantic were given their first
American showing at the gallery: Henri
Matisse, Pablo Picasso, Paul Cézanne, and

Constantin Brancusi, as well as Arthur
Dove, John Marin, Alfred Maurer,
Georgia O'Keeffe, Abraham Walkowitz,
and Max Weber.

Few would challenge the preeminent
position established by Alfred Stieglitz in
the promotion of modern art. And
although he may never have fully
embraced the tenets of Dada, a number
of early articles published in his magazine
were so forcefully written and so totally
committed to renouncing traditional aes-

thetic values that today they read almost
like Dada manifestos.

Among those who best formulated
these concerns were the American social
critic Benjamin de Casseres (1873–1945)
and the Mexican author and caricature
artist Marius de Zayas (1880–1961). The
two had known one another from their
days in Mexico City, where de Casseres
had gone in 1906 to found the newspaper
El Diario Ilustrado, to which de Zayas con-
tributed caricatures satirizing some of

Mexico City's most prominent citizens. With the increasing unrest under President Porfirio Díaz's totalitarian regime, however, de Zayas and de Casseres were forced to flee the city, and by 1907, they were both in New York struggling to resume their respective careers.

Stieglitz, who had always been fascinated by the art of caricature, learned of de Zayas's work through the photographer and critic John Nilsen Laurvik. On his first visit to the artist's studio, Stieglitz was so impressed by what he saw that he immediately proposed an exhibition, and on January 4, 1909, a show of twenty-five caricatures by Marius de Zayas opened at 291. Other than for a favorable review written by de Casseres—published, appropriately, in *Camera Work*—and scattered notices in the press, the exhibition passed largely unnoticed.[2]

De Casseres's review was the first of many articles by this self-styled philosopher to grace the pages of *Camera Work* over the course of the next four years. His first thematic essay was entitled "American Indifference," a lamentable attitude which, in artistic matters, he felt was the country's greatest crime, whereupon he went on to identify the art patron as the greatest violator. "This giant conspiracy of mediocrity," he wrote, "has in all ages been the sworn enemy of all that is new."[3] This condemnation was quickly followed by an attack on art critics, whom he called art "puffers . . . the go-between between the advertising staff of many of the great metropolitan dailies and the art dealers, who pay, pay, pay."[4]

With each new article, de Casseres's writings become increasingly sarcastic and panegyric, until some of the essays present little more than a string of poignant aphorisms and epigraphs, the majority of which relate only peripherally to the subject of art. In an essay entitled "The Ironical in Art," however, published in the April 1912 issue of *Camera Work*, de Casseres proclaimed that "all revolutionary art, like all religion, is a kind of vengeance," whereupon he observed that "all Futurism, Post-Impressionism, is spite." In de Casseres's mind, however,

these were not reasons for despair, but quite the opposite. "There is a revaluation going on in the art of the world today," he wrote, "there is a healthy mockery, a healthy anarchic spirit abroad. Some men are spitting on themselves and their work; and that is healthy, too." He concluded with the rhetorical question: "Is all painting, all art, ascending into the heaven of irony, the zenith of scorn and mockery?"[5]

In one of the last articles de Casseres wrote for *Camera Work*, he defended the trait of insincerity, which he had heard— allegedly from visitors to the Armory Show—the Cubists were accused of. "There is no form of sincerity," he thundered, "that in the last analysis is not interchangeable with stupidity. . . . We should mock existence at each moment, mock ourselves, mock others, mock everything by the perpetual creation of fantastic and grotesque attitudes, gestures and attributes."[6] In his final article, de Casseres announced the triumph of the irrational, asserting that some of the most important expressions in modern art could be traced back to the philosophy of Heraclitus. In a remarkably prophetic statement, he wrote that "the irrational is the groundwork of all existence." Finally, after having traced the soul of the movement to Picasso, Debussy, Nietzsche, Stirner, Picabia, and others, he dismissed logic and proclaimed "Chance King."[7]

Years later, the American playwright Eugene O'Neill would trace de Casseres's philosophic origins to Schopenhauer and Nietzsche, sources the critic would hardly have denied.[8] In fact, as early as 1910, de Casseres had already been identified as a "spiritual nihilist" whose writings were spawned by the pessimism of Schopenhauer, the philosophical egotism of Stirner, and the concept of a supermorality espoused by Nietzsche.[9] To nascent Dada sensibilities in New York, the influence of these three German philosophers cannot be over-emphasized. During the second decade of this century, Nietzsche was unquestionably the best known; by 1910, his most important books were all available in English translations, and H. L. Mencken,

Willard Huntington Wright, and de Casseres did much to introduce and popularize his writings for an American audience.[10]

In the final analysis, in spite of de Casseres's sharp, aphoristic style—which, inevitably, was derived from the writings of Nietzsche—his proclamations fell short of providing the biting philosophical diatribes that were so readily embraced by the Dadaists.[11] Yet, it was de Casseres's anarchic spirit that eventually led Stieglitz to stop publishing his work: "You have lost touch with what is really going on at '291' and in *Camera Work*," he wrote de Casseres in 1915. "I have some of your MSS still on hand unused. I know I shall never be able to use them, as they don't fit into what I am doing, or trying to do."[12]

Eventually, de Zayas, too, would fall victim to Stieglitz's unchanging, doctrinaire vision of his gallery and its purpose, but not before the two engaged in one of the most harmonious and successful working relationships to have taken place in the formative period of American modernism. For approximately a six-year period—from the time of their meeting in 1908, to the time when de Zayas opened a separate gallery in 1915— Stieglitz and de Zayas worked as a team to bring the most current and complex expressions of modern European art to a curious, though sometimes resistant American audience. On a number of trips to Paris, de Zayas acted as Stieglitz's emissary and agent, scouting out what was new and noteworthy, passing on his recommendations of what should be shown at 291. During a trip to Paris in the fall of 1910, de Zayas visited the Salon d'Automne, but, even after four separate viewings of the exhibition, he reported to Stieglitz that he couldn't make sense out of anything. Though he claimed the important work at 291 prepared him to see the exhibition with "open eyes," he was blinded by the most recent experiments in Cubism. "I looked," he confessed to readers of *Camera Work*, "but did not see."[13]

Within three months, through his encounters with some of the most important artists and critics then living in

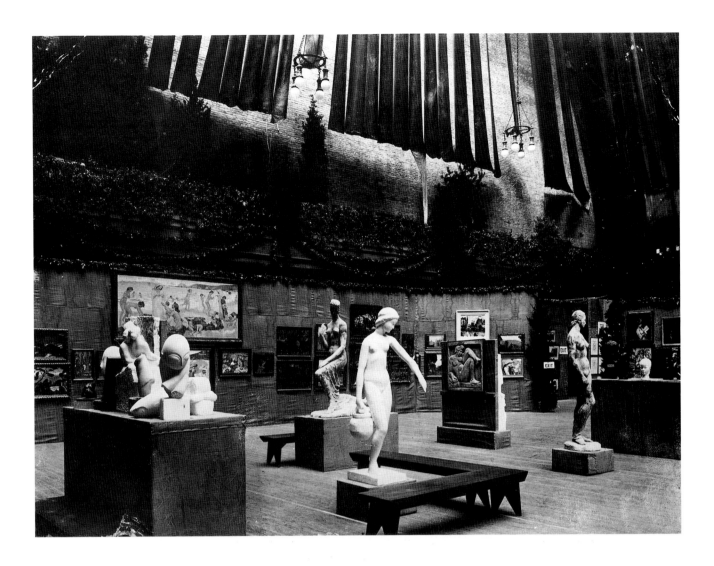

Paris, de Zayas underwent a complete and radical aesthetic transformation. He met Picasso, and, because of their common language, spoke with the artist at length. This formed the basis of the first important interview with this famous Spaniard to be published in the American press.[14] De Zayas not only learned to see Cubism, but soon became one of the movement's most ardent defenders. He arranged for the first showing of Picasso's work in America, an exhibition of drawings and watercolors at 291 in April 1911. And it was probably through his conversations with Picasso that de Zayas became aware of the importance of African art and its influence on the development of modern art. He pro-

posed an exhibition of African sculpture at 291 (a show that materialized only two years later), and the relationship between "primitive" and modern art continued to interest de Zayas throughout his career.

African art, Picasso, and Cubist theory contributed in varying degrees to de Zayas's conception and formulation of "absolute caricature," where subjects were studied not merely for their physical appearance, but for a deeper analysis of their inner, "intrinsic expression."[15] One of the first works realized in this new, more abstract style, was de Zayas's *Portrait of Alfred Stieglitz*, a caricature wherein only certain selected features of the photographer's physical appearance are preserved: two dark central circles recall Stieglitz's spectacles, and a sharp, striated wedge shape is reminiscent of his finely trimmed mustache. But the basic form of paired circles attached to a cen-

tral vertical line, de Zayas later explained, was inspired by a "primitive" artifact he had seen in the collection of the British Museum: a series of hanging circles in twine made by the natives of Danger Island, a so-called Soul Catcher, empowered, as its name suggests, with the mystic power of entrapping souls. De Zayas, who had earlier entitled a caricature of Stieglitz *L'Accoucheur d'idées* (*The Midwife of Ideas*), felt that in the photographer's abilities to attract adherents to the promotion of modern art, Stieglitz functioned as a true and effective catcher of souls.[16]

Throughout the years of his association with Stieglitz and the artists who showed at 291, de Zayas's thoughts and theories about the new art appeared regularly in *Camera Work*. It was in this magazine that he outlined his new approach to the art of caricature, and it was here that his ideas about African art

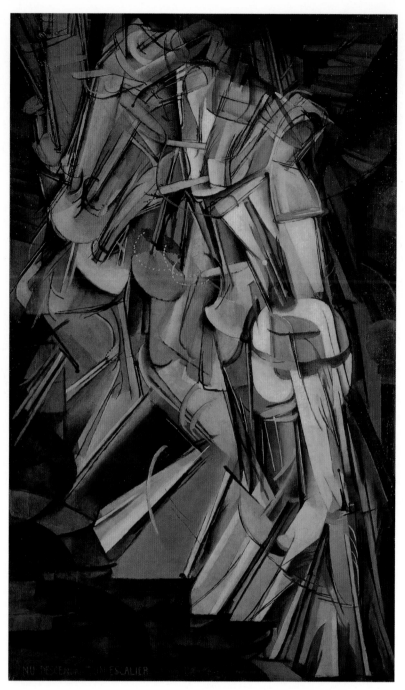

and the evolution of form—both subjects of subsequent books—were first presented to the public.[17] But the article that has drawn the most attention is one that begins with the outspoken proclamation: "Art is dead." Although the negative connotation of these words is often cited as one of the earliest published manifestations of a Dada sensibility, the sentence was in fact meant to serve as a positive statement about the birth of a new art. "We know that death is not absolute but relative," he wrote, "and that every end is but the beginning of a new and fresh manifestation."[18]

Within a matter of months, this new manifestation in the arts would make its first grand-scale public appearance in New York at the International Exhibition of Modern Art, organized by the newly formed Association of American Painters and Sculptors and held at the Sixty-ninth Infantry Regiment Armory, on Lexington Avenue at Twenty-fifth Street in Manhattan.[19]

Whereas exhibitions at 291 may have prepared some artists and critics for what they saw at the Armory Show, most of the American public was baffled, some even repulsed, by certain examples of the more extreme manifestations of modern European art. They were especially confused by the Cubist room, which they called a "chamber of horrors," and with few exceptions, they regarded Marcel Duchamp's *Nude Descending a Staircase* the greatest horror of all. Most

Marcel Duchamp. Nude Descending a Staircase, No. 2. *1912. Oil on canvas, 58 x 35".* Philadelphia Museum of Art. The Louise and Walter Arensberg Collection

J. F. Griswold. The Rude Descending a Staircase. New York Evening Sun, *March 20, 1913*

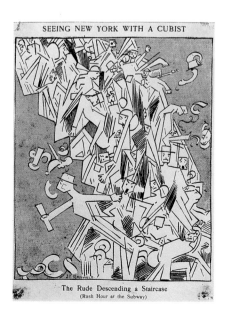

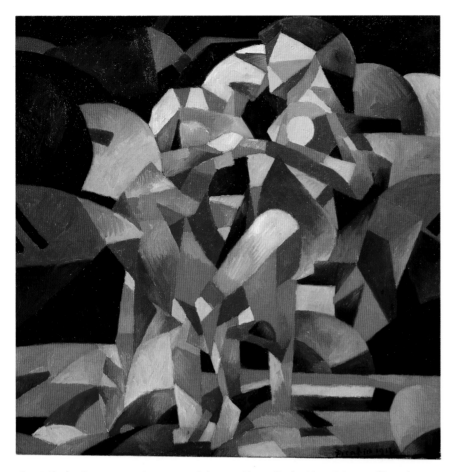

thought the painting unintelligible: considerable attention was devoted to locating the nude figure within the jumble of jagged lines. In what was little more than yet another gesture of derision, *American Art News* offered a ten-dollar reward for the best solution to this problem, a challenge met by the Chicago lawyer and art collector Arthur Jerome Eddy, who even went so far as to supply a diagram pinpointing the precise location of the descending figure. The painting was described as everything from an "elevated railroad stairway in ruins after an earthquake," to an "academic painting of an artichoke." Even former President Theodore Roosevelt took a jab at the picture by comparing it to a Navaho rug, but the most memorable description of the painting was "an explosion in a shingle factory." Cartoonists contributed the most amusing commentaries, one rendering the picture as "The Rude Descending a Staircase," or as the caption continued, "Rush Hour at the Subway."[20]

Francis Picabia. Dances at the Spring. *1912. Oil on canvas, 47 ½ x 47 ½". Philadelphia Museum of Art. The Louise and Walter Arensberg Collection*

Francis Picabia. New York. *1913. Watercolor and gouache, over pencil, on white wove paper, 21 ⅞ x 29 ¾". The Art Institute of Chicago. Alfred Stieglitz Collection, 1949.577*

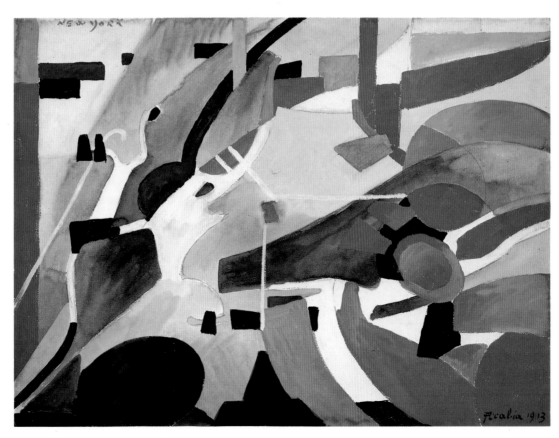

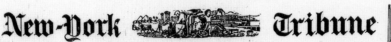

"A Post-Cubist's Impressions of New York," New-York Tribune, *March 8, 1913*

Among the works hanging in the Cubist room that generated the most extreme response were two paintings by the Paris-born Spaniard Francis Picabia: *Dances at the Spring* and *Procession Seville* (private collection, New York), their blocklike forms causing one critic to say that one of the paintings resembled "a chipped block of maple sugar."[21] Anticipating, perhaps, that his paintings would cause such a controversy, Picabia and his wife, Gabrielle Buffet, decided to sail to New York to attend the exhibition. Upon their arrival in late January, the press descended upon them, wanting to know whether or not this self-appointed representative of the new and eccentric in painting could shed any light on these bewildering images. "I have come here," Picabia told these interviewers, "to appeal to the American people to accept the New Movement in Art."[22]

In response to an invitation from an editor of the *New York Tribune*, Picabia produced a series of brilliant watercolors based on his impressions of New York. "They express the spirit of New York as I feel it," he told a reporter, "the crowded streets . . . their surging, their unrest, their commercialism, their atmospheric charm." Indeed, these very qualities of city life are accurately reflected by the chaotic intersection of lines and the dynamic composition of many of these watercolor studies. "You of New York," Picabia explained, "should be quick to understand me and my fellow painters [because] your New York is the cubist, futurist, city"—qualities which, he said, are expressed "in its architecture, its life, its spirit."[23]

Three of Picabia's New York watercolors, along with a photograph of the artist in his Paris studio, were reproduced in a full-page article published by the *New York Tribune*. But these were not mere facile recordings of people, buildings, and street scenes—as the editor of the newspaper might have hoped—they were abstract images inspired by the artist's emotional response to the city and its inhabitants. "In M. Picabia's pictures of New York," the reporter wrote, "we are to look, not for topography, for objective reproduction, but for moods expressed in form." The reporter went on to explain Picabia's rationale for this new departure in painting, comparing the mood invoked by his abstractions with the emotions generated by musical compositions.[24] His editors were less convinced of Picabia's genius; feeling, apparently, that the results of his efforts could be compared to the activities of a child, they accompanied the reproductions of his watercolors with small cartoons of children at play (on the left, an infant toys with blocks; on the right, a boy pieces together a puzzle), images joined by the inscription: "The Expression of an Impression . . . What Dreams May Come."

Though many resisted Picabia's appeal, Stieglitz found the artist and his wife both charming and intelligent, and he immediately scheduled a showing of Picabia's watercolors to open at 291 two days after the Armory Show closed.

While Picabia and Stieglitz were in the process of hanging these watercolors at 291, Arthur Dove, the pioneering American abstractionist who had shown at the gallery a year earlier, stopped by to see what all the fuss was about. A reporter for the *New York Sun* who witnessed this encounter reported that Stieglitz produced a painting by Dove from under a shelf and explained that the young American painter, "working independently . . . and evolving these symbols out of his inner consciousness, utilized similar modes of expression a year ago." According to the columnist, when Picabia saw Dove's painting, "recognition followed as quickly as though two persons born with strawberry marks upon their arms had suddenly discovered the fact." From this point onward, whenever Dove's works were discussed by critics, they were inevitably compared to paintings by Picabia and/or to his well-publicized theories of abstraction.[25]

Picabia's theories were more thoroughly outlined in a statement he wrote especially for this exhibition. This "Preface" was translated by Paul Haviland and printed up on a single sheet for distribution to visitors at 291. But to most readers, Picabia's words were as unintelligible as his pictures: "The objective representation of nature through which the painter used to express the mysterious feeling of his ego in front of his subject 'motive' no longer suffices for the fullness of his new consciousness of nature." One New York newspaper even offered a prize for its translation.[26] Stieglitz seems to have been the only one who responded, by running two articles in *Camera Work* in defense of his artist and his ideas: the first by a chemist, Maurice Aisen, a second by Picabia's wife, writing under her maiden name, Gabrielle Buffet. The latter essay provided an extremely sensitive, lucid, and highly articulate explanation of her husband's work and the theories behind it.[27]

Gabrielle Buffet-Picabia was a former music student, and, if one considers her intelligence and background in musical theory, it is tempting to speculate that she may have played an ever more crucial role in Picabia's evolution toward a more abstract art. Both the artist and his wife maintained that his work should be looked at and understood in the same fashion as one listens to and appreciates a musical composition. They even took this idea one step further: "We believe that the abstract idea in pure line and pure color is conveyed to our understanding more directly than in the musical form," wrote Gabrielle Buffet, "for in the latter we cannot completely appreciate it without an initiation into the arbitrary laws of composition and harmony."[28]

Just as Picabia was invited by the press to render his impressions of New York, Gabrielle Buffet was asked to summarize her impression of the burgeoning metropolis and its inhabitants. "My first impression on landing," she said, "was that New York must certainly be the dirtiest and dustiest city in the world." As for New Yorkers themselves, she was especially impressed by their ability to consistently circumvent prescribed social customs and laws. "Behind those severe spectacles," she said (speaking, perhaps, of Stieglitz), "their eyes are clear and sparkling and full of childish laughter . . . all that outward austerity of depth and preoccupation (which is part of that mysterious American bluff) vanishes like a

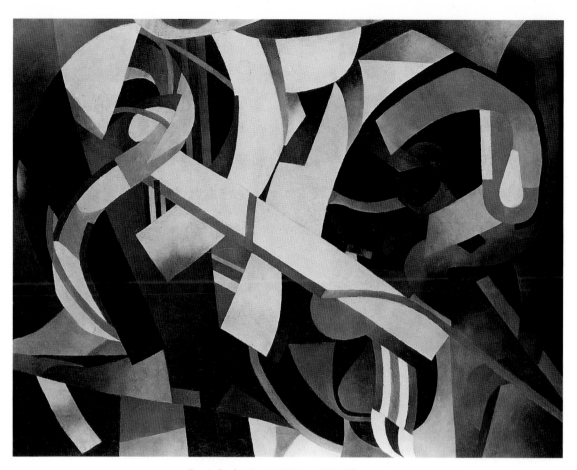

Francis Picabia. Physical Culture. *1913. Oil on canvas, 35 ⅛ x 46". Philadelphia Museum of Art. The Louise and Walter Arensberg Collection*

mirage on the slightest occasion."[29]

By the time Picabia and his wife returned to Europe in April 1913, Stieglitz had grown quite fond of the couple. "All at '291' will miss them," he wrote to the painter Arthur B. Carles a day after their departure. "[Picabia] and his wife were about the cleanest propositions I ever met in my whole career. They were one hundred percent purity."[30] By all indications, Picabia was similarly impressed by his experiences of New York. On the basis of information he apparently derived from the artist himself, one reviewer of Picabia's exhibition at 291 reported that the subjects of his watercolors would serve as the basis for pictures to be realized at some point in the future: "Perhaps Picabia, after he has returned to Paris, will summarize these multitudinous impressions and expressions in a few large canvases, compositely setting forth what New York has meant to him."[31]

Indeed, not too long after his exhibition at 291 closed, Picabia embarked upon the painting of several larger, more highly finished compositions, images whose subjects were unmistakably derived from his experiences in New York. Although stylistically reminiscent of paintings that were made during the course of his first sojourn in America, one of the most abstract of these compositions, *Physical Culture*, was probably painted shortly after Picabia's return to Paris. The title may have been derived from the term that in those days referred to health and physical fitness, or as one observer has noted, it may have been borrowed from *Culture physique*, a magazine edited by Apollinaire.[32] But if we take the title literally, then "physical culture" could very well have been a reference to the material properties of the painting itself and, more specifically, to its function as a portable commodity within the art/market system (in other words,

as the material product of culture itself). Although this painting was first exhibited in France in 1914—where it generated a small degree of controversy—it would soon reach an even greater audience in New York. Picabia probably brought the painting with him to America during his second trip, in 1915. During these years in New York, *Physical Culture* served to represent Picabia's work in a number of group exhibitions, and eventually it was acquired by Walter and Louise Arensberg, who hung it in a prominent position on the wall of the main studio of their West Sixty-seventh Street apartment (see pp. 26–27), where, for the next four to five years, it would be seen by a nearly continuous flow of artists and critics.

Few artists in New York were more receptive to Picabia's theories than de Zayas, whose third and last exhibition at 291—entitled "Caricature: Abstract and Relative"—opened three days after

Picabia's closed. As the show's title suggests, along with a number of earlier, more traditional caricatures, the artist showed examples of his more abstract work, so-called absolute portraits, such as his *Portrait of Alfred Stieglitz* (p. 13) and *Abstract Portrait of Francis Picabia*. In the Picabia portrait, three saw-toothed projections—each surmounted by cryptic, algebraic formulae—run diagonally through the center of the composition. Exactly how these elements relate to Picabia—either physiognomically or intellectually—is difficult to say, for the image is so abstractly conceived that only the title allows us to identify its subject accurately. Indeed, the pronounced degree of abstraction in this portrait may have been intended—in and of itself—as a conspicuous reference to Picabia, who, while he was in New York, had so vocally condemned a strict reliance upon clearly recognizable subjects in his own work.

Few critics reacted favorably to de Zayas's caricatures. "Marius de Zayas has got it," jeered William McCormick in *The New York Press*, "an attack of the prevailing disease for the fantastically obscure in art." Another critic dismissed the show as "a joke," while in the *New York Tribune* Royal Cortissoz characterized the entire exhibition as "an affair of bizarre absurdity."[33] Picabia, on the other hand, quickly praised de Zayas's abilities and, although it is difficult to establish who was the first to formulate these ideas, there can be little doubt that de Zayas was one of the first artists on either side of the Atlantic to apply the principles of abstraction to portraiture.

Early in 1914, de Zayas returned to Paris, where he resumed his friendship with Picabia, who immediately introduced him to the artists and writers who contributed to the avant-garde magazine *Les Soirées de Paris*, particularly its editor, Guillaume Apollinaire. In his letters to Stieglitz, de Zayas repeatedly stresses the importance of establishing closer contacts with the avant-garde ideas and activities of Paris, whereupon he proposes new exhibitions of the most recent work of Picasso and Picabia, and suggests the first American showings of Rousseau, Braque, and Marie Laurencin.[34]

De Zayas could not have known that less than a month after he made these suggestions, a major political upheaval would occur in Europe that would inadvertently result in strengthening a rapport between French and American avant-gardists. On August 2, 1914, war was declared between France and Germany, and over the course of the next two years, thousands of Parisians abandoned their capital, seeking refuge in neutral Switzerland or the United States. The vanguard artists who fled to New York were welcomed by a uniquely receptive audience. Exhibitions at 291 and the Armory Show had paved the way for new modern galleries, and even some of the older, more established institutions opened their doors to the new art. Not only did these activities encourage young artists to experiment, but they also served to educate a host of new collectors, some of whom purchased with the idea of investment, others for the sheer pleasure of possession. But one unusual collector, Walter Arensberg, was attracted to the new art because of its mysterious, intellectual content, qualities which were, as we shall see, reflected in his own complex and highly enigmatic personality.

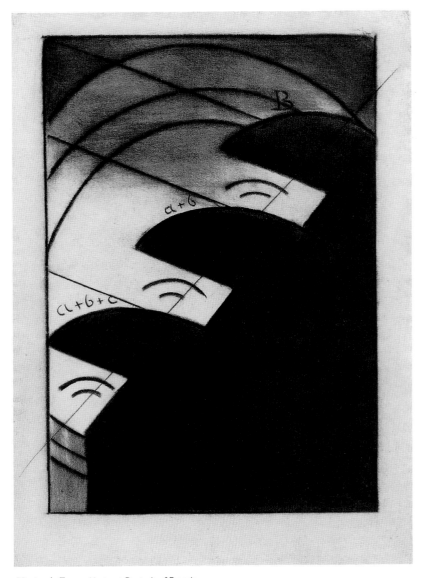

Marius de Zayas. Abstract Portrait of Francis Picabia. *c. 1913. Photogravure. Reproduced in* Camera Work, *vol. 46 (dated April 1914; published October 1914). Yale Collection of American Literature, Beinecke Rare Book and Manuscript Library, Yale University, New Haven*

2 · THE ARENSBERGS

"Walter Arensberg is quite mad," concluded a visitor to the Arensberg home in 1920. "Mrs. Arensberg is mad, too."[1] Similar opinions were shared by many who saw the simply furnished but luxurious apartment of Walter and Louise Arensberg during and just after the years of the First World War. But what some have attributed to an act of lunacy, time has proved to have been the product of intelligent, insightful, and understanding minds. By 1919, when the interior of their apartment was recorded in a series of photographs by the American artist Charles Sheeler (see pp. 121–25), the Arensbergs had already assembled one of the finest collections of modern art in America. It was in this conducive environment that the most important avant-garde theories of the day were formulated and discussed, for between the years 1915 and 1920, the Arensberg apartment served as a virtual open house for an international group of artists and writers, many of whom had sought refuge in this country from Europe's war-torn shores. Aside from exhibitions held in experimental galleries, there was really no other place in New York where such an extensive and daring collection of contemporary art could be viewed. Because of the accessibility of their collection, and because of Walter Arensberg's support and participation in avant-garde activities, the important and influential role he and his wife played in

the formation and development of the avant-garde in this period cannot be overestimated.[2]

From the years of Walter Arensberg's childhood in Pittsburgh, there was little to suggest the commitment to the fine arts that he would make in his mature years. His father, part owner and president of a successful crucible company, gave his entire family music lessons, and young Walter took up the violin. There were a number of ornately framed engravings and reproductions that hung throughout the house, as well as a large sculptural group by the popular genre artist John Rogers that dominated the sitting room. But it was not until Arensberg attended high school that he displayed his first interest in literature, and upon graduation was admitted to Harvard University to continue his studies. There he majored in English, but also took numerous courses in philosophy and aesthetics, subjects that were undoubt-

Walter Conrad Arensberg, signed passport photograph. 1928

Louise Stevens Arensberg in her New York apartment. c. 1917–18. Photograph by Beatrice Wood

edly influential in nurturing his subsequent interest in modern art. Although he spent a great deal of his free time playing chess, winning many victories for the Harvard team, he was graduated *cum laude* in 1900, receiving honorable

mention in English and philosophy, and his fellow students nominated him class poet.[3]

It was probably immediately upon graduation that Arensberg took his first trip to Europe, where he studied for a brief period in Berlin. He then traveled to Italy, spending about a year in Florence, where he learned Italian and began a new translation of Dante's *Divine Comedy*. But it was in Paris that he had his first taste of a genuinely bohemian life-style. Paul Sachs, a fellow classmate from Harvard, met him there and was particularly struck by his disheveled appearance: "Unkempt and unshaven, and typical of the kind of youth[ful] American[s], who lived on the Left Bank and looked as if he were at loose ends."[4] By 1903, Arensberg returned to Harvard, where he registered for a course in the English department and served as a teaching assistant. It was in this period that he seems to have first contemplated the possibility of becoming a professional journalist. He wrote a long article on the social reformer and journalist Jacob Riis, which was published in *Craftsman*, and reviewed various cultural events for a number of magazines. He even worked for a brief period for the *Evening Post* in New York, where he occasionally pinch-hit for the newspaper's regular art critic Frank Jewett Mather.[5] It was probably at this time that Arensberg developed his first serious interest in modern art, and it must have been during this brief sojourn in New York that he purchased his first works of art, acquisitions that were, in retrospect, rather modest: etchings and the like, mostly by popular artists who emulated the bravura style of Impressionism.

By the summer of 1907 Arensberg was back in Boston, where on the twenty-sixth of June he married Louise Stevens, the sister of one of his Harvard class-mates. Arensberg's appearance was to change little from the time of his marriage at the age of thirty. He stood five feet ten and one-quarter inches tall, with thin brown hair and hazel eyes.[6] His ovoid features and rounded chin gave him a boyish appearance, and unmanage-able strands of hair persistently formed

into bangs over his high forehead—compounded by the fact that he rarely allowed time for haircuts, usually being preoccupied with more important intellectual pursuits. Although his fair complexion sometimes gave him a peaked look, he was generally in good health, with the exception of a chronic sinus condition aggravated by his habit of chain-smoking cigarettes. He was never overly concerned with his manner of dress, preferring well-worn jackets to his new ones. At times he could give the impression of the distracted scholar, letting his glasses slide down over his nose and gazing out above their frames. He was a compulsive worker, and there was almost no interest he did not carry to the point of obsession. He would frequently become so involved in some abstract problem or idea that he would virtually "phase out" from the world around him, and no one could penetrate his locked concentration. Those who knew him well were captivated by his charm, yet he could be mercilessly sharp-tongued with those who could not keep up with his rapid train of thought. He very much enjoyed wordy battles over differences of opinion. He was a deeply intelligent man, his knowledge encyclopedic, and there was hardly a topic of conversation to which he could not add at least one interesting detail.

By contrast, his wife, Louise, was more withdrawn. What some mistakenly interpreted as snobbery was actually the expression of her unusually shy and quiet nature. Those with whom she felt at ease invariably found her extremely sensitive, forthright, and in possession of a delightfully rare and dry wit. She had been a music student and through the years developed a very wide and sophisticated range of taste—from the *bel canto* style of the Baroque to the most radical of avant-garde composers (such as Schönberg, Satie, and later, Edgard Varèse). Her shyness prevented her from performing professionally, but she often played the piano for the entertainment of close friends. Like her husband, she had rather rounded facial features, though she was always thin and delicate in appearance, taking certain delight in

wearing fashionable, though somewhat conservative clothing. She was the only daughter of John Edward Stevens, who managed a successful textile mill in their hometown of Ludlow, Massachusetts. He died two years before Louise's marriage, leaving her the heir to funds that would be important for the formation of her and her husband's collection as well as for their generous support of the avant-garde.

Together, Lou—as she was called by close friends—and Walter formed the ideal team. As with many successful marriages, their personalities complemented one another. It amused them, for example, to note that in political matters they often took opposing points of view, causing their votes to cancel each other out at the polls. When it came to selecting works of art for their collection, however, they were almost always in agreement. It was probably Walter who sought out most of the objects, but no acquisition was made without his wife's unreserved approval.[7]

Shortly after their marriage, the Arensbergs purchased an estate in Cambridge known as Shady Hill, famous as the home of Henry Wadsworth Longfellow and later of Charles Eliot Norton. Norton, who died in 1908, had founded the department of art history at Harvard and was also noted for his excellent translations of Dante. Shady Hill, therefore, was a fitting residence for a couple who shared similar literary and artistic interests. It was in this period that Walter developed a serious interest in becoming a poet. His earliest compositions were stylistically dependent upon late-nineteenth-century French Symbolist writing, a debt he readily acknowledged through his translations of Laforgue, Verlaine, and Mallarmé. A number of these translations were included in his first book of collected verse, released by Houghton Mifflin and Company in 1914 under the simple title *Poems*. The writings in his volume, as critics have observed, suffer not just from their limitations of subject, which Arensberg drew primarily from memories of his European trip, but more from their calculated rhythmic patterns, which rely heavily on

his immersion in the tradition of Italian and English verse.[8] The conservative style of Arensberg's poetry, however, would soon undergo a radical change, as would that of many vanguard writers of this period, through exposure to the most recent developments in the visual arts.

Shortly before they moved from Boston, the Arensbergs had gone to New York to see the Armory Show, an experience that was to change the direction of their lives. "The Armory Show," a friend recalled, "hit [Walter] between wind and water."[9] Louise, on the other hand, reacted adversely to what she saw: "Most of the paintings," she told a friend, "are weird and grotesque and simply frightful."[10] But Walter's fascination persisted, and eventually he decided that he could better understand the new art if he lived with it. However, because he had not visited the exhibition in New York until its closing days, most of the works that interested him had already been sold (later, though, he managed to obtain seven paintings from this exhibition).[11] After procrastinating for so long that he lost out on an opportunity to purchase a Rodin drawing, he put down twelve dollars for a Vuillard lithograph. After almost two months of prolonged deliberation, he returned to the exhibition on its closing day in Boston to exchange the lithograph and purchase

Apartment building in which the Arensbergs lived, 33 West Sixty-seventh Street, New York. c. 1908. They lived in apartment 2FE (2nd floor east). Photograph: Museum of the City of New York

two other prints: one by Cézanne and another by Gauguin. Considerably more daring, however, was his next move. He paid eighty-one dollars to acquire the last available painting in the exhibition by the French artist Jacques Villon—a small landscape with such a pronounced degree of abstraction that its subject was barely detectable. It is remarkable that Arensberg had the courage to make such an investment in the painting of a contemporary artist whose work he could have known only through the few examples in this exhibition. He may have heard more of Villon, however, and of the modern art scene in Paris, through Walter Pach, the artist and author who had helped to organize the Armory Show and, from their first meeting at this exhibition, one of the Arensbergs' closest lifelong friends.

Pach undoubtedly provided the Arensbergs with the encouragement and reassurance they needed to take this first bold step. They spent numerous evenings together in Boston during the time of the Armory Show discussing the modern works they had seen.[12] And later, in New York, Pach would continue to supply the advice, assistance, and expertise they required in the formulation of such a challenging collection of modern art. In 1915, for example, Pach organized the first major Matisse exhibition at the Montross Gallery in New York, a show from which Arensberg purchased the portrait of *Mlle. Yvonne Landsberg*, a work with such a shockingly unconventional style and appearance that few would have disagreed with the opinion of a critic who dubbed Matisse "Apostle of the Ugly."[13] It was probably also on Pach's advice that Arensberg purchased Albert Gleizes's *Woman at the Piano*, a large Cubist painting that was included in the last of three exhibitions of "Contemporary French Art" organized by the Carroll Galleries in New York.[14]

The Arensbergs enjoyed Boston's thriving cultural community, but it could not compare to the numerous activities in the theaters and galleries of New York. Louise, in particular, disliked the isolation of Shady Hill. "She used to take her electric car and park at the corner of

Boylston, or near Commonwealth Avenue," Paul Sachs recalled, "just to see the traffic pass."[15] So in 1914 they rented a large apartment at 33 West Sixty-seventh Street, between Central Park West and Columbus Avenue. James Montgomery Flagg, the famous illustrator, lived upstairs in the same building, and he recalled that the neighborhood was well known for its nightly activities: "There was never such a street in town as West 67th, fine modern apartment houses on the north side; and on the south, stables . . . and on the corner, a notorious saloon which kept the night raucous with female yells, stabbings and bums hurtling out onto the icy pavements in wintertime."[16]

By 1915, the artistic climate of New York had changed considerably since Walter had lived there six years earlier. As a result of the interest in modern art generated by the Armory Show, at least five new galleries had opened for the exclusive showing of this new, or what was then called "progressive," art: the Bourgeois, Daniel, Carroll, Washington Square, and Modern galleries.[17] Stieglitz continued to display advanced work from both the European and American schools. Many of the older, more established institutions also opened their doors for the first time to the new art.

It was from exhibitions at the new galleries that Arensberg made most of his first major purchases—the Gleizes and a small Roger de La Fresnaye landscape were acquired from the Carroll Galleries, while many other Cubist works, such as the Arensbergs' numerous Picassos, Braques, and Brancusis, were probably secured from exhibitions either at 291, or at its offshoot, the Modern Gallery, directed by Marius de Zayas.[18]

Between 1915 and 1920, de Zayas was an adviser and good friend of the Arensbergs, and it was perhaps he who first interested them in the Romanian sculptor Constantin Brancusi (whose work they were eventually to acquire in impressive quantities). Brancusi's sculpture was introduced to the American public at the Armory Show, and he was given his first one-man exhibition in the United States at 291 in March of 1914, with many subsequent showings at the

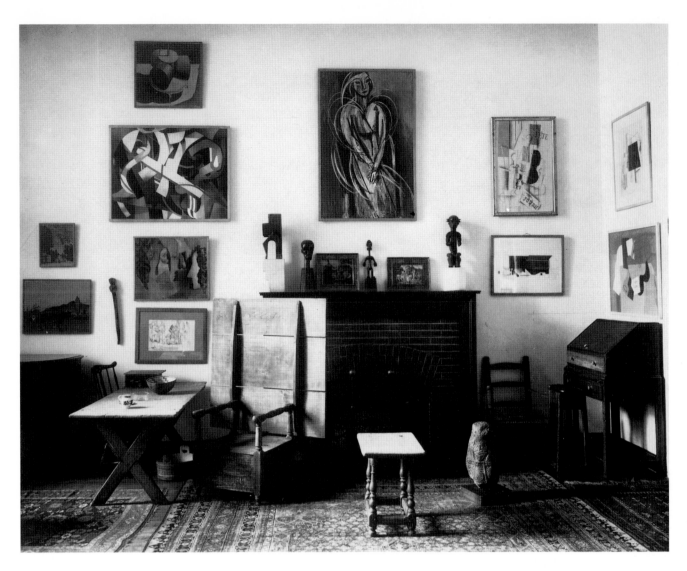

East wall (above) of the Arensbergs' apartment,
New York. c. 1919. Photograph by Charles Sheeler.
Collection Charles C. Arensberg, Pittsburgh, PA.
Duchamp's Chocolate Grinder *is at top left; below
it,* Picabia's Physical Culture. *Center:* Matisse's
Mlle. Yvonne Landsberg

Floor plan (below) of the Arensbergs' apartment.
By the author. Sixty-seventh Street is to the right,
east is at the top of the plan, north to the left, and
west at the bottom

East wall (opposite) of the Arensbergs' apartment,
New York. c. 1919. Photograph by Charles Sheeler.
Whitney Museum of American Art. Gift of James
Maroney. *Directly over the piano, at left top is*
Duchamp's Portrait (Dulcinea); *below it, his* The
King and Queen Surrounded by Swift Nudes; *at
right top is* Covert's Hydro Cell

South wall of the Arensbergs' apartment, New York.
c. 1919. Photograph by Charles Sheeler. Gelatin
silver print, image: 7 5/8 x 9 5/8"; sheet: 8 x 9 15/16".
Philadelphia Museum of Art. Arensberg Archives.
Over the door is Duchamp's The Sonata; *to the
right is his* Chocolate Grinder, No. 2, *and at the
far right,* Nude Descending a Staircase, No. 3

Northwest wall of the Arensbergs' apartment, New
York. c. 1919. Photograph by Charles Sheeler.
Gelatin silver print, image: 7 11/16 x 9 11/16";
sheet: 8 x 9 15/16". Philadelphia Museum of Art.
Arensberg Archives. *At the far right are* Schamberg's
Mechanical Abstraction *and two works by Sheeler.*
Nude Descending a Staircase, No. 2 *is at center,
and to the left, behind the sconce, is* Stella's
Landscape

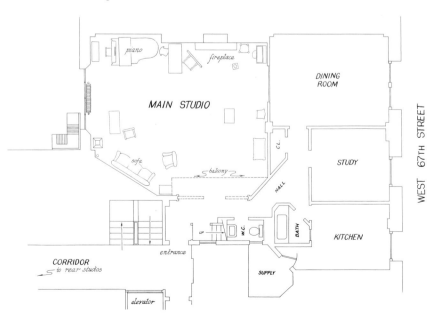

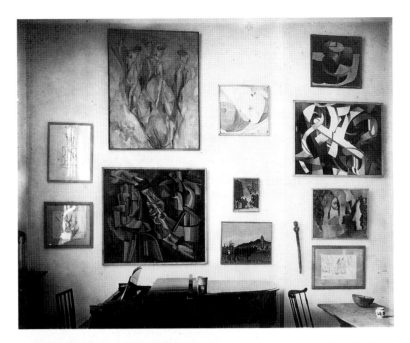

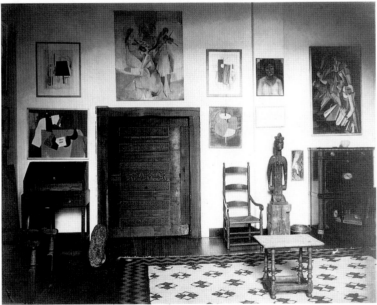

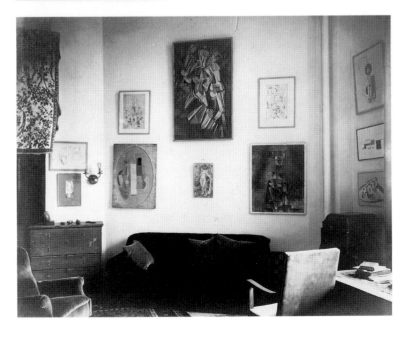

Modern Gallery and its successor, the de Zayas Gallery (1919–21). In their galleries, both Stieglitz and de Zayas displayed "primitive" artifacts alongside examples of modern art, a practice the Arensbergs repeated throughout the rooms of their New York apartment (note, opposite, for example, the African figure and Brancusi sculpture on opposite ends of the mantelpiece). It was from de Zayas that Arensberg purchased his first pre-Columbian sculpture in 1915 (the Aztec figure on the floor in front of the fireplace), and in later years, after their move from New York, the Arensbergs gathered one of the most important holdings of pre-Columbian art assembled by private collectors in America. The Arensbergs collected not only art, but as many of their friends from this period recalled, they collected the artists as well.

Frequently after dinner and the theater, the Arensbergs returned home to host their open house; friends arrived at almost any hour—usually unannounced—and stayed until the early morning hours, eating, drinking, listening to music, playing chess, and engaging in stimulating conversation. Over the course of five years—from 1915 through 1921—they created a literary and artistic salon that could be ranked in importance with the circle that had formed around Gertrude Stein and her brothers in Paris a few years earlier. Guests usually gathered around the fireplace in the impressively large studio (see plan, opposite), whose seventeen-foot-high walls were overcrowded with examples of the most recent expressions of the modern school. Around midnight, Lou would wheel out a cart laden with hors-d'oeuvres and desserts, and expectant artists would often use the opportunity to fill their stomachs (and pockets) discreetly in anticipation of hungry days to come.

At first, other than close personal friends, most visitors to the Arensberg apartment were Walter's literary associates—vanguard writers, poets, publishers, and magazine editors who had shared his interest and involvement in the modern poetry movement: Donald Evans (founder of the Marie Claire Press,

a short-lived publishing venture that gave Gertrude Stein her first American exposure), Allen and Louise Norton (a husband and wife team who edited *Rogue*, an ephemeral publication to which Arensberg often contributed), Wallace Stevens (an insurance lawyer and poet and one of Arensberg's former classmates from Harvard), Carl Van Vechten (a journalist who was then editor of *Trend*, a poetry review to which Arensberg also contributed), and Fania Marinoff (an actress who had just become Van Vechten's wife).[19] By the fall of 1915, this group was joined by a host of European artists—mostly French—émigrés who had come to America in an attempt to avoid the ravages of war that had engulfed their country.

The most important and influential of these was Marcel Duchamp, who arrived in New York during the summer of 1915 and, before long, became the center of attraction at the Arensberg gatherings. He was met at the pier by Walter Pach, who had been befriended by Duchamp and his brothers during his earlier sojourns in Europe, and with whom he had remained in contact.[20] After a brief stay at Pach's home on Beekman Place, Pach arranged for Duchamp to stay at the Arensberg apartment, which the French artist used temporarily as his resi-

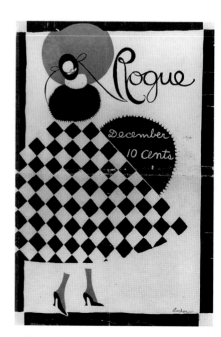

Robert Locher. Cover for Rogue,
December 1916

dence and studio while the collectors were away during the summer months at their country home in Pomfret Center, Connecticut.

Duchamp had been in America for only two weeks when Arensberg came down from his country home and invited the French artist to dinner in the restaurant of the Hotel Brevoort. At that time, the Brevoort—located in Greenwich Village on Fifth Avenue and Eighth Street—was a favorite meeting place for both New York's bohemian and upper-class *cognoscenti*. Because it was owned, managed, staffed, and frequented by expatriate Frenchmen, the hotel and its café were regarded by many as a slice of Paris transferred to New York. Arensberg and Duchamp were joined for dinner by Wallace Stevens, who, in a letter to his wife the next day, described the evening in characteristically poetic terms: "When the three of us spoke French," he reported, "it sounded like sparrows around a pool of water."[21]

Conversations at the Arensbergs' were intense, topical, and always engaging, ranging in subject from the current state of the arts to the rationality of Freudian analysis. As for the latter, informed and expert commentary was often provided by the noted psychiatrist Elmer Ernest Southard, another one of Arensberg's old friends from Harvard, who was then director of the Boston Psychopathic Hospital. On his frequent visits to New York, Southard often dropped in on the Arensberg soirées, where he was known to have asked guests to recall their dreams so that he could publicly submit them to analysis (an activity recorded in a sketch by Beatrice Wood; see p. 114). He also categorized the artists in attendance into "rounds, squares, and triangles," in accordance with the predominant shapes displayed in their paintings.[22] Through his visits to the Arensberg apartment, Southard developed such a keen interest in modern art that he composed a "psychopathic novelette" entitled "Mlle de l'escalier," where he recounted a conversation with Duchamp about his famous painting, *Nude Descending a Staircase* (see p. 16). "It is idle to explain it," Duchamp told

Southard. "I do not explain it. It is, after all, the fourth dimension."[23]

Walter especially enjoyed showing new guests the many paintings he had acquired, and on one occasion took special delight in explaining each piece in the collection to the famous Dolly Sisters, Hungarian-born twins who were well known in New York for their comic roles on the vaudeville stage and in silent movies. Other entertainers made their appearance at the Arensberg apartment as well; on one particularly lively evening, the dancer Isadora Duncan was responsible for the loss of Walter's front teeth! After having consumed more than her limit of champagne, with an overly affectionate parting embrace she brought her frail host to a face-first crash on the floor of his elevator. Another indulgent evening would see Arensberg battered again, when he, Duchamp, and some friends went out to a local bar and found themselves having to defend their lady friends from the taunts of several drunken bruisers. Walter was knocked down and Duchamp suffered quite a punch to the ear.[24]

Paul Sachs found the atmosphere at the Arensbergs most disagreeable: "[It was] a big and noisy apartment house, with people banging the piano above and below him, and it seemed to me incredible that he should have moved from Shady Hill."[25]

It is difficult to assess Louise Arensberg's participation in these activities. We know that she often played the piano for the entertainment of guests, but she did not drink and therefore took little part in her husband's alcoholic escapades. As a visitor to the apartment during these years later recalled, she was "a perfect dear, who, however, just could not acquire the knack of misbehaving, so always felt rather wistfully 'out-of-it.'"[26] Louise often visited friends and relatives in Boston, but when they came to see her in New York, she reportedly felt some embarrassment in discussing certain art objects in the apartment. To her puritanical friends, for example, she would provide a "straight" anatomical description of Brancusi's *Princess X*, pointing out the head, facial details, and shoul-

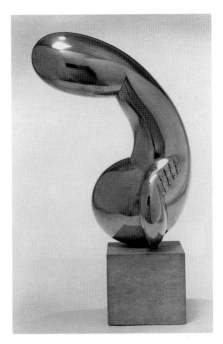

Constantin Brancusi. Princess X. *Formerly called* Portrait of Princess Bonaparte. *1916. Bronze, h.: 22″; limestone base, h.: 7 ¼″. Philadelphia Museum of Art. The Louise and Walter Arensberg Collection*

ders, but intentionally avoiding reference to its obviously phallic shape.[27]

Perhaps the best description of the spirit that pervaded the Arensbergs' is found in a poem by Allen Norton entitled "Walter's Room":

> *The * * * room*
> *Which Walter conceived one day*
> *Instead of walking with Pitts in the Park*
> *Or celebrating Sex on the Avenue*
>
> *Where people who lived in glass houses*
> *Threw stones connubially at one another;*
> *And the super pictures on the walls*
> *Had intercourse with the poems that were*
> * never written . . .*
>
> *Where I first saw Time in the Nude;*
> *Where I met Mme. Picabia;*
> *Where Christ would have had to sit down*
> *And Moses might have been born with*
> * propriety.*[28]

As the last lines of the second stanza indicate, there was an acknowledged interchange between modern painting and the new poetry.

Walter's interest in the latest literary experiments continued to attract many talented writers to his apartment. By

1916 many other noted American poets also made their way to these evening gatherings: Alfred Kreymborg, William Carlos Williams, Pitts Sanborn, Maxwell Bodenheim, and numerous others. It was in collaboration with Alfred Kreymborg, during an overnight discussion in his apartment, that Arensberg co-founded and agreed to supply the financial backing for a new poetry magazine to be called *Others.* Many of the magazine's first contributors are pictured in a photograph taken in April of 1916 at the home of William Carlos Williams in Rutherford, New Jersey (p. 30).[29] By this time, most members of the Others Group, as they had become known, had already made decisive breaks with the poetry of the newly formed Imagist movement. Imagism sought a poetic form that emphasized the direct treatment of subject as well as a careful and accurate selection of descriptive words and phrases to define narrative content.

It was no mere coincidence that the poets of the Others Group sought different methods of expression immediately following the revolution that had taken place in the visual arts. Williams, for example (though he later complained of having been snubbed by Duchamp one evening at the Arensberg apartment), admitted: "It was the French painters rather than the writers who influenced us, and their influence was very great. They created an atmosphere of release, color release, release from stereotyped forms, trite subjects."[30] Arensberg's radical departure from the standard poetic form that characterized his first book can be explained primarily by his understanding of the new art, particularly as its theories were revealed to him by the artist who can be seen affectionately clasping his arm in the photograph of the Others Group: Marcel Duchamp.

Just as the Cubists devised new ways to represent three-dimensional objects on a flat canvas surface, abandoning traditional methods of representation, the more revolutionary poets invented a completely new way to describe their subjects, discarding the traditional patterns and rhythms, and soon even the narrative sequence, which had been con-

sidered essential in preserving a poem's ability to convey meaningful content. Parallels between the new forms of literature and the most recent developments in the visual arts must have been a frequent topic of discussion at the apartment, and when the second volume of Arensberg's collected poems appeared in 1916 under the title *Idols,* a reviewer, Max Michelson, was quick to recognize the relationship between Arensberg's poetic form and the visual qualities of the new art.[31]

Most of the poems in *Idols* continued to be styled on the writings of Mallarmé (Arensberg received considerable praise for his translation of "L'Après-midi d'un Faune," which was included at the close of this volume). But his poem "Autobiographic," the most advanced to appear in this collection, was singled out by reviewers for its incomprehensible qualities and, as Michelson put it, for its similarity to "the mystical side of Cubism":

> *Permanently in a space that is anywhere here*
> *While I am I,*
> *I am temporarily*
> *Always now.*
>
> *And at the eternal*
> *Instant*
> *I look—*
> *The eye-glassed I*
> *At the not I, the opaque*
> *Others,*
> *Eye-glassed too.*
> *And I who see of them*
> *Only the glasses*
> *Looking,*
> *See of myself*
> *In looking-glasses·*
> *Faces*
> *Distorted.*
>
> * And throughout the transparent*
> *Spaciousness,*
> *Which is so extensively*
> *The present*
> *Point*
> *Located personally—*
> *A solid geometry*
> *Of vacancy*
> *Bounded by the infinite*
> *Absence,*
> *I*
> *Foreshorten*
> *To the end*
> *Of me . . .*
> *Walls and ceilings*

Of my cellular
Isolation
Wrecked by perspective,
Habitable cubes
Of static
Surfaces of plaster
Prolonged in flight.
And it is I who hold them back,
And it is I who let them go,
These gray planes plunging
In an emptiness
Blue,
These rampant sides of pyramids
That converge
To nothing

While I am I.

In this poem Arensberg describes the process by which he views the world around him, in a manner not unlike the way in which the Cubist painters fuse the disparate elements of their subjects into a single image. In the review of *Idols*, however, Michelson warned "that a color-symphony of Kandinsky's has some charm even for those who can not see in it what that painter expects them to see. While words without sense would of course be nonsense." But it was to exactly such a combination of seemingly sense-less words and phrases that the formal

structure of Arensberg's poetry would soon be directed. In his most radical works of this period, many of which were published in the somewhat obscure "lit-tle" magazines, Arensberg so emphasized the value of the words themselves that the physical appearance took precedence over narrative content.

One such poem, entitled "Partie d'échecs entre Picabia et Roché," appeared in a New York issue of Picabia's magazine *391* in August 1917, and anoth-er—perhaps the most radical poem Arensberg was ever to publish—was entitled "Vacuum Tires: A Formula for the Digestion of Figments," which appeared in the single issue of Man Ray's *TNT* in 1919. Despite the claim offered in the poem's title, no formula was provid-ed to assist the reader in deciphering the apparently random figments of words and phrases presented by the poem. Though arranged in a grammatically cor-rect sequence, the phrases present a multitude of variant thoughts and images that defy organization into a meaningful or coherent whole. The technique employed, therefore, goes even beyond the equivalent structure in Cubist paint-ing, whose subject matter, no matter

The Others Group. Front row, from left: Alanson Hartpence, Alfred Kreymborg, William Carlos Williams, Skip Cannell; back row: Jean Crotti, Marcel Duchamp, Walter Arensberg, Man Ray (?), R. A. Sanborn, Maxwell Bodenheim. 1916. Lockwood Memorial Library, State University of New York at Buffalo

how fragmented in presentation, usually consists of the analytical portrayal of a single image—be it a portrait by Picasso, or a still life by Braque.

The art critic Henry McBride felt that "Vacuum Tires" was too heavily depen-dent on the works of Gertrude Stein, whose writings, some felt, were sup-posed to be appreciated for "their inher-ent quality rather than for their accepted meaning."[32] But Arensberg was unsure of the importance of Stein's contribution to vanguard literature; in the summer of 1914, he wrote to Van Vechten: "Nothing that you said pleased me more than your saying 'Miss Stein has added enormously to the vagueness of the English language.' When you said that, you made the obvi-ous profound. But it is a vagueness which has still to be defined."[33]

Ironically, it was to precisely such a defined level of vagueness—in the

absolute sense—that Arensberg was to direct his most extreme poetic style. But, unlike the writings of Stein, which readers were asked to appreciate for their subconscious content, as well as for their cadence, rhythm, and pure sound, the harsh juxtaposition of discontinuous thoughts in Arensberg's most radical poems implies that he selected the phrases with the intention of avoiding the possibility of any aesthetic reading. In fact, in most cases, the phrases in these prose poems appear to have been taken from diverse contexts and arranged in an intentionally random sequence.

As could be expected, few understood what Arensberg was up to, either in his poetic endeavors, or as an art collector. When he saw the poems Arensberg published in *391*, William Ivins, another one of Arensberg's classmates from Harvard, immediately wrote to Paul Sachs chastising their old friend for going too far.

> [Arensberg is] a man who has gradually got so beside himself that he's no longer to be reckoned with by the likes of you and me, a man whose exasperated nerves and over-keenness, whose flying from the "obvious," has for the time being landed him in a metaphysical revulsional quagmire. Today he is what the French call a verbomane, a person for whom words are things to be arranged, just as some of the French of the period just before the war arranged pieces of newspapers and bits of rubber with old match boxes on a canvas and called it great painting. It was the natural result of having no hold on life and of life having no hold on him, of [a] financial, domestic, and social situation where "life" means nothing. The whole thing is aberrational, a case of virtuosity carried so far that it has lost all meaning and validity.[34]

Even though Arensberg's more radical poems appear—at least at face value—to contain no semblance of meaning, it is entirely possible that he carefully arranged for these compositions to be printed in such a way as to contain secret messages, cryptic communications between the author and his reader that could be discovered only by subjecting the poem's formal structure to some form of elaborate decipherment. Although no such messages were ever found in poems such as "Vacuum Tires," evidence that Arensberg may have used such a procedure comes from his unusual study of Renaissance literature; between 1915 and 1920, he spent the majority of his waking hours deciphering secret messages he believed were deliberately concealed by means of ciphers in the writings of Dante and Shakespeare. His interest in this arcane process—which can be traced back to his student days at Harvard (and which developed into a lifelong preoccupation)—became so intense, that, at times, Arensberg lost touch with the world around him, causing him to ignore basic daily needs and responsibilities. In March of 1921, for example, he told a federal court judge in New York City that he was so involved in a cryptograph in Dante, that he forgot to acknowledge a summons he had received to appear for jury duty. He was fined twenty-five dollars.[35]

The subject of cryptography must have come up often at the Arensberg gatherings, for it was during these years in New York that he prepared the publication of his two most controversial books: *The Cryptography of Dante*, which appeared in 1921, on the occasion of the six-hundredth anniversary of Dante's death, and *The Cryptography of Shakespeare*, published the following year.[36] In both of these books, Arensberg presented his discovery of secret messages that he believed were cryptically encoded within the writings of these Renaissance authors. In the case of Dante, he thought that this procedure could be used to unveil the fundamental symbolism of the *Divina Commedia*; in the case of Shakespeare's plays, he attempted to prove that by means of cryptic signatures hidden throughout the texts of the original folio publications, he could prove that Francis Bacon was actually their true author.

Arensberg utilized basically four types of cryptographic structures: the simple pun, the acrostic, the anagram, and something he termed "the anagrammatic acrostic." In the acrostic, a single word or sequence of words is identified utilizing only letters found at the extremity of consecutive units of text. Even if the letters do not fall into the proper sequence, they can be—utilizing Arensberg's application of the acrostic—conveniently rearranged. An example of this procedure can be found in the following passage from Bacon's *The Advancement of Learning*:

> **B**ut this precept touching the politicke knowledge of
> **o**ur selues hath many other branches whereupon we
> **c**annot insist:
> **N**ext to the wellvnderstanding and discerning of
> **a** mans selfe, there followeth the well opening and . . .

Reading only the initial letters of each line, we have: **BocNa**; transposing these letters as in the use of a simple anagram, we have: **BacoN**. Since this process required the reading of marginal letters, as in an acrostic, as well as a transposition of letters, as in an anagram, Arensberg appropriately called this "the anagrammatic acrostic."

A well-known acrostic cited by Arensberg from the *Divina Commedia* can be found in its opening stanza:

> **N**el mezzo del cammin di nostra vita
> Mi ritrovai per una selva oscura,
> Che la diritta via era smarrita.
> **A**hi quanto a dir qual era è cosa dura
> Questa selva selvaggia ed aspra e forte
> Che nel pensier rinnuova la paura!
> **T**anto è amara, che poco è piu morte:
> Ma per trattar del ben ch'i'vi trovai,
> Diro dell'altre cose ch'io v'ho scorte.
> **I**'non so ben ridir com'io v'entrai;
> Tant'era pien di sonno in su quel punto,
> Che la verace via abbandonai.

The marginal letters of the first four *terzine* (highlighted in the passage) spell out the word **NATI**, the plural form of the past participle of the Italian verb *nascere*: to be born.

Arensberg then interpreted what he believed was the significance of **NATI**. It not only announces the opening, or birth of the book, but was, he believed, a pronouncement of Dante's moral rebirth into divine life. According to Arensberg,

the entire text of this epic trilogy reenacts various aspects of the primitive mother cult, where, in this case, Dante is reunited in memory with his mother, Bella, whom he had lost in childhood. Bella is then identified with Beatrice, Dante's spiritual love, traditionally the poem's *donna angelicata*. Beatrice herself is later seen to symbolize the Virgin Mary, thus alluding to Dante's identification with Christ. Arensberg finds this elaborate Freudian analysis to be supported by cryptographic evidence concealed throughout the text. That Dante's mother, Bella, is to be identified with Beatrice, for example, is found in a pun on both names in the second Canto of the *Inferno*, where Virgil speaks to Dante: "E donna me chiamo *beata* e *bella*"; "beata" refers to Beatrice, and "bella" to Dante's mother.

Arensberg suggests that hell, purgatory, and paradise represent physical aspects of Dante's mother's reproductive organs, through which Dante was first born, and which, through an act of incestuous love, he is destined (like Christ) to be born again. It was the sexual symbolism—a topic Arensberg planned to explore more fully in a subsequent volume—that critics found most offensive.

The *New York Evening Journal*, for example, devoted an entire page to an attack on Arensberg's theories. Its reviewer asserted that in due course, *The Cryptography of Dante* would become "the foremost literary scandal of modern times." Describing the reaction of other critics, he went on to say: "Walter Arensberg's volume has exploded like a noxious gas bomb at a sacred symphony." A critic for *The Literary Review* noted: "The writer of the 'Divine Comedy' was not a gynecologist; he was a poet."[37] And in an article appropriately entitled "The Dadaistic Dante," another reviewer insightfully suggested that Arensberg's convoluted analyses might better be applied to the works of Picabia and Duchamp: "He [Arensberg] reads Dante as he would read Picabia; and the 'Comedy' turns out in his hands, a maze of points and oblongs, of convexes and concaves—symbolical all, to be sure—like a new Nude Descending the Stairs."[38]

As one could easily imagine, Arensberg's publications failed to gain any degree of recognition from the conservative literary establishment. But as the last reviewer suggests, his cryptographic studies had certain parallels in the most recent expressions in the visual arts.

In August 1920, the Arensbergs took their first extended trip to California and, a few years later, made the decision to settle there permanently. Duchamp found the news of their move particularly distressing, and in November 1922, he wrote to them: "Your letters announced some pretty sad things—Aren't you coming back to N.Y. at all? Staying in California? Very depressing." And, in an unusually early example of the now familiar East-West rivalry, he asked: "What could you be doing 24 hours a day in California [?]—nature must repeat itself quite often."[39]

The reason for the Arensbergs' departure from New York is uncertain, though we know that Louise reportedly sought relief from the endless evenings of entertainment. The discovery of mutual infidelities doubtlessly also contributed to their decision; in September 1919, Louise revealed to her husband that for two years, she had been having an affair with Duchamp's friend Henri-Pierre Roché. Although she had permitted her husband to have affairs of his own (he seems to have had at least one, with Yvonne Crotti), in a classic example of the double standard, this was more than Arensberg could accept. He threatened suicide. She, in fear, agreed to end it, but for the remaining years of their lives, whenever the name Roché came up among friends, it was followed only by silence.[40]

Louise Arensberg also complained about the way her husband spent *her* money (her family wealth far outweighing his), complaints that were apparently justified, for Walter made many poor investments, and he lent large sums of money to friends who made little or no effort to repay. The results were that by the early 1920s, the Arensbergs began to experience serious financial reversals. Much of their collection was put into storage, while they were forced to make certain

works available for sale. Few works, however, were actually sold. The collector John Quinn purchased a small Brancusi sculpture and a Rousseau portrait, while Katherine Dreier paid two thousand dollars for Duchamp's *Large Glass*,[41] which the Arensbergs sold primarily for fear it would have been damaged if shipped to California (ironically, the *Glass* did break when being returned to storage after its first public showing in 1926 at the International Exhibition of Modern Art in Brooklyn).

With the Arensbergs living in California, the avant-garde community of New York lost not only the vitality supplied by two of its most active members, but was also deprived of the support of one of its most generous patrons. Katherine Dreier expressed precisely these sentiments in 1925, when she wrote to Walter Arensberg requesting support for her museum: "I do hope . . . you are again in the financial position to give to the movement of Modern Art the aid which made you of such tremendous value in New York and which has caused all lovers of Modern Art to regret your leaving."[42]

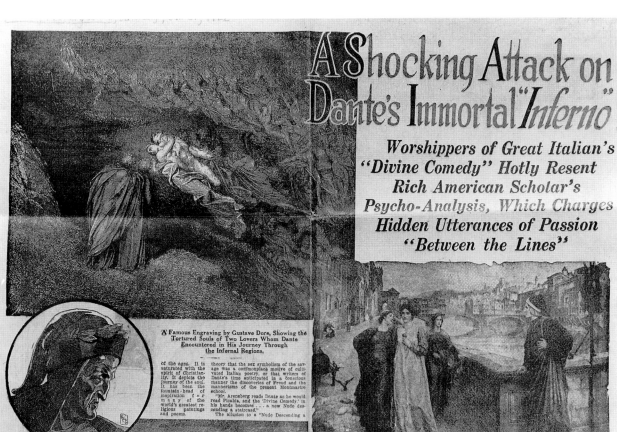

"A Shocking Attack on Dante's Immortal 'Inferno,'"
New York Evening Journal, *January 21, 1922.*
Courtesy Arensberg Archives, The Francis Bacon
Library, Claremont, CA

3 • MARCEL DUCHAMP

When the SS *Rochambeau* steamed into New York harbor on June 15, 1915, it carried aboard an impressionable twenty-seven-year-old artist, who, like many of his fellow passengers, must have seen the Manhattan skyline gently unfold before his eyes as he wondered exactly what the New World held for him. It would be natural to assume that Duchamp came to America in order to capitalize on his earlier successes at the Armory Show, but nothing could be further from the truth. He came for quite the contrary purpose: to free himself from the expectations of an artistic life. "I do not go to New York," he emphasized in a letter to Walter Pach written just a few weeks before his departure, "I leave Paris."[1]

Ever since his friends and fellow painters had urged him to withdraw his painting of a descending nude from the Indépendants' exhibition of 1912, Duchamp had little reason to expect that his colleagues—who included his two brothers—would ever understand his more iconoclastic inclinations. Pach, on the other hand, had selected this very painting for inclusion in the Armory Show, and not only did it find a buyer, but all four of Duchamp's pictures sold. It would have been natural, consequently, for Duchamp to identify Pach as the principal source of his liberation, the one person in America who could perhaps be most effective in helping to remove him

from the stifling, entrenched art scene of Paris. So he wrote Pach and informed him of his intentions, and asked if he could help to find a small job to cover his living expenses. "I am afraid to end up being in need to sell canvases," he explained to Pach, "in other words, to be a society painter."[2]

An examination of the SS *Rochambeau's* manifest provides a fairly accurate physical description of its illustrious passenger: "Marcel Henri Duchamp, age 28 [*sic*], single, artist painter, 5' 10" tall, fair complexion, brown hair, chestnut eyes, citizen of France."[3] But what this document does not provide are two words that inevitably came to mind when people met the man himself: "handsome" and "charming." This, at least, was the consensus expressed by a host of New York journalists who managed to find Duchamp and conduct interviews with him: "He has red hair," wrote one reporter, "blue [*sic*] eyes, a face . . . and a figure that would seem American even among Americans."[4] And a reporter for the *New York Tribune* reported that he "dresses most correctly in the mode, and is quite handsome," noting: "One would take him for a well-groomed Englishman rather than a Frenchman."[5]

Indeed, Duchamp hardly had the appearance of the impoverished artist, preferring, instead, to look like a hard-working professional, more the serious scientist than the disheveled painter. In a

publicity photograph taken a few months after his arrival (see p. 35, a portrait prepared by the Pach Brothers Studio, a firm belonging to Walter Pach's father), Duchamp appears exceptionally well dressed, his hair neatly parted, and he sports a fashionable polka-dot bow tie. He stares directly into the camera, his intense gaze relaying some sense of his profound intellect, conveying the impression that this is an artist who clearly contradicts the old French saying: "Bête comme un peintre" ("Stupid as a painter").

Duchamp had known Pach for about five or six years, from the time when Pach lived in Paris just before the First World War. They had been corresponding since the Armory Show, and aboard ship, it was Pach's address that Duchamp listed as his destination in America. Pach was probably the only person to greet Duchamp upon his arrival. He apparently took him directly to his apartment on Beekman Place, but because the space was limited (his wife had given birth to their first child just six months earlier), he arranged for Duchamp to stay at the home of Walter and Louise Arensberg.[6]

There, over the course of the next two to three months, the artist and his

"The Nude-Descending-a-Staircase Man Surveys Us," New York Tribune, September 12, 1915. Yale Collection of American Literature, Beinecke Rare Book and Manuscript Library, Yale University, New Haven. Papers of Henry McBride

collectors would establish a friendship and working rapport that was to last the rest of their lives. For Duchamp, the Arensbergs represented his most devoted American patrons; for the Arensbergs, Duchamp was to become their most trusted adviser and confidant. During these years in New York their mutually beneficial exchange went even further, affecting, in some cases—as we shall see—the creative production of both the artist and his patrons.

Duchamp's first interviews with the American press did not appear for some two to three months after his arrival, perhaps because, before accepting questions from reporters, he wanted to gain a more secure grasp of the English language, of which he spoke almost nothing upon his arrival. In the earliest article to appear in the New York papers, the artist himself is pictured (perhaps from a snapshot taken aboard ship) comfortably reclining on a deck chair, while his thoughts concerning American art and American women are prominently displayed in the surrounding columns of print.[7] The reporter writes that he was surprised to find the painter of the infamous *Nude Descending a Staircase* such a calm, collected, and retiring individual, "given [more] to listening to the views of those about him than speaking of his own." Nevertheless, even though he had not yet spent three months in this country, Duchamp was willing to provide the American public with a spirited and

apparently personally informed account of American art and American women. "The American woman is the most intelligent woman in the world today," he said, "the only one that always knows what she wants, and therefore always gets it."

In this same interview, Duchamp went on to denounce America's reliance on European tradition. "If only America would realize that the art of Europe is finished—dead," he said, "and that America is the country of the art of the future." He then declared the skyscraper a more beautiful object than anything Europe had to offer. "I have been trying to get a studio in one of their highest turrets," he said, "but unfortunately I find people are not permitted to live in them." Duchamp was not only impressed by the grandeur of American architecture, but also with the way in which New Yorkers readily accepted the destruction of old buildings to make space for the new. He expounded on this very point in an interview with an editor of the magazine *Arts & Decoration*:

New York itself is a work of art, a complete work of art. Its growth is harmonious, like the growth of ripples that come on the water when a stone has been thrown into it. And I believe that your idea of demolishing old buildings, old souvenirs, is fine. It is in line with that so much misunderstood manifesto issued by the Italian Futurists which demanded, in symbol only however, though it was taken literally, the destruction of the

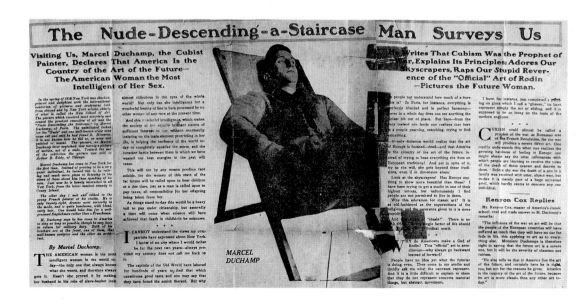

museums and libraries. The dead should not be permitted to be so much stronger than the living. We must learn to forget the past, to live our own lives in our own time.[8]

"I came over here," he explained to another interviewer, "not because I couldn't paint at home, but because I hadn't any one to talk with."[9] After the outbreak of war, most of his friends had been mobilized, and he explained that the cafés and usual night spots for which Paris was famous had all been closed. When asked to comment on the war, he had no reservations about expressing his pacifist position: "What an absurd thing such a conception of patriotism is," he exclaimed. "Personally I must say I admire the attitude of combating invasion with folded arms." In his first interview with the *Tribune*, he said that he thought the war would have a decisive effect on the art of the future: "Cubism could almost be called a prophet of the war, as Rousseau was of the French Revolution, for the war will produce a severe direct art."

Duchamp's remarks on the art of the future must have been considered so extreme and controversial that the paper's editors felt they necessitated the presentation of a counter, or opposing view. They solicited a rejoinder from the arch-conservative artist and critic Kenyon Cox, who, predictably, proceeded to misinterpret Duchamp's statements: "Monsieur Duchamps [*sic*] is . . . right in saying that the future art is a severe one," he

wrote, "but it will be the severity of classi[ci]sm not cubism." But the "severe" art of which Duchamp spoke was not Cubism; at this point, he was—as we shall see—already two steps ahead of Cox, who regarded Cubism as the ultimate manifestation of the modern school.

In nearly all of his interviews, Duchamp condemned the attention and respect that had been accorded the art of the past—including his own—a staunch defiance of tradition that caused several journalists to label him an "iconoclast." He was repeatedly asked to comment on the *Nude Descending a Staircase*, which had made such an unforgettable impression at the Armory Show. In fact, just a month before Duchamp's arrival, it was lampooned again in an amusing cartoon by Robert Locher of two shy nudes on a staircase, appropriately entitled "Prudes Descending a Staircase." But Duchamp preferred not to discuss his earlier work. "I am interested in what there is to do," he told Alfred Kreymborg, "not in what I have done."[10] And he was particularly scornful of those who used the word *Cubism* indiscriminately. "They call Picasso the leader of the cubists," he explained, "but he is not a cubist strictly speaking. He is a cubist to-day—something else tomorrow. The only cubists to-day are Gleizes and Metzinger." His words were even harsher for the imitators of Cubism: "Now we have a lot of little cubists," he said, "monkeys following the motions of

the leader without comprehension of their significance."[11] In these same interviews, he consistently acknowledged a debt to Cézanne, but he identified Seurat as "the greatest scientific spirit of the nineteenth century." In Duchamp's opinion, Seurat "saw deeper and more prophetically into concrete objects and their nature than did Cézanne." He predicted that the art of the future would be "still more abstract, more cold, more scientific."[12]

If these were to be the identifying characteristics of the art of the future, then by the time he arrived in America, Duchamp must have considered his own work to be well ahead of its time. In fact, even before he set foot in this country, representative examples of his new mechanical work had been placed on exhibition in New York. Some three months before his arrival, he sent Pach both versions of his *Chocolate Grinder*, and the paintings were shown in March 1915, in an "Exhibition of Contemporary French Art" at the Carroll Galleries in New York.[13] In retrospect, these mechanical images can be considered among Duchamp's most important works of these years, for not only are they his first significant departure from the pictorial vocabulary of Cubism, but they are among the earliest examples of his work made in a conscious effort to defy the conventions of taste, the kind of judgmental reactions he sought to avoid. "He did not want his taste to intervene," a

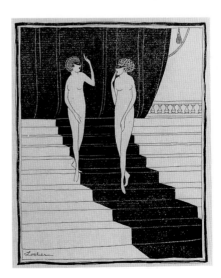

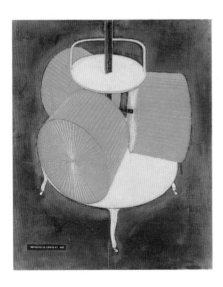

Robert Locher. "Prudes Descending a Staircase," Rogue, *May 15, 1915*

Marcel Duchamp. Chocolate Grinder, No. 2. *1914. Oil, thread, and pencil on canvas, 25 ½ x 21 ¼". Philadelphia Museum of Art. The Louise and Walter Arensberg Collection*

friend from this period recalled years later, let alone any facility of the hand. "That was anathema to him."[14] Duchamp himself later explained that he chose the technique of mechanical drawing because it "upholds no taste, since it is outside all pictorial convention."[15] "I wanted things to get on the surface [of] the canvas by themselves," he said of his paintings of this period, "from my subconscious if possible."[16]

The *Chocolate Grinder* was one of several mechanical images that Duchamp incorporated into the composition of his masterwork from these years, *The Bride Stripped Bare by Her Bachelors, Even*, a painting on the surface of two large rectangular plates of glass—one placed directly above the other—more commonly referred to as the *Large Glass*. Intricate notes for this work had been in preparation for three years, and several studies were completed in France before Duchamp's departure, but its actual construction was not begun until shortly after his arrival in New York. Years later, he explained that the idea for this work came from the games he had seen at country fairs, where, in order to win a prize, contestants throw balls at the figure of a bride and her surrounding retinue.[17] Although this may have been the initial source of inspiration for its subject, some scholars have chosen to interpret the *Large Glass* as a more personal and self-referential statement, pointing out, for example, that the French title contains an amalgam of Duchamp's first name: *MAR*[iée] (bride) / *CEL*[ibataires] (bachelors).[18]

From the time the *Large Glass* was conceived, and throughout the period of its physical construction, Duchamp kept a series of elaborate and detailed notes referring to every facet of its iconography and production. Initially, he wanted these notes to be compiled and made available to viewers in the form of a catalogue attached to the *Large Glass* itself, a sort of literary guide that was to be consulted in order to follow the workings of its individual elements in a step-by-step fashion. Though this catalogue never materialized, Duchamp's notes have survived. They never inform us whether or not the

Bride in the upper section of the glass ever attains union with her sexually aroused Bachelors (represented by the nine moldlike figures below). What is clear is that the pseudomachinery of this elaborate construction is designed with one primary function in mind: to exercise the rites of courtship and lovemaking.

According to the notes, it is the Bride's desire that stimulates the Bachelors, which causes the flow of "illuminating gas" into their moldlike bodies. They, in turn, seem to receive a constant source of energy from the flow of an "imaginary waterfall," which descends upon the blades of a water-mill wheel within a "glider" or "sleigh" attached to the base of the chocolate grinder in the immediate central foreground. While emitting a monotonous litany, this glider slides back and forth, inducing the gas to flow through a series of "capillary tubes" to the base of seven conic-shaped "sieves." As the gas passes through these sieves, it solidifies into "spangles of frosted gas,"

before being transformed into a liquid substance that descends into the area of the "splash" (in the lower right corner of the Bachelors section). The drops from this liquid substance are then "dazzled," propelled upward at great speed through the centers of the Oculist Witnesses and a magnifying glass before reaching the domain of the Bride. These drops scatter into "nine shots" (one for each Malic Mold or Bachelor), but none of these shots—whose positions were determined by the chance firing of matches from a toy cannon—actually strikes the body of the Bride (only one penetrates her "cinematic blossoming," the large cloudlike formation at the top). The fact that these drops manage to miss their mark, after such a long and arduous jour-

Marcel Duchamp. The Bride Stripped Bare by Her Bachelors, Even, *or* Large Glass. *1915–23. Oil and lead wire on glass, 109 ¼ x 69 ⅛". Philadelphia Museum of Art. Bequest of Katherine S. Dreier*

ney, compounds the observer's initial sense of futility. Of course, none of the elements in this fanciful construction was meant to "function"—either literally or figuratively—and the ultimate lack of fulfillment is just one more intentionally frustrating aspect of its design.[19]

In his first interview for the *Tribune*, Duchamp described a study for a section of the *Glass* he had just completed, a work whose mechanical execution and untraditional materials clearly represented a departure from the Cubist paintings that had made him famous. "I have, for instance, just completed a painting on glass which I call a 'glissoir,' its lines represent simply the act of sliding, and it is supposed to be an irony on the feats of the modern engineer." This "glissoir," whose full title is *Water Mill Within Glider (in Neighboring Metals)*, was one of three glass constructions that Duchamp brought with him to New York. Most who saw these works found them utterly incomprehensible. Kreymborg thought that another study for the glass looked like "mannikins," noting that the results might be thought of by some as representing "the mad cross purposes of a dressmaker." And earlier, a critic who had seen both versions of the *Chocolate Grinder* on display at the Carroll Galleries said that these paintings looked like "two engines for grinding chocolate impeccably drawn and colored as if for a machinery catalogue," and he went on to question their artistic merit, asserting, "it is not easy to take seriously as 'Art' two such mechanical evocations."[20]

If people found these works difficult to accept as art, we can only imagine what they would have thought of Duchamp's readymades, commonplace prefabricated objects, isolated from their functional context and, with or without alteration, elevated to the status of art by a mere act of declaration. Although Duchamp had brought his first readymade into being two years earlier in Paris—when he mounted an inverted bicycle wheel onto the seat of an ordinary kitchen stool (p. 40)—it was only after settling in New York that he came up with a name for these unusual artistic creations. Within a few months of his arrival, he

Marcel Duchamp. Water Mill Within Glider (in Neighboring Metals). *1913–15. Oil and lead wire on glass, 60 ¼ x 33". Philadelphia Museum of Art. The Louise and Walter Arensberg Collection*

walked into a hardware store on Columbus Avenue and purchased a snow shovel, brought it to his studio, and added the inscription: "In Advance of the Broken Arm / [from] Marcel Duchamp." The word *from* enclosed in brackets was intended to make it clear that Duchamp wanted observers to know that this item had come *from* him, rather than having been made *by* him. He then hung the snow shovel from the ceiling of his studio (p. 41), thereby completing the action necessary for the creation of an item that would later be classified as the first American readymade. Important as these curious artifacts certainly were in the general history of twentieth-century art, most visitors to Duchamp's studio ignored them. If anyone took notice, Duchamp usually dismissed their significance, saying only: "Cela n'a pas d'importance."[21]

Of course, Duchamp knew that the concept of the readymade was not something everyone would be willing to

accept, not even those who professed to embrace the most advanced notions of modern art. If an ordinary object could be declared a work of art, most would have reasoned, then by inference, why couldn't virtually everything be considered art?—a question that continues to be the main objection for countless critics and historians who still reject the importance of these objects even today. As if in response to these arguments, Duchamp decided almost immediately to establish certain criteria and rules to govern the selection of readymades: "Limit the numb. of rdymades / yearly (?)," he wrote on a scrap of paper.[22] And later he explained that "the choice of these 'Readymades' was based on a reaction of visual indifference . . . a total absence of good or bad taste . . . a complete anes-

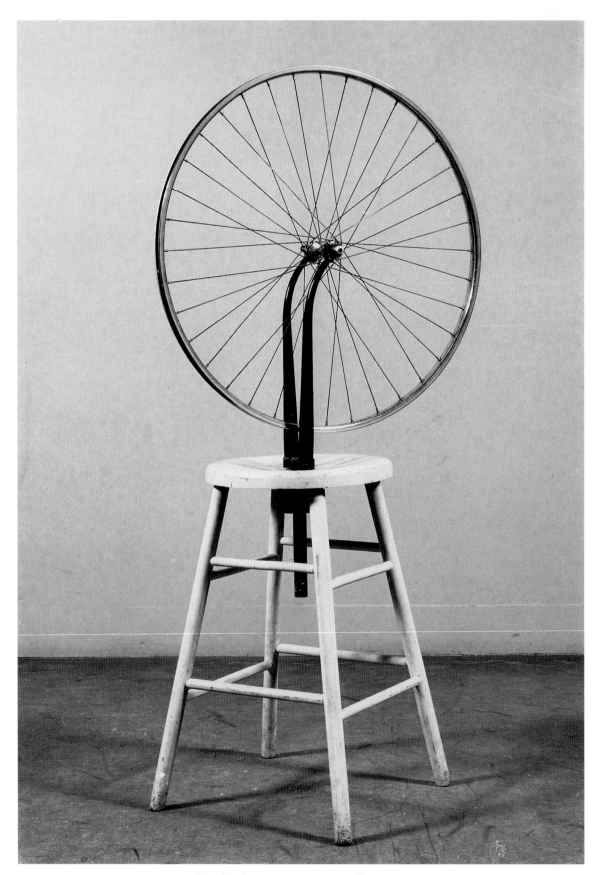

Marcel Duchamp. Bicycle Wheel. 1913. (New York, 1951; third version, after lost original). Assemblage: metal wheel, 25 ¹/₂″ d., mounted on painted wood stool, 23 ³/₄″ h.; overall, 50 ¹/₂″ h. The Museum of Modern Art, New York. The Sidney and Harriet Janis Collection

thesia."[23] He also wanted the inscriptions added to these items not to be interpreted literally. "Don't try too hard to understand it in the Romantic or Impressionist or Cubist sense," he wrote in a letter to his sister Suzanne, after telling her what he had written on the snow shovel; "that does not have any connection with it."[24] And whether he was conscious of his operational methods at the time or not, the selection and design of each successive readymade was significantly different from those that had preceded it—both from the standpoint of technique (in regard to their physical composition; thus, later, the need for such terms as "assisted," "rectified," etc., to describe them) and of iconography (as they related to Duchamp's interests and other work). Years later, he explained: "The readymade can be seen as a sort of irony, or an attempt at showing the futility of trying to define art."[25]

When he had been in New York only a few months, Duchamp seems to have extended his idea of a readymade to include even words, oral and written symbols of communication which, for a person who barely spoke the language, must have taken on a unique physical presence, a sort of literal manifestation of the object or objects that these words were intended to signify. And for one trying to master English—especially for one whose native tongue is French (or, for that matter, any other Romance language)—it must come somewhat as a relief to be informed that articles do not change according to the number or gender of the noun they modify. If the article "the" never changes its identity, Duchamp must have reasoned, then one could readily replace it with any abstract sign or symbol, which is precisely what he did when composing the text for his first published prose work (p. 42), completed just a few weeks after his arrival in America.[26] In reading this piece, readers were asked to substitute the article "the" for every appearance of an asterisk in the text. But even if we follow Duchamp's instructions, we are still left with a series of meaningless sentences, gaining information that does nothing to enhance our understanding of the text,

which—like the titles he had given to the readymades—was composed with the conscious intention of carrying no meaning.

In a similar spirit, a few months later he mailed the Arensbergs a series of four postcards which were comprised of a series of random phrases that were,

Marcel Duchamp. In Advance of the Broken Arm. *1915. Readymade: snow shovel. Original lost or discarded. Photograph from* Box in a Valise, *1941–42. Gelatin silver print: 5 ¾ x 2 ¾". Philadelphia Museum of Art. The Louise and Walter Arensberg Collection*

The

If you come into ✱ linen, your time is thirsty because ✱ ink saw some wood intelligent enough to get giddiness from a sister. However, even it should be smilable to shut ✱ hair ✱ which ✱ water writes always plural, they have avoided ✱ frequency, meaning mother in law; ✱ powder will take a chance; and ✱ road could try. But after somebody brought any multiplication as soon as ✱ stamp was out, a great many cords refused to go through. Around ✱ wire's people, who will be able to sweeten ✱ rug that is to say why must every petents look for a wife? Pushing four dangers near ✱ listening-place, ✱ vacation had not dug absolutely nor this likeness has eaten.

remplacer chaque ✱ par le mot: the

Marcel Duchamp. The. *1915. India ink and pencil manuscript, 8 ¾ x 5 ⅝". Philadelphia Museum of Art. The Louise and Walter Arensberg Collection*

Marcel Duchamp. Rendez-vous du Dimanche 6 février 1916. (Appointment on Sunday, February 6) *1916. Typewritten text on four postcards taped together, 11 ¼ x 6 ½". Philadelphia Museum of Art. The Louise and Walter Arensberg Collection*

again, intended to contain no semblance of meaning. Duchamp later explained the procedure he employed: "The construction was very painful in a way, because the minute I *did* think of a verb to add to the subject, I would very often see a meaning and immediately I saw a meaning I would cross out the verb and change it, until, working it out for quite a number of hours, the text finally read without any echo of the physical world.... That was the main point in it."[27] The resultant text bears a remarkable similarity to the method Arensberg employed in trying to discover secret messages in Renaissance texts, an affinity that might not have been altogether coincidental. And Duchamp admired Arensberg's more radical poems. "They are the only things one can read these days," he told Arensberg; everything else is just "literature."[28]

The influence of Arensberg's cryptographic studies is most clearly apparent in Duchamp's *With Hidden Noise*, a small readymade from 1916 consisting of a ball of twine secured by four long bolts between two brass plates, a work that could almost be considered the product of a collaboration between the artist and his patron. Its title, for example, was derived from the fact that just before its completion, Arensberg put something secret—hidden—into the ball of twine, so that the finished object makes a mysterious sound when shaken (Arensberg told no one what the object was, not even Duchamp, who said that he did not want to know). But Arensberg's influence is even more evident in the inscriptions Duchamp provided on the surface of both brass plates. Within the format of a three-line grid, Duchamp painted a series of uncompleted French and English words, their missing letters—represented by points—to be determined by follow-ing the instructions Duchamp provided: "Replace each point by a letter / Suitably selected from the same column." The resultant deciphering process is almost identical to the technique required by the "anagrammatic acrostic," the most unusual cryptographic cipher of Arens-berg's invention and design. Yet even when we follow Duchamp's instructions, the resultant text makes no sense, sug-gesting, perhaps, that Duchamp was expressing a subtle (though at the same time direct and literal) opinion of his patron's unremitting obsession with such a bizarre, arcane literary pursuit. Years later Duchamp admitted that he consid-ered Arensberg's cryptographic studies of little value: "It was the conviction of a

-toir. On manquera, à la fois, de moins qu'avant cinq élections et aussi quelque accointance avec q--uatre petites bêtes; il faut oc--cuper ce délice afin d'en décli--ner toute responsabilité. Après douze photos, notre hésitation de--vant vingt fibres était compréh--ensible; même le pire accrochage demande coins porte-bonheur sans compter interdiction aux lins: C--omment ne pas épouser son moind--re opticien plutôt que supporter leurs mèches? Non, décidément, der--rière ta canne se cachent marbr--ures puis tire-bouchon. "Cepend--ant, avouèrent-ils, pourquoi viss--er, indisposer? Les autres ont p--ris démangeaisons pour construi--re, par douzaines, ses lacements. Dieu sait si nous avons besoin, q--uoique nombreux mangeurs, dans un défalquage." Défense donc au tri--ple, quand j'ourlerai, dis je, pr-

-onent, après avoir fini votre gâ--ne. N'empêche que le fait d'éte--indre six boutons l'un ses autr--es paraît (sauf si, lui, tourne a--utour) faire culbuter les bouto--nnières. Reste à choisir: de lo--ngues, fortes, extensibles défect--ions trouées par trois filets u--sés, ou bien, la seule enveloppe pour éte-ndre. Avez vous accepté des manches? Pouvais tu prendre sa file? Peut-être devons nous a--ttendre mon pilotis, en même tem--ps ma difficulté; avec ces chos--es là, impossible ajouter une hu--itième laisse. Sur trente misé--rables postes deux actuels veul--ent errer, remboursés civiquement, refusent toute compensation hors leur sphère. Pendant combien, pou--rquoi comment, limitera-t-on min--ce étiage? autrement dit: clous refroidissent lorsque beaucoup p--lissent enfin derrière, contenant

-este pour les profits, devant le--squels et, par précaution à prop--os, elle défonce desserts, même c--eux qu'il est défendu de nouer. Ensuite, sept ou huit poteaux boi--vent quelques conséquences main--tenant appointées; ne pas oubli--er, entre parenthèses, que sans l--économat, puis avec mainte sembl--able occasion, reviennent quatre fois leurs énormes limes; quoi! alors, si la férocité débouche der--rière son propre tapis. Dès dem--ain j'aurai enfin mis exactemen--t des piles là où plusieurs fen--dent, acceptent quoique mandant le pourtour. D'abord, piquait on ligues sur bouteilles, malgré le--ur importance dans cent séréni--tés? Une liquide algarade, après semaines dénonciatrices, va en y détester ta valise car un bord suffit. Nous sommes actuellement assez essuyés, voyez quel désarroi

porte, dès maintenant par grande quantité, pourront faire valoir l--e clan oblong qui, sans ôter auc--un traversin ni contourner moin--s de grelots, va remettre. Deux fois seulement, tout élève voudra--it traire, quand il facilite la bascule disséminée; mais, comme q--uelqu'un démonte puis avale des déchirements nains nombreux, soi compris, on est obligé d'entamer plusieurs grandes horloges pour obtenir un tiroir à bas âge. Co--nclusion: après maints efforts en vue du peigne, quel dommage! tous les fourreurs sont partis e--t signifient riz. Aucune deman--de ne nettoie l'ignorant ou sc--ié teneur; toutefois, étant don--nées quelques cages, c'eut une profonde émotion qu'éxécutent t--outes colles alitées. Tenues, v--ous auriez manqué si s'était t--rouvée là quelque prononciation

man at play," he explained. "Arensberg twisted words to make them say what he wanted."[29]

After staying a few months with the Arensbergs, Duchamp took a studio in the Lincoln Arcade Building, a structure composed almost entirely of artists' studios on Broadway at Sixty-sixth Street, just a block away from the Arensberg apartment. Here, he continued to work slowly but methodically on the *Large Glass*, reviewing notes he had written in Paris and, whenever the mood to work struck him, adding details to the surface of the two large glass panels. At first, it seems, he aspired to complete it quickly. "I spend these free days in working hard," he told John Quinn, an important early collector of his work. "I have almost finished that big glass you have seen when I began it."[30] Duchamp also continued to issue occasional readymades—from a dog comb bearing a cryptic inscription, to a tin chimney ventilator he entitled "Pulled at Four Pins" (a literal translation of the French idiomatic expression *tiré à quatre épingles*, meaning "impeccably groomed"). He renewed his acquaintance with some old friends from Paris, artists who, like himself, had left their homeland to avoid involvement with the war.

Almost immediately, the American press took notice of the mass migration and predicted (as it turns out, accurately) that the influx of European artists would have a decisive effect on the future development of American art. In October of 1915, the *New York Tribune* ran a full-page article entitled "French Artists Spur on American Art," featuring interviews with Duchamp, Albert Gleizes, Marius de Zayas, Picabia, Jean Crotti, and the American sculptor Frederick MacMonnies. Crotti closely echoed the philosophy of his friend and studio mate, Duchamp, when he told the reporter that he was no longer concerned with an art that dealt with mere facile representation: "It is not nature that concerns me," he proclaimed, "but ideas."[31] This, of course, was precisely the position professed by Duchamp. "I was interested in ideas," he later said of this period, "not merely visual products. I

wanted to put painting once again at the service of the mind."[32]

Duchamp and Crotti were soon given the opportunity to put their conceptual ideals to the test when they, with Gleizes and Metzinger, were shown together in an exhibition of modern art at the Montross Gallery in April 1916, a show that generated a revealing, behind-the-scenes controversy between Gleizes and Crotti (see pp. 101–2). In this exhibition, Duchamp was represented by two paintings and two drawings, as well as by the readymade *Pharmacy* (p. 44), a dime-store print of a winter landscape, to which he added a dot of red and green paint, allusions to the colored bottles displayed in the windows of French pharmacies.[33] "As for Duchamp's drug-store effects imposed on a landscape," one critic noted, "we think the druggist's

Marcel Duchamp. With Hidden Noise. *1916. Readymade: metal and twine, h.: 5″. Philadelphia Museum of Art. The Louise and Walter Arensberg Collection*

name should have been added with a copy of his license or certificate." Another reviewer failed to notice that the item was made from a commercial print, and he proceeded to compliment Duchamp for having created "a delicate and quite understandable landscape."[34]

If these works were misunderstood, what, if anything, did reviewers make of the unaltered readymades—objects that were simply displaced from their original context without change and displayed as works of art? Two such items—the snow shovel (see p. 41) and a typewriter cover called *Traveller's Folding Item*—may have been the "Two Ready-mades" (as they

Marcel Duchamp. Pharmacy. 1914.
Rectified readymade: gouache on commercial print,
10 x 7 ½". Collection Arakawa, New York

Marcel Duchamp. Apolinère Enameled. 1916–17.
Readymade: painted tin advertisement, retouched,
9 ¼ x 13 ¼". Philadelphia Museum of Art.
The Louise and Walter Arensberg Collection

were identified in the accompanying cat-alogue) shown in the "Exhibition of Modern Art" at the Bourgeois Gallery in April 1916, which ran concurrently with the Montross exhibition. Without excep-tion, reviewers chose to ignore the readymades, either because they failed to understand their significance, or more likely, because they were reluctant to dis-cuss them as works of art, fearing that they might later discover that they had fallen victim to a typical fakir's ploy.[35]

One exceptionally confused reviewer of the Montross exhibition, a Nixola Greeley-Smith, took it upon herself to interview Crotti and Duchamp in their studio, and for her patience, she was rewarded with the first recorded exchange on the subject of Duchamp's readymades (see p. 102).[36] In a discussion about beauty, Crotti told her that he found a pair of galoshes in the corner of the studio more beautiful than a pretty girl. "As an artist," he said, "I consider that shovel the most beautiful object I have ever seen."

Among the more unusual of Du-champ's readymades from these years was a tin Sapolin Enamel advertising sign depicting the image of a little girl painting a bed frame. Duchamp slightly altered—or "rectified"—the advertisement by overpainting certain letters and adding others to the words "SAPOLIN ENAMEL," causing the sign to read "APOLINÈRE ENAM-ELED," a reference to his old friend in Paris the poet and art critic Guillaume Apollinaire. In addition to adding a reflec-tion of the girl's hair in the background mirror, he also altered the inscription "MANUFACTURED BY GERSTENDORFER BROS" to read: "ANY ACT RED BY HER TEN OR EPERGNE," a meaningless combination of French and English words.[37] Knowing of Duchamp's future rejection of painting and his interest in sexual themes, one can have little doubt that he must have been attracted to the image of a young female painting (customarily a male activity) in the privacy of a bedroom (a place usually associated with more sensuous activities). Sadly, Apollinaire never lived to see Duchamp's homage; he died in 1918 as a result of war wounds.

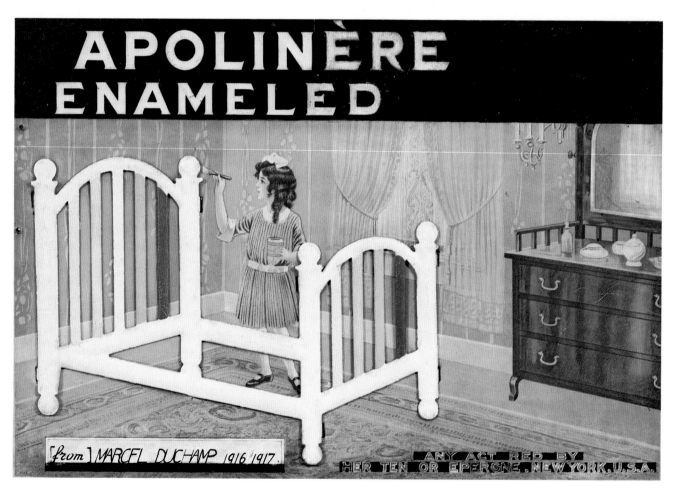

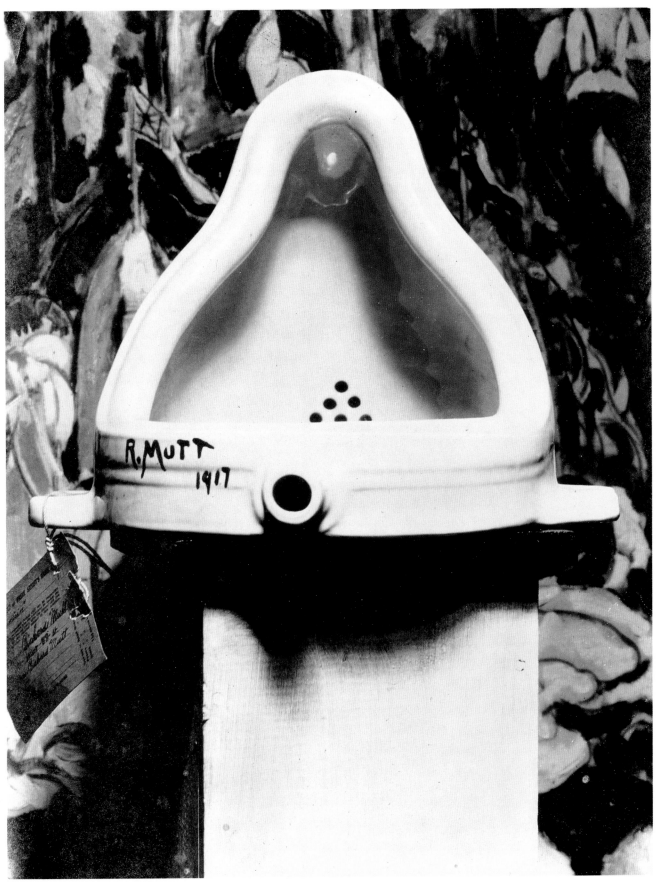

*Marcel Duchamp. Fountain. 1917. Original work
lost. Photograph by Alfred Stieglitz. Gelatin silver
print, 9 ¼ x 7". Private collection, New York*

Even though many may not have understood Duchamp's work, a small, more informed, and tightly knit group of close friends and associates did. They may not have understood the historical significance of these items within the evolution of modern sculpture, or how they related to Duchamp's work as a whole, but his circle certainly understood the spirit in which the pieces were created, and they generally delighted in the uproar and negative criticism their display invariably generated. This was certainly the case when the Society of Independent Artists refused in 1917 to exhibit Duchamp's infamous *Fountain*. The alleged indecency of this object forced artists and members of the general public alike (see chapter 7) to confront the obvious philosophical issues raised by an artist who, upon the placement of his signature, assumed the near godlike power of transforming a pristine, mass-produced object into a unique work of art—even if, in the end, viewers chose to exclude it from the realm of aesthetic consideration.

Although Duchamp could have easily predicted that his urinal would create a controversy, until recently, few have questioned why he chose this particular artifact, as opposed to any of a number of other commercially available implements of personal hygiene, many of which could have been considered equally inappropriate for public display. Certainly a urinal was something women—in particular—would have found of exceptional visual interest (having, presumably, ventured into a men's room on only rare occasions, if ever). It is also possible that Duchamp was himself attracted to the shape, as many have suggested, because when viewed on its back from a specific angle, the inverted urinal created the visual appearance of a Buddha, or a

Marcel Duchamp. Rongwrong, *cover. 1917.
Philadelphia Museum of Art. Arensberg Archives*

Marcel Duchamp. *c. 1916–17. Gelatin silver print,
1 ³⁄₄ x 2 ¹⁄₄". Collection Timothy Baum, New York*

Madonna (as it would almost immediately be interpreted by Louise Norton, who wrote an editorial in its defense).[38] But the initial motive for picking a urinal might have been the result of an incident that took place one night at the Arensberg apartment. According to a story told years later by Duchamp himself, during a party there one evening, one of the more inebriated guests climbed a staircase in the apartment in search of a bathroom. "A little because of the mounting pressure inside of his bladder, and a little in the spirit of a prank, he [the guest] pissed down the stairs. A little stream, bounce by bounce, step by step, found its way down to the front door and [to] the crowd of invited guests."[39] Presumably, Duchamp would have purchased the urinal in response to the collector's sudden need to install more accessible facilities in his apartment.

In conjunction with the Independents' Exhibition, Duchamp, with the help of a few friends, oversaw the publication of two issues of a short-lived magazine, *The Blind Man*. During the course of the next few months, he gathered material for inclusion in another ephemeral publication, this time entirely of his own design. *Rongwrong*, as it was titled, contained on its cover the photograph of a matchbook with two dogs sniffing one another's rear ends. One of the matches is pulled out to the side, as if readied for immediate use. The results create an interesting relationship between the sense of smell (the activity of the dogs combined with a potentially exploding match), and the verbal/visual pun between the title, *Rongwrong* (which Duchamp later explained was the result of a printer's error) and the two matching dogs, whose communicative instincts could be thought of as "wrong," or, when considering both of them: "Rong-Wrong."[40]

A good number of the people who sympathized with Duchamp and his ideas met informally at the evening gatherings held at the Arensberg apartment. Many who frequented these soirées reported that Duchamp somehow always seemed to be the guest of honor, even though he usually spent most of the evening either

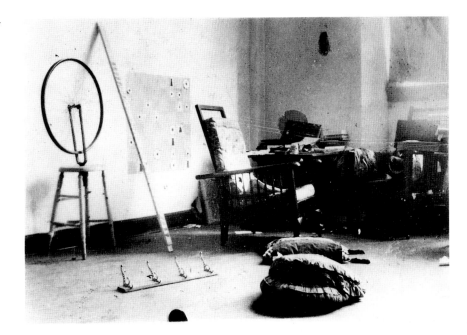

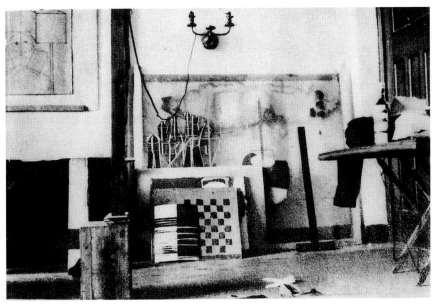

playing chess or engaged in quiet conversation with friends. He did, however, drink heavily. A snapshot from the period captures the artist asleep on his toilet, exhausted after an evening that likely involved some form of excessive consumption. When Gleizes once criticized him for these indulgences, Duchamp explained that it was a necessity. "If I didn't drink so much alcohol," he said, "I would have committed suicide long ago!"[41]

For approximately two years, beginning in the fall of 1916, he occupied a small studio accessible to the upper floor of the Arensberg apartment through a short hallway. In exchange for ownership

Interior of Marcel Duchamp's studio, 33 West Sixty-seventh Street, New York. c. 1918. His studio was apartment 3FW (3rd floor west), just behind the Arensberg apartment

of the *Large Glass*, Arensberg agreed to pay Duchamp's rent, a convenient arrangement for both the artist and collector.[42] If a visitor knew Duchamp well enough, he/she might be invited up to his studio, where one would not have failed to see a sampling of his readymades, like the *Bicycle Wheel* (a replica of the 1913 original), nor could one have missed stumbling over *Trébuchet*, a coatrack nailed to the floor. Other snapshots of

the studio show that Duchamp hung the snow shovel and a hat rack from the ceiling, while the *Fountain* dangled precariously from the lintel of an interior doorway.

The studio was usually unkempt. "The place looked as though it had never been swept," recalled Georgia O'Keeffe, who visited the West Sixty-seventh Street studio on one occasion with Alfred Stieglitz. "The dust everywhere was so thick that it was hard to believe."[43] A more frequent visitor recalled that the room was always in disorder. "On the window sill lay boxes of crackers and packages of Swiss chocolate," she remembered, "his usual diet."[44] And another friend remembered that "vertical rows of great chess boards [painted directly] on the walls showed the progress of games unfolding little by little

through the correspondence which [Duchamp] maintained with far-off masters"[45] (see p. 215).

Conspicuously absent from Duchamp's studio were the usual accoutrements of a painter: turpentine, oil paint, brushes, an easel, etc. Even though he had not painted a picture in over four years, in January 1918, he accepted a commission from the collector and art patron Katherine Dreier to paint a long rectangular composition

to fill the area above a series of bookcases in the library of her apartment on Central Park West. *Tu m'* took about six or seven months to complete, and the finished product has often been said to represent a visual summation of Duchamp's earlier work.[46] Indeed, the painting contains shadow projections of three earlier readymades: the *Bicycle Wheel* (on the left); a *Corkscrew* (in the center; the original is no longer extant);

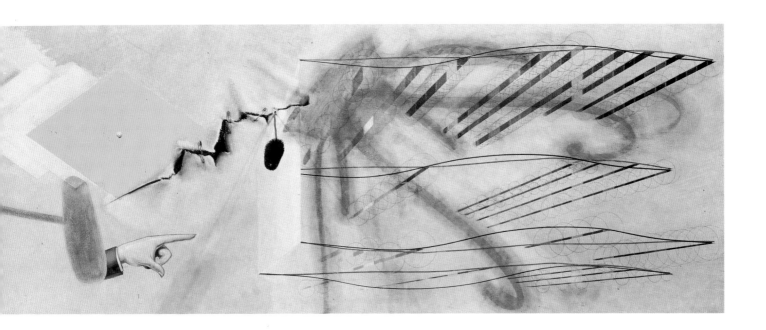

and the *Hat Rack* (on the right). Moreover, a series of undulating lines in the lower left and right corners of the composition were traced from templates echoing the irregular shapes of three measuring devices that were used in the making of the *Large Glass*. In having derived these details from his earlier work, Duchamp threw into question the concept of uniqueness and originality in art, an issue that had already been challenged by the institution of the readymade.

As if to accentuate this very point, Duchamp arranged for a professional sign painter to insert the stock image of a pointing hand just to the right of the *Corkscrew* in the center of the painting (which the illustrator, A. Klang, prominently signed), thereby incorporating the work of one artist into the creative efforts of another. Finally, in the center of the composition and just above the hand, Duchamp added two *trompe l'oeil* details, the illusionism of both strengthened by the addition of actual objects. To the left, he asked Jean Crotti's wife, Yvonne, to paint a series of perspectively receding square color samples,[47] the first seemingly held in position by an actual bolt fastened to the surface of the canvas; to the right, Duchamp skillfully painted the illusion of a tear, to which he affixed three actual safety pins, giving the impression that they serve to hold the rupture together physically. Finally, protruding

prominently from this tear, Duchamp inserted an actual bottle brush (a reference, perhaps, to the *Bottle Rack*, a readymade he had left behind in Paris).

The resultant play between various levels of illusion and reality is complex and fascinating, although Duchamp never thought very much of this painting, his very last oil on canvas composition. "I have never liked it because it is too decorative," he later explained; "summarizing

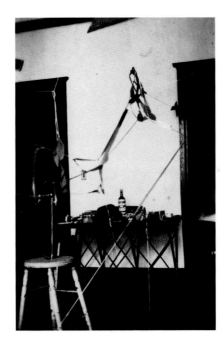

Marcel Duchamp. Sculpture for Traveling. *1918. Stretched rubber bathing caps. Lost or discarded. Photographed in Duchamp's studio at 33 West Sixty-seventh Street, New York. 1918. Collection Mme. Alexina Duchamp*

one's works in a painting is not a very attractive form of activity."[48] It may have been this attitude that caused him to give this work the provocative title *Tu m'*, which suggests the French expression *tu m'ennuies*, meaning "you bore me," or *tu m'emmerdes*, a much harsher expression.

Duchamp had long been bored with the activity of painting, and throughout these years in New York, he rigorously explored new and innovative possibilities of artistic expression. If *Tu m'* challenged the limitations of painting, his next creation—a haphazard arrangement of colored bathing caps stretched from various corners of his studio—effectively shattered the traditional boundaries of sculpture. In a letter to Crotti, who by this time had returned to Paris, Duchamp said that this new assembly resembled "a sort of multicolored cobweb."[49] Because this sculpture could be easily dismantled for transport, Duchamp called it *Sculpture for Traveling*, an especially well-chosen title, for he would soon take it apart, pack it into his bags, and travel with it to Buenos Aires.

Exactly why Duchamp elected to leave New York at this time is difficult to say. Certainly, just as he had left Paris three years earlier, he wanted to avoid the oppressive political atmosphere prevalent in a country at war (America had officially entered the conflict in April 1917), and in his letter to Crotti, he alluded to problems the Arensbergs were experiencing

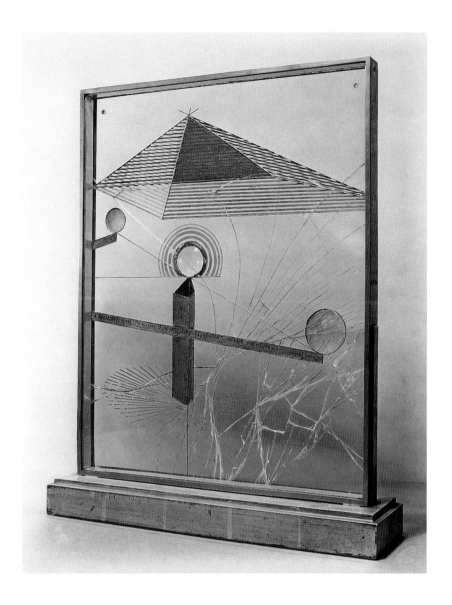

longer be exhibited. Nevertheless, he continued to work on studies for the *Large Glass*, completing a portion of the lower section that was given the long and amusing title: *To Be Looked At (From the Other Side of the Glass) with One Eye, Close To, for Almost an Hour.*

Only portions of this important study were incorporated into the *Large Glass*, and it, too—like so many other works by Duchamp from this period that were made on the surface of glass—eventually shattered, only to be painstakingly repaired by the artist himself. It is likely that upon completion of this study, Duchamp gave it to Katherine Dreier, who arrived in Buenos Aires a few days after he had. Dreier, who never really understood Duchamp's work, preferred to call this study *Perpetual Balance*, a title the artist totally rejected.[54] Only the

Marcel Duchamp. To Be Looked At (From the Other Side of the Glass) with One Eye, Close To, for Almost an Hour. 1918. Oil paint, silver leaf, lead wire, and magnifying lens on glass (cracked), 19 ½ x 15 ⅝", mounted between two panes of glass in a standing metal frame, 20 ⅛ x 16 ¼ x 1 ½", on painted wood base, 1 ⅞ x 17 ⅞ x 4 ½". The Museum of Modern Art, New York. Katherine S. Dreier Bequest

that led to a certain "fatigue" (a situation that must have affected him as well).[50] Just before his departure, he wrote Picabia that he was going to Buenos Aires "without a mission," though in his magazine, *391*, Picabia jokingly announced that Duchamp was going in order to set up a business of cleaning urinals, an activity he jokingly termed "Rady-made."[51] Later, Duchamp told an interviewer that he had specifically selected Argentina because the parents of a friend he knew from Paris were running a brothel in Buenos Aires.[52] Whatever his motives, on August 13, 1918, Duchamp boarded the SS *Crofton Hall*, taking with him the *Sculpture for Traveling*, his notes for the *Large Glass*, and the beautiful former wife of his studio mate, Yvonne Crotti. Duchamp wrote and told his old friend about these plans with Yvonne, at the very moment when Crotti was pursuing

an amorous relationship with Duchamp's sister Suzanne (an amicable exchange that some have suspected Duchamp engineered).

In Buenos Aires, the two made an effort to acclimate themselves to the slow pace of Argentine life. Yvonne found the adjustment difficult and left within six months, but Duchamp seems to have genuinely enjoyed the more relaxed atmosphere of this southern capital. He spent most of his free time reviewing old chess games and, for a brief period, he entertained the prospect of organizing an exhibition of Cubist paintings, a project that never materialized because a number of his friends in New York—to whom he had written for assistance—were reluctant to cooperate.[53] In spite of his efforts to mount this exhibition, it was while in Buenos Aires that he came to the decision that his own work should no

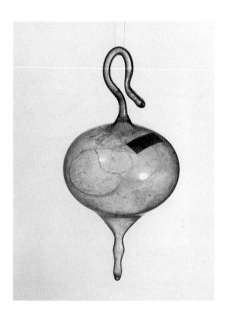

Marcel Duchamp. 50cc of Paris Air. 1919. Readymade: glass ampule (on printed label: "Sérum Physiologique"), h.: 5 ¼". Philadelphia Museum of Art. The Louise and Walter Arensberg Collection

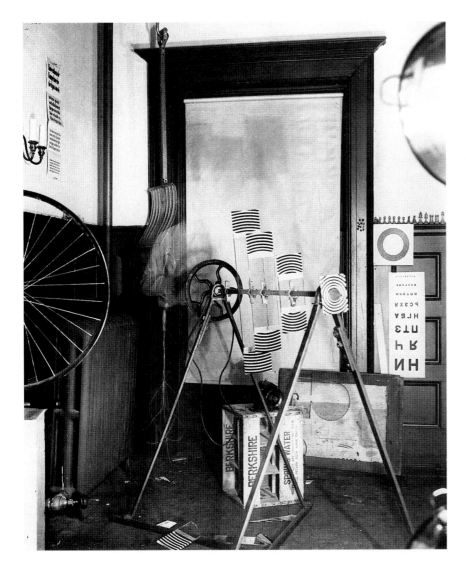

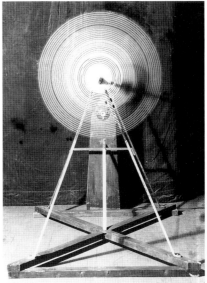

longer title makes reference—however oblique—to the science of optics, an interest the artist began to pursue in earnest in Buenos Aires, but one that would gradually expand into a lifelong preoccupation.

After only nine months in South America, Duchamp returned to Europe. But the Paris he had left four years earlier had changed considerably; the war had taken its toll in lives—including those of Apollinaire and his brother Raymond Duchamp-Villon—and the art scene could no longer be characterized as a battleground for or against Cubism. Rather, in what could be considered a delayed reaction to the atrocities of war, a group of French artists rallied under the battle cry of Dada. But when asked if he thought the war influenced the development of the arts in general, Duchamp dismissed the question, saying only: "I don't weigh potatoes with shit."[55]

Throughout his life, the artist steadfastly avoided such influences, refusing to be categorized as an official adherent of any group, political or artistic. In Paris, for example, he was the house guest of

Picabia—then one of Dada's most involved participants—yet he refused to partake in any of its organized activities. After spending only about five months in Paris, Duchamp returned to New York in

1920, bearing an appropriate gift for Walter Arensberg: a fresh breath of Paris air (see p. 50).

(see p. 50)

Just before his departure, Duchamp asked a Parisian pharmacist to empty a glass ampule of serum and reseal it, trapping within the container exactly 50 cc of Paris air. "I thought of it as a present for Arensberg," Duchamp later explained, "who had everything money could buy."[56] In this respect, the gift was an especially appropriate choice, for even though Arensberg had all the money he needed to assemble one of the most extensive collections of modern French art to be found anywhere in America, he lacked direct contact with the most omnipotent and essential ingredient of Parisian life, namely, its air. This interpretation is in part supported by the inscription found on the printed label: "Sérum Physiologique" (Physiological Serum). Taken in the most literal sense, this inscription might refer to a serum or remedy that could be used as a treatment in adjusting the normal functioning of the human body, which, when applied to the process of collecting modern art, would require, in Duchamp's mind, a fresh breath of Parisian air.

Upon his return, Duchamp found New York somewhat changed but pleasant. "I am very pleased with New York again," he told John Quinn, "in spite of the few changes New York is the same old New York." By contrast, he added, "Paris seemed dull to me."[57] Nevertheless, it would not be long before Duchamp discovered that the war had left its destructive mark on America as well. Many of the galleries that had been devoted to modern art were closed, and the tightly knit unit of friends who had congregated at the Arensberg apartment had largely dispersed.

Perhaps as a direct result of the sparsity of social activities, this year was one of

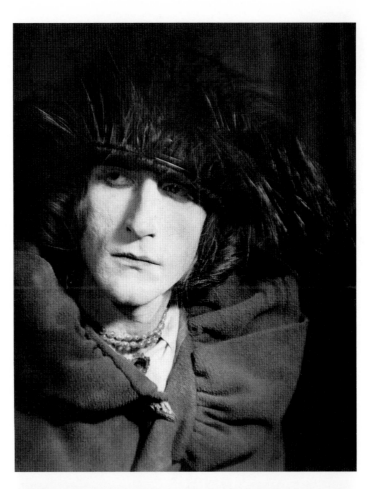

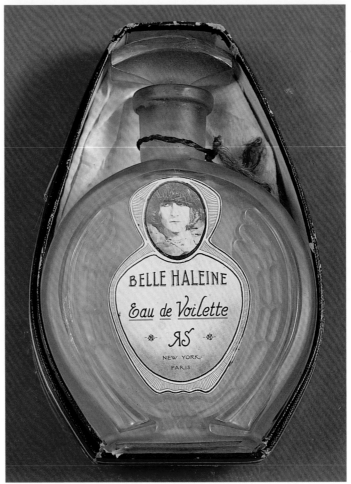

Man Ray. Rose Sélavy. *1921. Photograph. Original negative: Estate of the Artist, Paris*

Marcel Duchamp. Belle Haleine, Eau de Voilette. *1921. Rectified readymade: perfume bottle, 6"; oval cardboard box, 6 ⁷⁄₁₆ x 4 ⁷⁄₁₆". Private collection, Paris*

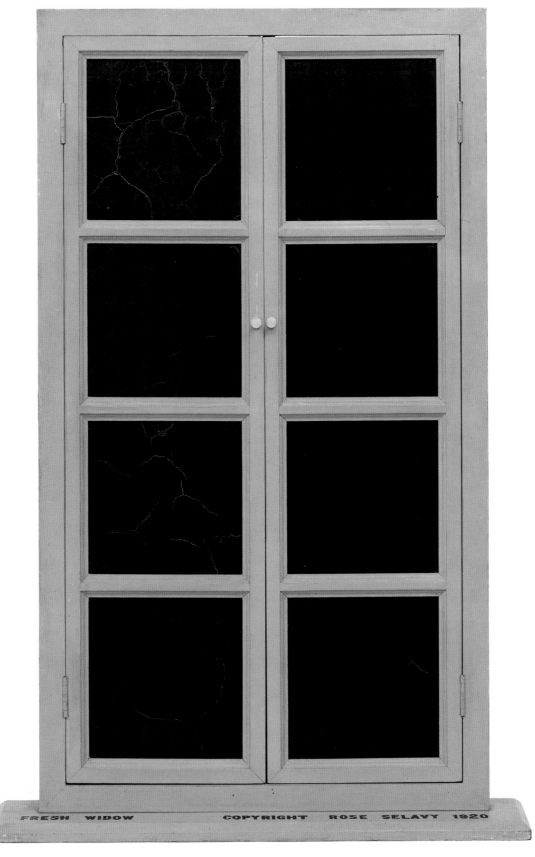

Marcel Duchamp. Fresh Widow. *1920. Miniature
French window, painted wood frame and eight panes
of glass covered with black leather, 30 ½ x 17 ⅝";
on wood sill, ¼ x 21 x 4". The Museum of Modern
Art, New York. Katherine S. Dreier Bequest*

53

the most productive in Duchamp's career. He rented a small apartment on the Upper West Side, where his experiments in optics continued. Here, he completed the construction of a large motorized device consisting of five separate rectangular plates of glass, each slightly larger than the next, aligned along a single horizontal axis. When the plates of glass are spun rapidly, they create the impression of a single plane, thereby effectively conflating three dimensions into two. In order to capture and preserve the resultant sensation, Duchamp enlisted the photographic talents of Man Ray, who was nearly killed when one of the glass plates shattered and almost decapitated him (broken plates of glass can be seen on the floor of Duchamp's studio: see p. 51).

In the winter months of 1920–21, Duchamp moved back into the Lincoln Arcade Building, where Man Ray's photographic skills were once again solicited, this time to record the accumulation of dust on the surface of the *Large Glass*, the resultant time-exposed image preserving more the impression of a lunar landscape than of a work of art (see p. 51). Apparently, Duchamp had spent years selectively "breeding" the dust; one visitor to his studio a number of years earlier remembered having seen the two large glass panels resting on sawhorses: "There were parts that were spotless, while others were cloaked in layers of dust of varying thickness." This same visitor also noticed that Duchamp had fashioned a little warning sign to protect this process of chance accumulation; it read: "DUST BREEDING. TO BE RESPECTED."[58]

Man Ray also witnessed and recorded the birth of Duchamp's notorious female alter ego, Rose Sélavy (see p. 52). In one of the earliest photographic sessions to record Rose in all her grandeur, she sports a wig, pearls, and a large feathered hat, while clearly posed with a somewhat scornful, sidelong glance, suggesting, perhaps, a readiness to defend herself, should anyone dare to criticize her questionable sexual identity.[59]

This image of Rose was featured on the face of a small perfume bottle labeled "Belle Haleine, Eau de Voilette" (Beautiful Breath, Veil Water), an assisted readymade that Duchamp fashioned from a bottle of Rigaud perfume. In April 1921, the bottle was reproduced on the cover of *New York Dada* (see p. 202), but even before Rose attained cover-girl status, she had effectively replaced Duchamp's identity as an artist. A work from 1920 entitled *Fresh Widow* was the first to bear her signature, or, more accurately, to be copyrighted under the name Rose Sélavy. Duchamp had a carpenter in New York construct a miniature replica of a standard French-style window; he then covered each pane of glass with a panel of black patent leather. The result is a frustrating visual obstruction that may have been designed to refer to Duchamp's recent abandonment of painting. Since the Renaissance, the picture plane had been described as a glass plane or window opening the passage of sight from the eyes. The leather panels of *Fresh Widow* obstruct the visual rays and thus deny the possibility of perspective— or painting, as it had been practiced since the Renaissance. In this context, then, the title *Fresh Widow* goes beyond the obvious wordplay with "French window"; Duchamp may have considered himself the "fresh widow," a woman who recently (freshly) lost (through abandonment) her spiritual partner in art (painting).

Duchamp's female alter ego is also credited as the author of *Why Not Sneeze Rose Sélavy?*—an object originally commissioned by Dorothea Dreier, the sister of Katherine Dreier. Normally, in accordance with his principles, Duchamp would not have agreed to work under the restraints and obligations of a commission, but he accepted on this occasion because he was given *carte blanche*. So in a small white-painted birdcage, he placed 152 cubes of solid white marble, added a cuttlebone and thermometer, and finished off the assemblage by affixing the title in black tape to the bottom of the cage. The small blocks of marble appear to be sugar cubes; only by lifting the finished assembly does one realize that, as Duchamp put it, "it weighs a ton. That was one of the elements that interested me when I made it," he said. "It is a Readymade in which the sugar is changed to marble. It is sort of a mythological

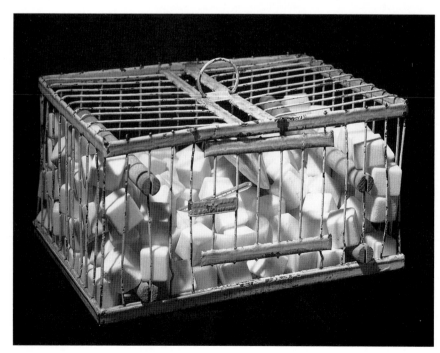

Marcel Duchamp. Why Not Sneeze Rose Sélavy? *1921. Readymade: marble blocks, thermometer, wood, and cuttlebone in a small birdcage, 4 ½ x 8 ⅝ x 6 ⅜". Philadelphia Museum of Art. The Louise and Walter Arensberg Collection*

Marcel Duchamp. Some French Moderns Says McBride. *1922. Book designed by Duchamp, 11 ¹³/₁₆ x 9 ¼". Collection Robert Shapazian, Los Angeles*

effect."[60] Amusing though these connections may have been, Dorothea Dreier was dissatisfied with the results and sold the work to her sister Katherine. Even this loyal patron, however, failed to comprehend its artistic merits; she returned the work to Duchamp and asked if he could sell it for her. Eventually, like so many other important works by Duchamp, the original ended up in the Arensberg Collection.

In June of 1921, Duchamp returned to Paris, staying for about six months with his sister Suzanne and her new husband, Jean Crotti. Here he resumed contact with a number of his old friends, including Picabia, who by this time had broken his ties with the Dadaists, and Man Ray, who left New York at just about the same time as Duchamp. From Paris, he wrote to the Arensbergs to say that he still planned to complete work on the *Large Glass*, which he told them, was nearly finished. "All that's left is a little work with threads of lead without anything extraordinary," he explained. "Maybe I'll die before it's finished."[61]

Even though Duchamp did not intend his remarks to be taken seriously, in actual fact, he would—by his own choosing—not live to see this work completed (nor, for that matter, would anyone else). In January 1922, he returned to New York, where he rented another studio in the Lincoln Arcade Building and began in earnest to finally finish off "*cette grande saloperie*," as he once referred to the *Large Glass*.[62] But the project no longer held his interest, and he made little progress toward its completion. Instead, with another French artist, Leon Hartl, he opened a fabric-dyeing shop. "I am a *teintre* [dyer]," he wrote to Tristan Tzara (obviously punning on the French *peintre*), and as he told Man Ray, "I am a businessman. He [Hartl] dyes and I keep the books. If we are successful, we don't know what we'll do."[63] Within six months, the business failed.

While running the business, Duchamp continued to work on a number of other projects. One of them was the design and layout of a spiral-bound booklet containing a selection of Henry McBride's writings on French art. The type used for each essay increased in size and boldness in the course of the booklet, until the last page, where it is suddenly reduced to a minuscule size. Bound into the notebook are seven photographs of works of art taken by Charles Sheeler (each print labeled on the verso: "PHOTO SWEELER"). The twenty-eight letters that make up the title of the publication are attached to separate pages by means of blue file tabs running along the edge, "in the fashion," Duchamp told McBride, "of these alphabets [you see] in offices in dust-proof files."[64] The format bears the copyright of Rrose Sélavy, where, for the first time on a work produced in New York, Duchamp used a double *r* in the spelling of Rose's first name.[65] A reviewer found the layout the publication's most unusual feature, for which, he says, "Rrose Sélavy, a gentleman familiar under another alias, will be held chiefly responsible." But he cannot accept all the blame, this critic notes, "for Henry McBride has committed himself by allowing M. Rose to play with the seriousness which backs his critical methods."[66]

In January 1923—after seven years of work on the *Large Glass*—Duchamp finally signed it, leaving his most important work to this point in a permanent state of incompletion. The resultant dates—1915 to 1923—mark the beginning and end of Duchamp's years in New York. Even before he added his signature, the Arensbergs had sold the *Large Glass* to Katherine Dreier, for they feared the fragile work could be damaged if they risked transporting it to California, where they now intended to stay.[67] His obligations satisfied, Duchamp boarded a steamer for Paris, where, other than for three brief excursions to America, he would remain for the next twenty years.

4 · FRANCIS PICABIA

Picabia's first trip to New York had been such a success—from the standpoints of contacts, exposure, and publicity—that he made almost immediate plans to return. While in Paris, he maintained continuous contact with his friends in New York, and as he had announced before his departure, he painted several large canvases whose subjects were inspired by his experiences in New York. When de Zayas saw these pictures during a trip to Paris in the summer of 1914, he was especially impressed by their size, particularly one large canvas that he said measured some two and one-half meters high (about eight feet; probably *I See Again in Memory My Dear Udnie;* see p. 58). De Zayas wrote to Stieglitz, recommending that he consider mounting another exhibition of Picabia's work at 291, this one to consist of "only three big paintings . . . covering almost the entire three walls from the floor to the ceiling."[1]

On January 12, 1915, a show of precisely this description opened at 291, billed as "An Exhibition of Recent Paintings— Never Before Exhibited Anywhere—by Francis Picabia." In such a small space, the scale alone of three large, abstract canvases must have overwhelmed visitors to the gallery. Elizabeth Luther Carey, conservative critic for the *New York Times,* could see in them only "most unpleasant arrangements of strangely sinister abstract forms that convey the sense of evil without direct statement."[2] When

Francis Picabia. c. 1915. Photograph by Alfred Stieglitz. Platinum print, 9 ⁵/8 x 7 ⁵/8″. National Gallery of Art, Washington, D.C. Alfred Stieglitz Collection

Stieglitz told a reviewer that one of the pictures was painted by Picabia just before he left for the front, the reviewer described it as "a lot of curves, angles and streaks that look as if they might be the result of a collision between an aeroplane, an automobile and a submarine." Apparently, with additional information provided by the gallery owner, this same reviewer went on to inform his readers that Picabia was once a successful academic painter. "Financial independence obtained," the critic explained, "he [Picabia] began to paint as he wished and not as his clients wanted."[3]

No matter what critics of the day might have thought of these pictures, they are among Picabia's most accomplished and resolved works of these years. Today, *I See Again in Memory My Dear Udnie* is widely considered a masterpiece, ranking in importance with the greatest examples of abstract art painted in the decade prior to the First World War. Recent scholarship has convincingly demonstrated that the title of this enormous canvas—as with many other paintings by Picabia from this period—was derived from an entry in the *Petit Larousse*.[4] But the subject was unmistakably drawn from events Picabia had witnessed aboard ship during his first trip to America in 1913, where he had seen a popular Polish dancer by the name of Napierkowska. Her dancing served as the inspiration for a number of paintings, this

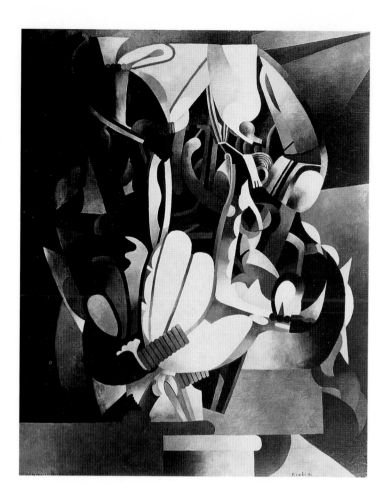

Francis Picabia. Je revois en souvenir ma chère Udnie (I See Again in Memory My Dear Udnie). 1914, perhaps begun 1913. Oil on canvas, 8' 2 ½" x 6' 6 ¼". The Museum of Modern Art, New York. Hillman Periodicals Fund

being the last in the series. But little would be gained by searching for direct visual references to the dancer in this picture, although the sense of arousal the artist experienced is well preserved in its undulation of sensuous, abstract forms. Male and female elements interact; probing, coiled springs in the lower left quadrant lie in clear contrast to the surrounding cream-colored, amorphic shapes that open up behind it like the petals of a flower. These elements, however, were clearly not envisioned as objective representations, but rather, like visceral schematizations, meant more to record the impression—or, in this case, the memory—of a sensuous experience, than the experience itself.

With the publicity generated by his exhibition at 291 in January, and with a

host of friends awaiting his arrival, Picabia certainly must have hoped to make a return trip to New York. The opportunity came in the spring of 1915, when, as a member of the French military, he received orders to serve on a mission to the Caribbean, a trip that incorporated a stopover in New York. No longer in the company of his wife, Gabrielle Buffet, who had ably served as his translator during their first trip, he could fortunately (since he still barely spoke a word of English) join the company of New York's many expatriate French artists; Duchamp, for example, arrived only a few days after Picabia. Although the two had been friends for a number of years in Paris, it is unlikely that they had timed their trips to coincide; after the outbreak of war, many Frenchmen left Europe to seek refuge in America.

Picabia probably went directly from the pier to the Hotel Brevoort, where, from his 1913 stay, he knew that most of the waiters and clientele either were French, or at least spoke French. Before the day was out, Picabia paid a visit to

291, some twenty-five blocks up Fifth Avenue, renewing his friendship with de Zayas and Stieglitz. It might have been on one of these first visits to the gallery that Picabia sat before Stieglitz's camera. Sporting a finely tailored French suit and bow tie, the artist sits comfortably in a bentwood chair, staring directly into the camera lens, conveying an air of confidence and determination. Appropriately, Stieglitz positioned Picabia in front of one of his own paintings—a large abstraction that had been shown at 291 earlier in the year.[5]

Picabia's visit came at a time when Stieglitz was in the process of trying to decide whether or not his gallery was worth the effort. The year before, he had solicited the opinions of all the gallery associates on the question: "What does 291 mean to me?" The responses filled an entire issue of Camera Work, where, like many others, Picabia seized the opportunity to praise the gallery and its accomplishments: "291 arranges the locks on its forehead," he wrote, "but the flames cannot scorch it; its soul is filled with a life that fills each hour with sunshine; its eyes, its ears announce an intelligence; that is why it has been taught neither craft nor art, but it will find its place in the sublime sequence." Picabia concluded his statement with unreserved praise for Stieglitz himself: "He knows him not; he is good; he is a God; I love him."[6]

No matter what others thought, in the public struggle to promote modern art, Stieglitz was determined to let a younger generation take over—and for some time, de Zayas had expressed an interest not only in continuing the efforts of Camera Work and 291, but in accelerating them. It was with these goals in mind that de Zayas proposed the publication of a magazine that was to be more distinctly avant-garde in appearance and content, and that he began plans to open a gallery that was to be more commercially oriented. Even though Stieglitz had little enthusiasm for the new gallery, both projects were undertaken with his cooperation and approval. The magazine— entitled 291 after the gallery—began publication in March (the first issue fea-

turing a caricature of Stieglitz by de Zayas; see p. 13). And the new gallery—named, fittingly, the Modern Gallery—opened at 500 Fifth Avenue (at Forty-second Street) in October 1915.

291 was printed in an oversized format on high-quality paper and was available in both regular and deluxe editions. It was immediately more vanguard and experimental in appearance than any prior publication in the United States. From the very first issue, the new magazine presented material that had never before been seen by an American audience, such as an *idéogramme* or *calligramme* by Apollinaire (examples of which had appeared earlier in issues of *Les Soirées de Paris*). De Zayas used the new magazine to present his "psychotypes," which, like Apollinaire's poetic experiments,

were composed of a free-floating text arranged in an expressive format. But unlike the *calligrammes*, these new fusions of typography and art were made as portraits, meant to capture "the expression of thoughts" and "the states of the soul."[7]

Even before Picabia's arrival, de Zayas took the liberty of reproducing a small ink drawing by the artist in the pages of 291, a sketch from 1913 based on Picabia's impressions of New York. The imagery in the drawing was so completely indecipherable that a literary critic explained—with an obvious infusion of sarcasm—that it was "a picture of a black cat prowling around in a dark cellar at midnight." The absence of detail, he further explained, was caused by the artist, who "was just about to suffer another severe

attack of the jim-jams when he began work on this precious masterpiece."[8]

Whether or not Picabia knew of these comments, they did not prevent him from contributing again to 291, which he did within a few days of his arrival. In the June 1915 issue, he allowed his first drawing made in a decidedly machinist style—appropriately entitled *Fille Née sans Mère* (*Girl Born Without a Mother*)—to be reproduced as a full-page illustration in the magazine (p. 60). A photograph records Picabia diligently hand-coloring this image for deluxe editions of 291, while de Zayas attentively looks on. In spite of its title, this drawing doubtless possesses a clear maternal lineage, in that it relates to one of Picabia's earlier paintings, *I See Again in Memory My Dear Udnie*, of 1915. The pair of coiled,

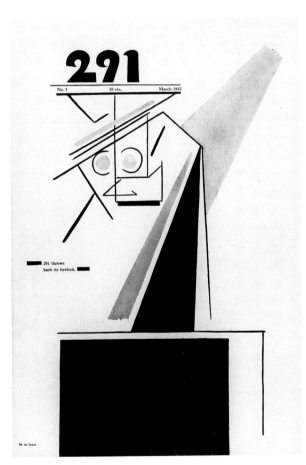

Marius de Zayas. 291 Throws Back Its Forelock. Cover of 291, March 1915. Yale Collection of American Literature, Beinecke Rare Book and Manuscript Library, Yale University, New Haven

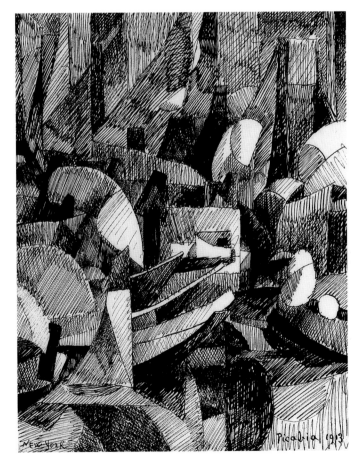

Francis Picabia. New York. 1913. (Original ink drawing lost; reproduced in 291, 1915.) Yale Collection of American Literature, Beinecke Rare Book and Manuscript Library, Yale University, New Haven

mechanical inventions were more than inventions to facilitate man's work. "The machine has become more than a mere adjunct of human life," he said. "It is really a part of human life—perhaps the very soul."[10]

As if to demonstrate this very point, Picabia prepared a series of five mechanical portraits—of himself and his American colleagues—which were published as a special, six-page fold-out in the July–August 1915 issue of *291*. The cover featured his portrait of Stieglitz, appropriately represented in the form of a camera, its bellows extended and col-lapsed, as if to imply that Stieglitz, by means of "foi et amour" ("faith and love"), has failed to attain his "IDEAL" (a word in Gothic script appearing above the lens at the top of the image). This interpretation is reinforced by the parking brake and gearshift lever rendered in red ink behind the camera; it has been observed that the gear is in a neutral position, while the brake is set, implying, perhaps, that Stieglitz is powerless to affect his situation, and thus, he can no longer be considered a guiding force in the promotion of modern art.

springlike elements in the lower left quadrant of the drawing, are clearly derived from objects of a similar shape and positioning in the painting. But in the smaller drawing, these mechanical elements are more assertive components within the visual field, thereby announcing a completely new and radical stylistic departure in Picabia's work.[9]

The new style was based on the most recent advancements of modern technology, more specifically, on images drawn from the burgeoning machine age. Just as Picabia's first visit to New York had crystallized his thoughts on abstraction, the second trip was destined to mark an equally momentous change. "Almost immediately upon coming to America," he informed the press, "it flashed on me that the genius of the modern world is machinery." In Picabia's mind, these

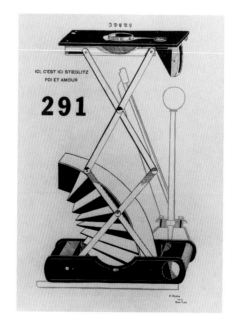

Francis Picabia. Ici, c'est ici Stieglitz / Foi et Amour (Here, This Is Stieglitz / Faith and Love). *Cover of* 291, *July–August 1915*

Francis Picabia. Le Saint des saints / C'est de moi qu'il s'agit dans ce portrait (The Saint of Saints / This Is a Portrait About Me). 291, *July–August 1915*

The next image was conceived as a self-portrait, wherein the artist represented himself through the juxtaposition of two mechanical elements: the precise rendering of a car horn positioned vertically, against the diagrammatic depiction of what appears to be an automobile cylinder and accompanying spark plug in cross section. The use of automobile parts was consistent with Picabia's reputation; his taste for fast cars was legendary. But he then appropriated one of these car parts—the simple spark plug labeled "FOR-EVER"—to symbolize the characteristics of an image whose title translates as "Portrait of a Young American Girl in the State of Nudity." One scholar has convincingly demonstrated that the spark plug was a portrait of Agnes Ernst Meyer, a wealthy collector who was the initiating force (colloquially speaking, "spark plug") behind de Zayas's efforts to infuse renewed vigor into the atmosphere of 291.[11]

The most complex portrait in the series is meant to represent de Zayas, depicted in the schematic style of an electrical wiring chart that seems to function in the fashion of a Rube Goldberg cartoon. A spark plug in the upper right corner connects to a corset, which is attached by means of a wire to an electrical post. This post is connected to a gyrating mechanical device, which, in turn, appears to provide electrical energy to a pair of automobile headlights (lower right and left corners of the composition). If this reading is correct, then Picabia might have intended the sequence of these images to provide a clue to their meaning. De Zayas, then, was envisioned as the catalyst through which an aesthetic transformation could be realized, from its initial spark (which preceded this image), to its final end product: illumination (which, as we shall see, is the central theme in the last caricature of the series).

The last caricature, *Voilà Haviland*, is a symbolic machine portrait of Paul Haviland, a wealthy collector, author, and photographer, who was the representative of his family's Limoges porcelain factory in America and, thus, financially in a position to be a generous supporter of modern art (he served as associate editor of *Camera Work* and, with Stieglitz and Agnes Meyer, underwrote the publishing expenses for *291*). As Picabia's most reliable biographer discovered, this portrait was taken from an advertisement for a portable electric lamp, thereby suggesting that Haviland was a convenient source of light, whose illumi-nation could be easily transported from room to room, just as Haviland traveled between France and America, continuously disseminating information on the newest advancements of modern art.[12]

The last page of this publication presented a statement by de Zayas, wherein he declared that "America remains to be discovered," noting that in his efforts to realize this ambition, "[Stieglitz] has failed." He concluded by stating that only Picabia has managed to transcend convention. "Of all those who have come to conquer America," de Zayas wrote, "Picabia is the only one who has done as did Cortez. He has burned his ship behind him. He does not protect himself with any shield. He has married America like a man who is not afraid of consequences. He has obtained results."

Picabia's proclamation that the machine was an appropriate symbol for modern life became a guiding principle for the editorial associates of *291*. The next issue began with an editorial by Haviland, where, in an effort to describe the machine as an extension of man, he makes a specific reference to a title Picabia had assigned one of his first drawings in the new machinist style: "We are living in the age of the machine," Haviland declared. "Man made the machine in his

Francis Picabia. Portrait d'une jeune fille américaine dans l'état de nudité (Portrait of a Young American Girl in a State of Nudity). 291, July-August 1915

Francis Picabia. De Zayas! De Zayas! 291, July–August 1915

Francis Picabia. Voilà Haviland (Here Is Haviland). 291, July–August 1915

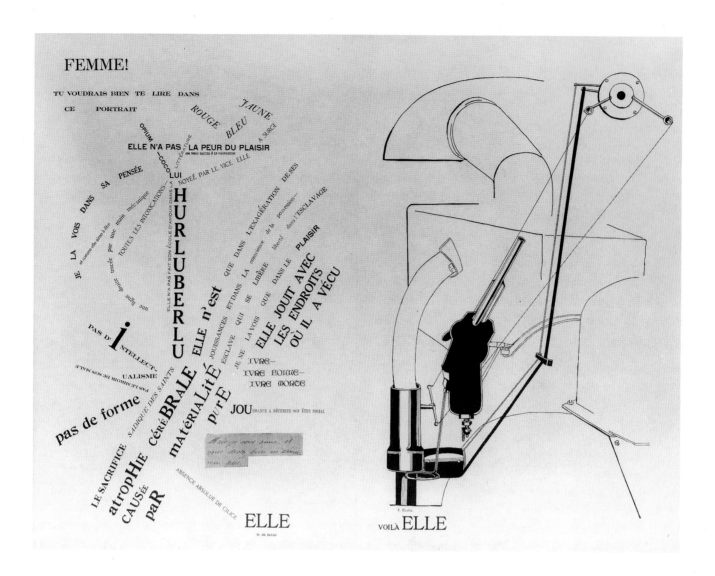

FEMME!

TU VOUDRAIS BIEN TE LIRE DANS CE PORTRAIT ROUGE JAUNE BLEU

ELLE N'A PAS LA PEUR DU PLAISIR

HURLUBERLU

ELLE

VOILÀ ELLE

own image. She has limbs which act;

own image. She has limbs which act; lungs which breathe; a heart which beats; a nervous system through which runs electricity. The phonograph is the image of his voice; the camera the image of his eye. The machine is his 'daughter born without a mother.' "[13]

The second of de Zayas's new projects, the Modern Gallery, opened with a showing of paintings by Picabia, Braque, and Picasso, photographs by Alfred Stieglitz, and a selection of African sculpture. Picabia was represented by some of the mechanical portraits he had already published in *291*, which one critic described as a display of "mechanical draftsmanship raised to the heights of fine art." This same critic believed that Picabia's portraits were intended to reveal specific characteristics of their subject. "Picabia has fallen in love with the scientific spirit which is America, he thinks. He likes to draw beautifully

objects as interesting as steam radiators and Kodaks and to juggle with his drawing until he feels that he has expressed something of the spirit of the man who uses the Kodak (Mr. Stieglitz) or the less famous genius who invented the steam radiator."[14]

Picabia was also represented in the exhibition by *Voilà Elle (Here She Is)*, a drawing that was shown alongside a psychotype by de Zayas entitled *Femme! (Woman!)*. A journalist who reviewed the exhibition was so struck by the similarity of the two portraits that he asked the artists themselves if the images were a product of conscious collaboration. "They were executed at separate times in separate places," the critic reported, "and according to the artists' sworn word without collusion."[15] If we read all of the phrases that make up de Zayas's *Femme!* we will find that she is envisioned as a mindless being, driven only by her own

Left: Marius de Zayas. Femme! *(Woman!); right: Francis Picabia.* Voilà Elle *(Here She Is). Ink on paper.* 291, *November 1915. Yale Collection of American Literature, Beinecke Rare Book and Manuscript Library, Yale University, New Haven*

physical indulgence; the main trunk of her body is formed by the letters: "HURLUBERLU" ("HAREBRAINED"), whereas, ironically, the only curve in her physique is made from the phrase: "A straight line drawn by a mechanical hand." Other expressive lines read: "She has no fear of pleasure"; "Brain atrophy caused by unadulterated materialism"; "She exists only in the extremes of her pleasures and in the awareness of possession."

A related denunciation of female indulgence can be read into the imagery of *Voilà Elle*, where a revolver is aimed toward a target, which in turn is attached to the trigger of the firing pistol. If this

contraption were put into motion, the woman depicted would repeatedly fire upon herself, thereby producing a mechanical, self-induced repetitive action that can be more readily associated with another, more sensuous human activity. If this interpretation is accurate, then this drawing is among the first in a series of mechanical images produced by Picabia that were designed to fuse the theme of human sexuality with the functioning of modern machinery. At first, however, Picabia was not certain of the direction his work would take. "At the present time I am doing research in art," he told a reporter when this exhibition was being held. "I cannot explain my present researches until I have myself evolved out of them, that is to say, until I have gone further in my artistic evolution."[16]

Within the next few months—before the year was out—Picabia's artistic evolution would progress to such a degree that, today (with the possible exception of contemporary works by Duchamp), the paintings produced by Picabia in this period can be considered the earliest and most sophisticated incorporation of machinist technology by any artist up to that time, a momentous accomplishment that would influence a generation of artists on both sides of the Atlantic. This mechanomorphic style was given its first grand-scale showing in an exhibition of sixteen works at the Modern Gallery in January 1916.[17]

Voilà la femme (translated in the catalogue as *Behold the Woman*; p. 64) was one of the more obvious invocations of sexual identity, although this point was either overlooked or intentionally ignored by reviewers of the exhibition. In this painting, woman is depicted as a machine part with two cylindrical openings, one of which is filled by a metallic shaft, which, presumably, undulates in a repetitive fashion once the machine is set into motion. *Révérence*, on the other hand, depicts a less obviously functional machine, although the paired, striated elements have been compared to the drums of a chocolate grinder (linking this image to precedents in the work of Duchamp).[18] One reviewer, however, identified a specific machine source for

Above:
Francis Picabia. Révérence (Reverence). 1915. Oil on cardboard, 39 ¼ x 39 ¼". The Baltimore Museum of Art. Bequest of Saidie A. May. BMA 1951.347

Below:
Francis Picabia. This Thing Is Made to Perpetuate My Memory (Cette chose est faite pour perpétuer mon souvenir). 1915. Oil and metallic paint on board, 39 x 40". Collection The Arts Club of Chicago

VOILA LA FEMME

Picabia

Francis Picabia. Voilà la femme (Behold the Woman). *1915. Watercolor and oil on paper, 29 ½ x 19 ¼". Collection Jean-Jacques Lebel, Paris*

this painting. "*Révérence* is an exceptionally literal representation of the chief parts of an aeroplane," he wrote, asserting that this interpretation is verified by Picabia's inscription: "Objet qui ne fait pas l'éloge du temps passé," which was translated as "Here Is Something that Does Not Eulogize Times Gone By."[19]

If we take this inscription literally, it would seem that Picabia did not want this painting to commemorate or in other ways refer to events from the past. But

the title given to another painting in the exhibition, *This Thing Is Made to Perpetuate My Memory*, would indicate that the picture was made for the opposite reason. This reading is in part supported by the overall design, which takes on the appearance of a large recording device: four disks resembling gramophone records are connected to a central core, which, in turn, looks as if it is channeling out the sound through a silvered tube. But apparently, as the title suggests, this mechanical device serves only its maker, for an inscription at the bottom of the painting reads: "They turn—you have ears and you do not hear." Two review-

ers of the exhibition, however, taking their clue from the gold metallic background, thought the painting evoked a specific memory of Japanese art, while one went further and thought Picabia was influenced by "the latest scientific war weapons."[20]

There can be little doubt that Picabia did not design these paintings as illustrations of specific mechanical functions, but rather, as metaphorical models for the human condition, particularly his own. *Paroxysme de la douleur* (*Paroxysm of Sadness*), for example, is a title that may have been intended as a reference to his own emotional state, which in this period oscillated unpredictably from feelings of extreme happiness to outright depression. The machine in this painting—which is composed of a central cylinder surrounded by a cooling coil—even seems to have been designed with a therapeutic function in mind: i.e., bouts of sadness could be "cooled," or lessened, when run through this simple machine.

Attempts to locate the original mechanical source for *Paroxysme de la douleur* have proven inconclusive, although the central cylinder has been found to bear a casual resemblance to "lubricators for steam engines."[21] A specific and certainly more appropriate source might well be located if we follow a suggestion provided by Picabia himself in his choice of title: paroxysm was a term commonly used as a euphemism for orgasm, particularly within the medical profession. For women suffering from acute hysteria, vulvular massage was often prescribed and administered by physicians in their offices, with the intention of exciting patients to the state of "hysterical paroxysm," thereby releasing nervous tension and bringing about temporary relief from their affliction (numerous sessions were usually necessary to effect a total cure). In the late nineteenth century, this practice was facilitated through the invention of hydromechanical vibrators, large and cumbersome devices that were replaced at the beginning of this century by more portable electric models, relatively inexpensive machines that could be brought into the home and self-administered. Of course, the sexual

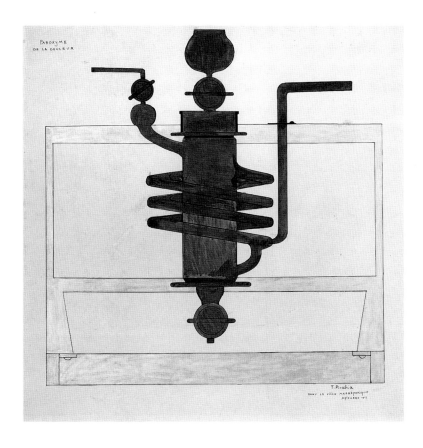

Francis Picabia. Paroxysme de la douleur
(Paroxysm of Sadness). *1915. Ink and metallic
paint on cardboard, 31 ½ x 31 ½". National
Gallery of Canada, Ottawa*

Cortissoz concluded that they were
"plans for plumbing or steam pumps or
something of the sort."[28] When attempt-
ing to decipher the elaborate titles, a
good number of critics concluded that
the show should not be taken seriously.
"The war makes many artists serious,"
wrote one. "But not Picabia!"[29] "The
inscriptions are immensely funny," warned
another, "and a really very clever artist
is making fun of those who take him
seriously."[30]

Strangely, Picabia may not even have
been present to witness this important
exhibition of his machinist works. In the
fall of 1915, Gabrielle Buffet returned to
New York to accompany her husband on
the completion of his military mission to
the Caribbean.

use of these devices was discouraged by
most physicians, though manufacturers
and their advertisers were ingenious in
their ability to disguise this alternate func-
tion.[22]

Other paintings in the Modern Gallery
exhibition, however, do not appear to
have been designed with any function in
mind, mechanical or metaphorical.
Machine sans nom (*Machine Without
Name*), for example, is precisely that,
leaving us with no clue as to its possible
intention. Thin lines in black, white, and
red gouache define the schematic outline
of a tall, vertically oriented machine, the
background unpainted, as if to reinforce
the impression that this is a large
mechanical diagram for a machine ren-
dered in cross section.

Another painting in the exhibition can
be interpreted in a similar fashion, such
as *Très rare tableau sur la terre* (*Very Rare
Picture on Earth*; p. 66), a work that made
such unusual use of materials that it drew
considerable attention from the press.
Indeed, technically, the work is more an
assemblage than a painting. To a flat
board, Picabia affixed two wooden half-
cylinders and a rod, which he in turn col-
ored so skillfully with metallic paint that

at least two reviewers described these
elements as having been made of actual
brass.[23] The specific machine source for
this painting has not yet been identified;
although one may someday be found, it is
worth considering the possibility that the
image was a product of free invention,
Picabia's fanciful vision of a machine that
has no precedent, so different and
unique—even in his own work—as to
constitute a "very rare picture on
earth."[24]

Whereas most visitors to the exhibi-
tion found Picabia's machine images
utterly incomprehensible as art, they
were at no loss for words in characteriz-
ing the artist. "Picabia has been called
cubist, futurist, etc., and denied all these
labels," wrote one critic. "But there is no
doubt about him now— He is a machin-
ist."[25] Most reviewers made a futile effort
to identify sources for the machine
images. "They appear to be drawings of
engines," explained one, "or illustrations
to patent office reports."[26] Another
reviewer could see only "circles, curves,
right lines, angles, rectangles, parallels,
toggle joints, cylinders, stopcocks, traps,
siphons, and other mechanical units,"[27]
while the conservative critic Royal

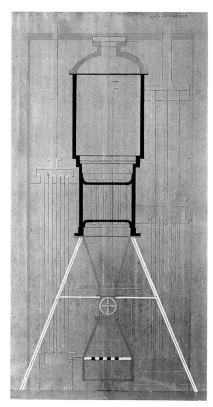

Francis Picabia. Machine sans nom (Machine
Without Name). *1915. Gouache and metallic paint
on board, 45 ⅞ x 27 ⅞". The Carnegie Museum of
Art, Pittsburgh. Gift of G. David Thompson,
55.55.6*

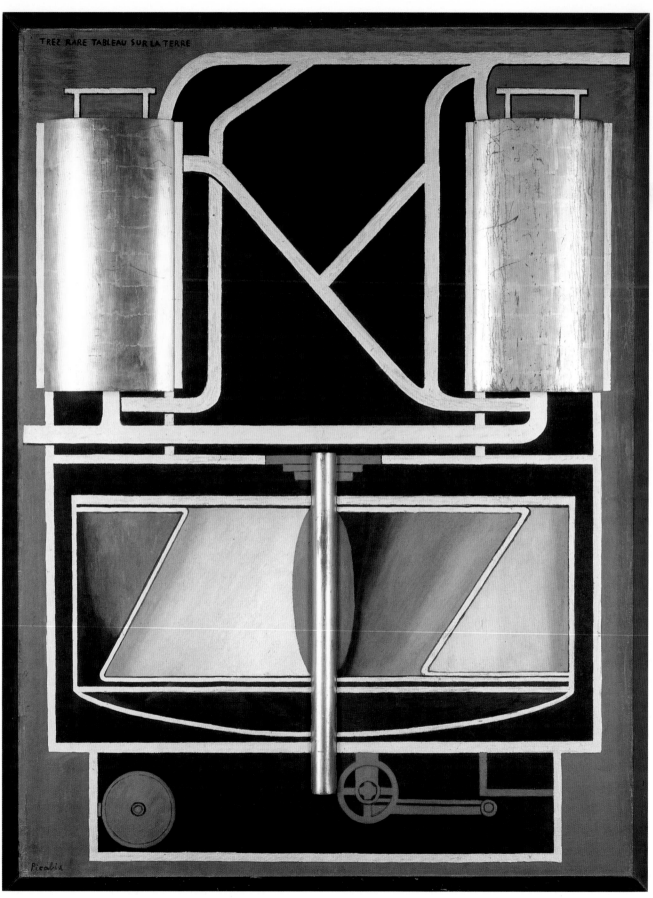

Francis Picabia. Très rare tableau sur la terre (Very Rare Picture on Earth). *1915. Oil and metallic paint on board, and silver and gold leaf on wood; including artist's painted frame, 49 ½" x 38 ½". Peggy Guggenheim Collection, Venice. The Solomon R. Guggenheim Foundation*

Although Picabia's precise whereabouts are difficult to establish with certainty over the next few months, by the spring of 1916, he was back in New York with Gabrielle Buffet. De Zayas continued to show selected examples of Picabia's work in his gallery. In September 1916—even though the artist and his wife had just left New York for Spain—de Zayas opened the new season by showing at least three paintings by Picabia in a group exhibition.[31] Although two of the pictures had been exhibited before, one entitled *La Musique est comme la peinture* (*Music Is Like Painting*) was shown in this exhibition for the first time. The image was derived from a physics diagram illustrating the deflection of alpha, beta, and gamma particles on a magnetic field.[32] The appropriation of this image is so straightforward and unaltered that it would appear to mark an abrupt stylistic departure from Picabia's machinist work; its theme, however, can be readily linked to his earlier preoccupation with abstraction and music.

While away in Spain, Picabia maintained almost continuous contact with de Zayas in New York, writing, on at least one occasion, that "not a day passes that one does not talk of the Modern Gallery."[33] In the same letter, he announced his intention to begin a magazine, and less than two weeks later, the first issue of *391* appeared. Even though named in obvious homage to *291*, the magazine bore little resemblance to its predecessor. From the very first issue, Picabia envisioned his magazine as a more ephemeral publication, a personal forum that was intended to preserve the spirit of *291* without any effort to duplicate its printed quality. One of the more important aspects of the magazine is that it served as a vehicle through which to disseminate information, not only pertaining to Picabia's activities, but—by means of a self-styled international gossip column that appeared periodically (though much was written in jest)—one could keep up with the activities of a host of other artists and writers.

After a number of failed attempts to return to America, Picabia and his wife finally left Barcelona at the end of March 1917, arriving in New York on April 4, 1917. Though he would only stay for approximately six months, this third and last trip to America was probably Picabia's most productive and entertaining, for not only did he renew his former contact with Stieglitz and de Zayas, but he broadened the scope of his entourage to include members of the Arensberg circle: Henri-Pierre Roché, Beatrice Wood, Edgard Varèse and most notably, Marcel Duchamp. "No sooner had we

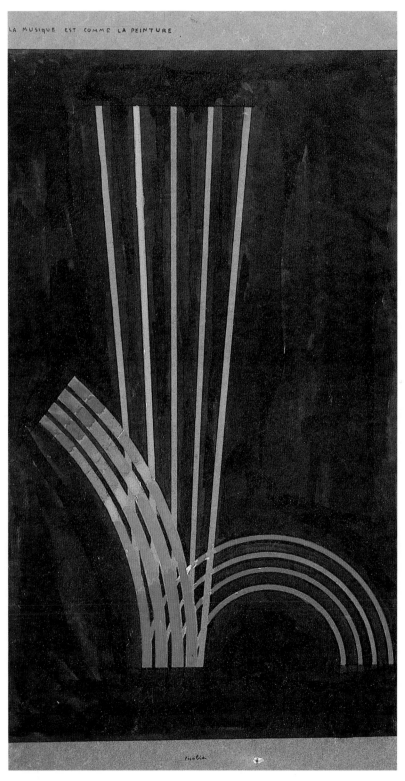

Francis Picabia. La Musique est comme la peinture (Music Is Like Painting). *c. 1913–17. Watercolor and gouache (?) on board, 48 x 26". Formerly collection N. Manoukian, Paris*

arrived," recalled Gabrielle Buffet some years later, "than we became part of a motley international band which turned night into day, conscientious objectors of all nationalities and walks of life living an inconceivable orgy of sexuality, jazz and alcohol." The Picabias especially enjoyed the evenings they spent at the Arensbergs, "where," as Picabia's wife also recalled, "at any hour of the night one was sure of finding sandwiches, first-class chess players, and an atmosphere free from conventional prejudice."[34]

Picabia captured the mood and spirit of these gatherings at the Arensberg apartment in a poem scrawled quickly on Hotel Brevoort stationery and dated May 4, 1917:

> *Big Girls and Great Men*
> *At the Arensbergs'*
>
> *In the white light*
> *They are eating*
> *In the white light*
> *Some girls were sitting on the floor*
> *In the white light*
> *The patron goes wherever he wants*
>
> *Chinese music*
> *It was wonderful*
> *Chinese music*
> *Leaning poses*

Chinese music
They cross their legs

Charming spectacle
Of big nonchalant girls
Charming spectacle
Of chess players
Charming spectacle
Of dancers

In the studio of my friends
There is no enigma
In the studio of my friends
There is no soldier
In the studio of my friends
All eyes are pure.[35]

Each of the four stanzas of this poem is organized around a pattern of treble refrains, a relatively rigid structure that Picabia might have employed in order to suggest the regularity and dependability of these evening gatherings at the Arensbergs'.

At the time this poem was written, two works by Picabia represented his contribution to the Independents exhibition: *Physical Culture* (see p. 20) and *La Musique est comme la peinture* (*Music Is Like Painting*) (see p. 67). But even more than the public exhibition of his work, Picabia's private life took on a spirit of its own. During the summer of 1917, the Gleizeses

and Picabias rented separate apartments in the home of Louise Norton. As Gleizes's wife later recounted: "Picabia could not live without being surrounded morning and night by a troop of uprooted, floating, bizarre people whom he supported more or less."[36] In a letter to his secretary, Stieglitz provides a rare, first-hand report of an evening spent at the Picabias', an account so immediate and fresh that it is worth quoting at length:

> *On Saturday evening Mrs. S[tieglitz] & I visited the Picabias. Mrs. P[icabia] is to be operated on to-morrow—gallstones—It was a pleasant evening—a change—She looked charming lying on a couch—her negligée, blue shirt—the Gleizes [sic] were there too—he in a white tennis shirt—a long clay pipe being on a sofa—Duchamps [sic] sitting modestly there at his feet—D[uchamp]. always makes me think of Haviland—Has the same inborn refinement—gentleness.—*
>
> *There was Arensberg too—He & Mrs. G[leizes] sitting on cushions on the floor— And a Russian.—A revolutionist who had spent 3 years in prison—Siberia— chained—Escaped 12 years ago—to Paris. Here since 6 months—He sang for us— unaccompanied—Russian folksongs—prisoners' songs—Weird—Fanatical—very real—It was great to hear him talk—It was 291 all over again—And he from Siberia— Prison—*

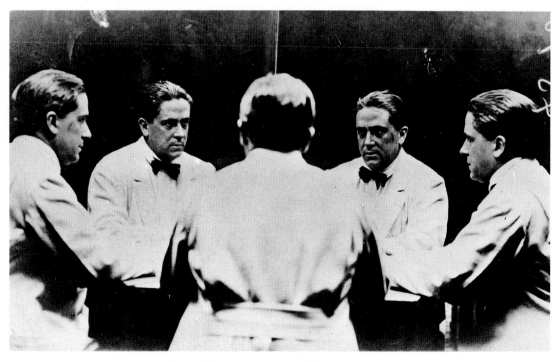

Multiple photograph of Francis Picabia. 1917. Collection Y. Poupard-Lieussou, Paris

I sat very quietly all evening—just seeing & hearing—Outside of everything it seemed—yet as if I had touched & been in everything—sometime or other—

He related stories about the War in Paris—He is naturally anti-War–anti-Flags - & anti-nationality—Just believes that one human is as good or bad as another— whatever race or system—

Related how in a Paris Café while the talk was going on about the German "atrocities"—a darkey—French soldier— grinned—took out of his huge pocket some- thing—& called out: "look—a Boche"—It was a German's head.—And all the people in the Café applauded & laughed!—

German atrocity.

I guess all men are brutes—under certain conditions—& perhaps women too.—

Mrs. S[tieglitz] enjoyed the evening— especially Mrs. P[icabia] & the Russian. He was the real thing—the artists—intel- lectuals—at least men like Picabia & Gleizes—Duchamps [sic] intellectual—but more.—They are coming to see the new 291—[37]

During the summer of 1917, Duchamp and Picabia saw one another frequently. On one occasion, after a night out cavorting, the two convened at Louise Norton's apartment. Famished, they raid- ed the icebox, where they found a leg of lamb that Norton was keeping refrigerat- ed for her neighbors the Gleizeses. Disregarding Louise's protests, they ate everything, claiming that Norton pos- sessed no sense of humor and the Gleizeses would understand. Upon com- pletion, they left the skinned bone in front of the Gleizeses' door, a gesture the French painter and his wife found any- thing but amusing.[38]

Rather than curtail Picabia's artistic production, nightly activities of this type served only to stimulate his creative energies. It was probably in this period that he produced one of the purest examples of his machinist style, the stark rendition of a single mechanical device (possibly the differential assembly of a car) profiled against an opaque black

Francis Picabia (behind wheel), Gabrielle Buffet-Picabia (seated on hood), Walter Arensberg (seated on running board), Louise Arensberg (standing), and unidentified man (Henri-Pierre Roché?), New York. 1917. Collection Maria Lluïsa Borràs, Barcelona

ground. The title, Vertu (Virtue)—promi- nently inscribed in the lower left corner of the image—was intended as a sullen reference to Juliette Gleizes, who Picabia must have thought was, like her husband, entirely too serious (i.e., virtuous) to be taken seriously. Picabia knew that the Gleizeses had become disillusioned in their hope that America would be the aesthetic salvation of modern art, and he even claimed to have known that under her husband's surveillance, Madame Gleizes had sought homeopathic relief through the consumption of whiskey.[39]

In this same period, Picabia continued to devote more time to the writing of poetry, which he had first pursued in earnest during his stay in Barcelona. And it could be said that his paintings of this

period—while still deriving their imagery from the machine—became more dependent on literary qualities, that is to say, the titles he selected provide the imagery with a more precise narrative content. Moreover, these titles often serve to prompt humorous and, at times, even scurrilous interpretations of the picture. Finally, as William Camfield has observed, the machine paintings from this, the second phase of Picabia's mechanomorphic style (after c. 1916), are generally asymmetrical in composition.[40]

These qualities can be discerned in two thematically related paintings from this period: *Fille Née sans Mère (Girl Born Without a Mother)* (using the same title that had been employed in an earlier

Above:
Francis Picabia. Vertu (Virtue). *c. 1917. India ink and gouache on paper, 9 5/8 x 12 5/8″. Musée National d'Art Moderne, Paris. Purchase by the CNAC GP 1976*

Below:
Francis Picabia. Fille Née sans Mère (Girl Born Without a Mother). *c. 1916–18. Gouache and metallic paint on paper, 19 5/8 x 23 5/8″. Private collection, London*

Opposite:
Francis Picabia. Machine tournez vite (Machine Turn Quickly). *c. 1916–18. Gouache and metallic paint, 19 1/2 x 12 7/8″. National Gallery of Art, Washington, D.C. Patrons' Permanent Fund*

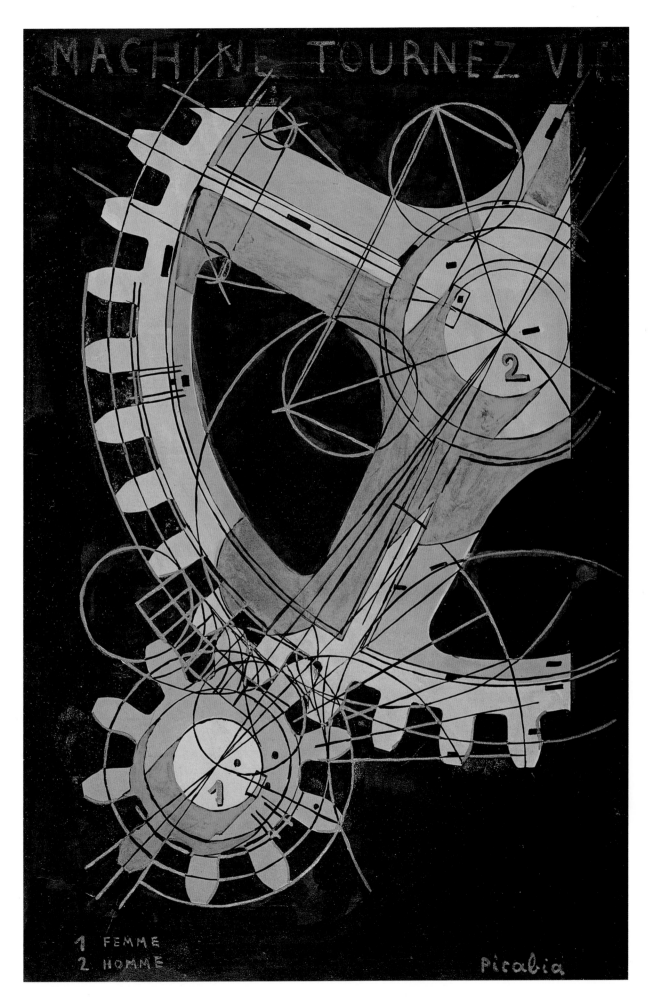

sketch (see p. 60), but different in all other respects) and *Machine tournez vite* (*Machine Turn Quickly*), both from c. 1916–18.[41] In the first of these pictures, Picabia has painted directly over a diagram for a railway machine, accentuating selected details in green gouache and, by means of a gold metallic paint, obscuring most of the printed background. The surface is so elegantly brushed that it skillfully disguises the appropriation of this image, while at the same time creating the impression of a collage. It should be noted that Picabia did not employ such a technique solely to disguise his source, but rather to highlight the details of this machine that best evoke its anthropomorphic qualities; more specifically, to create a visual metaphor with the repeated, mechanical action of sexual intercourse. The large central flywheel of this machine is attached to a shaft, which, by means of a rotating joint, connects to a valve encased in a sleeve in the lower left corner of the composition (rendered in cross section). If the machine were put into motion, little would be required to envision this valve moving up and down within its sleeve, and even less imagination is necessary to realize Picabia's intentions. *Fille Née sans Mère* is precisely that; sexual intercourse may have produced man, but man created the machine. And having created the machine in his own

image (as God created him), the machine naturally emulates his actions.

A similar rationale inspired the design of *Machine tournez vite* (*Machine Turn Quickly*), which depicts two meshing gears, the smaller of the two labeled "1" and the other "2." A legend in the lower left corner provides a guide: 1 = Femme / 2 = Homme. If the instructions provided in the title are followed, the cogs on each gear will mesh rapidly and, because of the circular form of the gears themselves, endlessly. Whereas a certain degree of caution should be exercised in reading the symbolism of these machine paintings, it is worthwhile noting that in labeling the two gears in this picture as he has, Picabia has assigned very specific yet distinct gender identities. If this machine were put into action, woman would have to turn at approximately three times the speed of man. If we can take the liberty of assuming that Picabia established these sexual identities on the basis of personal experience, then it is possible to conclude that he envisioned himself as a lethargic, though at the same time dominant and controlling force in all intimate relations. Whatever he may have intended, even to the casual observer, the essential symbolism is clear: together, man and woman function like machines and, in turn, machines function like them.

While in New York, Picabia continued the publication of *391*, releasing three numbers during the summer months of 1917. For the covers of these issues, Picabia reproduced three very distinct objects: a ship's screw labeled: "*ÂNE*" (*DONKEY*); the photograph of a light bulb, retouched to simulate the reflection in a shop window of the words "FLIRT" and "DIVORCE," the whole labeled: "*AMÉRICAINE*" (*AMERICAN*; female gender); and a circular, segmented automobile part labeled "*Ballet Mécanique*" (*Mechanical Ballet*). Although it is doubtful that Picabia intended any significance in the sequence of these three images, the order in which they appeared curiously paralleled events in his private life: the ship's propeller could refer to his voyage to New York; the words FLIRT and DIVORCE on the light bulb might refer to a number of amorous affairs experienced in New York, which could (and eventually did) lead him to divorce; and the mechanical ballet could refer to the mindless motion or silent dance that one is compelled to follow in such complicated situations (in the last of these examples, Picabia may even have intended a reference to Isadora Duncan, the well-known dancer with whom he was, at the time, having an affair).

The contents of these three issues reflect Picabia's new circle of friends. There were poems by Arensberg, state-

Francis Picabia. Âne (Donkey). 391, *June 1917. Cover. Yale Collection of American Literature, Beinecke Rare Book and Manuscript Library, Yale University, New Haven*

Francis Picabia. Américaine (American). 391, *July 1917. Cover. Yale Collection of American Literature, Beinecke Rare Book and Manuscript Library, Yale University, New Haven*

Francis Picabia. Ballet Mécanique (Mechanical Ballet). 391, *August 1917. Cover. Yale Collection of American Literature, Beinecke Rare Book and Manuscript Library, Yale University, New Haven*

ments on music by Varèse, an article on modern painting by Gleizes, and a verbal/visual caricature of a woman by de Zayas. Picabia continued to use *391* as a vehicle for the release of his poetry, and he put together another gossip column, with the information in this case divided into three city centers: Paris (as reported by Max Jacob), Barcelona (by Pharamousse, one of Picabia's pseudonyms), and New York (unsigned, but doubtless written by Picabia as well). In the last section, Picabia provided his readers with current reports on the activities of several friends and acquaintances in New York: M. de Zayas, whom he denounces for having shown paintings by R. Frost at his gallery; Mme. Duncan ("whom," he says, "we have never admired"); A. Cravan (reporting on his scandalous lecture at the Independents); Marcel Duchamp, who he tells us is a professor of French at Washington Square University, and has recently handed in his resignation at the Independents; Leo Stein ("like Cuban fish he blows up when tickled"); and Francis Picabia, who, "upon his return to America has declared the only poets who ever existed are Guillaume Apollinaire and Max Jacob." He also includes a report on someone he calls Hachepé, clearly a phonetic equivalent of "H-P," Henri-Pierre Roché, who, he says, "declared that it is impossible to have lunch or dinner with the reunited Mr. and Mrs. Picabia."[42]

Picabia's paintings from 1917 resort to similarly rich levels of sarcasm and humor. In *Parade Amoureuse* (*Amorous Parade*) (p. 74), two machines are placed on public exhibition—as in a parade—the intimacy of their amorous exchange presented openly and visibly for all to see. Picabia has placed these erect, mechanical devices within a sharply receding space, but the machines themselves ignore the perspective schema defined by their surroundings. This serves to isolate the machines from their background, as if to indicate that they were painted on the surface of a wholly independent, invisible frontal plane, like glass (a reading reinforced by the white modulated brushwork of the background). Of course, the painting of mechanical forms on glass is a

technique pioneered by Duchamp, and in view of the deep friendship that developed between these artists at this time, it is tempting to suggest that *Parade Amoureuse* might have been painted in direct response to Picabia's first viewing of the *Large Glass* (see p. 38).

Indeed, in an analysis of *Parade Amoureuse*, one scholar has gone so far as to identify specific elements within Picabia's painting that relate to certain details of the *Large Glass*, details that could have been known only through an examination of Duchamp's notes for this elaborate construction.[43] But an even more intimate rapport can be established between the works of Duchamp and Picabia in this period if these two works are compared on the basis of their iconographic similarities. The machines of Duchamp and Picabia were never intended to function, at least not in the literal sense. Rather, they are mindless mechanisms that work continuously, but produce nothing. And just as Duchamp had divided the male and female elements of his composition into different domains, in *Parade Amoureuse*, Picabia has placed the female machine on the left (the dual cylinders and rectangular base reminiscent of the machine in *Voilà la femme*: see p. 64) and the male machine, with its blocky and more weighty forms, on the right—the two connected to one another by a complicated series of pivoting metal shapes, to which are attached noisemaking devices which, we can imagine, will clang and rattle loudly when the machine is activated. Although sound was never incorporated into Duchamp's final design for the *Large Glass*, he did toy with the idea of creating a musical sculpture, wherein sounds emanating from different places might create "a sounding sculpture which lasts."[44]

If we could take the liberty of relating the theme of this painting to certain events in Picabia's private life, we note that he may have intended even more in this rendition of a noisy sex machine. In this period, Picabia entered into the care of a neurologist, to treat repeated bouts of neurasthenia (a psychic and emotional disorder characterized by chronic fatigue and lack of motivation).[45] In mid-September

ber 1917, Gabrielle left New York and returned to Switzerland to care for their children; on the day before her departure, she left a revealing note for Stieglitz, telling him of her exhaustion and explaining that she had to leave in order to secure some "solitude and repose."[46] Indeed, by the end of the summer, the situation must have become intolerable.

When Gabrielle left, Varèse moved into Picabia's apartment, and the two indulged in a rather hedonistic life-style, which Varèse described as: "a Gemini month of drinking, laughing, and girl-chasing." As Louise Norton later explained: "It had been a hot summer (as usual) and Varèse and Picabia would lie around and stalk around the apartment within a few inches, if that, of stark nakedness, thus informally receiving their feminine guests." Among these guests, according to Louise Norton, was "Isadora Duncan, who, as creator of barefoot dancing in diaphanous veils, thought nothing of nudity either."[47]

Upon Gabrielle's departure, Picabia's affair with Isadora Duncan intensified, while at the same time he composed highly intimate and sentimental poems dedicated to his wife. The emotional contradictions in his private life are referred to—if only obliquely—in *Prostitution Universelle* (*Universal Prostitution*) (p. 75), the image of a stark upright male machine (on the left) attached to a crouching female machine (labeled "SEXE FEMININ IDEOLOGIQUE") by means of electrodes and connecting cables. Spewing forth from the male machine are the words "convier . . . ignorer . . . corps humain" ("to bring together . . . to ignore . . . human body"). These words, combined with the title, make the meaning clear: at this point, Picabia must have considered the act of making love as a detached, unemotional process, one that persists universally, and thus is to be no more highly regarded than prostitution. Picabia may have intended the female machine in this picture to represent the absence of his wife, for the words "SAC DE VOYAGE" are inscribed on a bag hanging from below the body of this figure. Could Picabia have meant to imply that making love to his wife was a form of

"universal prostitution," or did he simply mean to suggest that in her absence, lovemaking was reduced to a simplistic mechanical procedure, where sexual satisfaction could be attained from a distance, without intimacy, in this case, by means of an electrical discharge?[48]

With Picabia, we can only guess. He left no guide. Unlike Duchamp, who made available his notes for the *Large Glass*, for Picabia, we have only his published statements and events from his private life that can be used in our efforts to decipher the function of these com-

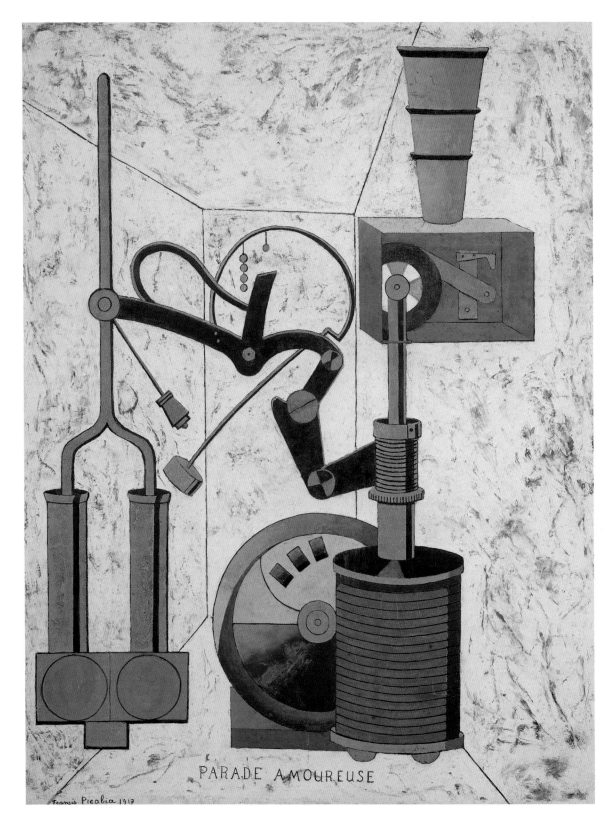

PARADE AMOUREUSE

Francis Picabia 1917

·····CONVIER·······IGNORER··········CORPS HUMAIN············

SEXE FEMININ IDEOLOGIQUE

SAC DE VOYAGE

plex machines. In October of 1917, Picabia left New York and returned to Europe. On a respite in the South of France, he made a quick little portrait sketch of Duchamp, whom, apparently, from this distance, he envisoned as the living embodiment of New York (the city's name is prominently emblazoned across the artist's forehead).[49] As the chess pieces in the background suggest, Picabia and Duchamp played often, usually at the Arensberg apartment (as they were recorded in a sketch by Beatrice Wood: p. 113).

But for Picabia, these carefree days in New York were destined not to repeat themselves; he would never again return to America. Through correspondence, however, he remained in contact with a number of friends, serving as a vital disseminator of information on the European Dada movement (see chapter

Francis Picabia. Prostitution Universelle (Universal Prostitution). *1916–17. Pen and ink and tempera on cardboard, 31 $^{11}/_{16}$ x 43 $^{3}/_{4}$". Yale University Art Gallery. Gift of Collection Société Anonyme*

Francis Picabia. Portrait of Marcel Duchamp. *1917. Ink on paper, 7 x 4 $^{1}/_{4}$". Philadelphia Museum of Art. Arensberg Archives*

8). His machinist paintings remain his legacy. They are, unquestionably, among the most elegant, yet powerful images created during the entire Dada period in New York. And even long after his departure, Picabia's paintings would continue to influence a generation of American artists, one of whom in particular—Man Ray—would not only embrace the machine aesthetic, but the nihilistic qualities of the emergent Dada movement as well.

5 · MAN RAY

During the summer of 1915, Man Ray was busy preparing for his first one-man show at the Daniel Gallery. He wanted to take pictures of his paintings, so that he could provide potential reviewers and critics with illustrations of his work. To this end, he sought the advice of Alfred Stieglitz, the photographer, whose gallery he had visited on many earlier occasions to view the various exhibitions of modern art that were held there. This time, however, he wanted to know the type of camera and filters Stieglitz recommended for translating the colors of his paintings into accurate black and white prints. It may have been on this visit to the gallery that Stieglitz asked the young painter if he would pose for his portrait. He set up his camera on a rickety old tripod and asked Man Ray to position himself securely against one of the gallery walls, for he had planned an exceptionally long exposure. With the shutter left open, Man Ray stood as still as he possibly could, while Stieglitz waved a screen of stretched cheesecloth about the head of his subject, allowing the light-sensitive film to record its imagery in muted, soft-focus tones. In the resultant print, the twenty-five-year-old artist looks directly into the camera lens, locked into a time-less gaze with the viewer, his deep-set eyes, dark curly hair, and rounded facial

Man Ray. Photograph by Alfred Stieglitz (?). c. 1915

features emerging gently from the subtle, soft gray effusion of photographic emulsion.

At the time when this picture was taken, Man Ray had been working as a painter for some seven years, but it was only in this period that his work began to take on an identity that was uniquely his, exhibiting characteristics that reflected his innate defiance toward the art of the past. To a certain extent, this rebellious attitude continued to affect virtually everything Man Ray ever did. From the earliest years of his life, he instinctively sought alternatives to expected modes of behavior, preferring to elicit reactions of surprise, rather than approval. Even when he first decided to pursue the career of a professional artist, this attitude of rebellion served Man Ray as a positive force in guiding his development.

Upon graduation from high school, he purchased a set of paints, brushes, and an easel, and went about the daily practice of painting pictures—landscapes, still lifes, and portraits—the majority of which, he later confessed, failed to communicate what he was trying to express. In an effort to improve the technical quality of his work, he enrolled in classes at the National Academy of Design and Art Students League, only to discover that

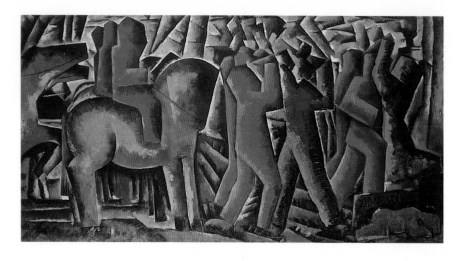

the regimen in these institutions stifled his creative impulses. Within a short time he adopted a philosophic position that was to serve him well during the course of a long and unconventional artistic career. "I shall from now on," he declared, "do the things I am not supposed to do."[1]

This attitude was not only accepted, but encouraged by instructors at the Ferrer Center, a progressive educational institution located on East 107th Street in Harlem, where Man Ray began attending classes in 1912. The Ferrer Center, or Modern School, as it was also known, was a gathering place for some of the most celebrated cultural and political radicals of the day: Leonard Abbott, Alexander Berkman, Will Durant, Emma Goldman, Margaret Sanger, Upton Sinclair, Lincoln Steffens, and a host of others, all of whom either lectured or offered courses at the school.[2] The art classes were an especially important part of the curriculum, for here, rather than follow the slow and methodical approach stipulated through academic training, students were strongly encouraged to explore the impetus provided by their own fertile imaginations. Man Ray's most memorable teacher was Robert Henri, who encouraged all of his students to assert their individuality, even at the risk of being misunderstood. Years later, Man Ray recalled that Henri's ideas were even more stimulating than his artistic criticism (in fact, they closely echoed his own guiding principles): Henri "was against what most people were for, and for what most were against."[3]

Man Ray's participation in the activities of the Ferrer Center coincided with his earliest exposure to modern art. In these years, he worked as a calligrapher and layout artist for a large publishing company in Manhattan, and on his lunch hours he frequently rushed over to Stieglitz's gallery, where he saw most of the important exhibitions that were held there: drawings and watercolors by Rodin (1910), watercolors by Cézanne (1911), sculpture by Brancusi (1914), and drawings and collages by Picasso (1911 and 1914). As with many other American artists from this period, Man Ray used the modern art he saw at 291 to help prepare for the Armory Show. Yet the enormity of the exhibition overwhelmed him to the point of inactivity. "I did nothing for six months," he later told a reporter. "It took me that time to digest what I had seen."[4]

In the spring of 1913, a few months after the Armory Show had closed in New York, Man Ray moved out of his parents' home to live in an artists' colony in Ridgefield, New Jersey, a village located across the Hudson River from Manhattan. The artist shared rent on a small shack with Samuel Halpert, an older painter who had befriended him in art classes at the Ferrer Center. On occasion, the two were joined by a loosely knit group of vanguard poets and painters who came out to Ridgefield for weekend excursions. On one particularly auspicious afternoon in late summer, they were visited by a half-dozen friends from the Ferrer Center, a group that included Adolf Wolff, a self-proclaimed "poet,

sculptor and revolutionist," and, as he himself emphasized, "mostly revolutionist." Wolff, with whom Man Ray had briefly shared a studio in Manhattan, came in the company of his former wife, the beautiful Belgian poet Adon Lacroix. Man Ray and Lacroix fell in love almost immediately and, within six months, they were married.[5]

It was while living in Ridgefield that Man Ray began to explore the more purely formal concerns of picture making, from both a historical and a modern perspective. Having experimented briefly with the fragmented, intersecting planes of Analytic Cubism, he decided that "for the sake of a new reality," in terms of both approach and technique, the modern artist should make every effort to acknowledge the inherent two-dimensional quality of the canvas surface.[6] To this end, he was led to investigate the various solutions offered for this problem by the art of the past, looking for inspira-

tion to Byzantine and Early Renaissance sources. These historical precedents, combined with his pacifist reaction toward the outbreak of war in Europe, were doubtless the most significant factors to influence the selection of technique and subject in his most important politically inspired pictures of this period: *War (ADMCMXIV)* and *Madonna*.

War (ADMCMXIV), measuring just under six feet in width, remains Man Ray's most monumental Cubist composition. According to his recollections, the unusual size of this canvas was determined by a space he had to fill in his living room, and its inordinate scale and positioning reminded him of the kind of problems that must have confronted the wall painters of the Renaissance. In emulation of these earlier masters, he prepared the canvas with a base of fish glue and plaster dissolved in water, to provide a chalky, mat surface reminiscent of the *intonaco* used in fresco.[7] The subject, he then claims, was inspired by a reproduction of one of Uccello's famous battle scenes. But rather than allow the recessional effect created by a strict application of the rules governing Renaissance perspective systems—of which Uccello was a well-known master—Man Ray rendered the figures and background shapes in his composition as if they were reflections of one another. The blunt, angular, and unarticulated forms of horses and soldiers are echoed in their surrounding environment, creating a uniform surface tension that serves to reassert the painting's physicality. Modeled almost entirely with a palette knife, the figures are rendered as overbearing, cylindrical forms—the severe geometry and lack of articulation recalling the sculptures of Adolf Wolff—while their frozen postures seem to imply the frustration and inevitability of their struggle. Locked into never-ending combat with their oppressors, these soldiers are rendered as automatons, mindlessly engaged in their struggle, obeying without question the futile orders of their commanders.

According to Man Ray, the title given to this painting, *War*, was suggested by his wife, who was especially affected by the European conflict, for her parents were still living in the country of her birth, Belgium, which, despite its neutrality, was ruthlessly invaded by German troops in August of 1914.

The ongoing struggle in Europe also inspired the making of *Madonna*, a painting whose subject, cruciform format, and flat, unarticulated forms evoke the religious icons of the Byzantine period. The artist later subtitled this picture "In Mourning—War I,"[8] but the relationship of this image to the war in Europe can be understood only when preparatory studies for this picture are examined; they reveal that the tapering black shape used to describe the Madonna's arm in the finished painting was actually derived from the neck of a large black cannon, while the halos given to the figures are taken from billowing, cloudlike formations issuing from the cannon's smoldering mouth. "Perhaps the idea was to express my desire for peace as against war," Man Ray later explained; "there were no religious intentions."[9]

Years later, Man Ray characterized these years as his "Romantic-Expressionist-Cubist period." Indeed, the very qualities of these three artistic styles—combined with a conceptual component that guided nearly everything he did—are evident in the painting *Man Ray 1914*, a mountain landscape whose jagged peaks are defined entirely by a graphic rendering of the artist's name and the date of the painting. While the main inspiration for this picture can be traced to the artist's verbal-visual preoccupations in this period (he illustrated poems, both his own and Adon Lacroix's), the unique fusion of word and image have resulted in a virtual collapse of illusory space—adding yet one more possible solution to the artist's growing repertoire of means by which to avoid a formalist contradiction with the inherent flatness of a painting's surface.

In spite of the seriousness with which Man Ray treated formalist theories, when an observer of this image discovers that

Man Ray. Man Ray 1914. *1914. Oil on board, 6 ¹¹/₁₆ x 4 ²³/₃₂". Collection Anthony Penrose, London. Penrose Film Productions, East Sussex*

its forms are composed entirely of letters and ciphers announcing the artist's name and the painting's date, it is virtually impossible to disregard the humorous content.

On at least one occasion, Man Ray's somewhat droll sense of humor rose to the level of unquestionable sarcasm, when he put together the text and accompanying illustrations for *The Ridgefield Gazook*, a four-page pamphlet (made from a single folded sheet) that appeared only once, in March 1915. Reproduced on the cover was a drawing of two insects engaged in the act of mating, captioned "The Cosmic Urge—with ape-ologies to PICASSo." The remaining contents were devoted primarily to parodies of his friends: Adolf Wolff ("Adolf Lupo"), Adon Lacroix ("Adon La+"), Hippolyte Havel ("Hipp O'Havel"), and Manuel Komroff ("Kumoff"). But other than a passing reference to the Czech anarchist Joseph Kucera ("MacKucera"), the only portion of this publication referring specifically to anarchist activities is found in a poem entitled "THREE BOMBS," illustrated by Man Ray and allegedly written by Wolff. It consists of nothing more than a series of blank lines, two exclamation marks, and a sequence of seemingly arbitrarily distributed letters, all of which are enveloped by the smoke of three sizzling explosives placed in a dish, flanked by accompanying knife and fork, located below the poem. While the literary value of this work is questionable, the three bombs are undoubtedly a reference to three young anarchists from the Ferrer Center who were killed when a bomb they were preparing accidentally blew up.[10]

It was a few months after the appearance of this pamphlet that Man Ray first met Duchamp, who was taken out to Ridgefield one Sunday afternoon by Walter Arensberg. The French artist found this remote enclave of artists puzzling. "Why do you live so far?" he asked. "Is there something you do out here [that] can't be done nearer town?"[11] At first, without a language in common, the artists found communication difficult, although Adon Lacroix served as an occasional translator. As if in an effort to

Man Ray. *Ridgefield Gazook.* 1915. Destroyed. *Formerly collection Arnold H. Crane, Chicago*

avoid these difficulties, Man Ray invited Duchamp to play a game of tennis, their conversation simplified to Man Ray calling out the score, while Duchamp responded by repeating the word "yes." In spite of their inability to converse, Man Ray must have been attracted to Duchamp's known and highly publicized iconoclastic tendencies.

On occasional trips into the city, Man Ray saw more of his new French friend. They met at Duchamp's studio or at the Arensberg apartment, where Man Ray attended a number of the famous gatherings. Years later, the artist recalled a spe-

cific incident that took place one evening at the Arensbergs' that illustrates the basic aesthetic differences that separated European artists from their American counterparts. According to Man Ray, one night Picabia showed up with some of his lady friends, while Duchamp spent most of the evening quietly engaged in a game of chess with the psychiatrist Elmer Ernest Southard. George Bellows, the celebrated American painter and Man Ray's former teacher at the Ferrer Center, was also in attendance. Bellows "walked around with a disdainful and patronizing air," Man Ray remembered, "evidently out of place in the surroundings." At one point during the course of the evening, Man Ray saw Bellows pick

up an apple, eat it, and then throw the core across the room into a fireplace "with the skill of a baseball player." In and of itself, this incident would have little significance, but Man Ray used it to dramatize the American painter's frustration in being unable to adjust to an environment dominated by Europeans and European art. By contrast, Man Ray felt at home. "I had enjoyed myself," he recalled, "there had been great variety; it was rare to find oneself in such a heterogeneous group."[12]

It may have been Duchamp's depiction of simple mechanical devices, or Picabia's pronouncements in the press, that first drew Man Ray's attention to an increasing tendency among young European painters to acknowledge the revolutionary implications of the machine age. Whatever the sources, in the closing weeks of 1915 Man Ray and his wife moved from the rural environment of Ridgefield to a studio in midtown Manhattan, where they were literally surrounded by the most recent advances in modern mechanical technology. "They were building the Lexington Avenue subway," he recalled, "and the racket of concrete mixers and steam drills was constant." But the incessant noise did not bother him. "It was music to me and even a source of inspiration," he said. "I who had been thinking of turning away from nature to man-made productions . . . with my new surroundings in a busy and changing city," he added, "it was inevitable that I change my influences and technique."[13]

This change occurred almost immediately. Shortly after moving into his Lexington Avenue studio, he began the largest and most important work of his early career, a painting whose title succinctly describes its subject: *The Rope Dancer Accompanies Herself with Her Shadows* (p. 82). The inspiration for the theme of this painting came from Man Ray's attendance at a vaudeville performance, where a tightrope walker or dancer, illuminated by bright floodlights, danced precariously on a rope stretched over the heads of her audience. Upon returning home after the show, Man Ray executed a number of quick sketches

recalling the movements of the dancer. He then rendered the dancer in a more mechanical fashion, showing her in a sequence of animated positions, which he in turn transferred to the surface of the canvas.

Then, in an effort to determine the colors of the dancer, he rendered multiple impressions of their shape on different-colored sheets of construction paper, which he in turn cut out and attempted to position in a satisfying arrangement. While so doing, he realized that the irregularly cut waste paper that had fallen to the floor was of such compelling visual interest, he later explained, that he abandoned the original design of the painting and decided, instead, to use these chance configurations as the basis of his composition. He selected six scraps and arranged them in an overlapping format for maximum color contrast. These abstract shapes were then faithfully transcribed to canvas, where they were rendered in an almost *trompe-l'oeil* fashion. Apparently, it was only at the very end of this process that Man Ray decided to recall the original dancer. At the top of the composition, he painted a sharp, almost crystalline form representing three superimposed figures joined in a single point at the waist, implying that the translucent beings were multiple readings of the same figure. From this connecting point, he painted three lines that link the dancers to their "shadows" below (the ends of three more lines, or ropes, are held in the dancers' hands). Thus, the dancer accompanies her shadows—as someone accompanies a dog on a leash—a visual image that suggested the lengthy, narrative title boldly inscribed across the base of the painting.

This painting was shown in Man Ray's second one-man show at the Daniel Gallery, held during the closing months of 1916. But by this time, the formalist concerns that had been of such importance to his earlier work had given way to an alternative approach that more thoroughly emphasized a painting's inherent physical properties. Man Ray attained the desired effects through a variety of essentially sculptural techniques: the physical buildup of paint, the application

of texture, the creation of an illusion of shallow relief, and even the attachment of actual two- and three-dimensional objects to the canvas surface.

The painting in the Daniel exhibition that drew the most attention from the press was a mixed-media assemblage that consisted of a vertical panel painted in black and aluminum, apparently meant to represent a doorway, but amusingly entitled *Self Portrait* (see p. 83). Upon the panel were affixed two doorbells and a push button, as if to suggest that if one pushed the button, the bells would ring. This was not the case, however, and it caused considerable disappointment among visitors to the exhibition. "They were furious," Man Ray later recalled. "They thought I was a bad electrician." He had never intended, though, to set up a simplistic stimulus-response demonstration, as in a psychological experiment. As he himself explained, "I simply wished the spectator to take an active part in the creation."[14]

The painting from this period that most clearly exhibits Man Ray's growing interest in mechanical forms is *Percolator,* or *Filter* (p. 83), his only extant "object-painting," that is to say, the only surviving example of the artist's work in oil from these years to represent the form of a single object (although a number of images in other media would incorporate a similar approach). Unlike the machinist paintings of Duchamp and Picabia, the unusual subject of this work carries a rather ironic, domestic focus. While the image of a coffee filter bears an obvious iconographic relationship to Duchamp's *Coffee Mill* of 1911 (Tate Gallery, London)—a painting Man Ray could have known only through reproduction—the stark isolation of such a commonplace, manufactured item bears an even greater resemblance to the subject of Duchamp's *Chocolate Grinder, No. 2* (see p. 37), a painting which by this date Man Ray certainly would have known.

Percolator is painted on a cardboard panel, its surface built up and highly textural, for the pigment was applied almost entirely with a palette knife. Man Ray may have employed this technique in order to emphasize the sculptural prop-

The Rope Dancer Accompanies Herself With Her Shadows

Man Ray. The Rope Dancer Accompanies Herself with Her Shadows. 1916. Oil on canvas, 52" x 6' 1 3/8". The Museum of Modern Art, New York. Gift of G. David Thompson

erties of the object he depicted, while at the same time underscoring the innate physical properties of the painting itself.

Curiously, in the very same period he began to experiment with an opposing approach, virtually eliminating all cues to tactility. In his exploration of this alternative direction, the artist's pursuit of painting for purely formalist concerns was dramatically curtailed. "My efforts [during] the last couple years," he later said of this period, "had been in the direction of freeing myself totally from painting and its aesthetic implications." The freedom he sought was fueled by an obsession to be different. "I wanted to find something new," he later recalled, "something where I would no longer need an easel, paint, and all the other paraphernalia of the traditional painter."

The solution presented itself in the form of a mechanical device that he had learned to use in his commercial work:

the airbrush, an instrument used by illustrators to produce a light, even spray of ink or paint. The airbrush was usually employed to produce large areas of color or to create a convincing impression of reflective surfaces and shadow. "When I discovered the airbrush," he later wrote, "it was a revelation—it was wonderful to paint a picture without touching the canvas; this was a pure cerebral activity. It was also like painting in 3-D; to obtain the desired effect you had to move the airbrush nearer or farther from the canvas."[15]

One of the first of Man Ray's aerographs—as his works in this medium are called—was Suicide. Originally the work was entitled Theatre of the Soul, after a play by the Russian director and playwright Nikolai Evreinov, best known for his theatrical parodies, satires, and monodramas. Man Ray knew the play well and a few years later published an English translation of the text.[16] It is unlikely that the work was ever intended for production, although performances were later staged in England and America. "The action," Evreinov wrote, "passes in the

soul in the period of half a second." The principal character is identified only as a professor, who, before the curtain rises, appears before the audience to introduce the other characters and the play itself. On a blackboard, the professor then begins to illustrate the plot. He draws a diagram representing a "large heart, with the beginning of its main artery . . . [which] lies between two lungs," as well as a "little system of nerves, threads of nerves, pale in color, and constantly agitated by vibration." According to Man Ray, Suicide was meant to represent the "dramatic situation on the professor's blackboard."[17] Although the various abstract elements in the aerograph are not a literal visualization of the professor's words, the ovoid forms suspended in the foreground of the composition probably refer to the two lungs, while the triangular configuration of lines in the upper center illustrates the system of nerves.

With the invention of the aerograph, Man Ray added one additional medium to those he had already mastered. "To express what I feel," he later explained,

Above left: Man Ray. Self Portrait. *1916. Mixed media assemblage: pushbutton and doorbells, mounted on panel. Original work lost. Gelatin silver print, 3 ¹³/₁₆ x 1 ¹³/₁₆". The J. Paul Getty Museum, Malibu*

Above right: Man Ray. Percolator, or Filter. *1917. Oil on board, 15 ³/₇ x 11 ³/₄". The Art Institute of Chicago. Through prior gift of the Albert Kunstadter Family Foundation, 1989.487*

Right: Man Ray. Theatre of the Soul *(later titled* Suicide). *1917. Ink and tempera and varnish on cardboard, 24 x 18 ¼". Courtesy of The Menil Collection, Houston*

"I use the medium that is best suited to express that idea."[18] In this respect, Man Ray owed a considerable debt to Duchamp, who maintained that art should avoid a purely visual, or "retinal" approach, and that the art-making process should be a "cerebral" act. The precedence of idea over form had one inevitable result: painting as a pure exercise in the exploration of formal properties would cease. Duchamp painted his last picture in 1918, and except for occasional experiments, after 1917 Man Ray

painted only when some other medium was not appropriate for the expression of a specific concept. As he clearly explained, "Perhaps I wasn't as interested in painting itself as in the development of ideas."[19]

From 1917 through 1921, Man Ray discovered that most of his ideas were best expressed through the use of objects. Even though he often appropriated the elements that comprise these works from his immediate environment, they differed from Duchamp's readymades, which were usually chosen at random and given titles that had nothing to do

Man Ray. New York. 1917. Wood slats and C-clamp assemblage. Original sculpture lost. Photograph: Estate of the Artist, Paris

with the objects themselves. Rather than select a commonplace, utilitarian item, with what Duchamp described as "aesthetic indifference," Man Ray preferred to alter or manipulate the design of the manufactured piece, sometimes by combining it with other objects and/or by adding provocative titles to create a sense of poetic expression. "Whatever elements that may come to hand or that are selected from the profusion of materials," he explained, "are combined with words to create a simple poetic image."[20]

Thus, when an assembly of wood strips held together by a C-clamp is entitled New York, we immediately see more than the simple elements with which the object was constructed; the sleek verticality and ascending angular profile recall a New York skyscraper, in the sharp geometric style of numerous high-rise buildings then under construction in the city.

In two sculptures conceived during the course of the following year—entitled, respectively, By Itself I and By Itself II—it is likely that their labeling as objects of art came only after they had been found and admired for a period as objects of worthwhile visual interest in and of themselves. It is perhaps for this reason that Man Ray gave them such obviously self-reflective titles, implying that he had little to do with their creation—that the sculptures, in effect, had made themselves. It was probably the anthropomorphic quality that these sculptures share, however, which first drew Man Ray's attention to their design. Indeed, a purely formal reading suggests that at one point the artist might have envisioned them as mechanical representations of the sexes: By Itself I contains two circular indentations in its mid-section, which could be read as marking for the position of breasts, while By Itself II carries an obvious phallic identity in its overall shape and vertical orientation. If this reading is correct, then by having conceived woman before man—as the roman numerals I and II in the titles suggest—Man Ray may have intentionally meant to set up a mock reversal of the events of biblical creation, where, of course, it is told that woman was created from the rib of man.

In the same year when these sculptures were conceived, Man Ray carefully prepared photographic images of two objects that were clearly intended to be recognized for their opposing gender identities: an eggbeater, entitled Man, and an assembly of miscellaneous objects from his darkroom, entitled Woman. In the first of these photographs, the lighting is carefully adjusted in order to create a pronounced shadow along the entire length of the object, making the anthropomorphic reading possible. The lower

portion of the eggbeater is duplicated, suggesting dual appendages, while the assembly of gears can be seen to represent a torso, and the ovoid handle at the top, the head of a figure. Given this reading, the tapering, cylindrical handle attached to the large central gear and carefully positioned between the two floating "appendages," creates an obviously phallic detail.

In Woman, two metal light reflectors and six clothespins attached to the edge of a strip of glass are illuminated in such a way that they are duplicated in sharp shadow. Just as the eggbeater can be read for its uniquely male characteristics, the paired circular reflectors in Woman can be read as breasts, while the angular pattern created by the glass and the evenly spaced rows of clothespins create a highly provocative channel of entrapment, suggesting that the slightest touch could snap the glass panel(s) shut like the leaves of a Venus flytrap. In this context, the circular opening at the upper convergence of the glass strip and its shadows alludes, perhaps, to a singular orifice, a common anatomical metaphor for woman.[21]

It is tempting to interpret these works in light of events that were taking place in Man Ray's personal life, for at the time when they were created, he was beginning to experience certain marital difficulties. In the spring of 1917, after the close of his second exhibition at the Daniel Gallery, Adon Lacroix apparently became concerned that nothing had managed to sell. So she and Man Ray decided to move into less expensive quarters in Greenwich Village, to a small apartment on Eighth Street between Fifth and Sixth avenues, not far from the famed Brevoort Hotel, in an area that had long been established as the heart of Manhattan's growing bohemian district. As comfortable as these new, more domestic surroundings may have been, Man Ray found himself unable to carry out his work in these smaller and more restrained quarters. In 1918, his landlady offered him a large space in the brownstone she owned next door, a basement room she had been using primarily for storage. As soon as the space was

Man Ray. By Itself I. 1918. Wood, iron, and cork, 16 6/8 x 7 ¼ x 7 ⁷/₁₆". Westfälisches Landesmuseum für Kunst und Kulturgeschichte, Münster

Man Ray. By Itself II. 1918. Wood, h.: 23". Kunsthaus, Zurich

his wife—would later serve as the basis for an aerograph. And in 1919, he would virtually duplicate the subject and design of an earlier painting to make the aerograph *Seguidilla* (p. 86), an image whose subject was originally inspired by his attendance at a performance given by a group of Spanish dancers. Although the work is abstractly conceived, on the upper left, the black pants and lower torso of a male figure can be seen dancing on a table top, while the six large white fans in the lower foreground were meant to represent the staccato movement of several female dancers. Cones of Spanish lace reinforce the ethnic identity of the subject, while the three umbrella-like shapes in the upper right were probably inspired by the whirling skirts of the female dancers.

Man Ray occupied this new basement studio for his remaining years in New York, and it was in these surroundings that his work rapidly developed a more self-consciously conceptual and uniquely individualistic style. In a photograph that he took of this studio around 1920, we can see that the space was surprisingly comfortable, with exceptionally high ceilings and a large fireplace. In order to make the basement room feel more lived in, Man Ray displayed a number of his paintings and aerographs about the room, hanging a large unstretched canvas composed of mechanical diagrams and

cleared out, the artist moved in, asking his landlady if she would leave a few miscellaneous items behind, things that he might find of some use in the future: a table, some chairs, a bed, and some old dress forms, which Man Ray said he wanted because "they seemed to furnish the place with a substitute for human company."[22]

Almost immediately, the environment of his new studio provided the subject matter for a large painting on board, to which he gave the alternate titles *Interior* or *Still Life + Room* (p. 86). Here, as in the aerographs, the natural coloration of the two-dimensional support is integrated within our visual comprehension of the depicted space, allowing the actual surface of the wallboard to represent the overall background upon which the various objects in the interior scene are positioned. The objects themselves consist of several pieces of furniture—a table, chair, screen, rug, and overhead lamp—and in the center of the composition, just to the side of the paneled door on the right wall, can be seen a depiction of the artist's earlier painting *Madonna* (see p. 78).

Man Ray felt no compunction about using his earlier work, whether in the form of a direct quotation, as here, or as a free variation on the original theme. The unclothed dressmaker's form on the right side of this painting, for example—a headless female figure that could be thought to represent the potential loss of

Man Ray. Man. 1918. Photograph. 19 ¹⁵/₁₆ x 15 ⅛". Jedermann, N.A., Collection

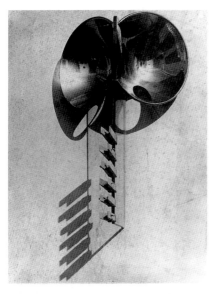

Man Ray. Woman. 1918. Silver print, 17 ³/₁₆ x 13 ¼". Gilman Paper Company Collection

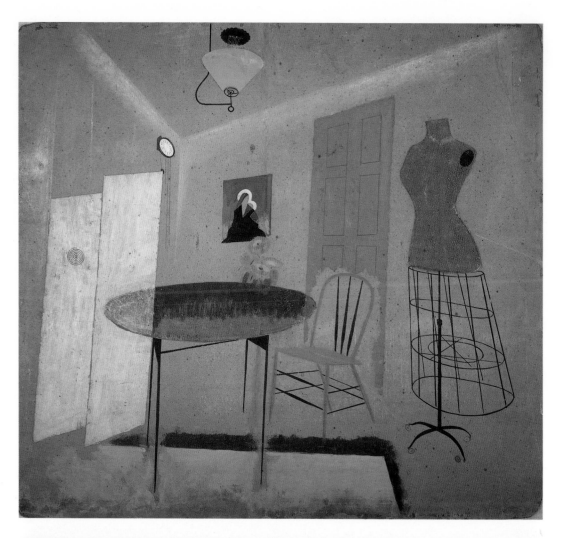

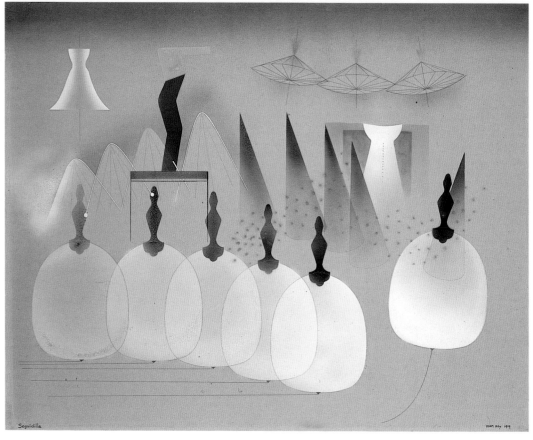

chess figures that he had made a few years earlier (in 1917) on the main expanse of wall between two large rectangular pilasters with carved Corinthian capitals, decorative enhancements to the Victorian architecture that gave the room a rather classical, yet warm and inviting appearance.

In this same photograph, we can see *By Itself II* hanging on the wall of his studio in a fashion not dissimilar to the method whereby fashionable collectors might display an African throwing stick, or some other highly prized primitive artifact (compare, for example, this object with the similarly shaped item hanging from the wall in the Arensberg apartment: see p. 26). In 1919, Man Ray used this sculpture—literally, as a template—in the making of one of his most elegant and refined aerographs of this period (p. 88), where *By Itself II* can be seen to form the dominant vertical motif in the center of the composition. Rendered entirely in subtle shades of gray and black, this ovoid image was strongly reminiscent of the general shape and monochromatic tone given to many Cubist paintings, a rather ironical source, but one the artist may very well have intended. If such images were already accepted as classic examples of the modernist aesthetic, then why not recast them through the most advanced mechanical devices of the new age? Only then, Man Ray might have reasoned, would the critics recognize the uniqueness of his invention.

In March 1919, Man Ray released the one and only issue of a magazine he sin-

gle-handedly edited—*TNT*—reproducing on its cover an abstract bronze sculpture by his old friend Adolf Wolff (p. 88). Years later, Man Ray described this publication as "a political paper with a very radical slant," which he also claimed was "a tirade against industrialists, the exploiters of workers."[23] But other than the magazine's explosive title—which ran across the cover in large black letters—there was little in the publication that could be even remotely construed as politically subversive. Rather, the review contained a selection of vanguard poems and prose pieces by a few friends, including Walter Arensberg, Adon Lacroix, Mitchell Dawson, and others, such as Philippe Soupault, whom Man Ray could have known only through French publications. The art works he reproduced were a painting by the American painter Louis Bouché, a drawing by Charles Sheeler, an aerograph by himself, and a note by Duchamp for an uncompleted section of the *Large Glass*. From Buenos Aires, Duchamp wrote the Arensbergs that he enjoyed Man Ray's magazine, and that he planned to write a letter to his old friend expressing his gratitude for having reproduced one of his drawings.[24]

Man Ray's third and last exhibition at the Daniel Gallery opened in November 1919, and was designed as a sort of minia-

ture retrospective, featuring work that had been produced in New York over the course of the previous six years. Included in the show were examples of his recent airbrush paintings, such as *Seguidilla*, probably the abstract oval 1919 *Aerograph* and another smaller work entitled *Eye That Beholds All* (p. 89). In spite of its grandiose title, the latter work consisted of nothing more than the enlarged image of a metal ball bearing, so skillfully rendered that its polished surface accurately captures a reflection of the interior of the artist's studio. The sphere is positioned against a neutral background, giving the impression that the orb hovers in space mysteriously, like some kind of floating crystal ball (which probably suggested the artist's choice of title).

At least one critic objected to Man Ray's selection of such elaborate titles; Hamilton Easter Field thought they interfered with an appreciation of the essentially abstract message contained within the works themselves, which he felt was more important. But he liked Man Ray's use of commercial instruments. "In his hands," wrote Field, "the despised air brush has created beauty." But it was precisely his use of these instruments that other critics found objectionable. "Fantasticalities of this sort are believed in some quarters to acquire all the validi-

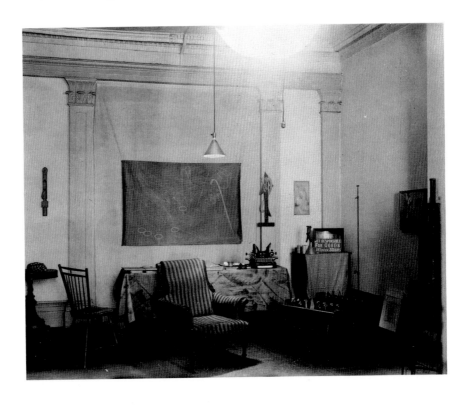

ty they need from the artist's inner conviction that what he is doing is worth doing," wrote Royal Cortissoz, the notoriously conservative critic for the *New York Tribune*. "They will have to justify themselves on broader grounds before they can be taken seriously." Perhaps the most perceptive remarks were made by a reviewer who was so interested in the show that he arranged a meeting with the artist in his studio. "He [Man Ray] strives to escape from technique," this critic wrote (presumably reflecting Man Ray's concerns), "to give not a quality of paint, but a quality of idea."[25]

When Duchamp returned to New York in January 1920, he renewed his friendship with Man Ray, and over the course of the next eighteen months, the two artists worked so closely that some have regarded the objects they produced as collaborative works. In truth, however, with the exception of a failed attempt to make a film together, Man Ray served more in the capacity of a documentarian—albeit an exceptionally creative one—for Duchamp's various projects and experiments. It was in this period that he took a compelling photograph of Duchamp and the painter Joseph Stella (p. 90), the two seated below one of Man Ray's photographs of a woman's

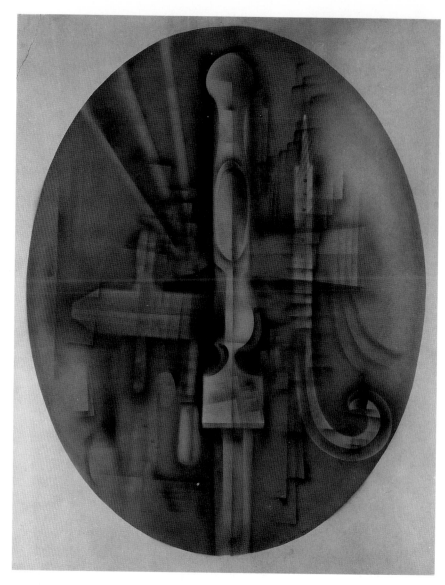

Man Ray. Aerograph *or* Untitled. *1919. Spray paint on cardboard, 26 ³/₈ x 19 ⁵/₈". Graphische Sammlung der Staatsgalerie, Stuttgart*

Man Ray. TNT. *1919. Cover. Yale Collection of American Literature, Beinecke Rare Book and Manuscript Library, Yale University, New Haven*

head seen from above, the cigarette in her mouth resembling an obelisk. It was also in 1920 that Duchamp and Man Ray, with the financial support of Katherine Dreier, served as founding members of the Société Anonyme, Inc., the first museum devoted to the display and promotion of modern art (see Dreier: chapter 6).

For the inaugural exhibition of this organization, Man Ray submitted a work he had made the previous year entitled *Lampshade* (p. 90), an object which consisted of literally nothing more than the discarded shade of a lamp he had salvaged from a refuse heap. The glue holding the paper material together had unfastened, causing the shade to unwind from its original cylindrical form. Man Ray hung the flaccid shade from a metal support, allowing its natural, undulating curves to fall into the pattern of an elegant, descending spiral. Dreier found this curious object to be among Man Ray's most successful creations, and she allowed it to represent his work in the next three exhibitions of the Société Anonyme, until the relatively fragile paper of which it was constructed began to give out. So she wrote to the artist and asked if he would consider remaking it out of metal. Man Ray quickly followed Dreier's suggestion, tracing the spiral pattern on a flat sheet of metal, which he asked a tinsmith to cut out for him. He then applied a coat of white paint and

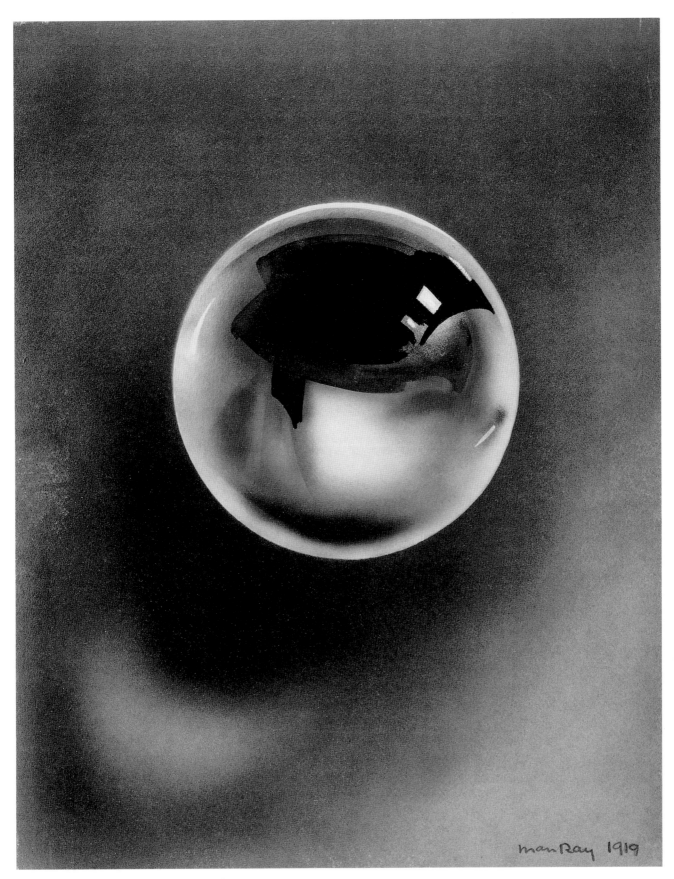

Man Ray. Eye That Beholds All *(now called* The
Eye That Sees Everything). *1919. Oil on paper,
11 ¹³/₁₆ x 9 ⁵/₈″. Art Institute of Chicago. Mary
Reynolds Collection, 1956*

Man Ray. Joseph Stella and Marcel Duchamp. *1920. Gelatin silver print, 8 1/16 x 6 1/8".* *The J. Paul Getty Museum, Malibu*

hung the resultant assembly from the same metal stand that had supported the original paper version. The *Lampshade* was the first of Man Ray's objects to undergo the process of replication, a procedure the artist would follow without hesitation throughout the course of his mature artistic career. "If it's a good copy," he later remarked, "it's just as good as the original to me."[26]

In spite of Dreier's professed admiration for Man Ray's *Lampshade,* outside of certain perfunctory tasks she had him perform on behalf of the Société Anonyme and the operation of its gallery, the domineering collector seems to have had little use for the talents of this young, nonconformist American artist. Man Ray held a similarly disparaging opinion of Dreier, one which is perhaps most succinctly expressed in a construction he entitled *Catherine Barometer,* ostensibly an allegorical portrait of this prominent figure whom he once described as a "large, blonde woman with an air of authority."[27] While one would be misguided to examine this object in search of these purely physical characteristics, certain aspects of Dreier's complex personality seem to have been consciously integrated within its individual components. Measuring an impressive four feet in height, the object is composed from an assortment of unusual materials: a metal washboard, sample paint strips, a glass tube, wire, and a cluster of steel wool. The title of the object appears in a prominent inscription at the base of the washboard. In an ovoid shape below and to the right of the title, the viewer is advised to "SHAKE WELL BEFORE USING." From a distance, the object takes on the appearance of a giant barometer, which, of course, would act erratically if shaken.

This, perhaps, is precisely what Man Ray intended. If Dreier were shaken up by some avant-garde object she did not understand, for example, then the well-intentioned though uninitiated collector was likely to act irrationally. Moreover, if the purpose of a barometer is to record

Man Ray. Lampshade. *1919–21. Painted metal on wood stand, h. 25". Yale University Art Gallery, New Haven. Bequest of Katherine S. Dreier*

Man Ray. Catherine Barometer. *1920. Mixed mediums: washboard, tube, color chart, 47 1/4 x 11 3/4". Private collection, Paris*

changes in atmospheric pressure, then the *Catherine Barometer* could be thought of as an instrument to record Dreier's continuous changes of temperament, particularly as these changes pertained to her fluctuating range of taste in the visual arts (for the only gauge in this barometer is provided by the miscellaneous assortment of colored paint strips affixed to the background). Finally, the spelling of "Catherine" in the work's title may have been an unconscious misspelling of Dreier's first name, or it may have been done intentionally in order to mask the identity of his subject, who probably would not have understood or appreciated being portrayed in this particular fashion. There is also the possibility that Man Ray incorporated an oblique reference to the collector's last name. Being that the purpose of an actual barometer is to inform its user whether the atmosphere is going to be more humid or drier, then, as has been observed, the object may have been intended to elicit a verbal/visual pun on Dreier's last name.[28]

The striking visual similarity between the *Catherine Barometer* (when it is turned on its side), and the long rectangular painting Duchamp made a few years earlier for Dreier (*Tu m'*; see pp. 48–49), may not be entirely a matter of pure coincidence. The influence of both Duchamp and Picabia is fairly evident in Man Ray's *L'Impossibilité* (*The Impossibility*). Based on a drawing made two years earlier entitled *Perpetual Motion*, this aerograph is painted entirely on the surface of a glass panel, which, alas, like so many works by Duchamp executed on this fragile material, cracked and was subsequently repaired by the artist. In stylistic terms, the work owes its most obvious debt to the mechanomorphic paintings and drawings of Francis Picabia (compare, for example, this work to Picabia's *Machine tournez vite*; see p. 71). According to Man Ray, however, this assembly of interlocking gears was inspired by the gyrations of a Spanish dancer whom he had seen perform in a local musical,[29] which accounts for the word "DANCER" inscribed across the upper center of the composition. Because

the letter "C" in this word can be easily misread for a "G," the work is often entitled *Danger/Dancer*. When Man Ray asked a mechanic to assemble the three gears he wanted to incorporate into the glass version of this work, the mechanic reportedly exclaimed: "Oh! you're crazy, these wheels won't work."[30] It is perhaps with this observation in mind that the artist chose the title *Impossibility*.

It was the straightforward juxtaposition of extraneous artifacts—with or without an apparent rationale for their

combination—that provided the principal *modus operandi* for the many objects Man Ray created during these years. In certain instances, the effect alone justified the means. The combination of a toy revolver affixed to the polarized end of a hanging magnet, for example—entitled simply *Compass* (p. 92)—produced a potent symbol of human violence. One could, of course, find even more meaning in the combination of these two simple elements. Years later, for example, one observer emphasized the attractive pow-

Man Ray. Danger/Dancer *or* L'Impossibilité. *1920. Airbrush on glass, 25 ¾ x 14 ⅛". Private collection, Paris*

Man Ray. Compass. 1920. Gelatin silver print, 4 ⅝ x 3 ⅜". Metropolitan Museum of Art, New York. Ford Motor Company Collection. Gift of Ford Motor Company Collection and John C. Waddell, 1987. (1987.100.40)

Man Ray. New York or Export Commodity. 1920. Metal ball bearings in glass olive jar, 10 ¼ x 2 ⅜". Original object lost. Gelatin silver print, 11 ½ x 8". Courtesy of The Menil Collection, Houston

ufactured object—the simple wooden coat hanger—was the only element to be included in *Obstruction*, an assemblage meant to hang freely and, in this regard, considered to be one of the first mobile sculptures ever created. The hangers were hung from one another in accordance with the rules of a strict mathematical progression, which the artist carefully described in a set of directions he prepared for inclusion in a later edition of this work. If the procedure he outlines is followed accurately, sixty-four hangers make up the final assemblage, but one is invited to keep up the progression indefinitely. Man Ray once confessed that he would like to see this work fill the entire space of a gallery, making it impossible for visitors to see any of the works of art on display. Only then would the inherent logic of its title—*Obstruction*—become apparent. "It would be amusing," he once noted, "to keep the game going and obstruct the whole universe."[32]

During the fall of 1920, Man Ray maintained his close friendship with Duchamp,

and he continued to lend his photographic skills to document a number of diverse projects. It was at this time that he took the picture of dust accumulating on the surface of the *Large Glass* (see p. 38). It may have been while preparing this photograph that he came up with the idea for a somewhat related image of debris wherein the contents of an overturned ashtray serve as the entire visual field. But unlike the photograph he prepared for Duchamp, Man Ray wanted his image to convey a disparaging view of his immediate environment—and, perhaps, of the deteriorating artistic climate of the times —for he gave it the descriptive title *New York 1920*.

In fact, in 1920, New York had very little to offer for Man Ray. His personal life had suffered as a result of a separation from Adon Lacroix, and his artistic career had not fared any better. His last show at the Daniel Gallery had not been well received. Faced with continuous and sustained resistance to his ideas, as well as with a lack of interest in his work (nothing sold from the exhibition), Man

ers of the magnet, seeing in them a force of attraction to restrain the destructive powers of the gun.[31] Indeed, a more thorough examination of the image reveals that the artist may have intended this unusual combination of elements to carry an even more threatening or precarious message. Man Ray carefully linked a thin string from the trigger of the revolver to the upper portion of the magnet, implying that if for some reason the forces of the magnet were to give way, then the revolver would discharge at random—not a pleasant or very comforting thought for someone standing within range.

Practically any random or incidental assortment of materials Man Ray found on the street or lying about his studio was capable of setting off his fertile imagination. A group of steel ball bearings housed in a cylindrical beaker, for example, took on the appearance of a jar of olives, of a type which, of course, could only be consumed by automatons. Another even more commonplace man-

Man Ray. Obstruction. 1920/1961. Replica:
Clothes hangers, h. overall: 29 ½"; each hanger
approximately 4" h. Moderna Museet, Stockholm

Man Ray. New York 1920. 1920. Photograph,
9 ⁵/₁₆ x 11 ½". Courtesy Studio Marconi, Milan

Ray began seriously to contemplate the possibility of relocating to a more supportive environment.

The extent to which Man Ray had hoped his ideas would take precedence over the objects he created to represent them (a conceptual position that anticipated developments in modern art by some fifty years) is evident in his response to a request from a newspaper reporter to explain the concept of *tactilism*, a term that had been promoted in this period to accentuate the physical, three-dimensional values of a work of art. "I want to eliminate the material," he explained, "show the idea." For Man Ray, it was no longer enough for artists simply to provide their audience with a simulation of objects found in their everyday environment. "We don't want a record of the actual object," he said. "We want a result of it."[33]

It was in this very period—during the early months of 1921—that the call from Europe grew ever louder, as Man Ray entered into correspondence with the Dadaists, vanguard European poets and painters whose artistic aspirations and views of creative freedom so closely paralleled his own. In April 1921, with Duchamp's assistance, Man Ray edited and published the only issue of an American periodical devoted exclusively to the subject of Dada in New York (see pp. 202–6). But few of his colleagues were interested in such a far-flung European enterprise, so his efforts to gain adherents in New York completely failed. When Duchamp announced his plans to return to Paris, Man Ray promised to follow. With funds advanced from an out-of-town collector against the future purchase of paintings, he bought a ticket aboard the SS *Savoie* and set sail for Paris on July 14, 1921. Man Ray's years in New York were over. Other than for a few brief trips back to visit relatives, Man Ray remained in Paris for the next nineteen years.

6

THE
ARENSBERG
CIRCLE

For a period of approximately five years—from 1915 through 1920—the matrix of New York Dada can be traced to the Arensbergs and their associates. With the exception of the Independents Exhibition of 1917 (see the next chapter), these individuals never really organized themselves into a cohesive group, at least not with the intention of establishing a separate, unified identity. They did, nonetheless, meet frequently—though informally—in evening gatherings at the Arensberg apartment, and they shared many of the same aesthetic principles, reaffirmed in the vanguard works they either supported or produced. The coherence of this group was recognized by the members themselves; in 1920, Louise Arensberg referred to the group as their "circle of friends,"[1] and years later, many would come to identify the group collectively as "the Arensberg Circle."

Those who made up the circle can be divided into roughly three categories: Walter Arensberg's literary associates and/or friends from Harvard, who were frequent visitors to the apartment in the early years just after the Arensbergs moved from Boston to New York (Wallace Stevens, William Carlos Williams, Carl Van Vechten, Fania Marinoff, Donald Evans, Pitts Sanborn, Alfred Kreymborg, William Ivins, Elmer Ernest Southard, Allen and Louise Norton, and others, many of whom were discussed in chapter 2); French artists: painters, sculptors, musicians, writers, etc., who sought refuge in New York during the years of the First World War (Marcel Duchamp, Francis Picabia, Henri-Pierre Roché, Albert Gleizes and

his wife, Juliette Roche, Jean and Yvonne Crotti, Edgard Varèse); and a host of Americans who would carry the legacy of these European contacts well into the twentieth century (Man Ray, Walter Pach, Charles Demuth, Charles Sheeler, Morton Schamberg, John Covert, Katherine Dreier, Beatrice Wood, Clara Tice, Joseph Stella, Florine Stettheimer, and others). And there were some who are far more difficult to categorize, not because of their different nationalities, but because of their unusual personalities. Three of those in this last group were important, though unknowing, contributors to the New York Dada enterprise: the brilliant English-born poet Mina Loy and the object of her affection, Arthur Cravan, both of whom entered the Arensberg entourage for a brief period in 1917; and finally, the Baroness Elsa von Freytag-Loringhoven, a German-born poet, artist, and artist's model whose eccentricities were well known to most members of this group, and though she may not have attended many gatherings at the Arensberg apartment, her notorious behavior was the embodiment of the spirit of New York Dada.

Thus far, only four major personalities have been isolated for discussion: Arensberg, Picabia, Duchamp, and Man Ray. It is necessary also to consider the accomplishments of others whose historical importance may appear far less consequential. Nevertheless, each contributed significantly to the activities of the Arensberg Circle, and ultimately, their participation serves to broaden our understanding of New York Dada and the extent to which an entire generation of artists was affected by it.

ALBERT GLEIZES

AND

JULIETTE ROCHE

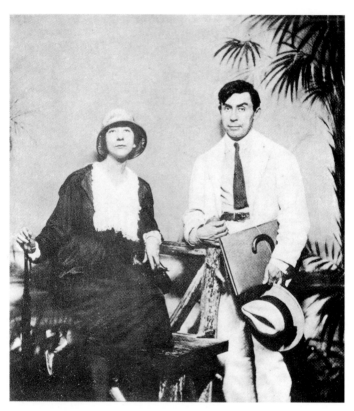

Juliette Roche and Albert Gleizes in Bermuda. 1917

In September 1915, the French painter Albert Gleizes and his wife, Juliette Roche, sailed to New York on their honeymoon. They arrived in the late afternoon and went directly to the Albemarle Hotel on Forty-fifth Street. After a promenade down Broadway—where they were impressed by the crowds and bright lights—they went into a restaurant for dinner, and found a black group playing jazz with such intensity and originality that they could compare it only to the music of Stravinsky. The following morning they were met at their hotel by Duchamp, whom Gleizes had known through Cubist circles in Paris (particularly through exchanges with Duchamp's older brothers and with other members of the Puteaux group—named after the Paris suburb where Duchamp's brothers, František Kupka, and other artists lived).[1]

Even though Duchamp had himself arrived in New York only a few months earlier, he was familiar enough with the city to take his friends on a grand tour of Manhattan; before the day was out, they would take a ferry, ride the "Elevated" train, climb to the top of a skyscraper, and visit a drugstore soda fountain. For the next evening, Duchamp organized a gala dinner at the Brevoort, inviting, according to the recollections of Juliette Roche, the Arensbergs, Louise Norton, Man Ray, Joseph Stella, Natalie Curtis (a specialist in Native American Indian music), Max Weber, Alfred Stieglitz, and the Stettheimers (the artist, Florine, and her sisters, Ettie and Carrie).

At first, the Gleizeses must have looked upon their sojourn in America with some degree of optimism. Not only were they quickly introduced to some of the most important people in the New York art world, but Gleizes had all reasons to believe a new market would develop for his work. A painting he had shown in the Armory Show two years earlier sold to a notable collector, and just a few months before he arrived, another large Cubist canvas had been purchased by Walter Arensberg from an

Albert Gleizes. Brooklyn Bridge. *1915. Oil and gouache on canvas, 40 1/8 x 40 1/8". Solomon R. Guggenheim Museum, New York*

Albert Gleizes. Le Port, arrivée à New York (The Port, Arriving in New York). *1915. Pencil and red crayon on tan paper, 84 5/8 x 55 1/8". Private collection, Dallas*

exhibition of modern French art at the Carroll Galleries.[2] "We think New York is more than France ever was," the couple told an interviewer, "and more stimulating." Both were convinced the new environment would serve to inspire new work. "I am here in America," Gleizes told another interviewer, "to study American life." He was particularly impressed by New York's skyscrapers and bridges, which he thought should be classified as works of art. "The genius who built the Brooklyn Bridge," he said, "is to be classed alongside the genius who built Notre Dame de Paris."[3]

The Gleizeses were so stimulated by their surroundings that within a few days of their arrival, working in the cramped quarters of their hotel room, they began—in their own separate ways—to record the exciting new environment of New York. Gleizes had already made a quick sketch of their first view of New York seen through the porthole of their

room on the ship as they entered the harbor. Steamships, smaller boats with vertical masts, and tall skyscrapers in the distance are fused into a singular vision in characteristic Cubist fashion. Gleizes's optimism is revealed in the name given to the ship in the immediate foreground—"LUCKO"—a vessel that proudly displays an American flag on its stern. Gleizes also made some Cubist renderings of Broadway, and then directed his attention to the bridges he so admired, completing at least three canvases depicting the Brooklyn Bridge, one of which accurately captures the diagonal thrust of its massive cables against a background cityscape.

Although Juliette Roche, too, was inspired by the city, she told an interviewer: "I shall never be a Cubist, though, of course, that art interests me a great deal." Her interest in Cubism, however, was caused not by Gleizes's preeminent position within the movement, as we

might have expected ("even my husband cannot influence me there," she told the interviewer), but by her conviction that, as she explained, "Cubist art is a definite reflection of the life we lead these days. Cubist art tries to see all the aspects concentrated: we in our living are trying to get all viewpoints and all visions, and perhaps our lives are as unintelligible as a Cubist picture is to some people."[4]

By all accounts, the Gleizeses thoroughly enjoyed the first year they spent in New York. In April of 1916, a number of Albert Gleizes's Cubist depictions of New York were shown at the Montross Gallery in a group exhibition that also included work by Metzinger, Duchamp, and Crotti. Although Gleizes objected to the titles Crotti had selected for his work (see Introduction), from the viewpoint of exposure and sales, Gleizes must have considered the exhibition a success. His painting of the Brooklyn Bridge (p. 97), for example, was purchased by the noted collector John Quinn, and one reviewer of the exhibition identified Gleizes as "the most intellectual of the quartet."[5]

Shortly after this exhibition closed, the Gleizeses left New York for Barcelona, where Albert was scheduled for a one-man show at the Galeries Dalmau. During the summer months, they were joined by the Picabias, themselves recent travelers to the United States, and together, the couples formed part of an international group of refugee artists and writers who made Barcelona their home during the war.[6] Exactly four days after Gleizes's exhibition closed, they returned to America, stopping off for short visits to Cuba and Bermuda. Back in New York, they linked up again with the Picabias, but during the summer of 1917, the Gleizeses had become increasingly disillusioned in their hope that America was the country of the future.[7]

The Gleizeses' disillusionment with America is accurately reflected in the text of *The Mineralization of Dudley Craving Mac Adam*, a long fictional narrative composed by Juliette Roche in New York in 1918.[8] The principal character in this text, Dudley Craving Mac Adam, is an amalgam of at least four different people: Dudley, the first name of a customs

officer they had to deal with upon their arrival in New York; the boxer Arthur Cravan, apparent from the name Craving (who also appears in the story as a separate character, an Englishman by the name of Lloyd Willow, Lloyd being Cravan's original family name); Marcel Duchamp, whose works are alluded to on a number of occasions; and, finally, Walter Arensberg, whose identity is thinly disguised throughout the text.[9]

Mac Adam, according to the story, is an ex-poet who has turned into a Dante scholar, and in a proto-Surrealist style, the ensuing narrative is devoted to a description of this man's complicated passage from one end of Manhattan to the other. At the end of the story, Mac Adam commits suicide, by choking to death while attempting to swallow a metal key, which causes him to become mineralized—as sterile and isolated from nature as the mechanical environment in which he lives.

Apparently, as this story suggests, the Gleizeses believed that the excesses of New York could result in a personal demise, which they elected to avoid. In

Juliette Roche. Brevoort. 1917. Visual poem. Reproduced in Demi Cercle, *1920. Yale Collection of American Literature, Beinecke Rare Book and Manuscript Library, Yale University, New Haven*

the fall of 1917, they moved from Manhattan to suburban Pelham, where Albert Gleizes became increasingly religious, eventually returning to the Catholicism of his youth. Gleizes felt that if civilization were to be saved, then people would have to return to the time-honored traditions and ideals of the past. He concluded that all artists should seek to establish the identity they had in the Middle Ages: i.e., they should live communally and revert to their original function as artisans. Earlier in the century, Gleizes had assumed precisely such an identity when he took part in the Abbaye de Créteil, a Utopian Socialist experiment in communal artistic living. To disseminate his ideas, in October 1918—on the heels of the Russian Revolution—Gleizes published an article on the abbey for *The Modern School Magazine,* a Socialist journal edited by Carl Zigrosser and published by the Ferrer Center, the anarchist center in New York that Man Ray had frequented.[10]

Gleizes's admiration for artistry and craftsmanship motivated a more detailed investigation of primitive art, and to this end, he and his wife spent many days in New York's Museum of Natural History examining the jewelry, clothing, pottery, and various other artifacts of the American Indian. Although these sources are not formally evident in Gleizes's paintings of this period, they are in a number of works by his wife. In a painting entitled *American Picnic,* for example, groupings of highly attenuated nude figures frolic in an idyllic landscape, resulting in a crowded composition that resembles the overall decorative schema of Navaho fabric design and certain examples of Hopi pottery. Black, white, and red figures recline on a carpet in the central foreground—as if to suggest the commingling of races—while two fashionably dressed women on the right (one of whom likely represents the artist herself) serve as witnesses to this uniquely American picnic. The subject of primitive societies and their moral superiority over modern civilization is a subject that possessed Albert Gleizes during these years in New York, resulting in his authorship of a treatise entitled "L'Art dans l'Évolu-

Juliette Roche. American Picnic. *c. 1915–19. Original work lost*

tion Générale," an unpublished manuscript that he began in 1917 but abandoned, unfinished, in 1919.[11]

In the spring of 1919, Gleizes was invited to write the preface to a catalogue for an exhibition of modern European and American art held at the Bourgeois Galleries. Pondering the question of whether or not there was an indigenous American art, Gleizes concluded that there wasn't, saying only that "its strength lies in its lack of individuality." Although he believed that American art lacked spirituality and soul, he maintained that this was not to be considered an entirely negative feature; to a certain extent, it provided American art with unity. "It is not impossible that Europe will yet be unified," he wrote, "but America has at present her total form."[12]

During their stay in Pelham, Juliette Roche continued to write poems, prose pieces, and at least one visual poem, *Brevoort,* based on her experiences in New York. Composed in the fashion of de Zayas's "psychotypes" (see p. 63), this poem contains the fragments of many different conversations that might have been overheard in the café or dining room of the Brevoort Hotel. According to information provided by the poem, the clientele at the Brevoort "includes all countries." But, other than the orchestra,

which accompanies a song in Italian, most people's conversations are in French. An official repeatedly proclaims: "All is well," while someone else counters with the refrain: "Long live anarchy." Among other conversations (few of which make any sense), we hear: "NIETZSCHE said: 'THE TIME OF GREAT WARS IS COMING,'" while we are all informed: "a ZONE of boredom opens up / because the color of yellow stagecoaches is missing from Washington Square."[13]

According to Duchamp, Gleizes was so naïve that when he arrived in New York, he had expected "to find cowboys on Broadway."[14] Clearly disillusioned by their American sojourn, the Gleizeses remained in Pelham for only a few months, returning permanently to Paris in the spring of 1919.

JEAN AND YVONNE CROTTI

Jean Crotti. Ivonne Crotti.

*Jean Crotti and Yvonne Crotti. Photographs reproduced
to illustrate "French Artists Spur on an American Art,"
New York Tribune, October 1915*

Jean Crotti and his wife, Yvonne, arrived in New York at about the same time as the Gleizeses, in September 1915. After spending a month in Columbus, Ohio, visiting relatives, they returned to New York. In October, the Crottis were included in an important article published by the *New York Tribune* on the influx of French artists during the war. For this article, Crotti told an interviewer that conditions in Europe made it impossible to work, but by contrast, America had much to offer. "It seems very possible," he said, "that New York is destined to become the artistic center of the world."

However, when asked if he thought the new environment would affect his painting, he explained that he worked in a fashion quite in contrast to that of M. Gleizes: "I do not portray what I see," he said, "but what I feel." Crotti emphasized: "It is not with nature [that] I am concerned, but with ideas."[1]

These words could not have failed to catch the attention of Marcel Duchamp, who—along with de Zayas, Picabia, the Gleizeses, and Frederick MacMonnies—was one of the six artists included in this interview. It is not known whether Crotti had known Duchamp earlier in Paris, but

from this point onward, their friendship developed and endured throughout the remaining years of their lives.

In the fall of 1915, Crotti and Duchamp shared a studio together in the Lincoln Arcade Building on Broadway at Sixty-seventh Street. It was while living in these quarters that Duchamp purchased two glass panels and began work on the *Large Glass*. While witnessing Duchamp's progress on this elaborate construction, Crotti changed his style and working methods dramatically; his conversations with Duchamp had an even greater effect on his ideas about art. Later, he remarked that this period marked his second birth as an artist, which, he said, came to him "by auto-procreation and self delivery without umbilical cord."[2] Before he came to America, Crotti's paintings could be described as a somewhat unresolved mixture of Orphism and Cubism. But after only six months in America, he could easily be ranked among the most noteworthy and original members of the French avant-garde.

Crotti's work was given its first public showing in New York at the Montross Gallery in 1916, in the so-called Four Musketeers Exhibition, which also included Gleizes, Metzinger, and Duchamp. It was at this exhibition that Gleizes voiced his objection to Crotti's selection of titles, which he thought were too provocative (see Introduction). As a gesture of compromise, Crotti pasted cards over the wall labels, which at least one reviewer reported, were "picked [at] industriously by inquisitive visitors."[3] The titles offended not only Gleizes, but also reviewers of the exhibition. Charles Caffin, for example, art critic for the *New York American*, found Crotti's contributions boring, a condition, he said, that was in no way "alleviated by the witless titles that a pin-

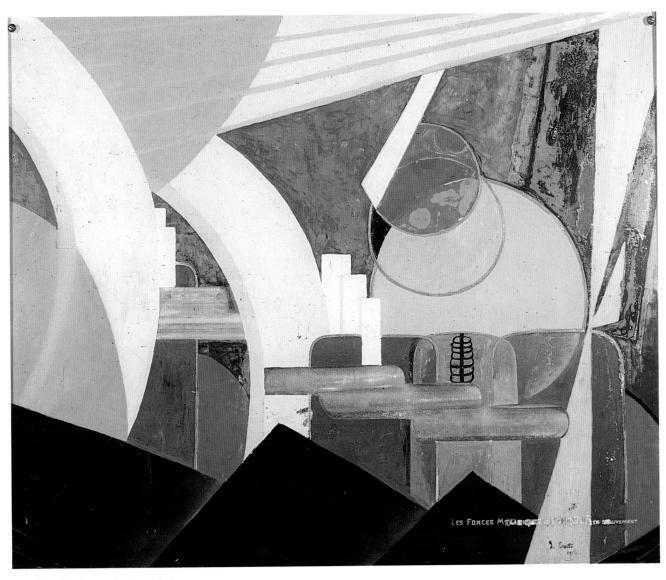

Jean Crotti. Les forces mécaniques de l'amour en mouvement (The Mechanical Forces of Love in Movement). *1916. Oil, metal tubing, and wire affixed to glass, 23 ⅝ x 29 ⅛". Private collection, Paris*

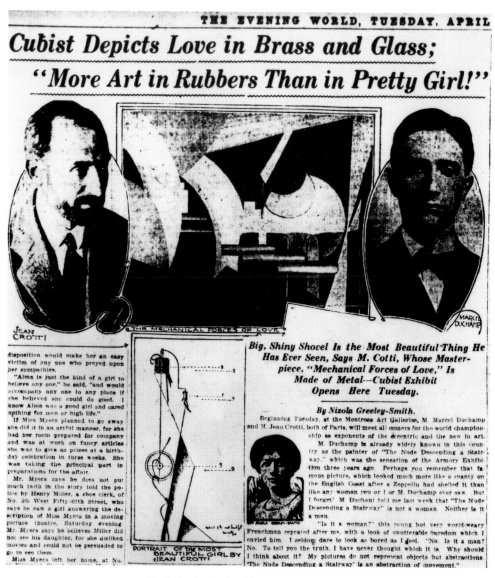

Nixola Greeley-Smith. "Cubist Depicts Love in Brass and Glass; 'More Art in Rubbers Than in Pretty Girl!'" The Evening World, April 4, 1916

headed sense of humor has devised for them after they were painted."[4]

Whether because of Gleizes's censorship, the radical quality of the work itself, or perhaps, his provocative titles, reviewers singled out Crotti's work as among the most extreme examples of the new art. The most controversial title was the one Crotti gave to a construction on glass entitled *The Mechanical Forces of Love in Movement*. This work was reproduced between portraits of Crotti and Duchamp in an article by Nixola Greeley-Smith, an exceptionally confused critic who took it upon herself to interview the artists in their studio a few days before the exhibition opened. In spite of

a rather awkward interchange—where she could not really fathom how Crotti found a pair of galoshes in the corner of the studio more beautiful than a pretty girl (alluded to in the headline)—she did understand that in aesthetic terms, these two artists were in the process of securing forefront positions in the avant-garde: "At the Montross Art Galleries," she wrote, "Marcel Duchamp and Jean Crotti, both of Paris, will meet all comers for the world championship as exponents of the eccentric and the new in art."[5]

In this same interview, Crotti was given the opportunity to explain the symbolism he intended in the various abstract shapes of *The Mechanical Forces*

of Love: red, he told the reporter, represented "love"; blue, "the ideal"; green, "hope." Other colors, he said, were intended to represent the young trees of spring. He went on to explain the forms at the far right of the composition: Here, he said, "I have indicated the extent to which love may carry human beings away by suggesting an aeroplane." After divulging that the brass rods represent "machinery, energy, power," he was asked if the symbolism in his construction had anything to do with his wife (who was present during the interview). "My picture does not undertake to express sentimental love," he said. "It is love in the most primitive sense."

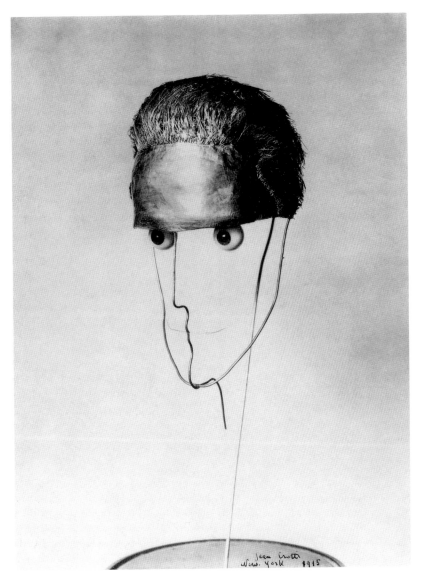

Jean Crotti. Portrait of Marcel Duchamp
(Sculpture Made to Measure.) *1915. Original
work lost. Photograph: Collection Ronny van
de Velde, Antwerp*

Another lead and glass construction by
Crotti included in this show was entitled
The Clown (p. 104), an equally abstract
assembly of geometric shapes, but in this
case, the addition of three detached
doll's eyes lends the image a more spirited
or playful quality, better suited, perhaps,
to the humor intended by its subject. But
the one work in this exhibition that drew
the most attention from the press, was
Crotti's *Portrait of Marcel Duchamp
(Sculpture Made to Measure)*, a lead and
wire construction that echoed the fea-
tures of his friend. The sculpture consist-
ed of essentially two elements: a
forehead (with hair), which gave the
appearance of having been cast directly

from the subject's features, and a pair of
artificial eyes, all held in position by a thin
wire support limning Duchamp's smiling
profile. The emphasis on only two details
of the artist's facial features—his fore-
head and eyes—is a clear illustration of
the artistic dichotomy that was of such
great concern to Duchamp in these
years: namely, the intellectual or cerebral
quality of the mind, versus the retinal or
purely visual properties of the eyes. In
the end, of course, it would be the con-
ceptually oriented approach of Duchamp
and Crotti that best distinguishes their
works in this period from the more reti-
nally oriented paintings of their Cubist
colleagues.

Crotti's *Portrait of Marcel Duchamp*
caught the attention of most reviewers
because of its unusual use of materials
(most were accustomed to seeing sculp-
tural portraits made in wood, marble, or
bronze). "Crotti's whole show," according
to Caffin, "suggests an emasculated pre-
cocity, which reaches its climax of empty-
headedness" in this portrait. A critic for
the *Evening Sun* thought the sculpture
looked like "a variation of the old fash-
ioned wax figure, more skillfully done." A
New York Times reviewer described the
work as "a clever linear performance,"
while most agreed that no matter how
unusual the medium, the portrait was "a
convincing likeness."[6]

The Crottis' stay in America would not last long, due, in part, to the disintegration of their marriage. In the fall of 1916, Crotti traveled to Europe alone, leaving Yvonne behind in New York. Before his trip, Duchamp asked Crotti to carry messages to various members of his family, particularly to his sister Suzanne. Though the precise chronology of the personal events that followed is still unclear, we do know that it was late in 1916 or sometime during the early part of 1917 that Crotti fell in love with Suzanne Duchamp, whose first marriage had ended in divorce a few years earlier. In December 1917, Crotti's nine-and-one-half-year marriage also ended in divorce, and shortly thereafter (if not before), his ex-wife Yvonne found herself entangled in an intimate relationship with Duchamp! In April 1919, Crotti married Duchamp's sister in Paris, and together, the two went on to develop an artistic enterprise of their own invention, TABU, an offshoot of Dada.

Jean Crotti. The Clown. 1916. Miscellaneous objects attached to glass, 14 9/16 x 7 7/8". Musée d'Art Moderne de la Ville de Paris

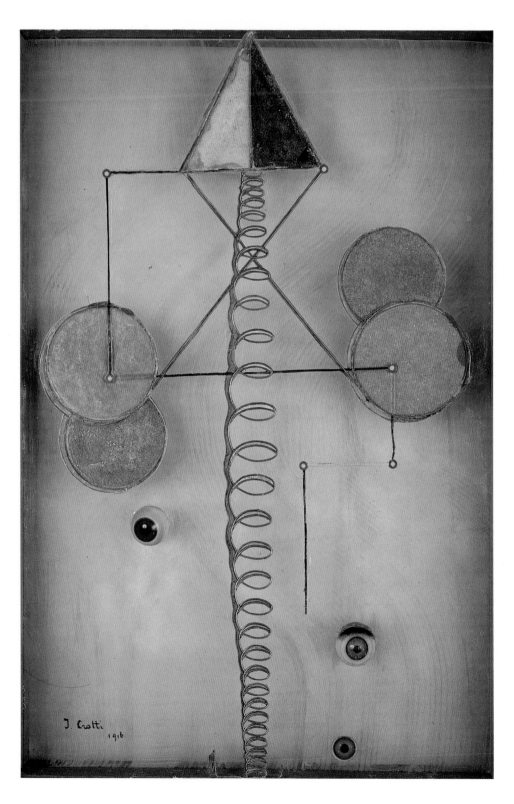

EDGARD VARÈSE

Portrait of Edgard Varèse. *Photograph by Man Ray. c. 1920*

Destined to be acknowledged as one of the greatest pioneers of modern music, Edgard Varèse was only thirty-two years old when he arrived in New York on December 29, 1915. Despite his youth, he had attained a relatively high degree of success as a composer before his departure from Paris. In 1910, a symphony he had written was performed publicly in Berlin, and because of its unconventional nature, Varèse had established a reputa-tion as a new and adventurous composer. While still a student at the Paris Conservatory, he had experimented with the possibility of incorporating sounds from life into his musical scores, which may have been a contributing factor in his dismissal from the school and his lifelong admonition against academic musical training. Certainly, it was Varèse's attraction to the unconventional in music that drew him to the work of Debussy, the

French composer who was well known for his dissonant harmonies and unusual chord progressions (it was, of course, Debussy's prelude to Mallarmé's poem *L'Après-Midi d'un faune* that set Paris on its ears in 1912, when the famous dancer Nijinsky used the composition for a ballet he choreographed and danced, in a performance that shocked the conservative audience).

Although he had known some of the most renowned people in the music world of his day (Debussy, Strauss, Busoni, Satie), Varèse had, by his own admission, "been rather more closely associated with painters, poets, architects, and scientists than musicians."[1] Indeed, a list of his friends and acquaintances in Paris reads like a who-was-who in modern French art during the first decade of this century: Picasso, Manolo, Derain, Dufy, Apollinaire, Léger, Modigliani, Albert Gleizes, Robert and Sonia Delaunay, Max Jacob, Cocteau, and countless others.

Like many who left Paris to get away from the war in Europe, Varèse came to the United States in order to find a more conducive atmosphere in which to work and, of course, he had hoped to enlist the support of some wealthy and open-minded American patrons. Less than two months after his arrival, however, he did not hold a very high opinion of the people with whom he came into contact: "New York: banal city and dirty," he wrote a friend, "and the inhabitants handsome sportsman type—not more. I see only Europeans with whom contact is possible. With the natives all conversation impossible no matter what the subject except the question of the 'Dollar,' which is the only one that is of any interest or importance to them."[2]

Of course, in spite of his disdain for such mercenary concerns, money—or, more precisely, a lack of it—was something that was very much on Varèse's mind during these early months in New York. But he wanted everyone to know that he was not willing to conform in order to please public taste. In an interview he granted to a journalist from the *New York Telegraph* just a few months after his arrival, Varèse declared: "In my

own work I have always felt the need of new mediums of expression. I refuse to limit myself to sounds that have already been heard. What I am looking for is new mechanical mediums which will lend themselves to every expression of thought and keep up with thought."[3]

Varèse's conceptual approach to music was surely recognized by another expatriate Frenchman, Marcel Duchamp, who arrived in New York about six months before Varèse. Whether they knew one another from Paris is unknown, but they certainly would have had ample opportunity to become better acquainted in the café of the Brevoort Hotel, Varèse's residence in New York after the spring of 1916. In September of that year, an unfortunate accident occurred that would result—inadvertently—in expanding Varèse's entourage of friends; he was waiting for a bus on Fifth Avenue when an automobile jumped the curb and struck him, breaking his leg. He was taken to Saint Vincent's Hospital, where, during the weeks of Varèse's recuperation, Duchamp brought along many of his French-speaking friends to visit: Henri-Pierre Roché, Beatrice Wood, and others. Through Duchamp, Varèse met the Arensbergs, and through them, virtually the entire avant-garde community of New York.

Many of these new friends attended Varèse's American debut as a conductor, held on April 1, 1917, at the old Hippodrome Theatre on Sixth Avenue. For his premiere, Varèse decided to present Hector Berlioz's *Requiem Mass*, as a memorial to all soldiers (on both sides!) who had been—and were still being—killed in the war. The reviews were generally favorable; one critic even said that Varèse "seemed to possess the inspiration of genius."[4] But the conductor's opening success was not destined to be quickly repeated. A year later he was invited to conduct the Cincinnati Symphony Orchestra, and instead of putting together a program of old favorites, which the midwestern audience was accustomed to hearing, he introduced two *Gymnopédies* by Erik Satie, orchestrated by Debussy, and Debussy's *Prélude à l'après-midi d'un faune*, as well as

a number of other unusual selections. Surprisingly, the crowd reacted enthusiastically, but the promoters were dissatisfied with the way Varèse conducted his private life. During his trip to Cincinnati, he had brought along a girlfriend, Louise Norton (former wife of Allen Norton, editor of *Rogue*), and the promoters did not approve of the fact that they were staying together in the same hotel. As a result, the tour that was to follow was promptly canceled.[5]

In subsequent years, other opportunities came and went in a similar fashion. In 1918, Varèse was appointed musical director of the New Symphony Orchestra of the New York Federation of Musicians, an organization devoted to the presentation of advanced contemporary music. Varèse was given complete autonomy over the musical programs, a decision the organizing committee would come to regret. Because of Varèse's unorthodox taste, the first concert—held in Carnegie Hall on April 12, 1919—was not well received. It was Varèse's policy to begin concerts with the work of a familiar composer, so he began with a sonata by Bach. But this was the only name on the program the audience would have recognized; Bach was followed by Bartók's *Deux Images*, Alfredo Casella's *Notte di Maggio*, Debussy's *Gigue*, and Gabriel Dupont's *Le Chant de la Destinée*, all works of relatively recent vintage. "The artistic atmosphere," wrote one reviewer, "had been made stagnant and oppressive by unrelieved and dissonant clashing of keys, reiteration of unmeaningful rhythmical figures, paucity of melody and monotonous striving for unwanted combination of instrumental timbres."[6] Other reviewers concurred. As a result, the organizers of the New Symphony Orchestra asked Varèse to arrange all future concerts with a more modified program. Rather than comply, Varèse resigned. Throughout his career, he refused to popularize his music, "for," as he called them, "a bunch of lazy, ignorant performers, smug rich men, and smugger critics."[7]

Varèse's own musical compositions were anything but conventional. During these years in New York he worked on

Edgard Varèse. Score for Amériques. *c. 1918–21.*
Collection Henry Weinberg, New York

107

the score for his first major symphony, *Amériques: Americas, New Worlds* (begun in 1918, completed in 1921), which, for the first time in his work, contained street sounds as an integral part of the instrumentation. "When I wrote 'Amériques,'" he later explained, "I was still under the spell of my first impressions of New York—not only New York seen, but more especially heard." He wrote the composition while living in the West Side apartment of Louise Norton, who remembered that he often worked late into the night, when he could more clearly hear the sounds of the city. "I could hear all the river sounds," he said, "the lovely foghorns, the shrill peremptory whistles, the whole wonderful river symphony which moved me more than anything ever had."[8] Indeed, one could say that the explosive rhythms, as well as the constant buildup and release of tension, are elements that aptly relate to the chaotic, sporadic, and unpredictable nature of a sound that is continuously generated by a densely populated metropolitan center. The finished score requires myriad wind instruments (twenty-one in all), ten percussionists, and a number of other musicians who are given the task of generating a single lion's roar, the snap of a whip, and the periodic sound of a microtonal siren, gradually rising and falling throughout the composition.

When *Amériques* was first performed publicly in 1926, critics immediately interpreted the street noises as a reflection of America's burgeoning urban centers. Varèse, however, thought these analyses were too restrictive. "This composition is the interpretation of a mood," he said, "a piece of pure music absolutely unrelated to the noises of modern life. . . . If anything, the theme is a meditative one, the impression of a foreigner as he interrogates the tremendous possibilities of this

new civilization of yours." Above all, Varèse wanted his audience to know that street sounds were not incorporated into his compositions for the sheer purpose of being different. "To be modern is to be natural," he explained. "I can assure you that I am not straining after the unusual."[9]

Although it has been claimed that Varèse's use of street sounds came from the Futurists, he reprimanded them for relying upon conventional instruments. He was given the opportunity to speak out on this subject in the first New York issue of Picabia's *391*: "Music, which should be alive and vibrating, needs new means of expression and science alone can infuse it with youthful sap. Why, Italian Futurists, do you reproduce only what is most superficial and boring in our daily lives? I dream of instruments obedient to thought—and which, supported by a flowering of undreamed-of timbres, will lend themselves to any combination I choose to impose and will submit to the exigencies of my inner rhythm."[10]

Varèse's music has often been identified as being not only Futurist but Dadaist, although he objected to either classification. "I have always avoided groups and isms," he said, "though I have had good and very clever Dadaist friends, Tzara, Duchamp, Picabia . . . [but] unlike the Dadaists I am not an iconoclast."[11] Varèse did not compose with the intention of challenging tradition (he certainly never wanted to destroy our admiration and respect for the great classical composers of the past). Indeed, even when he introduced instruments that were never used before in musical compositions—as he did with the sirens in *Amériques*—he did so by integrating their parabolic and hyperbolic effects within the internal harmonics of the composition. Recently, the structure of Varèse's music has been convincingly compared to the planar fragmentation and spatial con-

cerns of Cubist painting (particularly as these formal devices relate to the concept of simultaneity).[12]

Whereas various precedents in the visual arts certainly affected Varèse's method of musical composition in these years, in the end, the single most important source of inspiration for *Amériques* is the spirit of liberation the composer experienced immediately upon his arrival to New York—or perhaps even more significantly, to the physical and psychological detachment from European tradition that this separation also represented. Some forty years later, Varèse would still recall these feelings when discussing the composition of *Amériques*:

> Amériques! *You know, I came to this country: the opening of horizons, new things in the minds of man, in the sky, and everything.* Amériques: *it's the point of departure. You know, I came from Europe, and, you know, shit on Europe.* Amériques. *You think of freedom; you think of expanding. To be completely free. . . . Nothing can ever beat . . . the euphoria of discovery.*[13]

In spite of Varèse's denial of any aesthetic affiliations during these early years in New York, his name was repeatedly included within the context of Dada; not only was his statement (quoted earlier) and a poem included in a New York issue of *391*, but for the next few years, Picabia persisted in listing his friend's name as one of the members of the Dada Movement in New York (see, for example, pages 193 and 194). In 1920—as a recent Varèse scholar has discovered—the composer submitted contributions to a proposed Dada publication in Paris (see chapter 8)—a fact that not only establishes Varèse's direct contact with Dadaists in Europe, but also reveals his willingness to be included as an active member of their group.[14]

HENRI-PIERRE ROCHÉ

Henri-Pierre Roché. June 1918. Photograph: Centre
National d'Art et de Culture Georges Pompidou
Musée National d'Art Moderne, Paris

On October 29, 1916, Henri-Pierre Roché—a thirty-seven-year-old art collector, author, diplomat, and friend to many vanguard Parisian artists—arrived in New York, sent to the United States by the French government as an emissary to the American Industrial Commission to France during the war. At first, he must have looked upon his sojourn with a certain degree of apprehension, for in Paris, he left behind a wide circle of friends, particularly among young artists and collectors. He knew so many people that Gertrude Stein called him "a great introducer" (it was Roché who had introduced her to Picasso), while the attention he paid to the ideas of Leo Stein caused that Stein to say he had a

"great ear." For years, Roché had made a specialty of bringing artists and collectors together, helping Picasso, Braque, Marie Laurencin, and later, Brancusi to find important buyers for their work.

It would not be long before Roché established similar connections in New York. But on his first day in Manhattan, he found no reasons for optimism. After checking into the Biltmore Hotel, he took a bus down Fifth Avenue, and discovered an Automat. Doubtless struck by the sheer physical expanse of the city and its towering buildings, Roché gave his first impression of its inhabitants in surprisingly cautious and reserved terms: "There are few people," he wrote a few years later, "who really seemed to enjoy them-

selves, few couples who looked cheerful." In spite of this opinion, he found that some of its citizens exhibited a number of admirable characteristics: "Americans have comradeship, confidence, generosity, optimism," he observed, "and those things have not been sung by chance by Walt Whitman."[1]

In the days immediately following his arrival, Roché assessed America and Americans as a reflection of their literary production, the one aspect of their culture with which he—as a writer—was most familiar. Years later, for example, he remembered that on his first day in New York he spent some time wandering through Central Park, which impressed him for its vastness; as he strolled through avenues of trees, eating peanuts, he could think only of what the American landscape must have looked like before the advent of civilization, an idea that brought to mind James Fenimore Cooper's *Last of the Mohicans*. Before the day was out, however, Roché would come to regard Americans on a less arcadian level. In the evening he attended a movie, where he saw the audience applaud a newsreel showing French troops in their trenches. But, to his surprise, they also cheered a procession of German troops goose-stepping. For all their indifference, he concluded, "It might just as well have been a football match."[2]

Almost immediately upon his arrival, Roché met and formed a close friendship with Marcel Duchamp, a fellow French-man who possessed nearly all of the favorable characteristics he had identified as American. According to Roché's recollections (published years later), one of the first things they did together was to attend a fancy dress ball, where Roché was so impressed by the artist's unstinting generosity, he started calling him Victor (from the word "victorious"), a name he and a few select friends eventually shortened to "Totor."[3] Roché also had a high regard for Duchamp's work, particularly for the *Large Glass*, which he considered one of the more exceptional and important works he had ever seen. "I do not know of any other work of art more 'unique,'" he told a friend a few years later, and he would eventually add a number of works by Duchamp to his own collection.[4]

It would not be long before Duchamp introduced Roché to the Arensbergs and, for the next two and one-half years—until his return to Paris in 1919—Roché would be one of the more frequent attendants at their famous nightly gatherings. If not traveling to Washington or Philadelphia in connection with his diplomatic mission, Roché could be found at the Arensbergs, drinking and conversing with friends, or quietly engaged in a game of chess (in their first encounter, Duchamp beat him soundly). Roché came to the Arensbergs at a time when most of the guests were preoccupied with plans for the organization of the Society of Independent Artists (see chap-

ter 7), and his talents as a writer were almost immediately enlisted to assist in the project. Roché was asked to write the guidelines for the organization, a task he willingly accepted. At first, it was proposed that these guidelines be published in a magazine to be called *P.E.T.*, an acronym probably meant to identify the magazine's two editors: P[ierre]. E[t]. T[otor].[5] At some point, however, the title was changed to *The Blindman*, a word that must have seemed a more appropriate reference to the review's intended audience. But the magazine was destined for a short run—due, surprisingly, to Roché's inadequacies as a chess player. In a match against Picabia, Roché agreed that if he lost, *The Blindman* would cease publication; if Picabia lost, he would stop releasing issues of *391*. The moves of this rather boring game were carefully recorded by Duchamp and published in *Rongwrong*; after thirty-four uneventful moves, Roché resigned, and *The Blindman* ceased to exist.

In all, only two issues of *The Blindman* were published. For the second and last number, a third name was added to the editorial masthead: Beatrice Wood (acknowledged by the letters P.B.T.—standing for: P[ierre]. B[eatrice]. and T[otor].—on its cover; see p. 184). It was through the Arensbergs that Roché met

Henri-Pierre Roché. 1917. Multiple photograph. The Harry Ransom Humanities Research Center, The University of Texas at Austin

Wood, an encounter that was, for her, one of the most significant events of her life. She almost immediately fell in love with him, an *affaire de coeur* that, for the young actress, represented her first real romantic experience. But, as she was soon to discover—somewhat tragically—the relationship was for Roché, a man fourteen years her senior, just one of a hundred intimate encounters.

Roché's sexual prowess is—today—largely a matter of record. For a period of nearly fifty years, Roché carefully noted every encounter in his diary, in which he not only entered his most private thoughts concerning a given individual, but wherein—by means of an intricately devised sexual code (to keep casual observers from garnering any significant details)—he also preserved an accurate record of his physical exploits, from the number of orgasms he and his partner achieved, to specifically which parts of the body were involved.[6]

Although he would later write admiringly of Duchamp's ability to attract women, in terms of numbers, it was Roché's amicable manner and charm that were more effective. As Gertrude Stein once accurately observed: "Certainly this one [Roché] is one who would be very pleasant to very many in loving."[7] Indeed, it was not uncommon for Roché to have more than one affair going simultaneously: at the same time that he was seeing Beatrice Wood, for example, we know that he was also involved with one of her friends, a journalist by the name of Alissa Frank. And without either of these two women knowing, during the summer of 1917 he entered into an affair with Louise Arensberg, a liaison that continued in secrecy for over two years, until Roché's return to Paris in 1919.

No matter how frequent and intense, Roché's many amorous encounters never interfered with his work. In March 1917, he met the powerful New York lawyer and art collector John Quinn, who was then in the process of assembling one of the greatest collections of modern art in this century. Although they met often during this period, and Roché openly expressed his admiration for Quinn's taste as a collector, it was only on the day

before Roché's departure for Paris, that Quinn proposed a more professional relationship, asking the Frenchman to act as his European agent. Roché accepted, and for the next five years—until the time of Quinn's death in 1924—he served as the collector's most trusted adviser and confidant in acquiring modern French art. Through correspondence, Roché arranged for countless sales, and when Quinn came to Paris, he served as the collector's personal guide and liaison to a host of artists, collectors, and dealers.

An exceptionally long entry from Roché's journal—dated December 31, 1917—provides a rare, first-hand account of an evening spent with the Arensbergs and their friends. The occasion was a New Year's Eve party, which began with dinner at the Café des Artistes and concluded with a party at the Arensberg apartment:

Invited to dine by Walter [Arensberg]. At Artistes. The de Meyers [Baron Adolph and his wife] / Louise [Norton] and [Edgard] Varèse, [many] kisses marked on the menu by lips reddened with carmine. I am keeping it. I [sit] at the right of Aileen [Dresser]. Walter charming.
At 11 [o'clock] in the studio, great wood fire, lights out, cushions, champagne. Alissa [Frank] arrives in full dress, not unpleasant (she came in for the first time this morning, unasked, at my place, sure of herself, I made her weep telling her of my love for Béa [Beatrice Wood], and that we are great friends, but not sexual—a little consoled, without kissing). The Perrets arrive, champagne at midnight. Kiss all the women—poker game in dining room. Perret winning. I am flat on my belly in front of the fire—Aileen's feet on me—talks with Alissa. Lou [Arensberg] in the big armchair with Kittie. Alissa discovers and makes me feel how admirable Lou's hands are to touch. Lou peels an apple, which I eat. Marion, [the] servant, back from a trip. Lou & she embrace. Lou—admirable hostess—forgets herself. I am in humble admiration. "Le bunch" this evening truly harmonious and happy. Mme Perret recounts memories. Miss Dodge (?) also. Stella and Tango each sleep on a divan.
Return home at 4 in the morning . . . with Alissa, whom I accompany to her place as a friendly gesture. She exaggerates the abstention from kisses—If only that could continue Night—sleep of love.[8]

Another more private entry—this one written in September 1919 (a few days prior to Roché's return to Paris)—concerns the discovery of his affair with Louise Arensberg (whose identity he protects by referring to her as "Cligneur," a name probably derived from the French verb *cligner*, meaning "to wink" or "to look with eyelids half-shut"):

Cligneur told me that her husband, sensitive and gentle but also cruel . . . is suspicious of us again. . . . She doesn't love him. She allows him, makes easy for him, infidelities, which he tells her about. He wants her to be faithful. She fears that if he knew she were unfaithful, he'd kill himself, as he threatened. Perhaps he is indispensable to her; outside our love, she wouldn't know what to do in this world, she is afraid of taking risks, of solitude, of public opinion. Their money is hers, he spends it. Now, he is jealous again—like 2 years ago.
Suddenly phone rings, Béa's voice, at Cligneur's: they suggest movies. . . . Afterwards we go to Béa's apartment, simple, pleasant, tidy, odd, with drawings by her on the wall. . . .
There had been a terrible scene between [Cligneur] and her husband. . . . He said he would go away. . . . Cligneur is afraid he will kill himself . . . to calm him, she was obliged to suggest a weekend trip, just the two of them, instead of the two of us, as it should have been on this last weekend before my departure. . . .
The night before, Friday the 5th, dinner with her alone at Holland House, where she told me all this. She is wearing for the first time this year the gold and black-enamel bracelet . . . that I found and selected for her and the diamond "wedding ring," which we bought together.
. . . We take the bus—Riverside Drive— . . . words of love . . . I take her home.[9]

Back in Paris, Roché maintained his reputation as "a great introducer" and, one afternoon in late 1919, arranged for Duchamp and Katherine Dreier to meet Gertrude Stein.

Though Roché often contemplated a return trip to the United States, other commitments always kept him in Paris. Nevertheless, through correspondence, for the next forty years—until the time of his death, in 1959—Roché continued to keep in close contact with many of the friends he had made in New York.

B E A T R I C E W O O D

Beatrice Wood. c. 1917. Beatrice Wood Papers, Ojai, CA

On December 11, 1916—under the stage name Patricia—a twenty-three-year-old actress by the name of Beatrice Wood made her debut as Eglantine in *Les Deux Sourds*, a one-act play by Jules Moinaux sponsored by the Théâtre Français and staged at the Garrick Theatre in Manhattan. Although she did not think her performance was very good, one critic reported that the audience seemed to like her, noting that "she speaks French wonderfully well for an American."[1] It was this young actress's facility with the language, as well as her warm, personable manner, that led her to establish close and lasting friendships with a number of Frenchmen living in New York during the war years.

Some three months before her acting debut, an older friend of hers—a journalist by the name of Alissa Frank—had asked if she would consider paying a visit to the composer Edgard Varèse, who had been hospitalized with a broken leg. At first Wood declined, saying that she knew nothing about music. But when

Alissa said that he had no one to speak to because of his inadequate English, she agreed—a decision that was to change her life. On September 20, 1916, she went to the hospital to see Varèse, whom she found handsome and virile. On a subsequent visit, she met Marcel Duchamp, and they hit it off so well that, according to her own recollections, they "tutoyed" one another almost immediately.[2]

Shortly after their meeting, Duchamp introduced Wood to the Arensbergs and, for the next four years, when her career as an actress did not require travel outside of New York, she could be found nearly every evening at the gatherings in their apartment. It was probably while dining with the Arensbergs one evening—in the restaurant of the Hotel Lafayette—that she first met Henri-Pierre Roché.[3] Apparently, her first encounter was not memorable, but it would not be long before she found this Frenchman so irresistible that she was willing to surrender her carefully guarded innocence to his worldly charms. Over the course of the next two years, Roché, Wood, and Duchamp became inseparable friends. For a brief period, it could even be said that she played the bride, an alluring foil to the role assumed by these two debonair bachelors. Indeed, on one occasion, when she and Roché were looking through Duchamp's notes for the

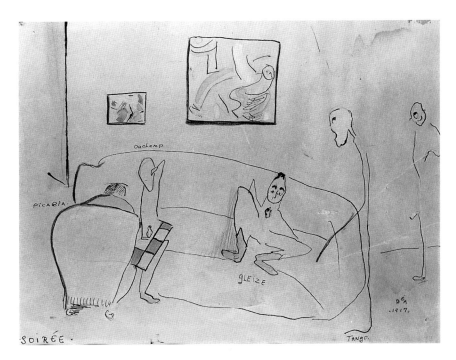

Beatrice Wood. Soirée. 1917. Pencil, watercolor, and ink on paper, 8 5/8 x 10 7/8". Private collection, New York

Large Glass, Wood noted certain characteristics she claimed to have shared with Duchamp's *Bride*. When Roché picked up a scrap of paper and read: "The Bride, apotheosis of virginity. It is ignorant desire, blank desire, with a point of malice," Wood supposedly responded: "Yes . . . like me."[4]

Both Roché and Duchamp encouraged their new young American friend to resume her artistic interests (she had tried her hand at painting some years earlier in Paris). But she insisted that as far as she could tell, modern art seemed to be something anyone could do. Duchamp challenged her to try, so she went home and produced an imaginative little sketch entitled *Mariage D'une Amie (Marriage of a Friend)*, a drawing Duchamp liked so much that he arranged for it to be reproduced in an issue of *Rogue*. Although Wood later described this drawing as "a tortured abstraction," the dark, jagged linear element enveloping the stalklike creature in the foreground was meant to represent the contrast in ages between two people who had recently married: Elizabeth Reynolds, her own age and a close friend since high school, and Norman Hapgood, a much older man.[5]

Knowing that Wood's parents disapproved of her artistic aspirations, and that she had no space in which to work at home, Duchamp invited her to use his live-in studio (see p. 47), lending her a key to provide access whenever he wasn't there. The studio was located just above the Arensberg apartment, and during these years, Wood spent so much time in this building visiting the artist and his patrons that she began to regard it as a second home. An assiduous chronicler of events in her life, Wood kept a small three-line diary in which she entered cursory notes about her daily activities. Consulting these documents, and viewing the many drawings she made in this period—when combined with her own personal recollections—provide the most complete and accurate first-hand account of the activities of the Arensberg Circle.

In a drawing of 1917 entitled *Soirée*, for example, we find Duchamp and Picabia intently engaged in a game of chess, while farther down on the couch, Albert Gleizes appears sprawled out, legs spread-eagled, staring oblivious into space. A fourth man labeled "Tango" appears to observe the progress of the match, while a fifth, unidentified figure lurks mysteriously in the background. Another sketch records an evening at the Arensbergs when Wood was asked by a noted psychiatrist to recall her dreams, while yet another drawing shows her

Beatrice Wood. Mariage D'une Amie (Marriage of a Friend). *1916. Drawing. Original work lost. Reproduced in* Rogue, *December 1916*

Beatrice Wood. Béatrice lisant ses Rêves aux Arensberg (Beatrice Recounting Her Dreams to the Arensbergs). *1917–18. Ink and colored pencil on paper, 10 x 8″. Philadelphia Museum of Art. Gift of the Francis Bacon Foundation*

Beatrice Wood. 7:45 p.m.—Béatrice Attendant Marcel (7:45 p.m.—Beatrice Awaiting Marcel). *1917–18. Ink and colored pencil on paper, 10 x 8″. Philadelphia Museum of Art. Gift of the Francis Bacon Foundation*

member of the Arensberg group: represented are Joseph Stella, Arthur Cravan, Gabrielle Buffet-Picabia, Roché ("Pierre"; four times), Duchamp (under his nickname "Totor"), Louise and Walter Arensberg, Frederick Sides (a Lebanese rug dealer and friend of the Arensbergs), and Harrison Reeves (an American oil prospector with interests in France).[6]

In late 1916, Wood helped Duchamp and Roché to organize the Society of Independent Artists, and in 1917, she participated in the first exhibition and helped to publish its magazine (see chapter 7). After attending The Blindman's Ball, which was held in honor of these publications, Wood retired with a number of friends to the Arensberg apartment. Exhausted by the evening's festivities, she, Duchamp, and three other friends—including the poet Mina Loy and the painter Charles Demuth—went up to Duchamp's one-room studio and fell asleep on his bed. Five people compressed into such a narrow space could present an awkward situation, but it was one Wood openly welcomed: "Marcel, as host," she recalled, "took the least space and squeezed himself tight

reclining on the bed in Duchamp's studio as she counts off the minutes until his arrival. In a more fanciful work from this same period, Wood depicts herself as the mother of twelve children, each of whom is labeled with the name of a

against the wall, while I tried to stretch out in the two inches left between him and the wall, an opportunity of discomfort that took me to heaven because I was so close to him."[7] A few days later, she produced a spontaneous little watercolor sketch recalling the event (p. 116),

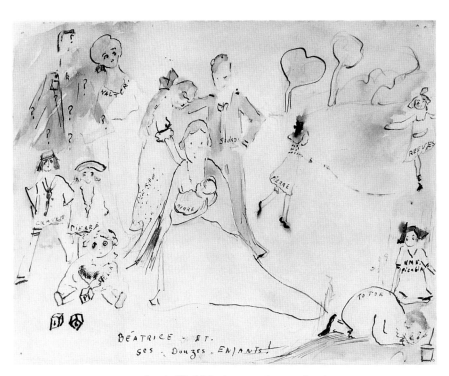

Beatrice Wood. Béatrice et ses douzes enfants! (Beatrice and Her Twelve Children!). *c. 1917. Watercolor, ink, and pencil on paper, 8 ¾ x 10 ¾″. Philadelphia Museum of Art. Gift of the Artist*

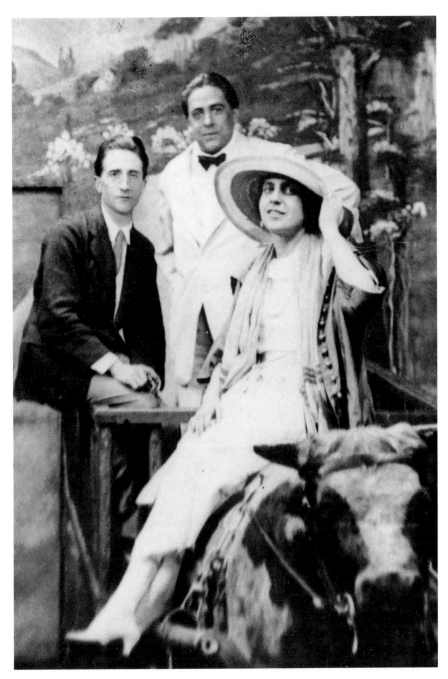

Marcel Duchamp, Francis Picabia, and Beatrice
Wood, Coney Island, NY, June 21, 1917

allowing a jumble of freely intersecting lines and swatches of color to capture the exciting, though doubtless crowded and uncomfortable confines of Duchamp's bed.

Although the events of this period would eventually take on a certain historical importance, Wood was so thoroughly preoccupied with the personal relationships in which she had become involved that, at the time, she was oblivious to their significance. When her love affair with Roché soured, she sought

solace in his friend, Marcel. On one evening that she recalls vividly, Duchamp and Picabia took her to Coney Island, where the two artists forced her to keep riding the roller coaster until she stopped screaming. "With Marcel's arm around me," she recalled, "I would have gone on any ride into hell, with the same heroic abandon as a Japanese lover standing on the rim of a volcano ready to take the suicide leap."[8] After the ride, the three posed for a memorable souvenir, a photograph that shows the smiling artists in

a farmer's cart, while Wood poses on the back of an artificial cow, still holding on to her hat.

In January 1918, Wood departed for Montreal to accept an acting engagement with the French Theatre. There she entered into an unhappy marriage with the manager of the theatre. After moving back to New York with her husband in 1920, she continued to see her old friends, Duchamp and the Arensbergs included. But as she learned only a few years later, her husband secretly bor-

Beatrice Wood. Lit de Marcel (Marcel's Bed).
1917. Watercolor, 8 ¾ x 5 ¾". Private collection,
New York

rowed a great deal of money from the Arensbergs (totaling, Wood recalled, some $19,000, not including interest), creating an unhappy situation that got even worse when Wood learned that her estranged husband was still married to a woman living in Belgium. They soon separated and the marriage was annulled, but the unpaid debt he had amassed naturally created a strain on her relationship with the Arensbergs. Eventually these problems were resolved, but by then the Arensbergs were living in California, where Wood herself was soon to follow.

CLARA TICE

Clara Tice. Vanity Fair, *January 1917*

In 1915, Clara Tice—a little-known, twenty-seven-year-old artist and illustrator, who had studied for a brief period with Robert Henri—became an overnight sensation. A series of small, almost thumbnail-size sketches of nude girls dancing, along with drawings of domestic animals and insects, were considered morally indecent and were confiscated by the police from an exhibition at Polly's Restaurant on Washington Place in Greenwich Village. Seventy-year-old

Anthony Comstock, retired captain of the Society for the Suppression of Vice (who was then famous for having seized Paul Chabas's *September Morn* from its showing at the Braun Gallery two years earlier) proudly conducted the raid.[1]

Not everyone agreed with Comstock's action. *Vanity Fair*, for example, under the editorial guidance of Frank Crowninshield, ran an article reproducing the censored nudes (p. 118), and announced a mock trial to be held in Tice's defense

at Bruno's Garret on Washington Square South. The general public was invited to attend this event in order to act as the plaintiff's attorney, witness, jury, and judge: "She will be tried," an announcement read, "and therefore acquitted of the charges of having committed unspeakable, black atrocities on white paper, abusing slender bodies of girls, cats, peacocks and butterflies." Tice defended herself from the lid of a coffin, refusing to provide any excuses for her work. "I would never tell anybody in the world what I am trying to do."[2]

Because of the controversy created by Comstock ("All I can say," she later remarked, "is that he [Comstock] was some press agent"), Tice was accorded the opportunity to exhibit her work frequently in New York galleries. In a review of one such showing, the famous caricature artist Carlo de Fornaro went so far as to say that one of Tice's paintings was worthy of comparison to "the great modern French masters." But what attracted him most to her work was its blatant defiance of convention. "Sketch after sketch, drawing after drawing," he

wrote, "is a slap at the academy, a silvery laugh at the fossils, the Puritans, the Philistines, a quip and a sally to the morose, the dyspeptics, the impotents in art."[3]

It would not be long before this defiant young illustrator drew the attention of another artist whose painting of a nude had created a similar stir among prudish critics in New York a few years earlier: Marcel Duchamp. In September 1916, Clara Tice won first prize for a costume she wore to a Rogue Ball, while Duchamp, who also served as one of the

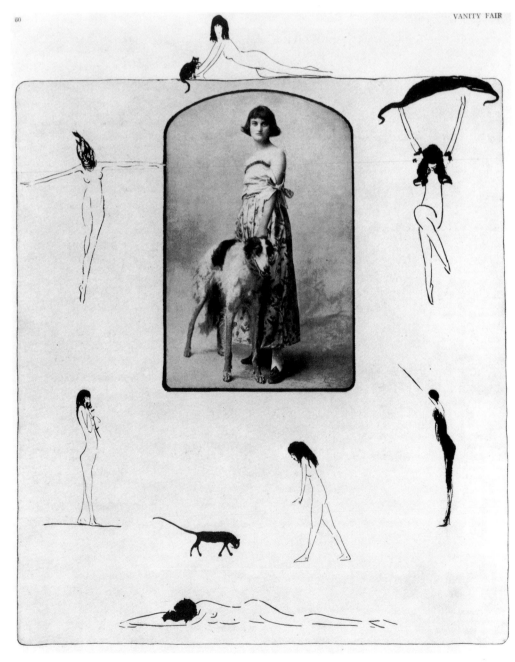

Clara Tice. "The Blacks and Whites of Clara Tice,"
Vanity Fair, *September 1915*

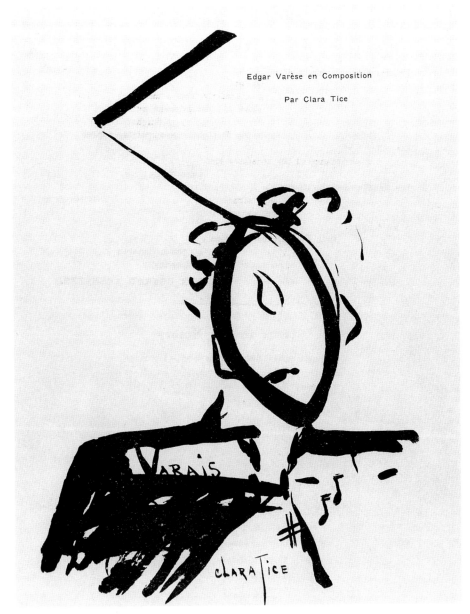

Clara Tice. Edgar[d] Varèse en Composition
(Edgar[d] Varèse Composing). *Reproduced in* The
Blind Man, *May 1917*

judges, was awarded the booby prize.[4] In 1917, she seems to have entered into a brief liaison with Henri-Pierre Roché, and through these relationships, was introduced to the Arensbergs and, for a brief period, became an intimate of their salon. She participated in the Independents Exhibition of 1917—showing one of her dancing nudes and a drawing of a nude with cat—and contributed a portrait of *Edgar[d] Varèse Composing* to the second and last issue of *The Blind Man.* More abstract than most of her drawings from this period, the Varèse portrait bears little resemblance to the handsome Frenchman; rather, a second look will reveal that the composer's head is appropriately formed by the shape of a large musical note.

Other members of the Arensberg salon—at least a number of the women—are represented in a group portrait by Tice of well-known women in Manhattan around 1917 (p.120). Here, showing them sporting examples of fashionable clothing, Tice has provided quick little caricature sketches of Mina Loy, Louise Norton, Aileen Dresser, Fania Marinoff, Lou Arensberg, and others. Tice might well have included herself among these women, for she had established a considerable reputation in underground bohemian circles for having been the first to bob her hair (even though Irene Castle would usually be given credit for introducing the style). "Short hair is worn for convenience and for looks," she later explained. "I hate those cootie cage coiffure effects—they make the hair look

Clara Tice. "Who's Who in Manhattan,"
Cartoons Magazine, August 1917. Philadelphia
Museum of Art. The Arensberg Archives

like it had been combed with an egg beater."[5]

Even more than her delicate little drawings of nudes, Tice's adventurous wardrobe did much to change the conservative attitudes of her day. She was among the first to advocate wearing short dresses and rolled up stockings, although she warned anyone who was willing to listen that women were misguided in trying to attract men on the basis of their appearance alone. "Brains [and] the ability to do things," she said, "are the things that attract a man."[6]

During these years in New York, Tice's clear and nimble drawing style was much in demand; she served as a feature artist for various newspapers, including the *World, Tribune, Sun, Globe, Mail, Times,* and others. For a brief period, she was employed as a staff artist for *Vanity Fair,* and contributed to *Theatre Magazine, Cartoon, Green Book, Billboard,* and others. After 1917, she would continue to produce delicate little drawings of nudes and animals, and she would go on to attain a considerable degree of popular success as an engraver and book illustrator.

CHARLES SHEELER

Charles Sheeler. 1922–23. Photograph by Marcel Duchamp. Vanity Fair, March 1923

Although Charles Sheeler lived in Philadelphia until 1919, by means of numerous visits to New York, for more than a decade, he maintained close contact with the most current developments in modern art. Sheeler was included in the Armory Show, and while still in his early thirties, he had been recognized as one of America's most progressive artists. Alfred Stieglitz invited him to participate in the March 1916 Forum Exhibition of Modern American Painters, a show that was designed, as stated in its catalogue, to present "the very best examples of the more modern American art." And in 1917, Sheeler's photographs were shown for the first time in two exhibitions held at the Modern Gallery.[1]

In a review of the first Modern Gallery exhibition—which also included photographs by Paul Strand and Morton Schamberg—Henry McBride percep-

tively noted that Sheeler's photographs displayed certain qualities that could be compared to the work of modern artists: "Sheeler keeps himself most severely within the limits of true camera form," wrote McBride, "and a photograph of a New York business has the incision of a Meryon print and the inevitableness of Cézanne's 'Bouquet de fleurs.' " In a review of the first solo exhibition of Sheeler photographs held at the Modern Gallery later in the year, an anonymous critic for *American Art News* went even further: "In a series of photographs the cold, hard realities of stone, wood or iron [are recorded] so graphically that the 'sensorial significance' of matter was vividly conveyed. From this point of view the exhibition was of interest, and its value in demonstrating a certain fundamental truth underlying the 'modernist' theories is undoubted."[2]

The relationship between Sheeler's photographs and his own paintings in this period is even closer than the comparisons cited by these reviewers; indeed, one could go so far as to proclaim (as

many later did) that it forms the very basis of his art. The purity of line and a detached, Precisionist view of a given object form the hallmark of Sheeler's modernist vision, and it is probably these qualities that attracted Stieglitz and de Zayas to his work. "It was Charles Sheeler," de Zayas later said, "who proved that cubism exists in nature and that photography can record it."[3] In 1917, Sheeler was employed as a photographer for the Modern Gallery, and for the next four years (until 1921, when de Zayas's second gallery closed), Sheeler not only prepared photographs of work that was exhibited in the gallery, but when de Zayas had to be away on business, he often acted as manager.[4]

It was probably through de Zayas that Sheeler was introduced to Marcel Duchamp and, through him, to Walter and Louise Arensberg. From 1917 on, Sheeler frequently attended the soirées in their apartment, and his own work—a black chalk drawing on Japanese paper entitled *Barn Abstraction*—was added to their collection as early as 1917.[5] The

sheer simplicity of this image, based on examples of vernacular architecture from Bucks County, Pennsylvania, must have appealed to the Arensbergs, who were already drawn to a similar clarity of line in Shaker furniture, examples of which they collected and distributed throughout their New York apartment. In this setting, alongside works by Picasso and Braque, the Arensbergs displayed one of Sheeler's paintings and two barn abstractions (see pp. 26 and 27). It may have been the interest they displayed in Sheeler's work that led him later to describe the Arensbergs as "top people, because," as he said, "they had that great ability, radar eye."[6]

During these years in New York, Sheeler was to become one of the Arensbergs' most trusted advisers, accompanying them on excursions to buy antiques, scouting out property for them to purchase, and later, acting as their agent in the disposal of several works from their collection. Early in 1919, he took a series of important installation photographs of their apartment (see pp.

Charles Sheeler. Barn Abstraction. *1917. Black and conté crayon, 14 1/8 x 19 1/2". Philadelphia Museum of Art. The Louise and Walter Arensberg Collection*

26–27), and while they were away in California during the summer of 1921, he stayed in their apartment. It was probably at this time that he photographed Duchamp's *Large Glass* (see p. 38), but this was not to be a mere attempt to record this work for the purposes of reproduction. Rather, Sheeler elected to focus his camera on the lower section of the glass, allowing an assortment of free-floating elements to be viewed against the complex forms of a Cubist painting in the background (Gleizes's *Woman at the Piano*). Years later, Sheeler discussed Duchamp's *Large Glass* in a fashion that almost describes this photograph:

In these years he [Duchamp] was planning and executing some notable works in glass which added a considerable plus to his achievements—abstract forms with their outlines defined by a wire-like line of lead painted on the back of the glass. Large areas of clear glass remained, and when the work was placed in position in a room the observer also saw in addition to the design whatever casual things occurred behind the unpainted areas. The results were interesting in relating mobile to static forms, and the exquisite craftsmanship gave evidence of the remarkable ability of this artist's hand to carry out the orders of the eye.[7]

Duchamp's influence on Sheeler has been the subject of several detailed investigations. Sheeler openly professed his admiration for the French artist, saying that he was "in a class by himself," that "he had a very fine mind," and that his pictures were "outstanding in French art or in any art."[8] And on at least one occasion, Duchamp mentioned having admired one of Sheeler's drawings, and

MOVEMENT AND MASS
A view of Broadway through the balustrade on the roof of the Empire Building, contrasting the flickering liveliness of movement in the street with the static architecture

THE MOVING STREET (Below)
The Church Street elevated railway, as seen from the Empire Building. A study in the relation between movement of the street and the stability of the buildings

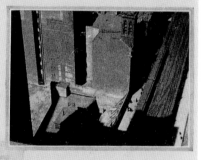

STEEL STRUCTURE
Showing the relation of structural masses to the spaces made by the open sky as it appears above and behind the steel design

MECHANICAL MONOTONY
The Equitable Building, in which the photographers were interested in the monotonous repetition of windows and other utilitarian details, which give so forceful a sense of the vast scale and mechanical precision of the skyscraper

Charles Sheeler is well known as one of our modern painters; Paul Strand is a master in photography, a tireless experimenter in the possibilities of the camera. The interest of these two artists did not lie in presenting places of value to the sightseer but rather in expressing certain phases of New York through dynamic patterns

SPACE AND LINE (Right)
A view of Brooklyn Bridge, in which space, in the third dimension, is emphasized by the direction of lines—indicated by cables—and planes, the boundaries of which are marked off by these lines

Manhattan—"The Proud and Passionate City"
Two American Artists Interpret the Spirit of Modern New York Photographically in Terms of Line and Mass

he even took a portrait photograph of Sheeler that was published in *Vanity Fair* (p. 121). Certainly, as Sheeler's statements and subsequent work confirmed, he admired the precision with which Duchamp executed his mechanical images—unemotional, detached, and analytical qualities that he emulated in his own work. But the extent to which Sheeler embraced the nihilism of Dada is another question, for even though one of his barn abstractions was reproduced in Man Ray's *TNT* (p. 88), and he later provided photographs for one of Duchamp's publications (p. 55), it is unlikely that he would have felt comfortable in the company of Dada's more outspoken participants, or that he would have taken part in any of their more outlandish high jinks.[9]

Charles Sheeler and Paul Strand. Stills from the film Manhatta. *Reproduced in* Vanity Fair, *April 1922*

The closest Sheeler would ever come to being included within the context of Dada is when the copy of a film he prepared in collaboration with Paul Strand was taken to Paris by Duchamp and shown as part of a Dada festival.[10] Although the film had been completed by the fall of 1920, it did not receive its first public showing in New York until July 24, 1921, at the Rialto Theatre on Broadway (where it was shown as a "scenic" under the title *New York the Magnificent*). Some interesting stills were featured in the April 1922 issue of *Vanity Fair*.

Known today as *Manhatta*, this six-and-a-half-minute silent film is composed entirely of a tightly organized series of rapidly moving images of Manhattan—its harbor, boats, people, and buildings recorded from a number of unusual angles and vantage points—all of which is supposed to be comprehended within

the context of quotations from Whitman, which are interspersed throughout the film. There is no real plot. The images rush by so quickly that it is difficult to decipher one before the next appears. Rather than present viewers with an objective, documentary-style narrative about Manhattan, the film left most members of the audience with a general feeling for the city's compressed spaces, its tall skyscrapers, and the teeming, chaotic masses of people that live within. In this respect, *Manhatta* represents the cinematic equivalent of Picabia's New York watercolors (e.g., p. 17), which, we recall, rather than representing the city and its buildings objectively, were intended to capture a sense of its spirit and vitality.

MORTON SCHAMBERG

Morton Livingston Schamberg. Self-Portrait. c. 1915

Morton Schamberg is best remembered for a work entitled *God* (see p. 129), a sculpture that—in terms of form (readymade plumbing) and subject (sacrilegious title)—is so powerfully iconoclastic that it has come to represent the single purest expression of Dada sensibilities in New York. The only problem is that when we attempt to integrate this work within the context of Schamberg's painterly production from this period, we can only conclude that it is so exceptional as to constitute an aesthetic aberration, or that the sculpture has been misattributed. To a certain extent, as we shall see, both alternatives are tenable.

After receiving his degree in architecture from the University of Pennsylvania, Schamberg enrolled in painting classes at the Pennsylvania Academy of the Fine Arts, where he met Charles Sheeler, a fellow student in the classes of William Merritt Chase. The two youths took a number of summer excursions to

Europe, and upon graduation from the academy in 1906, they shared a studio together on Chestnut Street in Philadelphia, where in addition to pursuing their careers as painters, they earned their living working as professional photographers. For the next thirteen years—until the time of Schamberg's untimely death in 1918—these two artists maintained an exceptionally close friendship and a good working relationship.

In his travels in Europe, Schamberg saw his first examples of modern French art, and for a two- to three-year period, he painted in a predominantly Fauve style. After the Armory Show—in which he and Sheeler were both included—however, his paintings began to exhibit the volumetric division and planar fragmentation of Cubism. These paintings became increasingly abstract, until they reached a point where the subject was no longer readily discernible. In 1916—the year Picabia's machinist paintings were given their first major showing at de Zayas's gallery in New York—Schamberg's style suddenly changed, incorporating, for the first time, machines and machine parts as the primary subject of his painting.[1]

Schamberg's machine pictures were given their first public showing in a group exhibition at the Bourgeois Gallery in April 1916 (the same show in which Duchamp exhibited two readymades). One reviewer wrote: "Picabia has a doughty follower in the mechanical drawing allegories of Morton L. Schamberg."[2] Whereas Picabia's influence is a matter of chronological record, there can be little doubt that Schamberg also sought inspiration in the work of Marcel Duchamp, whose paintings he had known from the Armory Show, as well as from select exhibitions in New York, particularly at the Carroll, Bourgeois, and Montross galleries. Years later, Duchamp recalled Schamberg's occasional visits to the Arensberg apartment, where he said the young painter was charming, though somewhat reticent.[3] Schamberg must have felt quite at home in these surroundings, however, for one of his best machinist paintings hung in a prominent position—above two works by Sheeler—

in the main sitting room of the Arensberg apartment (see p. 27, bottom).

The many examples of modern art Schamberg had seen in New York caused him to wish that something similar could be seen in his own hometown. With a former classmate from the academy (the painter Lyman Sayen), Schamberg organized the first major showing of avantgarde art in Philadelphia, an exhibition that opened at the McClees Gallery in May 1916. The show included not only the best-known names in modern French art—Brancusi, Braque, Derain, Dufy, Duchamp, Gleizes, Matisse, Picasso, and Picabia (among others)—it also featured the work of several noted Americans: Pach, Sheeler, Stella, Man Ray, Weber, and of course, Sayen and Schamberg.[4]

During the course of the exhibition, Sayen and Schamberg were present in the galleries to answer questions and to explain the rationale behind many of the works they had selected for the show. Always articulate, Schamberg evoked metaphors with music to explain the abstract qualities of many pictures, including his own. "Painting is the orchestration of visual qualities," he told an interviewer. "Natural objects interest me as an artist only because of their visual qualities. I have to arrange them so as to express my sense of balance, rhythm, order, my most profound visual experience."[5]

This same interviewer did not know what to make of Schamberg's two machinist paintings, which he described as "two geometrical diagrams in bright, flat tints, which look much like a wedding of architect's plans, machinist's drawings and a strange sort of an Egyptian relief." Schamberg, on the other hand, explained that these works should not have to elicit such specific associations, which is why he gave them no titles. "I call those things of mine just 'Paintings,'" he told the reporter. "There's no reason why we should put any name on our work except to indicate the relation of the thing that stimulated the picture to the picture itself. It's only part of the principle behind the whole proposition. Are you after the original inspiration or the result, the concrete object or the aesthetic statement?"

In spite of the artist's intentions, a great deal of time and effort has been devoted to determining the specific source for Schamberg's machinist paintings. It was first believed that they were derived from illustrated machinery catalogues borrowed from the artist's brother-in-law, who at the time was a manufacturer of ladies' cotton stockings.[6] It has been suggested that Schamberg's two most refined machine paintings were both derived "from a sewing machine"; this idea, once accepted, allows us to see various elements in the composition as machine parts made to hold and direct thread. And more recently, the historian William Agee has discovered that at least one of these machine paintings was specifically derived from the diagram of an automated wire stitcher, a machine used in binding books.[7]

Whatever sources Schamberg may have consulted, he produced surprisingly few machinist paintings, though, apparently, he had planned many. "He talked constantly about pictures he was going to paint in which mechanical objects were to be a major subject," Sheeler recalled, "describing them in detail down to the last line and nuance of color."[8] Indeed, Schamberg was always precise, as careful and accurate in the mechanical execution of his pictures as he was fastidious in attire. As photographs from this period confirm, the artist dressed impeccably, sporting elegant and finely tailored suits. It is hard to imagine that a person with such a dandified and punctilious temperament would have embraced the more nihilistic aspects of Dada. If anything, because of his passionate stance against the war, a position so strong that it nearly halted his artistic production, he may have harbored certain sympathies for Dada's anarchistic leanings. But even then, it would be difficult to prove that his political beliefs alone could cause him to abandon his elegant and highly refined machinist vision in favor of producing a sculptural artifact consisting only of a plumbing trap inverted in a miter box and called *God* (see p. 172).

Indeed, it is now known that this sculpture was not created entirely by Schamberg, but rather, that it was pro-

duced with the assistance of the Baroness Elsa von Freytag-Loringhoven (see pp. 168–75). Based on our knowledge of other works by the Baroness from this period, it is logical to conclude that she probably came up with the idea of combining the extraneous elements in this sculpture, as well as of assigning the unusual title, while Schamberg was probably responsible only for mounting the assembly and for recording the work, as he did in a small photograph of the sculpture positioned before one of his machinist paintings, a print which he carefully signed—in his usual machinist script—and dated "1917."[9]

In the months immediately preceding his death, it seems that Schamberg reverted to an earlier, more figurative style. But as Walter Pach observed in a review of Schamberg's memorial exhibition in 1919 at the Knoedler Gallery, these "last pictures are built on the earlier works and contain their qualities in a purer and more intense form."[10] Whatever is thought of Schamberg's last paintings, it is tempting—though admittedly fruitless—to imagine the direction his work might have taken in the future had he not died in the influenza epidemic of 1918, just two days before his thirty-seventh birthday.

Morton Livingston Schamberg. Mechanical Abstraction, *1916. Oil on canvas, 30 x 20 ¼".* *Philadelphia Museum of Art. The Louise and Walter Arensberg Collection*

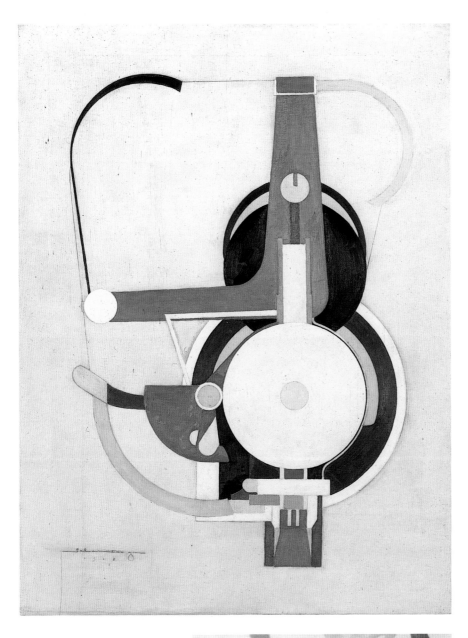

Morton Livingston Schamberg. Machine. 1916.
Oil on canvas, 30 ⅛ x 22 ¾″. Yale University Art
Gallery. Gift of Collection Société Anonyme

Morton Livingston Schamberg. Photograph of God
by Schamberg and Baroness Elsa von Freytag-
Loringhoven, 1917. The Metropolitan Museum of
Art, New York. The Elisha Whittelsey Collection,
The Elisha Whittelsey Fund, 1973. Cf. p. 172

CHARLES DEMUTH

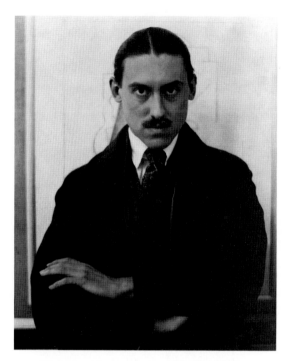

Charles Demuth. 1915. Photograph by Alfred Stieglitz.
Platinum print, 9 5/8 x 7 5/8". National Gallery of Art,
Washington, D.C. Alfred Stieglitz Collection

In 1916, when Charles Demuth met Marcel Duchamp and began frequenting the Arensberg soirées, he was already considered an artist of some accomplishment. In the immediately preceding years, he had two showings of his watercolors at the Daniel Gallery, both of which were relatively well received. For his third exhibition, however—held at the gallery in November 1917—the reviews were mixed, one critic finding the artist's color insensitive, while another—no one less than the brilliant Willard Huntington Wright—thought that Demuth's exhibition represented "the most important modern show of the month."[1] Apparently, the Arensbergs agreed with the latter assessment, and acquired one of Demuth's delicate watercolor studies of Bermuda, which they displayed in their apartment alongside drawings by Cézanne, Brancusi, Rodin,

Picasso, and a host of other notable European artists whose work Demuth had himself admired.[2]

Although he lived in Lancaster, Pennsylvania, and had attended the Academy of the Fine Arts in Philadelphia, from 1915 through 1920, Demuth made frequent trips to New York—"at least once a week," Duchamp later recalled.[3] His frequent trips to the city were more socially motivated than professional; he must have found the small-town atmosphere of Lancaster somewhat oppressive, particularly since he had a vision of himself as a sort of twentieth-century dandy. He was always well dressed and impeccably groomed, but was born slightly cross-eyed and, due to a childhood ailment, limped, and walked only with the help of a cane. His face was drawn, and he often appeared quite pale, probably due to the fact that he was a diabetic (without being properly diagnosed or treated until around 1920).

Most of Demuth's associates enjoyed his company, and he was a welcome guest at any social function. As a friend later recalled, he went often to New York because "Mabel Dodge would want him at one soirée and Louise Norton Varèse at another."[4] Duchamp especially liked his "wonderful sense of humor," a quality that, he said, made him "very sweet." But there was a dark side to the artist's personality, one likely brought on by repressed homosexuality. This is probably what Duchamp was referring to when he later observed that Demuth maintained a "curtain of mental privacy," adding that he knew of the special relationship that existed between the artist and his mother, "which you call," he said, "a Freudian relationship."

Although much has been made of Demuth's homosexuality—and he did, on at least a number of occasions, graphically represent scenes that were unquestionably homoerotic—it is not this aspect of his personality that most directly affected the nature of his creative efforts in these years.[5] Like a host of other young American painters in New York in the period immediately following the Armory Show, Demuth looked to European modern art for inspiration. He was a regular visitor to the galleries in New York, particularly to 291, and by 1914, he had already made several extended trips to Europe, where as early as 1912, he was introduced to Gertrude Stein and saw the many important works in her collection of modern French art. As is evident in the Arensbergs' watercolor study of Bermuda—a work which Demuth preferred to classify as an "Interpretive Landscape"—the artist was clearly influenced by the unfinished quality he had seen in Cézanne's watercolors, while at the same time, in the enframed grouping of houses in the center of the composition, he consciously emulated the volumetric, though translucent, effect found in many examples of Analytic Cubist painting.

In 1915, at about the same time that his work began to exhibit obvious allegiances to advanced manifestations in European art, Demuth directed his energies and talents to the art of illustration, not for financial reasons, but for his own edification. From 1915 through 1919, he produced hundreds of illustrations, most for books by authors who were considered controversial, due, primarily, to their incorporation of themes that were thought inappropriate for fine literature: sex, sin, death, and starvation. Even Demuth's dealer, Charles Daniel, thought that some of these works were too sensitive for public display, and kept them hidden in the back of his gallery in a portfolio, allowing only museum directors and other select clients to view them.[6]

In this same illustrative style, Demuth also produced a brilliant visual record of vaudeville performances he attended, as well as of the many nightclubs, bars, bathhouses, and cafés he frequented in these years—locales that some considered of questionable moral value. This was precisely the position taken by Henry McBride, who stepped beyond the bound of his expertise as an art critic in order to provide readers with his opinion of these lowly haunts. "Races of various colors intermingled, danced and drank there," he explained with some disdain. "I hold it was entirely right of Mr. Demuth to have studied it, so evidently in the interests of higher morality." But he quickly chastised two of the artist's friends for having accompanied him. "What excuses young Mr. Duchamp and young Mr. Fisk [Edward Fisk, a painter] can offer for descending into such resorts I cannot imagine."[7]

Charles Demuth. Bermuda. *1917. Watercolor and pencil on paper, 9 ¾ x 15". Philadelphia Museum of Art. The Louise and Walter Arensberg Collection*

Charles Demuth. At the Golden Swan. *1919. Watercolor on paper, 8 x 10 ½". Collection Irwin Goldstein, M.D.*

Demuth and Duchamp saw quite a bit of one another during these years, and they often met for late-night drinking sprees in a number of Harlem jazz clubs or at some seedy Village bar. "It was fun to be with Demuth," Duchamp explained, "because he didn't care where he belonged or was in the social scale." We know that on a number of occasions the two artists went to Barron Wilkins's Little Savoy, a club on West Thirty-fifth Street that featured ragtime music and jazz. And they also met often at the Golden Swan, a bar so-named because of a large painting of a gilt swan that graced a wall in its main sitting room. This bar was better known as "the Hell-Hole," for it was patronized primarily by poor writers and petty thieves. In a spirited watercolor of 1919, Demuth depicted the interior of this colorful establishment, showing himself, which he did only rarely (in the foreground, in profile, with his back to the viewer), and Duchamp (to his immediate right, cigar in mouth), being served drinks. Apparently oblivious to the sound of laughter coming from an adjoining table, these two artists look as

though they are ignoring—at least for the moment—the advances of a some-what lascivious, probably intoxicated young woman on the far left, who looks as if she is about to fall back on her chair.

In addition to his friendship with Duchamp, Demuth also professed a great respect and admiration for his work, even though in this period, its decidedly more conceptual approach had little bearing on his own aesthetic concerns. When Duchamp's urinal was rejected from the Independents, for example, Demuth wrote a letter to Henry McBride urging the critic to write about the affair in his column.[8] And when Duchamp organized the publication of *The Blind Man*, Demuth contributed a poem entitled "For Richard Mutt," wherein he seems to have acknowledged the merit in Duchamp's effort to advance our understanding of what could be accepted as a work of art. "For some there is no stopping," he wrote. "Most stop or get a style. / When they stop they make a convention . . . / The going run right along. / The going just keep going."[9] Demuth also attended The Blindman's Ball, and when the dancing was over in Webster Hall, he was one of four friends who piled into bed with Duchamp and spent the night.

Demuth especially admired Duchamp's

Large Glass (p. 38). "The big glass thing," he told Stieglitz many years later, "is still the great picture of our time."[10] In this masterpiece of mechanical precision, it was Duchamp's elimination of texture and his detached, unemotional execution that most appealed to Demuth—the very qualities he would begin to incorporate into his own work in 1919. In that year, he began a series of architectural studies in tempera and watercolor, Cubist-inspired paintings that are characterized by a translucent overlay of thin intersecting lines, which, in most cases, zigzag back and forth across the surface of the composition, affecting the surrounding space more than the buildings that these lines either overlap or envelop.

In one such picture, painted in 1920—*In the Province (Lancaster)*—Demuth has rendered a Cubist-inspired vision of a local cotton mill, a cluster of buildings that were located not far from Demuth's home in Lancaster. It was, perhaps, the contrast between this building's elegant classical lantern and the surrounding industrial structures that attracted Demuth to the subject, which he addressed in a reductivist style that would later be labeled Precisionist. The Arensbergs acquired this picture shortly after it was painted, either in 1920 or 1921.[11]

It was probably the nationalist ideas espoused by his friend William Carlos Williams, the poet-doctor from Rutherford, New Jersey (who, by this time, Demuth had known for some fifteen years), that inspired the artist to address the forms of America's industrial landscape in the first place. For all forms of creative expression, Williams advocated the development of indigenous American art. "We will be American," he wrote in an editorial statement published in a magazine he founded in 1920 with the poet Robert McAlmon, "because we are of America."[12] He renounced a blind reliance upon the precedent of European modernism, although it seems that for at least a number of years, well into the

1920s, Demuth continued to believe that some of the most exciting examples of modern art were being produced by European artists. It is perhaps for this reason that he took one last trip to London and Paris in 1921, even though over the course of the preceding year, he had suffered innumerable diabetic episodes.

In Paris, Demuth resumed contact with Duchamp, who had arrived from New York only a few weeks earlier. Even the Europeans were telling Demuth that the art of the future was not in France. "New York is the place," Duchamp and Gleizes told him. "Europe is finished."[13] Demuth was in Paris only a month before becoming so sick that he checked

into the American Hospital in Neuilly, where he remained for about a week. He was forced to return to Lancaster three weeks later, where he would remain for the last fourteen years of his life, his trips to New York far less frequent due to continual bouts of deteriorating health.

In convalescence, Demuth painted primarily in tempera and watercolor, selecting subjects drawn from his immediate environment: still lifes, flower studies, and occasional views of the industrial landscape in the area around his home. In the early 1920s, these works were displayed in a series of exhibitions at the Daniel Gallery, shows that invariably elicited favorable reviews.

In preparation for an article on Demuth's recent work, the critic Thomas Craven asked the artist to provide a statement about his art. Demuth responded by saying something that could be read as the virtual antithesis of Duchamp's position that an artist should be treated as a thinking being, and not merely as a mindless practitioner of his craft. "With few exceptions," Demuth said, "artists think of themselves too constantly as 'artists,' or men of genius—we should always be children and fools."[14] Whatever prompted Demuth to make such a misleading statement is unknown, but he surely must have regarded himself—and probably even Duchamp—as among the "few exceptions" to which he refers.

The influence of Duchamp on Demuth's work of this period was observed by a number of perceptive critics, one of whom, Forbes Watson, concluded that the artist's selection of elaborate titles could be traced directly to the painter of the *Nude Descending a Staircase*. Indeed, in 1923, Demuth admitted to Watson that Duchamp was the "strongest influence" on his recent work.[15]

Although rarely discussed in historical overviews of Demuth's work, it is this influence—ingeniously fused with the artist's Cubo-Realist style—that determines his unique artistic vision, one that would form an essential contribution to the subsequent development of modern art in America.

Charles Demuth. In the Province (Lancaster). 1920. Tempera and pencil on paper, 23 3/8 x 19 1/4". Philadelphia Museum of Art. The Louise and Walter Arensberg Collection

JOHN COVERT

John Covert. c. 1917.
Collection Charles C. Arensberg, Pittsburgh, PA

John Covert—among the most productive and original artists in New York during the second decade of this century —was Walter Arensberg's first cousin (the son of his uncle, Alexander William Covert, a pharmacist). During his boyhood in Pittsburgh, Covert took little interest in art, preferring to study mathematics in high school. But upon graduation, he enrolled in art classes at the Pittsburgh School of Design, and from 1901 through 1907, he studied with Martin Leisser, a well-known local realist painter who had trained in Germany. In 1909, probably at Leisser's urging, Covert went to Munich and enrolled at the Akademie der bildenden Künste, where he remained for three years, before departing for Paris in 1912, at the age of thirty. There he continued to work and study until the outbreak of the First World War.[1]

Although he was in Paris during one of the most important periods in the development of modern art, Covert's allegiance to a rather conservative style of painting insulated him from these more vanguard activities. "I didn't get to know a modern artist, or see a modern show, or even meet the Steins," he recalled years later. "It's incredible. I must have lived in armor."[2] When war activities became threatening, Covert returned to the United States and Pittsburgh, where for at least another year, he continued to paint in a realist fashion, devoting himself primarily to landscapes and portraits of relatives. But Covert's commitment to realist painting was destined to change—suddenly, and without warning—on a single day during the summer of 1916.

Walter and Louise Arensberg usually spent the hot summer months at their country home in Pomfret, Connecticut. During the summer of 1916, Walter invited his cousin to join them, where he could paint outdoor scenes in the relatively relaxed atmosphere of their summer retreat. One morning, as Covert himself later described his own epiphany, everything changed:

Suddenly, with the same trees and hills all around I couldn't find a subject. I tramped until noon, getting hotter and more disgusted by the minute, finally plopped down in the grass. The sun was blazing down from straight overhead so that each tree floated in its own shadow. Everything was trembling; it was like looking through molten glass; I was trembling, too. I was painting without knowing it: the trees were like gallows and the shadows, the hills, were triangles. I was sopping wet with perspiration when I carted it home. Tried to hide it—God knows I didn't know what I had. But nosey Walter saw it.

"Well," Arensberg declared upon seeing Covert's painting, "now we have a modern artist!"[3] Although this first landscape does not survive, Covert immedi-

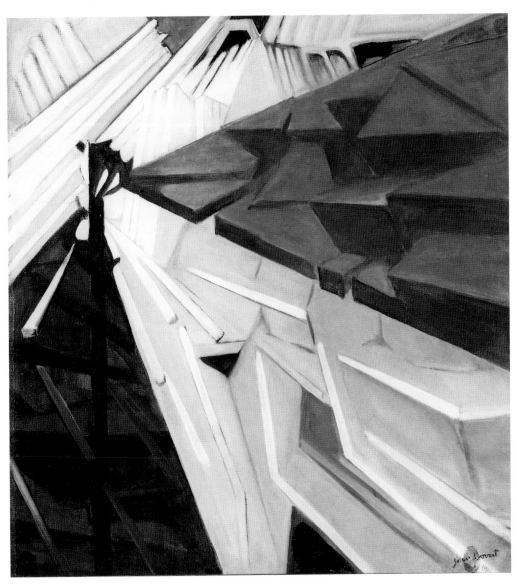

John Covert. Temptation of Saint Anthony. 1916. Oil on canvas, 25 ¹¹/₁₆ x 23 ³/₄". Yale University Art Gallery, New Haven. Gift of Collection Société Anonyme

ately followed it with a series of paintings that reveal an obvious allegiance to the most advanced expressions of modern European and American art, examples of which he could have seen on any wall in his cousin's New York apartment. Indeed, not long after this experience, Covert moved to Manhattan, taking a studio on West Thirty-fifth Street off Fifth Avenue. It was probably here that he painted the *Temptation of Saint Anthony*, a large, square Cubist composition, signed and dated 1916. Subsequent historians have noted stylistic similarities between this picture and Duchamp's *Nude Descending a Staircase* (p. 16), and because of sexual references implicit in the subject of Covert's picture, they have also suggested the possible influence of Duchamp's *Large Glass* (p. 38). While Duchamp and Covert were good friends in this period, and they often played chess together at the Arensberg apartment, it is unlikely that Covert relied on any such specific sources of inspiration.

In 1917, Covert showed the *Temptation of Saint Anthony* (along with another painting entitled *The Arc of a Landscape*, now lost, but possibly the very painting that initiated his conversion to modern art) at the first exhibition of the Society of Independent Artists, an organization for which he had served as secretary (see chapter 7). A few weeks after the exhibition opened, a reviewer chanced upon Covert in front of his two paintings, and the artist provided the following very rare and valuable description of the *Temptation*:

> *At the upper left-hand corner is the motive of the Cross. Near it is the hand of the saint thrusting from him temptation in the guise of a candle which is held by a woman. Her head is seen just to the right of the Cross, and her form is suggested by the sweeping lines that run down through the picture and out of it at the bottom in knee-like angles. The monk's cowl is to the right, just above the vast shadowy arm.*[4]

In addition to the details pointed out by the artist, one can also clearly discern a dark triangular shape in the near center of the composition. Although he was too tactful to provide an explanation of this detail in such a public forum, there can be no doubt that Covert intended this stylized vision of the temptress's pudendum to represent the most difficult-to-resist element in the process of Saint Anthony's trial by temptation.

In this period, Covert was also deeply affected by his cousin's obsession with cryptography. His contribution to these studies is documented by Arensberg himself, who acknowledged Covert's assistance in the introduction to his book on Dante, thanking him for suggesting the possible application of capital letters in cryptographic ciphers, and especially for the important discovery of a Dante signature in the *Purgatorio*.[5] It may have been Arensberg's pursuit of hidden meanings in words, or, perhaps, Duchamp's preoccupation with the exchange between things verbal and visual, that led Covert to pursue similar interests.

In a painting of 1918, for example, which depicts a close-focus view of two apples—one cut, the other whole—it has been suggested that the entire image could be interpreted on the basis of its unusual title: *Hydro Cell*. Hydrocele is a medical term referring to the accumulation of fluid in the scrotum.[6] Therefore, the pairing of apples could very well have been intended to refer to this particular

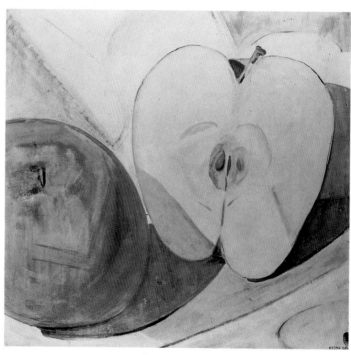

John Covert. Hydro Cell. *1918. Oil on cardboard, 23 1/2 x 25 3/4". Philadelphia Museum of Art. The Louise and Walter Arensberg Collection*

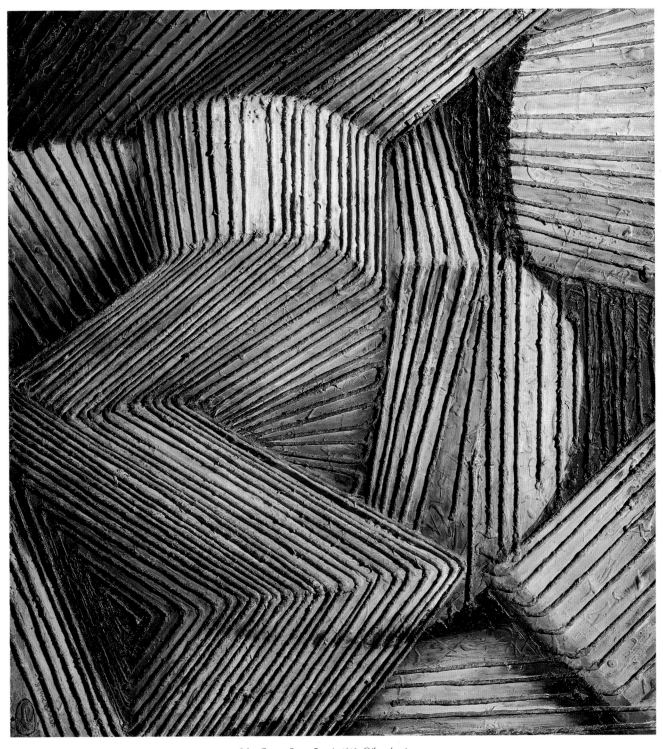

John Covert. Brass Band. *1919. Oil and string on
composition board, 26 x 24". Yale University Art Gallery,
New Haven. Gift of Collection Société Anonyme*

detail of the male anatomy, and the fact
that Covert selected apples over any
other fruit suggests that he might have
intended a hidden reference to the
theme of man's original temptation in the
Garden of Eden.

Whether or not this interpretation is
correct, of one thing we can be relatively

certain: Arensberg, who had found far
more controversial meanings in his read-
ings of Renaissance texts, would have
loved it. His high regard for this particu-
lar picture is evident not only from the
fact that he acquired it, but that he chose
to hang it in a very prominent position
above the piano in the main room of

their apartment (see p. 27, top), appro-
priately positioned between paintings by
Duchamp and Picabia.

Further evidence that Covert applied
his knowledge of cryptography to his cre-
ative work can be found in a work from
1919 entitled *Time*, wherein numbers, let-
ters, algebraic formulas, and other cryptic

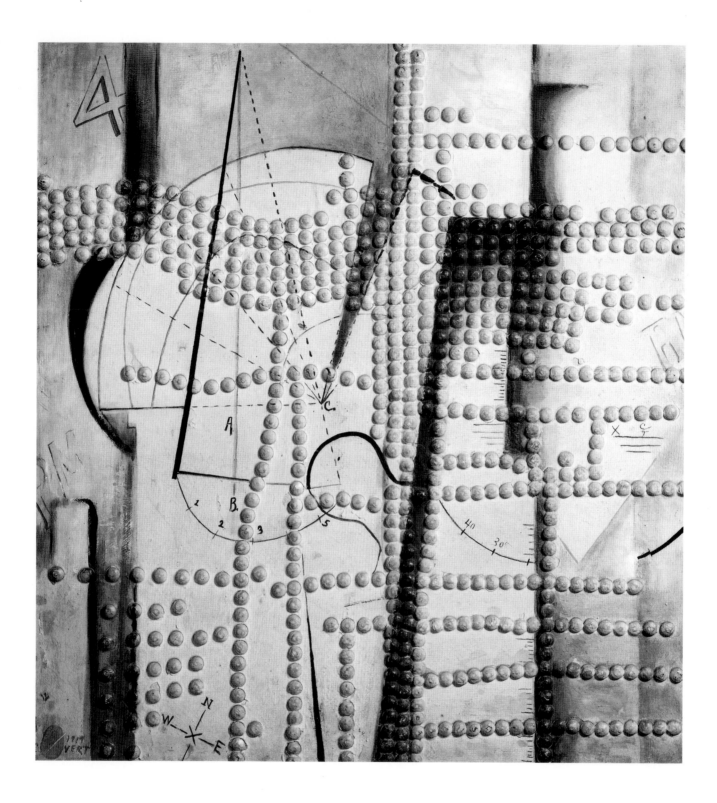

signs and symbols can be seen inscribed directly onto the painting's surface. The work is given a heavily textured appearance by the insertion of numerous upholstery tacks that seem to run in consciously constructed patterns across the surface of the composition. "I was on my feet eighteen hours a day," he later told an interviewer. "I was carpenter, upholsterer, painter—what have you."[7] In spite of his unusual use of materials, the subject of this picture betrays Covert's earlier pursuit of a far less mundane profession, namely, mathematics, which had held his interest since his youth.

It has been convincingly demonstrated that *Time* was directly inspired by Einstein's theory of relativity, a momentous scientific discovery that had actually occurred some years earlier, but which was explained to the general public in popular journals only during the course of the second decade of the century.[8] The merit of Einstein's theory was hotly debated in American newspapers and magazines, particularly in 1919—the year of Covert's painting. The artist's reference to the concept of a time continuum

Louise Arensberg in the studio of John Covert. c. 1919.
Louise Arensberg Photograph Album (#2), Arensberg
Archives, Francis Bacon Library. © Copyright 1994
The Francis Bacon Foundation

is evident by his placement of PM on the extreme left side of the composition, while AM can be found approximately at the same lateral level on the far right. But an even more specific reference to Einstein's theory can be found in the algebraic formula inscribed on the right edge of the painting: $x [=] \frac{c}{t}$, where the letter "x" represents an unknown quantity, "c" the velocity of light, and "t" time.

It has also been suggested that in Covert's use of such unusual materials—tacks—he may have intended a punning reference to the sound commonly associated with a clock: "tick-tock." And it has also been noted that he accompanied his signature with a large thumbprint (as he had with most pictures since 1916), but in this case, the print is placed directly over the letter "o" in his name, leaving the word "vert" clearly visible, which one observer has suggested refers to the overall green tonality of the picture.[9] While the paint surface may have yellowed slightly with time, there is no actual green coloration visible within the pigment of this picture, which suggests that Covert may not have wanted the second syllable of his name emphasized,

but rather the first. Since this thumbprint replaces the letter "o" in his name, the signature could be read "co–vert," as in concealed, secret, or disguised.

Covert was certainly aware of the possible double reading of his name. A few years earlier, he accompanied his signature on a painting with the drawing of a four-leaf clover, obviously punning on the similar sound and spelling of the words "covert" and "clover." And years later, in signing a letter to Louise Arensberg, he drew two leaves of a four-leaf clover in such a way as to form the first letter of his last name.[10] Puns of this type were common to the work of Duchamp, and Covert resorted to their use repeatedly, particularly in his selection of titles.

In another painting from 1919, entitled *Brass Band* (p. 137), for example, which is made entirely of strings glued to the surface of composition board, it is unlikely that Covert would have missed the multiple readings of its title: first, "brass band," as in a band of brass instruments—trumpets, trombones, etc.—common to many Negro ensembles that formed in the southern United States during the early years of this century, some of whom played in popular jazz clubs throughout New York City. And second, the overall, striated pattern of the painting has been more convincingly compared to the parallel metal braces sometimes seen on the side of playing

drums, as well as to specific examples of African primitive art, particularly to related details on Basonge masks.[11] *Brass Band* has also been compared to contemporaneous works by Picabia and Duchamp, particularly to the latter's *Chocolate Grinder* (p. 37), which also partly consists of actual filaments attached directly to the surface of the composition.[12]

Whatever his sources, in *Brass Band*, Covert has created an image that is singularly powerful and totally abstract, a work which for these qualities alone would secure this artist an honored and rightful position in the formative phases of modern art in America.

Brass Band, *Time*, *Hydro Cell*, and the *Temptation of Saint Anthony*, along with twenty-nine other paintings by Covert, were included in the first and only one-man show mounted in the artist's lifetime, held at the de Zayas Gallery in the spring of 1920. Although the exhibition received scant mention in the press, Henry McBride wrote enthusiastically about the artist's use of unusual materials:

> [Covert] goes into cubism deeply. Like
> Picasso, if he happens to feel it to be cement,
> he acknowledges it on the picture in real
> cement. In fact, Mr. Covert's muse is at
> home in what most artists would consider
> the unlikeliest materials. Some of the panels
> have rows of small objects resembling corks
> glued all over them and the painting that is

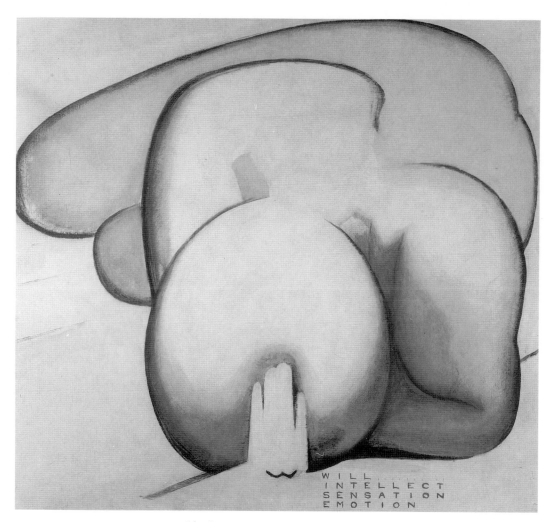

John Covert. Will Intellect Sensation Emotion.
1923. Oil on composition board, 23 $^3/_{16}$ x 25 $^7/_{16}$".
Yale University Art Gallery, New Haven. Gift of
Collection Société Anonyme

done upon them; others may have fine strips of molding beneath the glass, as it were, and still others appear to have been achieved upon boiler iron with the rivets left in. These various textures prevent the artist dropping into perfunctory habits. [13]

McBride went on to tell his readers that he considered *Brass Band* the best picture in the show, which, he said, "at a distance . . . has the effect of a group of extended accordions."

McBride's favorable opinion of the artist and his work must have given Covert renewed encouragement to continue painting, even though few collectors expressed any desire to acquire his work. He continued to glue slats of wood and

the like to the surfaces of his pictures, producing works that are, technically, more assemblages than paintings (several can be seen hanging on the walls of his studio in a series of portrait photographs of Louise Arensberg).

In the early 1920s, Covert seems to have resumed his interest in cryptography, and the mechanics of this arcane procedure—particularly as it was practiced by Walter Arensberg—are evident in at least two paintings from this period: *Will Intellect Sensation Emotion* and *From Word to Object.*

In the first of these pictures, the outline of a headlong, foreshortened nude, with one hand positioned to mask the

top of her head, recedes into the square format of the composition. It has been suggested that this hand is made to resemble the shape of a "W," referring to the first letter of the painting's title, which is prominently inscribed on the canvas surface. If this reading is accepted, then the "WISE" (spelled out by the first letters of the four-word title) can be associated with the figure's intellect (i.e., its mind), while the arms and shoulders relate to sensation, and its lower extremities to emotion. [14] This evidences a direct relationship to Arensberg's methods in examining the interior sequence of cryptograms in Dante and Shakespeare (see chapter 2).

Both Arensberg and Covert delighted in such verbal-visual games. In *The Cryptography of Dante*, for example, Arensberg pointed out that the word *omo* (old Italian for man) graphically mirrors the features of a human face, the M forming the nose and outline of the cheeks, while the two flanking O's represent the eyes.[15] In a similar fashion, if we follow the suggestion implied in Covert's title, the bust that appears in *From Word to Object* was probably composed entirely from the letters of a single word, in this case, the artist's last name: COVERT (with sufficient examination, all six letters can be deciphered; in his signature, Covert even provides a hint for finding the last letter, "t," which he renders turned 45 degrees on its side).

But the hidden signature in this painting reveals more than Covert's cryptographic interests, for the downcast eyes and downturned mouth indicate a state of depression, which certainly reflects Covert's continued lack of success as a painter. "In 1923," he later confessed, "I woke up. There was nothing in the studio to eat and no money in my pocket."[16] After an unsuccessful attempt to solicit financial aid from several wealthy patrons in New York, he closed his studio and took a job as a salesman in the crucible company owned by the Arensberg family in Pittsburgh. For the thirty-seven remaining years of his life, he never painted again.

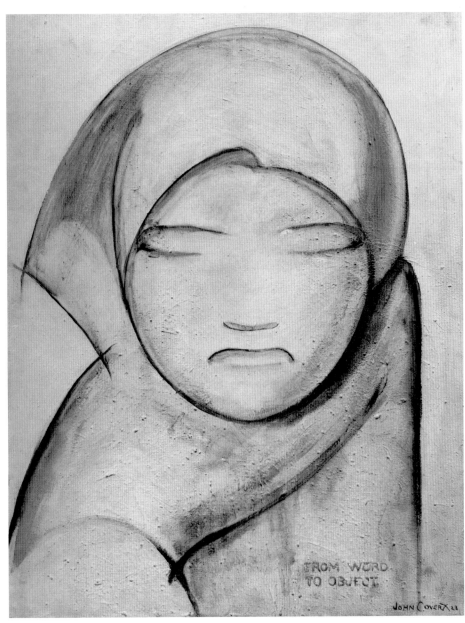

John Covert. From Word to Object. 1923. Oil on canvas, 27 x 20". Yale University Art Gallery, New Haven. Gift of Collection Société Anonyme

JOSEPH STELLA

Joseph Stella. c. 1920. Photograph by Man Ray.
Silver print, 9 ⁹/₁₆ x 6 ³/₄". Courtesy of
Zabriskie Gallery, New York

When Joseph Stella met Marcel Duchamp in 1915–16, the Italian-born Futurist painter had already been recognized as one of America's most progressive painters. Well over a year before Duchamp arrived in New York, Stella had painted a large Futurist-inspired canvas based on the glittering lights and exciting atmosphere of Coney Island, a painting that one critic rightly called "the last word in modernism."[1] Stella's conversion to modern art, however, came rela-

tively late in his career; by the time he decided that an artist should not seek inspiration exclusively from the art of the past, he was already thirty-six years old. For some fifteen years, he had worked in a rather conservative style, and, because of his remarkable abilities as a draftsman, had attained some success in New York as a magazine illustrator.

Stella was born, raised, and educated in Italy. Upon graduation from high school, he left for the United States, join-

ing his father and three brothers who had emigrated some years earlier. After studying medicine and pharmacology for over a year, he decided to pursue his childhood dream of becoming an artist. In 1897, he enrolled in classes at the Art Students League and, later, the New York School of Art, where he studied with William Merritt Chase. Living on the Lower East Side, he was immersed in the most poverty-stricken center of the American immigrant population; for over ten years, he produced literally hundreds of sketches and detailed illustrations of its burgeoning populace, drawings that readily convey the emotional affiliations he felt with its plight.[2]

This naturalist style would continue until 1911, the year when Stella took the advice of Walter Pach and took a trip to Paris.[3] It was in the French capital that he saw his first examples of Fauvism and Cubism. And it was also in Paris that he attended the exhibition of Italian Futurism held at the Galerie Bernheim-Jeune in February 1912.

The modern paintings he saw affected him deeply. Upon his return to the United States, he declared that "True art is always more or less a reflection of everything that is going on in its epoch, and therefore cannot live on the crumbs of the past."[4] He almost immediately began to work in a Futurist style, culminating in *Battle of Lights, Coney Island, Mardi Gras*, 1913 (Yale University Art Gallery, New Haven; gift of the Société Anonyme), an enormous canvas that was shown in several exhibitions of modern art in New York and that was repeatedly singled out by reviewers as one of the more extreme examples of the new art. "This artist believes that the static traditions and conventions of the past must be abandoned," wrote one reviewer, "before art can reflect the changing material conditions and theories on which a new civilization is being founded."[5]

Having adopted principles such as these, Stella, we can safely assume, would have been immediately attracted to the iconoclastic ideas of Marcel Duchamp, who, in nearly every interview with the New York press, openly chas-

Joseph Stella. Collage, Number 21. c. 1920. Collage on paper, 10 1/2 x 7 1/2". Collection of Whitney Museum of American Art, New York. Purchase 61.42

tised American artists for relying too heavily on the precedents of European art. It was probably their mutual friend, Walter Pach, who introduced the two artists. They either met in the latter half of 1915 or, at the very latest, during the early months of 1916, for by April of that year, in an exhibition of modern art at the Bourgeois Gallery (in which Duchamp was also included), Stella showed two works on glass that—in terms of medium alone—exhibit the

unmistakable influence of the young French artist.

Shortly after their meeting, Duchamp must have shown Stella the various works on glass that he brought with him to the United States—such as the glider (p. 39)—and he probably also kept him informed of his progress on the *Large Glass* (p. 38), which he began almost immediately upon his arrival. At about the same time, Stella probably also saw Jean Crotti's works on glass (pp. 101 and 104), for Duchamp and Crotti then shared a studio in the Lincoln Arcade Building. The two works on glass that Stella exhibited in the Bourgeois exhibition were *Man in Elevated (Train)* and

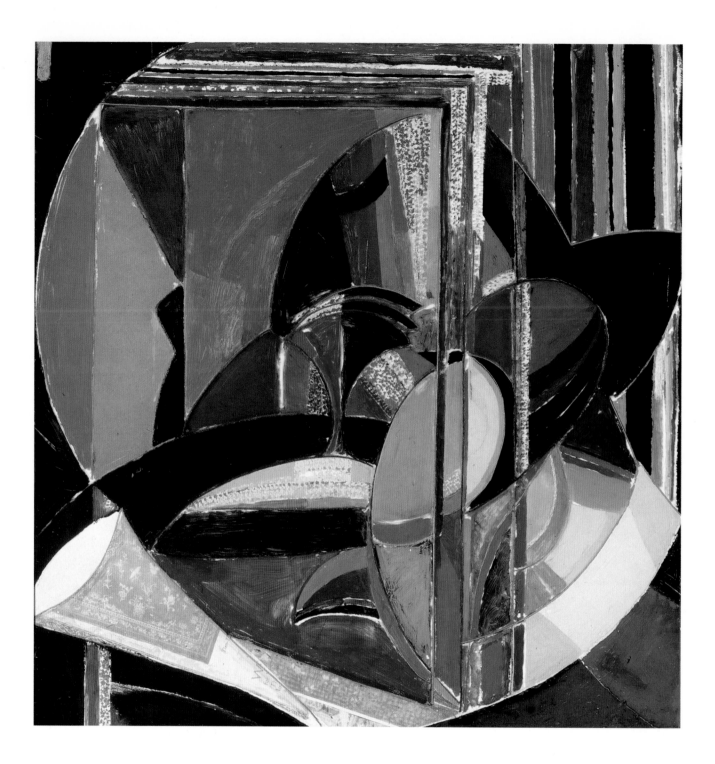

Prestidigitator (p. 146), important paintings by the artist which, until now, have been either unidentified or thought to date from a later period.[6]

By allowing the internal shapes of his composition to be defined almost entirely by means of lead wire glued to the verso of the glass panel, in his execution of these pictures, Stella has closely followed the precedent of Duchamp's unusual technique. And for both of these paintings, the original titles Stella gave them provide a clue to the imagery he intended to represent, or at least they give an indication of the general theme he had in mind when they were made. From the catalogue that accompanied the Bourgeois exhibition, we know that Stella entitled the first of these paintings "Man Seen through the Window on the Elevated." With the advantage of this descriptive title, it is not difficult to make out the profile of a man, facing left, seen only from the shoulders up and wearing a bowler hat. His facial features are obscured by a series of interlocking, abstract colored shapes in the center of the composition, but his neck, the white starched collar of his shirt, and the profile of his hat can be seen on the right side of the painting, while on the far left, a white triangular shape represents the flaccid open page of a newspaper the man is presumably reading (which is fur-

ther defined by the illustration of an oriental rug, clipped from a magazine and attached in this position on the verso of the glass). Even the window referred to in the title is clearly visible, as a series of overlapping and penetrating vertical lines placed to the right of center, which are in turn met at the summit of the image by a horizontal element that completes at least a portion of its rectangular format.[7]

The other work shown in the Bourgeois Gallery exhibition was *Prestidigitator*, which can be described as the image of two exceptionally bright electric lights, their intensity directed downward by a pair of inverted, funnel-shaped shades. Both of these lights are suspended from a curving, snakelike form that is wrapped around a stark black vertical support in the center of the painting. If we can take the title literally (a prestidigitator is one who specializes in sleight of hand), then the bright lights could have been intended to define a magician's arena, the kind of brightly illuminated stage where tricks of this type are customarily performed. Alternately, the undulating whitish form which envelops the support vaguely delineates a human shape, whose "brain"—indicated by a swelling in the tube—appears to issue energy that spirals downward to fuel its prestidigitating hands, represented by the dual lampshades.

Few reviewers seem to have paid any attention to these works by Stella, preferring instead to confine their remarks to the European modernists in the exhibition. A reviewer for *American Art News*, however, mentioned in passing that Stella showed "colors under glass." And when most of the works in this exhibition traveled to Philadelphia for an extended showing, another reviewer noted that a certain unnamed artist had made an aesthetic distinction between these two works on glass. "A noted painter decides that though Joseph Stella's 'Man Seen through the Window on the Elevated' is just 'easy Futurist guff,' his 'Prestidigitator,' with its search-lights dangling on some weird trickery of curving tentacles, is the only one I think pretty."[8]

For a four-year period, at least until 1920, Stella continued to paint and exhib-it his works on glass. In February of 1917, for example, in another group exhibition of modern art organized by the Bourgeois Gallery, he showed *Chinatown* (p. 147), visually one of his most exciting and successful works in this new medium.[9] Within a slender vertical format, the artist has captured the true ambience and spirit of Chinatown, preserving in elegant abstract terms the bright colors and shapes associated with a Chinese festival. Angular rays of light interpenetrate a circular orb, itself defined by a rainbow of colors and overlapped by a curving, amorphic shape that ends in a fishtail, suggesting the undulating movement of a Chinese dragon. Other decorative arabesques loosely resemble the design and configuration of Oriental characters, while the overall scroll-like appearance of the painting, and the bar running parallel to the right edge of the frame, may have been intended as additional references to Chinese calligraphy, which is read from right to left, in long vertical columns.

The Arensbergs acquired *Chinatown*, and hung it next to a large African carving in the main studio of their apartment (p. 27, middle). In 1917, Stella often attended their nightly gatherings, where his formidable countenance and unpredictable temperament made a memorable impression on many fellow guests. Edgard Varèse, who saw quite a bit of Stella during these years, found him a contradiction on many levels. "Sometimes friendly, and sometimes hostile—you never knew, with Stella, how he would be. . . . He was in some ways so refined, so delicate—a purist—and then he could be so vulgar, obscene. And physically, too, he was a paradox—big, fat, heavy-bodied, and yet so graceful."[10]

A certain sense of these qualities can be gleaned from photographs in which the artist appears (pp. 90 and 142). But outside of his public pronouncements, few really knew anything about Stella's private life; even though he was married to a woman from Barbados (whom no one ever saw), he always played the part of the inveterate bachelor. "He was very vain," Man Ray recalled, "considered himself a Don Juan and acted as if he was always involved in some escapade." Beatrice Wood recalled that one night he even challenged someone to a duel in a valiant effort to protect her honor.[11]

Because of his friendship with Duchamp and the Arensbergs, in 1917, Stella was asked to serve on the board of the Society of Independent Artists, and he showed his large Futurist painting *Coney Island* in the Independents' first annual exhibition. He attended the Blindman's Ball (where the incident over Beatrice Wood took place), and although he lived in Brooklyn, he attended most of the important exhibitions of modern art held in Manhattan during these years. In the spring of 1918, he showed another work on glass in a group show at the Bourgeois Gallery, and in 1919, he exhibited *Pittsburgh*, a painting on glass (now lost) that depicted a nocturnal view of this industrial city, reportedly rendered in dramatic fashion.[12] When this painting was shown again in a group exhibition at the Société Anonyme during the fall of 1920, one critic provided a detailed description of Stella's depiction of a Pittsburgh steel mill:

> *Joseph Stella, an Italian, who has lived a number of years in this country, has depicted the civilization of America by a design that brings together a bare steel framework, a heavy beam, a shaft of green light, the blaze of a furnace and spaces of geometrical shapes in different colors that do not pretend to represent any real objects at all. In no possible landscape could you see those things all together. The beam of light does not come from any lamp, the blaze of the furnace is under the steel framework where there could not possibly be a furnace.*
>
> *Mr. Stella was not interested in picturing any real scene. He was attempting to convey an emotion, and any one who has travelled through the Pittsburgh country at night will recognize the terror of raw power, of naked cruelty, of speed and confusion that the blazing furnaces and queer lights do make one feel.*[13]

In 1920, Stella joined forces with Duchamp, Man Ray, and Katherine Dreier to support the activities of the Société Anonyme. It was probably in its galleries that Stella first saw the collages of Kurt Schwitters, a German Dada artist

Joseph Stella. Prestidigitator. 1916. Oil and wire on glass, 13 ⁵⁄₁₆ x 8 ¹⁄₂". Collection of Whitney Museum of American Art, New York. Daisy V. Shapiro Bequest 85.29

whose work Dreier greatly admired. For the next few years, Stella took up this new medium in earnest, producing a brilliant series of collages (e.g., p. 143) that have been called his "greatest innovation."[14]

Although these works occasionally combine fragments of printed material—in the manner of Schwitters—they are more often composed of crumpled and discarded pieces of paper, sometimes presented just as they were found, in the fashion of an *objet trouvé*. "Walking along the street," one of his friends recalled, "[Stella] would . . . pick up torn, discolored pieces of paper which would be pasted on color backgrounds . . . interesting patterns made by footprints, auto tire prints, plain dirt and dirty water."[15]

In January of 1921, Stella delivered a lecture on modern painting at the Société Anonyme, where he voiced his disapproval of organized movements that

he felt served only to restrict an artist's creative potential:

"The motto of the modern artist is freedom," he told the audience, "real freedom." He went on to explain that artists were under no obligation to follow tradition, but cautioned: "Every declaration of Independence carries somewhat a declaration of a new slavery. And according to [the modern artist's] credo, he will always prefer the emotions as expressed by a child to the lucubrations of those warbling theorists who throw harlequin mantles on insipid soapy academic nudes. . . ."[16]

Stella's conversion to modernism was complete. In the summer of 1921, one of his pastels of *Coney Island* was included in the famous Salon Dada organized by Tristan Tzara at the Galerie Montaigne in Paris, and in the fall of 1922, *The Little Review* devoted one of its issues to Stella, reproducing sixteen works, including one painting on glass (*Chinatown*), two collages, and as if to acknowledge his debt, a magnificent silverprint *Portrait of Marcel Duchamp* (The Museum of Modern Art, New York).[17] In January 1923, he was given his first major one-man exhibition at the Société Anonyme, where he showed his epic five-panel series *New York Interpreted* (The Newark Museum, New Jersey), paintings of such arresting visual impact that they caused many critics to call Stella "one of the great American artists of today."[18]

Although Stella's future reputation in the history of American art would be established primarily on the basis of his famous Cubo-Futurist interpretations of New York and the Brooklyn Bridge (works that are considered of seminal importance to the development of Precisionism), his early exposure to the ideas and techniques of Duchamp, as well as to the more irreverent implications of Dada, continued, to a certain extent, to influence his work for the next twenty-five years.

Joseph Stella. Chinatown. *c. 1917. Oil on glass, 19 1/4 x 8 3/8". Philadelphia Museum of Art. The Louise and Walter Arensberg Collection*

THE STETTHEIMER
SISTERS

The Stettheimer sisters: Florine, Carrie, and Ettie. c. 1914. Collection R. Kirk Askew, Jr.

In the same period when the Arensberg salon was most active—from roughly 1915 through 1920—there was another, far more formal gathering place in Manhattan to which artists, musicians, critics, and a host of others drawn from New York's cultural elite were periodically invited. Every so often, either by telephone or through the mail, these individuals could expect to receive a formal invitation to attend lunch, tea, or dinner at the home of the wealthy Stettheimer sisters—Carrie, Florine, and Ettie—three charming socialites who lived with their mother in a large, sprawling apartment on West Seventy-sixth Street off Columbus Avenue (exactly nine blocks—about a ten-minute walk—directly uptown from the Arensbergs).

Many of the people who attended the Arensberg gatherings—Duchamp, Picabia, Henri-Pierre Roché, Albert

Gleizes, Juliette Roche, Edgard Varèse, Carl Van Vechten, Charles Demuth, Marsden Hartley, Joseph Stella, Henry McBride, and others—were also occasional guests at the Stettheimers. We know that the three sisters were seen together at least once at the Arensbergs',[1] but their appearances were rare, for they preferred to socialize almost exclusively within the controlled environment of their own apartment, venturing beyond its confines only to attend public performances (mostly the opera and ballet, or an occasional movie). No matter how much time was spent in their company, however, virtually everyone who came into contact with the sisters found their public personas impenetrable. Although they were always cordial and gracious, to most guests their attire and demeanor appeared comparatively formal and rigid. Nevertheless, few who attended their gatherings failed to appreciate the quantity and quality of food, usually prepared by servants at the instruction of Carrie. Nor could they have missed the highly original paintings by Florine that hung in nearly every room of the apartment. And last, Ettie was always willing to engage guests in spirited conversation, on topics ranging from painting to politics, or from literature to philosophy (the latter two were her special areas of expertise). Collectively, it might be said that these three sisters represented the ultimate expression of feminine ideals: domesticity (Carrie), creativity (Florine), and the driving force of intellect (Ettie).

Of German-Jewish extraction, the three sisters were born and raised in the United States. But when their father abandoned the family, around 1900, they moved with their mother to Europe, living nearly the entire next decade in Italy, Germany, France, and Switzerland. Whereas Carrie spent much of her time caring for their mother (who always seemed to be in failing health), Ettie entered the University of Freiburg in Germany, where in 1908 she received her Ph.D. in philosophy. Meanwhile, Florine, who had studied earlier at the Art Students League in New York, took a studio in Munich, and although she saw

many examples of modern art, she preferred the old masters (particularly Bruegel). When war broke out in 1914, the family was forced to return to the United States, where, in the company of their mother, the three aging spinsters—now each over forty years old—established residence at 102 West Seventy-sixth Street in Manhattan.

Carrie was the oldest, and perhaps the most retiring. With the others in pursuit of their respective careers, she decided to enter into philanthropy and, during the summer of 1916, volunteered her assistance in a fund-raising project for infantile paralysis. Out of boxes donated by a grocer, she fashioned a dollhouse, a child's toy that was raffled off and earned an impressive amount of money for the charity. Motivated by her sudden and unexpected success, Carrie immediately began building a far more ambitious structure, a large and impressive dollhouse with furnishings based on the decor of their West Seventy-sixth Street apartment. Its inhabitants (made after the artist's death) were modeled after the many guests who attended their celebrated parties, thereby preserving for posterity a rare and privileged view into the everyday activities of the Stettheimers and their friends.[2]

Of the many dollhouse rooms that Carrie constructed, none attracts more attention today than the ballroom, where, on the left, the sculptor Gaston Lachaise can be seen conversing with Duchamp, while on the opposite side of the room, Virgil Thomson (who only entered into the Stettheimer entourage years later) plays the piano as Fania Marinoff (Carl Van Vechten's wife) looks on. Hanging on the wall in the background are a series of modern paintings—not replicas, but actual miniatures specially made by the Stettheimers' artist friends for inclusion in the dollhouse. Among them are nudes by Gaston Lachaise, Archipenko, and Marguerite Zorach, an abstraction by Carl Sprinchorn over the fireplace, while just to the left of the piano hangs the most famous painting in the room: a miniature version of Marcel Duchamp's *Nude Descending a Staircase*, which the artist made in 1918 and gave to Carrie Stettheimer on the occasion of her forty-eighth birthday.

Duchamp probably met the Stettheimers in the fall of 1916, likely through the introduction of Carl Van Vechten, who was a good friend of Walter Arensberg's and who had known the sisters for about a year. Almost

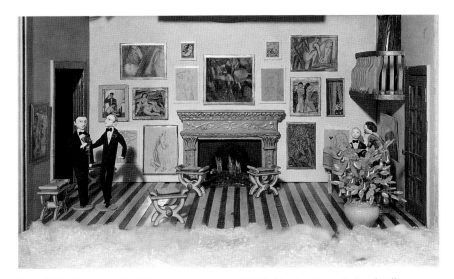

Carrie Walter Stettheimer. The Ballroom, Dollhouse. 1920s. Left: Gaston Lachaise talking with Marcel Duchamp; right: Virgil Thomson playing the piano for Fania Marinoff. Paintings and drawings by Alexander Archipenko, Mme.

Gela Archipenko, Marguerite Zorach, Albert Gleizes, Louis Bouché, Gaston Lachaise, Claggett Wilson, Carl Sprinchorn, and Marcel Duchamp. (Figures added later.) Museum of the City of New York, 45.125

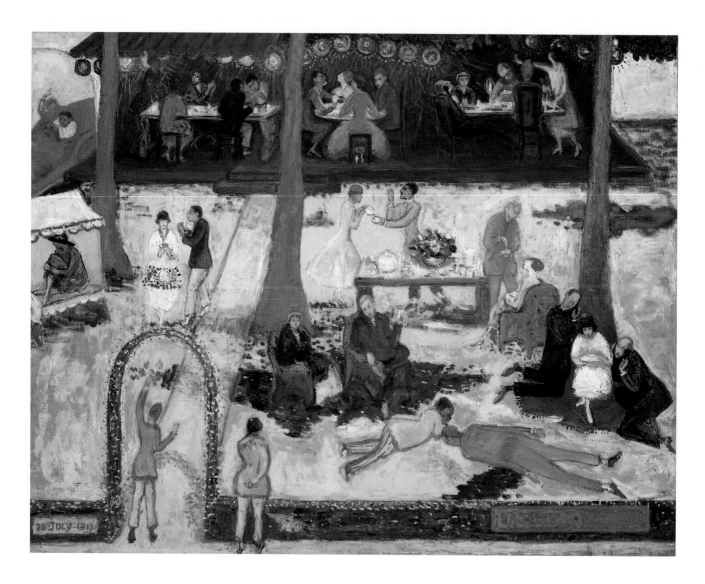

Florine Stettheimer. La Fête à Duchamp. *1917. Oil on canvas, 35 x 45 ½". Collection Mrs. John D. Gordan, New York*

immediately, Duchamp was hired to give them French lessons, which none of the three women actually needed after having lived in France for a number of years. The lessons began in the very period when Florine was preparing for her first one-person exhibition, which opened at the Knoedler Gallery on October 16, 1916. For months, she anticipated the exhibition with ever-increasing anxiety and trepidation—which, it turns out, were both accurate and justified. "Only one person asked to see the price list," she noted in her diary, which shortly thereafter was followed by an entry stating only: "Sold nothing."[3]

Apparently, the exhibition was both a financial and critical failure, an experience

Florine was never to forget and never to repeat. Frederick W. Eddy said she was "a versatile and pleasing painter,"[4] while another critic said she was "independent without being entirely personal,"[5] a cryptic remark that, nevertheless, might have been interpreted literally by the artist, for she would soon forge an independent style, one characterized by an even more emphatically personal subject matter. Whereas her earlier works owed an unmistakable debt to Symbolist painting, from this point onward, she would dismiss all foreign influences, instead painting environments that were extensions of her life—mythic, almost ethereal spaces that were invariably populated by individuals she knew and cared for: her mother, her sisters, and her close circle of friends. As Florine herself expressed this decision in verse: "Our Picnics / Our Banquets / Our Friends / Have at Last a raison-d'être / Seen in color and design / It

amuses me / To recreate them / To paint them."[6]

Among the first pictures in this new style is *La Fête à Duchamp*, commemorating, as the title indicates, a party that was thrown for Duchamp—whom the sisters had nicknamed "Duche"—on the occasion of his thirtieth birthday. Many of the artist's good friends were invited for the afternoon to the Stettheimer summer home just outside of Tarrytown, New York. The party was conceived as a true *fête champêtre* and, by all reports, turned out to be one of the most successful and memorable events of the summer. In her diaries, Ettie Stettheimer provided a vivid and accurate description of what took place:

Marcel Duchamp's party was a great success. A series of pretty pictures—first tea on the lawn under the maples and some of us "sur l'herbe," and afterwards 3 tables on the terrace and Japanese lanterns, blue and

green and yellow (alone) strung across
Duchamp's *table of painters: Picabia (a*
fat womanish enfant terrible, self-centered
Bohemian with a high power automobile in
which he and Duche came out later than
anyone else). Gleizes (a serious, very talk-
ative, amiable, long-winded one) Florrie
and Fania. *Middle table:* Carrie, Van
Vechten, *Mme. Gleizes (a refined*
Emanuella, interesting, European and "fem-
inine") and Buenavista. *Next: I,*
Elizabeth Duncan, Leo Stein, Roché
and Avery Hopwood. *Quite an atmos-*
phere. I read "Emotion" to Leo Stein and
Roché sur l'herbe and it was atmospheric
and amused me and they seemed to like it.[7]

Her frank opinion of certain individuals
was, of course, something Ettie Stett-
heimer would have revealed only in the
privacy of her journals. Nevertheless, her
entry provides an invaluable account of
what took place that afternoon, an event
vividly amplified shortly thereafter by her
sister Florine, who almost immediately
decided to paint a picture of the party.
"It seemed very real, French, and classi-
cal," she noted about the party in her
diaries. "In my memory it has become a
classic. I am about to paint it and entitle
it *La Fête à Duchamp*. One more adver-
tisement for him added to the already
long list."[8]

Why she would have envisioned her
painting as an advertisement for
Duchamp is difficult to say, unless she
thought that whenever it was displayed,
more attention would be directed to this
French artist who—unlike herself—
seemed always to be in the public eye
(even though he personally shunned pub-
licity). At any rate, in the finished compo-
sition Duchamp appears three times: in
the upper left corner, arriving in Picabia's
speeding car as he waves to the crowd of
assembled guests; in the immediate fore-
ground, he appears again with Picabia,
still waving as he passes through a floral
entry arch to the yard; and, finally, he can
be seen rising from the left end of the
tables located in the roofed terrace
depicted at the top of the painting, his
hand raised in response to a toast being
proposed in his honor. It is interesting to
note that in this last appearance, Florine
Stettheimer has rendered the artist's
head at approximately the same level as

a circular Japanese lantern directly behind
him, resulting in silhouetting his profile
against a luminous orb, as if intended to
mimic the radiance of a halo, thereby
metaphorically elevating Duchamp to the
level of artistic sainthood.

Of course, the three Stettheimer sis-
ters were also in attendance: just above

the archway, the artist depicted herself in
the midst of an exchange with Albert
Gleizes, though she breaks away from
her conversation at the moment when
she notices the late arrival of the guest of
honor (Florine must have agreed with
her sister's opinion that Gleizes was "talk-
ative" and "long-winded"); in the center

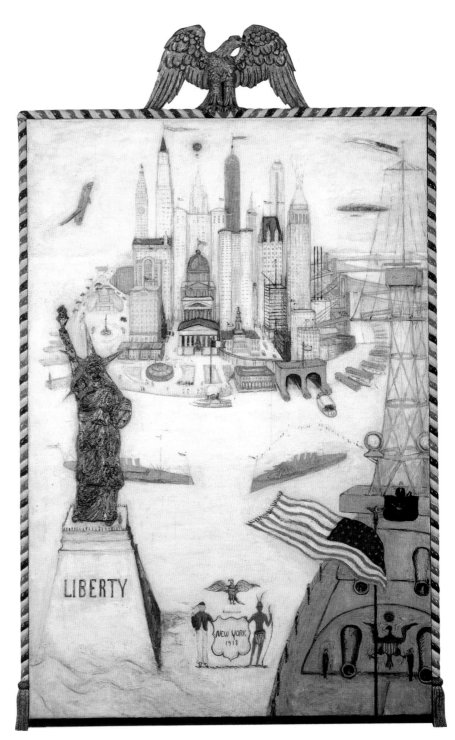

Florine Stettheimer. New York. *1918.*
Oil on canvas, 4' x 3'6" (without frame).
Collection William Kelly Simpson

151

of the picture, just beyond the refreshment table, Carrie can be seen serving tea to the Marquis de Buenavista (then Peruvian ambassador to the United States); while at the foot of the tree on the right, Ettie reads from a book while flanked by duplicate images of the critic and collector, Leo Stein (a man she thought brilliant, but simply too opinionated and argumentative for her liking).[9]

Others in the crowd include Elizabeth Duncan (sister of the famous dancer and well known for her own performances) and Carl Van Vechten, seated on lawn chairs in the center of the composition, while slightly behind them and to the right of the refreshment table, Avery Hopwood (a playwright who had known the Stettheimers in Europe) speaks to Juliette Roche. Finally, reclining on the foreground lawn are Picabia and Roché, the latter with his arms and legs spread against the ground, his head curiously facing down, directly into the grass. As in primitive paintings of the early Renaissance, figures are freely repeated within the same contiguous space, as if to indicate temporally removed, though sequentially related events within the same narrative context. In a similar fashion, all of the individuals represented in this scene are repeated again in the dining area, seated in places marked by place cards designed by Duchamp himself.[10]

When La Fête à Duchamp was shown at the Independents in 1918, the painter Abraham Walkowitz declared it to be the "most joyous" painting in the exhibition. When he relayed his opinion to Henry McBride, the critic agreed. Certainly he had known who Duchamp was, but when Walkowitz identified the other people in the picture and added that they were all "extremely well known in the most advanced Greenwich Village circles," McBride admitted with some embarrassment that he had never heard of the painting's creator. "Not to know the fair artist of the picture," he declared, "is to argue oneself unknown." He concluded his comments by expressing some regret in having missed the event. "The more I think of it," he said, "the more miffed I am that I wasn't asked to that party."[11]

It would not be long before McBride met the artist and, over the years, became one of the more frequent guests at their many parties and one of the most ardent defenders of her work. He was one of the first to classify her genre pictures as conversation pieces, although Duchamp preferred to call them simply "group pictures." As early as 1919, Duchamp wrote to the artist explaining why he thought this was the most appropriate term to describe her work:

"Group" is an excellent designation for the type of paintings that you have made. Group has nothing to do with the irksome [word] "composition" and is mobile, that is to say, instead of considering only the different situations colored or formulated on the canvas, one has to join [together] what the different points would give if they changed places, and a virtual multiplication through color adds to the mobility of these points. The whole is not left to the imagination but is regulated by optical necessities, common to nearly every individual.[12]

However these pictures are categorized, they remain among Florine Stettheimer's most original creations, particularly when their subject was not drawn exclusively from the relatively uneventful and sundry family gatherings. In a painting from 1918, for example, entitled New York—said to have been inspired by President Wilson's return from his travels through Europe after the war—the artist assumes a more objective and worldly view of current events, depicting the Statue of Liberty and the borough of Manhattan in full patriotic splendor. In contrast to many artists in this period who refused even to discuss the war, the Stettheimers made their patriotism known (though in a letter to a friend living in France during the war, Ettie admitted that "people here are rather amateurish about their politics").[13] When peace was announced in 1918, Duchamp wrote to the three sisters from Buenos Aires to tell them about the celebration that was taking place in the streets. "I can imagine what New York must be like now," he wrote, "even though I detest these demonstrations, I know that all of you like them and am happy that you are participating."[14]

New York assumes an aerial view of lower Manhattan, seen through flanking depictions of the Statue of Liberty (built up on the surface of the canvas with putty that was later gilded) and a large military vessel prominently displaying the American flag, which appears to be heading toward the East River. Other ships populate the harbor, while a biplane and zeppelin flank our view of the city in the central background, where we can see that several of its buildings are still under construction. Many of the structures are accurately portrayed and can be readily identified (though a number have been repositioned for fuller view): the Gothic tower of the Woolworth Building; the dome of the Custom House; the former U.S. Sub-Treasury Building, with the statue of George Washington clearly visible on the main steps; and towers of the Metropolitan Life, Bankers Trust, and Municipal buildings contribute to the impressive skyline, while all the major bridges crossing the East River are carefully accounted for. In addition to depicting cars and people on the street, Florine has also carefully recorded the old fort in Battery Park (by then the New York Aquarium), as well as the arched entries to the Municipal Ferry Piers, terminuses for the ferries that shuttled back and forth to the various islands in the harbor. Even Columbus Circle and Grant's Tomb have been conveniently relocated for this special view of Manhattan. Finally, at the base of the picture, Stettheimer has fancifully reconstructed the official seal of New York: two figures—presumably a Chinese immigrant and clearly a Native American—stand holding a plaque that provides the name of the picture, the whole surmounted by the national symbol of liberty, an American eagle—one of three in the work.

In addition to her group pictures and patriotic cityscapes, Florine Stettheimer excelled at portrait painting. She could capture the features of a given individual with uncanny accuracy, as in her Portrait of Marcel Duchamp, whose detached head floats against a radiant background, meant again, perhaps, to suggest his near-godlike stature among certain artists.[15]

And even though one of her most intimate friends speculated that Frans Hals might have been Stettheimer's favorite painter,[16] her portraits were never made with traditional objectives in mind. Rather, they were intended to capture a sense of the subject's complete psyche or persona, a feat most often accomplished by means of a highly personal symbolism, one that would have been recognized and understood only by those who knew the subject well.

In a subsequent, more ambitiously conceived *Portrait of Marcel Duchamp* (p. 154)—framed by a continuous frieze of letters made entirely from the artist's initials—Duchamp is shown comfortably seated in an armchair, on the side of which are portrayed American and French flags symbolically crossed and joined. Hovering above the artist and to the right is the personification of his female alter ego, Rrose Sélavy, who is presented in the form of a ghostly

apparition, dressed, appropriately enough (considering the meaning of "rose" in French), in pink. As Stettheimer sees him, Duchamp appears capable of controlling his body double, for he holds in his left hand a cranking mechanism attached to the base of Rrose Sélavy's stool, itself emanating from a flower in the floor and supported by an element the artist herself called "a silver-tin thin spiral."[17] Above Duchamp appears the head of a horse, detached and stylized into the Knight of a chess game. This playing piece is mysteriously positioned between two plates of glass, their surfaces etched with lines to resemble French windows, an allusion, perhaps, to Duchamp's *Fresh Widow*. In the center of the painting, midway between the artist and his alter ego, can be seen the image of a small clock. Is this a reference—as at least one person has suggested—to a chess clock, or could it have been intended to represent something far more profound within the

general symbolism of the picture? Could it, for example, have been meant as a cosmic clock, thereby referring to a higher dimension,[18] or was Florine Stettheimer simply trying to indicate that at given points in time, Duchamp's identity was capable of complete transformation?

Of the three Stettheimer sisters, Duchamp unquestionably formed the strongest attachment to Ettie, who, thirteen years his senior, was the most educated and intellectual of the group. She was, by her own admission, also the most overtly flirtatious. In her first novel, *Philosophy*—published in 1917 under the pseudonym Henrie Waste (from her full name: Henrietta Walter Stettheimer)—she tells the story of an American girl studying in Germany who falls in love with a boy named Taddeus. In what is little more than a thinly disguised autobiographical account, she writes a letter to this character explaining the reasons for her behavior. "I flirt to arouse feeling," she says, "irrespective of its nature, and in order to see something in the outside world happen through my instrumentality and thus to quicken my sense of power and of life." Later, in this same letter, she is even more explicit. "Sex is woman's instrument," she explains, "because she is its master and man its slave."[19]

There is considerable evidence that Ettie Stettheimer succeeded in establishing precisely such a relationship with at least two men, both younger than she and both handsome bachelors: the sculptor Elie Nadelman and Marcel Duchamp. The flirtation with Nadelman ended badly when he abruptly married another woman, but with Duchamp it continued for years. In fact, with Duchamp it went so far that just before leaving for Buenos Aires in 1918, he asked her at least three times to accompany him, and when she refused, he presented her with a gold guard ring (probably not meant, however, to be understood as a formal gesture of engagement).[20]

Her "affairs" with both Nadelman and Duchamp were given fictionalized treatment in *Love Days*, Stettheimer's second and last novel, published in 1923, again under the pseudonym Henrie Waste. In this book Duchamp appears as Pierre

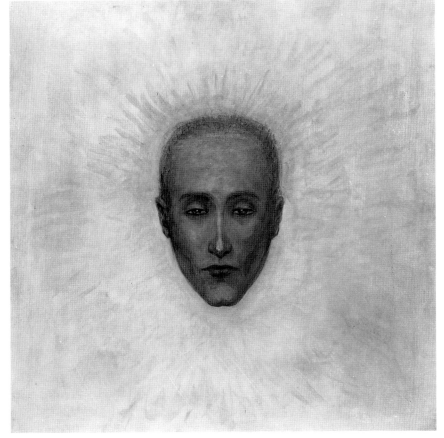

Florine Stettheimer. Portrait of Marcel Duchamp. c. 1923. Oil on canvas, 23 x 23". Gift from the Estate of Ettie and Florine Stettheimer, Museum of Fine Arts, Springfield, MA

Delaire, a French Cubist painter who, at one point, shows up unexpectedly at the apartment of Susanna Moore, the main character of the novel who is, of course, Ettie Stettheimer. Here, their relationship is portrayed as it probably really was, a kiss on the cheek followed by a warm exchange between two close friends who had not seen one another for quite some time. In one passage, she provides her readers with a remarkably insightful assessment of Duchamp's character and intellect:

She felt him pleasantly as a charming and rare creature, sensitive, delicate and with a rare polished finish. She knew him as set,

definitely set somehow, in character, and subtly eccentric in intellect, although she was unable to follow rationally his philosophy of complete rejection of what he conceived to be the trammels of convention,—and convention for him included all intellectual tools that had become masters: language and logic itself, and indeed all forms of culture that were past and yet potent.[21]

When Ettie sent Duchamp a copy of the book and asked for his opinion, he responded: "It's not for me to tell you if it is accurate or not—(You would claim not to have treated me kindly enough), and it is of secondary importance. But I suppose that you use Susanna as an incomplete or intentionally deceiving double so

that your real self becomes even more mysterious. What strange confessions would you write!"[22]

Unfortunately, we do not have an equivalent response from Nadelman, who was cast as a far more involved and serious lover in the book, but who ended up (as in real life?) abandoning her. Sadly, at the age of seventy-six, five years before her death, Ettie Stettheimer would express profound regret in never having allowed a serious relationship to be fully accepted or carried to fruition. "When a chance for true fulfillment in love came to her," she wrote of Susanna Moore, "she no longer had the wholeness to understand the character of this love and to receive it into her being."[23]

Even though he would remain largely in Paris during the next twenty years, Duchamp's friendship with the three Stettheimer sisters continued unabated, periodically renewed through correspondence or occasional visits to the United States. While it might be argued that the joint contribution of these three sisters to New York Dada was, at best, peripheral, the more eccentric aspects of Florine's paintings, and her adamant position against allowing them to be shown in a commercial context, are characteristics that amply justify her inclusion in this context.

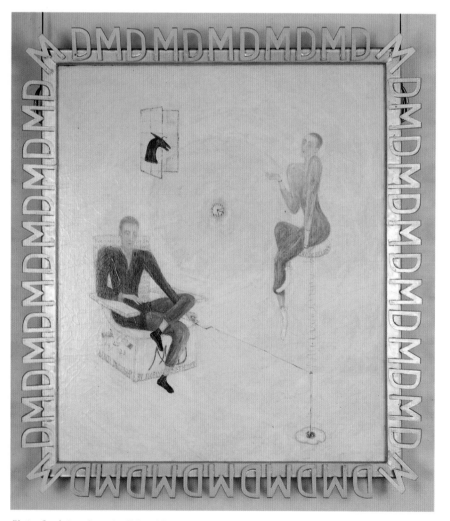

Florine Stettheimer. Portrait of Marcel Duchamp. *1923. Oil on canvas, 30 x 26" (including wooden frame with painted letters). Collection William Kelly Simpson*

KATHERINE DREIER

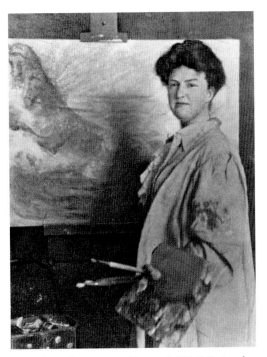

*Katherine Dreier. c. 1910. Photograph. Yale Collection of
American Literature, Beinecke Rare Book and Manuscript Library,
Yale University, New Haven*

In March 1920, Katherine Sophie Dreier, a forty-three-year-old artist and dedicated social activist, founded the Société Anonyme, Inc., the first museum in America devoted exclusively to the display and promotion of modern art. From the beginning, Dreier intended this museum to be a showcase for contemporary art, where at all times, there would be "on view a permanent exhibition of good examples of the so-called 'Modern Expression of Art.'"[1]

Many of the artists discussed here—Duchamp, Man Ray, Picabia, Gleizes, Crotti, Schamberg, Demuth, Covert, and Stella—were to be included in the exhibitions she assembled for this pioneering organization, some gaining their first exposure to New York audiences in the galleries of the Société Anonyme. In its

first year of operation, the museum succeeded in enlisting over eighty patron members, including some of New York's most prominent art world figures: Walter Arensberg, Marsden Hartley, the critics Henry McBride and Christian Brinton, the Stettheimer sisters, and the dealers Stephane Bourgeois, Charles Daniel, and Mitchell Kennerley (president of the Anderson Galleries, with whom Dreier was to establish the most successful working relationship).

When it finally came, Dreier's commitment to modern art was total and lasting, but she earlier spent many years in pursuit of a more academic approach to the study of art. The youngest of five children, she was born in 1877 to a family of wealthy German immigrants living in Brooklyn. She received her first artistic training from a private tutor at the age of twelve. Upon graduation from high school, she attended the Brooklyn Art School for two years, and in 1900, she enrolled in art classes at Pratt Institute, where her older sister Dorothea was also a student. Inspired by her family's long-standing commitment to social causes, in 1903—while still pursuing her art studies—she co-founded a settlement house for Italian immigrants in Brooklyn, and was named a director of the Manhattan Trade School for Girls. In 1914, Dreier successfully merged her interests in art with her commitment to social reform by establishing the Cooperative Mural Workshops, an organization modeled after a medieval guild system where participating artists were dedicated to serving the needs of society. Members were encouraged not only to paint murals, but to extend their aesthetic concerns to all aspects of the decorative arts.

In her own paintings of this period, it is clear that by 1914 Dreier had already absorbed the basic lessons of modern art. Over the previous four years, she rapidly evolved from the painting of landscapes inspired by Whistler to the execution of large decorative panels in bright colors, which incorporated a simplified figurative style reminiscent of Gauguin and lesser-known Post-Impressionists. As with a host of other American artists in

this period, Dreier's conversion to the cause of modern art was facilitated by her knowledge of recent European activities, most of which she had witnessed firsthand during frequent trips to France and Germany. As early as 1907–8, for example, she had seen paintings by Matisse, Picasso, and other modern French artists at the apartment of Gertrude Stein in Paris, but at first, she was too overwhelmed to comprehend their significance. "It was an esthetic shock," she later recalled: "like a douche of cold water it left one gasping."[2]

During the course of a trip to Germany in the spring of 1912, however, everything changed. In Cologne, she saw the famous Sonderbund exhibition of modern art (after which the Armory Show was modeled), where she was particularly impressed by the paintings of van Gogh, whose one hundred and twenty-five canvases dominated the exhibition. Her admiration for the Dutch artist was so great that she immediately purchased one of his pictures, and went to Holland to find out everything she could about this charismatic painter, who had committed suicide in relative obscurity some twenty years earlier. Here, joined by Dorothea, she painted a series of landscapes in a thick, impasto style reminiscent of van Gogh. And in her efforts to learn more about the artist, she sought out his sister, who had written a book of personal recollections about her brother. With her permission, Dreier promptly translated the text into English and arranged for publication in America.[3]

In February 1913, at the invitation of Arthur B. Davies (who had written the foreword to her book on van Gogh), two of Dreier's paintings and her recently acquired van Gogh portrait were included in the Armory Show, the exhibition that reaffirmed and subsequently solidified her commitment to modern art. At first, however, her own paintings lagged behind this resolution, a situation that was to change dramatically upon her meeting Marcel Duchamp, whose Cubo-Futurist rendition of a descending nude (p. 16) had created such a stir at the Armory Show. In the fall of 1916, John Covert invited Dreier to become a char-

ter member of the Society of Independent Artists, and it was probably at one of their meetings at the Arensberg apartment that she first encountered Duchamp.

Noting the striking differences in their personalities—Dreier: autocratic, opinionated, doctrinaire, domineering / Duchamp: reserved, soft-spoken, always tolerant and considerate—it may be difficult to understand how these two managed to establish such an immediate and long-lasting friendship. Certainly for Dreier, as her principal biographer has noted, Duchamp offered an entrée into avant-garde circles to which she would not otherwise have gained access.[4] And Duchamp must have recognized Dreier's unfailing commitment to modern art as a characteristic worthy of admiration in itself, even though when they met, she had collected primarily the work of German Expressionists, artists whose painterly and emotive style was antithetical to Duchamp's cool and intellectual approach to art.

Even though Dreier was some ten years older than Duchamp, and the Frenchman never exhibited anything more effusive than a genuine respect for his senior colleague, some have suspected that their relationship surpassed the bounds of mere friendship.[5] There can be no doubt that Dreier felt a special fascination with Duchamp—both as an artist and as a man—though there is evidence that she experienced considerable difficulty in comprehending either aspect of his complex persona. In 1917, for example, when Duchamp resigned from the Independents over the matter of R. Mutt's rejected urinal (which Dreier voted against showing), she wrote a long letter to Duchamp in an effort to explain her motives. "It is a rare combination to have originality of so high a grade as yours," she wrote, "combined with such strength of character and spiritual sensitiveness."[6] In this same letter, she admitted that the concept of a readymade as a "single object" was new to her, so at a meeting of the society's board of directors, she proposed that Duchamp be invited to present a lecture on his readymades (an offer he apparently declined).

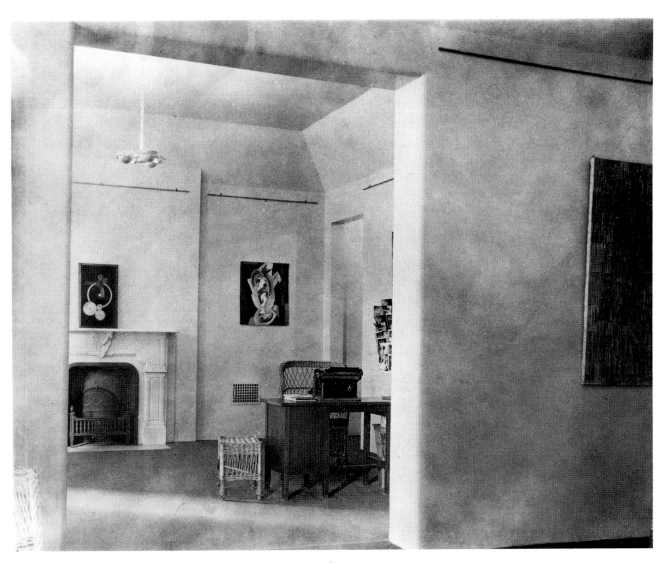

Installation view of the Société Anonyme Galleries. 1920.
Photograph by Man Ray. Studio Marconi, Milan

In a follow-up letter to William Glackens, who then served as president of the organization, she was explicit about her high regard for Duchamp. "I feel so conscious of Duchamp's brilliancy and originality," she wrote, "as well as my own limitation . . . but I have never questioned his absolute sincerity which would always make me want to listen to what he has to say. The very fact that he does not try to force his ideas on others but tries to let them develop truly along their own lines, is in essence the guarantee of his real bigness."[7]

It is in comments such as these that Dreier perhaps best reveals the underlying motives for her attraction to Duchamp. For years (in fact from childhood), she had been an advocate and

firm believer in the teachings of the Theosophical Society, an organization founded in the late nineteenth century that professed the existence of a deeper spiritual reality, one that could be achieved only by those in possession of higher psychic states, which either came naturally—as in the case of certain clairvoyants—or which could be attained by common individuals through years of dedicated study and meditation. In accordance with their beliefs, theosophists claimed that this special state of being came through a deepened spiritual knowledge, which could be garnered only from feelings transmitted physically through the senses. Rudolf Steiner, founder of the German Theosophical Society (for whom, due to her nationalis-

tic inclinations, Dreier must have felt a special affiliation), took these ideas one step further and claimed that one could derive a great deal of essential knowledge by "seeing"—by means of what he called "a thought-picture"—directly into the spiritual world already achieved by another. Steiner also believed that artists were uniquely equipped with the ability to "penetrate [the] spiritual basis [of color and form] with thought and feeling," whereby through the imagery an artist produces, he would be capable of exerting a "tremendous" influence on "all human evolution."[8]

In Kandinsky's well-known treatise on abstract painting, *Concerning the Spiritual in Art*, 1912, which Dreier probably read in its first published English translation in

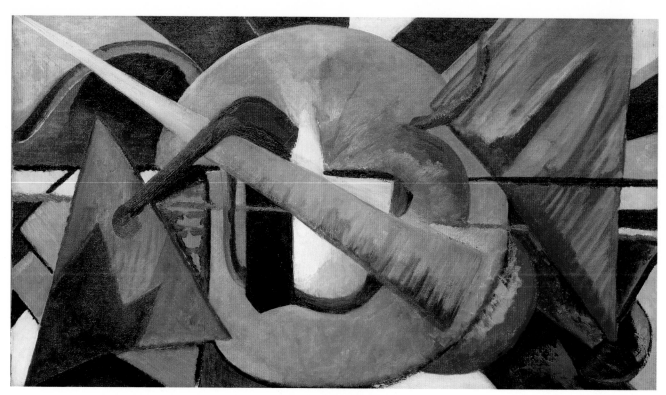

1914, the great Russian theorist (an avowed theosophist himself) carefully explains the structure of a spiritual triangle: "The life of the spirit may be graphically represented as a large acute-angled triangle," he writes, "divided horizontally into unequal parts, with the narrowest segment uppermost." He then goes on to explain that a single man stands at the apex of this triangle, a genius (like Beethoven) whom practically no one is capable of understanding, so the people "abuse" him, call him a "charlatan or madman." All segments of this triangle, he notes, are filled with artists who advance within the hierarchy of this triangle, presumably as they gain a greater spiritual awareness. Apparently, only a few of these artists are capable of comprehending the importance of the genius at the top. "He who can see beyond the limits of his own segment is a prophet and helps the advance." The ultimate goal, of course, is to attain unity with the figure at the top. "Everyone who immerses himself in the hidden internal treasures of his art is an enviable co-worker on the spiritual pyramid which will reach to heaven."[9]

The antimaterialist position implicit in all theosophical thinking is, of course, one that Dreier could not have failed but to perceive in Duchamp, who categorically dismissed both money and fame as goals, and whose art—particularly through the example of his readymades—made it abundantly clear that material gain was never to be construed as a motivating factor in the making of his art. Given Dreier's belief in theosophy, it is tempting to speculate that she might have regarded Duchamp as one who naturally, though unknowingly, possessed a heightened spiritual awareness, and perhaps, she might have felt that through his example, she too could come closer to achieving an enlightened spiritual state. As noted earlier, by 1917, she had already told him that he possessed a unique "spiritual sensitiveness," while at about the same time, she informed others of her own comparatively limited degree of intelligence and originality. The hierarchic relationship she establishes is one that is remarkably similar to that which exists between a Brahman and his people, a guru and his religious community, a mahatma and his students, or a clairvoyant and those seeking insight into the inner realities of the spiritual world.

It must have been feelings such as these that caused Dreier to seek every conceivable excuse to be in Duchamp's company, in New York or while traveling abroad. In 1918, for example, she commissioned him to paint a mural above the bookcase in her apartment (see pp. 48–49), and when Duchamp left for Buenos Aires in August 1918, she followed a few days later, ostensibly to research a series of articles on Argentine life. But the experience of a single woman traveling in South America was probably more than she had anticipated: "She [Miss Dreier] suffers from the city," Duchamp reported in a letter to the Arensbergs. "I mean to say that Buenos Aires does not accept unaccompanied women—It's senseless, the insolence and the stupidity of men here."[10] Upon her return, Dreier wrote and published a

book entitled *Five Months in the Argentine: From a Woman's Point of View*, the subtitle informing readers of its early feminist message.[11]

It was probably while living in Buenos Aires that she painted her *Abstract Portrait of Marcel Duchamp*, a long horizontal painting that approaches the exaggerated format of *Tu m'* (pp. 48–49) and whose internal components are vaguely reminiscent of the geometric forms in *To Be Looked At* (see p. 50), the small work on glass Duchamp completed in Buenos Aires and which he eventually gave to Dreier. Whereas these common formal elements were probably selected to serve the more recognizable functions of portraiture, it is enticing to speculate that the repetition of a prominent triangular shape on flanking ends of the composition—as well as, perhaps, the pointed, tapering conelike shape in the center—are elements that may have been incorporated as conscious allusions to specific theosophical beliefs, such as those described by Kandinsky.

Did Dreier see Duchamp as the genius at the top of this pyramid, and did she hope that through his example and tutelage, she too could eventually arrive at a similar position at the apex of a spiritual pyramid? Just six years before her death, Dreier wrote a passage about Duchamp for inclusion in a retrospective catalogue of the Société Anonyme, wherein she stated that "through his deep interest in philosophy he was always searching to give it expression through his art."[12] If the interpretation of her painting is correct, then the same could be said for Dreier, who, in her *Abstract Portrait of Marcel Duchamp*, has certainly found an expressive outlet for her own personal philosophy. For the same catalogue in which Dreier wrote about Duchamp, he would remember her primarily as a pioneer abstractionist, in terms that recall his portrait: "Katherine Dreier applied her own measure to a series of canvases in a delicate balancing of abstract forms and mellow colors. Geometric patterns and deep backgrounds interwoven in the general framing of the theme are the chief characteristics of her personal contribution to abstract painting," to which

Dreier appended, "best shown in her 'psychological portraits' as well as in her 'cosmological' interpretations."[13]

Few would have been able to guess that Dreier's theosophical beliefs formed the basis for her art. When her *Abstract Portrait of Marcel Duchamp* was shown in a group exhibition at the Société Anonyme a few years later, one critic failed to recognize anything within the image that he could relate to Duchamp's features, but he went on to provide an amusing description of the painting and, half-jokingly, suggested an intriguing identity for one particular detail:

Lacking the cult's optical lens, I am unable to see anything in the canvas beyond its yellow, jaundiced disk pierced by a grayish brown mottled cornucopia, with a long, pointed end shot from a tense blue funnel topped by a rim of deep red and orange. Said funnel—perhaps it is a miniature howitzer—is richly flanked with mottled brown patches, indicative to our untrained perception of liver complaint. Before the cornucopia wholly escapes the yellow jaundiced disk is caught in the embrace of a dark reddish bar not unlike the handle of a talking machine. Two generous patches of blue and white back up the handle. Are they Marcel Duchamps' [sic] liver or his soul? Search me![14]

Whereas Dreier, with her immersion in spirituality, would probably have taken offense at this critic's sarcastic assertion that an element within her painting might have been meant to represent a specific organ of Duchamp's, it is doubtful that she would have objected to his speculation that this same detail might have been intended to represent his soul.

In the summer of 1919, Dreier again sailed for Europe, where she was met in Rotterdam by Duchamp. In Paris, Duchamp and Roché accompanied her on a return visit to the Stein apartment, where this time she was better equipped to appreciate the works of modern art that surrounded her in every room. But it was inevitable that these two domineering women would strike discordant notes. "Not a success," Roché noted in his diary, "the shock of two heavy masses."[15] Duchamp even brought Dreier to meet his family in Rouen, and later introduced her to a host of Dada painters and

poets who then populated the many Parisian cafés. On a trip through Germany, she visited Herwarth Walden's Sturm gallery in Berlin, saw a Dada exhibition in Cologne, and also met Max Ernst.

Enthused by these firsthand contacts with the European avant-garde, she returned to America with the idea of opening the first permanent exhibition space in New York featuring an international display of modern art.

Following Duchamp's return to New York in January 1920, she called him to her apartment to discuss the idea. He arrived in the company of Man Ray, brought along, perhaps, to lend some levity to Dreier's ambitious project. Almost immediately, Man Ray lived up to expectation. When it came time to determine a name for the new museum, he promptly suggested Société Anonyme, a name he had seen in a French magazine and thought especially appropriate to the altruistic and self-effacing nature of the proposed organization. But when Duchamp explained that it was not possible to translate the term literally—as "anonymous society"—but rather that it was a French business term that carried essentially the same meaning as the American word "incorporated," everyone agreed that it was perfect. On April 29, 1920, the Société Anonyme was officially sanctioned by the state of New York, whereupon the redundant three letters "Inc." were legally appended to its name.

Shortly after the meeting, Dreier located a suitable space for the new museum in two rented rooms on the third floor of a brownstone at 19 East Forty-seventh Street, in a fashionable section of Manhattan just across the street from the Ritz Hotel. Duchamp was asked to serve as decorator, and Man Ray was asked to handle the lighting. The first exhibition—which included both European and American modernists—opened on April 30, 1920 (a day after the official incorporation). Henry McBride provided the most vivid and informed report of the gallery:

One must mount two steep flights of stairs and then pay 25 cents to obtain admission to the first exhibition of the Société Anonyme

. . . [which] has covered its walls with a pale bluish white oilcloth than which nothing could be purer, and tinted the fireplace and woodwork to match. The floor covering is of gray ribbed rubber. It seems to have been chosen for its quality of texture and color, and not at all with the idea of inspiring firmer foothold for tottering Academicians who drift into these precincts in search of ideas. . . . Then there are some nice wicker chairs, and some electroliers that are so astonishingly neat that they must be included in the works of art.

He goes on to say that his use of the term "neat" was not meant to be misleading, for he informs his readers that "the pictures are not the kind that Academicians permit their wives and daughters to see." He warns: "Danger lurks in this neatness."

From this preamble, McBride slides into a description of the works in the exhibition, reserving his most extensive comments for Duchamp's *To Be Looked At* (p. 50), whose complete title he mistakenly associates with a reemergence of narrative art, and Man Ray's *Lampshade* (see p. 90), which he confesses reminds him of an old piano lamp, a memory that sets him off on a nostalgic excursion of unrelated reminiscences drawn from his youth. In closing, he describes a Cubist work by Georges Ribemont-Dessaignes, still lifes by Jacques Villon and Patrick Henry Bruce, Brooklyn Bridges by James Daugherty and Joseph Stella, all of which he adds, "are framed in strips of lace paper."[16]

The lace paper was, of course, Duchamp's delicate touch, which to a certain measure, could be felt in nearly all of the Société's activities during its initial, 1920–21, gallery season. To outsiders, the museum presented itself as a genuine showcase for modern art, featuring everything from Cubism to Dada. In conjunction with the exhibition program, lectures were scheduled, one of which was devoted to answering the question: "What Is Dadaism?"[17]

Man Ray was asked to assist in the day-to-day operation of the museum. He also served as the organization's official cameraman (see p. 157), taking pictures of the works on display, which were made available for publicity purposes or printed as postcards and sold during the exhibitions. He also designed the Société Anonyme's banner, which hung from a flagpole over the street. But due to vast differences in their temperaments, he and Dreier never really hit it off. "If it hadn't been for Duchamp," he confessed years later, "Miss Dreier would never have accepted me as a collaborator."[18]

Dreier's regard for Man Ray was demonstrated on the evening when he was assigned to lecture at the Société Anonyme on the subject of modern art. As might have been expected, he showed up unprepared. According to his own account, he got the idea for his lecture only at the last minute, while riding the bus uptown to the gallery. Instead of telling his audience about modern art, he decided to tell them a story about a picture he had taken that mysteriously changed in the developing process. Although the crowd apparently enjoyed his fanciful narrative, Dreier did not. After he was finished, she took the podium and said she would continue the lecture, but announced that she would "now speak *seriously* on art."[19]

Dreier certainly understood the value humor played in the development of

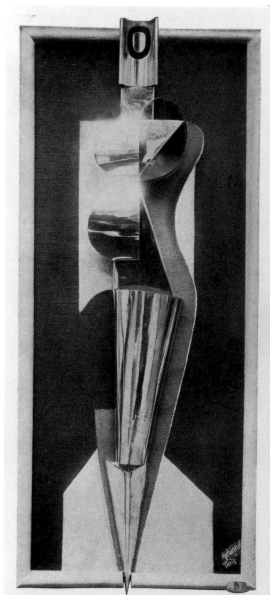

Marcel Duchamp (?). "Archie Pen Co." The Arts, *February–March 1921*

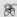

modern art. "We took as our emblem," she recalled years later, "the head of a laughing ass [designed by Duchamp] to show that we, too, could laugh at ourselves."[20] However, she took her proselytizing efforts so seriously that she was reluctant to tolerate anything that might jeopardize her mission. The Société's most successful tribute to humor came in *The Arts* magazine in the form of an advertisement for the Archie Pen Co., an obvious pun on Archipenko, the Russian sculptor whose works were then being shown at the Société Anonyme. Although the advertisement's designer is not identified, the editors provided the following statement: "This brilliant caricature of a modern machine advertisement is the work of an artist well-known in many fields who, unfortunately, objects to having his identity revealed." The artist "well-known in many fields" was, of course, Duchamp, whose identity can be detected behind every word in the accompanying text.[21]

According to this text, the new pen was capable of performing certain tasks on its own power. "An Archie Pen draws automatically a line of accurate length such as, for instance, the hypothenuse [*sic*] of a possible triangle in which the length of the two other sides is given arithmetically." The advertisement then goes on to say: "It thinks for you," which can only be taken as a specific reference to Dreier, whose mystical use of triangles and pyramids has already been well documented. In spite of these inside jokes, the accompanying illustration made the advertisement appear somewhat convincing, for it reproduced one of Archipenko's metal relief sculptures of a figure whose legs taper to a sharp point, the whole taking on the general appearance of an adventurously designed futuristic fountain pen.

How Dreier reacted to this advertisement is unknown. Certainly she did not understand the more profound implications of Duchamp's work. In *Western Art and the New Era*, for example, which appeared in 1923 (at the height of the Société Anonyme's most active period), she tried to explain that the value in Duchamp's readymades was a direct product of the artist's ability to make important aesthetic decisions when selecting his objects. "In selecting a common snow-shovel out of a variety of maybe sixty different ones he had looked at," she said, "he [Duchamp] laid emphasis on the one good design he found."[22] Apparently, she either was unaware of, or failed to understand Duchamp's theory of "aesthetic indifference," whereby readymades were chosen without any concern for their appearance, in a conscious effort to avoid the influence of good or bad taste.

In spite of her inability to fully understand the ideas of Duchamp, at a remarkably early stage in the development of modern art, Katherine Dreier was extraordinary in her ability to recognize and appreciate some of the most important artists of the twentieth century. It was, perhaps, only through the common denominator of her theosophical beliefs that she could place artists as disparate in their work as Kandinsky and Duchamp on the same aesthetic plane. As she expressed it in a lecture given in 1931: "All art must be a fusion of the emotions and the mind."[23]

ARTHUR CRAVAN AND MINA LOY

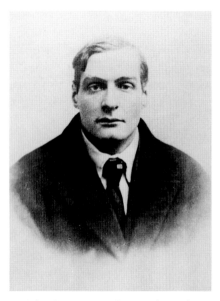

Arthur Cravan. c. 1917. Passport photograph.
Courtesy Roger Conover

Man Ray. Portrait (Mina Loy). *1920. Gelatin silver print*
mounted onto wood pulp paper. Image: 4 ⅛ x 3 ⅛".
The Menil Collection, Houston

In early 1916, a frenzied group of fight promoters gathered in Barcelona to organize what promised to be "a sensational encounter" between former world heavyweight champion Jack Johnson (the famous black American fighter who was living in Europe, a fugitive from his native land because of charges of having violated the Mann Act) and Arthur Cravan, an outspoken, notoriously eccentric Englishman, who claimed to be not only a professional fighter, but also the nephew of Oscar Wilde. Posters were hung throughout the city to publicize the event. In the controversial match, which took place at the Plaza de Toros Monumental on Sunday afternoon, April 23, we can safely surmise that Cravan fought true to form, that is, leading more with his mouth than with his fists. After six rounds of what must have amounted to little more than a skillful demonstration of shadow boxing—staged more for the benefit of a rolling camera than the disappointed crowd—Johnson finally dropped Cravan with an upper-right/left-

cross combination. Knockout or not, the audience smelled farce, and, because of the guaranteed fifty-thousand-peseta purse, the next day the daily press proclaimed the fight "The Great Swindle."[1]

For Johnson, it was just one more relatively uneventful "ring contest," as he called it, arranged for the benefit of his pocketbook. For Cravan, it was the main event in his tragically short life; two and one-half years later, at the age of thirty-one, he would disappear off the coast of Mexico, leaving behind only scant traces of a fascinating and adventurous life, one that stretched from the outback of Australia to the inner circle of vanguard artists and poets on both sides of the Atlantic. Far more significant than the footnote he left in pugilistic histories was the undying legacy of his outrageous behavior, which played a unique role within the development of an artistic and literary avant-garde. Arthur Cravan was, as Gabrielle Buffet-Picabia later asserted, "a man who personified, within himself and without premeditation, all the elements of surprise to be wished for by a demonstration that was not yet called 'Dada.'"[2]

Of Cravan's many claims, the one that has been proved beyond doubt is his relationship to Oscar Wilde; born Fabian Avenarius Lloyd in Lausanne, Switzerland, on May 22, 1887, Cravan was the son of Otho Holland Lloyd, whose sister, Constance Mary Lloyd, had married Oscar Wilde. Even though their relationship was not one bound by blood, something of the famous author's rebellious attitude toward conventional social practices seems to have filtered down to his nephew, who as a youth was thrown out of one school after the other for recalcitrant behavior. At the age of sixteen he took his first trip to America, where, after spending a few months in New York, he worked his way west. It was during this journey that he learned to box, a skill that he would employ repeatedly over the remaining years of his life, satisfying the needs of both sport and income.

Back in Europe, he would be expelled from one more school before settling in Berlin, where in 1904, a friend found him

a job as a driver for a sugar factory. But his nightly escapades with prostitutes eventually got him into trouble with the police, who banished him from the German capital. When he returned to Lausanne, his mother urged him to put into practice his childhood desire to become a writer, but Fabian (as he was still called) was not yet ready to settle down. He went to sea instead, taking a job as a fireman on a French ship, which he abandoned as soon as it reached Australia. By 1907 he was back in Lausanne, where he stayed with his brother, Otho, who was studying to become a painter. Two years later he was in Paris, where he decided to pursue the sport of boxing professionally. Doubtless he was possessed of a raw, natural talent: in 1909 he was ranked first in his division in the Amateur Boxing Championship of

Arthur Cravan vs. Jack Johnson. Fight poster. 1916. Private collection. Courtesy Roger Conover

France, and within a year, he would earn the title of Amateur Light-Heavyweight Champion of France.

It was also in 1909 that the twenty-two-year-old boxer wrote and published his first article, entitled "To Be or Not to Be . . . American." The essay, as its title suggests, outlines what it takes to be an American (outside of the obvious considerations of birth and residency). Because the article was devoted to the physical attributes and customs of American men, and because it was written by a boxer, it appeared, appropriately, in a Parisian sporting magazine. Based, seemingly, on what he had learned during his trip to the United States six years earlier, he provided a long list of the various traits required in assimilating the look of an American gentleman:

> Be a little above average size; be hairless; part your hair in the middle of your head; chew tobacco; spit in parlors; sit on your fingers; never speak; dance the jig; keep your money in your pocket, and not in your wallet; always watch your hat around the boss; greet people by touching your index finger to the rim of your hat; always give the impression of doing business; frequent bars and do not drink "American drinks"; hold women in contempt.[3]

It would not be long before this young writer's self-styled arrogance expanded its force and range in a more public arena. Apparently, before every boxing match, Arthur Cravan (he changed his name in 1911) made it a practice to stand up in his corner and scream out an endless series of dubious accolades, some of which, it should be noted, were perfectly legitimate claims: "hotel thief, muleteer, snake-charmer, chauffeur, ailurophile, grandson of the Queen's Chancellor, nephew of Oscar Wilde, sailor, gold prospector, poet with the shortest hair in the world."[4] It was also in this period that Cravan became an integral member of the Parisian café scene, which is where he probably met and made friends with some of the city's most important painters, poets, and art collectors: Paul Fort, Guillaume Apollinaire, Félix Fénéon, Robert and Sonia Delaunay, Blaise Cendrars, the collector André Level, and

the American painters Morgan Russell, Patrick Henry Bruce, and Arthur Burdett Frost, Jr. He was especially close to the Dutch-born Expressionist painter Kees van Dongen, whose spacious studio he used to stage a series of popular boxing demonstrations—exciting events that were attended by artists of every nationality and stylistic persuasion.

Cravan's skills as a vocal opponent and writer were combined with the interests of his literary and artistic acquaintances in a magazine called *Maintenant*, which he wrote in its entirety (sometimes under a pseudonym) and published in five numbers beginning in April 1912.[5] The magazine was sold by Cravan him-

Arthur Cravan. c. 1915. Photograph. Original reproduced in The Soil, *April 1917. Yale Collection of American Literature, Beinecke Rare Book and Manuscript Library, Yale University, New Haven*

self, who loaded copies into his wheelbarrow and peddled them from street corners all over Paris, wherever and whenever crowds assembled. At first, the review was used as a forum for his prose and poetry, as well as for the presentation of unpublished material on his uncle, Oscar Wilde. In one issue, he even claimed to have met recently with the famous author who, of course, by this time was already dead some thirteen years. Nevertheless, his account was so detailed and convincing that at least one American newspaper reporter believed it, and sent word back to his readers in New York: "Oscar Wilde is Alive!"[6]

The most scandalous issue of the magazine appeared in March 1914, and featured Cravan's vituperative review of the Salon des Indépendants. In his introduction, he made no effort to conceal his intentions. "If I write it is to infuriate my

colleagues," he admitted, "to make people talk about me and to try making a name for myself. With a name, you succeed with women and in business." He singled out the artists by national groups, writing a somewhat cryptic commentary about Americans, which he began by reporting their average height:

> *There are also young Americans of one meter ninety, happy in their shoulders, who know how to box and who come from lands watered by the Mississippi, where swim negroes with the snouts of hippopotami; from regions where beautiful girls with firm behinds ride horses; who come from New York full of skyscrapers, from New York on the banks of the Hudson where sleep torpedoes like heavy clouds. There are also fresh Americans, oh poor Skyscraper!!*

He then proceeded to attack systematically every artist in the exhibition, sparing none, not even his closest friends. Most ignored his commentary—knowing better than to take Cravan's insulting remarks seriously—but Apollinaire was naturally offended when he read what Cravan had to say about his mistress, Marie Laurencin. "Now there's one who would need to have her skirt lifted," Cravan wrote, and even though he admitted to not having seen her entry, he proceeded to dismiss her painting as painfully insignificant (an opinion echoed by many a modern critic). He ended his commentary with a disclaimer: "Not being able to defend myself in the press against the critics who hypocritically insinuated that I allied myself with either Apollinaire or with Marinetti, I should like to inform them that, if they begin again, I will twist their sexual parts."

In a poem published in the first issue of *Maintenant*, Cravan wrote: "New York! New York! I would like to inhabit you." And in the last issue, published in March 1915, he announced to his readers: "Halleluia! I will leave in 32 hours for America." But his plans were not destined for immediate fulfillment. Instead, with money earned by selling a Matisse and a Manuel Ortiz de Zarte—which he fraudulently represented as an early Cubist painting by Picasso—to André Level, he fled to Barcelona, avoiding

Johnson and Cravan—and their wives.
Reproduced in The Soil, *April 1917. Yale Collection of American Literature, Beinecke Rare Book and Manuscript Library, Yale University, New Haven*

possible conscription during the war. With his girlfriend, Renée, Cravan escaped to Spain with his brother, Otho, who was accompanied by his future wife, the Russian painter Olga Sacharoff. Soon they were joined by an international group of refugee artists: Serge Charchoune, van Dongen, Sonia Delaunay, Marie Laurencin and her new husband, the painter Otto von Wätjen. In May 1916, the Gleizeses arrived, followed in the late summer by the Picabias, both couples coming directly from sojourns in America.

Cravan had no intention of remaining in Barcelona; it was only a stopover, a place to make some money boxing before departing for America. "I cannot stay here," he wrote to Level shortly after his arrival. "I am going to leave, first for the Canary Islands, probably Las Palmas, and from there for America, for Brazil." In the event that his friend might question his motives, Cravan asks rhetorically: "What will I do there?" to which he immediately responds: "I can only reply that I will be going to see the butterflies." He goes on to explain that he despises Montparnasse, "where art only exists by theft, by deception, and by intrigue, where ardor is calculated, where

tenderness is replaced by syntax and the heart by reason and where not a single noble artist breathes and where a hundred people make a living by manipulating novelty."[7]

Eight months after his bout with Johnson, Cravan boarded the *Montserrat*, an old Spanish steamer headed for New York. In *391*, Picabia announced the boxer's departure: "Arthur Cravan has also taken the transatlantic. He will deliver lectures. Will he be dressed as a man of the world or a cow-boy? At the moment of departure he was inclined towards the second outfit and proposed to make an impressive entry on the scene: on horseback, and shooting three times at the chandeliers with a revolver."[8] Aboard ship, Cravan met Leon Trotsky, the Russian revolutionary whose political views had caused his recent expulsion from France. "The passengers were of varying types and, all in all, not very attractive," Trotsky recalled. "A boxer, who was also some sort of a writer and a cousin of Oscar Wilde, confessed frankly that he preferred crushing the jaws of the Yankee gentlemen in a noble sport to letting his ribs be broken by a German."[9]

Though it is doubtful he made the impressive entry predicted by Picabia, Cravan arrived in New York on January 13, 1917, where poverty and the need for a place to stay forced him to seek out some of the Americans he had known in

Paris before the war. "He was in very bad straits, without money," Gabrielle Buffet-Picabia recalled, "and was trailing along after more fortunate friends, especially the painter, [Arthur Burdett] Frost [Jr.]."[10] When the Picabias returned to New York in April, Cravan resumed his friendship with the couple and, probably through them, was introduced to Duchamp and the Arensbergs. His presence could not have come at a more opportune time, for the Independents were about to launch their first exhibition and, perhaps, because of his well-known attack on the Indépendants of Paris, Cravan was asked by Duchamp to lecture on "The Independent Artists of France and America" (an event designed for disaster; see chapter 7).

More people would have been drawn to Cravan's lecture because of his reputation as a boxer than because of his credentials in art criticism. About a month earlier, he had been interviewed on the subject of his fight with Johnson by the American art dealer Robert Coady, who published the account in his magazine, *The Soil*. Coady, a self-styled promoter for the establishment of an indigenous American art, had already known about Cravan and his controversial magazine, *Maintenant*. A month before Cravan arrived in America, Coady had published an English translation of Cravan's poem about wanting to inhabit America (quoted earlier), and it was Coady's Washington Square Gallery that Cravan gave as his forwarding address to friends and relatives before leaving for America.[11] Now that the Englishman was here in the flesh, Coady seized the opportunity to ask him about the famous bout. "How does he stand in the ring?" Coady asked. "His left droops a bit," responded Cravan, "and that is the hand he uses mostly, leaning on his right leg. He's a defensive fighter." Cravan then went on to speak about Johnson's personality; he clearly admired and emulated his notorious behavior. "Outside the ring he's a man of scandal—I like him for that— eccentric, he's lively, good-natured and gloriously vain." He concluded with a remark that must have pleased Coady. "After Poe, Whitman, Emerson, he is the

most glorious American. If there is a revolution here I shall fight to have him enthroned King of the United States."[12]

The article was accompanied by a photograph of Cravan seated on a Victorian divan, petting two exotic Siamese cats, his good looks and physical mass both clearly in evidence (p. 164). Coady also ran a press photograph of Johnson and Cravan in the ring, as well as a cartoon of the fighters in a friendly face-off, their respective "wives" rendered as small, doll-like figures: Cravan's with folded arms, as if to reinforce his own stand-off position, while Johnson's is shown safely within his protective grasp (a reference, perhaps, to the well-known fact that the black fighter was seen only in the company of white women whom he would need to shield from society's condemnation). It was probably this article and Cravan's highly publicized activities with the Independents that caused fight promoters in New York to learn of his presence. "I'll get him to work for me if it is possible," declared James Jitney Johnston. "Think of a man with that much bulk wasting his talents painting a little picture." [13]

On April 20, 1917, the day following his famous lecture at the Independents, Cravan attended a costume ball at the Grand Central Palace. When the dance was over, Cravan—who wore only a bedspread, his head wrapped in a towel—retired with several friends to the Arensberg apartment. It was here that he met Mina Loy, the beautiful and brilliant English poet whose writings had already won the praises of T. S. Eliot and Ezra Pound. At first, Loy reacted with indifference to the eccentric Englishman, for she had seen his photograph in *The Soil* and, because of "a certain sleekness" in the image, had mistaken Cravan for a homosexual. But upon their meeting, this impression was immediately dismissed. He was "not handsome," Loy recalled later, but looked "more like a farmer—a husband."[14]

Over the course of the next six months, Arthur Cravan and Mina Loy would develop a relationship to equal some of the most passionate love affairs in history. Loy was certainly prepared for

Mina Loy in her New York apartment, dressed for The Blindman's Ball, May 25, 1917. Private collection. Courtesy Roger Conover

such an encounter. Some fifteen years earlier, she had entered into a disastrous marriage with an English painter, Stephen Haweis, who, a few years after the birth of their third child, abandoned the entire family and—following the hedonistic precedent of Gauguin—went on an extended painting excursion to the South Sea Islands. Loy, who was then living in Italy, where she had been recently spurned in a love affair with the Futurist poet Filippo Tommaso Marinetti, pressed for a divorce from her estranged husband, and immediately made plans to come to New York. "Do you think there is a man in America one *could* love?"[15] she wrote to Carl Van Vechten, whom she had met in 1913 at one of Mabel Dodge's famous soirées at the Villa Curonia outside of Florence.

Van Vechten was one of the earliest to recognize Loy's talents as a poet, and it was he who introduced her writings to Walter Arensberg, who concurred. While she was still living in Europe, they arranged for the publication of her poems in the magazines *Rogue*, *Trend*, and *Others*. When she arrived in New York at the end of October 1916, her name was already well known to most members of the vanguard literary community. In a profile for *The Evening Sun*,

she was hailed as exemplary of the "modern woman," someone, the reporter noted, who "can tell why futurism is and where it came from." Described as a "lady [who] is always half way through the door into To-morrow," Loy, in words that might help to clarify her later attraction to Cravan's impulsive behavior, explained why she was aptly identified as modern: "The modern flings herself at life and lets herself feel what she does feel; then upon the very thick of the second she snatches the images of life that fly through the brain." The interview ends with her reasons for coming to New York: "No one who has not lived in New York has lived in the Modern world."[16]

Although reputed to be "difficult," Loy's poetry from this period can be safely classified among the most innovative and progressive verse produced during the second decade of this century. After reading examples of her poetry, and those of her rival, the American poet Marianne Moore, Ezra Pound felt their verse was so completely different from anything he had known before, that he promptly invented a new word to describe it: *"logopoeia,"* which he said was a form of "poetry that is akin to nothing but language."[17]

To most, Loy's language was utterly incomprehensible, a problem compounded by her insistence upon eliminating all commas and other speech-generated

directives of punctuation. Moreover, in the first poem to appear in *Others*—"Love Songs," a verse divided into four parts (later expanded to thirty-four separate poems)—she shocked her audience by addressing a subject that was considered taboo within the constraints of proper poetry. Two verses are sufficient to provide an example of what the puritanical American public found most offensive:

> *We might have coupled*
> *In the bed-ridden monopoly of a moment*
> *Or broken flesh with one another*
> *At the profane communion table*
> *Where wine is spilled on promiscuous lips*
>
> *We might have given birth to a butterfly*
> *With the daily news*
> *Printed in blood on its wings. . . .*[18]

It is ironic, although certainly coincidental, that Loy speaks of giving "birth to a butterfly" at approximately the same time when Cravan wrote to a friend in Paris and said that he was going to America in order "to see the butterflies." It is tempting to conclude that these two highly diverse, yet near-complementary English personalities were destined—at least on a cosmic level—to meet and conjoin.

Their courtship was not, however, a smooth and gradual transition from infatuation to love. Cravan seems to have resisted a potential loss of his independence (girls of all types willingly clung to his powerful arms), and through a series of rejected advances, Loy made the boxer's conquest a real struggle. They probably attended The Blindman's Ball together, where Loy went dressed as a lampshade, a costume that would have been immediately recognized by those who knew the poet well, for in addition to her writings, she was also known for her vibrant and innovative decorated lampshades (to the Independents, she submitted a painting entitled *Making Lampshades* [now lost]). Exactly what transpired between the two that evening is unknown, but we do know that after the ball, Loy went to the Arensberg apartment and—without Cravan—spent the night with four other friends sleeping in Duchamp's bed (an event memorably

recorded in a sketch by Beatrice Wood; p. 116).

By the summer, they were madly in love. At first, marriage seems to have been out of the question, for Mina Loy was still legally married (her divorce from her first husband would not come through until October), and Cravan's resistance to convention caused him to pursue the potential for a more adventurous life. In September 1917, he and Arthur Burdett Frost put on soldier's uniforms and hitchhiked to Newfoundland, with the idea of boarding a ship for Mexico. Frost, however, fell seriously ill and died just before they were supposed to leave. Cravan continued on his travels, finally arriving in Mexico on December 18, 1917. He wrote to Mina Loy nearly every day, pouring out his heart in a series of letters and postcards imploring her to drop everything and join him in Mexico. "I miss you . . . I love you . . . I can't live without you . . . send a lock of your hair or, better yet, come with all of your hair." Some letters even carried messages of desperation. "Shoot off a telegram with the word goodbye, if you want, and five minutes after getting it I will be dead."[19] He wrote with plans of taking her to Buenos Aires, and he asked her to pass on his salutations to a number of friends back in New York, particularly Walter Arensberg. Apparently, at one point, the collector must have sent Cravan some money, for he wrote to Loy: "Don't forget to tell Walter that I appreciated his kindness and I shall never forget it."[20]

His letters must have been convincing, for Mina Loy arrived in Mexico City just after January 1, 1918, and a few days later, they were married.

Little is known of the year they spent together in Mexico, except to say that Cravan tried again to earn a living by exercising his pugilistic skills. He sent telegrams to Jack Johnson asking him to come to Mexico, but Johnson responded by asking for five thousand pesetas and three first-class tickets to Veracruz, something Cravan could not afford.[21] So in September 1918, he arranged for a fight with Black Diamond Jim Smith, which he lost by knockout in the second round. In

view of his tendency of boasting before a fight, the humiliation must have been more than he could endure. So in November or December, he and Mina decided to leave for Buenos Aires. By then, Mina Loy was pregnant, so it was arranged for her to book passage on a sanitary Japanese vessel passing through Veracruz. Cravan was to find a less expensive mode of travel and join her a few weeks later in Buenos Aires. He was never heard from again.

Mina Loy spent the next month searching everywhere for her lost husband. Duchamp was in Buenos Aires at the time, and the Arensbergs wrote and asked if he had seen the couple. "No, I haven't seen Mina and Cravan," he responded. "I would be very surprised if they were here and I didn't run into them."[22] He never would, for after a frantic search, Mina Loy finally gave up and boarded a steamer for England.

There, in the spring of 1919, she gave birth to Fabienne, Cravan's only child, a beautiful baby girl who would grow up to resemble her father strongly. A year later, Mina Loy returned to New York, hoping to learn that her husband was somehow still alive. There, she rejoined the bohemian literary set in Greenwich Village, and again established contact with some of the artists whom she had met during her last trip to New York. It was at this time that she posed for Man Ray's camera, a session that resulted in a striking profile portrait in which she wears a thermometer as an earring. Exactly what the photographer might have intended through the prominent display of this unusual accessory is unknown; it might have been nothing more than a casual reference to his own use of a thermometer in the darkroom, or it could have been a subtle reference to Loy's ever-changing mood over the loss of her husband (just as Man Ray used a similar device in referring to Katherine Dreier's oscillating temperament; see p. 90).

Unfortunately, Mina Loy was not successful in her search for Cravan. His fighting days were over, but in literary and artistic circles, his reputation would soon attain the status of legend. He would not be forgotten.

BARONESS
ELSA VON FREYTAG-LORINGHOVEN

*Baroness Elsa von Freytag-Loringhoven. 1920.
Photograph by Man Ray. University of Maryland
at College Park Libraries. Special Collections*

In 1920, the Baroness Elsa von Freytag-Loringhoven was identified as the living embodiment of Dada. "Paris has had *Dada* for five years," noted John Rodker in *The Little Review* (the first magazine to publish her poetry), "and we have had Elsa von Freytag-Loringhoven for quite two years." Rodker considered her a critical link between the American and European avant-garde. "In Elsa von Freytag-Loringhoven," he wrote, "Paris is mystically united [with] New York." And

two years later, the same journal proclaimed her to be "the first American dada . . . she is the only one living anywhere who dresses dada, loves dada, lives dada."[1]

From 1918 through 1923, the Baroness was a frequent and memorable sight walking along the streets of Greenwich Village, where artists went to seek her out when they needed a model willing to pose entirely in the nude. Few who caught a glimpse of this unusual character

ever forgot her. What she put on her head alone was enough to engrave her curious countenance permanently in memory. "She wore the lid of a coal scuttle," one person remembered, "strapped under her chin like a helmet." Someone else saw her in a hat "tastefully but inconspicuously trimmed with gilded carrots, beets and other vegetables," while another said she was once seen wearing an inverted wastepaper basket, "with a simple but effective garnishing of parsley." Others saw her "wearing a peach basket for a hat," and yet others claimed she usually wore "a French Poilu's blue trench helmet." But her headdress was most memorable when she wore none at all; she was often seen on the streets with her scalp clean shaven and painted purple! (The latter, it turns out, was not a fashion statement, but rather a cure for a common fungous infection: ringworm.)[2]

The Baroness's eccentricities of dress —which she preferred to call "fanciful artistic clothes"—did not stop with headgear. She wore black lipstick, stuck canceled postage stamps to her cheeks, and sported "a wooden bird cage around her neck housing a live canary." On one arm—strung from wrist to shoulder— she wore bracelets of "celluloid curtain rings," reportedly stolen from a department store. The hem of one skirt was decorated with horse blanket pins, and she often felt compelled to "improve" upon the design of her dresses. On one, she attached "some sixty to eighty lead, tin or cast iron toys: dolls, soldiers, automobiles, locomotives and music boxes" (also said to have been stolen), while to the bustle of another dress, she affixed "an electric battery tail light." When the artist Louis Bouché asked her why she wore it, she responded logically: "Cars and bicycles have tail lights. Why not I? Also, people won't bump into me in the dark."

Nearly every exchange in which she was involved ended either in confusion or in anger. During the war years in New York, she had been arrested several times for trying to bathe in public pools. "She leaped from patrol wagons with such agility that policemen let her go in admiration," recalled Margaret Anderson

(with Jane Heap, founder and editor of *The Little Review*). Eventually the Baroness found work in a cigarette factory, where, in an argument with a fellow worker, she lost two of her teeth. Once she attended a party held in honor of a famous opera singer, who told the Baroness she sang only for humanity. "I wouldn't lift my leg for humanity," the Baroness reportedly quipped, whereupon she was quickly shown the door. One afternoon she attended an art opening held at a fashionable New York department store, only to rearrange the pictures, hanging some at angles, others upside down, while a few she particularly disliked were even removed from the wall and placed face down on the carpet. She felt that in their hanging of modern art, they "had achieved the uninspired symmetry of a parking lot." At a costume ball at Webster Hall, this prankster "wouldn't get off the stage until she was given a prize."[3]

Before she entered into vanguard artistic circles in New York, the Baroness had led a colorful, though tragic life in her native Germany.[4] Born Elsa Hildegard Ploetz in the northern German town of Swinemünde in 1874, she was the daughter of a prosperous, middle-class businessman, and her mother, according to her recollections, was a gifted musician who died of cancer of the uterus when her children (Elsa was the elder of two daughters) were still teenagers. Her father quickly remarried, taking a woman whose bourgeois background Elsa despised. So at the age of eighteen, she ran away, settling in Berlin where she lived with an aunt who, almost immediately, grew impatient with the girl's sexual awakening. "I had become mansick up to my ear tips," she recalled. "No," she emphasized, "over the top of my head, permeating my brain, stabbing out my eyeballs." As a result of this newfound obsession, her aunt eventually threw Elsa out of her home and onto the streets of Berlin. "Now I began to know what 'life' meant," the Baroness recalled, "every night another man."

Over the course of the next five years, she studied acting and took a job as a chorus girl in order to support herself. In

1896, she entered into an affair with the well-known Jugendstil artist Melchior Lechter, and through him, she was introduced to an important circle of German painters and poets. In 1898, she lived with the painter Richard Schmitz for a brief period in Italy, where, without any formal artistic training, she also began painting. "She was a tall, slim blond with a perfectly shaped body," recalled Schmitz's brother, Oskar, who also knew her in this period. "Her stare was ice-cold, her eyes light-green in color . . . her wheat yellow hair worn in the austere style of the early Renaissance." Oskar also reported that

Man Ray. Standing Figure in Female Attire [Baroness Elsa von Freytag-Loringhoven]. *1920. Gelatin silver print, 4 5/8 x 3 7/16". The J. Paul Getty Museum, Malibu*

she had forced her way into the gallery of pornographic antiquities from Pompeii and Herculaneum at the National Museum in Naples (a room then closed to women), where she became especially entranced by the phallic images on decorative oil lamps.[5]

It was in this period that the Baroness first entertained the idea of earning a living through art, and with this objective in mind, she returned to Germany and entered into an apprenticeship with an applied artist working in Munich. Through him, she met August Endell, a self-taught German architect whom, in 1901, she married—not for love, as she recalled, but out of a desire to try the

"famed state" of matrimony. Endell had already gained a considerable reputation as a decorator, having designed a sweeping plaster relief for the façade of the Atelier Elvira, a photography studio in Munich (now destroyed). Committed to the ideals of the German Arts and Crafts movement, Endell was equally known for his writings, which have been recognized today as highly influential texts for the development of abstract art.[6] Important though he may have been in the history of German art, his marriage to Elsa was a disaster, for according to her, he was impotent, leaving her sexually unfulfilled and still in search of a lover.

Shortly after she married Endell, she found one: Felix Paul Greve, a young German translator and friend of Endell's who years later—after changing his name and identity—became a well-known novelist. This was Elsa's first mature love, a relationship that sustained mutual infidelities and lasted some ten years. At first, if nothing else, their affair was sexually satisfying. "I had only one god," she wrote, whether "in attendance or not . . . that was *passion.*" Eventually she discovered that like her husband, Greve, too, was undemonstrative, and not only frowned on a public display of affection, but even tried to prevent her from expressing emotion. These difficulties were compounded by financial problems, and when Greve was unable to pay a debt, he was imprisoned for a year. Upon his release, he published his first novel, *Fanny Essler* (1905), the heroine based, in part, on Elsa. Finding it increasingly difficult to earn a living as an author, Greve longed to try his luck in America. In 1909, he staged a fake suicide and left with Elsa for the United States, settling on a farm in Kentucky. Their relationship deteriorated, and within a year, he left her. She never saw him again.[7]

By 1912, Greve settled in Canada, where he had changed his name to Frederick Philip Grove, married, became a father, took a job as a teacher, wrote more novels, and went on to become one of Canada's most distinguished writers.[8] Elsa tried her hand at the theater in Cincinnati and, by 1913, made her way to New York. There she met and married

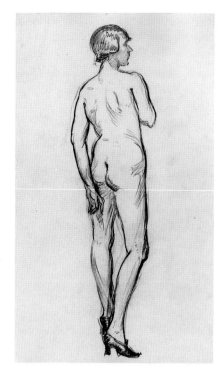

Theresa Bernstein. The Baroness. *c. 1916. Pencil on paper, 9 ¾ x 6 ⅞". Private collection, New York*

Baron Leopold von Freytag-Loringhoven, a young German some ten years her junior. For a short time, we are told, they lived in splendor at the Ritz Hotel.

Unfortunately, little is known about the Baron. He came from a distinguished German family whose origins can be traced to the Baltic countries in the fifteenth century. He had entered the Prussian army at a very early age, but because of mounting personal debts, he was forced to take a leave of absence from his military career to seek more gainful employment. With support from his father, he left for America. When the war broke out in 1914, he boarded a ship for return passage to Germany. But his ship was captured by the French, and the Baron was arrested, sent to Brest and imprisoned for the duration of the war. After nearly four years of internment, and just a few months before peace was declared, he committed suicide in his jail cell, an act the Baroness later characterized as "the bravest of his life."[9]

With no source of income, the Baroness was forced to sleep on park benches, often in the company of a sailor she had met earlier in the day. Eventually, she gravitated to Greenwich Village, where she tried making money by offer-

ing her services as an artist's model. "She had the body of a Greek ephebe," George Biddle recalled, "with small firm breasts, narrow hips and long smooth shanks." In 1921, Biddle prepared a lithographic stone with multiple renditions of the Baroness's angular features (p. 173), her Teutonic, almost androgynous physiognomy clearly in evidence. Over the years, she posed for Robert Henri, George Bellows, William Glackens, Louis Bouché, and others. "When I started posing," she recalled a few years later, "I took the hardest poses—nobody would have dared to ask and keep them— because I had given myself my word not to stop—unless I should break down— for ambition and curiosity—to *test my strength.*"[10]

She also posed for the young Theresa Bernstein, who applied her remarkable abilities as a draftsman to record the model's androgynous figure. Most artists claimed the Baroness was a delight to sketch, particularly her back, which they found especially well-defined and muscular. As the writer Claude McKay explained, her back was "a natural work of art." McKay also recalled the Baroness herself describing this special feature of her anatomy, speaking in her usual mixed German-English dialect: "*Mein* features not same, schön, but *mein* back, *gut*. The artists love to paint it."[11]

Bernstein, who also made some impressive paintings of the Baroness, said she was always being arrested for shoplifting. Once, when she was jailed for having stolen a pair of silver earrings, she asked Bernstein to go over to her studio and feed her parrot. Apparently, the Baroness loved animals, and her apartment was filled with dogs and cats she picked up off the streets. "It [her studio] was crowded and reeking with the strange relics which she had purloined over a period of years from the New York gutters," Biddle remembered. "Old bits of ironware, automobile tires, gilded vegetables, a dozen starved dogs, celluloid paintings, ash cans, every conceivable horror, which to her tortured, yet highly sensitized perception, became objects of formal beauty."[12] Indeed, the Baroness seems to have been born with a natural

penchant for the found object, a tendency that might have found aesthetic reinforcement through the readymades of Duchamp, an artist for whom she developed an unrequited amorous longing.

"She had a passion for Marcel Duchamp," recalled Bouché. "One day I brought her a clipping of Duchamp's 'Nude Descending the Stairs.' She was all joy, took the clipping and gave herself a rub down with it, missing no part of her anatomy. The climax was a poem she had composed for Duchamp. It went, 'Marcel, Marcel, I love you like Hell, Marcel.' " That Duchamp's concept of the readymade might have found application in the Baroness's creative endeavors is evidenced by her contribution to the making of *God*, the plumbing trap inverted in a miter box usually attributed to Morton Schamberg (p. 172). The use of found objects without alteration, however, and the assembly's sacrilegious title

Baroness Elsa von Freytag-Loringhoven. Portrait of Marcel Duchamp. *c. 1919. Pastel and collage, 12 ³⁄₁₆ x 18 ¹⁄₈". Collection Arturo Schwarz, Milan*

are both qualities more easily associated with the unusual and outlandish penchants of the Baroness than with the sleek machinist aesthetic of Schamberg (who is probably responsible only for taking the photograph; see p. 129).

Using objects found strewn about her studio, the Baroness made two impressive portraits of Marcel Duchamp: the first a collage colored with pastel and crayon showing the artist smiling as he puffs away on his pipe, the twisted wheel of a bicycle to one side of his head and, directly below it, a chess piece. The second (p. 174) is made entirely of found objects: feathers, a ring, a detached gear and wound-up clock spring, a long metal coil surmounted by a fishing lure, the whole supported within a wine glass, the resultant assemblage looking less like a portrait than a trophy (intended, perhaps, as the Baroness envisioned it, for "Most Inventive Artist of the Year").

In addition to these portraits, the Baroness also paid tribute to the various objects of her affection in poetry, a pursuit she had practiced in earnest since

childhood. "Love—Chemical Relationship," for example, was dedicated to Duchamp, as she made clear in the declaration following its title: "un enfant français: Marcel (a Futurist), ein deutsches Kind: Elsa (a future Futurist)." Although the poem resorts to no rhyme and little reason, parts are composed as unmistakable references to the artist and his work:

> *Everything now is glass—motionless!*
> *THAT WAS IT THOU DIS-*
> *COVERDST—AND WHICH IS*
> *GIVEN TO THEE*
> *AFTER THINE DEATH—MARCEL!*
>
>
>
> *Thou now livest motionless in a mirror!*
> *Everything is a mirage in thee—thine world*
> *is glass—glassy!*
> *Glassy are thine ears—thine hands—thine*
> *feet and thine face.*
> *Of glass are the poplars and the sun.*
>
> *Unity—Einklang—harmony—*
> *Zweifellosigkeit!*
> *Thou art resurrected—hast won—livest—*
> *art dead!*
> *BUT I LOVE THEE LIKE BEFORE.*
> *BECAUSE I AM FAT YELLOW CLAY!*

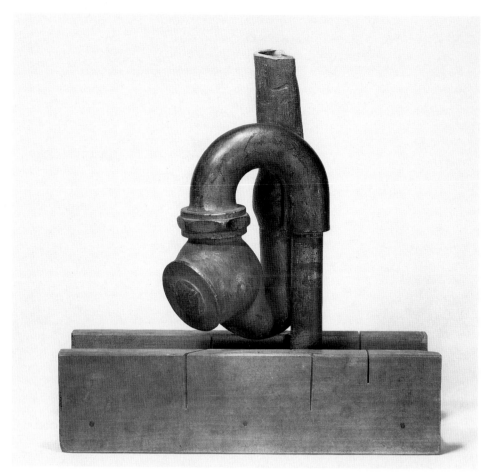

Baroness Elsa von Freytag-Loringhoven, with the collaboration of Morton Schamberg. God. 1917. Wood miter box and cast-iron plumbing trap, 10 ¹/₂ x 11 ⁵/₈ x 4″. *Philadelphia Museum of Art. The Louise and Walter Arensberg Collection*

Both this poem and her object-portrait of Duchamp were published in the *The Little Review*, the highly respected literary magazine that had moved from Chicago to New York in 1917.[13] Margaret Anderson recalled the Baroness's appearance when she first showed up—unannounced—in the magazine's office on West Fourteenth Street: "She wore high white spats with a band of decorative furniture braid around the top. Hanging from her bust were two tea-balls from which the nickel had worn away. On her head was a black velvet tam o'shanter with a feather and several spoons—long ice-cream-soda spoons. She had enormous earrings of tarnished silver and on her hands were many rings, on the little finger high peasant buttons filled with shot. Her hair was the color of a bay horse." When one of the magazine's writers said that a poem she had submitted was "beautiful," the Baroness

responded: "Yes, it is." Before leaving, she proclaimed *The Little Review* "the only magazine of art that is art," and promptly left, stealing a sheet of two-cent stamps on her way out.[14]

During the years of her association with *The Little Review*, both Jane Heap and Margaret Anderson were inundated with long and rambling missives from the Baroness, most of which contained pleas to help relieve her depressed financial state. In a number of these letters, she openly reveals her motives for writing. "How I hate myself," she wrote, "that I *always* have to write for my loneliness." Pathologically self-deprecating, she added: "I look in the mirror and see a nylected [*sic*] dispirited left over old woman!" On several occasions, she complained about the paucity of available men in New York, confessing once: "*Marcel* is the *man* I *want*." At times, she could be genuinely insulting, even to those from whom she

Baroness Elsa von Freytag-Loringhoven. c. 1920. Photograph by Man Ray. Reproduced in The Little Review, *September–December 1920*

sought assistance. When she asked Heap and Anderson to look at a work she made that Duchamp found of exceptional merit, she wrote: "He [Duchamp] was fascinated—but he is *real*—you are fantoms [*sic*]." [15]

In her letters to the editors of *The Little Review*, she repeatedly tried to rationalize why people treated her so badly, and why Duchamp, who accepted ordinary artifacts for what they were, was in a unique position to accept her for what she was. "M'ars," as she called him, "came to *this country*—protected—carried by fame—to use its plumbing fixtures—mechanical comforts—so he takes you as you *are!*" At one point, Jane Heap tried to explain Duchamp's attitude toward the Baroness, only to have her react by composing a fourteen-page letter outlining her feelings about Duchamp and condemning followers. "He is worthwhile," she wrote. "And all of Marcel's proteges are *clever fakers*—*shitarses*—*prestidigitators*." She was especially critical of Joseph Stella. "The man's very stupidity, his grossness—his *cheap* incessant *industry*, his conceit—his absence of refinement . . . the Americanism of Stella—tickles Marcel, that is it!"

Djuna Barnes, an occasional contributor to *The Little Review* and one of the Baroness's most dedicated supporters, remembered that in these years, Elsa lived in a subbasement apartment on West Eighteenth Street, a small space that she shared with bugs, rats, and her faithful dog. She lived in abject poverty, relying upon the generosity of a delivery boy to bring her extra loaves of bread from the bakery where he worked. She was known to have tried dancing in restaurants for a free meal, only to be ridiculed and taken as insane by the horrified clientele. Once, while strolling through Greenwich Village, she was mugged by a band of thugs who tore off her rings and earrings, mistaking the costume jewelry she pilfered from Woolworth's to be genuine.

Apparently, she delighted in her own eccentricities. Barnes recalls that she liked to draw obscenities on the verso of envelopes, a practice that almost landed her in jail, and she made a plaster cast of

a penis that she showed to all the "old maids" she came into contact with. The Baroness's only reliable source of income came from petty theft, shoving whatever she could under her coat or into her pockets for a quick trip to the local pawnbroker. Eventually, she even decided that her talents were being exploited by *The Little Review*, so she took letters out of their mailbox in order to steal cash from an occasional subscription. [16]

When William Carlos Williams saw the Baroness's object-portrait of Duchamp in the offices of *The Little Review* (p. 174), he inquired about its creator, only to be informed that the artist—who was said to be crazy—was a great admirer of his writing. He couldn't get her out of his mind, so back at his home in Rutherford, New Jersey, he wrote to the editors of the magazine requesting to be introduced to this curious creature. He learned that she had been imprisoned for stealing an umbrella, so on the day of her release, he arranged a meeting. "She talked and he listened," Williams wrote of this encounter two years later, "till their heads melted together and went up in a vermillion balloon through the ceiling drawing Europe and America after them." A few days

later, Williams paid a visit to her studio. "She lived in the most unspeakably filthy tenement in the city," he recalled. "Romantically, mystically dirty, of grimy walls, dark, gaslit halls and narrow stairs, it smelt of black waterclosets, one to a floor, with low gasflame always burning and torn newspapers trodden in the wet. Waves of stench thickened on each landing as one moved up." [17]

When Williams's first book appeared in 1920, the Baroness took it upon herself to write a lengthy review. She submitted her article to Anderson at *The Little Review*, who proceeded to edit out the repetitions, only to be greeted by a violent protest from its author, who insisted that the piece be published in its entirety. Anderson, who considered it "one of the most intelligent pieces of criticism" ever submitted to the magazine, agreed, and published the essay—or, more accurately, the extended prose piece—in two parts, the second of which had to be printed in reduced type to save space. [18]

In a gesture he would live to regret, Williams wrote a note to the Baroness saying that he loved her. She quickly misinterpreted his intentions and, when they next met, asked him for a kiss. Williams complied, reluctantly, whereupon she

George Biddle. The Baroness Elsa von Freytag-Loringhoven. *1921. Lithograph, sheet: 14 1/8 x 17 7/16"; image: 10 x 13 5/16"*

immediately proposed they make love, transferring her syphilis infection to him so that in the future, she said, he could "free his mind for serious art." That was more than Williams could tolerate, so he left. But the Baroness did not give up, firing off one letter after another, threatening to make his earlier pronouncements of affection public. Williams invited her to do so, whereupon in frustration, when they next met she struck him against the side of the neck. He, in turn, bought a punching bag and practiced for a future encounter, which came

in due course. This time he flattened her, putting to an end, once and for all, her romantic fantasies.

In 1920, the Baroness often posed for Man Ray's camera, resulting in at least four striking portraits, one of which was sent to Tristan Tzara for inclusion in an international anthology of Dada he planned to publish.[19] In 1921, two other more provocative pictures appeared in the review *New York Dada*, and shortly thereafter, the Baroness served as a nude model in a film made by Man Ray and Marcel Duchamp (the action of which consisted of the Baroness shaving her pubic hair).

Through Charles Duncan (a poet and sign painter who had a showing of drawings and watercolors at 291), the Baroness was introduced to Berenice Abbott, a young sculptor who would soon

become better known in Paris as a photographer. In 1922–23, the Baroness completed a collage portrait of Abbott, made from paper, stones, metal, glass, cloth, paint, and a variety of other materials. Abbott's features are rendered as a large floating mask in the center of the composition, a feather in her cap fashioned from the brush of an old eraser. Just to the right of her head can be seen an ovoid glass gem, embedded directly into the picture, a piece of cheap costume jewelry that is balanced by a large circular lens on the lower left, a reference, perhaps, to Abbott's photographic pursuits. Abbott appears again as a full figure on the left, crouched on a platform and opening an umbrella, while her dog, "Pinky"—of whom Abbott recalls the Baroness having been especially fond—sits on a carpet in the center foreground looking directly at

Baroness Elsa von Freytag-Loringhoven. Portrait of Marcel Duchamp. *c. 1920. Assemblage: miscellaneous objects in a wine glass. Photograph by Charles Sheeler. Collection Ronny van de Velde, Antwerp*

the viewer. On the far right appears another figure, perhaps the man Abbott reports being involved with at the time, whom the Baroness allegedly despised. When the portrait was completed, she gave it to Abbott, only to steal it back during an argument a few years later.[20]

In spite of their earlier altercation, in 1923, William Carlos Williams—who still admired the Baroness and her eccentric behavior—gave her enough money to return to Germany. In April, she boarded the SS *Yorck*, but was quickly disillusioned by the country of her birth. "It has collapsed beneath mediocrity," she wrote a few years before her death. "If I ever am permitted to return [to America] . . . I will embrace it as my spiritual father." But she doubted this opportunity would ever come to pass. "It is more than questionable," she wrote, that "I shall escape alive to embrace my beloved jolly father." Her premonitions were correct. She was never to return.

Baroness Elsa von Freytag-Loringhoven. Dada Portrait of Berenice Abbott. c. 1922–23. Collage of synthetic materials, cellophane, metal foils, paper, stones, metal objects, cloth, paint, etc., 8 ⅝ x 9 ¼". The Museum of Modern Art, New York. From the collection of Mary Louise Reynolds

7 · THE INDEPENDENTS

The one activity that took place during these years in New York for which the Arensbergs and members of their coterie were primarily responsible was the formation of the Society of Independent Artists in the fall of 1916, and the staging of their inaugural exhibition in April 1917. According to the "Certificate of Incorporation," members of this organization sought to join forces for the express purpose of "afford[ing] American and foreign artists an opportunity to exhibit their work independently of a jury." While they listed a number of other reasons for establishing the organization— one of which was a desire to promote a degree of "cooperation" and "cordiality" with their foreign counterparts—its main purpose was to provide its artist-members with a dependable, no-questions-asked public forum in which to display their work. *Anyone* who paid the modest initiation fee of one dollar and annual dues of five dollars automatically became a member and was allowed to show two works in the annual exhibition. The open invitation was a resounding success; within two weeks, over six hundred applications were received, and before the exhibition opened, membership climbed to some twelve hundred members, drawn from thirty-eight states in the Union.[1]

The Grand Central Palace, Lexington Avenue between Forty-sixth and Forty-seventh streets, New York, July 13, 1923. Photograph: Museum of the City of New York. The Byron Collection

The First Exhibition of the Society of Independent Artists opened at the Grand Central Palace on the evening of April 10, 1917. Thousands gathered to celebrate the largest art exhibition ever held in New York, almost twice the size of the famous Armory Show four years earlier. This first exhibition—"The Big Show," as Rockwell Kent appropriately called it[2]—contained 2,125 works of painting and sculpture, diverse in size and, as was to be expected, in quality. The governing principle of the exhibition, emphatically stated in the numerous press releases, was taken directly from the Société des Artistes Indépendants of Paris: "No jury—no prizes." Quotations from both Ingres and Renoir were evoked in the foreword to the first catalogue, confirming the adoption of such a liberal platform, and it was hoped that the unrestricted exhibition policy would for the first time reveal the true state of contemporary American art.

The founding members of the society were highly diverse in artistic temperament, ranging from liberal academic to ultramodernist. They held in common a defiance of the elitism of the National Academy, which, with its annual juried exhibition, determined artistic success by a formula of rigid conformity to accepted tradition.

Two artists who had assisted in the organization of the Armory Show were given high posts in the newly formed society: William Glackens was elected president, perhaps because he had served as chairman for the selection of American art at the Armory Show, and Walter Pach, who had handled most of the liaison with Europe for the earlier exhibition, became the society's treasurer (a position he held for the next fifteen years). Charles Prendergast (brother of painter Maurice) was elected vice-president, while John Covert served as secretary. A host of eminent artists filled the roster of directors, including: George Bellows, Katherine Dreier, Rockwell Kent, John Marin, Man Ray, Morton Schamberg, and Joseph Stella. Although Albert

Gleizes, Jean Crotti, and Henri-Pierre Roché helped to establish the society, Marcel Duchamp was the only European listed in the catalogue as a director.

Exactly who thought of forming an independent society at this time is difficult to say, although one instinctively suspects Duchamp, whose aim it was (even before his arrival in America) to systematically challenge accepted notions of the artistic process. The idea of a jury-free exhibition, however, was not entirely new to this country; precedents had been established as recently as 1907 and 1910, when Robert Henri, in defiance of the rigid and inbred selection processes of the National Academy, organized independent exhibitions. But the new Independents' exhibition was to be differ-

ent; unlike the earlier showings, it was conceived from the very beginning on a grand scale, with the total absence of any selection committee.

During the spring of 1917, the society's founders met at the Arensberg apartment to discuss various points that would be eventually incorporated into the organization's official bylaws (which were drafted by John Quinn, the art collector and lawyer who served as the society's legal counsel). Duchamp and Covert assembled twelve backers, who together guaranteed approximately ten thousand dollars to cover expenses incurred for the first exhibition. The list of guarantors was headed by Arensberg and Dreier, and also contained the names of other prominent patrons of the arts, such as

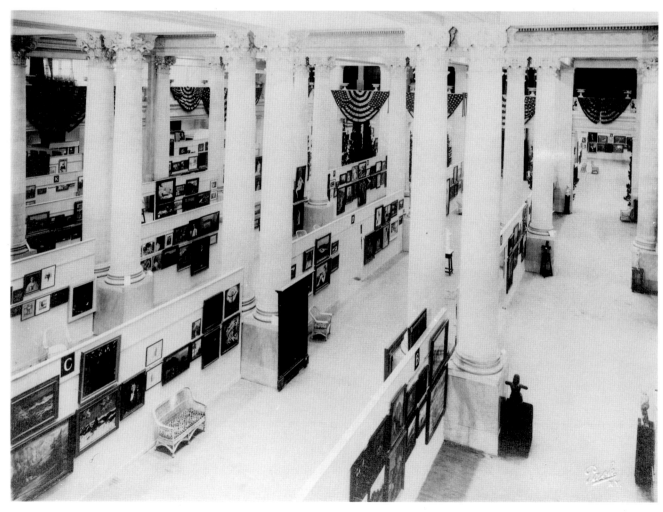

Installation photograph of the First Exhibition of the Society of Independent Artists, the Grand Central Palace, April 1917. Photograph by the Pach Brothers. Pach Papers, Archives of American Art, Smithsonian Institution, Washington, D.C.

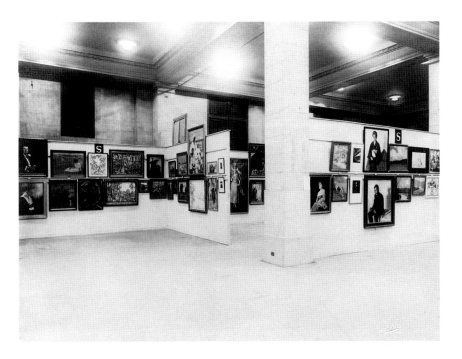

Installation photograph of the First Exhibition of the Society of Independent Artists, the Grand Central Palace, April 1917. Photograph by the Pach Brothers. Pach Papers, Archives of American Art, Smithsonian Institution, Washington, D.C.

Archer M. Huntington, Mrs. Philip M. Lydig, Eugene Meyer, Jr., Mrs. C. C. Rumsey, Mrs. William K. Vanderbilt, and Mrs. Harry Payne Whitney (Gertrude Vanderbilt Whitney, herself a sculptor, was later founder of the museum of American art that bears her name).[3]

On opening night Mrs. Whitney headed the reception committee to greet the throng of well-wishers, who were, reportedly, as diverse in appearance as the paintings hanging on the walls. Nearly everyone associated with the New York art world made an appearance—from the crudely clad long-haired artists of downtown Washington Square to the starch-fronted academicians in formal evening attire, accompanied by their consorts in flowing opera gowns. Along with a full brass band, invited guests patiently awaited the arrival of Mayor John Mitchell, who was scheduled to open the exhibition. Though he never showed up, that did nothing to diminish the enthusiasm of a high-keyed crowd, which strolled up and down the seemingly endless avenues of exhibition space, long aisles formed by large temporary parti-tions set up between the classical columns of the palace. It was even reported that a fleet of wheelchairs was hired to save fatigue and, as one reporter explained, in order "to get by some of the horrors quickly."[4]

For a nominal fee, visitors to the exhibition could purchase a catalogue, choos-ing between two different editions: one illustrated, the other not (for a fee of $4.00, exhibitors could have their works reproduced in the catalogue). With the exception of a foreword briefly outlining the aims of the Independents, the catalogue consisted of little more than an alphabetical listing of the exhibitors and the titles of their works. But for ten cents, you could purchase a copy of *The Blindman*, a magazine especially created to serve the needs of the Independents; the inaugural issue featured on its cover a cartoon by the American illustrator Alfred J. Frueh, showing a blind man being led by his seeing-eye dog past a picture of a nude woman thumbing her nose. In a long editorial statement by Henri-Pierre Roché—divided into twenty-four numbered paragraphs—we are provided with an elaborate explanation of why the Independents came into being, and a prediction of their effect on the future course of American art: "New York, far ahead in so many ways, yet indifferent to art in the making," wrote Roché, "is going to learn to think for itself, and no longer accept, mechanically,

The Blindman, no. 1, April 10, 1917. Cover.
Philadelphia Museum of Art. Arensberg Archives

the art reputations made abroad." In an intentionally ironic statement, he declared that the purpose of the magazine was to provide a public forum for the Independents: "The Blind Man will be the link between the pictures and the public—and even between the painters themselves." Roché then went on to solicit contributions to the magazine, inviting readers to submit questions about the works exhibited. The pamphlet concluded with three short, somewhat fanciful articles about the Independents by Beatrice Wood, and a statement by Mina Loy, in which she predicted, pessimistically though accurately, that the Independents would do little to educate the unreceptive minds and untrained eyes of the general public.

With these documents as their only guide, visitors would have quickly noticed that some two thousand works were all arranged alphabetically—a device to insure against personal prejudices within the hanging committee. This was Duchamp's idea.[5] He was also responsible for the suggestion that the first submission to be hung should be determined by the chance drawing of letters from a hat—thus the first of the entries began at the northeast corner of the main gallery with the letter "R."

In the first alcove, visitors to the exhibition encountered a work which was widely discussed by reviewers, the major-

ity of whom found the painting worthy only of disgust. Dorothy Rice's *Claire Twins*, now lost, was an enormous canvas—about five by six feet—depicting two overweight, middle-aged women, which one critic described as "portraits of circus avoirdupois freaks." Henry McBride, one of the society's most outspoken defenders and, through his weekly art column in the *New York Sun*, one of the exhibition's most assiduous chroniclers, recorded an amusing conversation that took place in front of this painting on opening night:

> *But Glackens laughed again when he saw the "Clair [sic] Twins" by Miss Dorothy Rice. Everybody laughs when they see those twins. Even the Baron de Meyer laughed. Marius de Zayas of the Modern Gallery seemed positively glued to the floor in front of them. "You'll be having that down in your gallery next," I bantered him. "I should be only too proud," he returned. "I can't believe a woman did that. It's strong."*[6]

It is not surprising in a period when the independent American woman was first given serious recognition that the most talked about and daring works in the exhibition were by women artists. Charles Buchanan of *The Bookman* noted that "nine times out of ten, when my attention was arrested by a picture, that picture was painted by a woman."[7] In fact, the most arresting work in the exhi-

Gertrude Vanderbilt Whitney. Titanic Memorial. *1914–17. Reproduced in* The Soil, *July 1917*

bition, if by virtue of sheer bulk alone, was Gertrude Vanderbilt Whitney's *Titanic Memorial.* Carved from a single block of granite, this figure of a partly clad male youth stands eighteen feet high, with outstretched arms spanning over fifteen feet (its ultimate destination was Washington, D.C., where it now stands as a gift to the nation in the name of American women).

If most reviewers applauded the classic monumentality of Mrs. Whitney's sculpture, they found the humor and ephemeral nature of Beatrice Wood's *Un peut [sic] d'eau dans du savon (A Little Water in Some Soap;* p. 182) downright offensive. The original assemblage depicted a nude woman emerging from the waters of her bath, her only covering provided by an actual bar of soap, which—in accordance with Duchamp's suggestion—was nailed directly to the canvas surface. On opening night, crowds gathered before the work, and when it was discovered that such a suggestive image was the creation of a woman, aspiring suitors left their calling cards attached to the frame. One fortunate reporter by the name of Theodora Bean even had the opportunity to interview the artist. To the cryptic question: "Are you living for soul years?" Wood responded in a manner revealing both the serious intent and the humor-

Dorothy Rice. Claire Twins. *c. 1915. Oil (?) on canvas, approximately 5 x 6'. Original work lost. Reproduced in the* New York Sun, *April 15, 1917*

ous content of her entry: "The emotions of a jeune fille can be acquired at home. I am out for red blood. I want to return to the ecstasy and wild imaginings of childhood. To laugh is very serious. Of course, to be able not to laugh is more serious still." She went on to describe the difficulties she had experienced in assisting the hanging committee to arrange the great quantity of works alphabetically. Here is her discussion of her own entry, as fanciful as something extracted from a dream sequence:

I ran in and on and over walls. Once I jumped in a picture and sat still, looking like a Chinese god while men passed. "I am worth $800," I thought, and I laughed. And I was a piece of soap, with nails in my back, stuck on a canvas. A big flood came and swamped all the first floor, and the canvases began whirling on the ground: blue arms and green legs floated past, and I said to myself, "Those are the art critics."[8]

Not so disjointed, however, were the opinions of art critics, who resounded unanimously with distaste for this work. Most dismissed it as simply "a bad joke," but Harvey M. Watts of the *Philadelphia Public Ledger* went further, calling it "the keynote of childish whim, the unbridled extravagance, the undisciplined impudence and immature ignorance and even derangement that have been allowed free fling. . . ."[9] Although critics apparently were morally offended by the use of a bar of soap in the traditional fig-leaf position, they were equally concerned with the threat implied to the almost sacred tradition of the painted female nude. They found any variation from Ingresque representation unacceptable; the nude

human form was the perfection of natural beauty, and to tamper with it in any way was considered a defiant, well-nigh blasphemous act.

Nudes of every imagined position and proportion filled the alcoves and avenues of the exhibition space. A staff reporter for the *New York American* observed that among the many "isms" represented in the exhibition, "Nudism seem[ed] to claim the largest number of votaries."[10] Another nude that displeased the academicians was George E. Lothrop's. His *Nude* was admired for its technical proficiency, but received considerable ridicule for having violated the traditional rules of painterly illusionism; Lothrop apparently attached real pieces of jewelry to the fingers and hair of the model represented in his canvas.

Far less sculpture was exhibited than painting, and most of what was shown was figurative and rather conservative. Notable exceptions were Raymond Duchamp-Villon's *Torso*, Brancusi's *Portrait of Princess Bonaparte* (p. 29), and Adelheid Roosevelt's *Tennis Player*.[11] The last work, which was widely reproduced in reviews of the exhibition, was one of the most advanced sculptural works produced in America at this time. Mrs. Roosevelt, who was related by marriage to ex-President Theodore Roosevelt, was immediately labeled a "futurist," a term reviewers often employed to describe whatever modern work they did not understand. Harvey M. Watts, who had failed to understand anything in the show (save Mrs. Whitney's *Titanic Memorial*), made a characteristically igno-

Adelheid Roosevelt. Tennis Player. c. 1915. Original work lost. Reproduced in Independent Artists, *exhibition catalogue, 1917*

George E. Lothrop. Nude. c. 1917. Original work lost. Reproduced in Independent Artists, *exhibition catalogue, 1917*

rant attempt to trace the inspiration for the two works submitted by Mrs. Roosevelt: "Mrs. Roosevelt goes to the Negroes of the Niger basin for her inspiration for her bronze statuette, 'The Tennis Player,' while she goes freely over to the mumbo-jumbo fetish idea of art in her slightly carved piece of wood stained brown, entitled 'Munga,' which belongs to 'the sticks and stones and worse than senseless things' of the African taboo." Watts also attacked the primitive aspect of Brancusi's entries: "Brancusi, one of the sensations of years ago, who develops all human beings from the egg form, has a 'baby crying' and a 'Portrait of Princess Bonaparte,' which present forms usually consigned to the alcohol jars in biological museums, while forcing the primitive to its extremes of savage expression."[12]

Many reviewers complained that, in spite of their titles, nothing human could be deciphered in Brancusi's strange

Beatrice Wood. Un peut *[sic]* d'eau dans du savon
(A Little Water in Some Soap). *1917/1977. Replica: pencil,
colored pencil, and soap on cardboard, 10 ½ x 8 ¼".*
Private collection, New York

Edith Clifford Williams. Two Rhythms. *1916. Oil on canvas, 29 x 29". Philadelphia Museum of Art. The Louise and Walter Arensberg Collection*

forms. One reviewer said that the *Princess Bonaparte* "look[ed] like a retort filled with quicksilver," while W. H. de B. Nelson may have been the first critic to publicly recognize an erotic content in Brancusi's work, complaining accordingly: "We are not of the class that favors drapery for the legs of the piano stool, but phallic symbolism under the guise of portraiture should not be permitted in any public exhibition hall, jury or no jury. . . . America likes and demands clean art."[13]

From the time of the Armory Show, most objects open to double readings were met with bewilderment by the American critics. The reviewer for *The Outlook* calls works of this type "puzzle pictures," and suggests that the only way one could truly solve their mysteries would be to experience a personal tour through the exhibition with the artists themselves. John Covert graciously provided a detailed explanation of his painting the *Temptation of Saint Anthony* (see p. 135), but not every interview with an artist proved so illuminating. The same reviewer who interviewed Covert, for example, reported that Edith Clifford Williams refused to provide such an enlightening explanation of her painting

Two Rhythms, preferring that her art "make whatever impression it might on the beholder." It was further mentioned, however, that Williams had objected to the interpretation that her painting represented a flea climbing a hair (the most popular analysis among critics), stating simply "it was plain enough that 'it conveyed the idea of rhythm.'"[14]

The organizers of the exhibition had hoped that the jury-free show would reveal at least one new artist-genius. This hope was echoed in the art columns long before the opening. As if not to disappoint such aspiration, Marcel Duchamp, employing a strategy similar to that with which he selected his numerous ready-mades, announced on opening night that Dorothy Rice's *Claire Twins* (p. 180) and Louis Eilshemius's *Supplication* were the two great paintings that the exhibition had brought forth.

For some reason, several critics were in agreement with Duchamp's selection of the *Claire Twins*, but most regarded his choice of Eilshemius a mistake. Eilshemius, who had long bombarded New York art critics—in vain—with letters complaining that he was a neglected genius, was in fact to receive considerable recognition as a result of Duchamp's

discovery. Thanks to the scandal his *Nude* had created at the Armory Show, Duchamp's name was associated with the most advanced level of modern taste, and a nod of approval from him was taken seriously, despite the numerous reservations that critics immediately expressed. McBride even suggested that Duchamp might have been affected in his decision by the exorbitant price tags on the two paintings: *Claire Twins* was marked at $5,000, and *Supplication* at $6,000.[15]

Long before the opening of the exhibition, reporters were naturally curious to know what Duchamp planned to exhibit. Apparently, in an intentional effort to mislead them, the rumor was circulated that he was to submit a painting entitled *Tulip Hysteria Coordinating*, a Cubist canvas said to have been inspired by a yellow tulip bed he had seen at a flower show earlier at the Grand Central Palace.[16] The now infamous object that Duchamp actually submitted, however, was to challenge the very principles of the society he had helped to establish.

On behalf of a so-called Philadelphia artist by the name of "R. Mutt," Duchamp submitted a glistening white porcelain urinal (p. 45), under the simple but suggestive title *Fountain*.[17] Objections,

Louis Michel Eilshemius. Supplication (Rose-Marie Calling). *1916. Oil on wood, 61 x 40 1/2". Roy R. Neuberger Collection*

on both aesthetic and moral grounds, were immediately voiced, and an emergency meeting of the society's directors was called to decide whether R. Mutt's contribution was to be accepted. Heated arguments were heard from opposing viewpoints before the issue was finally put to a vote. Throwing open to question the jury-free principles of the exhibition, George Bellows proclaimed: "You mean to say, if a man sent in horse manure glued to a canvas that we would have to accept it?" We know that Arensberg, who was probably in on Duchamp's charade from the very beginning, responded affirmatively.[18] But the conservative majority refused to yield to such logic. Glackens, the society's president, declared that matters of this sort were the product of "suppressed adolescence," and Dreier, who carried both an affection for Duchamp and a great respect for his intelligence, never really grasped the essence of his work, and, therefore, also cast a negative vote on this issue. The "nays" had it, and *Fountain*

was never seen by the public. The day after the opening, the society's board of directors released the following statement to the press: "*The Fountain* may be a very useful object in its place, but its place is not an art exhibition and it is, by no definition, a work of art."[19]

In protest, Duchamp and Arensberg immediately resigned from the society. In an apologetic letter to Duchamp, Dreier pleaded that he reconsider his resignation, fearing that his break with the society would endanger its future growth. She further stressed that it was his presence, and not "the piece of plumbing" that was of such importance to the independent spirit of the organization.[20] Ironically, even though this entry had failed to make its appearance among the thousands of alphabetically arranged works, Duchamp's omnipotent presence was physically manifest in the "C" section of the exhibition—if even in a somewhat ghostly form—where Jean Crotti's portrait of the artist in wire and drawn lead (p. 103) was prominently displayed. But

few reacted favorably to Crotti's inventiveness. Even the society's president publicly objected to this portrait: "Hunting for new expressions is all very well," said Glackens, "but it cannot be very important unless you now and then find one."[21]

Exactly what happened to Duchamp's *Fountain* after its rejection at the Independents may never be known. There are a number of accounts, one of which would have us believe that during the meeting of the executive committee, Glackens resolved the controversy by quietly walking into the corner of a room, raising the disputed item high above a partition, and letting it drop—smashing the urinal to pieces.[22] But this account is surely specious, for nine days after the opening of the exhibition, we know that the readymade was safely preserved in the gallery of Alfred Stieglitz. On April 19, 1917, Stieglitz sent a letter to Henry McBride, inviting him to stop by the gallery and see his photograph of the rejected object, as well as the object itself: "The Fountain," Stieglitz informed McBride, "is here too." Although Stieglitz does not specifically identify Duchamp as the author of this rejected entry, he does tell McBride that he was asked to take the photograph "at the request of Roché, Covert, Miss Wood, Duchamp & Co."[23]

So it appears that for a few days, at least, Stieglitz opened his gallery to a public display of this rejected artifact. In one of his many letters to Gertrude Stein, Carl Van Vechten reported that Stieglitz "made some wonderful photographs of it," which "make it look like anything from a Madonna to a Buddha."[24] Indeed, one suspects that it was probably Stieglitz's idea to record the urinal from such a provocative viewpoint; certainly, it must have been the unique eye of this photographer/dealer that noted a configuration similar to the inverted urinal in the center of Marsden Hartley's *The Warriors* (Regis Collection, Minneapolis)—against which he placed and photographed *Fountain*—a painting that

P·B·T

THE BLIND MAN

33 WEST 67th STREET, NEW YORK

BROYEUSE DE CHOCOLAT Marcel Duchamp

MAY, 1917 *No. 2* *Price 15 Cents*

The Blind Man, *no. 2, May 1917. Cover.*
Philadelphia Museum of Art. Arensberg Archives

Two-page spread with Duchamp's Fountain *(photograph by Alfred Stieglitz) and "The Richard Mutt Case" by Beatrice Wood and "Buddha of the Bathroom" by Louise Norton.* The Blind Man, *no. 2, May 1917*

records the images of soldiers on horseback ascending the slopes of a multitiered, symmetrical mountain.[25]

Though it may have been the formal properties of Hartley's painting that first inspired Stieglitz to select it from his gallery stock as an appropriate background for *Fountain*, he could not have failed to recognize a relatively obvious thematic association between the image of warring soldiers and the ongoing struggle for artistic democracy, which, at this particular moment in time, the Independents personified. Although Duchamp recognized Stieglitz's keen sensitivity to these issues, it seems that he did not reveal his identity as author of this work even to Stieglitz. Indeed, from the few factual documents to survive pertaining to this incident, it would appear that for a period of at least a

month following the opening of the Independents, Duchamp intentionally withheld his identity. In a letter written to his sister Yvonne the day after the exhibition opened, he described the rejection of this work without even revealing to her that he was actually the artist; in fact, he went so far as to say that the urinal was submitted to the exhibition by one of his female friends (the same explanation he had given to Stieglitz).[26] In a letter to Henry McBride, Charles Demuth revealed that *Fountain* was made "by one of our friends," but he adds that if the critic should want to know anything more about the work, he should either call Marcel Duchamp at "4225 Columbus," or Richard Mutte [*sic*] at "9255 Schuyler." If McBride followed Demuth's invitation, he would have reached Duchamp at the first number, and Louise Norton at the second.[27]

Either one of these individuals could indeed have provided more information on the urinal and its subsequent fate, for at that very moment, Duchamp and his friends were busy assembling documents

that would provide *Fountain* with its first public defense. The second and final issue of *The Blind Man* was devoted to the topic of R. Mutt's rejected submission. Duchamp, Henri-Pierre Roché, and Beatrice Wood all helped with the production of the magazine. The editorial spread featured a reproduction of Stieglitz's photograph of the urinal (cf. p. 45), followed by a statement written by Beatrice Wood (though often attributed to Duchamp): "As for plumbing, that is absurd. The only works of art America has given are her plumbing and her bridges."[28] This proclamation was followed by Louise Norton's article entitled "Buddha of the Bathroom," where it was argued that the *Fountain* was no more immoral than a bathtub, and could claim originality by virtue of the artist's choice, and placement of that object in a new context.

The Blind Man also contained contributions by a number of other individuals who frequented the Arensberg salon: Clara Tice submitted her cartoon portrait of Edgard Varèse (p. 119); Arensberg

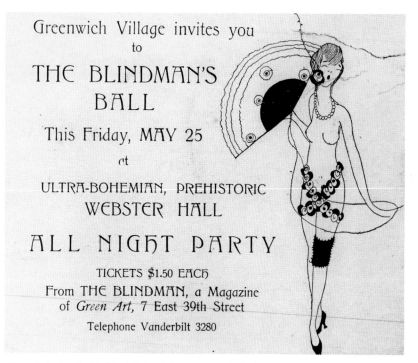

Greenwich Village invites you

to

THE BLINDMAN'S BALL

This Friday, MAY 25

at

ULTRA-BOHEMIAN, PREHISTORIC
WEBSTER HALL

ALL NIGHT PARTY

TICKETS $1.50 EACH

From THE BLINDMAN, a Magazine
of *Green Art*, 7 East 39th Street

Telephone Vanderbilt 3280

Above: Invitation Card for The Blindman's Ball.
*1917. Cardstock, 4 x 5". Collection Alexina
Duchamp, Villiers-sous-Grez, France*

Right: Beatrice Wood. Poster for The Blindman's
Ball. *1917. Offset lithograph, 27 ½ x 9 ¹¹⁄₁₆".
Yale University Art Gallery, New Haven.
Gift of Francis M. Naumann*

and Western dance, Ito probably performed his famous *Fox Dance*, in which, wearing a lupine mask, he darted back and forth across the stage in a series of staccato movements, crouched in a stalking position to mimic the cunning actions of a fox.[32]

In his recollections of the ball, Roché tells of an incident that took place later in the evening, where Duchamp, having consumed too many cocktails, scared everyone half to death by climbing a very high flagpole placed in the center of the dance floor. Everyone feared for the artist's safety, and they cheered lustily when he finally reached the top. "He thanked them," Roché recalled, "by tipping his party hat of pink-colored paper," then quickly slid back down the pole, unharmed, but victorious. "Victor had

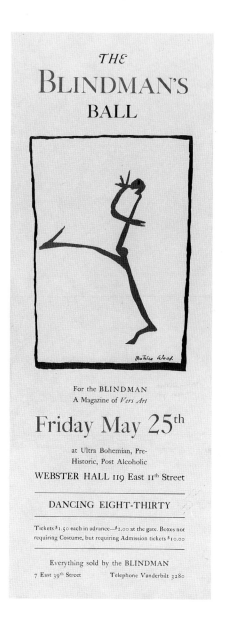

THE BLINDMAN'S BALL

For the BLINDMAN
A Magazine of *Vers Art*

Friday May 25th

at Ultra Bohemian, Pre-
Historic, Post Alcoholic

WEBSTER HALL 119 East 11th Street

DANCING EIGHT-THIRTY

Tickets $1.50 each in advance—$2.00 at the gate. Boxes not
requiring Costume, but requiring Admission tickets $10.00

Everything sold by the BLINDMAN

7 East 39th Street Telephone Vanderbilt 3280

submitted two radical poems; Frank Crowninshield and Alfred Stieglitz wrote letters of support for the Independents; there was an article about Marie Laurencin by Gabrielle Buffet; an article on Eilshemius and a free-verse text by Mina Loy; a visual poem by Robert Carlton Brown; poetry by Charles Duncan, Allen Norton, Frances Simpson Stevens, Charles Demuth, and Francis Picabia.

In celebration of its publication, this final issue of *The Blind Man* also announced a costume ball to be held on Friday evening, May 25, "at Ultra Bohemian, Pre-Historic, Post Alcoholic Webster Hall." The invited guests were informed that "Romantic Rags are requested," warning, "there is a difference between a tuxedo and a Turk and guests not in costume must sit in bought-and-paid-for boxes." An invitation card was prepared, featuring the line drawing of a scantily clad young woman—attired in only a few strategically positioned accessories—an intentionally provocative image (taken from an illustration by Frances Gifford that had originally appeared in *Rogue*) probably selected to

increase attendance at the ball.[29] Beatrice Wood was given the task of designing the poster, and she came up with a stick figure arrogantly thumbing its nose at the world, "a red, skeletal, ascetic-looking figure," as Roché described it, "lost in a mad dance."[30] Doubtless inspired by the framed image of a nude making a similar gesture in Freuh's cartoon on the cover of the first issue (p. 179), the message conveyed by this figure succinctly expressed the editors' collective disdain for bourgeois attitudes toward art.

The ball began with a Russian folk dance performed by Beatrice Wood, which was received enthusiastically by the audience. "Dressed as a muzhik," Roché recalled years later, she "opened the ball with a Russian peasant dance, arms crossed, knees bending, valiantly kicking out her tiny boots before her. Her playful eyes, her smile, rewarded with great ovation."[31] This performance was followed by Michio Ito, the famous Japanese dancer, who, after a successful tour in England, had come to the United States a few months earlier. Well known for his ability to combine styles of Eastern

enjoyed himself immensely," Roché concluded. "The Ball had been a success."[33]

In a highly personal album composed for Roché a few months later, Wood also provided him with a delicate sketch illustrating a moment in the evening's riotous festivities (p. 188). She later recalled that at the ball, Joseph Stella had challenged someone to a duel over her, though she never found out why: "Something about protecting my honor," she said, "which no longer existed!"[34]

Fancy costume balls were very much in fashion in this period, and another had been staged a month earlier on the mezzanine floor of the Grand Central Palace in honor of the Independents' exhibition. The guests were said to have worn costumes representing the various modern schools of art—from Post-Impressionism through Cubism. Unusual sights were certainly plentiful; it was reported that John Covert appeared in the costume of a hard-boiled egg, Selma Cudlipp as an Egyptian lady, and Clara Tice in "her familiar steam radiator costume." Arthur Cravan was said to have shown up wearing very little more than a bedspread, with his head wrapped in a towel. Guests became apprehensive when he removed the bedspread and disrobed to the waist, for he had created quite a similar sensation a day earlier at the Palace when he had been invited to lecture on "The Independent Artists in France and America."[35]

Retold later in many conflicting versions, the incident is accurately recorded by a journalist of the New York Sun, who attended the affair and published his account in the next day's paper.[36] Cravan arrived in the company of some friends who escorted him to the speaker's table. The crowd of several hundred men and women craned their necks to get a good look at the handsome six-foot frame of this man "who combined poetry and pugilism without even mussing his hair." Apparently drunk, Cravan faced the crowd and silently swayed back and forth until he fell, "striking the hard surface of the speaker's table with an independence of expression plainly heard on Lexington Avenue." Back on his feet again, he began disrobing, first removing his coat, vest,

Beatrice Wood dancing a Russian dance. 1917. Beatrice Wood Archives, Ojai, CA

then collar, and finally suspenders. His attention was then drawn to a painting in the exhibition hall of a beautiful nude *Eve*, and fearing his assured inspiration from this source, the crowd fled the lecture hall and house detectives were quickly summoned. A group of men immediately encircled the star lecturer, who threatened to employ his boxing talents when detectives revealed their shiny metal handcuffs. Cravan and friends were then escorted to the Forty-sixth Street entrance of the Palace and quickly whisked away in an automobile. Picabia's wife, Gabrielle Buffet, tells us he was taken to the home of Walter Arensberg, where he quietly recovered from his drunken stupor.[37]

This was just one of the many events staged by the Independents, who sought "a common ground for the free expression of all the arts." Poets were invited to read, while on other evenings, films, concerts, and various other lectures were presented. Robert Coady spoke on recent American film; and one evening, inmates from Sing Sing gave a talk in the Palace's Tea Garden on their experiences as prisoners.[38] Elmer Ernest Southard, Arensberg's psychiatrist-friend from Boston, was also invited to deliver a lecture. On May 4, 1917, he addressed members of the Society of Independent Artists on the topic "Are Cubists

Insane?" In spite of its title, according to Arensberg, it was not Southard's intention to suggest that Cubists were crazy. "He selected this title, I suppose," Arensberg recalled, "as a sort of teaser. What he proposed to show was a parallel between certain types of modern painting and certain psychopathic types as corresponding, *in extremis*, to certain normal types. Thus he classified Marcel Duchamp as belonging to the schizophrenic group." From the preparatory notes that still exist for this lecture, it can be determined that Southard probably also presented his views on grammatical categories, a remarkably early linguistic study where he compared various characteristics of Cubism with mode variations of verbs.[39]

Michio Ito in his Fox Dance *mask. 1915. Photograph by Alvin Langdon Coburn*

Although the exhibition and its accompanying program were seen as a success—over twenty thousand people attended during its four-week run—it turned out to be a financial failure. The income earned from a ten percent commission on works sold, combined with gate receipts, was not enough to cover the operational expenses, forcing the society's treasurer, Walter Pach, to call upon the individual guarantors to make

Beatrice Wood. Marcel, Roché, Louise au bal (Marcel, Roché, Louise at the Ball). *From Pour Toi, Adventure [sic] de Vièrge! (For You, Adventure of a Virgin!), 1917. Manuscript album with drawings in ink, colored pencil, watercolor, and pencil on paper, 8 x 10". Philadelphia Museum of Art. Gift of the Artist*

up the deficit of over eight thousand dollars. In spite of the fact that exhibitors were urged to set low prices on their works in order to encourage sales, prominent collectors of the time took little advantage of the situation. Only John Quinn made significant purchases, buying both works exhibited by Charles Sheeler, the two paintings by Delaunay, and several minor works by J. Garvey. Katherine Dreier purchased Roosevelt's *Munga*, and a river scene by Walter Fitch, and although she did not purchase them directly from the exhibition, she eventually secured four major paintings by Stella, Covert, and Patrick Henry Bruce that were in the show. We also have no conclusive evidence that Walter Arensberg made purchases from this exhibition, although he too would eventually secure five works that were exhibited here for the first time. In all, only forty-five works were sold of the more than two thousand on view.[40]

On the whole, the exhibition was enthusiastically received by artists of every persuasion, including even some academics who had already been accepted under the protective wing of the National Academy. While many reviewers agreed that it was at least an admirable accomplishment to have found space for the display of so many works of art, most thought that the general public was ill-equipped to separate wheat from chaff, and few granted their total approval when examining the ruling principles of the society. But their most consistent objection was aimed at the immense size of the exhibition itself, which they found physically exhausting. John Covert and Marcel Duchamp paced off the long avenue of pictures and estimated that they extended for almost two miles, although some critics felt compelled to stretch this calculation to over three in their reviews. The monstrous size of the show and the entertaining nature of some exhibits—and the fact that Barnum & Bailey's Circus was then in town—led to inevitable comparisons; both contained their share of clowns and freaks. Gustav Kobbe began his amusing review for the *Herald* conjuring up the patterned repertoire of the sideshow promoter:

> *Step up, ladies and gentlemen! Pay six dollars and be an artist—an independent artist! . . . Cheap isn't it? Yet that is all it costs. You and I, even if we've never wielded a brush, squeezed paint from a tube, spoiled good paper with crayon, or worked with a modelling tool, can buy six dollars worth of wall or floor space at the Grand Central Palace. . . .*[41]

Others considered the show such a spectacular production that they proclaimed it an easy rival to the evangelical preaching of Billy Sunday, whose New York revival meetings had, coincidentally, been scheduled during the same week as the opening of the exhibition.

It was Duchamp's idea to hang the works alphabetically that generated the greatest opposition, even from some of the exhibition's most fervent supporters. McBride, for example, came out against the alphabetical system even before the exhibition officially opened, fearing that a happenstance environment could only be injurious to a work of real quality.[42] Robert Henri was so strongly opposed to the alphabetical system that before the opening of the show he withdrew from the society. He called the system of hanging a "disastrous hodge-podge," comparing it to a musical program "where Beethoven's Seventh Symphony would be followed by a foxtrot," or to "eating in sequence mustard, ice cream and pastry," arguing that if the artists sought freedom from the dictation of a jury, why should they not also resent the imposition of the alphabet? If order went into the formulation of a picture, he reasoned, why should it not also be preserved for its presentation? He reverted to a proposal he had suggested years earlier: exhibitors should break up into smaller groups and decide among themselves what hanging system they preferred. He wanted the artists themselves to have the final say about the hanging of their work.[43]

The artist Guy Pène du Bois, editor of the magazine *Arts and Decoration* and a long-time defender of the modernist position, devoted an entire editorial to railing against the alphabetical system. He found the logic of such a democratic method admirable, but he said the results were "visionary," "unreasonable," and "a complete failure." Further, he argued that "a picture of the old Academy cannot hang next to one of the new without a clash in which both will suffer."[44] Here Pène du Bois was certainly in agreement with McBride, who complained that the average spectator would probably find Beatrice Wood's scandalous entry (p. 182) such an attraction that they would inadvertently miss Max Weber's *Women and Tents* (private collection, New York) hanging alongside—a

painting McBride regarded as "one of the finest works of modern art yet produced by an American." He also thought that Lothrop's gem-studded *Nude* (p. 181) so detracted from Mina Loy's *Making Lampshades* that, with his usual flair for original solutions, he suggested to Loy at the opening that she remove the gold earrings she was wearing and attach them to her work![45]

The more radical organizers of the exhibition, however, as well as many of the younger artists exhibiting, strongly supported the alphabetical placement of the works. Perhaps because of his commitment to even-handed journalism, McBride felt obligated in his Sunday column to present a viewpoint differing from his own. So he published a letter from Morton Schamberg, whose opinion

on the topic of alphabetical hanging he had solicited in a chance encounter at the exhibition on its closing day. Schamberg felt that the bewilderment created by this system was not necessarily to be regarded as a fault, but rather should be looked upon as a unique and positive feature of the exhibition—perhaps, as Arensberg more eloquently put it, to be admired "like the beauty of chaos."[46] In

L. M. Glackens. "Exeunt Independent Artists,"
New York Tribune, *May 6, 1917*

fact, many who attended the exhibition recalled in later years the delight experienced by the confusion of pictures, and especially at having had the opportunity to act as their own judges. Louise Varèse, then still the wife of Allen Norton, remembers walking up and down the long avenues of pictures and turning over those she didn't like toward the wall![47]

Professional critics, on the other hand, did not consider the general public capable of making sound judgments of quality: that was *their* job. In addition to the faulty alphabetical system, the ultimate fiasco was assured by allowing so many poor works to pass without the benefit of a qualified jury in the first place. As W. H. de B. Nelson succinctly put it for *International Studio*, "the good ship Independent was wrecked upon the Scylla of No Jury and the Charybdis of Alphabetical Hanging."[48] What would happen, the critics wondered, if magazines accepted everything submitted to them for publication, if every playwright were given a hearing, or if department stores sold everything they were offered? James B. Townsend, editor of *American Art News*, responded by asserting that you would end up with an "olla podrida," a "salmagundi," a "bouillabaisse," a "Church Fair Oyster Stew," a "Plum Duff pudding"—in other words, a mishmash, "in which one may find here and there an art oyster or raisin of merit."[49]

If "freedom" was the slogan of the society, then "mediocrity" was the battle cry of the press. Many reviewers concluded that if the exhibition had presented a thorough cross section of the state of contemporary American art, as the catalogue had promised, then American art was frightfully insipid, "dull as dishwater."[50] Of course, this charge may have resulted partly from the fact that conservative critics chose to ignore the modernist contributions, perhaps in an effort to convince their public that modernism had failed to take effect after the Armory Show.

Except for an occasional mention of Brancusi, few remarks were directed to the entries by modern European artists, who had earlier received such notorious acclaim at the Armory Show. Matisse, Derain, Delaunay, Picasso, Gleizes, and Picabia were virtually ignored, while even less attention was given to the serious works of American artists attempting to assimilate the various tendencies of the modern European schools. As many reviewers pointed out, the alphabetical hanging system tended to neutralize the modernist works, and, in turn, served to emphasize the few "freak" displays among the primarily conservative works in the exhibition. Although the general consensus was that the various "isms" were all well represented, McBride placed the proportion of "inoffensive" to "offensive" works at the ratio of only ten to one, explaining that he meant "offensive" in the complimentary sense of being challenging. On the other hand, Frank Jewett Mather, art critic of *The Nation*, concluded that at least two-thirds of the contributions were tinged with one form of modernism or another.[51]

The society and the exhibition as a whole were heavily criticized for their reliance on European models by Robert J. Coady in his magazine, *The Soil*—a publication devoted to the identification and promotion of an indigenous American art: "To point, as the Society has done, to the Paris Indépendants, is a misuse of the index finger . . . they are as sick of it in Paris as we are of our academy . . . why should we nibble on a dead end of Europe?" Coady went on to discuss selected contributions in alphabetical order, leveling pejorative comments at modernist works by both the American and European schools. He said Brancusi's work was "no more curious than [a] Barnum freak," that Gleizes had "Metzingitis," that Marin's painting of the Water Gap "would never survive a windstorm," that he didn't believe Picabia really meant it, and that Stella's *Coney Island* was "less clear than a color cover by Howard Chandler Christy." Following a formula he had developed in his earlier writings, he approved of works that avoided the direct assimilation of any modern movement, such as the drawings in this exhibition by Michael Brenner, which he pointed out had "not cut up the Greek ideal into parts." But almost in

the same breath, Coady applauded modernist works that incorporated an understanding of what he called "ordered form," which he found evident only in Gris's *Man at Café* (Arensberg Collection; Philadelphia Museum of Art).[52]

Of some ninety published reviews of this exhibition, few seriously addressed the importance of its democratic principles, and curiously, fewer still noted the nearly simultaneous coincidence of America's entry into the war. Exceptions ranged from the opinions of Duncan Phillips, who proclaimed that a war was the only hope for the degenerate state of American art, to Forbes Watson, the liberal critic of the *New York Evening Post*, who felt that the no-jury and alphabetical-hanging systems would give every artist an equal opportunity, in the spirit of a true democracy. And Frederic James Gregg, who contributed many articles to *Vanity Fair* in support of America's stand for democracy in the war, predictably took the position that the exhibition "stands for the spirit of the greater freedom that all real Americans confidently believe will mark the end of the War," concluding, "art, like a man, can live truly only when it is free."[53]

As with the Armory Show, cartoonists also poked fun at this exhibition. In the case of the Independents, insult was added to injury when the *Tribune* asked L. M. Glackens, brother of the society's president, to record his privileged view of the exhibition. The text below these cartoons, tinged with subtle bigotry, explained that the *Tribune*'s artist "is able to claim the distinction of being the first white man (outside of the committee) to penetrate into the fastnesses of this display of modern art and to emerge alive with several of its secrets clasped tightly to his bosom."[54]

Cartoons by the artist Modest Stein, who was also an exhibitor, illustrate a rather unusual review of the exhibition by a Mrs. Jane Dixon in *The Sun*. That newspaper (to the regret, we can imagine, of Henry McBride, who was then its art critic) had apparently learned something from the society's liberal, unselective principles and published at least this one piece of junk journalism. Dixon,

who confessed at the outset that she knew nothing about art, proceeded in the remainder of the article to prove it. She discussed some of the more attention-getting exhibits and, defying the exhibition's no-prizes rule, went on to select her personal "winner" among the works in the show. Predictably, she chose a painting representing "a group of three Indians [and] their ponies huddled on the top of a hill," and another of "a field with the corn in the shock and nice fat, ripe pumpkins clambering over the warm brown earth."[55]

Harsh criticism of the exhibition and its rules apparently had little effect on the determined spirit of the society. Despite the prediction of some that a show of this kind would never happen again, the event was restaged in the spring of 1918, retaining both the no-jury, no-prize principle and the system of alphabetical hanging. Under the presidency of John Sloan, the Independents continued their annual exhibitions for the next fifteen years.

During the time when it flourished, the Society of Independent Artists accomplished a great deal for the advancement of modern American art. As Henry McBride insightfully observed just a few days before the opening of the first exhibition, history would remember the Independents not so much for the individual works of art that they would bring to light, but rather for the principle of freedom that the society stood for. At almost the same moment when President Wilson declared war on Germany with the memorable words, "The world must be made safe for democracy," the artists of New York joined hands to initiate a movement dedicated to the principle of freedom in the arts.

8 · NEW YORK DADA

There is evidence that a select group of artists in New York heard the term "Dada" as early as November 1916, less than ten months after its invention by the Zurich group and even less than five months after the word first appeared in print. On September 30, 1916, Tristan Tzara, the Romanian poet who helped to found the Dada movement, wrote Marius de Zayas in New York, telling him about the new venture and asking if he would circulate one of its publications. Although Tzara's letter does not survive, de Zayas's response clarifies the promotional intentions of the original communication. On November 16, 1916, de Zayas wrote:

I have just received, deplorably late your esteemed letter of the 30th of September and the ten copies of your interesting "Dada" publication. I am much obliged for the copy you had the kindness to dedicate to me, the rest will be distributed as you wished among the people interested in the modern art movement. I shall try to interest bookstores in New York in selling your publication."[1]

The publication Tzara sent, to which de Zayas refers, must have been copies of their single-issue magazine, *Cabaret Voltaire*, released in June 1916; here the word Dada appeared for the first time in print. In the introduction to this maga-

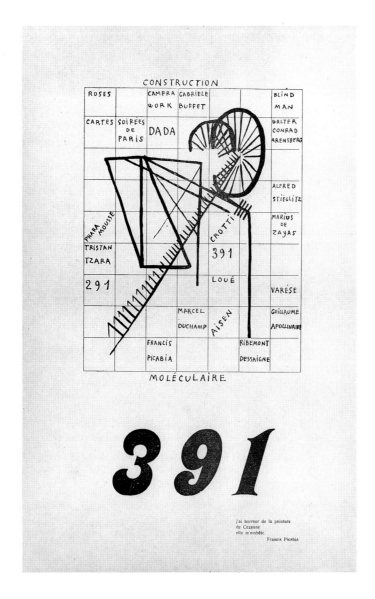

Francis Picabia. Construction Moléculaire. 391, *February 1919. Cover. Yale Collection of American Literature, Beinecke Rare Book and Manuscript Library, Yale University, New Haven*

zine, Hugo Ball, one of the founders of Dada, gave a brief account of the group's activities in Zurich and announced the purpose of their new cabaret:

its aim is to remind the world that there are independent men—beyond war and nationalism—who live for other ideals.

The intention of the artists here assembled is to publish an international review. The review will appear in Zurich and will be called DADA Dada Dada Dada Dada.[2]

Just how much of the original French and German text was understood by the artists in New York is difficult to say, but they seemingly took little interest at this time in joining forces with the Zurich group. Certainly they felt no immediate inclination to establish a similar movement of their own. In fact, on the basis of just this publication, the Americans might easily have regarded themselves as being far ahead of their European colleagues.

By comparison, for example, de Zayas's magazine, *291*, was—in terms of typesetting and printing—far more experimental and visually more exciting (see pp. 59, 60–61, and 63). Nevertheless, like Tzara, de Zayas wanted his activities and those of his colleagues to be recognized by a larger audience.

"For some time I have been working to establish artistic connections between Europe and America," he told Tzara, "for

I believe that the only way to succeed in maintaining the evolutionary progress of modern ideas is through the interchange of ideas among all peoples." With this in mind, de Zayas sent Tzara copies of *291*, and proposed sending him an exhibition he had organized at his gallery entitled "Abstract Art in America."[3]

"We are constantly battling here for new art," Tzara responded. "I am pleased to have connections with American artists, and to be able to be useful in our common interest." He went on to tell de Zayas that he had passed on his proposal for a showing of American art in Zurich to the gallery owner Hans

Corray, who, he reported, "is very eager to do it."[4] But the exhibition never materialized. Indeed, little came from this early contact with the Swiss Dada group, though the exchange introduced an awareness of European Dada activities to a select group of artists in New York.

From 1916 through 1920, avant-garde American artists continued their personal struggle with the National Academy and middle-class values. But perhaps because of their distance from the physical conflict of war, they did not feel the necessity to establish an official alliance with any radical European movement, no matter how similar in spirit. "It wasn't Dada,"

Duchamp recalled years later, "but it was in the same spirit, without, however, being in the Zurich spirit."[5] Duchamp admitted, however, that he and his friends in New York were aware of Dada activities in Zurich by 1916 or 1917; it was then, he said, that they had received a copy of Tzara's book *La Première Aventure Céleste de Monsieur Antipyrine* (*The First Celestial Adventure of Mr. Fire Extinguisher*), where Tzara supplied his French readers with a long, if somewhat contorted explanation of Dada:

> *Dada is our intensity; it sets up inconsequential bayonets the sumatran head of the german baby; Dada is life without carpet-slippers or parallels; it is for and against unity and definitely against the future; we are wise enough to know that our brains will become downy pillows that our anti-dogmatism is as exclusivist as a bureaucrat that we are not free yet shout freedom—*
> *A harsh necessity without discipline or morality and we spit on humanity. Dada remains within the European frame of weaknesses it's shit after all but from now on we mean to shit in assorted colors and bedeck the artistic zoo with the flags of every consulate. . . .*[6]

Despite the international appeal suggested by this statement, "the flags of every consulate" were not immediately flown in the name of Dada. In New York, artists were especially reluctant to embrace the tenets of such a distant movement—a foreign organization whose aims they really did not yet understand.

Europeans, on the other hand, were eager to receive as much information as they could about artistic activities in America. In 1916, for example, a journalist by the name of C. B. Clay learned of the sensation caused by Crotti's *Portrait of Marcel Duchamp* (see p. 103) in the Montross show, and wrote an article entitled "L'Amérique s'amuse" ("America Amuses Itself") for the Paris paper *Excelsior*. After informing his audience that evidence of French influence could

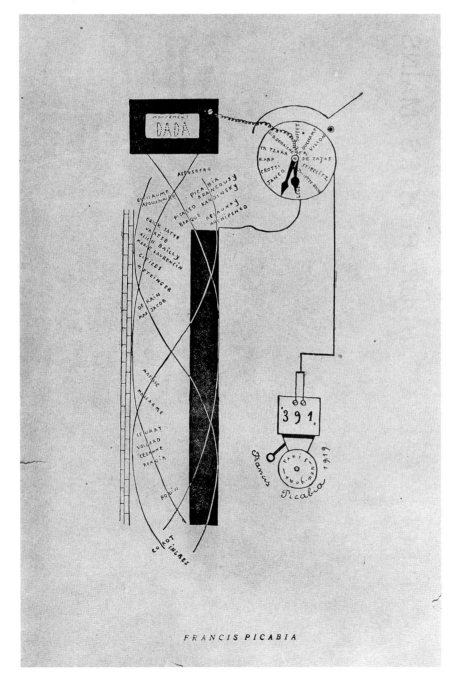

FRANCIS PICABIA

Francis Picabia. Mouvement Dada. *Page from Anthologie Dada, Zurich, May 19, 1919. Offset, printed in black on salmon-colored paper, 10 ⅞ x 7 ⁵⁄₁₆". Library, The Museum of Modern Art, New York*

be found everywhere in America—citing, as one example, the new fashion for terrace gardens and cafés—he told them that it was especially true in the arts. "They create joy in some and admiration and naïve surprise in others," he wrote of French artists living in New York, "and they launch work after work." He sarcastically predicted that Crotti's portrait would soon be the new vogue. "The critics have declared that this was a work of art [sic]. The debutantes of the next winter season and the new millionaires will have their portraits made in this fashion."[7]

Through correspondence, a number of other influential critics in Paris kept abreast of art activities in New York. When the second issue of *The Blind Man* (see p. 184) appeared in 1917, for example, Henri-Pierre Roché sent a copy to Guillaume Apollinaire. He wrote back acknowledging receipt of the publication and promised to announce its appearance in one of his forthcoming columns. Although it took him nearly a year, he devoted an entire article to "The Richard Mutt Case," in an issue of the *Mercure de France* during the summer of 1918. "The viewpoint of the Society of Independent Artists is evidently absurd," he concluded, "for it arises from the untenable point of view that art cannot ennoble an object."[8]

Occasional reports of artistic activities in Europe also appeared in the American press, but at this early stage, most reporters failed to grasp the meaning behind Dada's seemingly senseless activities. In an article entitled "What Is Dadaism?"—which appeared in an issue of the *New York Tribune* during the summer of 1918—a reporter attempted to provide his readers with a response. Quoting extensively from an article that had originally appeared in the *Kölnische Zeitung*, he provided the following definition: "The word 'dada' symbolizes the most primitive relationship to environing realities; with 'dadaism' a new reality comes into its own. Life appears as a simultaneous medley of sounds, colors and intellectual rhythms, which are unhesitatingly embodied in 'dadaist' art, with all the sensational cries and fevered

fancies of its venturesome average mood and in all its brutal reality." Continuing to translate from the German newspaper, this article informs American readers that the Dada movement originated in Zurich a few years earlier, but that its working methods and objectives seem to have added nothing new or original to those originally proposed by the Futurists. And even though the article concludes with the statement that Dadaism "cannot justify its right to exist," it warns that one particular aspect of the movement deserves the attention of all those who fear the threat of German nationalism (as, of course, would most Americans during the war years): "'Dadaism,' as its apostles always emphasize, professes internationalism, consciously and expressly."[9]

But even with access to periodic reports such as these, at this early date, few artists in New York took a serious interest in the rebellious activities of European intellectuals in a remote capital some three thousand miles away. The first significant American contact with the Zurich group came in the fall of 1918, during Picabia's visit to Switzerland. In August, Picabia had received a letter from Tzara inviting him to participate in the Dada movement in Zurich.[10] Picabia immediately responded, expressing curiosity and interest in Dada activities. A brief correspondence ensued and Picabia sent several contributions that were published in the third issue of *Dada*, the magazine Tzara edited for the group. But their collaboration reached its greatest intensity only when Picabia and his wife visited Zurich for three weeks in 1919. Years later Arp thought that because Picabia came directly from New York, he must have been sent "as an emissary of the American dadaists."[11] In Zurich, Picabia released another issue of *391*, which had been idle for about a year and a half since its last publication in New York. The cover of this Zurich number was a drawing by Picabia entitled *Construction Moléculaire* (*Molecular Construction*; p. 193), where members of the New York group were for the first time officially included within a specifically Dada context.

In the squares of a background graph, the names Arensberg, Stieglitz, Duchamp, de Zayas, and others appeared, as well as the titles of their respective magazines, *Camera Work, The Blind Man*, and *291*—all of which were integrated within the tessellated "molecular construction" of DADA (and where, of course, the name of Picabia's new friend, Tristan Tzara, also appears). The New York connection was further amplified in another Picabia drawing appearing several months later, this time in Tzara's publication *Anthologie Dada*, the most ambitious number in the Zurich Dada series, released in May 1919. Here the Dada movement was represented by the diagram of what appears to be an evolutionary fire alarm, the wires and clock of which were labeled with the names of Picabia's colleagues in New York, Zurich, and Paris, as well as a host of nineteenth-century French artists, beginning with Corot. The entire apparatus fed into an alarm box labeled "391," and the soon-to-be-activated bell below was labeled: "Paris-New York."

If this inscription was meant in any way to predict the direction of Dada's energies, it was uncanny in its accuracy, but for the moment, most reports of Dada that appeared in the American press were based either on activities that took place in Switzerland or in Germany, and most were still primarily devoted to explaining the nature of the phenomenon. In March 1919, for example, the first in a series of reports on Dada appeared in the editorial section of the *New York Times*. Quoting mostly from European newspapers, the *Times* told its readers that publications from Zurich claim "Dada doesn't mean anything." The following passage from Tzara's "Dada Manifesto 1918" was then cited:

Here we cast anchor in the rich earth. Here we have the right to proclaim, for we have known shivers and awakening. Ghosts, drunk with energy . . . we are tricklings of maledictions in tropical abundance of dizzy vegetations, gum and rain is our sweat; we bleed and burn thirst, our blood is strength.

Knowing this would do little to enlighten its readers, the *Times* writer then gave

examples, presenting, among other things, the translation of a poem by Vicente Huidobro about a Cow Boy who "Dances a Cake Walk [in] New York," and who, "On a violin string / Crosses the Ohio." The article concluded by warning that the Dada movement might someday find adherents in America: "Searing transcendences that he symbolizes or dadaizes may be left to the vigilance of the Huidobro Society, sure to be formed, if not here, then in Boston."[12]

A few months later, relaying information that had been discovered in a copy of the Journal de Genève, the Times provided a report on the last Dada soirée organized by Tzara in Zurich, at the Salle Kaufleuten on April 9, 1919 (an event that allegedly attracted an audience of over one thousand, the single most successful in a series of Dada soirées held in Zurich). Acknowledging, again, that it is difficult to determine exactly what Dada means, the editor identifies Zurich as "the capital of the preter-modern, preter-futurist movement," and points out that one of its main tenets is a contempt for the art of the past.[13] Although this editorial may have passed unnoticed by most artists living in New York, it was carefully cut from the newspaper and preserved in the papers of Walter Arensberg, who by this time seems to have developed a keen interest in European Dada activities.

One of the first Americans to see a Dada exhibition in Europe was Katherine Dreier, who, on a trip to Germany during the fall of 1919, visited the Society for the Arts exhibition in Cologne, the show where Max Ernst and his colleague, Johannes Baargeld, were forced to show their controversial works in a separate gallery, in a room they chose to label with the sign: "DADA." At the exhibition, Dreier met Ernst and Baargeld and told them that she had a friend in New York, Marcel Duchamp, who was sure to be interested in their work (as for herself, whose views of modern art were always guided by a social conscience, she must have been even more delighted to see the Dada works exhibited alongside paintings and drawings by the mentally ill and naïve). Both Ernst and Baargeld were familiar with the name Duchamp from

Apollinaire's book on Cubism and, thus, received Dreier warmly, especially her proposal that their exhibition be shown in New York.

"Next winter we would like to exhibit an ensemble of your pictures," Dreier proposed in a letter to Ernst written a few months after her return to New York, "together with some of the German Dadas." Ernst responded immediately and with enthusiasm, saying that, for some months, he had been "in continuous communication with the Paris Dadaists," and he agreed that a showing of Dada work in New York would be a good idea.[14] But when Dreier applied for an export license from the British occupation authorities in postwar Cologne, they refused, citing as their explanation the scandalous nature of the works in the exhibition. Her efforts to establish a rapport with the German Dadaists, however, were not diminished; on a subsequent trip to Germany, in search of new work for exhibition in the galleries of the Société Anonyme, Dreier arranged for a showing of works from the First International Dada Fair in Berlin (which featured the work of George Grosz, Raoul Hausmann, John Heartfield, Johannes Baader, and others), only to find that these works, too, were deemed too controversial to leave the country.[15]

Back in Zurich, Tzara continued his promotional activities in earnest, and made a concerted drive to expand Dada's influence in America. In the Anthologie Dada he announced that in a forthcoming issue of the magazine, two contributions would be coming from New York: Arensberg's "Caca and the Calculation of to Be," and Varèse's "Le Robinet Froid." More news of Dada would eventually reach New York via Duchamp, who had returned to Paris for a three-month sojourn in July of 1919. For a brief period, he was a house guest of the Picabias, where he certainly would have heard about any Dada activities that took place, and we know that at the Café Certà, he met a number of other French Dada poets (most of whom had themselves learned of Dada through their correspondence with Tzara).

In January 1920, the very month when Duchamp left to rejoin his friends in New York, Tzara triumphantly arrived in Paris, "awaited," it is said, "like a Messiah." If we can judge from notices in the foreign press, he took Dada with him. From this point onward, reports on Dada that appeared in the American newspapers were almost exclusively devoted to events that had taken place in Paris. As enthusiasm for Dada swelled, Tzara automatically began to list the names of Americans as adherents to the cause, even though he had rarely made an effort to secure their authorization. Even before his arrival in Paris, for example, he had a flyer printed up for insertion in Breton's magazine, Littérature, wherein he listed the names of forty-four American adherents to the Dada movement, including Arensberg and Charlie Chaplin.[16] And in February, Tzara issued the Bulletin Dada, the sixth number in his Dada series, where he listed seventy-six presidents of the movement, including even more Americans: Walter Pach, Alfred Stieglitz, and Abraham Walkowitz.[17]

With the exception of Arensberg, it is doubtful that any of the other Americans named by Tzara would have enthusiastically accepted their inclusion on this list. It is difficult to imagine, for example, that Stieglitz would have willingly lent his name to Dada, even though he had maintained a warm friendship with Picabia ever since the time of the Armory Show. At one point during the spring of 1920, however, it seems that he gave some serious thought to the prospect of publishing an American Dada magazine. Apparently, with all the attention paid to the movement in Europe, he must have concluded that the activities of his own artists might be better understood and appreciated if they were sanctioned by an internationally recognized enterprise. So during one of Gabrielle Buffet-Picabia's visits to New York, Stieglitz asked if she would write to Tzara asking for his authorization to open a branch of Dada in New York.[18] Tzara's response (if any) has not survived, but we can be reasonably certain that he would have welcomed the prospect of

creating an official extension of Dada in New York, for, as we have noted, he had already listed the names of many Americans as members of the movement.

Even though Stieglitz had consistently advocated the development of an indigenous American art, he was always interested in knowing what was going on in Paris, and various colleagues who traveled to Europe kept him regularly informed. In the spring of 1920, for example, the photographer Edward Steichen, who was sent to France during the war and remained, wrote to tell his old friend about the activities of Picabia, an artist for whom he had professed little regard during his earlier contacts in New York. "Picabia," Steichen explained, had become the "high apostle" of a new cult:

Dada or Dadaism & "391" is the vehicle of expression. It is the last word in "modernism," as vapid and empty as international diplomacy but unlike the latter is frankly & openly an expression of contempt for the public. The public enjoys it and is willing to pay for its enjoyment. It is part of the hollow empty laugh which is supposed to stand for gaiety & amusement in Europe today. It is smart to be gay. It is the heaviest clumsiest gaiety I have ever beheld. It reeks with sham and is a lie on the face of itself. It is cheap perfume used to quell the stench of seven million rotting bodies because the stench might interfere with money making. Money takes precedence over everything. [19]

Whereas opinions such as these may have prevented Stieglitz from accepting Dada with open arms, in her position as president of the Société Anonyme, Katherine Dreier wanted to do anything she could to strengthen a rapport with progressive European art. In May of 1920, she wrote to Gabrielle Buffet-Picabia asking her to find out if her husband would be interested in showing his work in a group exhibition of "French Dadas" at the Société Anonyme, or if he would prefer to be shown separately. In the same letter, she asked Gabrielle to get in touch with "Tzra" [sic], and ask "how much he would charge to send us a monthly public letter with short telegraphic sentences, telling us about the

general happenings and the exhibitions pertaining to the modern art movement in Europe." [20] She goes on to explain that she would like to post these notices on a bulletin board they are planning to hang in the library of the Société Anonyme. Whether or not Tzara ever received this message and complied with Dreier's request is unknown, but as we shall see, he would soon be employed to serve as Dada's European correspondent in a more public forum.

It was also in the spring of 1920, probably at Picabia's suggestion, that Tzara wrote to Arensberg requesting an American contribution to *Littérature*, which planned a forthcoming issue devoted to manifestos of the Dada movement. Arensberg responded by asking the American painter Louis Bouché, who was planning a trip to Paris, to hand deliver a letter he had prepared. Arensberg also asked Bouché to secure for him any Dada magazines and literature he could lay his hands on during his travels. In his letter to Tzara, he asks for Bouché to be received "in the name of Dada." After declaring himself honored at having received Tzara's letter, he warns that Dada may not be received with open arms in this country (apparently, Tzara had expressed tentative plans to make a promotional trip to New York). Arensberg writes:

I can't tell you how happy America would be to have you transplant the center of the world. I should not know how, however, to answer you as to the form of hospitality which the guardians of free speech would extend to you. . . . I look forward with impatience to seeing in the flesh the spirit of Dada. [21]

Arensberg complied with Tzara's request for a contribution to *Littérature* by composing a statement incorporating a scatological pun on the word Dada. He wrote: "The cable which I prepared to send you in answer to your letter read as follows—'benez [sic] tous d'avoir le mal de merde dans le mouvement kaka.'" Arensberg enclosed a blank sheet of white paper, with only the words "Dada est Américain" inscribed at the top. In what was probably a willful misunder-

standing of Arensberg's gesture, the editors of *Littérature* penciled in the rest of the page with an elaborate Dada manifesto, which they published under Arensberg's name in the May 1920 issue of their magazine. Arensberg later denied authorship of this document, though he was pleased to have been considered a member of the Dada movement. [22] For the readership of *Littérature*, however, this manifesto represented America's official participation in Dada, and established Arensberg's role as a spokesman for the American group.

Along with his message for Tzara, Arensberg also asked Bouché to deliver another letter to Picabia. In this second note, Arensberg warns his old French friend that the bearer of his message may not be fully sympathetic to Dada: "He [Bouché] has elements of a Dadaist in him," Arensberg wrote, "but to what extent these elements make him for or against Dada I can't at present say." He hopes that the Paris Dadaists might consider a trip to the United States, bringing with them renewed excitement to these quiet shores: "I wish you could come over with all the other Presidents [of Dada]," he remarked, adding the prediction: "I am sure that your adventures with the New York police would make the history of Cravan at the Independents a very pale affair." [23] He concludes his letter by expressing approval and continued interest in the activities of his Parisian friend: "The copies of 391 and Dada oe oe oe oe, if default of other word, have convinced me that you are not only alive but immortal. I am asking Bouché to hand you my subscription to whatever is new." Arensberg closes his message to Picabia with the words: "Montez, Montez," urging his friend's immediate return to New York.

A few weeks after the spurious manifesto of New York Dada appeared in *Littérature*, the famous Grand Festival Dada was held at the Salle Gaveau in Paris, an event which—like countless other Dada activities in this period—was dutifully observed by foreign correspondents and telegraphically relayed to their respective home offices for publication in the American press. For example, two

*Letter from Francis Picabia to Walter Arensberg, with
a postscript by Tristan Tzara. November 8, 1920.
Philadelphia Museum of Art. Arensberg Archives*

days after this event—which was unquestionably the climax of the Parisian Dada season—took place, an article appeared in the *New York Daily Mail* that described the festival as a regrettable disappointment, for the Dadaists, who had apparently announced to the press that they were going to shave their heads onstage, failed to make good on their promise. "The attraction was that the artists, all convinced Dadaists with green velvet coats, flowing red silk ties and hair hanging down over their shoulders, had promised to have a real barber on the stage who would cut their hair and beards," this reporter explained.

"Unfortunately, the barber never appeared." The evening ended to a persistent chorus of "Get your hair cut," while a shower of carrots and tomatoes was hurled at the stage.[24]

It was during the early months of 1920 that Picabia and Tzara joined forces to make Dada an international phenomenon. They were especially interested in seeing the movement expand to New York, so, unsolicited, they sent copies of their respective publications to the editors of various American newspapers, a scheme that succeeded in generating precisely the publicity they sought. It was probably Tzara who sent a copy of the

Bulletin Dada to the offices of the *New York Sun*, whose bewildered reporter found the sheet harmless, so long as the reader was in full possession of his senses. "If you suspect that you are crazy or that the world is crazy," he wrote, "then this document may seem a fearful confirmation of the fact." He noted that the *Bulletin* had nominated a number of Americans and expatriated Europeans to its roster of presidents: "Mabel Dodge, Alfred Stieglitz, Marcel Duchamp, Abram [*sic*] Walkowitz, Mina Lloyd [*sic*], John Marin, Katherine N. Rhoades, Walter Pach, W. C. Arensberg, and Edgar [*sic*] Varese."[25] And it was probably Picabia

"Dada" Will Get You if You Don't Watch Out; It Is on the Way Here

Paris Has Capitulated to New Literary Movement; London Laughs, but Will Probably Be Next Victim, and New York's Surrender Is Just Matter of Time.

This is a "dada poem" by M. Louis Aragon, who, according to the Chapbook, "Tantalizes you with half said things":

MYSTICAL CHARLIE.
"The lift still went down breathlessly
"and the staircase still went up
"That lady does not hear the speeches
"she is a fake
"and I who was already thinking of making
"love to her

"Oh the clerk
"so comical with his mustache and his
"artificial eyebrows
"He shouted when I pulled them
"Strange
"What do I see That noble foreign lady
"Sir I am not a light woman

"How isn't he ugly
"Happily we
"have pigskin bags
"hard-wearing
"This one
"Twenty dollars

"It holds a thousand
"it's always the same system
"No restraint
"or logic
"a bad theme."

By MARGERY REX.

What is Dada?

Who are the Dadaists?

Where?—But at least that is possible to explain—they are in Paris. They are taken very seriously in that city even if the rumors which have trickled over to London have caused howls of derision. And Dada is coming to New York.

Dada is a literary movement. It has attacked Paris with lunacies, jibes and insulting ironies, but Paris has nevertheless capitulated to Dada. New York has sympathetic souls awaiting Dada.

The younger French poets go in for Dada. Dada came in to being in the Cabaret Voltaire in Zurich in 1916. Its founder was Tristan Tzara, said to be a Rumanian. He is now at the head of the band of Dadaists who live in Paris.

One of Tzara's first Dadaistic performances was the reciting of one of his onomatopoeic poems to the accompaniment of an electric bell of eight-inch calibre, according to an account written by Mr. Aldous Huxley.

Founder Explains What It Means.

"Dada means nothing," said Tzara, as he is quoted in the November Chapbook, "If I shout:
"Ideal, ideal, ideal
"Knowledge, knowledge, knowledge
"Boomboom, boomboom, boomboom.
"I have set down exactly enough progress, law, morality and all the other fine qualities which so many intelligent people have discussed in so many books, to come finally to this, that, after all, each one has danced according to his own personal boomboom, and that so far as he is concerned, his boomboom is right: satisfaction of a sickly curiosity; private bell for inexplicable needs; bath; pecuniary difficulties; stomach with repercussion on life—

"If everybody is right and if all pills are not pink, let us try for once not to be right. People think they can explain rationally, by thought, what they write. But it is very relative—

What does it mean? What is Dada? The Isle de Paris is far away. But it was necessary to find someone on the Isle de Manhattan to throw light upon Dada.

Comment of New York Artists.

At the Societe Anonyme, at No. 19 East Forty-seventh street, moderne of the moderns, in painting, foregather. There I found Miss Katharine Dreier, director of the Societe, Marcel Duchamp, who painted the famous "Nude Descending the Staircase"; Joseph Stella, modern painter, and Man Ray, sculptor.

"Dada is irony," said Miss Dreier. "That is, its basic idea."

"Dada is nothing," said M. Duchamp. "For instance the Dadaists say that everything is nothing; nothing is good, nothing is interesting, nothing is important."

"It is a general movement in Paris, relating rather to literature than to painting," M. Duchamp went on. "It is very contradictory.

"Anything that seems wrong is right for a true Dadaist. As soon as a thing is produced they are against its production.

"It is destructive, does not produce, and yet in just that way it is constructive, do you see?"

Joseph Stella broke in with a wave of his expressive hands. He had just finished with his lecture on modern art.

"Dada means having a good time —the theatre, the dance, the dinner. But it is a movement that does away with everything that has always been taken seriously. To poke fun at, to break down, to laugh at, that is Dadaism."

"Dada is a state of mind," explained Man Ray, sculptor. "It consists largely of negations. It is the tail of every other movement—

Poésie de TRISTAN TZARA and FRANCIS PICABIA

Not an astronomical chart, but merely Monsieur Picabia's portrait of Tzara, whose personality is such, we are assured, that it perspires from the very joys of poetry he writes.

At the top is shown a cubist painting, "Nude Descending a Stairway," by Marcel Duchamp. Beneath it at the extreme right is one of the pictorial forms which is Dadaism. What can it mean, do you suppose?

Cubism, Futurism, Simultanism, the last being closely related."

Declares It Is Also Disgust.

But Tzara, who is Dada himself, says that Dada is also disgust.

"Every product of disgust capable of becoming a negation of the family is Dada—abolition of all hierarchy and social equation set up by our valets—Dada; abolition of the memory; Dada; abolition of the prophets; Dada; abolition of the future; Dada; liberty; Dada.

"Liberty; DADA DADA DADA, howling of irritated colors, interweaving of contraries and of all the contradictions, of grotesques, of inconsequences: LIFE."

Nonsense, with or without meaning, we learn, is Dada. Zulu yells, according to Mr. Flint of the Chapbook, special fondnesses, simulated imbecility, incoherent tumbles of words, and occasionally poetry—is Dada.

M. Francis Picabia, famous for many things, contributes this immortal bit of verse to the magazine mentioned:

"Dada smells of nothing, it is nothing, nothing.
"It is like your hopes: nothing.
"Like your paradise: nothing.
"Like your idols: nothing.
"Like your politicians: nothing.
"Like your artists: nothing.
"Like your religions: nothing.

No Prizes for Solutions.

No prizes, laments Mr. Flint, are offered for solutions of these bits of literature.

The Dadaists may be amusing themselves at the expense of the public, Mr. Flint warns, and they certainly know what they are doing in any case, he says, without letting us share the joke. Their ultimate object seems to be to discredit all the works of the mind.

As soon as any part or parcel of Dada becomes intelligible, some poets flee from it. Sense should be left to children, they feel. It saddens these poets to find sense in modern poetry.

More ironical and less Dadaistic, we are told, is verse by M. Paul Morand, who, according to the Chapbook, is a poet to be watched (?).

"Glorious day,
"The British Ambassador returns on foot from the Quai d'Orsay
"Like England
He is bounded below by gaiters of white chalk and above
By a chimney stack.
"In order not to spoil the success of the day for him the wounded DADA

are going to promise not to suffer any more."

Wouldn't This Make You Weep?

But now for your real uncompromising Dada—M. Pierre Albert-Birot:
"Pour Dada
"AN AN AN AN AN AN AN AN AN
"AN AN ÁN
IIII I I
"POUH-POUH POUH-POUH RRA
si si si
"drrrrr oum oum
"AN AN AN AN
"aaa aaaa aaa tainn
"UI IIIII
"HA HA HA HA HAA HA HA."

Like Ethel Monticue, in the "Young Visiters," we blush or faint at the "mystic words," yet without wishing to wound the sensitive and unintelligible soul of any of the visiting Dadaists we have heard this very identical verse issuing from the apartment next door at about 3 a. m. The young man uttering the words is less formal and less starched, especially at this time of night, than perhaps might be the Dadaist who originally proclaimed the poem from a platform. In common justice to our readers, we must state his attire is informal indeed.

He might be called a Simultanist also. Along with his cryptic song he beats a measure with his fist on the forehead of none other than his weary father, postmaster in Dadaism, himself, but unappreciative of its vocal aspects at this late hour. Indeed, he is actually held by his frantic father—we mean his DADA—and is also known to accompany his choral measures with movements of his feet.

Unreasonable, yes; but that is the essence of Dadaism.

"Dadaism will only continue to exist by ceasing to be," says J. E. Blanche.

"Painting had already begun to tear down the past—why not literature?" asked M. Duchamp. "But then I am in favor of Dada very much myself."

You Must and You Mustn't.

Paris is more serious, says the Chapbook, and in one of its reviews it prints the following:

"Madame Rachild has written an article on Dada. She has proved you must not write articles about Dada.

"Monsieur Georges Courteline spoke of DADA for an hour at Comoedia. He said that you must not speak of DADA.

"Monsieur Fernand Divoire never says DADA. He says 'the hobby horse' party.

"If you must speak of Dada, you must speak of DADA.

"If you must not speak of DADA, you must still speak of DADA.

The next step, after a cursory examination of Dadaism would seem to be a reactionary call for home and Mamaism, with all due respect, and rather all respect due, to the founder of DADA.

who sent a copy of the March issue of *391* to an editor at the *New York Evening Post* who had little positive to say about this bombastic periodical. "We have read this curious document from the Avenue Kléber [the address given on the last page for the Au Sans Pareil Gallery] without much reward," he wrote. "It seems to be patterned with a painstaking futility on the mock-pulpit obscenities which even the simple-minded tourist was hardly expected to be much impressed by [at] the old Moulin Rouge."[26]

It was during the course of the year 1920 that a number of European Dadaists published historical summations of the movement, wherein they specifically identified New York as a distant, though still active, extension of the enterprise Tzara and others had founded some four years earlier in Zurich. In an article published in the French magazine *Action*, for example, Albert Gleizes reported that he had known of certain Dadaists in New York, who were, he said, "bolder or more naïve than the others." And in his early, 1920 history of the Dada movement, Richard Huelsenbeck proclaimed that "In the countries of the Allies, including the United States, Dada has been victorious."[27]

By contrast, however, in accounts appearing in the American press, Dada was identified as a uniquely European phenomenon, although after the appearance of a long and important early article on Dada poetry by F. S. Flint in the London *Chapbook*, the activities of the movement were usually described more accurately and its objectives explained more succinctly. Utilizing Flint's reliable text, after 1920 most discerning critics chose to rationalize Dada's existence as an unavoidable, though necessary iconoclastic venture, justified, if on no other basis, by the sheer abundance of inferior Romantic poetry and art.[28]

Even more effective than these overviews in establishing an American branch of Dada, however, were Picabia's

Margery Rex. "'Dada' Will Get You if You Don't Watch Out; It Is on the Way Here," New York Evening Journal, January 29, 1921

continued assertions that the movement was active in New York. As if in an effort to bolster his claim, he periodically sent copies of *391* and assorted issues of Tzara's *Dada* magazine to friends back in New York, such as Stieglitz, who reported that he "always enjoys their receipt."[29] And it was doubtless Picabia who was also responsible for establishing Arensberg's newfound position as the preeminent spokesman for the movement in America. On November 8, 1920, he wrote to Arensberg on Mouvement Dada stationery requesting examples of his prose and poetry, as well as a picture of him, to be included in a proposed book to be entitled "Dadaglobe," an international compilation of Dada essays that never materialized.[30] Tzara added a postscript to this letter, remarking that "Picabia has told me that you are the true Dada of New York. I would like very much to see you in Paris. Speak to your friends about Dadaglobe."

On November 10, 1920 (two days after he wrote to Arensberg), Picabia sent a letter to Edgard Varèse in New York also asking him for a contribution to "Dadaglobe." Some six months earlier, he had sent the composer copies of *Dada* and *Cannibale*, so Varèse was already familiar with the movement and its publications. "I laughed myself silly reading them," he reported, and he assured his old friend that he was "doing passionate propaganda," presumably on behalf of the Dada cause. For "Dadaglobe," he sent Picabia a page of music, two little poems, a photograph of himself, and a caricature (possibly Clara Tice's abstract portrait: see p. 119). He closed off his communiqué by asking Picabia to pass on his greetings to Tzara, and to keep him abreast of all activities. In a follow-up letter, written in February 1921, he asked Picabia to send him "whatever you feel will help our propaganda," and he requested that copies of their publications be sent to the bookstore of a friend in New York, "so that he can exhibit them."[31]

On February 3, 1921, Tzara also wrote to Man Ray, soliciting further contributions to his proposed anthology. On February 24, 1921, Man Ray sent two

poems to Tzara, both written during the course of the previous year and both seemingly composed in the true spirit of Dada. Although neither composition was meant to be poetically intelligible, at least not in the traditional sense, one of the poems contained a prophetic message that Man Ray would eventually realize: "I'll see you again soon," he wrote, "sooner than you think." In an accompanying letter, he told Tzara that he would subscribe to a clipping service on his behalf (presumably to collect whatever notices were published in the American press on the subject of Dada), but he regretted that he did not have more to send him for inclusion in his proposed anthology. Apparently, Man Ray found a great deal of resistance to the acceptance of Dada among his American colleagues: "There were one or two others who promised some contributions for the American Da Da section," he explained, "but they have not given it to me."[32]

When news of Dada first hit the shores of this country, many Americans either failed to understand the movement or openly rejected it altogether. Even to some who professed a unique understanding of the avant-garde, Dada must have been considered just another four-letter word. The eminent New York lawyer and collector John Quinn, for example, reveals his prejudice against German art and displays a complete ignorance and lack of sympathy for this new movement, when he includes the following postscript in a letter to his friend and adviser Walt Kuhn:

I was called up last night about 8:30 by a woman who wanted to know whether I wanted to see an exhibition "of the German dada." I said, "What?" She said, "Dada." It sounded a little like Heep's [Jane Heap, of The Little Review] voice but was not Heep. I said, "What is it?" She said, "The German dada." "What?" I said. "Painting, batik and pottery." I said I was very busy. She said that it was only for one night at Arens' book shop. I said, "Why only one night?" She said, "Because Mr. Arens could not give time to it any longer," but that they might show the things to me "tomorrow morning if I cared to come." Dada work! The German dada! I said no, I did not admire German art and could not come down.[33]

Most early accounts of the Dada movement appearing in the American press were equally uninformed, though they certainly displayed a better knowledge of its origin and history than Quinn. Dada publications were readily available in several New York bookstores, where, at Picabia's request, Duchamp and Man Ray placed copies of *Dada* and *391*, as well as a number of other books, for sale. In January 1921, Duchamp wrote to Picabia and Germaine Everling to enclose a check and to tell them that sales had been good. "I hope to send you another check as big as this one soon," he wrote. In the same letter, he asked if they would ask Tzara to write a brief authorization for a Dada publication he, Man Ray, and a friend by the name of Bessie Breuer were planning. He closed the letter by confessing: "Here nothing, always nothing, very Dada."[34]

The first major newspaper article published in this country to acknowledge America's participation in the Dada movement appeared in the *New York Evening Journal* on January 29, 1921. In the piece, entitled " 'Dada' Will Get You if You Don't Watch Out; It Is on the Way Here," Margery Rex declares that New York will be Dada's next victim. In an attempt to come up with a definition of Dada, she refers extensively to the *Chapbook* article by F. S. Flint. But in order to supply an insight into the meaning of Dada, the columnist interviewed the founding members of the Société Anonyme—Katherine Dreier, Marcel Duchamp, and Man Ray—and the painter Joseph Stella, requesting from each a definition of Dada. Dreier, who never really understood the movement's more iconoclastic implications, said Dada's basic idea was "irony," while Duchamp exclaimed, "Dada is nothing." He asserted that it was essentially a Parisian movement, "relating rather to literature than to painting. It is very contradictory," he said. "Anything that seems wrong is right for a true Dadaist. As soon as a thing is produced they are against its publication. It is destructive, does not produce, and yet in just that way it is constructive." Whereupon Joseph Stella interrupted, "Dada means having a good

time—the theatre, the dance, the dinner. But it is a movement that does away with everything that has always been taken seriously. To poke fun at, to break down, to laugh at, that is Dadaism." Finally, Man Ray offered the last definition. "Dada is a state of mind," he remarked, echoing statements made by Parisian Dadaists. "It consists largely of negations. It is the tail of every other movement—Cubism, Futurism, Simultanism, the last being closely related."

It was at the Société Anonyme on April 1, 1921, that these artists held their first and only public gathering under the official auspices of the Dada movement. In conjunction with a group exhibition at the Société Anonyme of alleged Dada works (few of which actually were), Marsden Hartley was scheduled to lecture on the topic: "What Is Dadaism?" In order to encourage attendance, and perhaps to raise some revenue (admission was fifty cents), Dreier had cards printed up to advertise the event. The evening was visually reconstructed in a cartoon by Richard Boix, and its activities were documented by the press. Here is how one reporter recounted the evening's proceedings:

A lady wearing what is described as a "lace curtain shawl" and other flowering draperies [who can be identified as Mrs. Claire Dana Mumford, a painter, author, and psychologist enlisted by Dreier to represent the opposition] began the seance by berating the Dadaists and claiming it was nothing new anyhow. She then read long passages from Swinburne, apparently to prove that this writer was the original Dadaist. Joseph Stella, the cubist, was seated in the center of the room with a group of friends and apparently found it difficult to take this seriously. The lady who was reading from Swinburne broke off suddenly and said, "I wish that fat man," indicating Mr. Stella, "would say something. He has

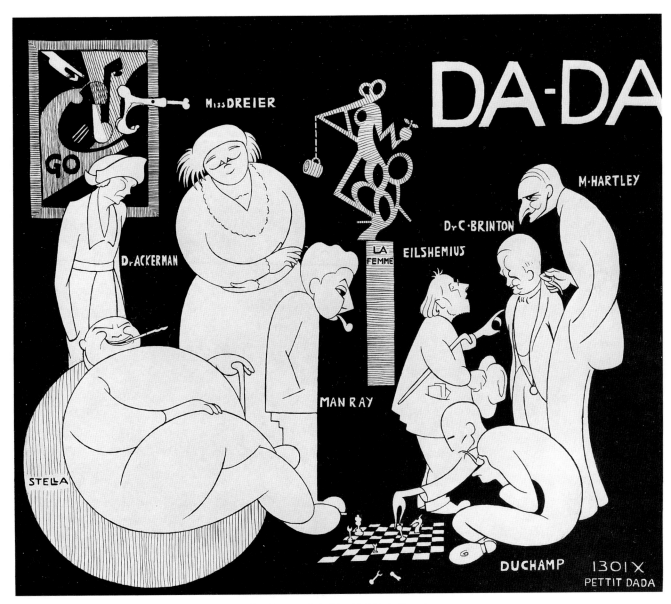

Richard Boix. DA-DA (New York Dada Group). 1921. Brush, pen and ink; sheet: 11 1/4 x 14 1/2", comp: 10 1/2 x 12 1/2". Study Collection, The Museum of Modern Art, New York. Katherine S. Dreier Bequest

Though this report makes no mention of Hartley's lecture, its text was published as an "afterword" to his 1921 collection of essays, *Adventures in the Arts*. In "The Importance of Being 'Dada,'" Hartley displayed a surprisingly thorough understanding of Dada's ideology and aims. He stated his position as an expressionist (affirmed by the style of his paintings), but explained that his acceptance of Dadaism was due to its freedom, humor, and ability "to deliver art from the clutches of its worshippers." He saw in the movement an opportunity to take "away from art its pricelessness and make of it a new and engaging diversion, pastime, even dissipation."[36]

But few who attended Hartley's lecture and witnessed the other festivities that took place at the Société Anonyme during this "Dada Evening" would have been capable of making any sense out of the movement's avowed nihilism. "Dadaists write lunatic verse and paint meaningless pictures," declared a writer for the conservative journal *The American Art News*, who had attended the gathering. He went on to predict that much was likely to be written about Dada in the near future, so readers were entitled to know exactly what the movement was all about; reflecting the magazine's characteristically myopic view of anything new, he proclaimed: "The Dada philosophy is the sickest, most paralyzing and most destructive thing that has ever originated in the brain of man."[37]

New York Dada, *1921. Cover by Marcel Duchamp. 14 ½ x 10 ¹⁄₁₆". Philadelphia Museum of Art. Lent by the Richard Feigen Gallery, New York*

In the same month that this Dada meeting was held at the Société Anonyme, in April 1921, the first and only American magazine to officially embrace Dadaism appeared in New York. Entitled appropriately *New York Dada*, the review was edited by Man Ray and Marcel Duchamp. The cover of this magazine reproduced Duchamp's *Belle Haleine*, the bottle of perfume carrying a photograph of Duchamp in the guise of his female alter ego, Rose Sélavy (p. 52). The label of this Rectified Readymade (it was originally a bottle of Rigaud toilet water) carried the inscription "NEW YORK—PARIS," expanding the original address to include America's connection. This perfume bottle was centered against a background mesh of minute, inverted, typed letters, repeatedly spelling out the words "new york dada april 1921," all printed in a sensuous violet-rose hue (another verbal-visual pun, perhaps on the color "rose" and Rose Sélavy).

The art critic Henry McBride used the cover of *New York Dada* as the critical focus for his brief though informative

review of this new and adventurous periodical. He took the opportunity to point out the importance of Duchamp's crucial role in this new movement: "he is a genuine dadaist, if not the first and original one. He's acknowledged by Paris and his name has been printed in the list of veritable dadaists ever since the sect was named." McBride then suggests that the intention of the magazine's cover might have been Duchamp's attempt to acknowledge America's precedence in the Dada movement: "They say in Europe, you know, that we are all dadas over here, and the countless repetition of the word upon the title page [of the magazine] may be M. Duchamp's sly allusion to that fact."[38]

This single issue of *New York Dada* ran a long letter from Tristan Tzara, responding to Duchamp's request for authorization to name their American periodical "Dada." Tzara wrote that "Dada belongs to everybody," and he gave many examples of how the word had already been put to use—from people's names to Picabia's dog, Zizi de Dada. It is in this letter that Tzara claims the word was accidentally discovered through random selection in a dictionary: "Night was upon us when a green hand placed its ugliness on the page of Larousse—pointing very precisely to Dada—my choice was made." The review also included a double-exposed portrait of Dorothy True by Stieglitz, who, later, in a letter addressed to both Duchamp and Man Ray, expressed his delight in how the magazine had turned out, adding that he thought "Tzara's letter [was] a real message."[39]

The magazine also reproduced a cartoon by Rube Goldberg, showing five old men in top hats holding sections of curved and twisted tubing, through which is directed a speeding bullet just released from a revolver. The man holding the firearm remarks: "I will now prove that a bullet doesn't lose any of its speed when it goes around corners." Waiting at the other end of this twisted channel is a seated boy, bound in rope, staring into the last section of tubing. This cartoon—probably unwittingly—can serve to illustrate the introduction of the

New York Dada, *1921. Page 1, 14 1/2 x 10 1/16".* Philadelphia Museum of Art. Lent by the Richard Feigen Gallery, New York

Dada movement in America, which, after having traveled through the twisted path of several European cities, lost a great deal of its momentum by the time it hit the artists in New York, most of whom were long bound to conservative traditions.

The last page of the magazine carried an advertisement for Kurt Schwitters's forthcoming exhibition at the Société Anonyme, a long unsigned poem by Hartley, and two photographs of the Baroness Elsa von Freytag-Loringhoven. When the poet Hart Crane heard of the Baroness's inclusion in this context, he wrote to his friend Matthew Josephson: "I hear 'New York' has gone mad about 'Dada' and that a most exotic and worthless review is being concocted by Man Ray and Duchamp, billets in a bag printed backwards, on rubber deluxe, etc. What next! . . . I like the way the discovery [of the Baroness] has suddenly been made that she has all along been, unconsciously, a Dadaist. I cannot figure out just what Dadaism is beyond an insane jumble of the four winds, the six senses, and plum pudding. But if the Baroness is to be a

keystone for it—then I think I can possibly know when it is coming and avoid it."[40]

"It was inevitable," wrote Henry McBride in his review, "that some manifestation of the dadaists would occur in New York, and at last a magazine appears, issued by the New York group." But predictably, not everyone welcomed its appearance. Agnes Smith, for example, a journalist for *The Morning Telegraph*, wanted to know exactly what Dada was before committing herself to a review of the journal, so she asked everyone she ran into, from a writer to a waitress in a local restaurant (all of whom, she says, refused to be named). The most informed response seems to have come from a housewife, "a woman with four children, a husband and a wealth of information about everything that does not pertain to the home." The woman quickly admonished the journalist for her ignorance. "Why I am surprised that you haven't heard all about it," she remarked. "Every well-informed person knows about it. It has been in all the newspapers and most of the magazines and every one is talking about it." When it came to defining the movement, however, she was a little less precise. "It isn't art and it isn't literature," she said. "It is a philosophy, something much too big for me to explain." She did add, however, that: "In Dada, you don't have to be coherent; you may talk as you please."[41]

The confused journalist then asked a friend—whom she described only as "100% American"—who told her that the movement was "German propaganda," and who said that recently "the Da Da leaders advertised for athletes to guard the exhibition" (see p. 207). The thought of an art exhibition being so controversial as to require guards posted at its entrance proved sufficiently stimulating for the newspaper to hire a cartoonist to visualize the event.[42] "As for the American attitude towards Da Da," the journalist noted, "you may learn all about it in Da Da, the magazine, for sale at the Washington Square book store." After citing long excerpts from the magazine without commentary, Smith then tells her readers: "You may take Da Da or

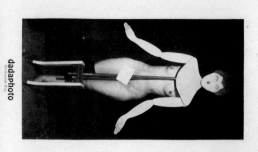

New York Dada, 1921. Page 2, 14 ½ x 10 ¹⁄₁₆".
Philadelphia Museum of Art. Lent by the Richard Feigen Gallery, New York

leave it alone. Maybe it does not exist. But don't say I didn't warn you."

In describing the publication of *New York Dada*, Man Ray later recalled that "the paper attracted little attention. There was only one issue. The effort was as futile as trying to grow lilies in a desert."[43] Persistent journalists, however, such as Margery Rex—who had earlier warned her readers of a possible Dada invasion (see p. 199)—continued to keep

readers of the *New York Evening Journal* informed of Dada activities in Europe. In May 1921, she published a long article describing the proposed excursions to various overlooked sites in Paris, where the Dadaists volunteered to provide tourists with factual details that they could not otherwise obtain through more conventional means. She begins her article by announcing: "Dada's loose again!" but comforts her New York readership by adding: "In Paris, of course!" Translating from an article that had appeared in *Comoedia* (the Paris newspaper that reported regularly on Dada activities), Rex, who seems to have taken

the Dada proposal more seriously than it was intended, tells future visitors to Paris that they might indeed benefit from the Dada tours: "The Dadaist guides might help out the tourists who enjoy contemplating palaces and art galleries which they think are named after Manhattan patisseries," she wrote, "and the plan will assist those Parisians who desire to 'visit' their own home town."44

Several months after the appearance of *New York Dada*, *The World Magazine* ran a feature article headlined: "DADA: The Cheerless Art of Idiocy" (p. 207), where a journalist by the name of Henry Tyrrell discussed mainly the European movement (particularly Picabia's activities in Paris). Tyrrell had been in correspondence with Picabia, who, about a year earlier, had sent him copies of several Dada publications. "The literature of 'Dada,'" he told Picabia, "I confess I do not understand."45 Apparently, Tyrrell considered Dada primarily a European phenomenon, telling his readers that "we do not see so much of it [Dadaism] in America." Nevertheless, he illustrated the article with reproductions of Man Ray's *Lampshade* (p. 90) and Jean Crotti's wire *Portrait of Marcel Duchamp* (p. 103).

Less than a month after this journalist observed the lack of Dada activities in New York, its principal proponents both left the country. Duchamp returned to Paris in June, and a few weeks later, Man Ray, seeking a more congenial atmosphere for his work, followed his good friend to the French capital. Just before his departure, however, Man Ray wrote a last letter to Tzara, summing up the state of Dada in New York:

> *Dada cannot live in New York. All New York is dada and will not tolerate a rival,—will not notice dada. It is true that no efforts to make it public have been made, beyond the placing of your and our dadas in the bookshops, but there is no one here to work for it, and no money to be taken in for it, or donated to it. So dada in New York must remain a secret.*46

Man Ray embellished this letter with a photograph of the Baroness posing in the nude (p. 208), with closely cropped head of hair and cleanly shaven pudendum (an

VENTILATION

On the question of proper ventilation opinions radically differ. It seems impossible to please all. It is our aim, however, to cater to the wishes of the majority. The conductor of this vehicle will gladly be governed accordingly. Your cooperation will be appreciated. DADATAXI, Limited.

R. Goldberg

I WILL ADJUST PROVE THAT A BULLET DOESN'T LOSE ANY OF ITS SPEED WHEN IT GOES AROUND CORNERS.

PUG DEBS MAKE SOCIETY BOW

Marsden Hartley May Make a Couple—Coming Out Party Next Friday

A beautiful pair of rough-eared debutantes will lead the grand sacking cotillion in Madison Square Garden when Mina Loy gives a coming-out party for her Queensberry proteges. Mina will introduce the Marsden Hartleys and the Joseph Stellas to society next week, and everybody who is who will be who-er than ever that night.

Master Marsden will be attired in a neat but not gaudy set of tight-fitting gloves and will have a V-back in front and on both sides. He will wear very short skirts gathered at the waist with a nickel's worth of live leather belting. His slippers will be heavily jewelled with brass eyelets, and a luxurious pair of dime laces will be woven in and out of the hooks. He may or may not wear socks. He has always been known as a daring dresser.

Attire of Debutantes

Master Joseph will wear a flesh-colored complexion, with the exception of his full-dress tights. He has created a furore in society by appearing at informal morning battles with coattails on his tights. The usual procedure at matinee massacres is for the guest of honor to wear tuxedo trunks with Bull Durham trimmings. He will affect the six-ounce steele glove with hard bandages and a little concrete in 'em if possible. His tights will be silk and he wears them very short.

Before the pug-debs are introduced, Miss Loy will turn a gold spigot and flocks of butterflies will be released from their cages. They will flitter through the magnificent Garden, which has been especially decorated with extra dust for the occasion. Each butterfly will flit around and then light on some particular head. If you get two oleoflees on your dome, try and keep it a secret.

Description of Ring

The ring will be from the Renaissance period with natural wood splinters. The gong will sound curfew chimes at the end of each round. It will be played by a specially imported pack of Swiss gong ringers. The ropes will be velvet and hung like portieres. Edgar Forrest, the violinist, has donated a piece of concert resin to be used on the canvas flooring, which will be made in Persia. Incidentally, the tights worn by the fighters will be made by Tweebleham, of London, purveyor to the Queen by highest award.

Master Marsden will give his first dance to his brother pug-deb Joseph, which will probably fill Marsden's card for the evening. Visiting diplomats in the gallery de luxe will please refrain from asking for waltzes.

—With apologies to "Bugs" Beer.

New York Dada, 1921. Page 3, 14 1/2 x 10 1/16". Philadelphia Museum of Art. Lent by the Richard Feigen Gallery, New York

image printed from a single frame salvaged from the film by Man Ray and Duchamp, which was accidentally destroyed in the developing process). This picture was flanked by the words "de l'a . . . merique," and across the very top of the page ran the continuous letters "merdemerdela . . . ," which can be read with the usual scatological inference, "la merde," or, with reference to the fact that this message of Dada comes from across the sea: "de la mer." On July 22, 1921, Man Ray's boat docked in Le Havre.

A short train ride brought him to Paris, where he was met by Duchamp and immediately introduced to the Paris Dada group.

Back in New York, at least one of Man Ray's former associates did not mind having her name associated with Dada: namely Baroness Elsa. In an effort to secure the return of a manuscript and drawing she had sent to Tzara through Man Ray, she initiated a correspondence by addressing a letter in English to the famous Dada impresario. "I do not know what happened to your 'Dada,'" she wrote, asking about his planned international anthology, "but I gave the ms. under special condition that I, of course, will have it returned—since you did not

offer payment." She warned Tzara that she would soon be going to Paris herself, and asks him to relay messages to two of her friends: Man Ray, who she says can "kiss her *cul* from across the Atlantic," and Marcel Duchamp, who should be given her love, but who, she adds: "might perhaps write me, the faithless pup!" Just exactly what Tzara thought of this letter is unknown, though it is unlikely he ever responded, for some years later the Baroness wrote again (this time in German), still demanding the return of her materials, and still warning that she planned a trip to Paris: "Can I put an appearance there without being hated, cursed?" she asked. "Will the French government act as an impediment toward an admirer of all things French, who wants to learn French?" Eventually, the Baroness kept good on her promise to see Paris, where it is possible that she met Tzara and finally secured the return of her possessions.[47]

After Man Ray's departure, Dada in New York would no longer be supplied the incentive necessary for its survival, though both he and Duchamp relayed occasional reports of Dada activities in Paris to friends back home. While in Paris, Duchamp observed Dada activities from a distance, refusing to become directly involved in any of the more public demonstrations. "The Dadas made too much noise [against] a show of noisemaking Futurists," he reported in a letter to Ettie Stettheimer during the summer of 1921. "To punish them, they closed their exhibition." In this same letter, he went on to caution that Dada activities such as these were really not as glamorous or as intriguing as they might appear from New York: "From a distance, these things, these Movements, take on a charm that they do not have close up, I assure you—but actually I'm becoming accustomed to Isms."[48] In the fall, Duchamp sent the Arensbergs a copy of André Breton's magazine *Littérature*, wherein poems by the Comte de Lautréamont appeared. "In it [the magazine]," he told them, "you will see the very seed of Dada."[49] And a few months later, just before returning to the United States, Duchamp wrote again to

New York Dada, *1921. Page 4, 14 ½ x 10 ¹/₁₆".*
Philadelphia Museum of Art. Lent by the Richard Feigen Gallery, New York

Ettie Stettheimer, telling her that he had seen a recent issue of *The Dial*, a magazine that he says has "a dada of genius," an expression he claims to prefer over saying "a genius of dada."[50]

The last vestige of Dada's life in America came from Duchamp, who returned to New York in January of 1922 for about a year's stay. He saw the Stettheimer sisters again, and even offered to arrange to publish one of Florine's poems in a Parisian Dada magazine.[51] And through correspondence, he

also kept in close contact with his friends in Paris. In September of 1922, for example, he wrote to Man Ray and Tzara with new ideas for Dada on both sides of the Atlantic. As a gift, he sent Man Ray a small religious pamphlet that he found at the house of a friend, which he turned into a Readymade by affixing to its cover the title and salutation: "The Non-Dada / Affectueusement, Rrose" (p. 209). In this same mailing he enclosed a letter for Tzara, proposing an amusing, if somewhat bizarre financial project. He wanted to market the word Dada as an insignia, cast in silver, gold, and platinum, to "be worn as a bracelet, badge, cuff links, or tie pin." The proposed item was to be sold in every country for a dollar or its

Oscar Frederick Howard. "'The Da Da leaders advertised for athletes to guard the exhibition,'" The New York Morning Telegraph, May 1, 1921 (Section II). Press clippings of Tristan Tzara, Bibliothèque Littéraire Jacques Doucet, Paris

Henry Tyrrell. "DADA: The Cheerless Art of Idiocy," The World Magazine, June 12, 1921

equivalent, with Duchamp handling the American enterprise. It would be accompanied by "a fairly short prospectus (about three pages in every language)," which would "enumerate the virtues of Dada." The purchaser would be informed that the insignia would protect him or her "against certain maladies, against life's multiple troubles," or as Duchamp put it, "something like Little Pink Pills which cure everything."[52] The lucrative potential of this scheme seems to have aroused little appeal among Duchamp's Paris friends, for it never materialized.

Duchamp closed his letter to Tzara by adding: "I'm going to have a look at Shadowland which has an article by Kreymborg on Dada. Maybe they'll take an article from you." The article Duchamp refers to, "Dada and the Dadas," appeared in the September issue of the popular theatre magazine *Shadowland*. Kreymborg, himself recently returned from Europe, focuses his attention on Tzara, whose portrait by Arp he reproduces. In fact, the entire account centers on the activities of the Paris group, many of whose members Kreymborg says he met during his trip abroad. His brief comment on Dada activities in New York, however, is obviously misinformed, probably due to his long absence from the city. In passing, he comments, "Even New York has a modest little group, led by the painters, Man Ray [who by this time had already been out of the country for over a year] and

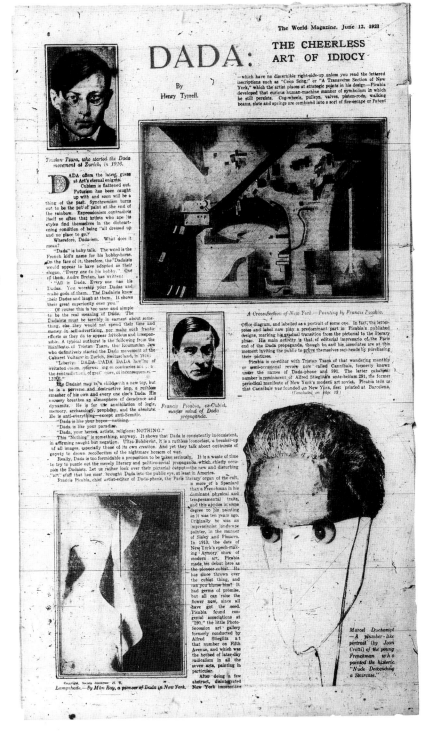

Joseph Stella, and Edgar [sic] Varèse, French conductor of the late New Symphony Orchestra."[53]

Actually, the year 1922 saw the first serious studies on Dada to appear in the American press. In February, *Vanity Fair* ran an article by the noted critic Edmund Wilson, Jr., who throughout his long career found little of value among the literary contributions to Dada. In this early essay, Wilson accuses the French Dadaists of going overboard in their attempt to free themselves from their Victorian past. He reports that Dadaism, which he calls "violent" and "sophomoric," has blindly turned to American skyscrapers, machinery, advertising, and jazz for its inspiration. In a satirical twist, he closes his article by requesting that the "barbarous," "harsh," and "horrible things" that make up the repertoire of European Dada be left to the Americans, for as he put it, "our monstrosities are at least created by people who know no better."[54]

Four months after the appearance of this essay, *Vanity Fair* nominated Tristan Tzara to their "Hall of Fame," which they followed a month later with a full-length article on Dada by no one less than its leading exponent—Tzara himself! Here, the Romanian poet provided his American audience with a clear and thorough history of the Dada movement, from its beginning in Zurich to its expansion in Germany, with the longest part of the essay devoted to a description of the various Dada events that took place in Paris. He ends his account by asserting that "Dada is known throughout the world," citing many European capitals to which it has spread, from Athens and Belgrade to Constantinople. But, curiously for this context, Tzara makes no mention of Dada's expansion to America.[55]

Tzara's article was preceded by an introductory text composed by the editors of *Vanity Fair* to provide readers with a basic background and factual history of the Dada movement. But shortly after the article appeared, Tzara told Matthew Josephson that he had not written the opening paragraphs of this article, even though they were published under his name, and that he had not authorized deletions that were made to his original text. When Edmund Wilson heard about Tzara's objections, he wrote a long letter of apology, attempting to explain why certain changes had been made.[56]

For a brief period, Tzara actually served as *Vanity Fair*'s most informed reporter of vanguard cultural activities in Europe. His Dada article was followed by three subsequent reports, the first on the Russian ballet, the second on Diaghilev's presentation of Stravinsky's *Mavra*, and the third on modern art in Germany. In all three of these articles, Tzara seized the opportunity to provide his American readers with an update on various Dada activities in Europe, telling them about Sophie Taeuber's marionette theater in Munich, the publication of his own *Le Coeur à Barbe* in Paris, a meeting with Schwitters in Hanover, and about a lecture he delivered in Weimar on "Dada in Paris."[57]

Initially, Frank Crowninshield, the editor of *Vanity Fair*, appears to have been satisfied with Tzara's periodic installments, but when his manuscripts stopped coming, Crowninshield must have suspected that his correspondent was beginning to run out of ideas. So at one point, he wrote asking the Dada impresario if he would consider providing his impressions of New York—"our buildings, women, social customs, hotels, dancing, music, society, scale upon which we live, the money we earn and spend, our sports, etc., etc."—in spite of the fact, as he readily acknowledged, that the author of this proposed article never set foot in America. "You can make this [article]," Crowninshield suggests, "just as cruel and just as merciless as you like."[58]

Tzara never wrote the article, but following the lead of *Vanity Fair*, during the course of 1922, a host of other American magazines published articles on the subject of Dada. In May, for example, *Century Magazine* ran a long article by the modern art critic Sheldon Cheney dedicated to answering the question: "Why Dada?" Somewhat belatedly, Cheney proclaimed, "There is to be a Dada invasion of America." "In fact," he added, "it is here in little already." After noting the recent appearance of *New York Dada* and several other American magazines, he makes the inaccurate prediction that in New York "we are likely to witness a mushroom growth of Dada journals and Dada activities." In response to the article's title, he further asserts, "we need Dada [in America] to destroy our whole mechanized system, which has blindly clamped the acquisitive supply-and-demand principles of business down over the realms of art and spiritual life."[59]

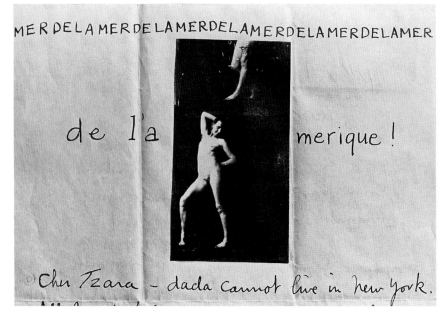

Man Ray. Letter to Tristan Tzara showing photograph of the Baroness, postmarked June 8, 1922. Bibliothèque Littéraire Jacques Doucet, Paris

Marcel Duchamp. The Non-Dada. *1922.*
Assisted readymade/found object. Courtesy Mayor
Gallery, London

Despite the need that Cheney shrewdly perceived, the presence in America of Duchamp, who preferred to keep a low profile in the art world, was not in itself enough to revive Dada's public life in this country. Privately, however, Duchamp occasionally admitted to friends that his artistic activities were inspired by Dada; in the fall of 1922, for example, while still aspiring to work in films, he told Paul Strand that "moving pictures are my dada now."[60] But when Tzara wrote and asked if Duchamp could help to organize a Dada tour in America, the artist advised that he seek the promotional talents of an agent in Paris, doubtless wishing to avoid the responsibilities of a potentially disastrous reception.[61] Indeed, Duchamp was cautious about having the names of his conservative American friends too strongly associated with the more outrageous expressions of Dada. When he was trying to decide upon the reproductions that would be included in the anthology he was preparing of McBride's writings (see p. 55), he wrote to the journalist and asked if he thought a certain work by

Picabia would be considered appropriate. "I have a copy of 391," he wrote, "in which there is a drawing by [Picabia] that is simply a stain of ink made by an overturned ink well (and which he calls the Virgin Mary)." The work by Picabia to which Duchamp referred was reproduced in a newspaper article on Dada that had appeared about eighteen months earlier in the *New York Evening Journal* (see p. 199; reproduced to the right below a photograph of Duchamp's *Nude*). "Do you think it's too Dada?" Duchamp asked McBride, adding "I could probably find something else by him [Picabia] at de Zayas's."[62]

Apparently, McBride thought that a splash of ink with a sacrilegious title was simply "too Dada," so, instead, as Duchamp had suggested, the photograph of a drawing by Picabia was lent by de Zayas and published in the final anthology. Nevertheless, a reviewer of the book used the opportunity to classify the publication as Dadaist, even though he wasn't altogether sure what Dada was. "Do you know what Da-da means?" he asked his readers, to which he responded: "Nor does anyone else." Whatever it was, the reviewer was inclined to think it was something radical, and he did not believe that McBride exactly fit the classi-

fication. "I would like to differentiate between it [Da-da] and something more reserved which we might agree to call Da," he proposed, whereupon he proclaimed: "Henry McBride is Da!"[63]

Although this reviewer was probably only trying to make a joke, his assessment of McBride was remarkably accurate. When reporting on Dada activities, as he did periodically, the newspaper critic displayed an obvious misunderstanding of the movement's more ideological objectives. But he wanted to know more, and used his monthly column in *The Dial* to inform readers of his communication with Dadaists in Paris. In November 1922, for example, he reviewed Pierre de Massot's *Essai de critique théâtrale*, which McBride presented to his readers as an example of Dada's latest effusion. "It was impatience at the cussed wilfulness of the gods who distributed this gift," he said, "that produced the movement Dada." He printed (in translation) excerpts from Massot's book that he felt might help his audience to understand the meaning of Dada:

> *Alas, the new efforts end in disappointing results and the boredom that is born out of uniformity and habit is getting stronger and stronger. From this boredom was born Dada, the only reasonable state of mind, Dada which is not dead and will never die. On the contrary, I believe more and more in the considerable importance of Dada; there is dada music, a dada painting, a dada literature; there might even be a dada metaphysic, a dada psychology, a dada medicine, etc. Dada that symbolizes disgust of everything.*[64]

When the French Dadaist Philippe Soupault saw McBride's review, he felt compelled to write the critic and straighten out his misconceptions of Dada—a letter McBride published in its entirety in the January 1923 issue of *The Dial*. "The time has not yet come to discuss and comment upon this movement and its consequences," Soupault told his American correspondent. "Time has to pass and the shady characters must disperse." Soupault felt that neither Massot nor Picabia (who wrote the preface to Massot's book) was a capable spokesman for Dada. "In America," Soupault wrote,

"you must see more clearly and separate wheat from chaff." He especially objected to Massot's claim that Dada was born out of boredom. "Our activity was intense and our desire to criticize without limit," wrote Soupault. "All the newspapers, the magazines, the books we published, all the musical, theatrical, poetic and pictorial manifestations that we organized did not permit us, I assure you, to be bored."

In his concluding comments, Soupault took the opportunity to provide McBride with an explanation of Dada's basic ideologies and aims:

Dada is not a school and never was a school under any circumstance. Dada is a state of mind. . . . We were driven by Dada to destroy that which seemed to us useless, to deny any unfound assertion, to mock traditional logic.

"Thanks for putting us right," McBride responded. "We have good eyes in America . . . but not good enough yet, I fear, to detect Dada wheat from chaff." He went on to explain to Soupault that Dada did not take hold in the United States because most Americans "had been vastly afraid of it," and that the movement was mistakenly understood as purely an artistic expression, rather than, as Soupault pointed out, "an état d'esprit."[65]

In the beginning of February 1923 (approximately a month after Soupault's letter appeared in McBride's column), two important articles on Dada were published in the New York press. The first was written for the New York Tribune by Kenneth Burke, a young American writer who would eventually become an influential literary critic and poet. Burke presented a straightforward, levelheaded assessment of Dada, identifying its principal exponents, citing appropriate examples of their work, and analyzing their objectives. He concluded by discussing Arthur Cravan, and even provided a poem about this notorious character, making one of the earliest attempts to include this legendary figure within the context of Dada.[66]

The second article appeared in The Freeman two days later, and was among the first notices to publicly proclaim: "Dada is dead." The author, a man by the name of Vincent O'Sullivan, living in Paris, reported that a vaudeville show had included a funeral procession for Dada, but no one had cried. "Dada was not a movement," he wrote, "it was an accident. . . . Dada leaves nothing—not even regrets . . . it deserved to die." But he warns his readers that "some middle-aged young men persist in believing that Dada is still alive, and, holding up the corpse by the arm-pits, they drag it through certain magazines and reviews in England and America." Later he identified these supporters as Americans living in Paris: "They still believe that Dada is alive. Nobody else does. These Americans will doubtless continue to speak for some time yet of Dada as a living thing. Don't believe them. Dada is dead."[67]

In mid-February 1923, Duchamp boarded a steamer and returned to Paris, where, as on earlier occasions, he wrote back to friends in New York providing periodic reports on Dada activities. In July, he told Ettie Stettheimer about an event that he actually did not witness: "There was a Dada session (which I didn't attend) and it ended up with a few blows exchanged, very funny, I was told."[68] The event to which Duchamp refers was the so-called "Soirée du coeur à barbe" ["Evening of the Bearded Heart"], organized by Tzara and held at the Théâtre Michel on the nights of July 6 and 7, 1923. The event—which did indeed end in a riot—featured avant-garde music, poetry, and drama, as well as two films by Americans: Man Ray's Le Retour de la Raison and Charles Sheeler and Paul Strand's Manhatta (retitled for the Paris audience Fumées de New-York). A reporter for the New York Herald described the festivities as virulent, saying that by contrast, he found Man Ray's film "mild and prosaic," though he noted that it managed to "arouse the indignation of the Super-Dadaists."[69] Fisticuffs ensued, and the evening ended with some of the participants carried off to the police station. Duchamp's absence from this event—fortuitous though doubtless planned—was somewhat ironic, for he

had certainly encouraged Man Ray's efforts in filmmaking, and it was he who had (nearly a year earlier) originally made arrangements for the premier showing of Manhatta in Paris.[70]

With Duchamp in Paris (where, other than for three brief trips to New York, he remained for the next twenty years), Dada in America was—technically speaking—dead. Indeed, as early as November 1923, a noted literary critic in New York assured readers of the Tribune that they would no longer have to fear the success of Dada in America. "While it may be a movement of subtle and far-reaching origins in Europe," he wrote, it "could not pretend to any designation more dignified than [that] of a passing and essentially futile fumisterie." In America, as he accurately observed, Dada was "tardily transplanted to a soil whose diversity was unindulgent of its genius and whose very composition at every point defeated its ends."[71]

And a few months later, Henry McBride, who had just returned from a trip to Paris, where he had attended the Dada performance at the Théâtre Michel, warned his audience that Tzara planned to stage similar events in America. "Mr. Tzara threatens to translate the scene of his activities to New York," McBride told his readers, "and actually contemplates an 'evening' here." Although he usually supported vanguard activities of all types, McBride reacted negatively to what he witnessed at the Théâtre Michel. He especially disliked Man Ray's film, which he said was "quite terribly-insulting-to-our-intelligence." After telling Tzara that he did not think his activities would be as well tolerated by police in New York, he tried to take credit for persuading him not to come. "If Mr. Tzara does not have an 'evening' soon in the Sheridan Square Theatre," he said, "I suppose I shall be to blame."[72] Apparently, McBride was convincing; Tzara never set foot in the United States.

By the end of 1923, most artists and critics in New York considered Dada a thing of the past, a movement that experienced a certain degree of success in Europe but which held little interest in America. In her important early book on

modern art, *Western Art and the New Era*—which appeared in 1923—Katherine Dreier, who never really appreciated the more nihilistic aspects of Dada, felt obligated, nevertheless, to assess its significance within the development of a modernist aesthetic. "Though cynical," she told her readers, "they [the Dadaists] do not wish only to destroy, for at the bottom they are constructive." According to Dreier, the artifacts produced by the Dadaists should still be evaluated on the basis of aesthetic merit, for, as she put it, they are often "capable of opening the eyes of many to beauty, which otherwise might have passed unseen." As for manifestations of Dada in America, she was unable to cite the work of any one specific painter or sculptor, claiming, however, that Dada existed naturally in certain aspects of popular culture:

> *One is constantly being asked in America, what is Dadaism? One might say in response that almost any form of our modern advertisements, which are essentially American and original, is some form of natural Dadaism in our country. As an illustration the advertisement of a young woman with attached hands, made out of paper, supposedly ironing with a real iron, is pure Dadaism. Where the Jazz band in our country has almost obliterated music, one gets an expression of Dadaism. Charlie Chaplin through his feet, is a pure expression on the stage. We in America often appear natural-born Dadaists as regards art, without possessing the constructive side. Therefore it seems doubtful whether an intellectual Dadaism would ever secure a foothold in America, with its intellectual constructive side as an undercurrent.*[73]

"No new activity in Paris, so far as I know," Duchamp wrote Ettie Stettheimer on January 1, 1924, indicating that he had nothing new to report on Dada, which, for all intents and purposes, was finished (soon to be subsumed by Surrealism).[74]

In the later 1920s and early 1930s, various magazines again took up the subject of Dada, but from a historical viewpoint, informing their readers of the movement's earlier demise.[75] Indeed, other than for certain memorable works by Man Ray and Picabia, it could be said that the more irrational and oblique implications of Dada had little effect on the immediate history of American art, though as many historians have noted,

Duchamp's machinist forms profoundly affected generations of artists in this country.

Dada's public life in America was so short that it has largely been overlooked in subsequent histories of this period—so brief, in fact, that the artists themselves tend to discredit its existence, bolstering Man Ray's assertion that there was no such thing as Dada in New York. In 1958, however, in a statement prepared for a Dada exhibition in Germany, Man Ray admitted his participation: "I might claim to be the author of Dada in New York," he wrote. "In 1919, with the permission and with the approval of other Dadaists I legalized Dada in New York. Just once. That was enough. The times did not deserve more."[76] But the short-lived existence of this movement in America can actually be looked upon as one of its more positive features. If Dadaism was designed from its inception to be nothing and self-destructive, as many of its proponents claimed, then the movement experienced its most successful manifestation in New York, where in the period of just a few months in the spring of 1921, it died almost before its birth!

9 • AFTERMATH

It would be a mistake to conclude that only the New York press reported on Dada, for in the years immediately following the First World War, a number of large metropolitan newspapers in the United States retained journalists in Paris to report on cultural activities abroad, and various wire services relayed news of the arts in Europe to regional centers throughout the United States. However, the very simplicity of Dada's message seems to have confounded reporters, particularly those removed from metropolitan centers who had never before reported on vanguard artistic activities, either at home or abroad.

As an example of just how misunderstood Dada could be, in an article by W. B. Seabrook—circulated throughout the country by the Newspaper Feature Service in 1921—we are told that leading critics have found the "queer canvases" of Dada "sheer insanity." The author directed his attention to Georges Ribemont-Dessaignes's *Jeune femme* (*Young Woman*; now in the collection of the Yale University Art Gallery, New Haven), a painting that was included in a traveling exhibition of works by members of the Société Anonyme during the fall of 1921 and the spring of 1922.[1] In an effort to find exactly how the features of a young woman could have been repre-

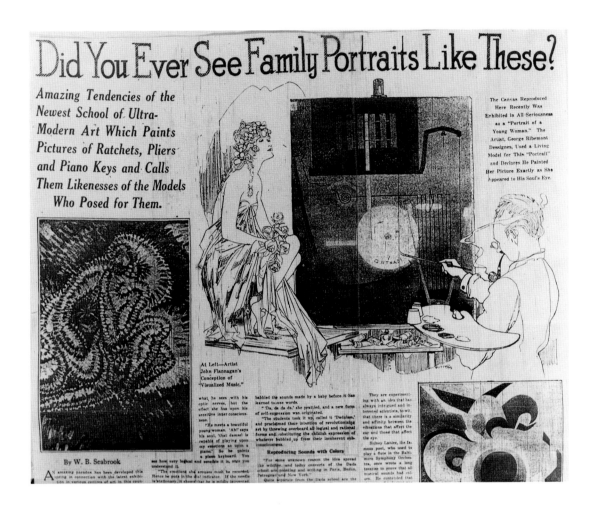

Did You Ever See Family Portraits Like These?

Amazing Tendencies of the Newest School of Ultra-Modern Art Which Paints Pictures of Ratchets, Pliers and Piano Keys and Calls Them Likenesses of the Models Who Posed for Them.

The Canvas Reproduced Here Recently Was Exhibited in All Seriousness as a "Portrait of a Young Woman." The Artist, George Ribemont Dessaignes, Used a Living Model for This "Portrait" and Declares He Painted Her Picture Exactly as She Appeared to His Soul's Eye.

At Left—Artist John Flannagan's Conception of "Visualized Music."

By W. B. Seabrook

sented by this essentially mechanical image, Seabrook told his readers that he had canvassed some of the artist's friends for an explanation. Ribemont-Dessaignes, he was surprised to discover, had actually employed "a living model," whom he claims to have painted "exactly as she appeared to his soul's eye."

Apparently dissatisfied with this explanation, Seabrook then informs his readers that he consulted a certain Mowgli Montague at the Columbia School of Journalism in New York, who claimed to have investigated the origins of Dada. This professor said he traced the movement to a neurotic Bohemian girl in Prague who attended school by day and danced barefoot on cabaret tables at night. "One night," reported Mr. Montague, "she danced in a more abandoned fashion than usual, and a fellow student tossed her a compliment and a rose across the absinthe-sticky tables." Surprised by this gesture, she supposedly babbled the sounds " 'Da, da da da,' " and, according to Montague, "a new form of self-expression was originated." As if to warn his readers, Seabrook then noted that Dada quickly found followers

in large cities worldwide. "For some unknown reason," he reported, "the idea spread like wildfire, and today, converts of the Dada school are painting and writing in Paris, Berlin, Petrograd and New York."

A few months earlier, a far more informed article on Dada had appeared in the pages of the *Boston Evening Transcript*. The author, Isaac Goldberg, derived most of his information from German Dada publications (indeed, the article featured photographs of the leading Berlin Dada artists), as well as from reports on Dada that had appeared in the Paris press. Readers are provided with a relatively accurate report about the origins of the movement in Zurich, but in analyzing a poem, the author speculates that Dada also seems to have found adherents in Japan. Goldberg goes on to say that since Charlie Chaplin had been identified as a Dadaist, he felt that the entire nation would likely soon be threatened by a conversion to Dada.

Unable to make sense of their verse, the author concludes that Dada is "perhaps jazz in terms of words instead of tones."[2]

After 1923, reports on Dada appeared with less frequency in the American press, as its European adherents broke into various factions. With the birth of Surrealism in 1924, the movement was officially declared dead. But Dada refused to die, at least in memory. In June 1923, Robert McAlmon had prophetically referred to Dada as "the small, sweet forget-me-not of the war." Indeed, throughout the 1920s, Dada came up repeatedly in literary and cultural journals, although inevitably, the movement was discussed as an event of some historical importance but with questionable influence upon the subsequent development of modern art and literature.[3]

With the exception of Tristan Tzara and his colleagues in Paris and Berlin, Europeans were equally content to forget the details of an artistic enterprise that was born out of a conflict they would

prefer to expunge from memory. In 1928, for example, in an article on Picabia that appeared in the Paris edition of the *Chicago Tribune*, a journalist—who probably only repeated information provided by the artist—reversed the chronology of Dada in such a way as to proclaim that the movement started in New York! "Not everybody knows that America was the birthplace of Dadaism," he wrote. "It was merely by chance that Picabia happened to be traveling in America when he had the first revelation of the doctrine that was destined to create such a stir in art circles after the war. . . . Picabia, Marcel Duchamp, and de Zayas constituted the triumvirate that set up the initial principles of what Tzara *later* christened Dadaism."[4]

The extent to which these issues were known or discussed among artists in New York is difficult to say, though we can be reasonably certain that for the remaining years of their lives, the leading protagonists of New York Dada—

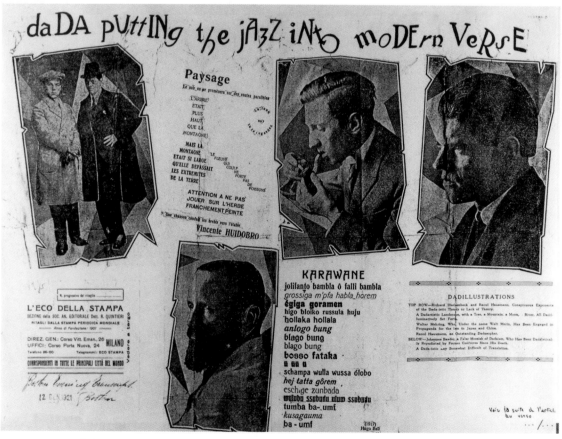

Isaac Goldberg. *"Dada Putting the Jazz into Modern Verse,"* Boston Evening Transcript, *January 12, 1921. Press clippings of Tristan Tzara. Bibliothèque Littéraire Jacques Doucet, Paris*

Arensberg, Duchamp, Picabia, and Man Ray—held fast to the principles of an artistic enterprise that openly disregarded convention and advocated an unrestricted progression of modern art.

After 1920, the Arensbergs spent increasingly more time in California, and consequently, for the remaining years of their lives, they were to see few of their friends from New York (with the exception of Beatrice Wood, who moved to Los Angeles herself in the late 1920s). At first, even Duchamp seems to have broken off communication with his old friends; other than for an occasional letter, over the course of the next decade, the artist and his patron communicated only rarely. After recuperating from financial losses, the Arensbergs continued to build their fine collection of modern and primitive art. But in the isolation of their Hollywood home—removed as it was from the activities of New York and Paris—Arensberg closely cherished the memory of his years in New York and his friendship with Duchamp.[5] They met briefly in the fall of 1926 when Duchamp came to New York to organize the Brancusi exhibition at the Brummer Gallery, but there is no indication of a subsequent contact or exchange for the next four years. "It is still the great lacuna that I never see you," Arensberg wrote to Duchamp in 1930. "There isn't a day that I don't pass some time with your pictures. They are your conversation."[6]

But if the paintings spoke, their message was not always clear to Arensberg, who wrote again to Duchamp in 1937:

I have been meaning for a long time to write you about those early paintings. To me, in view of your later work, they remain your greatest mystery. In the whole history of painting I know of no such complete and abrupt transition as these paintings show in relation to the work with which you immediately follow them. Can you remember at all anything that happened that would account for the change? Some autobiographical record of that period would be invaluable to the understanding of your work.[7]

Unfortunately, Duchamp's response to Arensberg—if ever there was one—no longer survives. But this inquiry serves to illustrate Arensberg's incessant search for meaning in the objects he so avidly assembled. Many art collectors amass vast quantities of paintings and sculptures for the sheer pleasure of possession. But Arensberg's obsession was different; each object he acquired was a reflection of his own complex personality. He surrounded himself with art works whose visual complexities and intellectual content stimulated his inquisitive mind on an endless quest for meaning, just as he would search for hidden messages in literary works in hopes of revealing their underlying significance. Because of his friendship with so many artists—particularly Duchamp—and because his involvement with modern poetry so closely paralleled the most advanced developments in the visual arts, Arensberg was perhaps closer to the formative process of the works he assembled in New York than any other American collector of his day.

Louise Arensberg died in November of 1953, followed by her husband just two months later. Before their passing, the Arensbergs had bequeathed their entire collection to the Philadelphia Museum of Art. By the time this generous gift was made, the modern collection consisted of some forty works by Duchamp, seventeen sculptures by Brancusi, fifteen Picasso drawings and paintings, eight Braques, and an equally impressive number of other important Cubist paintings, as well as a selection of works representing the various schools of modern art throughout the century (including many of the artists whose work is reproduced in the present volume).[8]

During the remaining years of his life, Duchamp would consistently cite Dada as the only movement in the history of twentieth-century art that bore any relationship to the aesthetic convictions that had informed his work, even though (excepting his involvement with the publication of *New York Dada*) he had never sought to establish any form of official affiliation with its founders or practitioners. "Dada was very serviceable as a purgative," he later explained. "And I think I was thoroughly conscious of this at the time and of a desire to effect a purgation in myself." The way Duchamp saw it, Dada was essentially a movement that had advocated a position of aesthetic anarchy, an attitude that already existed within him and a number of his colleagues even before there was a name for it. "It [Dada] is the non-conformist spirit which has existed in every century, every period since man was man," he remarked. "It is just that this time round [in 1916] they found a name for it."[9]

After he returned to Paris in 1923, Duchamp devoted more and more of his time and energies to the game of chess, playing regularly, training with grand masters, and entering into professional competition. Whereas chess occupied most of his time, it would be a mistake to conclude (as many did) that Duchamp had ceased artistic activities altogether. Although it is true that he maintained a low profile in the art world, denying all requests to exhibit his work publicly, throughout the remaining years of his life, he continued to develop ideas that can be traced to his earlier work and, thus, to his years in New York. These works shared one feature in common: they not only broke from the artistic conventions of the past, but they were consciously created with the intention of differing from the work he had himself earlier produced. It was the example of Dada's defiance of artistic tradition that caused Duchamp to maintain a lifelong admiration for its ideals. "I was in sympathy with dadaism," he explained a few years before his death. "The group that created dadaism felt they could liberate themselves from all that had gone before, from all conformism—both political and general."[10]

It was precisely these qualities that had initially attracted Man Ray to Dada, although he too maintained that the spirit had already possessed him. "I already had this instinct in me," he later explained, "and it would have developed whether I'd been encouraged or not."[11] But unlike Duchamp, from the very beginning of his career, Man Ray instinctively sought affiliation with other artists who shared his revolutionary ideals. Within days of his move to Paris, he had met many of the leading Dada painters and poets and was almost immediately accepted as an inti-

mate associate of their group. Before the end of the year, he was accorded a retrospective exhibition of the most important works produced during his years in New York, and within the next few months, he would discover a photographic process that uniquely combined his commitment to painting with his newly acquired proficiency as a photographer.

One evening, while preparing some contact prints from plate-glass negatives, he accidentally developed a sheet of light-sensitive paper, which—a few moments earlier—had been inadvertently exposed to the overhead light in his makeshift darkroom. The resultant print produced a startling impression. In a sort of reversed silhouette, an uneven pattern of opaque white shapes described the periphery of objects that had been lying on the surface of the light-sensitive paper at the time when it was exposed. Although photographers had experimented with similar techniques in the past, Man Ray believed his invention was so unique that—eventually—he decided the process should carry his own name: "rayograph."

He began informing friends and former patrons that the new technique had replaced his need and desire to paint. In April of 1922, he announced his discovery in a letter to the collector Ferdinand Howald, whose support in New York had made it possible for Man Ray to move to Paris. "In my new work I feel I have reached the climax of the things I have been searching the last ten years . . . you may regret to hear it, but I have finally freed myself from the sticky medium of paint."[12] Although Howald responded to Man Ray's report with a certain degree of curiosity—and he eventually purchased a number of photographs from the artist—we can be reasonably certain

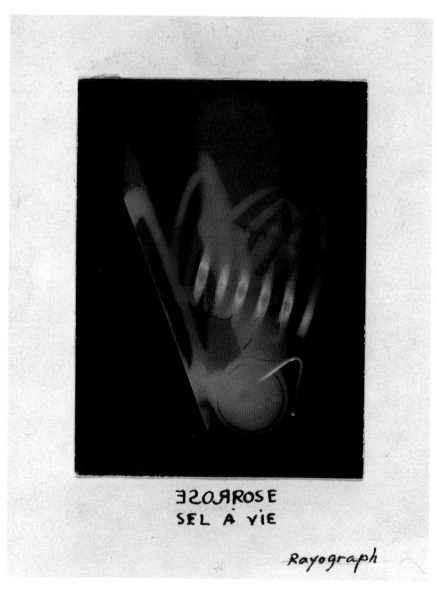

Man Ray. ƎꙄOЯ ROSE SEL A VIE. *1922. Rayograph (gelatin silver print), 2 7/8 x 2 9/16"; overall: 4 7/8 x 4". Papers of* The Little Review, *Golda Meir Library, University of Wisconsin*

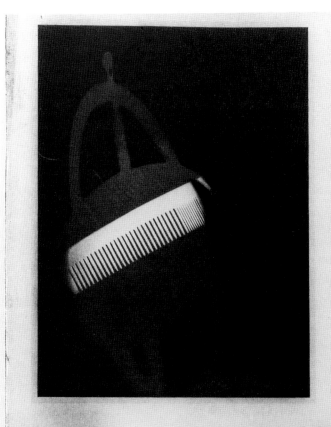

"A Comb Entering the Gyroscope"—a delicate and finely patterned abstract study in white, gray and black

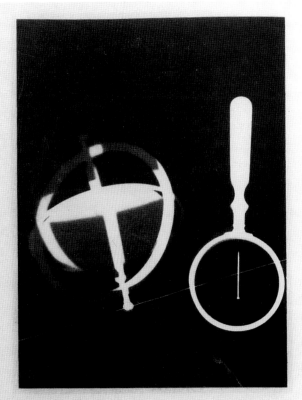

"Imitation of the Gyroscope by the Magnifying Glass, Assisted by a Pin." Note the contrasts of light and shade

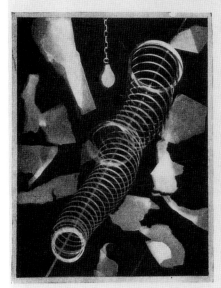

A Torn Letter, a Spool of Wire and a Watch Fob—a full and curiously satisfying photographic composition

*M*AN Ray—the well-known American painter now living in Paris and closely allied with the modern school of French art—has recently been experimenting along new lines with the artistic possibilities of photography. These "rayographs", as he calls them, are made, without the aid of a camera lens, by interposing the objects photographed between the light, which is made to fall upon them in a certain way, and a sheet of sensitive paper. Jean Cocteau, the French critic, has written of these prints that they are "meaningless masterpieces,in which are realized the most voluptuous velvets of the aquafortist. There has never been anyone else who has been able to produce anything like this scale of blacks sinking into each other, of shadows and half shadows? He has come to set painting free again. His mysterious groups are infinitely better than any of the ordinary still-lifes which attempt to conquer the flat canvas and the elusive mud of the colors."

"Composition of Objects Selected with Both Eyes Closed." This suggests the modern artistic passion for machinery

A New Method of Realizing the Artistic Possibilities of Photography

Experiments in Abstract Form, Made without a Camera Lens. by Man Ray. the American Painter

Man Ray. "A New Method of Realizing the Artistic Possibilities of Photography," Vanity Fair, November 1922. Photograph courtesy National Museum of American Art, Washington, D.C.

that the veteran collector would have preferred to see this young American painter pursue the "sticky medium." Duchamp, who by this time was back in New York, reacted quite differently. Upon learning of his friend's new work, he wrote: "I am delighted to know that you are having fun, and that above all you have given up painting."[13]

Man Ray was so excited about this new technique that not only did he write to all of his friends and relatives back home to tell them about it, but during the summer of 1922, he sent sample rayographs to various magazines in New York so that his discovery could be publicly announced.

The autumn issue of *The Little Review* reproduced an unusually mysterious image (identified, without further explanation, as a "Rayograph") accompanied by the equally enigmatic title: ƎꙄOЯ *ROSE SEL A VIE*. Whereas nearly every image of this type was made by recording the impression of inanimate objects, this rayograph appears to have been made by a pair of clasping hands, the palms immersed in shadow but the fingertips clearly discernible. The resultant image is that of hands reaching for one another in the darkness, which might have been precisely the impression Man Ray intended. The title makes it clear that the image should be read as a silent message from the artist to his friend back in New York, who, under the identity of Rose, was known to have sent telepathic messages across the Atlantic to Dada poets in Paris.[14]

At just about the time when this rayograph appeared, *Vanity Fair* ran a full-page article reproducing a portrait of the artist and four of these new photographic images, each of which is captioned by a long descriptive title. The accompanying text provides an explanation of the artist's technique, and includes an insightful comment by the poet Jean Cocteau, who proclaimed that with this new technique, "He [Man Ray] has come to set painting free again."

But no matter how successful Man Ray became as a photographer, he never really abandoned his devotion to painting, which he would always identify as his

"first passion." And even though he would go on to embrace the fantasy and mysterious qualities of Surrealism—attaining the status of one of its most highly regarded members—in whatever medium Man Ray worked, the lessons of Dada and the memory of his years in New York can be considered among the most influential components. Throughout his years in Paris (1921–40) and during a ten-year sojourn in Hollywood (1940–51), Man Ray would continue to approach all experiments in sculpture, painting, and photography with the iconoclastic sensibility of a true Dadaist.

Much the same could be said of Picabia, whose participation in official Dada activities was actually more direct and extensive than the involvement of either Duchamp or Man Ray. After his departure from New York in 1917, Picabia, we will recall, accepted an invitation from Tzara and went to Zurich, where he immersed himself in the hotbed of European Dada activities. There, and later in Paris, he continued to work in what has been called his "late dada-machinist style," producing memorable and exemplary works in both modes of artistic expression. With André Breton and Tzara, he became one of the most critical contributors to Paris Dada, a coordinated effort that continued until the spring of 1921, when conflicts within the group caused Picabia to declare his dissociation from the movement. A few years later, he would violently attack the aims and objectives of Surrealism, maintaining a disdain for organized artistic movements throughout the remaining years of his career as a painter.

Yet Dada—which, above all, professed a position of total artistic freedom—is the only organized movement with which Picabia had become involved that could be even remotely associated with the unbridled approach and stylistic divergences that marked his future development as an artist. With, perhaps, the exception of a realist phase during the time of the Second World War, Picabia's paintings bear little resemblance to any former or concurrent artistic style: the combined geometric and figurative images of the early 1920s, the collages

made from drinking straws, toothpicks, and other common objects (1923–25), the so-called monster pictures based on Old Master paintings (1924–27), the period of monumental transparencies (1927–32), and even the later anthropomorphic abstractions (1945–51), are all highly original contributions to the history of twentieth-century art. "In his fifty years of painting," Duchamp accurately observed in 1949, "Picabia has consistently avoided sticking to any formula, to wear a badge, and he could be called the greatest exponent of freedom in art, not only as against any academic slavery but also as against slavery to any given dogma."[15]

The spirit of freedom that had originally brought the Dada group together in New York slowly dissipated in the years immediately following the First World War. The enactment of Prohibition in 1919 and its enforcement during the 1920s certainly dampened many spirits, and renewed nationalism seems to have fostered a more conservative attitude in the arts. In February 1924, for example, Alfred Stieglitz wrote to Henry McBride to let him know that he was tearing up his remaining issues of *Camera Work* and *291* (the latter of which he had already discarded by selling some eight thousand issues to a paper refuse company in 1917, just two years after this ephemeral publication had originally appeared).[16] The reason Stieglitz took such a critical view of his earlier efforts to promote modern art is that now he had decided that the continued influence of European art could serve only to hamper the development of an indigenous American art. Choosing to forget the fact that he had given a number of important European artists their first showings in America, in 1923 he proclaimed that he had always fought for an "America without that damned French flavor!"[17]

Even though Stieglitz had taken a casual interest in Dada, he would never fully embrace its nihilistic message. Nevertheless, he was quick to recognize its influence on the artists he represented. When Arthur Dove showed him the first of his found-object assemblages in 1924, for example, Stieglitz reportedly

exclaimed: "Wait until Duchamp sees them!" Whereas Dove was certainly familiar with these precedents to his work, it is unlikely that their conception and making were directly inspired by either Duchamp or Dada, although shortly thereafter, it was works such as these that caused Katherine Dreier in 1926 to classify Dove as "the only American Dadaist."[18]

Although Dreier, too, never seems to have fully understood the more radical manifestations of Dada, we could very well agree with her summation if it were slightly altered to read that Dove could be considered "the only American [working like a] Dadaist [in 1926]." Indeed, with the dissolution of New York Dada's leading forces—Arensberg in California; Duchamp, Man Ray, and Picabia in Paris—those left behind must have felt some degree of aesthetic abandonment. Since, by definition, an avant-garde can exist only when its innovations are followed, what happens, we might well wonder, when its leaders disappear? In military terms, the defection of commanders and their generals would likely lead to the retreat or annihilation of all troops. But such was not entirely the case among artists in New York, who continued to hear about the activities of their former colleagues, and who were, in varying degrees, still influenced by their earlier contact with a group of artists and writers who were not willing to follow the rules of convention.

Whereas Duchamp, Man Ray, and Picabia would remain committed to the basic ideals of Dada throughout their lives, few of the other artists who came into contact with the Arensbergs and their circle during the war years in New York would go on to credit specifically either their participation in or knowledge of the Dada movement as such an important or influential factor in the development of their work. Nevertheless, with the possible exception of Albert Gleizes, who stayed with Cubism until his death, and of course, those who did not physically survive this period (such as Morton Livingston Schamberg, who died in 1918, and Arthur Cravan who disappeared in the same year), it could be argued that

literally every one of these artists was, in one way or another, affected by his or her early exposure to the liberating message of Dada.

Among the French, Jean Crotti was the only artist who returned to Europe and actually participated in Paris Dada activities. In January 1921, along with his wife, Suzanne Duchamp, he submitted a series of mechanomorphic paintings to the Salon des Indépendants, one of the central events of the spring Dada season. In the same period, Crotti would add his signature to a Dada tract, take part in the farcical "Visite Dada" to the Church of Saint-Julien le Pauvre, and attend the mock trial of Maurice Barrès. But before the year was out, he and Suzanne Duchamp would seek to classify their works as representative of a new movement, "Tabu," a word of their own invention meant to distinguish the serious and more positive nature of their production from the nihilistic aspects of Dada.

Not long after Tabu was announced in Paris, Crotti wrote an article explaining the basic idea behind the new movement, and he arranged for its publication in the special Picabia number of *The Little Review.* "Tabu," according to Crotti, was to be thought of as "a philosophical religion, without ethics," a movement devoted to expressing "the mystery, the divinity of the universe." And without invoking the word Dada, he admitted to his American readers that Tabu was nothing new. "Nothing is born," he said, "[it] all already exists. Things are only transformed by contact with others and manifest themselves under a new form."[19] This new form was defined by a series of abstract paintings that were remarkable innovations for their time, and even though the respective styles of their work would undergo diverse transformations, the subsequent explorations of both Jean Crotti and Suzanne Duchamp would retain certain telling reflections of their earlier involvement with Dada and Tabu.

Although he would later deny the influence of Dada, its iconoclastic overtones can clearly be detected in the subsequent musical compositions of Edgard Varèse, particularly in *Hyperprism* (1923),

which featured two woodwinds accompanied by a siren, and his most controversial work, *Ionisation* (1929–31), scored for thirty-five different percussion instruments to be played by thirteen musicians. After these remarkable compositions, Varèse would go on to produce virtually nothing original for the next twenty years, until the mid-1950s, when he wrote his first electronic score to integrate wind instruments, percussion, and taped sounds. Although Duchamp would recall that during their years in New York, the composer displayed almost no sense of humor and took himself and his work entirely too seriously for Duchamp's taste,[20] there can be little doubt that Varèse reflected the Dada spirit in his innovative and influential compositions of avant-garde music.

After Henri-Pierre Roché's return to Paris in the fall of 1919, he continued a close friendship with Duchamp and Beatrice Wood, and though he would still write an occasional letter to Louise Arensberg, their communication was naturally strained due to her husband's discovery of their affair. In the early 1920s, Roché spent increasingly more time serving in the capacity of European liaison for John Quinn, the powerful New York lawyer who was rapidly expanding his collection of modern European art.

During the summer of 1924, however, Roché received notice that Quinn had suddenly died, and his collection was to be put up at auction. Believing that the public sale of works by Brancusi would be a disaster—and, perhaps, feeling some personal responsibility to the artist, for he had arranged for many of Quinn's purchases—Roché formed an association with Duchamp and Mrs. Charles Rumsey (wife of the American sculptor) to purchase all of the Brancusis from the Quinn estate. In addition to his friendship with Duchamp, Roché and he were now business partners and would remain in close contact for the remaining years of their lives.

Throughout these years, Roché continued to keep daily records of his activities, journals that in the last decade of his life, he used as the basis for two successful novels, *Jules et Jim* (1953) and *Deux*

Anglaises et le Continent (1956), books that were transformed into even more successful films by François Truffaut. He would also look back upon the journals he kept in New York to write *Victor*, a novel based on his early friendship with Duchamp, which he began in the 1940s but that was published only posthumously.[21]

Among the Americans who came into contact with the Arensbergs and their circle, no one personally escorted the legacy of Dada further into the century than did Beatrice Wood, who, at the time of this writing, is still actively engaged in her career as an internationally renowned ceramic artist. Although she continues to produce whimsical and highly spirited drawings, the majority based on her everyday experiences, Wood is best known today for her brilliant lusterware glazes. It was only in 1932, when she was nearly forty years old, that Wood embarked upon a career in pottery. In the sixty years that she has worked in this medium, she has never forgotten her early years in New York, particularly her friendship with Duchamp and Roché, the Frenchmen who encouraged her first experiments in modern art. "Never do the commonplace," Duchamp once told her. "Rules are fatal to the progress of art." Appropriately, she has never allowed convention to dictate her approach to art, nor, for that matter, to life. In addition to making plates, bowls, chalices, and other ceramic items designed to serve utilitarian functions, she has also produced a remarkable array of figurative ceramic sculptures. Like her notorious submission to the first Independents exhibition in 1917 (see p. 182), most of these ceramic creations carry elaborate inscriptions, prankish titles that may not have been inspired by a direct participation in Dada, but certainly reveal the influence of at least two intimate friends who were.[22]

Although Clara Tice had also been involved with the men of Dada during her years in New York, she would never go on to embrace the dictates of any progressive artistic style. In the mid-1920s she moved out of Manhattan and, with the artist Harry Cunningham, who served as her lifelong companion and assistant, settled in the country around the city of Danbury, Connecticut. There she continued to support herself through commercial illustration, and although exhibitions of her work were occasionally held in New York, they would never draw the attention or create the scandal of her first showing in Greenwich Village. After Cunningham's death, she returned to New York and spent the last years of her life in a small apartment in Forest Hills. There, she continued to paint and sketch, combining her interests and skills in the production of a charming children's book, *ABC Dogs* (1940). Crippled by arthritis, blinded by glaucoma, and largely forgotten by the artistic community, she died in 1973, alone and in her eighty-fourth year.[23]

Of the artists who participated in the Arensberg gatherings, Charles Sheeler, Charles Demuth, and Joseph Stella went on to make the most significant contributions to modern art in America. Today, along with a host of other American painters with whom they shared certain stylistic affinities, these artists are classified as "Precisionists," a term meant not only to emphasize their precise and clearly delineated method of paint application, but which also acknowledges their reliance upon the machine. Moreover, all three artists went on to paint idealized visions of the American industrial landscape, celebrating the advance of technology. Whereas Sheeler and Demuth seem to have developed this style through the basic vocabulary of Cubism, Stella, as we have noted, was more directly influenced by the radiant and energized paintings of the Italian Futurists. With the possible exception of Demuth's series of poster portraits, it could well be argued that after 1923, the irrational and oblique implications of Dada were peripheral to their future development as artists. Yet few would question that the machinist paintings of Duchamp, Picabia, and Man Ray serve as the most important artistic precedent to the formation of a Precisionist style.[24]

Perhaps more than any other American painter of this period, John Covert, in his unorthodox use of materials and his sudden decision to terminate his career as an artist (although his motives were based more on personal finances than aesthetic concerns), most aptly embodies the nihilistic message of Dada. Finding no support for his work, in 1923 he took a job in Pittsburgh as a salesman for his uncle's company and gave his most important modern paintings to Katherine Dreier at the Société Anonyme. Dreier regretted his decision and, in 1924, offered him a position as "custodian-director" of the Société Anonyme Gallery, but he declined. "What the loss of such an artist has meant to the art world of America," she wrote a few years later, "one cannot gauge, as he was one of the most brilliant American artists of this day."[25]

Whether she understood Dada or not, Dreier's commitment to the development and display of modern art caused her to become one of the movement's most dedicated and reliable advocates in America. Lack of funds eventually forced her to close the galleries of the Société Anonyme, but over the course of the next thirty years, she would continue to organize displays of its collections. Her greatest achievement came with the International Exhibition of Modern Art, held at the Brooklyn Museum in the fall of 1926. In the seven weeks of its run, this enormous show drew some fifty thousand visitors, and featured recent work by over one hundred artists from over twenty different countries. But the success of this exhibition (comparable only to the Armory Show and the first Independents exhibition) was destined never to be repeated. Nevertheless, Dreier's donation of the Collection of the Société Anonyme to Yale University in 1941 and, after her death in 1952, the gift of selected paintings and sculptures from her private collection to various American museums, marked the most significant and lasting achievement of her lifelong dedication to modern art.

Among the artists considered within the context of New York Dada, Florine Stettheimer is arguably the one most removed from its radical and iconoclastic manifestations. The unique style for which she is best known—where slight,

sometimes ghostly figures occupy an equally ethereal environment, paintings that Duchamp later termed "group pictures"—was formed and fully defined by the end of 1916, probably long before she heard the word Dada (if ever she did). And with Duchamp's departure from New York in 1923, the famous dinner parties at the Stettheimer apartment would be attended increasingly by artists and critics who would have little reason to bring up the subject of Dada. Yet the fact that the paintings by Florine Stettheimer exhibit no apparent stylistic dependency upon the prevalent artistic movements of her day, their consistent disregard for academic figuration, and the fact that their subjects harbor an implicit commentary on doctrinaire social systems, are all factors to qualify their inclusion as appropriate extensions of the Dada spirit.

Similar reasoning allows us to consider the diverse poetic styles of Mina Loy and the Baroness Elsa von Freytag-Loringhoven, even though the writings of the former were almost always inventive, skillfully composed and sensitive, while the latter—though equally innovative in their own right—were usually disorganized and often lacked both direction and purpose. After the disappearance of Arthur Cravan off the coast of Mexico in 1918, Mina Loy returned to Europe, wondering if there was any possibility her husband could be still alive. She continued to write, and in 1923, *The Little Review* published the first portion of "Anglo-Mongrels And the Rose," the longest and most complex poem she was ever to compose. When the editors of this magazine asked if she would tell their readers what was the happiest moment of her life, she responded: "Every moment I spent with Arthur Cravan"; when they asked her about the unhappiest, she answered: "The rest of the time."[26] Years would pass before Mina Loy accepted the probability of Cravan's death, and he would make frequent appearances—often in disguised form—in her prose and poetry for the next forty years.

In 1923, the Baroness, who for years had wondered if she would be any more successful or prosperous in Europe, finally returned to Germany, where life treated her even more brutally. Living in dire poverty in Berlin, she sold newspapers in order to earn enough money to purchase food. Eventually, she sought rehabilitation in a German sanatorium, but even here she contemplated suicide, tortured still by the demons who had always struggled for her sanity. In 1926, she finally moved to Paris, where two friends from New York, Djuna Barnes and Berenice Abbott, generously supported her by contributing to her rent in a small transient hotel. Although the Baroness was no longer homeless, visitors described her hotel room as a complete abomination; not only was the plumbing inadequate (she reportedly used the flowerpots on her window ledge as a toilet), but the place was overrun with mice (which she fed), and she insisted upon sharing the small room with at least two or three dogs that she had picked up on the street, one of whom she named, appropriately, "Dada." After just over a year of living in these conditions, one night she and her dogs died quietly by asphyxiation, the tragic victims of either an accident or a cruel joke carried too far.[27]

Back in the United States, the groundwork that had been laid by Duchamp, Arensberg, Dreier, and others to promote the free and democratic display of modern art continued without interruption through the annual exhibitions of the Society of Independent Artists, although the excitement and controversy that surrounded the first show was never to be matched. Only for a brief period in the mid-1920s, during Holger Cahill's tenure as publicist for the organization, was the society's no-jury principle once again put to the test. In an effort to draw in members of the press and to increase attendance at the annual exhibitions, Cahill staged a series of elaborate farces. One year, he and another publicity agent sent in letters from a fictitious woman who claimed that her painting was not exhibited, and she threatened to make it appear mysteriously; the next day Cahill announced to the press that it had in fact materialized, creating a great sensation and trebling attendance to the exhibition.

Perhaps taking his lead from this story, Cahill went on to invent a movement he called "Interior Realism," where artists "painted" only blank canvases, mentally projecting the completed picture. "This is a very great and important movement," he announced to members of the press, "because it makes it possible for an artist to inject his picture into a museum exhibition or gallery without anyone knowing about it."[28]

Years later, Cahill acknowledged that his ideas were in part based on the antics of Dada, particularly his invention of an art movement that he called "Inje-Inje," deriving the name from what he claimed was the only word known to a group of South American Indians. He worked out an elaborate set of guidelines for potential members of this movement, which was to embrace not only the activities of painters and sculptors, but also actors, poets, and other participants in the arts. According to Cahill, the purpose of the movement was to acknowledge and emphasize the importance of the primitive: violence, vulgarity, and bad taste were to be celebrated as "the most vital elements in American life." Surprisingly, in the name of Inje-Inje, Cahill managed to enlist the support of some rather serious artists: poems were written by Malcolm Cowley and Orrick Johns, and paintings were submitted by William Gropper, Alfred Maurer, Mark Tobey, and John Sloan (who served as president of the Society of Independent Artists from 1918 through 1944).[29] But neither Cahill's publicity stunts nor Inje-Inje succeeded in revitalizing the Independents, who, however, continued to stage their annual exhibitions in New York until the Second World War.

In the years after the First World War, most Americans were possessed by a nationalistic spirit that made them distrustful of any foreign influence, political, social, or cultural. As a consequence, many artists promoted the development of an indigenous American art, and some—like the painter Charles Burchfield—genuinely regretted ever having been influenced by modern European art. Upon being discharged from the army in 1919, he reportedly

destroyed much of his earlier work because he found it degenerate. "The vagaries of the Da-da school were nothing compared to mine at this time," he later explained, "though I had never heard of Da-daism then."[30]

Though some artists may have considered Dada a subversive force that had little bearing on their own work, it was an artistic phenomenon of sufficient historical consequence not to be easily forgotten, even though most artists instinctively sought to isolate themselves from its message of negation. It may have remained out of sight, but not out of mind. The historical importance of Dada was first prominently acknowledged by Alfred H. Barr, Jr., director of the Museum of Modern Art in New York, who, in 1936, organized the exhibition "Fantastic Art, Dada, Surrealism." In the accompanying catalogue, Georges Hugnet—who wrote the Dada section—acknowledged that the activities of Duchamp, Picabia, and Man Ray in New York had actually taken place before there was a word to describe them, causing him to come up with the concept of "pre-Dada." As he put it: "When they discover Dada it is really Dada that discovers them."[31]

For almost a decade after this exhibition, Dada was still regarded as primarily a European concern, since all three of the protagonists mentioned by Hugnet were living in Europe. But with the outbreak of the Second World War, New York hosted a second wave of European artists who sought refuge in the United States, and Marcel Duchamp was among them. Even though most of these artists considered themselves Surrealists and followed the lead of their spokesman, André Breton (who also came to New York), Duchamp preferred to talk about his first sojourn to America. "During the other war life among the artists in New York was quite different," he told an interviewer, "much more congenial than it has been during these last few years." Dada still held his interest. "It was a sort of nihilism," he explained, "to which I am still very sympathetic."[32]

In the years immediately following the Second World War, Dada continued to be recognized for its historical importance, even though most surveys of this period emphasize Abstract Expressionism, which in the early 1950s was touted as the first significant American contribution to the art of this century. But in 1951, Robert Motherwell, a young painter and collage artist who was to become one of the most important members of this group, published *The Dada Painters and Poets*, the first comprehensive anthology of Dada writings. In researching the book, Motherwell sought out Duchamp, who advised him to include a section on pre-Dada. In his introductory text, Motherwell said Duchamp's *Bottle Rack* was "a more beautiful form than almost anything made, in 1914, as sculpture," a remark that made it clear to Duchamp that his readymades had been misunderstood. "I threw the bottle-rack and the urinal into their faces," he wrote in a letter to Hans Richter a few years later, "and now they admire them for their aesthetic beauty."[33]

It was also in 1951 that the first important article to trace the influence of Dada in American art appeared, written by John I. H. Baur, then curator of American Painting at the Brooklyn Museum, who later served as director of the Whitney Museum in New York. Baur was the first to observe a pre-Dada sensibility in the writings of de Casseres and de Zayas, and he singled out the machine paintings of Picabia and Duchamp for their influence on a number of American painters, like Charles Demuth and Morton Schamberg. But with some justification (considering his rather restricted view of Dada), Baur went on to claim that Man Ray was the only American who could be legitimately considered a follower of Dada. He was willing to speculate, however, that others might have taken on certain Dada sensibilities without ever having become directly involved in any of its activities. "Perhaps Dada's truest exponents in this country," he perceptively observed, "were men who were totally unaware of the existence of such a movement, but who were sensitive in their own way to the general disillusion which followed the war."[34]

In 1953, Duchamp organized a major Dada exhibition for the Sidney Janis

Gallery in New York. Both in the installation and in his design for the catalogue, Duchamp divided the objects that were displayed in accordance with the cities where they were produced: Zurich, New York, Hanover, Cologne, Berlin, Paris, Amsterdam, and other smaller city centers. Under New York, he placed thirteen of his own works from the Dada period and six by Man Ray (while, curiously, Picabia remained classified as a Parisian, even when most of the items included were made during his sojourns in New York).

Whether it was the example of Duchamp's presence in New York or not, in the mid-1950s two young artists— Robert Rauschenberg and Jasper Johns— separately forged artistic styles that then appeared to have their origins in Dada. Recognizing a connection between Duchamp's readymades and the literal incorporation of everyday objects in their work, critics came up with the label "neo-Dada." Before the decade was out, a host of other artists in America and England started to incorporate brash new subjects in their works, many deriving their imagery from modern advertising and other equally "disreputable" sources from the mass media. At first, there was no agreement upon what term should be used to categorize these artists; they were called *nouveaux réalistes*, factualists, commonists, neo-Dadaists, and a host of other names before the term Pop (introduced by the English critic Lawrence Alloway in 1958) won wide acceptance.

With Pop art considered the most important artistic tendency of the 1960s, Duchamp—and by association, Dada— were suddenly resuscitated and elevated to the status of subjects worthy of serious discussion. Even New York Dada would finally win recognition; those who continued to insist that it never existed were usually conservative artists, critics, and historians who preferred to think of American art as a national development that could not possibly have been influenced by a movement that they assumed to be only negative and destructive. Others knew better. In 1968, the year of Duchamp's death, the first important

article devoted exclusively to the subject of New York Dada appeared, although its author, William Agee, rather than discuss the work of Duchamp, Picabia, and Man Ray, directed his study to American artists who had been influenced by their work (often considering artists who were peripheral to the movement itself, such as Gerald Murphy, Stuart Davis, and Arthur Dove).[35]

In spite of the number of years that have passed since the subject of New York Dada was identified and studied as an independent artistic enterprise, it is only recently that we have come to recognize its far-reaching effect on subsequent developments in modern art. Virtually every artist of a modernist persuasion has been willing to acknowledge the importance of Duchamp, whether it be the example of his readymades, his keen intellect, his writings (especially the puns), or his unusual use of materials and fascination with themes of sexual identity (such as with the *Large Glass* and his invention of a female alter ego), ideas that all attained manifest form during his years in New York.

While few would dispute the influence of Duchamp, there are those whose myopic views of history will never allow them to accept his importance as an artist. Regardless of how much attention is focused on Duchamp—and more seems to be every day—it is unlikely that the general public will ever come to fully accept either the artist or the movement with which he is best associated, as they have, for example, Matisse and Fauvism, or Picasso and Cubism. No matter what attempt is made to popularize his work—from tee shirts and posters, to a shower curtain made from the *Large Glass* and sold in museum bookstores— no marketing effort will ever succeed in promoting the acceptance of an art that was intended, by its very design, to be accepted by only a select few.

There are even a number of critics who believe they are expressing the concerns of a "moral majority" when they identify Duchamp and Dada as among the most destructive and harmful elements that were ever allowed to contaminate the progression of modern art.

Perhaps in order to really understand the message of Dada, it will always be necessary to evaluate its contribution against the opinions of those who will remain forever blind to its merits, just as when in 1916 Duchamp and Crotti welcomed the opposition of Gleizes, or in 1920, when Walter Arensberg took special delight in his successful effort to *épater le bourgeois*. Today, the works produced during the New York Dada period—particularly those by Duchamp, Picabia, and Man Ray—have served as beacons of inspiration for an entirely new avant-garde, one who, like their predecessors, are firm in the conviction that theirs is the art of the future.

A key to the abbreviated references to archival sources is provided in the Bibliography (see section headed "ARCHIVES," p. 249).

ACKNOWLEDGMENTS

1. Barbara Rose, *American Art Since 1900* (New York: Praeger, 1967; rev. ed., 1975), pp. 76–77.
2. Roger Shattuck, *The Banquet Years: The Origins of the Avant-Garde in France, 1885 to World War I* (New York: Harcourt, Brace, 1958; rev. ed., New York: Vintage, 1968), and Calvin Tomkins, *The Bride and the Bachelors: The Heretical Courtship in Modern Art* (New York: Viking, 1965); in subsequent editions (1968), Merce Cunningham was added to the quartet of artists considered, whereupon the subtitle was changed to *Five Masters of the Avant-Garde*.

INTRODUCTION

1. Mary Phelps Jacob later went under the name Caresse Crosby, and her account of this invention is given in her autobiography, *The Passionate Years* (New York: Dial Press, 1953), pp. 61–64.
2. For a complete history of women's underclothing, see Elizabeth Ewing, *Dress and Undress* (New York: Drama Book Specialists, 1978); on the invention of the brassiere, see p. 115.
3. Encountering problems with distribution, Miss Jacob sold her invention to the corset firm of Warner Brothers Company for $1,500 (currently estimated to be the equivalent of over $15 million), and by 1915, a type of brassiere, not unlike today's more modern models, was put into widespread production.
4. Emanuel Julius, "This Summer's Style in Poetry, or the Elimination of Corsets in Versifying," *New York Call*, 16 May 1915, sec. II, pp. 3, 14. A few weeks later, this same critic followed up his article by analyzing the newest publications: "An Article on '291,' 'Others,' 'Tender Buttons,' Pink Noise and a Map of the Bronx," *New York Call*, 20 June 1915, sec. II, pp. 8–9.
5. On the discovery of the word Dada, see John Elderfield, " 'Dada': A Code-Word for Saints?" *Artforum* XII, no. 6 (February 1974), pp. 42–47.

6. Dada is treated as a natural forerunner to Surrealism in virtually every major survey text that includes a discussion of both movements. Dada in Paris, Zurich, and Berlin has been the subject of exhaustive monographic studies, while other than for a few pioneering articles (such as those by Baur, Agee), the Dada movement in New York has never been treated monographically, except in the form of a quickly thrown together exhibition catalogue (Schwarz), a collection of essays (Kuenzli), a small German photo book and text anthology (Pichon and Riha) and a single book-length study (Tashjian). Of all these studies, Tashjian's remains the most complete and reliable, although its focus is directed to an exploration of the literary contributions of this period, rather than a detailed analysis of the visual arts (a lacuna which the present study attempts to fill). For all references, see Bibliography.
7. Arturo Schwarz, "An Interview with Man Ray: 'This is Not for America,' " *Arts* 51, no. 9 (May 1977), pp. 116-21. For Duchamp's comments, see Pierre Cabanne, *Dialogues with Marcel Duchamp*, Ron Padgett trans. (New York: Viking Press, 1971), pp. 55–56, 65.
8. The Montross exhibition was the subject of a paper entitled "Marcel Duchamp and New York Dada: The Avant-Garde of the Avant-Garde," which I presented at the annual meeting of the College Art Association in New York on February 15, 1990. The following remarks are derived from that paper.
9. Albert Gleizes to Jean Crotti, dated only "Lundi soir" (Papers of Jean Crotti and Suzanne Duchamp, AAA).
10. Henry McBride, "The Walter Arenbergs [sic]," *The Dial* (July 1920), pp. 61–64; reprinted in Daniel Catton Rich, ed. *The Flow of Art: Essays and Criticisms of Henry McBride* (New York: Atheneum, 1975), pp. 156–59.
11. *Cannibale*, no. 2 (25 May 1920), n.p.
12. Walter Arensberg to Tristan Tzara, undated, but based on internal evidence, written during the spring of 1920 (Dossiers Tzara, BLJD).
13. Interview with James Johnson Sweeney, "Eleven Europeans in America," *Bulletin, Museum of Modern Art*, New York, vol. XIII, nos. 4–5 (1946), p. 21.

PROTO-DADA

1. Louise Varèse, "Marcel Duchamp at Play," in Anne d'Harnoncourt and Kynaston McShine, eds., *Marcel Duchamp*, exh. cat., Museum of Modern Art, New York; Philadelphia Museum of Art, Philadelphia, 1973, p. 224. On Stieglitz's role in the promotion of modern art, see Judith Zilczer, "The Aesthetic Struggle in America, 1913–1918: Abstract Art and Theory in the Stieglitz Circle," unpub. diss., University of Delaware, 1975, and William Innes Homer, *Alfred Stieglitz and the American Avant-Garde* (Boston: New York Graphic Society, 1977).
2. Benjamin de Casseres, "Caricature and New York," *Camera Work*, no. 26 (April 1909), pp. 17–18. De Zayas provided an account of his first meeting with Stieglitz in a conversation with Dorothy Norman, *Alfred Stieglitz: An American Seer* (Millerton, New York: Aperture, 1973), p. 107.
3. Benjamin de Casseres, "American Indifference," *Camera Work*, no. 27 (July 1909), pp. 24–25.
4. Benjamin de Casseres, "The Art 'Puffer,' " *Camera Work*, no. 28 (October, 1909), pp. 31–32.
5. Benjamin de Casseres, "The Ironical in Art," *Camera Work*, no. 38 (April 1912), pp. 17–19.
6. Benjamin de Casseres, "Insincerity: A New Vice," *Camera Work*, nos. 42–43 (April–July 1913; pub. November 1913), pp. 15–17.
7. Benjamin de Casseres, "The Renaissance of the Irrational," *Camera Work*, special no. (June 1913), pp. 22–24.
8. Eugene O'Neill, Foreword to Benjamin de Casseres, *Anathema! Litanies of Negation* (New York: Gotham Book Mart, 1928).
9. "Confessions of a Spiritual Nihilist," *Current Literature* 49 (December 1910), pp. 642–43.
10. See H. L. Mencken, *The Philosophy of Friedrich Nietzsche* (Boston: Luce, 1908; 3rd ed., 1913), Willard Huntington Wright, *What Nietzsche Taught* (New York: B. W. Huebsch, 1915), and Benjamin de Casseres, "Nietzsche: An Interpretation," *The International*, no. VI (June 1913), pp. 165–66.
11. In fact, throughout de Casseres's writings, one cannot fail to discern an underlying note of continued optimism; as he himself once wrote: "There is a latent yea in each great nay." (Benjamin de Casseres, "The Irony of

Negatives," *Chameleon: Being the Book of My Selves* [New York: Lieber & Lewis, 1922], p. 51).

12. Stieglitz to de Casseres, early 1915; quoted in Jonathan Green, ed., *Camera Work: A Critical Anthology* (Millerton, New York: Aperture, 1973), p. 335.

13. Marius de Zayas, "The New Art in Paris," *Camera Work*, nos. 34–35 (April–July 1911), p. 29. For de Zayas's own account of the role he played in the promotion and advancement of modern art in America, see his "How, When, and Why Modern Art Came to New York," Francis M. Naumann, ed., *Arts* 54, no. 87 (April 1980), pp. 96–126.

14. Marius de Zayas, "Pablo Picasso," *Camera Work*, nos. 34–35 (April–July 1911), pp. 65–67; this article was first written in Spanish and published in his father's magazine, *America: revista mensual ilustrada* (New York, May 1911), pp. 363–65, and it also appeared as a separate pamphlet for the Picasso exhibition held at the Photo-Secession Gallery in April 1911.

15. See de Zayas, "Caricature: Absolute and Relative," *Camera Work*, no. 45 (April 1914; pub. October 1914), pp. 19–27. On de Zayas's caricatures, see Douglas Hyland, *Marius de Zayas: Conjurer of Souls*, exh. cat., Spencer Museum of Art, University of Kansas, Lawrence, 1981.

16. The first person to identify the specific source for de Zayas's caricature of Stieglitz was Willard Bohn, "The Abstract Vision of Marius de Zayas," *Art Bulletin* 62, no. 3 (September 1980), p. 435f.

17. See Marius de Zayas and Paul B. Haviland, *A Study of the Modern Evolution of Plastic Expression* (New York: 291, 1913), and Marius de Zayas, *African Negro Art: Its Influence on Modern Art* (New York: Modern Gallery, 1916).

18. Marius de Zayas, "The Sun Has Set," *Camera Work*, no. 39 (July 1912), pp. 17–21.

19. The best and most reliable account of the Armory Show and its aftermath can be found in the writings of Milton W. Brown, *The Story of the Armory Show* (Greenwich: New York Graphic Society, 1963; 2d rev. ed., New York: Abbeville, 1988), and *American Painting From the Armory Show to the Depression* (Princeton: Princeton University Press, 1955).

20. On Duchamp's *Nude* and its reception at the Armory Show, see Brown, "The Rude Descending a Staircase," chap. 7, in *Armory Show*, pp. 133–42.

21. Quoted in William A. Camfield, *Francis Picabia: His Art, Life and Times* (Princeton: Princeton University Press, 1979), p. 44.

22. "Picabia, Art Rebel Here to Teach New Movement," *New York Times*, 16 February 1913, sec. 5, p. 9.

23. Francis Picabia, "How New York Looks to Me," *New York American*, 30 March 1913, mag. sec., p. 11.

24. Anon., "A Post-Cubist's Impressions of New York," *New York Tribune*, 9 March 1913, sec. II, p. 1.

25. Samuel Swift, "New York by Cubist is Very Confusing," *New York Sun*, 18 March 1913 (reprinted in *Camera Work* 42–43 [April–July 1913; pub. November 1913], pp. 48–49). In a long article on Picabia, the chemist and poet Maurice Aisen cited Dove as the only American—though, curiously, he also named Picasso and Duchamp—whose working methods could be identified with Picabia's commitment to pure painting ("The Latest Evolution in Art and Picabia," *Camera Work*, special issue [June 1913], pp. 14–21).

26. The prize was "one original cubist drawing to be made by a member of the art staff of the *Sunday World* on any subject the winner may select" (see "Cubist Art Explained!!!," *New York Sunday World*, 23 March 1913; cited in Camfield, *Francis Picabia*, p. 51). The "Preface" was reprinted in *Camera Work*, nos. 42–43 (April–July 1913; pub. November 1913), pp. 19–20.

27. Maurice Aisen, "The Latest Evolution in Art and Picabia," *Camera Work*, special no. (June 1913), pp. 14–21; and Gabrielle Buffet, "Modern Art and the Public," *Camera Work*, special no. (June 1913), pp. 10–14.

28. Ibid., p. 13. In an interview with Gabrielle Buffet-Picabia conducted in Paris on July 21, 1981 (when she was 99 years old), I asked her specifically if she should be given more credit for Picabia's interest in abstraction; she responded emphatically: "No, the ideas were entirely his."

29. Gabrielle Buffet-Picabia, "A Frenchwoman's Impressions of New York and Certain American Traits," unidentified newspaper clipping, ca. March–April 1913, Dossiers Picabia (BLJD; the date is provided by Camfield, *Francis Picabia*, p. 323).

30. Alfred Stieglitz to Arthur B. Carles, April 11, 1913 (Alfred Stieglitz Archive, YCAL; quoted in Camfield, *Francis Picabia*, p. 56).

31. Samuel Swift in the *New York Sun*; reprinted in *Camera Work*, nos. 42–43 (April–July 1913; pub. November 1913), p. 48.

32. Jean-Hubert Martin, *Francis Picabia*, exh. cat., Galeries Nationales du Grand Palais, Paris, 1976, pp. 72–73.

33. These and other reviews of de Zayas's exhibition are reprinted in *Camera Work*, nos. 42–43 (April–July 1913; pub. November 1913), pp. 51–54, 65.

34. De Zayas's letters to Stieglitz are preserved in the Alfred Stieglitz Archive (YCAL).

THE ARENSBERGS

1. Henry McBride, "The Walter Arenbergs [sic]," *The Dial* (July 1920), pp. 61–64; reprinted in Daniel Catton Rich, ed., *The Flow of Art: Essays and Criticism of Henry McBride* (New York: Atheneum, 1975), pp. 156–59.

2. Of course, there were other collectors of modern art in this period (see Milton W. Brown, *American Painting From the Armory Show to the Depression* [Princeton: Princeton University Press, 1955], pp. 92–99; and Aline B. Saarinen, *The Proud Possessors* [New York: Random House, 1958]). The most extensive collection of modern art in this period was that formed by the eminent and wealthy New York lawyer John Quinn (see Judith Zilczer, *"The Noble Buyer": John Quinn, Patron of the Avant-Garde*, exh. cat., Hirshhorn Museum and Sculpture Garden, Washington, D.C., 1978). Quinn's collection of some two thousand objects, however, provided little inspiration to New York's avant-garde community; though he occasionally lent works to exhibitions, few visitors were accorded a private view of his jam-packed eleven-room apartment on Central Park West (a short walk from the Arensbergs), and those who were, described it as a "warehouse" (see Brice Ryne, "John Quinn: The New York 'Stein,'" *Artforum* 17, no. 2 [October 1978], pp. 56–59; and Zilczer, *Noble Buyer*, pp. 38–39).

3. Much of Arensberg's family background is provided in an autobiographical account composed by Walter Arensberg's father, Conrad Christian Arensberg, and a photo album (both preserved in the Archives of Charles C. Arensberg, Pittsburgh). Information regarding Arensberg's years at Harvard was secured through correspondence with the Registrar of the University and from the accounts of his classmates, the latter of which were provided at the request of Fiske Kimball in 1954 (see Kimball, "Cubism and the Arensbergs," *Art News Annual* 53, no. 7 [November 1954], pt. 2, pp. 117–22, 174–78).

4. Paul Sachs, Oral History Program, p. 291 (BLCU). This reference was brought to my attention by Steven Watson.

5. Mather was also a distinguished professor of art and archaeology at Williams College and later at Princeton. See Walter C. Arensberg, "Jacob A. Riis, Practical Philanthropist," *Craftsman* 8, no. 3 (June 1905), pp. 274–89; and Walter C. Arensberg, "The National Academy of Design," *Burlington Magazine* X (February 1907), p. 336; and W. C. Brensberg [sic], "The art season in New York," *Burlington Magazine* X (October 1906–March 1907), pp. 271–72 (the last of these citations was drawn to my attention by Naomi Sawelson-Gorse). His assignments for the *Post* varied, for it is said that he wrote a review of Arthur Rubinstein's first New York concert, and we know that he wrote a review of a Pennell etching show at the Keppel Galleries in 1906 ("Mr. Pennell's Etchings of London," *Evening Post*, 1 March 1906, p. 9; reprinted in booklet form, New York: Frederick Keppel & Co., 1906).

6. This account of the Arensbergs was compiled

from information provided the author in correspondence and interviews with individuals who knew the collectors well: especially helpful and informative were the vivid recollections of Elizabeth S. Wrigley, Beatrice Wood, and Flora Dean. Statistical information on Walter Arensberg derives from his 1923 and 1928 passports (Arensberg Archives, FBL).

7. In an interview, Walter Arensberg reported that since their first purchase, he and his wife differed over only two pictures, which he did not identify (see Arthur Miller, "An Arensberg Profile," *Art Digest* 25, no. 9 [1 February 1951], p. 10).

8. For contemporary reviews of *Poems* see Pitts Sanborn, "Emergence of a Harvard Poet," *Boston Evening Transcript*, 2 May 1914; "Poems," *Chicago Post*, 22 May 1914; and "A Volume of Lyrics," *San Francisco Chronicle*, 14 January 1914. The most extensive overview of Arensberg's poetry is that by Kenneth Fields, "Past Masters: Walter Conrad Arensberg and Donald Evans," *The Southern Review* 6, n.s., no. 2 (April 1970), pp. 317–39. This article suffers, however, in discussing only the poetry that appeared in Arensberg's two books, *Poems* (1914) and *Idols* (1916), omitting from consideration the more radical works published in the little magazines between 1915 and 1919. This same omission is made by Samuel French Morse (*Wallace Stevens: Poetry as Life* [New York: Pegasus, 1970], pp. 44–121) and Robert Buttel (*Wallace Stevens: The Making of Harmonium* [Princeton: Princeton University Press, 1967], pp. 80–101).

9. William Ivins to Fiske Kimball, March 15, 1954 (Arensberg Archives, PMA).

10. Louise Arensberg to an unidentified friend, undated Armory Show postcard reproducing Wilhelm Lehmbruck's *Kneeling Woman*, about which Louise Arensberg writes: "This is almost the mildest atrocity in the exhibition" (Arensberg Archives, FBL; this document was brought to my attention by Naomi Sawelson-Gorse).

11. Arensberg's Armory Show purchases are recorded in Brown, *Armory Show*, pp. 102–3, 230, 245, 295, 297. Out of the Armory Show, Arensberg purchased Villon's *Sketch for "Puteaux"* and eventually six other paintings that were shown there: Duchamp's *Nude Descending a Staircase No. 2* and *The King and Queen Surrounded by Swift Nudes*, Gleizes's *Man on a Balcony*, La Fresnaye's *Landscape*, Picabia's *Dances at the Spring*, and Villon's *Young Girl*. On Arensberg's acquisition of Duchamp's *Nude*, see Francis M. Naumann, "Frederick C. Torrey and Duchamp's *Nude Descending a Staircase*," in Bonnie Clearwater, ed., *West Coast Duchamp* (Miami Beach: Grassfield Press, 1991), p. 20.

12. As recalled by Pach, "The Politer, the Cutt'n'er," draft of an article prepared as a review of the exhibition of the Arensberg Collection at the Art Institute of Chicago in 1949 (Arensberg Archives, PMA).

13. See "Matisse at Montross," *The American Art News* 13, no. 16 (January 23, 1915), p. 2. In the accompanying catalogue, the portrait of *Mlle. Yvonne Landsberg* was listed simply as "Portrait" (*Henri Matisse Exhibition*, Montross Gallery, New York, Jan. 20–Feb. 27, 1915, cat. no. 62, illus.). See also Walter Pach, "Why Matisse?," *Century Magazine* 89 (February 1915), pp. 633–36.

14. See *Third Exhibition of Contemporary French Art*, Carroll Galleries, New York, March 8–April 3, 1915, cat. no. 30 (in a marked copy of this catalogue in the Papers of Walter Pach [AAA], the painting is listed with a high price of $600, and a low of $400).

15. Paul Sachs, Oral History, pp. 291–93 (BLCU).

16. James Montgomery Flagg, *Roses and Buckshot* (New York: G. P. Putnam, 1946), p. 100.

17. See Judith Zilczer, " 'The World's New Art Center': Modern Art Exhibition in New York City, 1913–1918," *Archives of American Art Journal* 14, no. 3 (1974), pp. 2–7.

18. More about the formation of this gallery can be found in chapter 4.

19. For an amusing firsthand account of several evenings spent in the company of these individuals, see Carl Van Vechten, "Rogue Elephant in Porcelain," *Yale University Library Gazette* 38, no. 2 (October 1963), pp. 41–50.

20. Duchamp's correspondence with Pach is preserved in the Papers of Walter Pach (AAA); see Francis M. Naumann, "*Amicalement, Marcel*: Fourteen Letters from Marcel Duchamp to Walter Pach," *Archives of American Art Journal* 29, nos. 3–4 (1989), pp. 36–50.

21. Stevens to his wife, August 3, 1915 (Holly Stevens, ed., *The Letters of Wallace Stevens* [New York: Knopf, 1966], p. 185).

22. As reported by Man Ray, *Self Portrait* (Boston: Little, Brown, 1963), p. 70.

23. Frederick P. Gay, *The Open Mind: Elmer Ernest Southard 1876–1920* (Chicago: Normandie House, 1938), pp. 315–16.

24. This incident was related to Louise Arensberg in a letter from Duchamp, undated but postmarked August 25, 1917 (FBL); see Francis M. Naumann, "Marcel Duchamp's Letters to Walter and Louise Arensberg, 1917–1921," in Naumann and Rudolf E. Kuenzli, eds., *Marcel Duchamp: Artist of the Century* (Cambridge: MIT Press, 1989), pp. 204–5. There are many descriptions of what took place at the Arensberg apartment, the most notable being those from which the present account is derived: Beatrice Wood, "The Arensberg Circle," *I Shock Myself* (San Francisco: Chronicle Press, 1988), chapt. 4, pp. 26–36, and Louise Varèse, *Varèse: A Looking-Glass Diary, Volume I: 1883–1928* (New York: W. W. Norton, 1972), pp. 125, 202–3.

25. Paul Sachs, Oral History, p. 292 (BLCU).

26. Mina Loy, "Colossus," unpub. ms., pp. 4–5 (Archives of Joella Bayer, Montecito, California;

quoted here with the permission of Roger Conover).

27. As recalled by Gabrielle Buffet-Picabia, in an interview with Malitte Matta, "Un peu d'histoire," in *Paris-New York*, exh. cat., Centre National d'Art et de Culture Georges Pompidou, Paris, 1977, p. 61.

28. Quoted here only in part; see *The Quill* (June 1919), pp. 20–21. "Pitts" presumably refers to Walter Arensberg's classmate from Harvard, Pitts Sanborn (1879–1941).

29. On the formation of *Others* see Alfred Kreymborg, *Troubadour: An Autobiography* (New York: Liveright, 1925), pp. 218–23; for a contemporary account of the Others Group, see Margaret Johns, "Free Footed Verse Is Dance in Ridgefield, New Jersey," *The New York Tribune*, 25 July 1915, pt. III, p. 2. A photograph of women from the Others Group is reproduced in Paul Mariani, *William Carlos Williams: A New World Naked* (New York: McGraw-Hill, 1981), p. 460.

30. William Carlos Williams, quoted in Constance Rourke, *Charles Sheeler: Artist in the American Tradition* (New York: Harcourt, Brace and Co., 1938), p. 49. For Williams's account of his encounter with Duchamp, see *The Autobiography of William Carlos Williams* (New York: Random House, 1948), p. 137.

31. "Arensberg and the New Reality," *Poetry* 8, no. 4 (July 1916), pp. 208–11.

32. So thought Mabel Dodge, "Speculation, or Post-Impressionism in Prose," *Arts & Decoration* (March 1913), pp. 172, 174; reprinted as "Speculations," *Camera Work*, special no. (June 1913), pp. 6–9. McBride's opinion of Arensberg's poem was included in his review of *TNT*, *New York Sun*, 9 March 1919, sec. VI, p. 12.

33. Undated letter, postmarked September 11, 1914, Pomfret Center, Conn. (Van Vechten Papers, YCAL).

34. William Ivins to Paul Sachs, October 23, 1917 (Oral History, BLCU), pp. 294–95.

35. "Dante Costs Author $25," *New York Times*, 19 March 1921, p. 17. Arensberg's interest in cryptography dates from as early as 1908, through his friendship with the well-known philologist William Stone Booth.

36. *The Cryptography of Dante* was published by Alfred A. Knopf, New York; *The Cryptography of Shakespeare: Part I* was published by Howard Bowen, Los Angeles (part II of this volume never appeared).

37. Mary W. Smyth, "Dante's Symbolism," *The Literary Review* 2, no. 2 (17 September 1921), pp. 21–22. See also "A Shocking Attack on Dante's Immortal 'Inferno,' " *New York Evening Journal*, 21 January 1922.

38. Arthur Livingston, "The Dadaistic Dante," *The Nation* 113, no. 2926 (3 August 1921), p. 126.

39. Marcel Duchamp to Walter and Louise Arensbérg, written from Paris, November 15, 1921 (Papers of Marcel Duchamp, FBL); published in Naumann and Kuenzli, eds., *Marcel*

Duchamp, p. 221.

40. Louise Arensberg's confrontation with her husband was recorded by Henri-Pierre Roché in his diary, in entries dating from September 1 through 6, 1919 (Papers of Henri-Pierre Roché, HRC). Walter Arensberg's affair with Yvonne Crotti was reported by Louise Varèse: "I can't remember how I heard of it, perhaps from Walter or perhaps from Yvonne. No, it must have been Yvonne, because I remember she said that he made love with Louise just in the next room" (interview with the author, New York, January 19, 1983). Beatrice Wood recalled the silence that followed at the mention of Roché's name (telephone conversation with the author, June 20, 1991).

41. See John Quinn's letters to Henri-Pierre Roché, February 19, March 20, and May 1, 1922, as well as Quinn's correspondence with Charles Sheeler, c/o the Modern Gallery, February 13, 14, and June 2, 1922 (Quinn Archives, NYPL). On Dreier's purchase of the *Large Glass*, see her correspondence with the Arensbergs in the Archives of the Société Anonyme (YCAL).

42. Katherine Dreier to Walter Arensberg, June 23, 1925 (Archives of the Société Anonyme, YCAL).

MARCEL DUCHAMP

1. Duchamp to Pach, April 27 [1915] (Pach Papers, AAA; see Francis M. Naumann, "*Amicalement, Marcel*: Fourteen Letters from Marcel Duchamp to Walter Pach," *Archives of American Art Journal* [*AAAJ*] 29, nos. 3 and 4 [1989], p. 40).

2. Duchamp to Pach, April 27 [1915], ibid., p. 40.

3. Information provided by Maurice F. Kiley, District Director of the Immigration and Naturalization Service, New York District, United States Department of Justice (letter to the author, November 30, 1976).

4. "A Complete Reversal of Art Opinions by Marcel Duchamp, Iconoclast," *Arts & Decoration* 5 (September 1915), p. 427.

5. "The Nude-Descending-a-Staircase Man Surveys Us," *New York Tribune*, Special Feature Section, 12 September 1915, p. 2 (reproduced here on p. 36). Although the interviewer is not named, it is probably Henry McBride, whose identity can be established on the basis of a letter from Duchamp to McBride dated April 15, 1958 (Papers of Henry McBride, YCAL). In a reminiscence, the writer Bessie Breuer, who served as Sunday Editor for the *New York Tribune* in 1915, recalls that she sent Edward Alden Jewell to interview Duchamp (unpublished manuscript sec. VII, p. 1, Estate of Henry Varnum Poor, New York). This manuscript was drawn to my attention by Robert Reiss.

6. Exactly when Duchamp moved into the Arensberg apartment is difficult to say, though it was probably at some point in July 1915. In that month, Arensberg wrote to Pach from his summer home in Pomfret, Connecticut, saying, "I am going to see my mother [in Pittsburgh], and I shall pass through New York and see Duchamp en route" (letter undated, postmark partly illegible, except for a portion of the word: Jul[y]; based on internal evidence, written in 1915; Pach Papers, AAA). By the time of Duchamp's twenty-eighth birthday on July 28, 1915, he was already directing letters to Pach, which makes it clear that Duchamp was no longer staying at Pach's apartment (Duchamp to Pach, July 28, 1915, [AAA]; Naumann, "*Amicalement, Marcel*," p. 41).

7. "The Nude-Descending-a-Staircase Man Surveys Us," *New York Tribune*, p. 2.

8. "Reversal of Art Opinions," *Arts & Decoration*, p. 428.

9. "French Artists Spur on an American Art," *New York Tribune*, 24 October 1915, sec. 4, pp. 2–3 (repr. in Rudolf E. Kuenzli, ed., *New York Dada* [New York: Willis Locker & Owens, 1986], p. 133).

10. Alfred Kreymborg, "Why Marcel Duchamps [*sic*] Calls Hash a Picture," *Boston Evening Transcript*, 18 September 1915, p. 12.

11. "Reversal of Art Opinions," *Arts & Decoration*, p. 428.

12. Ibid., pp. 427–28.

13. *Third Exhibition of Contemporary French Art*, Carroll Galleries, New York, March 8–April 3, 1915, cat. nos. 16 and 17.

14. Henri-Pierre Roché, *Victor*, p. 66 (vol. IV of Jean Clair, ed., *Marcel Duchamp*, exh. cat., Centre National d'Art et de Culture Georges Pompidou, Musée National d'Art Moderne, Paris, 1977).

15. Pierre Cabanne, *Dialogues with Marcel Duchamp* (New York: Viking Press, 1971), p. 48.

16. From an interview with Harriet and Carroll Janis, New York, 1953, unpub. (transcription Carroll Janis, New York).

17. As explained to Arnold Eagle in a film by Lewis Jacobs, *Marcel Duchamp: In His Own Words*, 1978.

18. As noted, for example, in the title of Ulf Linde's essay, "MARiée CELibataire" in Walter Hopps, Ulf Linde and Arturo Schwarz, *Marcel Duchamp Ready-Mades, etc. (1913–1964)* (Paris: Le Terrain Vague, 1964), p. 39.

19. Many detailed analyses of the *Large Glass* have been published. The best general study is John Golding, *Marcel Duchamp: The Bride Stripped Bare by Her Bachelors, Even* (New York: Viking Press, 1972).

20. William B. McCormick, "Present Cubist Show is Most Representative Yet," *New York Press*, 21 March 1915, sec. V, p. 9. Duchamp showed five works in this exhibition (cf. n. 13 above; see cat. nos. 15–19).

21. Beatrice Wood, "Marcel," in Francis M. Naumann and Rudolf E. Kuenzli, eds., *Marcel Duchamp: Artist of the Century* (Cambridge: MIT Press, 1989), p. 13.

22. Arturo Schwarz, ed., *Notes and Projects for the Large Glass* (New York: Harry N. Abrams, 1969), p. 88, n. 53.

23. "Apropos of 'Readymades,'" a talk delivered by Duchamp at the Museum of Modern Art, New York, 19 October 1961 (published in *Art and Artists* 1, no. 4 [July 1966], p. 47).

24. Duchamp to Suzanne Duchamp [Desmares], "Around the 15th of January [1916]" (Papers of Jean Crotti and Suzanne Duchamp, AAA; published in Francis M. Naumann, "*Affectueusement, Marcel*: Ten Letters from Marcel Duchamp to Suzanne Duchamp and Jean Crotti," *AAAJ* 22, no. 4 [1982], p. 5). Although Duchamp maintained that the titles he chose for his readymades were not to be interpreted for their literal significance, he later confessed that some sense could be derived from the inscription on his snow shovel (see interview with Cabanne, *Dialogues with Duchamp*, p. 54). However, in the context of Duchamp's awareness of his position within a hierarchy of avant-garde activities—as outlined in the present text—it is tempting to speculate that he might have intended this inscription to read as a pun on the concept of being "in advance of the avant-garde," whereupon anyone following his lead (through the example of the readymades) is adequately forewarned of the perils inherent in following his direction.

25. Interview with George Heard Hamilton, New York, 19 January 1959 (published in *The Art Newspaper*, London, vol. III, no. 15 [February 1992]), p. 13).

26. Published under the title: "THE, Eye Test, Not a 'Nude Descending a Staircase,'" *Rogue* III [mismarked II], no. 1 (October 1916), p. 2.

27. Quoted from a letter to Arturo Schwarz, in Schwarz, *The Complete Works of Marcel Duchamp* (New York: Harry N. Abrams, 1970), p. 457.

28. Duchamp to the Arensbergs, dated "end of March—1919" (Naumann, "Arensberg Letters," p. 216).

29. Cabanne, *Dialogues with Duchamp*, p. 52.

30. Marcel Duchamp to John Quinn, undated but stamped "Received: January 27, 1916" (John Quinn Memorial Collection, NYPL).

31. "French Artists," *New York Tribune*, 1915.

32. James Johnson Sweeney, ed., "Eleven Europeans in America," *Bulletin* 13, nos. 4–5 (New York: Museum of Modern Art, 1946), p. 20.

33. *Exhibition of Pictures by Jean Crotti, Marcel Duchamp, Albert Gleizes, Jean Metzinger*, Montross Gallery, New York, 4–22 April 1916; *Pharmacy* (cat. no. 27) was mistakenly listed under "Drawings."

34. "More Modernists at Montross,'" *American Art News* 14, no. 2 (8 April 1916), p. 5. See also Robert J. Cole, "Studio and Gallery," *New York*

Evening Sun, 14 April 1916, p. 14.

35. I am here referring to the Society of American Fakirs, who held annual exhibitions in New York from 1891 through 1914 and who were dedicated to lampooning works by well-known American artists (see Ronald G. Pisano and Bruce Weber, *Parodies of the American Masters: Rediscovering the Society of American Fakirs, 1891–1914*, exh. cat., New York: Berry-Hill Galleries, 23 September–23 October 1993).

At the Bourgeois Gallery (*Exhibition of Modern Art*, New York, 3–29 April 1916), Duchamp was represented by four paintings (cat. nos. 5–8), a drawing (*Boxing-Match*, cat. no. 52a), and "Two Ready-mades," which were listed together as a single entry (cat. no. 50) and categorized as "sculptures." Because of this vague reference, the two readymades Duchamp exhibited have never been securely identified. Schwarz claims, however, that "from an examination of the reviews published at the time it appears that the two Ready-mades may very well have been *In Advance of the Broken Arm* and *Traveller's Folding Item*" (*Complete Works*, p. 463). No known review of the exhibition, however, provides this information. And some forty years after the event, Man Ray said that these two readymades, along with *Pharmacy*, were shown in an exhibition of modern art at the Montross Gallery ("Man Ray: Doyen of Dadaism," taped monologue, 1956 [released by The Center for Cassette Studies, North Hollywood, 1973]).

Two years before his death, Duchamp recalled that he was allowed to show his readymades only because he had made it a condition for allowing the gallery to show his paintings. The director "then put them in the entrance where you put your hats. Nobody knew what it was. There was no description, no denomination, no etiquette [name plate]" (interview with Richard Hamilton, R. Kitaj, Robert Melville and David Sylvester, 19 June 1966, London; unpub. transcript, p. 28). This statement suggests that at least one of the readymades shown was *Hat Rack*. This supposition would seem to be confirmed by Duchamp himself, who, in response to a questionnaire he received from Marcel Jean, said "my ready mades were exhibited in the umbrella stand at the gallery's entrance" (*Marcel Duchamp: Letters to Marcel Jean* [Munich: Silke Schreiber, 1987], p. 72). *Hat Rack* is traditionally dated to 1917, but it would of course have to be redated if it actually appeared in the Bourgeois exhibition.

36. Nixola Greeley-Smith, "Cubist Depicts Love in Brass and Glass; More Art in Rubbers Than in a Pretty Girl!" *The Evening World*, New York, 4 April 1916, p. 3.

37. See, however, the interesting analysis of this phrase in Jacques Caumont and Jennifer Gough-Cooper, "La Laque des signes (Final)."

in *Ýo Sermayer*, exh. cat., Kunsthalle, Bern, 1983, pp. 35–36.

38. Louise Norton, "Buddha of the Bathroom," *The Blind Man*, no. 2 (May 1917), pp. 5–6.

39. From a story told by Duchamp to the painter Enrico Baj, Milan, 1967 (as recalled by Baj, "Marcel Duchamp and Plumbing," in Wouter Kotte, *Marcel Duchamp als Zeitmaschine* [Köln: Walter König, 1987], pp. 104–5). Although Baj specifically states that this incident occurred in Philadelphia in 1917, he must not have recalled correctly, for the party surely took place at the Arensbergs' apartment in New York, the main room of which had an interior staircase that led to an upper level of the apartment.

40. To Arturo Schwarz, Duchamp explained that, originally, the title for this publication was supposed to be "Wrong-Wrong" (Schwarz, *Complete Works*, p. 586). The publication probably appeared around August 25, 1917, for on that date Duchamp sent a copy to Louise Arensberg, who was away in Boston visiting relatives (see Naumann, "Arensberg Letters," p. 204). It should be noted that in this letter, Duchamp spelled the title of this magazine: "RongwRong."

41. From the unpublished memoirs of Juliette Roche-Gleizes, "Souvenirs" (quoted in Daniel Robbins, "The Formation and Maturity of Albert Gleizes; A Biographical and Critical Study, 1881 Through 1920," unpub. diss., New York University, New York, 1975, p. 200).

42. According to surviving account ledgers for the building, Arensberg began paying a monthly rent of $58.33 for the studio on November 30, 1916, and his payments continue until October 31, 1918 (documents kindly made available by Peter Rose).

43. Georgia O'Keeffe, in Anne d'Harnoncourt and Kynaston McShine, eds., *Marcel Duchamp*, exh. cat., Museum of Modern Art, New York; Philadelphia Museum of Art, Philadelphia, 1973, pp. 212–13.

44. Beatrice Wood, *I Shock Myself* (San Francisco: Chronicle Books, 1988), p. 24.

45. Henri-Pierre Roché, *Victor*, p. 66.

46. Duchamp himself thought of the painting in these terms; he told Cabanne that "it was a sort of résumé of things I had made earlier" (*Dialogues*, p. 60). See also the interpretations of Lebel (*Marcel Duchamp*, trans. George Heard Hamilton [New York: Grove Press, 1959] pp. 42–43), Schwarz (*Complete Works*, pp. 470–71), and Robert Herbert (Herbert, Eleanor S. Apter, and Elise K. Kenney, eds., *The Société Anonyme and the Dreier Bequest at Yale University: A Catalogue Raisonné* [New Haven: Yale University Press, 1984], pp. 231–33).

47. As was recently discovered by Jennifer Gough-Cooper and Jacques Caumont, *Marcel Duchamp*, Pontus Hulten, ed. (Cambridge: MIT Press, 1993), entries for April 12, 1918 and July 8, 1918.

48. Quoted in Schwarz, *Complete Works*, p. 271.

49. Marcel Duchamp to Crotti, July 8 [1918] (Papers of Jean Crotti and Suzanne Duchamp, AAA; Naumann, "*Affectueusement, Marcel,*" p. 10).

50. Duchamp to Crotti, July 8, 1918, ibid.

51. Picabia, "New York," *391* (Zurich), no. 8 (February 1919); Duchamp's letter to Picabia is dated August 13 [1918] (Dossiers Picabia, vol. I, p. 249, BLJD).

52. Interview with Otto Hahn, *Art and Artists 1*, no. 4 (July 1966), p. 10.

53. These friends were: Jean Crotti (October 26, 1918; Naumann, "*Affectueusement, Marcel,*" p. 11); Walter Pach (November 15, [1918]; Naumann, "*Amicalement, Marcel,*" p. 42); and Walter Arensberg (November 8, 1918; Naumann, "Arensberg Letters," pp. 207–9).

54. As reported in Lebel, *Duchamp*, p. 44. Dreier continued to give this work the title *Disturbed Balance* throughout the years she owned it (see, for example, Alfred H. Barr, Jr., ed., *Modern Works of Art: Fifth Anniversary Exhibition* [New York: Museum of Modern Art, November 1934], item no. 164, pp. 35–36).

55. In response to a questionnaire published in Curnonsky, ed. (with caricatures by Georges de Zayas), *Huit Peintres, Deux Sculpteurs, et un Musicien très modernes* (Paris: Privately printed, 1919), n.p.

56. Quoted in Hans Richter, *Dada Art and Anti-Art* (New York: McGraw-Hill, 1965), p. 99.

57. Marcel Duchamp to John Quinn, February 16, 1920 (Quinn Memorial Collection, NYPL).

58. Henri-Pierre Roché, *Victor*, p. 65.

59. In the literature on Duchamp, the various photographs that Man Ray took of Rose Sélavy are usually grouped together and identified as having been taken in New York in 1921, which, in fact, is correct for the image reproduced here. But Rose posed again for Man Ray's camera in a subsequent photo session that took place in Paris just after Man Ray settled there in the fall of 1921. As Arturo Schwarz has noted (*Complete Works*, p. 487), some of these portraits feature the hat and hands of Picabia's mistress, Germaine Everling, who never traveled to the United States. Unfortunately, even the photographs of Rose taken in New York have been incorrectly identified as portraits of Rrose Sélavy—with the double-r (see, for example, Jean-Hubert Martin, ed., *Man Ray Photographs* [London: Thames and Hudson, 1982], fig. 17, pp. 43 and 49)—a subtle modification to the spelling of Rose's first name (see n. 65 below) that Duchamp did not use until after he returned to Paris during the summer of 1921 (it appeared for the first time on Picabia's painting, *L'Oeil cacodylate*, 1921 [Musée National d'Art Moderne, Paris]).

60. From an interview with James Johnson Sweeney, "Regions which are not ruled by time and space . . . ," in Michel Sanouillet and Elmer Peterson, eds., *Salt Seller: The Writings*

of Marcel Duchamp (Marchand Du Sel) (New York: Oxford University Press, 1973), p. 135.

61. Duchamp to Walter and Louise Arensberg, November 15, 1921 (Naumann, "Arensberg Letters," p. 221).

62. Letter to Jean Crotti, July 8 [1918] (Naumann, "*Affectueusement, Marcel,*" p. 27).

63. Marcel Duchamp to Man Ray, undated, but based on internal evidence, written in the fall of 1922 (original letter, collection Codognato, Venice, Italy).

64. Marcel Duchamp to Henry McBride, undated, but based on internal evidence, probably written in June 1922 (Papers of Henry McBride, YCAL). The letter to Tzara is undated (Dossiers Tzara, TZ.R.C. 1253, BLJD).

65. Later he explained that the double-r was intended as a pun on the word "arrose" (see Cabanne, *Dialogues with Duchamp,* p. 65), possibly a reference to the French verb *arroser,* which means to wet or moisten. It was probably also meant as a pun on the word eros, as in "eros c'est la vie."

66. Alan Burroughs, "Some French Modern Says McBride," review, *The Arts* 3 (January 1923), pp. 71–72.

67. The precise date when this sale was agreed upon is unknown, though it is first mentioned in a letter from Louise Arensberg to Dreier dated January 20 [1923] (Collection of the Société Anonyme, YCAL). Dreier continued to make payments on this acquisition until 1926.

FRANCIS PICABIA

1. De Zayas to Stieglitz, June 30, 1914 (Alfred Stieglitz Archive, YCAL). The most indispensable source for information on Picabia and his work can be found in the writings of William A. Camfield, particularly his monograph *Francis Picabia: His Art, Life and Times* (Princeton: Princeton University Press, 1979). I am indebted to Professor Camfield for having reviewed the present chapter and for having generously provided information pertaining to the work Picabia exhibited during these years in New York.

2. Elizabeth Luther Carey, *New York Times,* 24 January 1915; reprinted in Marius de Zayas, "How, When, and Why Modern Art Came to New York," Francis M. Naumann, ed., *Arts* 54, no 8 (April 1980), p. 108.

3. "Cubist Painter Paints Himself in Cubist Style," *New York Herald,* 18 January 1915, p. 3.

4. Jean-Hubert Martin, "Ses tableaux sont peints pour raconter non pour prouver," in *Francis Picabia,* exh. cat., Galeries Nationales du Grand Palais, Paris, 1976, pp. 40–49.

5. This painting can be identified as *This Has to Do with Me (C'est de moi qu'il s'agit),* 1914 (Museum of Modern Art, New York; gift from the children of Eugene and Agnes E. Meyer).

6. Francis Picabia, "Que Fais Tu, 291?" [translated as "What Doest Thou, 291?"], dated "St. Cloud, July 17, 1914," *Camera Work,* no. 47 (July 1914; published January 1915), p. 72. The original French reads: "*Il ne le connaît pas il est bon c'est un Dieu je l'aime.*"

7. Anonymous, "291—A New Publication," *Camera Work,* no. 48 (October 1916), p. 62.

8. Emanuel Julius, "An Article on '291,' 'Others,' 'Tender Buttons,' Pink Noise and a Map of the Bronx," *New York Call,* 29 June 1915, sec. III, p. 8. The original drawing is lost, and is known only from its appearance in *291,* no. 2 (April 1915).

9. Based on the fact that *Girl Born Without a Mother* was drawn on the verso of a piece of stationery from the Hotel Brevoort, where we know Picabia stayed during his first trip to New York in 1913, and because it bears a certain formal relationship to *I See Again in Memory My Dear Udnie,* some scholars have insisted that the drawing dates from 1913. Apparently, these scholars fail to realize that Picabia probably also stayed at the Brevoort in 1915, and they refuse to accept the possibility that a drawing could have been inspired by a painting. Why would Picabia have waited until 1915 to publish this work, particularly in *291* (where it is clearly labeled "New York, 1915"), the very publication where the artist would soon present his new mechanical portraits? Camfield has made a considerable effort to straighten out this confusion (*Francis Picabia,* pp. 80–81), though such sound reasoning was ignored by Maria Lluïsa Borràs (*Picabia* [New York: Rizzoli, 1985], p. 153), who, without offering any additional information, insists upon the earlier date.

10. "French Artists Spur on an American Art," *New York Tribune,* 24 October 1915, sec. 4, p. 2.

11. See William Innes Homer, "Picabia's *Jeune fille américaine dans l'état de nudité* and Her Friends," *Art Bulletin* LVII, no. 1 (March 1975), pp. 110–15.

12. William A. Camfield, "The Machinist Style of Francis Picabia," *Art Bulletin* XLVII, nos. 3–4 (September–December 1966), pp. 309–22.

13. Paul B. Haviland, untitled editorial statement, *291,* nos. 7–8 (September–October, 1915).

14. "Many Enjoyable Paintings in Modern Gallery—Woman's Work," unidentified newspaper clipping (Dossiers Picabia, BLJD).

15. "Exhibitions in the Galleries," *Arts and Decoration* (November 1915), p. 35.

16. "Francis Picabia and His Puzzling Art," *Vanity Fair* (November 1915), p. 42. This article reproduced Stieglitz's photographic portrait of Picabia (see p. 57).

17. *Picabia Exhibition,* Modern Gallery, New York, January 5–25, 1916. The catalogue consisted only of a listing of the titles of the sixteen works shown.

18. Jean-Hubert Martin, "Ses tableaux sont peints," p. 45. This source can be reconfirmed when *Révérence* is compared to the illustra-

tion of a French chocolate grinder of the type that may have inspired Duchamp (see Jennifer Gough Cooper and Jacques Caumont, *Plan pour écrire une vie de Marcel Duchamp,* p. 77, vol. I of Jean Clair, ed., *Marcel Duchamp,* exh. cat., Centre National d'Art et de Culture Georges Pompidou, Musée National d'Art Moderne, Paris, 1977).

19. "Picabia's Puzzles," *The Christian Science Monitor,* January 29, 1916.

20. "Current News of Art and the Exhibitions," *New York Sun,* 16 January 1916, sec. III, p. 7, and *New York Sun* 23 January 1916 (quoted in de Zayas, "Modern Art," p. 109).

21. Identified by Professor Alan Chapman; see William Camfield, introduction, *Picabia: Paintings and Drawings, 1913–1922,* Richard Gray Gallery, Chicago, 12 March–10 April 1982; cylinder lubricators of the type discovered by Professor Chapman can be found in James Ambrose Moyer, *Power Plant Testing* (New York: McGraw-Hill Book Company, 1934), figs. 312 and 313, p. 546.

22. See Rachel Maines, "Socially Camouflaged Technologies: The Case of the Electromechanical Vibrator," *IEEE Technology and Society Magazine,* 8, no. 2 (June 1989), pp. 3–11, 23 (I am grateful to Cynthia Henthorn who brought this article to my attention). In this context, if we follow the clue suggested by its title, the cooling coils in the picture may have been based on a diagram for the earlier, hydromechanical vibrators or, in a more general sense, Picabia may simply have wanted to indicate that with the new technology, it was no longer necessary to attain a paroxysmal state through laborious, manual stimulation; one could now rely upon the aid of a machine to seek relief from bouts of *la douleur.*

23. "Picabia Again in the Ring," *American Art News* XIV, no. 14 (January 8, 1916), p. 3, and *New York Evening Mail,* 8 January 1916, p. 6.

24. Angelica Zander Rudenstine has suggested that the image may have been modeled after a Stirling engine, "where," as she notes, "many of the main components of Picabia's design are found in a roughly comparable configuration" (*Peggy Guggenheim Collection, Venice* [New York: Harry N. Abrams, 1985], pp. 607–8).

25. "Picabia's Puzzles," *The Christian Science Monitor,* January 29, 1916.

26. "Current Exhibitions," *The New York Sun,* 16 January 1916, sec. III, p. 7.

27. *Minneapolis Tribune,* 16 January 1916 (repr. in de Zayas, "How, When and Why," p. 109).

28. Royal Cortissoz, "Random Impressions of Art in Current Exhibitions," *New York Tribune,* 9 January 1916.

29. *Evening Mail,* 8 January 1916.

30. "Picabia Again in the Ring," *American Art News,* p. 3.

31. Although no catalogue was published for this exhibition, the paintings Picabia showed were identified by an anonymous reviewer of the

exhibition (see "At the Modern Gallery," *American Art News* XIV, no. 38 [September 16, 1916]).

32. See the comparative illustration in William A. Camfield, *Francis Picabia* (The Solomon R. Guggenheim Museum, New York, 1970), p. 102.

33. Picabia to de Zayas, 20 December 1916 (published in Sanouillet, *Picabia et "391"*, vol. II, p. 253; quoted in Camfield, *Francis Picabia*, p. 93, n. 6).

34. Gabrielle Buffet-Picabia, "Some Memories of Pre-Dada: Picabia and Duchamp," trans. by Ralph Manheim, in Robert Motherwell, ed., *The Dada Painters and Poets: An Anthology* (New York: Wittenborn, 1951), pp. 259–60.

35. Picabia's writings—including all of his poems—were gathered for publication in Olivier Revault d'Allones, ed., *Francis Picabia: Ecrits*, vol. I, *1913–1920*, 1975; vol II: *1921–1953*, 1978 (Paris: Pierre Belfond). This poem, however, was not included, and was drawn to my attention by William Camfield. The original manuscript is preserved in the Arensberg Papers, Department of Twentieth Century Art, Philadelphia Museum of Art (Box 10, Folder 3). It is presented here for the first time in a translation by the author with the assistance of Chantal Combes.

36. Juliette Roche-Gleizes, "Mémoires," unpublished manuscript covering the years 1915–23, written 1959–63 (Estate of Albert Gleizes, Paris; quoted in Camfield, *Francis Picabia*, pp. 101–2).

37. Stieglitz to Marie Rapp Boursault, undated but postmarked July 23, 1917 (Stieglitz Archives, YCAL).

38. This story was told by Louise Norton Varèse, who remembered that only Duchamp ate the lamb, and acknowledged that Roché claimed to have been with Picabia (see Varèse, "Marcel Duchamp at Play," in Anne d'Harnoncourt and Kynaston McShine, *Marcel Duchamp*, exh. cat., Museum of Modern Art, New York; Philadelphia Museum of Art, Philadelphia, 1973, pp. 224–25). Later, she recalled in conversation that Edgard Varèse was present and also ate the lamb (interview with the author, January 15, 1980).

39. Francis Picabia, "New York," *391*, no. 5 (June 1917) n.p. It was Christian Derouet who first identified this image as a portrait of Juliette Roche (Musée National d'Art Moderne: Cabinet d'Art Graphique [Paris: Musées et Monuments de France, Centre Georges Pompidou, 1989], p. 26). Although Derouet dates the gouache to c. 1915, I believe it was more probably made during the time of Picabia's third sojourn in America in 1917, at which time he was in frequent contact with the Gleizeses.

40. Camfield, *Francis Picabia*, p. 99.

41. The dates for these works were taken from Camfield (*Francis Picabia*, color pl. VIII and fig. 133). They are discussed here to provide

examples of Picabia's changing style, and not because they were painted in New York (indeed, *Fille née sans mére* is inscribed "Barcelone," although it is not known if it was painted during the time of Picabia's first or second sojourn to that city). Though neither one of these two paintings was exhibited during this period in New York, they are not too large to have been shipped across the ocean.

42. *391* (June 1917); Hachepé is identified as Roché by Sanouillet, *Picabia et 391*, vol. II, pp. 77–78.

43. Borràs has noted a similar configuration between the cone-shaped red cup in the upper right corner of Picabia's painting, and Duchamp's drawing for the "Wasp" or "Sex Cylinder"; she has also noted Duchamp's intention to "put the whole *mariée* under a globe or in a transparent cage" (Borràs, *Picabia*, p. 177).

44. Michel Sanouillet and Elmer Peterson, eds., *Salt Seller: The Writings of Marcel Duchamp (Marchand du Sel)* (New York: Oxford University Press, 1973), p. 31.

45. In these years, neurasthenia was the most common diagnosis given for virtually all nervous disorders (see Tom Lutz, *American Nervousness: An Anecdotal History* [Ithaca: Cornell University Press, 1991]).

46. Gabrielle Buffet-Picabia to Alfred Stieglitz, September 15, 1917 (Alfred Stieglitz Archives, YCAL); quoted in Borràs, *Picabia*, p. 178.

47. Louise Varèse, *Varèse: A Looking-Glass Diary* (New York: W. W. Norton & Company, 1972), p. 132.

48. The general composition of this work closely resembles the design for a portable motor attached to a sewing machine, a device that could also be used in the fashion of a vibrator (as it appeared in a 1918 edition of the *Sears, Roebuck and Co.* catalogue, Chicago; see Maines, "Socially Camouflaged Technologies," [for full ref. see n. 22 above], p. 7).

49. This drawing can be dated to c. November–December 1917, for in the surrounding inscription, Picabia mentions that his little book *5.2 Miroirs* was just published, and *Cinquante-deux Miroirs* was released by O. de Vilanova, Barcelona, in October 1917. Moreover, the other half of this drawing (not reproduced here) is comprised of an abstract image labeled "MARTIQUES [*sic*] / Portrait de l'amie," referring to his new girlfriend, Germaine Everling, and to the southern French town of Martigues, where Picabia spent a few months with Everling during the winter of 1917–18.

MAN RAY

1. From an interview with Arturo Schwarz, "This Is Not for America," *Arts* 51, no. 9 (May 1977), p. 117; first published in Schwarz, *New York Dada: Duchamp, Man Ray, Picabia*, exh. cat. Städtische Galerie im Lenbachhaus,

Munich, 1973 (Munich: Prestel, 1973), pp. 79–100.

2. On the Ferrer Center, see Paul Avrich, *The Modern School Movement: Anarchism and Education in the United States* (Princeton: Princeton University Press, 1980) and Ann Uhry Abrams, "The Ferrer Center: New York's Unique Meeting of Anarchism and the Arts," *New York History* 59, no. 3 (July 1978), 306–25.

3. Man Ray, *Self Portrait* (Boston: Little, Brown, 1963), p. 23.

4. Quoted in C. Lewis Hind, "Wanted, A Name," *Christian Science Monitor*, ca. November–December 1919 (exact date of publication unknown; clipping preserved in the scrapbooks of Katherine Dreier, Société Anonyme Collection, YCAL); reprinted in Hind, *Art and I* (New York: John Lane, 1920), pp. 180–85.

5. Man Ray later reported that he met Adon Lacroix on August 27, 1913 (statement in André Breton and Paul Eluard, eds., "Enquête," *Minotaure*, no. 3–4 [October–December, 1933], p. 112). On Wolff, see Francis M. Naumann and Paul Avrich, "Adolf Wolff, 'Poet, Sculptor and Revolutionist, but Mostly Revolutionist,'" *The Art Bulletin* 67, no. 3 (September 1985), pp. 486–500.

6. Man Ray, *Self Portrait*, p. 49; on the artist's formalist preoccupations in this period, see Francis M. Naumann, "Man Ray, Early Paintings 1913–1916: Theory and Practice in the Art of Two Dimensions," *Artforum*, vol. 20, no. 9 (May 1982), pp. 37–46.

7. From an interview with Arturo Schwarz; quoted in Schwarz, *Man Ray: The Rigour of Imagination* (New York: Rizzoli, 1977), p. 32.

8. Information derived from a card file kept by the artist of works dating from the New York and Ridgefield years (Estate of the artist, Paris).

9. Statement by the artist published in Mary Lawrence, ed., *Mother and Child* (New York: Thomas Y. Crowell, 1975), p. 64.

10. For a detailed account of this incident, see "Lexington Avenue," chapter 6 in Avrich, *Modern School*, pp. 183–216.

11. Quoted in Alfred Kreymborg, *Troubadour: An Autobiography* (New York: Liveright, 1925), p. 239.

12. Man Ray, *Self Portrait*, p. 70.

13. Ibid., pp. 65, 66.

14. Quotations from "This Is Not for America," in Schwarz, *New York Dada*, p. 119; and Man Ray, *Self Portrait*, p. 71.

15. Quotations from Man Ray, *Self Portrait*, p. 82; and Schwarz, *Rigour of Imagination*, p. 39.

16. The text was published in *TNT* (1919). Evreinov (1879–1935) wrote several monodramas, which were designed for a single performer but relied on the participation of spectators. The original title for this aerograph was provided in Man Ray's card file (Estate of the artist, Paris).

17. Man Ray to Dominique de Menil, October 20, 1973 (excerpts quoted in *Gray Is the Color: An Exhibition of Grisaille Painting, Twelfth to Twentieth Centuries*, exh. cat., Rice Museum, Houston, 1973, p. 130).

18. Quoted in Schwarz, *Rigour of Imagination*, p. 12.

19. Man Ray, *Self Portrait*, p. 340.

20. Man Ray, "Objects of My Affection," in *Oggetti d'affezione* (Turin: Giulio Einaudi, 1970). For Man Ray's explanation of his titles, see his interview with Pierre Bourgeade in *Bon Soir, Man Ray* (Paris: Pierre Belfond, 1972), pp. 64–65, 68.

21. On at least one occasion, Man Ray reversed the sexual identities of these two items, labeling the eggbeater "La Femme" (Collection Musée National d'Art Moderne, Centre Georges Pompidou, Paris) and the light-reflector assembly "L'Homme" (Fondation Marguerite Arp, Locarno). Both of these prints are dated 1920.

22. Man Ray, *Self Portrait*, p. 85.

23. From an interview with Arturo Schwarz, "This Is Not for America," p. 120.

24. Marcel Duchamp to Walter and Louise Arensberg, dated "fin Mars–19[19]" (Duchamp Papers, FBL); published in Francis M. Naumann, "Marcel Duchamp's Letters to Walter and Louise Arensberg, 1917–1921," in Naumann and Rudolf E. Kuenzli, eds., *Marcel Duchamp: Artist of the Century* (Cambridge: MIT Press, 1989), pp. 213–17.

25. *Man Ray: An exhibition of selected drawings and paintings accomplished during the period 1913–1919*, exh. cat., Daniel Gallery, New York, November 17–December 1, 1919. The reviews referred to are: Hamilton Easter Field, "Man Ray at the Daniel Gallery," *Brooklyn Daily Eagle*, November 30, 1919, p. 4; Royal Cortissoz, "Random Impressions in Current Exhibitions," *New York Tribune*, November 23, 1919, sec. IV, pp. 11, 13; and C. Lewis Hind (for full ref. see n. 4 above).

26. Arturo Schwarz, "Interview with Man Ray," p. 121.

27. Man Ray, *Self Portrait*, p. 89.

28. Ruth L. Bohan, "Katherine Sophie Dreier and New York Dada," *Arts* 51, no. 9 (May 1977), p. 100.

29. Man Ray, *Self Portrait*, p. 92.

30. Quoted in Schwarz, *The Rigour of Imagination*, p. 214.

31. Jean-Hubert Martin, *Man Ray: Photographs* (London: Thames and Hudson, 1982), entry no. 224, p. 132.

32. Quoted in Schwarz, *The Rigour of Imagination*, p. 160.

33. Quoted in Margery Rex, "If You Feel Like a Feather After a Party, You're a Tactilist," *New York Evening Journal* (February 11, 1921). In January 1921, a public argument took place in the Paris press between Picabia and Marinetti over exactly who it was who had invented the concept of "tactilism"; Marinetti said that it was Boccioni in 1912, and Picabia argued that it was first conceived by the American sculptor Edith Clifford Williams in New York in 1916. In the American press, their exchange was billed as a struggle between Dadaism and Futurism (see, for example, "Tactilism Greeted by Dadaist Hoots," *New York Times*, January 17, 1921, p. 15; "Dadaists War on 'Tactilism,' Latest Art Form," *Chicago Tribune*, January 17, 1921; "Dadaists and Futurists," *New York Times*, January 18, 1921, p. 10; "Picabia and Marinetti Disagree on 'Tactilism,'" *New York Herald*, January 20, 1921; and "Fighting for the Last Word in Art," *The Literary Digest*, February 19, 1921, p. 31).

THE ARENSBERG CIRCLE

1. Louise Arensberg to Henri-Pierre Roché, undated but postmarked April 3, 1920 (Papers of Henri-Pierre Roché, HRC).

ALBERT GLEIZES AND JULIETTE ROCHE

1. Much of the biographical information provided in the present account is derived from Daniel Robbins, *The Formation and Maturity of Albert Gleizes; A Biographical and Critical Study, 1881 through 1920*, unpub. diss., Institute of Fine Arts, New York University, New York, 1975. Gleizes himself provided a rather detailed account of his years in New York in "Voyages: Amérique 1915–1919," unpublished manuscript (Papers of Albert Gleizes and Juliette Roche, Centre Georges Pompidou, Paris). See also Pierre Alibert, *Albert Gleizes: Naissance et avenir du cubisme* (Saint-Etienne: Dumas, 1982), pp. 120–25.

It should be acknowledged that Albert Gleizes never really embraced the tenets of Dada; in fact, he renounced them. His inclusion in the present context comes by virtue of his physical presence in New York during the war years, and because of his close contact with many members of the Arensberg Circle. As we shall see, however, the writings of his wife contain an innate Dada sensibility that can be compared favorably to contemporaneous examples of vanguard prose and poetry, whether composed on one side of the Atlantic or the other.

2. *Man on a Balcony*, 1912, was purchased from the Armory Show by Arthur Jerome Eddy for $540, and *Woman at the Piano*, 1914, was purchased from the *Third Exhibition of Contemporary French Art* at the Carroll Galleries (March 8–April 3, 1915; cat. no. 30). On Arensberg's behalf, Pach wrote to Gleizes and asked if he could provide an interpretation of his painting; Gleizes's response (undated, but postmarked May 16, 1915) is preserved in the Arensberg Papers (PMA).

3. "French Artists Spur on an American Art," *New York Tribune*, 24 October 1915, sec. IV, p. 2; see also Sarah Addington, "New York Is More Alive and Stimulating Than France Ever Was, Say Two French Painters," *New York Tribune*, 9 October 1915, p. 7.

4. Quoted in Sarah Addington, "Two French Painters," ibid.

5. *The Sun*, 9 April 1916, sec. VI, p. 8. Mme. Gleizes later recalled that *Brooklyn Bridge* was purchased by Quinn directly out of the Montross exhibition (see Angelica Zander Rudenstine, *The Guggenheim Museum Collection: Paintings 1880–1945* [New York: Solomon R. Guggenheim Museum, 1976], vol. I, p. 158, n. 1), whereas the actual sale seems to have taken place a few weeks after the exhibition closed (see Judith Zilczer, "The Noble Buyer": *John Quinn, Patron of the Avant-Garde*, exh. cat., Hirshhorn Museum and Sculpture Garden, Washington, D.C., 1978, p. 99).

6. See Christopher Green, "The foreign avant garde in Barcelona, 1912–1922," in *Homage to Barcelona: The City and its Art 1888–1936* (exh. cat., Hayward Gallery [Arts Council of Great Britain], London, 1985, pp. 182–93). Gleizes showed thirty-one paintings at the Galeries Dalmau in an exhibition that ran from November 29 through December 12, 1916 (see Maria Lluïsa Borràs, *Picabia* [New York: Rizzoli, 1985], p. 174).

7. In the gossip column of his magazine, Picabia reported that Gleizes was having some trouble on sketching excursions in Manhattan. According to Picabia, when shop owners on Fifth Avenue saw Gleizes copying the designs in their windows, they thought he was a "dangerous lunatic," and promptly closed their doors (see "New York," *391*, no. 5 [June 1917]).

8. Juliette Roche, "La Minéralisation de Dudley Craving Mac Adam," *La Vie des Lettres et des Arts* (Paris) VIII, n.s., 1922, pp. 23–271; also published as a booklet by Croutzet, Paris, 1924.

9. These individuals were identified by Daniel Robbins in "Expectations and Disillusion: The Gleizes in New York 1915–1919," a paper delivered at a session of the College Art Association, San Francisco, January 25, 1989 (a copy of the text for this paper was kindly provided by Professor Robbins). The following analysis of Roche's text parallels that outlined by Robbins in his paper. On Arthur Cravan, see the present text (pp. 162–67).

10. Albert Gleizes, "The Abbey of Créteil, A Communistic Experiment," trans. by Alexander Harvey, *The Modern School* (Stelton, New Jersey: October, 1918), pp. 300–15. See also Daniel Robbins, "From Symbolism to Cubism: The Abbaye of Créteil," *The Art Journal* 23, no. 2 (Winter 1963–64), pp. 111–16.

11. See Robbins, *The Formation and Maturity of Albert Gleizes*, pp. 204–10.

12. Albert Gleizes, Preface to *Annual Exhibition of*

Modern Art, Bourgeois Galleries, New York, May 3–24, 1919; essay reprinted as "The Impersonality of American Art," *Playboy: A Portfolio of Art and Satire*, nos. 4–5 (1919), pp. 25–26.

13. Juliette Roche, *Demi Cercle* (Paris: Editions d'art "La Cible," 1920). This publication was an anthology of Roche's poems and prose pieces written over the course of the previous seven years, the majority of which were composed during her stay in New York.

14. Pierre Cabanne, *Dialogues with Marcel Duchamp*, trans. by Ron Padgett (New York: Viking Press, 1971), p. 57.

JEAN AND YVONNE CROTTI

1. "French Artists Spur on an American Art," *New York Tribune*, 24 October 1915, sec. IV, p. 4.

2. "Jean Crotti deux fois est né," unpublished manuscript (Dossier Tzara, BLJD; quoted in William A. Camfield and Jean-Hubert Martin, *Tabu Dada: Jean Crotti & Suzanne Duchamp 1915–1922*, Kunsthalle, Bern, 22 January–27 February 1983, pp. 12, 82).

3. H. C. Redgrave, "Art and Artists: The Extremes of Contemporary American Painting," *The Globe and Commercial Advertiser*, New York, 14 April 1916, p. 16.

4. Charles H. Caffin, "Four Musketeers of 'Modernism'," *New York American*, 10 April 1916, p. 7.

5. Nixola Greeley-Smith, "Cubist Depicts Love in Brass and Glass; 'More Art in Rubbers Than in Pretty Girl!' " *The Evening World*, 4 April 1916, p. 3; this same article appeared with a slightly altered title and without illustrations in *Washington Post*, 9 April 1916, sec. III, p. 7.

6. Caffin, "Four Musketeers," *American*, p. 7. See also Robert J. Cole, "Studio and Gallery," *Evening Sun*, 14 April 1916, p. 14; "Art Notes," *New York Times*, 13 April 1916, p. 12; and Redgrave, "Art and Artists," *Globe*. For a summation of reviews mentioning this sculpture, see "The Climax of Audacity in the Modern Art Revolution," *Current Opinion* 60, no. 6 (June, 1916), p. 431.

EDGARD VARÈSE

1. "Visages d'Edgard Varèse," ed. by l'Hexagone, *Liberté* 59 (Montreal: September–October 1959), p. 11 (quoted in Fernand Ouellette, *Edgard Varèse*, trans. by Derek Coltman [New York: Orion Press, 1968], p. 49). Unless otherwise noted, most of the biographical details contained in the present account are derived from Louise Varèse, *Varèse: A Looking-Glass Diary*, vol. 1: *1883–1928* (New York: W. W. Norton, 1972), p. 53, and from numerous interviews with Louise Varèse conducted at her home in New York during the 1970s and early 1980s. Also helpful were the articles

by Varèse's most distinguished protégé, Professor Chou Wen-chung, "Varèse: A Sketch of the Man and His Music," *The Musical Quarterly* 52, no. 2 (April 1966), pp. 151–70, and "Open Rather than Bounded," *Perspectives of New Music* 5, no. 1 (Fall–Winter 1966), pp. 1–10.

2. Varèse to Mme. Kauffmann (mother of Varèse's first wife), written around February 29, 1916 (quoted in Varèse, *Looking-Glass Diary*, p. 122).

3. Quoted in ibid., p. 123.

4. From a review published in the *New York Evening Mail* (quoted in Varèse, *Looking-Glass Diary*, p. 129).

5. According to Ouellette, Varèse met Louise Norton in a bar late in 1917 (*Varèse*, pp. 50–51).

6. Henry Krehbiel, *New York Tribune* (quoted in Varèse, *Looking-Glass Diary*, p. 143).

7. Quoted in ibid., p. 146.

8. Edgard Varèse, "My Titles," unpub. ms. (Varèse Collection, Fernand Ouellette Archives, National Library of Canada, Ottawa); quoted in the program notes to *Varèse: Amériques, Nocturnal Ecuatorial*, conducted by Maurice Abravanel and the Utah Symphony Orchestra (Vanguard Classic, compact disc, 1991).

9. *The Evening Bulletin*, Philadelphia, April 12, 1926 (as quoted in Ouellette, *Varèse*, p. 57).

10. Edgard Varèse, "Que La Musique Sonne," *391* (June 1917); trans. by Louise Varèse in Varèse, *Looking-Glass Diary*, p. 132.

11. Edgard Varèse, letter to Thomas H. Greer, August 15, 1965; quoted in Olivia Mattis, "Varèse and Dada," unpublished paper, delivered before the American Musicological Society, Stanford University, April 24, 1988. A copy of this paper was kindly sent to the author by Mattis.

12. See Jonathan W. Bernard, "Varèse's Aesthetic Background," in *The Music of Edgard Varèse* (New Haven: Yale University Press, 1987), pp. 1–38. Bernard's book presents the first significant analysis of Varèse's music, a study that is especially valuable in its attempt to establish a theory for the structure of Varèse's music wherein each composition can be diagrammed and analyzed within the context of a "spatial" reading.

13. In an interview with Gilbert Chase, unpublished recorded interview, ca. 1961 (Collection of Olivia Mattis); quoted in Mattis, "Edgard Varèse and the Visual Arts," draft of an unpublished doctoral dissertation in preparation for the University of California, Berkeley (I am grateful to Ms. Mattis for having allowed me to consult selected passages of this thesis).

14. The Varèse scholar is Olivia Mattis (see previous note). In his biography of Varèse, Ouellette devotes considerable effort to dismissing the importance of Varèse's contacts with the Dadaists (*Varèse*, pp. 70–72).

HENRI-PIERRE ROCHÉ

1. Henri-Pierre Roché, "How New York Did Strike Me," unpublished ms., 1924 (Papers of Henri-Pierre Roché, HRC); quoted in Carlton Lake and Linda Ashton, eds., *Henri-Pierre Roché: An Introduction* (Austin: Humanities Research Center, University of Texas, 1991), pp. 72–73.

2. Henri-Pierre Roché, *Victor*, 1945–59, p. 38 (published posthumously in Jean Clair, *Marcel Duchamp*, exh. cat., Centre National d'Art et de Culture Georges Pompidou, Musée National d'Art Moderne, Paris, 1977, vol. IV). Naturally, many of the events incorporated into this novel are fictitious; however, many—such as those recalled here—appear to have been based on actual events that took place, if not on the first day of his arrival in New York, at some time shortly thereafter.

3. Henri-Pierre Roché, "Souvenirs of Marcel Duchamp," trans. by William N. Copley, in Robert Lebel, *Marcel Duchamp* (New York: Grove Press, 1959), pp. 79–80. Roché began compiling his recollections of Duchamp in 1945 (see previous note), and they were first published in a number of articles appearing during the 1950s ("Souvenirs sur Marcel Duchamp," *La Nouvelle revue française* I, no. 6 [June, 1953], pp. 1133–38; "Vie de Marcel Duchamp," *La Parisienne*, no. 24 [January 1955], pp. 63–69).

4. Henri-Pierre Roché to John Quinn, March 9, 1922 (John Quinn Memorial Collection, NYPL). Roché described his collection in an article published just a few months before his death: "Adieu, brave petite collection!" *L'Oeil* 51 (March 1959), pp. 34–40.

5. The word "Pet" appears for the first time in Roché's diaries in an entry dated 22 March 1917, and it is referred to again three days later by the letters "P.E.T." (Roché Journals; HRC). These same initials appear on the back cover of *The Blindman*, no. 1—which appeared on April 10, 1917—where it is noted that this magazine was still "in preparation."

6. These codes were deciphered and published in the introduction to Henri-Pierre Roché, *Carnets: Les Années Jules et Jim, Première Partie 1920–1921*, Marseille: André Dimanche, 1990).

7. Gertrude Stein, "Portrait of Henri-Pierre Roché," 1911, published in Stein, *Geography and Plays* (Boston: The Four Seas Company, 1922); original manuscript quoted in Lake and Ashton, *Henri-Pierre Roché*, p. 28.

8. Journal of Henri-Pierre Roché, unpublished (Roché Papers, Carlton Lake Collection, HRC); this particular excerpt was transcribed and translated for the author by Linda Henderson, whose assistance is greatly appreciated. Of the individuals mentioned in this account, Aileen Dressler was Beatrice Wood's landlady, who often came to the Arensberg apartment with her husband in order to "hobnob with the rich and famous" (interview with Wood, March 3, 1992, Ojai);

Miss Dodge is probably Mabel Dodge, who in prior years had maintained a distinguished salon of her own (see the biographies by Emily Hahn, *Mabel: A Biography of Mabel Dodge Luhan* [Boston: Houghton Mifflin Company, 1977], and Louis Palken Rudnick, *Mabel Dodge Luhan: New Woman, New Worlds* [Albuquerque: University of New Mexico Press, 1985]); the de Meyers were probably the celebrated fashion photographer Baron Adolph de Meyer and his wife, Olga Caraccio. It is not known who the Perrets were.

9. Roché Journal, entries for September 1–6, 1919 (HRC); selected passages translated by Linda Ashton.

BEATRICE WOOD

1. "New York Girl Makes Debut at Théâtre Français," undated newspaper clipping (Scrapbooks, Archives of Beatrice Wood, Ojai, California).

2. Much of the present account was derived from conversations with the artist held over the course of the past fifteen years. See also her own recollections of this period, Beatrice Wood, *I Shock Myself: The Autobiography of Beatrice Wood* (San Francisco: Chronicle Books, 1988), pp. 21–41.

3. Roché's name first appears in Wood's diaries in an entry dated February 25, 1917 (Personal Papers, Ojai, California); the name "Béatrice" first appears in Roché's diaries on the same date (Roché Journals, Carlton Lake Collection HRC).

4. Henri-Pierre Roché, *Victor*, p. 70 (published in Jean Clair, ed., *Marcel Duchamp*, exh. cat., Centre National d'Art et de Culture Georges Pompidou, Musée National d'Art Moderne, Paris, 1977, vol. IV). Although Roché's novel clearly fictionalized these events, Beatrice Wood has acknowledged that a conversation along these lines did in fact take place between herself and Roché (telephone conversation with the author, June 13, 1991).

5. My own earlier, mistaken interpretation of this drawing (Francis Naumann, "The Drawings of Beatrice Wood," *Arts* 57, no. 7 [March 1983], p. 108) was based on the artist's description of this drawing as an "imaginative sketch" (see Francis M. Naumann, "I Shock Myself: Excerpts from the Autobiography of Beatrice Wood," *Arts* 51, no. 9 [May 1977], p. 134). The Reynolds-Hapgood marriage took place in the Church of the Ascension in New York on December 13, 1916.

6. Roché and Louise Arensberg particularly admired this drawing. Roché provided a vivid description of this drawing in his novel *Victor*, pp. 44–45.

7. Wood, *I Shock Myself*, p. 33.

8. Ibid., p. 37. According to Wood's diary, this trip to Coney Island took place on June 21, 1917.

CLARA TICE

1. See Arnold I. Kisch, *The Romantic Ghost of Greenwich Village: Guido Bruno in His Garret* (Frankfurt, Germany: Peter Lang, 1976), pp. 36–37.

2. Quoted in Kisch, ibid., p. 38. The trial is also announced in an undated flyer reproducing an etching by Tice of a nymph in leopard skin in high marshy grass (Collection Elizabeth Yoell, Granby, Connecticut). See also "The Blacks and Whites of Clara Tice with a Recent Portrait of the Artist," *Vanity Fair* V, no. 1 (September 1915), p. 60, and Alfred Kreymborg, "Guido Bruno, A Literary Vagabond," *The Morning Telegraph*, 23 May 1915. Much of the present information on Tice was kindly provided by Marie Keller, who is presently preparing an article on the artist.

3. Quoted in Clara Tice, "How You Looked to Clara Tice That Day on the Meramec," *Saint Louis Star*, 3 July 1921.

4. See *Rogue* III, no. 1 (October 1916), p. 2; quoted in Glen MacLeod, *Wallace Stevens and Company: The Harmonium Years 1913–23* (Ann Arbor: UMI Press, 1983), p. 26. Clara Tice often contributed drawings to *Rogue*.

5. As quoted in "Greenwich Village 'Queen' Here Decries Beauty That Is Purchased," *Saint Louis Star*, 9 June 1921.

6. Ibid.

CHARLES SHEELER

1. Sheeler showed nine paintings and four drawings in the Forum Exhibition (see *The Forum Exhibition of Modern American Painters*, Anderson Galleries, New York, March 13–March 25, 1916); see also the checklist of works included in this exhibition (Papers of the Forum Exhibition, AAA). Sheeler's photographs were shown at the Modern Gallery, along with those of Strand and Schamberg, March 29–April 9, 1917; and the second show of Doylestown house photographs was held December 13–15, 1917.

2. Henry McBride, "Notes and Activities in the World of Art," *The New York Sun*, 8 April 1917, sec. V, p. 12; for a similar view, also see "Photographic Art at the Modern Gallery," *American Art News* XV, no. 25 (March 31, 1917), p. 3. The review of the second exhibition was entitled " 'Modernist' Photographs," and appeared in *American Art News*, no. 10 (December 15, 1917), p. 3.

3. Marius de Zayas, "How, When, and Why Modern Art Came to New York," Francis M. Naumann, ed., *Arts* 54, no. 8 (April 1980), p. 104.

4. See Carol Troyen, "From the Eyes Inward," in Troyen and Erica E. Hirshler, *Charles Sheeler: Paintings and Drawings* (Boston: Little, Brown, 1988), p. 7. In 1916, de Zayas published a deluxe album of his collection of "Negro sculpture" for which Sheeler provided the photographs.

5. According to Sheeler's first biographer, this work was purchased by the Arensbergs directly out of the Independents Exhibition of 1917 (see Constance Rourke, *Charles Sheeler: Artist in the American Tradition* [New York: Harcourt, Brace, 1938], p. 45).

6. Sheeler, interview by Bartlett Cowdrey, December 9, 1958 (AAA; quoted in Troyen, "From the Eyes Inward," p. 10).

7. Quoted in Rourke, *Charles Sheeler*, pp. 47–48.

8. Papers of Charles Sheeler, NS1: 78, and from an interview with Martin Friedman, June 18, 1959, pt. 2, p. 14 (both AAA; quoted in Troyen, "From the Eyes Inward," p. 10).

9. The Duchamp portrait of Sheeler appeared in "Among the Best of American Painters," *Vanity Fair* 20, no. 1 (March 1923), p. 52, a photo essay that also included Man Ray's photographic portrait of Duchamp and Joseph Stella (p. 90). The Sheeler drawing Duchamp admired (see interview with Friedman, pt. 2, p. 9) was his *Self Portrait*, 1923 [Museum of Modern Art], which was reproduced in *Broom* (vol. 5, no. 3 [October, 1923], p. 128), where it was called *Still Life*. For a somewhat exaggerated interpretation of this drawing as it compares to Duchamp's *Large Glass*, see Susan Fillin Yeh, "Charles Sheeler's 1923 'Self Portrait,' " *Arts* 52, no. 5 (January 1978), pp. 106–9.

10. See commentary in chapter 8. For an excellent account of the making of *Manhatta* and for an analysis of the film, see Theodore E. Stebbins, Jr., and Norman Keyes, Jr., *Charles Sheeler: The Photographs* (Boston: Little, Brown, 1987), pp. 17–21.

MORTON SCHAMBERG

1. It has been noted that Schamberg's first depiction of a machine actually predated Picabia's arrival by at least three months. The painting in question is a lost Cubist composition from 1914, shown in the Montross Gallery in the spring of that year, and known only through the photograph reproduced in the accompanying catalogue (*Exhibition of Paintings, Drawings and Sculpture*, March 23–April 24, 1915, no. 51). When this photograph is examined carefully, the translucent shape of a telephone can be faintly discerned (observed for the first time by William Camfield, *Francis Picabia: His Art, Life and Times* [Princeton: Princeton University Press, 1979], p. 107, n. 35). In stylistic terms, however, the overlay of geometric forms in this picture can be more closely associated with Schamberg's earlier Cubist style than it can with the machine paintings that follow in 1916.

2. "More Moderns at Bourgeois," *American Art News* XIV, no. 27 (April 8, 1916), p. 3. Schamberg exhibited six works, five simply entitled "Painting," and one called "Watercolor" (*Exhibition of Modern Art: Arranged by a Group of European and American Artists in*

New York, Bourgeois Gallery, New York, April 3–29, 1916; cat. nos. 34–39).

3. As reported in Ben Wolf, *Morton Livingston Schamberg* (Philadelphia: University of Pennsylvania Press, 1963), p. 39.

4. *Philadelphia Exhibition of Advanced Modern Art*, McClees Gallery, Philadelphia, May 17–June 15, 1916; in all, twenty-two artists were represented by thirty-one works.

5. See Kenneth Macgowan, "Philadelphia's Exhibit of 'What Is It?'" *Boston Evening Transcript* 27 May 1916, part III, p. 6.

6. After studying one of Schamberg's machinist paintings, this very relative supposedly remarked: "The goddam thing wouldn't work" (quoted in Wolf, *Schamberg*, p. 30).

7. William Agee, "Morton Livingston Schamberg: Notes on the Sources of the Machine Images," in Rudolf E. Kuenzli, ed., *New York Dada* (New York: Willis Locker & Owens, 1986), pp. 66–80. See also Robert L. Herbert, Eleanor S. Apter, Elise K, Kenney, eds., *The Société Anonyme and the Dreier Bequest at Yale University: A Catalogue Raisonné* (New Haven: Yale University Press, 1984), p. 586.

8. Reported in Constance Rourke, *Charles Sheeler: Artist in the American Tradition* (New York: Harcourt, Brace, 1938), p. 37.

9. In a list of the Arensberg Collection prepared by a secretary at the Francis Bacon Foundation in the early 1950s—and, thus, directly under Walter Arensberg's supervision—the work *God* is listed under Schamberg's name, to which is added: "This construction was made by *both* Schamberg and Von Loringshofen [*sic*]" ("Exhibit A: Given by Louise and Walter Arensberg"; Arensberg Archives, PMA [emphasis added]). When the catalogue of the Arensberg Collection was published by the Philadelphia Museum in 1954, this information is noted (*The Louise and Walter Arensberg Collection: 20th Century Section*, cat. no. 187, the Baroness's name is given more accurately as Elsa von Freytag Loringhoven). With the exception of Robert Reiss ("'My Baroness': Elsa von Freytag-Loringhoven," in Kuenzli, ed., *New York Dada*, p. 88) and William C. Agee (*Morton Livingston Schamberg: The Machine Pastels*, exh. cat., Salander-O'Reilly Galleries, Inc., 1986, n.p.)—both of whom I alerted to the Baroness's collaborative role in the creation of this object—all subsequent scholars writing on either the Baroness or Morton Schamberg have failed to note this dual attribution.

10. Walter Pach, "The Schamberg Exhibition," *The Dial* 66 (May 17, 1919), p. 505; repr. in Wolf, *Schamberg*, pp. 36–38.

CHARLES DEMUTH

1. Willard Huntington Wright, "Modern Art: Four Exhibitions of the New Style of Painting," *International Studio* 60 (January 1918), pp.

97–98, and H. C. Nelson, "Art and Artists," *New York Globe and Commercial Advertiser*, 30 November 1917, p. 12 (quoted in Emily Farnham, *Charles Demuth: Behind a Laughing Mask* [Norman: University of Oklahoma Press, 1971], pp. 114–15).

2. It is not known precisely when the Arensbergs acquired this watercolor, though it was certainly before 1919, when Charles Sheeler took the photographs of the interior of their apartment (as indicated on a list compiled by Arensberg and his secretaries in 1951 for the purposes of a United States Use Tax investigation: "Source Material for 20th Century Selection of Arensberg Collection," nos. 401 and 406 [Arensberg Papers, PMA]).

3. From an interview with Emily Farnham, quoted in Farnham, *Demuth*, p. 124. Unless otherwise noted, all quotations from Duchamp about Demuth are derived from this source.

4. According to the recollections of Susan Watts Street, a wealthy New York socialite and friend of Demuth's (quoted in Farnham, *Demuth*, p. 15).

5. See, for example, Kermit Champa, "Charlie Was That Way," *Artforum* XII, no. 6 (March, 1974), pp. 54–59. For examples of Demuth's homoerotic work, see Barbara Haskell, *Charles Demuth* (New York: Harry N. Abrams, 1988), figs. 20–21; 104–8, and pp. 57–61.

6. As reported by Henry McBride in his review of Demuth's show at the Daniel Gallery in 1917 (quoted in Farnham, *Demuth*, p. 116).

7. Henry McBride, "An Underground Search for Higher Moralities," *Evening Sun*, 25 November 1917 (quoted in Farnham, *Demuth*, p. 104).

8. Charles Demuth to Henry McBride, undated (Papers of Henry McBride, YCAL).

9. Charles Demuth, "For Richard Mutt," *The Blind Man*, no. 2 (May 1917), p. 6.

10. Charles Demuth to Alfred Stieglitz, February 5, 1928 (quoted in Farnham, *Demuth*, p. 12).

11. See Betsy Fahlman, *Pennsylvania Modern: Charles Demuth of Lancaster* (Philadelphia Museum of Art, 1983), p. 41.

12. Unsigned editorial statement, *Contact* I, no. 1 (December 1920), p. 1.

13. Charles Demuth to Alfred Stieglitz, October 10, 1921 (quoted in Farnham, *Demuth*, p. 131).

14. Quoted in Thomas Craven, "Charles Demuth," *Shadowland*, VII, no. 4 (December 1922), p. 11.

15. Forbes Watson, "Charles Demuth," *The Arts*, III, no. 1 (January 1923), p. 78.

JOHN COVERT

1. Unless otherwise noted, biographical details are derived from the writings of Michael Eugene Klein, Covert's most assiduous biographer: "The Art of John Covert," unpub. diss., Columbia University, New York, 1971, and *John Covert, 1882–1960*, exh. cat., Hirshhorn Museum and Sculpture Garden,

Washington, D.C., 1976.

2. From an interview with Rudi Blesh, conducted in New York in the early 1950s; quoted in Blesh, *Modern Art USA: Men, Rebellion, Conquest, 1900–1956* (New York: Alfred A. Knopf, New York, 1956), p. 92.

3. This remark and Covert's account are quoted in ibid., p. 92. On the basis of a letter written by Wallace Stevens to his wife in August 1915, wherein he reports that the Arensbergs were spending the summer in Pomfret, Klein believes this incident occurred in 1915 (Klein, "Covert," 1971, p. 49). However, there is no proof that Covert was with the Arensbergs that particular summer, and the paintings from this year bear no evidence of such a radical conversion to modern art. But they certainly do in 1916, which is why this date has been used here.

4. "The Society of Independent Artists: Pictures 'Independent' and Otherwise," *The Outlook* 116 (May 2, 1917), p. 10.

5. Walter Conrad Arensberg, *The Cryptography of Dante* (New York: Alfred A. Knopf, 1921), pp. ix and 55–56.

6. Klein, "Covert," 1971, p. 73. A similar interpretation of this title was suggested by Craig Bailey (letter to the author, 18 June 1980), who arrived at this conclusion independently.

7. Quoted in Blesh, *Modern Art USA*, p. 92.

8. Michael Klein, "John Covert's *Time*: Cubism, Duchamp, Einstein—A Quasi-Scientific Fantasy," *Art Journal* XXXIII, no. 4 (Summer 1974), pp. 314–20. The present analysis is based on Klein's interpretation of this picture.

9. Klein, "Covert's *Time*," p. 315.

10. John Covert to Louise Arensberg, undated, but marked in pencil on the first page: 1932 (Papers of John Covert, FBL). The painting referred to is *Leda and the Swan*, ca. 1916 [Seattle Art Museum].

11. See Klein, *Covert*, 1971, pp. 101–2, 105.

12. See, for example, George Heard Hamilton, "John Covert: Early American Modern," *Art Journal* XII (Fall 1952), p. 41.

13. Henry McBride, "Views and Reviews of Art," *The Sun and New York Herald*, 25 April 1920, sec. III, p. 4.

14. See Klein, *Covert*, 1971, p. 64.

15. Walter Arensberg, *Cryptography of Dante*, pp. 205–6.

16. Quoted in Blesh, *Modern Art USA*, p. 93.

JOSEPH STELLA

1. This description appeared below a reproduction of Stella's *Battle of Lights* (see below), in an article by Walter Pach, "The Point of View of the 'Moderns,'" *The Century* 87 (April 1914), p. [853]. It is not known whether Pach or the magazine's editors wrote this caption.

2. Biographical details were derived primarily from Stella's own writings, particularly his "Discovery of America: Autobiographical Notes," 1946, published in *Art News* 59

(November 1960), pp. 41–43, 64–67. Also helpful were the monographs of Irma B. Jaffe, *Joseph Stella* (Cambridge: Harvard University Press, 1970), and John I. H. Baur, *Joseph Stella* (New York: Praeger, 1971).

3. Stella himself acknowledged that it was a letter from Pach that convinced him to go to Paris (Stella, "The New Art," *Trend* 5 [June 1913], p. 394).

4. Stella, "The New Art," p. 395.

5. Pach, "The Moderns," *Century*. Stella's painting was first shown in *Exhibition of Paintings and Drawings*, Montross Gallery, New York, February 2–23, 1914, cat. no. 32, illus. The painting was singled out by at least three critics in addition to Walter Pach: Henry McBride, "The Growth of Cubism," *New York Sun*, 8 February 1914 (repr. in Daniel Catton Rich, ed., *Essays and Criticisms of Henry McBride* [New York: Atheneum, 1975], pp. 51–55); "Exhibition of Modernist Paintings at Montross Galleries Includes Many Interesting Productions," *New York Times*, 8 February 1914, sec. V, p. 15; and Edwin S. Parker, "An Analysis of Futurism," *International Studio* 58 (April 1916), p. 60.

6. In her otherwise reliable monograph on Stella, the only works on glass Jaffe mentions are *Pittsburgh*, *Man in the Elevated* and *La Fusée*, not one of which she was able to securely identify with known works by the artist. She illustrated only *Prestidigitator*, although she was unaware of its title (see Jaffe, *Stella*, pp. 61–62, plate 60).

7. My description of this painting closely follows that originally suggested by Ruth L. Bohan, "Joseph Stella's *Man in Elevated (Train)*," in Stephen C. Foster, ed., *Dada/Dimensions* (Ann Arbor: UMI Research Press, 1985), pp. 187–219. I do not, however, agree with this author's extended analysis of this painting in relation to specific works by Duchamp. The identification of the figure and newspaper are confirmed by the recent discovery of a drawing with collage attachments (reproduced in Joann Moser, *Visual Poetry: The Drawings of Joseph Stella* [Washington, D. C.: National Museum of American Art, 1990], p. 135: fig. 125). This drawing—which is signed and dated 1918—bears such a close formal relationship to the finished work on glass that it must have served as a preparatory drawing. Therefore, it is believed that the signature and date were probably added later, at a time when Stella no longer accurately recalled the year when this work was made.

8. Kenneth Macgowan, "Philadelphia's Exhibit of 'What Is It?'" *Boston Evening Transcript*, 27 May 1916, part III, p. 6.

9. *Exhibition of Modern Art: Arranged by a Group of European and American Artists in New York*, Bourgeois Galleries, New York, February 10–March 10, 1917, cat. no. 62. In addition to *Chinatown*, Stella showed two other works entitled *Landscape* and *The Acrobat* (cat. nos. 60 and 61).

10. Quoted in Jaffe, *Stella*, pp. 2–3.

11. Man Ray, *Self Portrait* (Boston: Little, Brown, 1963), p. 93; and Beatrice Wood, *I Shock Myself* (San Francisco: Chronicle Books, 1988), p. 33.

12. *Annual Exhibition of Modern Art: Arranged by a Group of European and American Artists in New York*, Bourgeois Gallery, New York, May 3–24, 1919, cat. no. 46; although Stella exhibited five other works in this show, the catalogue specifically indicates that this particular painting was on "glass." In 1918, he showed *La Fusée*, a work also reported to have been painted on glass (see Jaffe, *Stella*, p. 62).

13. "America's Rebellious Painters and New Style," *[New York] Globe and Commercial Advertiser*, 22 November 1920. Although this reviewer does not specifically report that this painting is on glass, the separate colors and geometric shapes he describes are characteristic of Stella's other work in this medium.

14. Baur, *Stella*, p. 41. Curiously, Baur dismisses the influence of Schwitters. Schwitters's collages were first shown in the United States in a group exhibition at the Société Anonyme November 1–December 2, 1920. A more detailed study of Stella's collages was recently undertaken by Joann Moser ("The Collages of Joseph Stella: *Macchie/Macchine Naturali*," *American Art* 6, no. 3, [Summer 1992], pp. 58–77); unfortunately this study suffers from an inability to more precisely date the collages.

15. August Mosca, quoted in Baur, *Stella*, p. 42.

16. The lecture was billed as "an informal talk on modern art," and was presented at the Société Anonyme on January 27, 1921. It was published as "On Painting" in *Broom* I, no. 2 (December 1921), pp. 119–22.

17. *Salon Dada*, Galerie Montaigne, Paris, June 6–30, 1921, cat. no. 74. *The Little Review* IX, no. 3 (Autumn 1922).

18. Henry Tyrrell, "New York in Epic Painting," *[New York] World*, 21 January 1923. *Joseph Stella: "New York Interpreted" and Other Paintings*, flier, no checklist; accompanying brochure by Katherine Dreier, *Stella* (New York: Société Anonyme, 1921).

THE STETTHEIMER SISTERS

1. Beatrice Wood was introduced to the Stettheimers at the Arensbergs, though she remembers little about them, except to say that "Duchamp talked about them all the time," and that all three "lacked bosoms" (conversation with the author, July 2, 1991).

2. The origin of the dollhouse is best told by Ettie Stettheimer, "Introductory Foreword," June 12, 1947 (published in John Noble, *A Fabulous Dollhouse of the Twenties* [New York: Dover, 1976], pp. 11–12). The dolls were added in the 1970s by John Noble, then curator of the Toy Collection at the Museum of the City of New York. From evidence that survives, it appears that Carrie Stettheimer initially planned for her dollhouse to be inhabited by dolls, but she was reluctant to actually construct them. In a letter to Gaston Lachaise (dated April 11, 1931) she wrote: "I think that the dolls after they are born, which they are not yet—ought to be the happiest and proudest dolls in the world. . . . I am now hoping they will never be born so that I can keep them forever in custody and enjoy them myself, while awaiting their arrival." (This letter was brought to my attention by Barbara J. Bloemink, who is writing a monograph on Florine Stettheimer.)

3. Florine Stettheimer, Journals (Stettheimer Papers, YCAL); these passages are quoted in Parker Tyler, *Florine Stettheimer: A Life in Art* (New York: Farrar, Straus, 1963), p. 30. Twelve paintings were shown in this exhibition (see *Exhibition of Paintings by Miss Florine Stettheimer*, exh. cat., Knoedler & Co., New York, October 16–28, 1916).

4. Eddy [Art Reviews], *New York World*, 22 October 1916 (Press Clippings, Florine Stettheimer Papers, BLCU).

5. "At the Galleries," *[New York] Evening Post*, 21 October 1916, mag. sec., p. 20 (Stettheimer Press Clippings, BLCU); quoted in Elisabeth Sussman, *Florine Stettheimer: Still Lifes, Portraits and Pageants 1910-1942* (Boston: Institute of Contemporary Art, 1980), [n. 17].

6. Florine Stettheimer, *Crystal Flowers* (New York: privately printed, 1949), p. 82. On the basis of a single painting that is signed and dated 1915, *Family Portrait No. 1* (Florine Stettheimer Collection, Columbia University; bequest of Ettie Stettheimer), which, as the title suggests, depicts members of the Stettheimer family, historians have concluded that Florine Stettheimer's mature style began in this year. This painting, however, depicts the three sisters and their mother in half-length portraits, very unlike the style of Florine Stettheimer's paintings after 1917, where figures are usually rendered as tiny beings interacting with one another in a crowded space, as in the paintings of Bruegel (or, for more contemporary sources, in the paintings of Juliette Roche: see p. 99). I should like to suggest that a stylistic transformation in her work did not occur until *after* she experienced the disappointment in her show at Knoedler's, which is to say only after October 30, 1916.

7. Ettie Stettheimer, Journals, July 30, 1917 (YCAL).

8. Florine Stettheimer, Journals (YCAL); quoted in Tyler, *Stettheimer*, p. 69.

9. Ettie Stettheimer, Journals, February 3, 1919 (YCAL).

10. At least four of these place cards have been preserved, those belonging to: Carl Van Vechten and Fania Marinoff (Collection Ronny van de Velde, Antwerp); Henri-Pierre Roché (Harry Ransom Humanities Research Center,

University of Texas, Austin); and Francis Picabia (formerly collection Pierre André Benoit, Alès; reproduced in Arturo Schwarz, *The Complete Works of Marcel Duchamp* [New York: Harry N. Abrams, 1970], p. 464).

11. Henry McBride, "Florine Stettheimer at the Independents," *The [New York] Sun*, 28 April 1918; reprinted in Daniel Catton Rich, ed., *Essays and Criticisms of Henry McBride* (New York: Atheneum, 1975), pp. 151–52.

12. Marcel Duchamp to F[lorine]. E[ttie]. and C[arrie] Stettheimer, 3 May [1919] (Stettheimer Papers, Collection Joseph Solomon, New York).

13. Ettie Stettheimer to "Gansy" [Henri Gans], 13 March 1918, transcribed and included in her journals (YCAL).

14. Marcel Duchamp to Ettie Stettheimer, 12 November 1918 (YCAL).

15. Based on the fact that in this period "Duchamp was in the immediate vicinity" Barbara Bloemink dates this painting to 1925–26 (*Friends and Family: Portraiture in the World of Florine Stettheimer*, exh. cat., Katonah Museum of Art, 1993, p. 9). But since Duchamp left New York in 1923, not to return until late October of 1926, I am inclined to date this picture earlier, to ca. 1922–23, when the artist was back in New York and saw the Stettheimers frequently. Indeed, the portrait records Duchamp with a closely cropped head of hair, which is how he appeared for some months after having had a star shaved into the back of his head in Paris in 1921 (and this is how he looked when greeting the Stettheimers upon his return to New York in the spring of 1922; see n. 21 below).

16. Carl Van Vechten, "The World of Florine Stettheimer," *Harper's Bazaar* 79 (October 1946), p. 354.

17. From the first line in "Duche," the poem about Duchamp in Florine Stettheimer, *Crystal Flowers*, p. 55; quoted in Tyler, *Stettheimer*, p. 56.

18. Tyler suggested both the chess and cosmic clocks (*Florine Stettheimer*, p. 41).

19. Ettie Stettheimer, *Philosophy* (New York: Longmans, Green, 1917); reprinted in *Memorial Volume of and by Ettie Stettheimer* (New York: Alfred A. Knopf, 1951), p. 460.

20. Ettie Stettheimer, Journals, July 24, 1918, and August 5, 1918 (YCAL).

21. Henrie Waste, *Love Days [Susanna Moore's]* (New York: Alfred A. Knopf, 1923), p. 109. Although this novel was not published until 1923, Ettie's description of her encounter with this French painter was probably based on a visit from Duchamp in the spring of 1922; she even notes that his hair was "clipped" (p. 107), a reference to the way in which Duchamp wore his hair upon his return from Paris (see n. 15 above).

22. Marcel Duchamp to Ettie Stettheimer, dated "En villégiature de Circoncision à Rouen 1923[-]24," indicating a date of January 1, 1924 (YCAL).

23. Ettie Stettheimer, *Memorial Volume*, p. x.

KATHERINE DREIER

1. Katherine Dreier, "The Modern Ark—A Private Museum," unpub. ms., 1920 (Papers of the Société Anonyme, YCAL); quoted in Robert L. Herbert, "Introduction," in Herbert, Eleanor S. Apter, and Elise K. Kenney, eds., *The Société Anonyme and the Dreier Bequest at Yale University: A Catalogue Raisonné* (New Haven: Yale University Press, 1984), p. 3. The list of members that follows below can be found in *Société Anonyme, Inc. (Museum of Modern Art): Report 1920–1921* (New York: Société Anonyme, 1921), pp. 28–29.

2. K[atherine]. S[ophie]. D[reier]., 1949, statement on Matisse in *Collection of the Société Anonyme: Museum of Modern Art 1920* (New Haven: Yale University Art Gallery, 1950), p. 15.

3. Elisabeth Huberta du Quesne-Van Gogh, *Personal Recollections of Vincent Van Gogh* (New York: Houghton Mifflin Company, 1913).

4. Ruth L. Bohan, *The Société Anonyme's Brooklyn Exhibition: Katherine Dreier and Modernism in America* (Ann Arbor: UMI Research Press, 1982), pp. 10–11.

5. Herbert surmised that by at least 1927, Dreier "must have been half-secretly in love with Duchamp for years" (*Dreier Bequest*, p. 12). This subject was singled out as one of the more frustrating aspects of Dreier's life in a review of the Herbert book by Ronny H. Cohen, *The Print Collector's Newsletter* XV, no. 5 (November–December, 1984), p. 185.

6. Dreier to Duchamp, April 13, 1917 (Papers of the Société Anonyme, YCAL).

7. Dreier to Glackens, April 26, 1917 (Papers of the Société Anonyme, YCAL).

8. Rudolf Steiner, *Theosophy*, 1903; quoted in Bohan, *Dreier*, p. 19. Bohan presents an excellent summary of prevalent theosophical beliefs, and it is she who first identified these sources as important factors in the formation of Dreier's artistic philosophy. In fact, in Dreier's introduction to the van Gogh book, she reveals that her interest in modern art is based primarily on spiritual concerns.

9. Wassily Kandinsky, *Concerning the Spiritual in Art* (New York: George Wittenborn, 1947), pp. 27, 40. The first English edition of this book was published as *The Art of Spiritual Harmony*, trans. M[ichael] T. H. Sadler (London: Constable and Company; and Boston: Houghton, Mifflin, 1914). This title is listed among the reference books available at the Société Anonyme (*Annual Report 1920–21*, p. 48).

10. Duchamp to Walter and Louise Arensberg, 8 November 1918 (Duchamp Papers, FBL); published in Francis M. Naumann, ed., "Marcel Duchamp's Letters to Walter and Louise Arensberg, 1917–1921," in Naumann and Rudolf E. Kuenzli, eds., *Marcel Duchamp: Artist of the Century* (Cambridge: MIT Press, 1989), p. 209.

11. Katherine Sophie Dreier, *Five Months in the Argentine: From a Woman's Point of View, 1918 to 1919* (New York: Frederic Fairchild Sherman, 1920).

12. Dreier in *Collection of the Société Anonyme*, p. 149.

13. M[arcel]. D[uchamp]., in *Collection of the Société*, p. 83. Duchamp's original 1946 text is published in Herbert, *Dreier Bequest*, p. 211.

14. "Palette and Brush: American Art at the Crossroad," signed "The Gilder," newspaper unknown, 16 June 1921 (clipping preserved in the Scrapbooks of Katherine Dreier, Papers of the Société Anonyme, YCAL).

15. Roché diary, November 28, 1919 (Papers of Henri-Pierre Roché, HRC); quoted in Carlton Lake and Linda Ashton, eds., *Henri-Pierre Roché: An Introduction* (Austin: University of Texas, 1991), p. 32.

16. Henry McBride, "News and Views of Art, Including the Clearing House for Works of the Cubists," *The Sun and New York Herald*, 16 May 1920, sec. III, p. 8.

17. This lecture was held on April 1, 1921, and is discussed at length in chapter 8.

18. Man Ray, *Self Portrait* (Boston: Little, Brown, 1963), p. 90.

19. Ibid., pp. 97–98.

20. Katherine S. Dreier, " 'Intrinsic Significance' in Modern Art," lecture delivered at the Yale University Art Gallery, March 5, 1948; in Dreier, James J. Sweeney, and Naum Gabo, *Three Lectures on Modern Art* (New York: Philosophical Library, 1949), p. 6.

21. "Archie Pen Co," *The Arts* I (February–March, 1921), p. [64]. The first person to recognize this advertisement and identify Duchamp as its author is Ruth L. Bohan, "Katherine Sophie Dreier and New York Dada," *Arts* 51, no. 9 (May 1977), p. 98.

22. Katherine S. Dreier, *Western Art and the New Era: An Introduction to Modern Art* (New York: Brentano's, 1923), pp. 70–71.

23. From a lecture given at the New School for Social Research, 16 March 1931; quoted in Herbert, *Dreier Bequest*, p. 16.

ARTHUR CRAVAN AND MINA LOY

1. The most reliable and entertaining account of this ill-fated bout can be found in Roger Conover's introduction to *Mina Loy: The Last Lunar Baedeker* (Highlands, N.C.: The Jargon Society, 1982), p. lv. Years later, Johnson mistakenly recalled having knocked out Cravan in the first round (see *Jack Johnson Is a Dandy: An Autobiography* [New York: Chelsea House, 1969], p. 73).

2. Gabrielle Buffet-Picabia, "Arthur Cravan and American Dada," *transition*, Paris, no. 27

(April–May 1938), p. 315.

3. Fabian Lloyd, "To Be or Not to Be . . . American," *L'Echo des Sports*, 6th year, no. 247 (June 10, 1909); repr. in Jean-Pierre Begot, *Arthur Cravan: Oeuvres: Poèmes, Articles, Lettres* (Paris: Gérard Lebovici, 1987), pp. 121–24.

4. Quoted in Conover, "Introduction," *Mina Loy: The Last Lunar Baedeker*, p. xlix.

5. A facsimile edition of *Maintenant*, with an introduction by Maria Lluïsa Borràs, was published by Editions Jean-Michel Place, Paris, 1977. See also the reprint published by Erik Losfeld, Paris, 1957, with an introduction by Bernard Delvaille.

6. Arthur Cravan, "Oscar Wilde est vivant!," *Maintenant* 2, no. 3 (October–November 1913), pp. 1–26; English translation appeared in *The Soil*, no. 4 (April 1917), pp. 145–48, and no. 5 (July 1917), pp. 195–200. Also see "Oscar Wilde Alive It Is Believed By Poet's Nephew," *New York World*, 2 November 1913, and "No One Found Who Saw Wilde Dead," *New York Times*, 9 November 1913, secs. III and IV, p. 4.

7. Arthur Cravan to André Level, 19 January 1916, quoted in Level, *Souvenirs d'un collectionneur* (Paris: Mazo, 1959), pp. 54–55; cited and trans. in Willard Bohn, "Chasing Butterflies with Arthur Cravan," in Rudolf E. Kuenzli, ed., *New York Dada* (New York: Willis Locker & Owens, 1986) pp. 121–22.

8. Pharamousse [a.k.a. Picabia], "Odeurs de Partout," *391* (January 25, 1917).

9. Léon Trotsky, *My Life: An Attempt at an Autobiography* (New York: Scribner's, 1930), p. 268.

10. Gabrielle Buffet-Picabia, "Arthur Cravan," p. 318.

11. Arthur Cravan, ["Sifflet"], *The Soil* I, no. 1 (December 1916), p. 36. Cravan told his girlfriend, Renée, to write to him in care of the Washington Square Gallery (Begot, ed., *Cravan*, p. 153). For more on Coady's activities in this period, see Judith Zilczer, "Primitivism and New York Dada," *Arts* 51, no. 9 (May 1977), pp. 140–42, and Zilczer, "Robert J. Coady, Man of The Soil," in Kuenzli, ed., *New York Dada*, pp. 31–43.

12. "Arthur Cravan vs. Jack Johnson," *The Soil* I, no. 4 (April 1917), pp. 161–62.

13. "Crowler: Sir Arthur Cravan Who Fought Jack Johnson, May Enter Ring Here," ca. April 1917, unidentified newspaper clipping (Courtesy Roger Conover, Portland, Me.).

14. Mina Loy, "Colossus" (original typescript collection Mrs. Herbert Bayer, Montecito, California); excerpts published in Roger Conover, "Mina Loy's 'Colossus': Arthur Cravan Undressed," in Kuenzli, ed., *New York Dada*, pp. 102–19.

15. Mina Loy to Carl Van Vechten, December 27 [1914] (YCAL); quoted without date in Virginia M. Kouidis, *Mina Loy: American Modernist Poet* (Baton Rouge: Louisiana State University Press, 1980), p. 11.

16. "Do You Strive to Capture the Symbols of Your Reactions? If Not You Are Quite Old Fashioned," *The Evening Sun*, 13 February 1917, p. 10.

17. Ezra Pound, "A List of Books: 'Others,' " *The Little Review* IV, no. 11 (March 1918), p. 57.

18. Mina Loy, "Love Songs," *Others: A Magazine of the New Verse* I, no. 1 (July [?] 1915), pp. 6–7 and 8 [mispaginated as 5].

19. Arthur Cravan to Mina Loy, 30 December [1917]; this and all of Cravan's other letters to Mina Loy from Mexico are published in Begot, *Cravan*, pp. 166–83.

20. Arthur Cravan to Mina Loy, 28 December [19]17 (ibid., p. 177).

21. Johnson's correspondence with Cravan in this period is preserved in the National Archives, Washington, D.C.; referred to in Randy Roberts, *Papa Jack: Jack Johnson and the Era of White Hopes* (New York: The Free Press, 1983), pp. 209–10.

22. Marcel Duchamp to Louise Arensberg, January 10, 1919 [postscript to a letter of January 7, 1919] (FBL); pub. in Naumann, "Marcel Duchamp's Letters to Walter and Louise Arensberg, 1917–1921," in Naumann and Rudolf E. Kuenzli, eds., *Marcel Duchamp: Artist of the Century* (Cambridge: MIT Press, 1989), p. 212.

THE BARONESS ELSA VON FREYTAG-LORINGHOVEN

1. John Rodker, " 'Dada' and Elsa von Freytag-Loringhoven," *The Little Review* VII, no. 2 (July–August 1920), p. 33, and J[ane] H[eap], "Dada," ibid., VIII, no. 2 (Spring 1922), p. 46.

2. My description of the Baroness's physical appearance was derived primarily from the following sources: Allen Churchill, *The Improper Bohemians: A Re-creation of Greenwich Village in Its Heyday* (New York: E. P. Dutton, 1959), p. 169; George Biddle, *An American Artist's Story* (Boston: Little, Brown, 1939), pp. 137–42; Margaret Anderson, *My Thirty Years' War: The Autobiography, Beginnings and Battles to 1930* (New York: Horizon Press, 1969), pp. 177–83; and Louis Bouché, "Autobiography," unpub. ms. (Bouché Papers, AAA; microfilm roll no. 688, frames 700–03).

3. These incidents were derived from the same sources as those credited in n. 2 above.

4. Biographical information is derived from Elsa von Freytag-Loringhoven, "Elsa," unpub. ms., edited and typed by Djuna Barnes (Elsa von Freytag-Loringhoven Collection, Papers of Djuna Barnes, University of Maryland Archives, College Park). Unless otherwise noted, all subsequent quotations are taken from this source. Unfortunately, this autobiographical account covers only the years from the Baroness's birth in 1874 to approximately 1904.

As the present book was being prepared for publication, the Baroness's autobiography was published by Paul I. Hjartarson and Douglas O. Spettigue (*Baroness Elsa*, Ottawa: Oberon Press, 1992). In their introduction to this book, these authors provide a wealth of biographical information on the Baroness and they convincingly date the writing of the original manuscript to 1923–25. They shed little new light on the Baroness's years in New York, but rather focus—as they had earlier (see notes 7 and 8 below)—on her relationship with the writer Frederick Philip Grove (Felix Paul Greve).

5. Oskar A. H. Schmitz, *Dämen Welt* (Munich: George Müller, 1926), pp. 226–27; this reference was drawn to my attention by Gisi Baronin Freytag von Loringhoven. I am grateful to Elsa Kosta who provided an English translation of the appropriate passages.

6. Endell (1871–1925) was born in Berlin, though his most important work was done during the 1890s in Munich. In 1918, he became director of the Breslauer Kunstakademie, a position he held until his death. On his influence on the development of abstraction, see Peg Weiss, "Kandinsky and the 'Jugendstil' Arts and Crafts Movement," *The Burlington Magazine* CXVII, no. 866 (May 1975), pp. 270–79; see also Rose-Carol Washton Long, *Kandinsky: The Development of an Abstract Style* (Oxford: Clarendon Press, 1980), p. 7.

7. See the analyses of Freytag-Loringhoven's autobiography by Lynn DeVore, "The Backgrounds of *Nightwood*: Robin, Felix, and Nora," *Journal of Modern Literature* X, no. 1 (March 1983), pp. 71–90, and Paul Hjartarson, "Of Greve, Grove, and Other Strangers: The Autobiography of the Baroness Elsa von Freytag-Loringhoven," in Hjartarson, ed., *A Stranger to My Life: Essays by and About Frederick Philip Grove* (Edmonton: New West Press, 1986), pp. 269–84.

8. See D. O. Spettigue, *Frederick Philip Grove* (Toronto: Copp-Clark, 1969); Spettigue, *FPG: The European Years* (Ottawa: Oberon, 1973); and Spettigue and A.W. Riley, "Introduction," *Fanny Essler*, trans. Christine Helmers, D. O. Spettigue, and A. W. Riley (Ottawa: Oberon Press, 1984).

9. Quoted in Margaret Anderson, *Thirty Years' War*, p. 179. Most biographical information on the Baron was provided by Gisi Baronin Freytag von Loringhoven (letter to the author, 13 August 1991). The Baron's father, Lieut. Gen. Baron von Freytag-Loringhoven, wrote a book entitled *Deductions from the World War*, which was published in 1917 (see the review, "Abuse for Americans by a German General," *New York Times*, 9 December 1917, part VIII, p. 8).

10. From a letter to Djuna Barnes, quoted in Barnes, ed., "Elsa Baroness von Freytag-Loringhoven," *transition*, no. 11 (February 1928), p. 26.

11. Claude McKay, *A Long Way from Home: An Autobiography*, introduction by St. Clair Drake (London: Pluto Press, 1885), p. 104. I am grateful to Steven Watson for having drawn this reference to my attention.

12. Biddle, *An American Artist's Story*, p. 140. The recollections of Bernstein are quoted from an interview with the author, New York, April 29, 1989. In addition to completing several nude figure studies of the Baroness in oil (Private Collection, New York), Bernstein also painted a magnificent portrait of the artist dressed in her unusual garb (see *Theresa Bernstein: Expressions of Cape Ann and New York, 1914–1972*, exh. cat., The Stamford Museum and Nature Center, Stamford, Connecticut, November 19, 1989–January 7, 1990, repro. n.p.).

13. The poem appeared in vol. VI, no. 2 (June 1918), pp. 58–59, and the photograph of the object-portrait (slightly different than the one reproduced here) appeared in vol. IX, no. 2 (Winter 1922), pp. 40f.

14. Anderson, *Thirty Years' War*, p. 178.

15. The material cited in this paragraph and the one that follows is derived from letters written by the Baroness to Jane Heap and Margaret Anderson, which are preserved in the Papers of *The Little Review*, Golda Meir Library, University of Wisconsin at Milwaukee. Unfortunately, none of the Baroness's letters is dated, but based on internal evidence, we can be reasonably certain that they were written sometime between 1920–22. Many are composed on the stationery of either the Brevoort or Hudson hotels, where it is unlikely the Baroness resided (she probably pilfered writing paper whenever she could). Although the University of Wisconsin acquired the Papers of *The Little Review* from the Estate of Jane Heap in 1966, to my knowledge, they have not been previously consulted in connection with any published writings on the Baroness.

16. From Djuna Barnes, "Elsa—Notes," unpublished manuscript dated April 24, [19]33 (The Papers of Djuna Barnes, Special Collections, University of Maryland, College Park).

17. William Carlos Williams, "Sample Prose Piece: The Three Letters," *Contact*, no. 4 (Summer 1921), p. 10. The present account is taken from this article and from Williams, *The Autobiography of William Carlos Williams* (New York: Random House, 1951), pp. 164–65, 168–69.

18. See Margaret Anderson, "William Carlos Williams' 'Kora in Hell' by Else von Freytag-Loringhoven [sic]," *The Little Review* VII, no. 3 (September–December, 1920), pp. 58–59, and Elsa von Freytag-Loringhoven, "Thee I call 'Hamlet of Wedding—Ring,' Criticism of William Carlos Williams's 'Kora in Hell' and why . . .", *The Little Review*, Part I: VII, no. 4 (January–March, 1921), pp. 48–60; Part II: VIII, no. 1 (Autumn 1921), pp. 108–11.

19. Man Ray to Tristan Tzara, 1 December 1920 (Dossier Tzara, BLJD). For more on the Baroness's Dada activities, see chapter 8.

20. Berenice Abbott shared her recollections of this portrait with the author (telephone conversation, November 1988), and the present account is based on information she generously provided. The collage has been customarily dated "before 1918," but as Abbott explained, she only met the Baroness in 1921. She also claims that it was not completed until after the Baroness left for Germany in 1923.

The Independents

1. Reports on early membership are provided in letters from Walter Pach to John Quinn, January 30, 1917 (The John Quinn Memorial Collection, NYPL), and to Henry McBride, January 31, 1917 (McBride Papers, YCAL). The "Certificate of Incorporation" is reprinted in Clark S. Marlor, ed., *The Society of Independent Artists: The Exhibition Record 1917–1944* (Park Ridge: Noyes Press, 1984), Appendix A, pp. 53–54; for a review of this book, see Francis M. Naumann, *Archives of American Art Journal* 26, nos 2–3 (1986), pp. 36–40.

2. Rockwell Kent, "The Big Show," pt. III, chap. VI, *It's Me O Lord: The Autobiography of Rockwell Kent* (New York: Dodd, Mead, 1955), pp. 311–18.

3. The first meetings of the Society of Independent Artists were held in the fall of 1916 at the studio of John Covert, at 20 West Thirty-first Street. In January 1917, a four-page invitational brochure was circulated among artists announcing the formation of the society and plans for its first exhibition (this document was drawn to my attention by Garnett McCoy). Curiously, although this brochure lists Duchamp's name among the society's board of directors, Walter Arensberg's name does not appear on this list. A few months later, however, Covert sent notification to the directors of a meeting to be held at the apartment of Walter Arensberg at 33 West Sixty-seventh Street, on the afternoon of March 13, 1917 (letter from Covert to Dreier on the stationery of the Society of Independent Artists, March 9, 1917; Société Anonyme Papers, YCAL). On the title page of the catalogue for the first exhibition, Arensberg is identified as the organization's Managing Director, and his name is also listed as one of the general directors.

4. H[arvey]. M. W[atts]., "'Greatest Ever' in Art Shows," *Philadelphia Public Ledger*, 10 April 1917, p. 5. Watts's identity is provided in a reprint of excerpts from this article in Harvey Watts, "The Independents Show," *American Art News* XV, no. 28 (April 21, 1917), p. 4.

5. As reported in Rudi Blesh, *Modern Art USA: Men, Rebellion, Conquest, 1900–1956* (New York: Alfred A. Knopf, 1956), p. 71.

6. Henry McBride, "News and Comment in the World of Art," *New York Sun*, 15 April 1917, sec. V, p. 12; in Daniel Catton Rich, ed., "Opening of the Independents," *The Flow of Art: Essays and Criticism of Henry McBride* (New York: Atheneum, 1975), p. 124. Dorothy Rice was a student of the Spanish genre and portrait painter Ignacio Zuloaga y Zaboleta, and the Claire Twins were an actual attraction at Barnum and Bailey's circus (see "The Clair Twins," *Vanity Fair*, vol. 4, no. 5 [July 1915], p. 57).

7. Charles L. Buchanan, "Art Versus License: Some Impressions of Contemporary American Painting," *The Bookman* 45 (June 1917), p. 369.

8. Quoted in Theodora Bean, "Your Country's Art Calls You," *The Morning Telegraph*, 15 April 1917, sec. II, p. 1. Wood credited Duchamp with suggesting that she affix an actual bar of soap to her composition (see Wood, *I Shock Myself: The Autobiography of Beatrice Wood* [San Francisco: Chronicle Books, 1988], p. 32).

9. Watts, "Greatest Ever," p. 5.

10. "Art Novelties Draw Society Folk to Show of the Independents," *New York American*, 10 April 1917, p. 7.

11. The only entry by Brancusi listed in the catalogue is the *Portrait of Princess Bonaparte*, but the so-called *Baby Crying* is recorded as having been in this exhibition by a number of reviewers. The latter work is illustrated in McBride's preview of the exhibition (*New York Sun*, sec. V, p. 12), and can be identified as the same work now entitled *The New-Born* (Arensberg Collection; Philadelphia Museum of Art).

12. Watts, "Greatest Ever," op cit. For more on Roosevelt, see Douglas Hyland, "Adelheid Lange Roosevelt: American Cubist Sculptor," *Archives of American Art Journal* 21, no. 4 (1981), pp. 10–17.

13. W. H. de B. Nelson, "Aesthetic Hysteria," *International Studio* LXI, no. 244 (June 1917), p. 125.

14. "The Society of Independent Artists: Pictures 'Independent' and Otherwise," *The Outlook* 116 (May 2, 1917), pp. 8, 10.

15. McBride, "News and Comment," 15 April 1917; in Rich, *Flow of Art*, pp. 124–25. See also "A Discovery in Art," *New York Tribune*, 22 April 1917. On Duchamp's discovery of Eilshemius, see Paul J. Karlstrom, *Louis Michel Eilshemius* (New York: Harry N. Abrams, Inc., 1978), p. 35.

16. No entry by Duchamp is listed in the catalogue. In her strange review of this exhibition (discussed below; see pp. 190–91), Jane Dixon supplies us with an interesting description of a painting with this title, without, however, identifying the name of the artist: "Those were the most hysterical tulips I ever saw in my life. So hysterical were they that every vestige of resemblance to their former sym-

metrical selves had been lost and they were merely lurid splotches of color running wild all over the canvas" ("An Outsider Explores Two Miles of Independent Art," *The New York Sun*, 22 April 1917, sec. IV, p. 11).

17. The most complete and detailed analysis of this single work of art is found in the monograph by William A. Camfield, *Marcel Duchamp: Fountain* (Houston: Menil Collection, 1989). In Stieglitz's original photograph of the urinal (p. 45), the title "Fountain," the name "Richard Mutt," and the address "[110] W[est] 88th St."—the address of Louise Norton—are discernible. Some of the early press notices report that Mr. Mutt was from Philadelphia, possibly information provided by Duchamp and friends to mislead journalists and better conceal his identity.

18. This conversation is reconstructed in Wood, *I Shock*, p. 29. On earlier occasions, Wood recalled that this conversation took place between Arensberg and Rockwell Kent (see Francis Naumann, ed., "I Shock Myself: Excerpts from the Autobiography of Beatrice Wood," *Arts* 51, no. 9 [May 1977], pp. 135–36).

19. "His Art Too Crude for Independents," *New York Herald*, 14 April 1917, p. 6. Glackens expressed his feeling regarding Duchamp's submission in a letter to Katherine Dreier (May 1, 1917; Papers of the Société Anonyme, YCAL).

20. Dreier to Duchamp, April 13, 1917 (Société Anonyme Coll., YCAL).

21. See "The Biggest Art Exhibition in America and, Incidentally, War, Discussed by W. J. Glackens," *The Touchstone* I (June 1917), p. 173.

22. According to a story told by Charles Prendergast and reported in Ira Glackens, *William Glackens and the Ashcan Group* (New York: Crown, 1957), p. 188.

23. Stieglitz to McBride, April 19, 1917 (Papers of Henry McBride, YCAL).

24. Van Vechten to Stein, undated but written in mid-April, 1917 (Papers of Gerturde Stein, YCAL; pub. in Edward Burns, ed., *The Letters of Gertrude Stein and Carl Van Vechten; vol. I: 1913–1935* [New York: Columbia University Press, 1986], p. 59).

25. In a letter to Georgia O'Keeffe, dated April 19, 1917, Alfred Stieglitz said that he had taken a picture of the *Fountain* in front of a painting by Marsden Hartley (Archives of Georgia O'Keeffe, YCAL). It was only after having been given this information (generously provided by William Camfield) that I was able to identify Hartley's *Warriors*.

26. Marcel Duchamp to Yvonne Duchamp, April 11 [1917] (Papers of Jean Crotti and Suzanne Duchamp, AAA); published in Francis M. Naumann, "Affectueusement, Marcel: Ten Letters from Marcel Duchamp to Suzanne Duchamp and Jean Crotti," *Archives of American Art Journal* 22, no. 4 (1982), p. 8.

27. It was Camfield who discovered this number belonged to Louise Norton

(*Fountain*, p. 30, n. 32).

28. In her autobiography, Wood acknowledged her authorship of these introductory comments (*I Shock*, p. 31), though before publication, they were probably approved by Duchamp himself.

29. See *Rogue* vol. III, no. 1 (October 1916), p. 2.

30. Henri-Pierre Roché, *Victor*, p. 55; pub. as vol. IV in Jean Clair, ed., *Marcel Duchamp*, exh., cat., Musée National d'Art Moderne, Centre National d'Art et de Culture Georges Pompidou, Paris, 1977.

31. Roché, *Victor*, p. 55.

32. The program printed on the last page of *Rongwrong* (pp. 46–47)—which lists and describes eight dances, including *Fox Dance*—is probably similar to the one presented by Ito at the Independents'. On this dancer's revolutionary style, see Helen Caldwell, *Michio Ito: The Dancer and His Dances* (Berkeley: University of California Press, 1977).

33. Roché, *Victor*, p. 56.

34. Wood, *I Shock*, p. 33. Wood's drawing of the ball comes from her illustrated album, *Pour Toi, Adventure de Vièrge!* dated June 2, 1917 (Collection the Philadelphia Museum of Art).

35. This ball was held on the mezzanine floor of the Grand Central Palace on the evening of April 20, 1917 (see "Artists Dance in Costume," *New York Times*, 21 April 1917; "Weird Sights at Ball of Independent Artists," *New York World*, 21 April 1917; and "Independent Artists Break Conventions," *New York Morning Telegram*, 21 April 1917). Cravan's lecture was announced in the *New York Evening Post* ("Poets to Talk at Art Show," 17 April 1917), and his appearance at the dress ball was described in "Poet-Pugilist at Artists' Ball," *New York Herald*, 21 April 1917, p. 6.

36. "Independents Get Unexpected Thrill," *The New York Sun*, 20 April 1917, p. 6.

37. Gabrielle Buffet-Picabia, "Arthur Cravan and American Dada" (1938), in Robert Motherwell, ed., *The Dada Painters and Poets* (New York: George Wittenborn, 1951), pp. 13–17.

38. See "Chance to See Live Poets," *New York Morning Telegram*, 18 April 1917; "Poets' Day at Independent Exhibit," *New York Times*, 18 April 1917; "Notice," *New York Times*, 22 April 1917; and "R. J. Coady to Lecture at Grand Central Palace," *Brooklyn Life*, 7 April 1917 (all clippings preserved in the Scrapbooks of Katherine Dreier, YCAL).

39. For Arensberg's commentaries and more on Southard's lecture, see Frederick P. Gay, *The Open Mind: Elmer Ernest Southard 1876–1920* (Chicago: Normandie House, 1938), pp. 252–53.

40. The total income from commissions on sales amounted to only $430.25 (see Marlor, *Independent Artists*, p. 12). On the collectors and collections referred to, see *The Louise and Walter Arensberg Collection*, vol. I: 20th

Century Section (Philadelphia Museum of Art, 1954); Robert L. Herbert, et al., *The Société Anonyme and the Dreier Bequest at Yale University* (New Haven: Yale Univerisity Press, 1984); and Judith Zilczer, "*The Noble Buyer*": *John Quinn, Patron of the Avant-Garde*, exh. cat. (Hirshhorn Museum and Sculpture Garden, Washington, D.C., 1978).

41. Gustav Kobbe, "What Is It? 'Independent Art,'" *New York Herald*, 1 April 1917, sec. III, p. 12. Critical opinions of this exhibition are examined in greater detail in Francis M. Naumann, "The Big Show: The First Exhibition of the Society of Independent Artists; Part II: The Critical Response," *Artforum* XVII, no. 8 (April 1979), pp. 49–53 (from which the present account is derived).

42. Henry McBride, *New York Sun*, 8 April 1917, sec. V, p. 12.

43. Robert Henri, "The 'Big Exhibition,' The Artist and the Public," *The Touchstone* I (June 1917), pp. 174–77.

44. Guy Pène du Bois, "Notes of the Studios and Galleries," *Arts and Decoration* VII (May 1917), pp. 371–74 (the article is unsigned, but the magazine's table of contents identifies it as "by the editor"; Pène du Bois is identified as the journal's editor on its masthead).

45. See McBride, "News and Comment in the World of Art," *New York Sun*, 22 April 1917, sec. V, p. 12, and McBride, ibid., 15 April 1917; in Rich, ed., *Flow of Art*, pp. 122–24.

46. Arensberg is quoted in the article by Glackens, *The Touchstone* I, p. 165 (see n. 21). Schamberg's letter was published in McBride's column in *New York Sun*, 13 May 1917, sec. V, p. 12; reprinted (with four paragraphs omitted) in Rich, ed., *Flow of Art*, pp. 125–29.

47. Interview with Louise Varèse, May 27, 1978.

48. W. H. de B. Nelson, "Aesthetic Hysteria," p. 121.

49. J[ames] B. T[ownsend], "America's First Art Salon," *American Art News* XV, no. 27 (April 14, 1917), p. 2.

50. Unsigned editorial statement (probably written by James B. Townsend), "A Disappointing Show," ibid., p. 4.

51. Frank Jewett Mather, Jr., "The Society of Independent Artists," *The Nation* 104, no. 2706 (May 10, 1917), pp. 574–75.

52. R. J. Coady, "The Indeps," *The Soil* I, no. 5 (July 1917), pp. 202–10.

53. Duncan Phillips's comments about the war and its effect on the future of art were made specifically in response to his viewing of the Independents' exhibition (see his "Fallacies of the New Dogmatism in Art," *The American Magazine of Art* IX, part I, no. 2 [December 1917], p. 44). See also Forbes Watson, "Art at the Galleries," *New York Evening Post*, mag. sec., 14 April 1917, pp. 11, 20. Frederic James Gregg, "A New Kind of Art Exhibition," *Vanity Fair* 8, no. 3 (May 1917), p. 47.

54. "Exeunt Independent Artists," *New York Tribune*, 6 May 1917, part V, p. 7 (only the car-

toons were by L. M. Glackens; the commentary was probably added by the newspaper's editors).

55. Jane Dixon, "An Outsider Explores Two Miles of Independent Art," *New York Sun*, 22 April 1917, sec. V, p. 11.

NEW YORK DADA

1. De Zayas to Tzara, 16 November 1916. Most of Tzara's correspondence is preserved in the Bibliothèque Littéraire Jacques Doucet, Paris (BLJD), and many important letters from this archive are published in Michel Sanouillet, *Dada à Paris* (Paris: Jean-Jacques Pauvert, 1965; for this letter from de Zayas, see pièce no. 225, p. 572).

2. Translation given in Robert Motherwell, ed., *The Dada Painters and Poets: An Anthology* (New York: George Wittenborn, 1951), p. xix.

3. De Zayas to Tzara, 16 November 1916 (BLJD; see n. 1 above).

4. Tzara to de Zayas, 28 December 1916 (original letter in the collection of Rodrigo de Zayas, Seville, Spain; copies of selected de Zayas documentation and correspondence on deposit in BLCU; for a transcription of this letter, see Sanouillet, pièce no. 222, p. 569).

5. Pierre Cabanne, *Dialogues with Marcel Duchamp* (New York: Viking Press, 1971), p. 56.

6. Tzara's writings from this period are reprinted in Henri Béhar, ed., *Tristan Tzara: Oeuvres Complètes, 1912–1924*, vol. I (Paris: Flammarion, 1975); the trans. of this passage is by Ralph Manheim, *Dada Painters and Poets*, p. 75.

7. C. B. Clay, "L'Amérique s'amuse: L'Art cubiste aux Etats-Unis," *Excelsior*, 20 July 1916, p. 5. The *sic* appeared after the word "art" in the original French text.

8. Guillaume Apollinaire, "Le cas de Richard Mutte," *Mercure de France*, Paris (June 16, 1918); repr. in "Echos et anecdotes inédits," in *Cahiers du Musée National d'Art Moderne 6* (Centre Georges Pompidou, Paris, 1981). This reference was drawn to my attention by Jennifer Gough-Cooper and Jacques Caumont. Apollinaire's correspondence with Roché is outlined in Carlton Lake and Linda Ashton, eds., *Henri-Pierre Roché: An Introduction* (Austin: Harry Ransom Humanities Research Center, University of Texas, 1991), pp. 87–88.

9. "What Is Dadaism?," *New York Tribune*, 9 July 1918 (newspaper clipping, Dossiers de Presse de Dada, Collection Tzara, BLJD); the date for this article was provided by the clipping service to which Tzara subscribed (Argus Suisse de la Presse, Geneva), but efforts to locate the original article in an issue of the *Tribune* from this date have been unsuccessful.

10. For the Tzara-Picabia correspondence, see Sanouillet, *Dada à Paris*, pp. 466–502.

11. See Jean Arp, "Francis Picabia," *Art d'Aujourd'hui*, no. 6 (Paris: January 1950); repr. in Marcel Jean, ed., *Arp on Arp: Poems, Essays, Memories*, trans. by Joachim Neugroschel (New York: Viking Press, 1972), p. 260. In *Dada* no. 3, Tzara published a line drawing by Picabia entitled *Abri*, a poem entitled "Salive Américaine," and a statement on the death of Apollinaire.

12. Editor, "The Dadas," *New York Times*, 30 March 1919, sec. III, p. 1 (cols. 5 and 6). This manifesto, as well as the poem by Huidobro, appeared in *Dada* no. 3.

13. "Intolerance at Zurich," *New York Times*, 8 June 1919, sec. III, p. 1 (col. 4).

14. Dreier to Ernst, 25 May 1920, and Ernst to Dreier, 16 June 1920 (Papers of the Société Anonyme, YCAL); I am grateful to Elsa Kosta who graciously translated these letters for me. In his letter to Dreier, Ernst enclosed a copy of the *Dada-Vorfrühling* catalogue (Cologne: April 1920), where at least one entry is marked "New York," indicating that, at this point, Dreier was still planning to show a selection of German Dada works at the Société Anonyme.

15. See the notice provided in the catalogue/poster for the *Erste Internationale Dada-Messe*, Berlin, June 24–August 5, 1920, where it is indicated that work followed in the listing by an asterisk would soon be shown in New York; this, it is noted, will constitute the first exhibition of Dada work in America. For Dreier's visit to the Cologne exhibition, see Max Ernst, "Notes pour une biographie," in Ernst, *Ecritures* (Paris: Gallimard, 1970), pp. 38–39, and Marc Dachy, *The Dada Movement: 1915–1923* (New York: Rizzoli, 1990), p. 124. I thank M. Dachy for drawing these references to my attention.

16. For an illustration of this handbill, entitled "La seule expression de l'homme moderne," see Y. Poupard-Lieussou and Michel Sanouillet, eds., *Documents Dada* (Geneva: Weber, 1974), doc. 6, p. 23.

17. The *Bulletin Dada* was distributed as the program to a Dada matinee held at the Grand Palais on February 5, 1920, which was scheduled to coincide with the Salon des Indépendants (see William Camfield, *Francis Picabia: His Art, Life and Times* [Princeton: Princeton University Press, 1979], pp. 136–37).

18. Gabrielle Buffet-Picabia to Tzara, March 2, 1920 (Dossier Tzara, TZR.C. 3052, BLJD). Without explanation, Dachy posits that it was Duchamp and Man Ray who put Gabrielle Buffet-Picabia up to writing this letter (*Dada Movement*, p. 87).

19. Steichen to Stieglitz, undated, but ca. spring 1920 (Papers of Alfred Stieglitz, YCAL); I am indebted to John Cauman, who drew my attention to this letter. For Steichen's opinion of Picabia, see Edward Steichen, *A Life in Photography* (Garden City, New York: Doubleday & Company, 1963), chapt. 5 [n.p.].

20. Katherine Dreier to Gabrielle Buffet-Picabia, 10 May 1920 (Papers of the Société Anonyme, YCAL).

21. Tzara's original communication to Arensberg no longer survives, but Arensberg's response is preserved among Tzara's papers in the Doucet Library (BLJD; undated, but based on internal evidence, written during the spring of 1920). For Bouché's recollections of this exchange, see his unpublished memoirs (Papers of Louis Bouché, AAA; microfilm roll 688, frame 756).

22. In a letter from Arensberg to Bernard Karpel, dated March 15, 1950 (Arensberg Archives, PMA). See *Littérature* 2, no. 13 (May 1920), pp. 15–16; English trans. in Jerome Rothenberg, ed., *The Revolution of the Word: A New Gathering of American Avant Garde Poetry 1914–1945* (New York: Seabury Press, 1974), pp. 3–4. François Chapon, Conservateur of the Doucet Library, believes that the text of this document may have been written by Picabia's friend Germaine Everling. The title inscribed at the head of the paper, however, is unmistakably Arensberg's. In a statement dating from this period, Gabrielle Buffet-Picabia admitted that it was a common Dadaist procedure "to usurp the signature of someone who is absent in order to make him write the most compromising things" (first published in *Picabia: Watercolors 1917–1919* [London: Hanover Gallery, 12 March–19 April, 1968], p. 7).

23. Arensberg to Picabia (Dossiers Picabia, BLJD); although undated, this and the letter to Tzara must both have been written during the spring of 1920: between February 5 (the date of the *Bulletin Dada*, to which Arensberg refers when he mentions the "other Presidents [of Dada]") and May (the date when "Dada est américain" appeared in *Littérature*). In his memoirs, Bouché also notes, that it was in 1920 that Arensberg sent him to Europe to purchase a painting by Rousseau and to gather copies of Dada publications. Of course, the Cravan affair—to which Arensberg refers—is a reference to Cravan's famous lecture and arrest at the Independents in 1917.

Arensberg then thanks Picabia for having dedicated his book of poems *L'Athlète des pompes funèbres*, dated November 24, 1918, to him (see Camfield, *Picabia*, p. 117, n. 14). Noting that he had thanked Picabia in an earlier letter sent to Switzerland when this book appeared, Arensberg acknowledges the fact that he had begun communication with Picabia in Zurich at least two years earlier.

24. "Paris Notes & News / Dadaists Disappoint / Still Unshaven," *New York Daily Mail*, May 28, 1920 (Dossier Picabia, vol. II, p. 66; BLJD).

25. *New York Sun*, April 4, 1920 (Coupures de presse, Dossiers Tzara; BLJD).

26. David Lloyd, "The Trouble With Art in an Art Museum and Its Cure," *New York Evening*

Post, 8 May 1920, Saturday mag. sec., p. 5.

27. Albert Gleizes, "The Dada Case," *Action*, no. 3 (April 1920); trans. by Ralph Manheim, in Motherwell, *Dada Painters and Poets*, p. 303; and Richard Huelsenbeck, *En Avant Dada: Eine Geschichte des Dadaismus* (Hanover, Leipzig, Vienna, Zurich: Paul Steegemann, 1920); trans. in Motherwell, *Dada Painters and Poets*, p. 35.

28. Similar opinions were gathered from a variety of sources in "Dada: The Newest Nihilism in the Arts," *Current Opinion* 68 (May 1920), pp. 685–87. See, also, F. S. Flint, "The Younger French Poets," *The Chapbook* 2, no. 17 (November 1920), pp. 1–32.

29. Stieglitz to Picabia, April 2, 1920 (Dossiers Picabia, vol. 4, pp. 365–70; BLJD).

30. For a complete history of this unpublished project, see Sanouillet, "Le Dossier de 'Dadaglobe,'" *Cahiers de l'Association Internationale pour l'étude de Dada et du Surréalisme*, no. 1 (Paris, 1966), pp. 111–43.

31. Varèse's first letter to Picabia is dated July 8, 1920, and is written on Hotel Brevoort stationery. He sent his contributions to "Dadaglobe" in a letter dated December 18, 1920, and the last letter cited here is undated but, based on internal evidence, ca. February 1921 (Dossiers Picabia, BLJD). The existence of this correspondence was first brought to my attention by William Camfield. I should also like to thank Olivia Mattis, who provided me with her transcription and translation of these letters, which will be included in her dissertation, "Edgard Varèse and the Visual Arts," in preparation for the University of California, Berkeley.

32. Tzara's letter to Man Ray of February 3, 1920, is lost, but Man Ray's response of February 24, 1920, is preserved in the Papers of Tristan Tzara (BLJD).

33. Quinn to Kuhn, July 3, 1920 (Quinn Papers, NYPL). "Arens" is Egmont Arens, proprietor of the Washington Square Bookshop.

34. Duchamp to Picabia and Germaine Everling, undated, but based on chronological placement in Picabia's albums, late January 1921 (Dossiers Picabia, vol. 4, p. 152; BLJD). By February 8, 1921, Duchamp had already received Tzara's authorization, for in a letter to Picabia and Everling, he addresses his remarks to Tzara directly: "Tzara, I will probably have your authorization translated so that everybody here may 'understand.'" (Dossiers Picabia, vol. 4, p. 289; BLJD).

35. The precise source and date of this clipping, entitled simply "Notes and Activities in the Art World," is unknown, though it must date from just after the event described. The clipping is preserved in the scrapbook of Katherine Dreier, Société Anonyme Archive (YCAL). The identities of Mumford and Ackerman are given in the *First Annual Report of the Société Anonyme 1920–1921*, p. 19.

36. Marsden Hartley, "The Importance of Being 'Dada,'" in *Adventures in the Arts: Informal Chapters on Painters, Vaudeville and Poets* (New York: Boni and Liveright, 1921), pp. 247–54; for a specific discussion of this essay on Dada, see the review of Hartley's book, "The Importance of being 'Dada,'" *The International Studio* LXXIV, no. 296 (November 1921), p. lxiii.

37. "Nothing is Here: Dada is its Name," *American Art News* XIV, no. 25 (April 2, 1921), p. 1.

38. Henry McBride, "New Dada Review Appears in New York," *New York Herald*, 24 April 1921, sec. III, p. 11. In the newspaper, this review is unsigned, although McBride's authorship is supplied by an inscription in the Dreier Scrapbooks (YCAL).

39. Stieglitz to Duchamp and Man Ray, April 17, 1921 (BLJD). The original letter from Tzara to Duchamp is dated "January 1921" and is preserved in the collection of Jean-Paul Kahn, Paris. Dorothy True was a friend of Georgia O'Keeffe's; Stieglitz made the portrait in 1919; the double exposure is said to have been the result of an accident in the developing process (see Dorothy Norman, *Alfred Stieglitz: An American Seer* [Millerton: Aperture, 1960], pp. 142–43).

40. Crane to Josephson, January 14, 1921 (Brom Weber, ed., *The Letters of Hart Crane 1916–1932* [New York: Heritage House, 1952], p. 52). Crane learned of the Baroness's "discovery" through the pages of *The Little Review* (see John Rodker, "'Dada' and Else von Freytag von Loringhoven," *The Little Review* VII, no 2 [July–August 1920], pp. 33–36).

41. Agnes Smith, "Introducing Da Da," *Morning Telegraph*, vol. 97, no. 121 (May 1, 1921), sec. II.

42. In what was probably intended as a promotional joke, organizers of the First International Dada Fair in Berlin (June 24–August 5, 1920) had indeed advertised for athletes to serve as doormen at their exhibition (see Dachy, *The Dada Movement*, p. 102).

43. Man Ray, *Self Portrait* (Boston: Little Brown, 1963), p. 101.

44. Margery Rex, "Dada is Busy Again in Paris; Now It's Going to Furnish Some Original Guides," *New York Evening Journal*, 24 May 1921.

45. Tyrrell to Picabia, 5 August 1920 (Dossiers Picabia, vol. VI, p. 288; BLJD).

46. Man Ray to Tristan Tzara, undated, but postmarked June 8, 1920 (Dossiers Tzara, BLJD).

47. No drawing or manuscript by the Baroness is preserved in Tzara's papers at the Bibliothèque Littéraire Jacques Doucet, indicating that he might have returned them to her (the first of her two letters to Tzara is undated but postmarked September 22, 1921 [TZR.C.1699]; the second is also undated [TZR.C.4.324]).

48. Marcel Duchamp to Ettie Stettheimer, dated around July 26 [1921], Rouen (Stettheimer Papers, YCAL).

49. Marcel Duchamp to the Arensbergs, fragment of a letter that can be dated to fall of 1921 (Duchamp Papers, FBL); pub. in Francis M. Naumann, ed., "Marcel Duchamp's Letters to Walter and Louise Arensberg, 1917–1921," in Naumann and Rudolf E. Kuenzli, eds., *Marcel Duchamp: Artist of the Century* (Cambridge: MIT Press, 1989), p. 220.

50. Marcel Duchamp to Ettie Stettheimer, 3 January [1922], Rouen (YCAL).

51. Marcel Duchamp to Ettie Stettheimer, undated but postmarked July 9, 1922 (YCAL). Duchamp sent Man Ray "a little quatrain by Florine Stettheimer," which he asked him to pass on to Tzara for publication in one of his Dada sheets (letter formerly collection Timothy Baum; for dating, see next note).

52. Duchamp to Man Ray (formerly collection Timothy Baum, New York) and Duchamp to Tzara (Dossier Tzara, TZR.C.1250 BLJD). Both letters are undated, but were estimated to have been written in the fall of 1922 or early spring of 1923 (see Sanouillet and Elmer Peterson, eds., *Salt Seller: The Writings of Marcel Duchamp* [New York: Oxford University Press, 1973], pp. 180–81, and Arturo Schwarz, *The Complete Works of Marcel Duchamp* [New York: Harry N. Abrams, 1970], p. 597). Based on the publications to which Duchamp refers, however, the date can be narrowed to September 1922 (see below).

53. Alfred Kreymborg, "Dada and the Dadas," *Shadowland* VII, no. 1 (September 1922), pp. 43, 70. Kreymborg briefly reported on his meeting with Tzara, Cocteau, Gleizes, and Duchamp in his "Paris Letter," *The Double Dealer*, New Orleans, II, nos. 8–9 (July 4, 1921), pp. 105–7. For a more detailed account, see Kreymborg, *Troubadour: An Autobiography* (New York: Boni and Liveright, 1925), pp. 364ff.

54. Edmund Wilson, Jr., "The Aesthetic Upheaval in France," *Vanity Fair* 18, no. 6 *[sic]* (February 1922), pp. 49, 100. See also Wilson, *Axel's Castle: A Study in the Imaginative Literature of 1870–1930* (New York: Charles Scribner's Sons, 1931), pp. 253–56.

55. Tristan Tzara, "Some Memoirs of Dadaism," *Vanity Fair* 18, no. 4 [5] (July 1922), pp. 70, 92, 94 (repr. in Wilson, *Axel's Castle*, pp. 304–12; for the original French text, see Tzara, *Oeuvres Complètes*, pp. 592–99). See also "We Nominate for the Hall of Fame," *Vanity Fair* 18, no. 4 (June 1922), p. 76.

56. See Matthew Josephson, "Blunderbuss," *Secession*, no. 3 (August 1922), pp. 29–30, and Wilson to Tzara, 8 December 1922 (Dossiers Tzara, BLJD).

57. See Tristan Tzara, "What We Are Doing in Europe," *Vanity Fair* 19, no. 1 (September 1922), pp. 68, 100; "News of the Seven Arts in Europe," *Vanity Fair* 19, no. 3 (November 1922), pp. 51, 88; and "Germany—A Serial

Film," *Vanity Fair* 20, no. 2 (April 1923), pp. 59, 104, 108.

58. Crowninshield to Tzara, November 7, 1923 (Dossiers Tzara, BLJD). Tzara's last contribution to the magazine was "The Dada Masks of Hiler," *Vanity Fair* 22, no. 5 (July 1924), pp. 48, 88.

59. Sheldon Cheney, "Why Dada?" *Century Magazine* 104, no. 1 (May 1922), pp. 22–29; see also Cheney, *A Primer of Modern Art* (New York: Boni and Liveright, 1924), pp. 139–45.

60. Duchamp to Strand, undated letter, but, based on internal evidence, fall 1922 (Paul Strand Collection, Center for Creative Photography, University of Arizona, Tucson).

61. Tzara's letter to Duchamp does not survive, but Duchamp's response does, undated, but based on internal evidence, fall 1922 (Dossiers Tzara, TZ.R.C. 1253; BLJD).

62. Duchamp to McBride, undated [ca. June 1922] (Papers of Henry McBride, YCAL). The copy of *391* to which Duchamp refers was no. 12 (March 1920), the same issue in which Duchamp's *L.H.O.O.Q.* was reproduced on the cover.

63. Alan Burroughs, review of *Some French Moderns Says McBride*, *The Arts* 3 (January 1923), pp. 71–72.

64. Henry McBride, "Modern Art," *The Dial* LXXIII, no. 5 (November 1922), pp. 587–88. Massot's book was published in 1922 by Editions Ravally, Paris.

65. Philippe Soupault to Henry McBride, 17 November 1922, in McBride, "Modern Art," *The Dial* LXXIV, no. 1 (January 1923), pp. 113–16.

66. Kenneth Burke, "Dadaisme Is France's Latest Literary Fad," *New York Tribune*, 6 February 1921, sec. VII, p. 6.

67. Vincent O'Sullivan, "Dada is Dead," *The Freeman* IV, no. 100 (8 February 1922): 518–19. Earlier, *The Freeman* had been among the earliest of the New York journals to report on Dada activities in Europe (see a notice signed only "Journeyman," *The Freeman* I, no. 21 [August 4, 1920]: 49).

68. Marcel Duchamp to Ettie Stettheimer, 26 July [1923], Rouen (YCAL).

69. "Dadaists Fight in Paris Theatre," *New York Herald*, 8 July 1923.

70. During the summer of 1922, Duchamp wrote to Strand recommending that he and Sheeler prepare a copy print of *Manhatta* and send it to a friend of his in Paris (undated, but postmarked August 8, 1922 [Center for Creative Photography, University of Arizona, Tucson]).

71. William A. Drake, "The Life of Dada," *New York Tribune*, 4 November 1923, sec. IX, p. 17.

72. Henry McBride, "Tzara at the Théâtre Michel," *The Dial* (December 1923); reprinted in Daniel Catton Rich, ed., *Essays and Criticisms of Henry McBride* (New York: Atheneum, 1975), pp. 179–81.

73. Katherine S. Dreier, *Western Art and the New Era: An Introduction to Modern Art* (New York: Brentano's, 1923), pp. 118–20.

74. Marcel Duchamp to Ettie Stettheimer, dated "En villégiature de Circoncision à Rouen 1923 [-] 24," indicating a date of January 1, 1924 (YCAL).

75. See, for example, Kenneth Burke, "Dada, Dead or Alive," *Aesthete 1925* (February 1925), pp. 23–26, and "Dada Is Dead," *The Living Age* 332, no. 4304 (April 15, 1927), p. 786.

76. Man Ray, "Dadadate," dated July 8, 1958, reprinted in facsimile in *Dada: Dokumente einer Bewegung*, exh. cat., Kunsthalle, Düsseldorf, 1958, unpaginated; repr. in Man Ray, *Self Portrait*, p. 389.

AFTERMATH

1. *Exhibition of Paintings by Members of the Société Anonyme*, 3 November–5 December 1921, Worcester Art Museum, Worcester, Massachusetts (catalogue and text by Christian Brinton); the exhibition then traveled to Smith College, in Northampton (7 January–5 February 1922), Detroit Institute of Fine Arts (March–5 April 1922), and finally to the MacDowell Club in New York (24 April–8 May 1922). I am indebted to Marie Keller for finding a copy of the Seabrook article in *The Saint Louis Star*.

2. This author's comparison to jazz would soon be affirmed by the release of a catchy tune entitled *Da Da Strain* (first recorded by Mamie Smith in September 1922, but within six months, followed by no fewer than five subsequent recordings, both vocal and instrumental). Although it is tempting to speculate that the title of this song was inspired by reports of Dada that had appeared in the American press, it is more likely that the syncopation and rhythmic beat of the sound "da-da" lent itself naturally to musical adaptations, particularly to the rhythm and tempo of jazz. Nevertheless, it is compelling to note that some thirty years later, when Duchamp was asked to organize a Dada retrospective for the Sidney Janis Gallery in New York, he chose to exhibit a copy of the original 78 rpm recording of this tune in a vitrine alongside other documents of the New York Dada period (cat. no. 56: *Dada Strain*, New Orleans Rhythm Kings, 1922, Gennett Records; see catalogue/poster designed by Marcel Duchamp for *DADA: 1916–1923*, Sidney Janis Gallery, New York, April 15–May 9, 1953).

3. Robert McAlmon, *Contact*, no. 5 (June 1923), n.p. See, for example, Waldo Frank, "Seriousness and Dada," *1924: A Magazine of the Arts*, no. 3 (September 1924), pp. 70–73, and citations provided in chap. 8, n. 75.

4. B. J. Kospoth, *Chicago Tribune*, Paris, 12 August 1928; reprinted in Hugh Ford, ed., *The Left Bank Revisited: Selections from the Paris Tribune 1917–1934* (University Park: Pennsylvania State University Press, 1972), pp. 199–200 (emphasis added).

5. On the Arensbergs' years in Hollywood, see Naomi Helene Sawelson-Gorse, " 'For the want of a nail': The Disposition of the Louise and Walter Arensberg Collection," M.A. thesis, University of California, Riverside, 1987, and Sawelson-Gorse, "Hollywood Conversations: Duchamp and the Arensbergs," in Bonnie Clearwater, ed., *West Coast Duchamp* (Miami Beach: Grassfield Press, 1991), pp. 25–45.

6. Walter Arensberg to Marcel Duchamp, May 23, 1930 (Duchamp Archive, FBL).

7. Arensberg to Duchamp, August 26, 1937 (Duchamp Archive, FBL).

8. Cf. Katharine Kuh and Daniel Catton Rich, *20th Century Art from the Louise and Walter Arensberg Collection*, The Art Institute of Chicago, 20 October–18 December 1949, and *The Louise and Walter Arensberg Collection*, vol. I: *20th Century Section*; vol. II: *Pre-Columbian Sculpture*, The Philadelphia Museum of Art, 1954.

9. Interview with George Heard Hamilton, New York, 19 January 1959 (published in *The Art Newspaper*, vol. III, no. 15 [February 1992], p. 13), and interview with James Johnson Sweeney, "Eleven Europeans in America," *Bulletin*, Museum of Modern Art, vol. XIII, nos. 4–5 (1946), pp. 20–21.

10. "Interview with Dorothy Norman," *Art in America*, vol. 57, no. 4 (July–August 1969), p. 38.

11. Man Ray, unpublished monologue, 1956 (released by The Center for Cassette Studies, Inc., Hollywood, 1973).

12. Man Ray to Ferdinand Howald, 5 April 1922 (Ferdinand Howald Papers, University Libraries, Ohio State University, Columbus, Ohio).

13. Marcel Duchamp to Man Ray, undated, but based on internal evidence, ca. spring 1922 (Man Ray Papers, HRC).

14. My interpretation of this image is based on the reproduction that appeared in *The Little Review*, IX, no. 3 (Autumn 1922), pp. 60f. In the original print reproduced here, however, it can be seen that the impression of fingertips was produced by the paper's contact with the coiled edges of a spring, while the shape of the palm seems to have been generated by a wrist watch and comb.

15. Quoted from Marcel Duchamp's original text for a statement on Picabia (quoted in Robert L. Herbert, et al., eds., *The Société Anonyme and the Dreier Bequest at Yale University: A Catalogue Raisonné* [New Haven: Yale University Press, 1984], p. 525).

16. Alfred Stieglitz to the American Waste Paper Company, April 12, 1917 (Stieglitz Archives, YCAL; quoted in Edward Abrahams, "Alfred Stieglitz's Faith and Vision," in Adele Heller and Lois Rudnick, eds. *1915, The Cultural*

Moment [New Brunswick, N.J.: Rutgers University Press, 1991], p. 194), and Stieglitz to McBride, February 24, 1923 [*sic*] ("Correspondence," *The New York Herald*, 10 February 1924, sec. 7, p. 13).

17. Stieglitz to Paul Rosenfeld, September 5, 1923 (Stieglitz Archives, YCAL); for an excellent account of Stieglitz's gradually changing attitude toward modern European art in this period, see Timothy Robert Rogers, "False Memories: Alfred Stieglitz and the Development of the Nationalist Aesthetic," in *Over Here! Modernism, The First Exile 1914–1919* (Providence: David Winton Bell Gallery, Brown University, 1989), pp. 59–66.

18. Stieglitz as quoted in Dove's diary, 4 December 1924 (as quoted in Ann Lee Morgan, *Arthur Dove: Life and Work, With a Catalogue Raisonné* [Newark, Del.: University of Delaware Press, 1984], p. 51). Katherine S. Dreier, *Modern Art 1926* (New York: Société Anonyme—Museum of Modern Art, 1926, p. 93); this book was published in conjunction with the "International Exhibition of Modern Art," organized by Dreier under the auspices of the Société Anonyme and shown at the Brooklyn Museum, 19 November 1926–1 January 1927. My omission of Dove in the context of New York Dada is one determined primarily on the basis of chronology, for all of his known found-object assemblies were made after 1923.

19. Jean Crotti, "Tabu," *The Little Review* VIII, no. 2 (Spring 1922), pp. 44–45.

20. "G255300" [interview with Otto Hahn], *Art and Artists* I, no. 4 (London: July 1966), p. 7.

21. Henri-Pierre Roché, *Victor*, 1945–59 (published as vol. IV in Jean Clair, ed., *Marcel Duchamp*, Centre National d'Art et de Culture Georges Pompidou, Musée National d'Art Moderne, Paris, 1977).

22. See Francis M. Naumann, "The Other Side of Beatrice Wood: Drawings, Tiles and Figurative Ceramic Sculpture," in *Intimate Appeal: The Figurative Art of Beatrice Wood*, The Oakland Museum, 18 November 1989–18 February 1990, pp. 23–41.

23. See S[ol] M. M[alkin], "Obituary Note," *AB Bookman's Weekly* 51, no. 8 (1973), p. 571. See also Clara Tice, *ABC Dogs* (New York: Wilfred Funk, Inc., 1940; rpt. with a biographical sketch of the artist by Marie Keller, New York: Harry N. Abrams, forthcoming).

24. The first to observe the influence of these machine-inspired pictures on subsequent developments in American art was Milton W. Brown, "Cubist-Realism: An American Style," *Marysas* (1943–45), pp. 139–60.

25. Katherine Dreier, *Modern Art* (New York: Société Anonyme—Museum of Modern Art, 1926), p. 98.

26. See her responses to a questionnaire, *The Little Review* XII, no. 2 (May 1929), p. 46. And Mina Loy, "Anglo-Mongrels and the Rose," *The Little Review* IX, no. 3 (Spring 1923), pp. 10–18, and *The Little Review* IX, no. 4 (Autumn–Winter 1923–24), pp. 41–51; the complete poem is published in Mina Loy, *The Last Lunar Baedeker*, Roger Conover, ed. (Highlands: The Jargon Society, 1982), pp. 111–75.

27. Djuna Barnes explained that the Baroness "came to her death by gas, a stupid joke that had not even the decency of maliciousness" (Barnes, "Elsa Baroness von Freytag-Loringhoven," *transition*, no. 11 [February 1928], p. 19). Events from the Baroness's stay in Paris are provided in "Elsa—Notes," unpublished manuscript dated April 14, [19]33 (The Papers of Djuna Barnes, Special Collections, University of Maryland, College Park).

28. "The Reminiscences of Holger Cahill," transcript of an interview, 1957 (Oral History Program, Columbia University, Manuscripts Division, Butler Library), pp. 120–21.

29. For more on Inje-Inje, see Cahill's account (cited in previous note) as well as in Cahill's interview with John D. Morse, 12 April 1960 (transcript AAA, pp. 8–10) and his letter to John I. H. Baur, June 10, 1950 (Cahill Papers, AAA). I am indebted to Alan Moore for having drawn the last two of these citations to my attention.

30. Charles Burchfield, "On the Middle Border," *Creative Art* XXV, no. 3 (September 1928); quoted in John I. H. Baur, *Revolution and Tradition in Modern American Art* (Cambridge: Harvard University Press, 1951), p. 28.

31. Georges Hugnet, "Dada," in Alfred H. Barr, Jr., *Fantastic Art, Dada, Surrealism*, Museum of Modern Art, New York, December 1936–January 1937, p. 19.

32. Interview with James Johnson Sweeney, "Eleven Europeans in America," *Bulletin* XIII, nos. 4–5 (New York: Museum of Modern Art, New York, 1946), pp. 19–20.

33. Quoted in Hans Richter, *Dada: Art and Anti-Art* (New York: McGraw-Hill, 1965), p. 208. For the comment about Duchamp's *Bottle Rack*, see Motherwell, ed., *The Dada Painters and Poets: An Anthology* (New York: George Wittenborn, Inc., 1951), p. xviii. See also Jack D. Flam, "Dada Old and New," *Arts* 56, no. 4 (December 1981), pp. 66–67.

34. John I. H. Baur, "The Machine and the Subconscious: Dada in America," *The Magazine of Art* 44, no. 6 (October 1951), pp. 233–37; this essay was derived from two chapters from Baur's book *Revolution and Tradition in Modern American Art*.

35. William Agee, "New York Dada, 1910–30," in Thomas B. Hess and John Ashbery, *The Avant-Garde, Art News Annual XXXIV* (New York: Macmillan Company, 1968), pp. 104–13.

SELECTED BIBLIOGRAPHY

GENERAL REFERENCES

Agee, William. "New York Dada, 1910–1930." *Art News Annual*, 34 (1968), 105–13.

Avrich, Paul. *The Modern School Movement: Anarchism and Education in the United States.* Princeton: Princeton University Press, 1980.

Baur, John I. H. "The Machine and the Subconscious: Dada in America." *Magazine of Art*, 44, no. 6 (October 1951), 233–37.

Buffet-Picabia, Gabrielle. "Un peu d'histoire." *Paris-New York*. Musée National d'Art Moderne, Centre Georges Pompidou, Paris, 1977, 54–62.

Champa, Kermit S., ed. *Over Here! Modernism, The First Exile, 1914–1919*. Brown University, Providence, Rhode Island, 15 April–29 May, 1989.

Dachy, Marc. "Two Havens: New York and Barcelona." Chapt. 4, *The Dada Movement 1915–1923*. New York: Rizzoli, 1990, 63–87.

Davidson, Abraham A. *Early American Modernist Painting 1910–1935*. New York: Harper & Row, 1981.

Dijkstra, Bram. *The Hieroglyphics of a New Speech: Cubism, Stieglitz, and the Early Poetry of William Carlos Williams*. Princeton: Princeton University Press, 1969.

Kuenzli, Rudolf E., ed. *New York Dada*. New York: Willis Locker & Owens, 1986.

Lincoln, Louise Hassett, and William Innes Homer. "New York Dada and the Arensberg Circle." *Avant-Garde Painting & Sculpture in America 1910–25*. Delaware Art Museum, Wilmington, 4 April–18 May, 1975, 21–24.

Mellow, James R. "Gertrude Stein Among the Dadaists." *Arts*, 51, no. 9 (May 1977), 124–26.

Milman, Estera. "Dada New York: An Historigraphic Analysis." Stephen Foster, ed. *Dada/Dimensions*. Ann Arbor: UMI Research Press, 1985, 165–86.

Naumann, Francis. "The New York Dada Movement: Better Late Than Never." *Arts*, 54, no. 6 (February 1980), 143–49.

Pichon, Brigitte, and Karl Riha, eds. *Dada New York: Von Rongwrong bis Ready-made*. Hamburg: Nautilus, 1991.

Schwarz, Arturo, ed. *Dada Americano* (reprints of New York Dada publications). Milan: Gabriele Mazzotta, Documenti e periodici Dada, 1970.

——— *New York Dada: Duchamp, Man Ray, Picabia*. Städtische Galerie im Lenbachhaus, Munich, 15 December 1973–27 January 1974.

Munich: Prestel, 1973.

Tashjian, Dickran. *Skyscraper Primitives: Dada and the American Avant-Garde, 1910–1925*. Middletown: Wesleyan University Press, 1975.

———. "American Dada Against Surrealism: Matthew Josephson." Rudolf E. Kuenzli, ed. *New York Dada*. New York: Willis Locker & Owens, 1986, 44–51.

Watson, Steven. *Strange Bedfellows: The First American Avant-Garde*. New York: Abbeville, 1991.

Wertheim, Arthur Frank. *The New York Little Renaissance: Iconoclasm, Modernism, and Nationalism in American Culture, 1908–1917*. New York: New York University Press, 1976.

Wilson, Richard Guy, Dianne H. Pilgrim, and Dickran Tashjian. *The Machine Age in America, 1918–1941*. New York: The Brooklyn Museum/Harry N. Abrams, 1986.

Zabel, Barbara. "The Machine as Metaphor, Model, and Microcosm: Technology in American Art, 1915–1930." *Arts*, 57, no. 4 (December 1982), 100–105.

Zilczer, Judith. "Robert J. Coady, Forgotten Spokesman for Avant-Garde Culture in America." *American Art Review*, 2 (November–December 1975), 77–89.

———. "Primitivism and New York Dada." *Arts*, 51, no. 9 (May 1977), 140–42.

———. "Robert J. Coady, Man of *The Soil*." Rudolf E. Kuenzli, ed. *New York Dada*. New York: Willis Locker & Owens, 1986, 31–43.

PROTO-DADA

Bohn, Willard. "The Abstract Vision of Marius de Zayas." *The Art Bulletin*, 62, no. 3 (September 1980), 434–52.

———. "Marius de Zayas and Visual Poetry: 'Mental Reactions.'" *Arts*, 55, no. 10 (June 1981), 114–17.

Brown, Milton W. *The Story of the Armory Show*. Greenwich: New York Graphic Society, 1963; 2nd rev. ed., New York: Abbeville, 1988.

Buffet-Picabia, Gabrielle. "Modern Art and the Public." *Camera Work*, special no. 41 (June 1913), 10–14.

De Casseres, Benjamin. "American Indifference." *Camera Work*, no. 27 (July 1909), 24–25.

———. "The Art 'Puffer.'" *Camera Work*, no. 28 (October 1909), 31–32.

———. "The Ironical in Art." *Camera Work*, no. 38 (April 1912), 17–19.

———. "Insincerity: A New Vice." *Camera Work*, nos. 42–43 (April–July 1913), 22–24.

———. "The Renaissance of the Irrational." *Camera Work*, special no. 41 (June 1913), 22–24.

———. "Nietzsche: An Interpretation." *The International*, no. 4 (June 1913), 165–66.

———. "Confessions of a Spiritual Nihilist." *Current Literature*, 49 (December 1910), 642–43.

———. *Chameleon: Being the Book of My Selves*. New York: Lieber & Lewis, 1922.

———. *Anathema! Litanies of Negation*. Foreword by Eugene O'Neill. New York: Gotham Book Mart, 1928.

De Zayas, Marius. "The Sun Has Set." *Camera Work*, no. 39 (July 1912), 17–21.

De Zayas, Marius, and Paul B. Haviland. *A Study of the Modern Evolution of Plastic Expression*. New York: 291, 1913.

De Zayas, Marius. "Caricature: Absolute and Relative." *Camera Work*, no. 46 (April 1914; pub. October 1914), 19–27.

———. *African Negro Art: Its Influence on Modern Art*. New York: Modern Gallery, 1916.

———. "How, When, and Why Modern Art Came to New York." Introduction and notes by Francis Naumann. *Arts*, 54, no. 8 (April 1980), 96–126.

Henderson, Linda Dalrymple. "Francis Picabia, Radiometers, and X-Rays in 1913." *The Art Bulletin*, 71, no. 1 (March 1989), 114–23.

Homer, William Innes. *Alfred Stieglitz and the American Avant-Garde*. Boston: New York Graphic Society, 1977.

Hulten, Pontus K. G. *The Machine as Seen at the End of the Mechanical Age*. New York: Museum of Modern Art, 1968.

Hyland, Douglas. *Marius de Zayas: Conjurer of Souls*. Spencer Museum of Art, University of Kansas, Lawrence, 27 September–8 November 1981.

Picabia, Francis. "Preface." *Camera Work*, 42–43 (April–July 1913), 19–20.

Wright, Willard Huntington. *What Nietzsche Taught*. New York: B.W. Huebsch, 1915.

Zilczer, Judith. "The Aesthetic Struggle in America, 1913–1918: Abstract Art and Theory in the Stieglitz Circle." Unpublished dissertation, University of Delaware, Newark, 1975.

———. "'The World's New Art Center': Modern Art Exhibitions In New York City, 1913–1918." *Archives of American Art Journal*, 14, no. 3 (1974), 2–7.

WALTER AND LOUISE ARENSBERG

Arensberg, Walter. *Poems*. New York: Houghton Mifflin, 1914.

———. *Idols*. New York: Houghton Mifflin, 1916.

———. *The Cryptography of Dante*. New York: Alfred A. Knopf, 1921.

———. *The Cryptography of Shakespeare*. Part I. Los Angeles: Howard Bowen, 1922.

Kimball, Fiske. "Cubism and the Arensbergs." *Art News Annual*, 53, no. 7 (November 1954), part 2, 117–22, 174–78.

Kuh, Katharine. "Walter Arensberg and Marcel Duchamp." *The Saturday Review* (September 5, 1970), 36–37, 58; reprinted in Kuh, *The Open Eye: In Pursuit of Art*. New York: Harper & Row, 1971, 56–64.

McBride, Henry. "The Walter Arenbergs [sic]." *The Dial* (July 1920), 61–64; reprinted in Daniel Catton Rich, ed. *The Flow of Art: Essays and Criticism of Henry McBride*. New York: Atheneum, 1975, 156–59.

Naumann, Francis. "Cryptography and the Arensberg Circle." *Arts* 51, no. 9 (May 1977), 127–33.

———. "Walter Conrad Arensberg: Poet, Patron, and Participant in the New York Avant-Garde, 1915–20." *Philadelphia Museum of Art, Bulletin*, 76, no. 328 (Spring 1980), 1–32.

———. "Marcel Duchamp's Letters to Walter and Louise Arensberg: 1917–1921." Introduction, translation and notes, *Dada/Surrealism* no. 16 (Iowa: The University of Iowa, 1987): 203–27; reprinted in Kuenzli and Naumann, eds. *Marcel Duchamp: Artist of the Century*. Cambridge: MIT Press, 1989, 203–27.

[Philadelphia]. *The Louise and Walter Arensberg Collection*. Vol. 1: *20th Century Section*; vol. 2: *Pre-Columbian Sculpture*. Philadelphia: The Philadelphia Museum of Art, 1954.

Sawelson-Gorse, Naomi. "Hollywood Conversations: Duchamp and the Arensbergs." In Bonnie Clearwater, ed. *West Coast Duchamp*. Miami Beach: Grassfield Press, 1991, 24–45.

Stewart, Patrick L. "The European Art Invasion: American Art and the Arensberg Circle, 1914–1918." *Arts*, 51, no. 9 (May 1977), 108–12.

Van Vechten, Carl. "Rogue Elephant in Porcelain." Yale University Art Library, *Gazette*, 38, no. 2 (October 1963), 41–50.

MARCEL DUCHAMP

Adcock, Craig. "Marcel Duchamp's Approach to New York: 'Find an Inscription for the Woolworth Building as a Ready-Made.'" Rudolf E. Kuenzli, ed. *New York Dada*. New York: Willis Locker & Owens, 1986, 52–65.

Cabanne, Pierre. *Dialogues with Marcel Duchamp*. New York: Viking, 1971.

Clair, Jean. ed. *L'Oeuvre de Marcel Duchamp*. 4 vols. Paris: Musée National d'Art Moderne, Centre Georges Pompidou, 1977.

"A Complete Reversal of Art Opinions by Marcel Duchamp, Iconoclast." *Arts & Decoration*, 5 (September 1915), 427–28, 442.

"Marcel Duchamp Visits New York." *Vanity Fair* (September 1915), 57.

"French Artists Spur on an American Art." *New York Tribune* (24 October 1915), sec. 4, 2–3; reprinted in Rudolf E. Kuenzli, ed. *New York Dada*. New York: Willis Locker & Owens, 1986, 128–35.

Golding, John. *Marcel Duchamp: "The Bride Stripped Bare by Her Bachelors, Even."* New York: Viking Press, 1973.

Greeley-Smith, Nixola. "Cubist Depicts Love in Brass and Glass; 'More Art in Rubbers Than in Pretty Girl.'" *New York Evening World* (4 April 1916), 3; reprinted in Rudolf E. Kuenzli, ed. *New York Dada*. New York: Willis Locker & Owens, 1986, 135–37.

Hulten, Pontus, ed. *Marcel Duchamp*, with text by Jennifer Gough-Cooper and Jacques Caumont. Cambridge: MIT Press, 1993.

d'Harnoncourt, Anne, and Kynaston McShine, eds. *Marcel Duchamp*. New York: Museum of Modern Art/Philadelphia: Philadelphia Museum of Art, 1973.

"The Iconoclastic Opinions of M. Marcel Duchamps [sic] Concerning Art and America." *Current Opinion*, 59 (November 1915), 346–47.

Kreymborg, Alfred. "Why Marcel Duchamps [sic] Calls Hash a Picture." *Boston Evening Transcript* (18 September 1915), 12.

Kuenzli, Rudolf E., and Francis M. Naumann, eds. *Marcel Duchamp: Artist of the Century*. Cambridge: MIT Press, 1989.

Lebel, Robert. *Marcel Duchamp*. New York: Paragraphic Press, 1959.

Levin, Kim. "Duchamp à New York: Le Grand Oeuvre." *Opus International*, 49 (March 1974), 50–54.

Marquis, Alice Goldfarb. *Marcel Duchamp: Eros C'est la Vie, a Biography*. Troy, N.Y.: Whitston, 1981.

Naumann, Francis. "*Affectueusement, Marcel*: Ten Letters from Marcel Duchamp to Suzanne Duchamp and Jean Crotti." *Archives of American Art Journal*, 22, no. 4 (Spring 1983), 2–19.

———. *The Mary and William Sisler Collection*. New York: Museum of Modern Art, 1984.

———. "Marcel Duchamp's Letters to Walter and Louise Arensberg: 1917–1921." Introduction, translation and notes, *Dada/Surrealism*, no. 16 (Iowa: The University of Iowa, 1987), 203–27; reprinted in Kuenzli and Naumann, eds. *Marcel Duchamp: Artist of the Century*. Cambridge: MIT Press, 1989, 203–27.

———. "*Amicalement, Marcel*: Fourteen Letters from Marcel Duchamp to Walter Pach." *Archives of American Art Journal*, 29, nos. 3–4 (1989), 36–50.

"The Nude-Descending-a-Staircase Man Surveys Us." *New York Tribune* (12 September 1915), part 4, 2.

Roth, Moira. "Marcel Duchamp in America: A

Self Ready-Made." *Arts*, 51, no. 9 (May 1977), 92–96.

Sanouillet, Michel, and Elmer Peterson, eds. *Salt Seller: The Writings of Marcel Duchamp*. New York: Oxford University Press, 1973.

Steefel, Lawrence D. *The Position of Duchamp's Glass in the Development of His Art*. New York: Garland, 1977.

Schwarz, Arturo. *The Complete Works of Marcel Duchamp*. New York: Harry N. Abrams, 1969; 2nd ed., 1970.

Sweeney, James Johnson. "Marcel Duchamp," in "Eleven Europeans in America." Museum of Modern Art, New York, *Bulletin*, 13, nos. 4–5 (1946), 19–21, 37.

Tashjian, Dickran. "Henry Adams and Marcel Duchamp: Liminal Views of the Dynamo and the Virgin." *Arts*, 51, no. 9 (May 1977), 102–7.

Tomkins, Calvin. *The World of Marcel Duchamp (1887–)*. New York: Time Incorporated, 1966.

FRANCIS PICABIA

Borràs, Maria-Lluïsa. *Picabia*. New York: Rizzoli, 1985.

Buffet-Picabia, Gabrielle. "Some Memories of Pre-Dada: Picabia and Duchamp." Robert Motherwell, ed. *The Dada Painters and Poets: An Anthology*. New York: George Wittenborn, 1951, 255–67.

———. *Rencontres avec Picabia, Apollinaire, Cravan, Duchamp, Arp, Calder*. Paris: Pierre Belfond, 1977.

Camfield, William A. *Francis Picabia*. Solomon R. Guggenheim Museum, New York, 1970.

———. "The Machinist Style of Francis Picabia." *Art Bulletin*, 48, nos. 3–4 (September–December 1966), 309–22.

———. *Francis Picabia: His Art, Life and Times*. Princeton: Princeton University Press, 1979.

Everling-Picabia, Germaine. *L'Anneau de Saturne*. Paris: Fayard, 1970.

Homer, William Innes. "Picabia's *Jeune fille américaine dans l'état de nudité* and Her Friends." *Art Bulletin*, 58, no. 1 (March 1975), 110–15.

Le Bot, Marc. *Francis Picabia et la crise des valeurs figuratives*. Paris: Klincksieck, 1968.

Martin, Jean-Hubert, ed. *Francis Picabia*. Galeries Nationales du Grand Palais, Paris, 1976.

Perlstein, Philip. "The Symbolic Language of Francis Picabia." *Arts*, 30 (January 1956), 37–43.

[Picabia, Francis]. *Ecrits*, ed. Olivier Revault d'Allonnes. Les Bâtisseurs du XXe siècle. Paris: Belfond, 1975–78.

———. "French Artists Spur on an American Art." *New York Tribune* (24 October 1915), sec. 4, 2–3; reprinted in Rudolf E. Kuenzli, ed. *New York Dada*. New York: Willis Locker & Owens, 1986, 128–35.

———. *391*, nos. 1–19 (1917–1924); reprinted in facsimile. Pierre Belfond/Eric Losfeld, Paris, 1960; vol. 2: Michel Sanouillet, *Francis Picabia et "391."* Paris: Losfeld, 1966.

"Francis Picabia and His Puzzling Art: An

Extremely Modernized Academician." *Vanity Fair* (November 1915), 35.

Sanouillet, Michel. *Picabia.* Paris: L'Oeil du Temps, 1964.

Thompson, Jan. "Picabia and His Influence on American Art, 1913–17." *Art Journal* 39, no. 1 (Fall 1979), 14–21.

MAN RAY

Baldwin, Neil. *Man Ray: American Artist.* New York: Clarkson Potter, 1988.

Belz, Carl. "Man Ray and New York Dada." *Art Journal*, 23, no. 3 (Spring 1964), 207–13.

Bourgeade, Pierre. *Bon Soir, Man Ray.* Paris: Pierre Belfond, 1972.

Foresta, Merry A. *Perpetual Motif: The Art of Man Ray.* Washington, D.C.: National Museum of American Art/New York: Abbeville, 1988.

Janus, ed. *Man Ray: Tutti gli scritti.* Milan: Feltrinelli, 1981.

Man Ray. *Self Portrait.* Boston: Little, Brown; London: André Deutsch, 1963; reprinted with additional illustrations. Boston: New York Graphic Society/Little, Brown, 1986.

———. *Ogetti d'Affezione.* Turin: Giulio Einaudi, 1970.

Martin, Jean-Hubert, ed. *Man Ray: Photographs.* New York: Thames and Hudson, 1982.

Naumann, Francis. "Man Ray's Early Paintings 1913–1916, Theory and Practice in the Art of Two Dimensions." *Artforum*, 20, no. 9 (May 1982), 37–46; reprinted in *Art Vivant*, no. 31 (1989), 73–91.

———. "Man Ray and the Ferrer Center: Art and Anarchy in the Pre-Dada Period." *Dada/Surrealism*, no. 14 (1985), 10–30; reprinted in Rudolf E. Kuenzli, ed. *New York Dada.* New York: Willis Locker & Owens, 1986, 10–30; reprinted in "Man Ray ed il Centro Ferrer: Arte ed Anarchia," *Volontà*, no. 2 (Milan: 1986), 80–102, and in *Drunken Boat*, no. 2 (1992).

———. "Man Ray, 1908–1921: From an Art in Two Dimensions to the Higher Dimension of Ideas." Merry A. Foresta, ed. *Perpetual Motif: The Art of Man Ray.* Washington, D.C.: National Museum of American Art/New York: Abbeville, 1988, 50–87.

———. *Man Ray: The New York Years, 1913–1921.* Zabriskie Gallery, New York, November 29, 1988–January 6, 1989.

Penrose, Sir Roland. *Man Ray.* Boston: New York Graphic Society, 1975.

Sers, Philippe, and Jean-Hubert Martin, eds. *Man Ray: Objets de mon affection.* Paris: Philippe Sers, 1983.

Schwarz, Arturo. *Man Ray: The Rigour of Imagination.* New York: Rizzoli, 1977.

———. "Interview with Man Ray." *New York Dada: Duchamp, Man Ray, Picabia.* Städtische Galerie im Lenbachhaus, Munich, 15 December 1973–27 January 1974/Munich: Prestel, 1973, 79–100; reprinted with slight variations in Schwarz, "An Interview with Man Ray: 'This

is Not for America,' " *Arts*, 51, no. 9 (May 1977), 116–21.

THE ARENSBERG CIRCLE

ALBERT GLEIZES AND JULIETTE ROCHE

Addington, Sarah. "New York is More Alive and Stimulating Than France Ever Was, Say Two French Painters." *New York Tribune* (9 October 1915), 7.

Alibert, Pierre. *Albert Gleizes: Naissance et avenir du cubisme.* Saint-Etienne: Dumas, 1982.

[Gleizes, Albert]. "French Artists Spur on an American Art." *New York Tribune* (24 October 1915), sec. 4, 2–3; reprinted in Rudolf E. Kuenzli, ed., *New York Dada.* New York: Willis Locker & Owens, 1986, 128–35.

———. "The Impersonality of American Art." *Playboy: A Portfolio of Art and Satire*, nos. 4–5 (1919), 25–26.

Robbins, Daniel. *Albert Gleizes 1881–1952: A Retrospective Exhibition.* Solomon R. Guggenheim Museum, New York, 1964.

———. "The Formation and Maturity of Albert Gleizes; A Biographic and Critical Study: 1881 through 1920." Unpublished dissertation, Institute of Fine Arts, New York University, 1975.

Roche, Juliette. "La Minéralisation de Dudley Craving Mac Adam." *La Vie des Lettres et des Arts*, Paris, 8, n.s. (1922), 22–271; reprinted in booklet form by Croutzet, Paris, 1924.

———. *Demi Cercle.* Paris: Editions d'art "La Cible," 1920.

JEAN CROTTI AND SUZANNE DUCHAMP

Camfield, William, and Jean-Hubert Martin. *TABU DADA: Jean Crotti & Suzanne Duchamp 1915–1922.* Musée National d'Art Moderne, Centre Georges Pompidou, Paris, 1983.

[Crotti, Jean]. "French Artists Spur on an American Art." *New York Tribune* (24 October 1915), sec. 4, 2–3; reprinted in Rudolf E. Kuenzli, ed. *New York Dada.* New York: Willis Locker & Owens, 1986, 128–35.

Crotti, Jean. "Tabu." *The Little Review*, 8, no. 2 (Spring 1922), 44–45.

George, Waldemar. *Jean Crotti et la Primauté du Spirituel.* Geneva: Pierre Cailler, 1959.

Greeley-Smith, Nixola. "Cubist Depicts Love in Brass and Glass; 'More Art in Rubbers Than in Pretty Girl,' " *New York Evening World* (4 April 1916), 3; reprinted in Rudolf E. Kuenzli, ed. *New York Dada.* New York: Willis Locker & Owens, 1986, 135–37.

Naumann, Francis. "*Affectueusement, Marcel:* Ten Letters from Marcel Duchamp to Suzanne Duchamp and Jean Crotti." *Archives of American Art Journal*, 22, no. 4 (Spring 1983), 2–19.

EDGARD VARÈSE

Bernard, Jonathan W. "Varèse's Aesthetic Background." Chapter I, *The Music of Edgard Varèse.* New Haven: Yale University Press, 1987, 1–38.

Mattis, Olivia. "Edgard Varèse and the Visual Arts." Unpublished dissertation. Stanford University, 1992.

Ouellette, Fernand. *Edgard Varèse*, trans. by Derek Coptman. New York: Orion Press, 1968.

Varèse, Louise. *Varèse: A Looking-Glass Diary.* Vol. I: *1883–1928.* New York: W. W. Norton, 1972.

HENRI-PIERRE ROCHÉ

Jones, Alan. "Roché and Victor." *Arts*, 63, no. 6 (February 1989), 21–24.

Lake, Carlton, and Linda Ashton, eds. *Henri-Pierre Roché: An Introduction.* Austin: University of Texas at Austin/Harry Ransom Humanities Research Center, 1991.

Roché, Henri-Pierre. "How New York Did Strike Me." Unpublished manuscript, 1924. Papers of Henri-Pierre Roché, Carlton Lake Collection, Harry Ransom Humanities Research Center, Austin, Texas.

———. *Victor*, 1945–59. Vol. 4 of Jean Clair, ed. *Marcel Duchamp.* Musée National d'Art Moderne, Centre Georges Pompidou, Paris, 1977.

———. "Adieu, brave petite collection!" *L'Oeil*, 51 (March 1959), 34–40.

———. "Souvenirs of Marcel Duchamp." William N. Copley, trans. Robert Lebel. *Marcel Duchamp.* New York: Grove Press, 1959, 79–87.

———. *Carnets: Les Années Jules et Jim 1920–1921.* Marseilles: André Dimanche, 1990.

BEATRICE WOOD

Hapgood, Elizabeth Reynolds. "All the Cataclysms: A Brief Survey of the Life of Beatrice Wood." *Arts*, 52, no. 7 (March 1978), 107–9.

Naumann, Francis. "Excerpts from the Autobiography of Beatrice Wood." Introduction and notes. *Arts*, 51, no. 9 (May 1977), 134–39.

———. "The Drawings of Beatrice Wood." *Beatrice Wood.* California State University at Fullerton, February 5–March 3, 1983, 8–20; abridged: *American Craft*, 43, no. 4 (August-September 1983), 24; expanded: *Arts*, 57, no. 7 (March 1983): 108–11.

———. "The Other Side of Beatrice Wood: Drawings, Tiles, and Figurative Ceramic Sculpture." *Intimate Appeal: The Figurative Art of Beatrice Wood.* Oakland Museum, November 18, 1989–February 18, 1990, 23–41.

———. "Beatrice Wood and the Dada State of Mind." *Beatrice Wood and Friends: From Dada to Deco.* New York: The Rosa Esman Gallery, May 16–June 16, 1978.

———. "Luster for Life" [Beatrice Wood at Ninety-Seven]. *House & Garden*, 162, no. 6

(June 1990), 70–73.

Wood, Beatrice. *I Shock Myself: The Autobiography of Beatrice Wood.* San Francisco: Chronicle Books, 1985.

CLARA TICE

"The Blacks and Whites of Clara Tice with a Recent Portrait of the Artist." *Vanity Fair,* 5, no. 1 (September 1915), 60.

Fornaro, Carlo de. "Action Plus and Art that Pulsates: A Word About Clara Tice and Her Rapid-Fire Drawings." *Arts & Decoration,* 18, no. 1 (November 1922), 14–15.

M[alkin], S[ol]. "Obituary Note." *AB Bookman's Weekly,* 51, no. 8 (1973), 571.

[Tice, Clara]. "How You Looked to Clara Tice That Day on the Meramec." *The Saint Louis Star* (3 July 1921).

CHARLES SHEELER

Cravan, Thomas. "Charles Sheeler." *Shadowland,* 8, no. 1 (March 1923), 10–11, 71.

Friedman, Martin L. *Charles Sheeler.* New York: Watson-Guptill, 1975.

Rourke, Constance. *Charles Sheeler: Artist in the American Tradition.* New York: Harcourt, Brace, 1938.

Stebbins, Theodore E., and Norman Keyes, Jr. *Charles Sheeler: The Photographs.* Boston: Little, Brown, 1987.

Sheeler, Charles. "Recent Photographs by Alfred Stieglitz." *The Arts,* 4, no. 5 (May 1923), 345.

Toyen, Carol, and Erica E. Hirshler. *Charles Sheeler: Paintings and Drawings.* Boston: Little, Brown, 1988.

Watson, Forbes. "Charles Sheeler." *The Arts,* 3, no. 5 (23 May 1923), 334–44.

Yeh, Susan Fillin. "Charles Sheeler's 1923 'Self-Portrait.' " *Arts,* 52, no. 5 (January 1978), 106–9.

MORTON SCHAMBERG

Agee, William C. *Morton Livingston Schamberg.* Catalogue by Pamela Ellison. New York: Salander-O'Reilly Galleries, 1982.

———. "Morton Livingston Schamberg (1881–1918): Color and the Evolution of His Painting." *Arts,* 57, no. 3 (November 1982), 108–19.

———. "Morton Livingston Schamberg: Notes on the Sources of the Machine Images." Rudolf E. Kuenzli, ed. *New York Dada.* New York: Willis Locker & Owens, 1986, 66–80.

McBride, Henry. "Posthumous Paintings." *The New York Sun* (25 May 1919), sec. 7, 12.

Powell III, Early A. "Morton Schamberg: The Machine as Icon." *Arts,* 51, no. 9 (May 1977), 122–23.

Wolf, Ben. *Morton Livingston Schamberg: A Monograph.* Philadelphia: University of Pennsylvania Press, 1963.

———. "Morton L. Schamberg." *Art in America,* 52, no. 1 (February 1964), 76–80.

CHARLES DEMUTH

Craven, Thomas. "Charles Demuth." *Shadowland,* 7, no. 4 (December 1922), 10–11, 78.

Davidson, Abraham A. "Demuth's Poster Portraits." *Artforum,* 17, no. 3 (November 1978), 54–57.

Eiseman, Alvord L. *Charles Demuth.* New York: Watson-Guptill, 1982.

Farnham, Emily. *Charles Demuth: Behind a Laughing Mask.* Norman: University of Oklahoma Press, 1971.

Fahlman, Betsy. *Pennsylvania Modern: Charles Demuth of Lancaster.* Philadelphia: Philadelphia Museum of Art, 1983.

Haskell, Barbara. *Charles Demuth.* New York: Whitney Museum of American Art/Harry N. Abrams, 1988.

Watson, Forbes. "Charles Demuth." *The Arts,* 3, no. 1 (January 1923), 74–80.

JOHN COVERT

Covert, John. "The Real Smell of War: A Personal Narrative." *The Trend,* 8 (November 1914), 204–10.

Hamilton, George Heard. "John Covert: Early American Modern." *College Art Journal,* 12 (Fall 1952), 37–42.

Klein, Michael. "The Art of John Covert." Unpublished dissertation, Columbia University, New York, 1972.

———. "John Covert's *Time:* Cubism, Duchamp, Einstein—A Quasi-Scientific Fantasy." *Art Journal,* 33, no. 4 (Summer 1974), 314–20.

———. *John Covert, 1882–1960.* Washington, D.C.: Hirshhorn Museum and Sculpture Garden/Smithsonian Institution Press, 1976.

———. "John Covert and the Arensberg Circle: Symbolism, Cubism, and Protosurrealism." *Arts,* 51, no. 9 (May 1977), 113–15.

———. "John Covert's Studios in 1916 and 1923: Two Views into the Past." *Art Journal,* 39, no. 1 (Fall 1979), 22–28.

JOSEPH STELLA

Baur, John I. H. *Joseph Stella.* New York: Praeger, 1971.

Bohan, Ruth. "Joseph Stella's *Man in Elevated (Train).*" Stephen C. Foster, ed. *Dada/Dimensions.* Ann Arbor: UMI Press, 1985, 187–219.

Corn, Wanda. "In Detail: Joseph Stella and *New York Interpreted.*" *Portfolio,* 4, no. 1 (January–February 1982), 40–45.

Craven, Thomas. "Joseph Stella." *Shadowland,* 7, no. 5 (January 1923), 10–11, 78.

Jaffe, Irma B. *Joseph Stella.* Cambridge: Harvard University Press, 1970.

Moser, Joann. *Visual Poetry: The Drawings of Joseph Stella.* Washington, D.C.: National Museum of American Art, 1990.

———. "The Collages of Joseph Stella: *Macchie/Macchine Naturali,*" *American Art,* 6, no. 3

(Summer 1992), pp. 59–77.

Stella, Joseph. "The New Art." *The Trend,* 5 (June 1913), 393–95.

———. "On Painting." *Broom,* 1, no. 2 (December 1921), 119–22.

———. "Discovery of America: Autobiographical notes." *Art News,* 59 (November 1960), 41–43, 64–67.

Zilczer, Judith. *Joseph Stella,* Hirshhorn Museum and Sculpture Garden. Washington, D.C.: Smithsonian Institution Press, 1983.

THE STETTHEIMER SISTERS

Bloemink, Barbara J. *Friends and Family: Portraiture in the World of Florine Stettheimer,* exh. cat. Katonah Museum of Art, September 19–November 28, 1993.

Hartley, Marsden. "The Paintings of Florine Stettheimer." *Creative Art,* 9 (July 1931), 18–23.

McBride, Henry. "Florine Stettheimer: A Reminiscence." *View,* series 5, no. 3 (October 1945), 13–15.

———. "Artists in the Drawing Room." *Town and Country,* 100, no. 4291 (December 1946), 74–77, 336–37.

Noble, John. *A Fabulous Dollhouse of the Twenties.* New York: Dover, 1976.

Richardson, John. "High Life in the Doll's House." *Vanity Fair* (December 1986), 109–17, 157–59.

Stettheimer, Ettie. *Philosophy.* New York: Longmans, Green & Co., 1917.

——— [Waste, Henrie, pseud.] *Love Days [Susanna Moore's].* New York: Alfred A. Knopf, 1923.

———. *Memorial Volume of and by Ettie Stettheimer.* New York: Alfred A. Knopf, 1951.

Stettheimer, Florine. *Crystal Flowers.* New York: privately printed, 1949.

Sussman, Elisabeth. *Florine Stettheimer: Still Lifes, Portraits and Pageants 1910–1942.* Boston: Institute of Contemporary Art, 1980.

Tyler, Parker. *Florine Stettheimer: A Life in Art.* New York: Farrar, Straus and Company, 1963.

Van Vechten, Carl. "The World of Florine Stettheimer." *Harper's Bazaar,* 79 (October 1946), 238, 353–56.

Watson, Steven. "Three Sisters." *Art and Antiques,* 9, no. 5 (May 1992), 60–67.

Zucker, Barbara. "An 'autobiography of visual poems.' " *Art News,* 76, no. 2 (February 1977), 68–73.

KATHERINE DREIER

Bohan, Ruth L. "Katherine Sophie Dreier and New York Dada." *Arts,* 51, no. 9 (May 1977), 97–101.

———. *The Société Anonyme's Brooklyn Exhibition: Katherine Dreier and Modernism in America.* Ann Arbor: UMI Research Press, 1982.

Dreier, Katherine Sophie. *Five Months in the Argentine: From a Woman's Point of View, 1918 to*

1919. New York: Frederic Fairchild Sherman, 1920.

————. *Western Art and the New Era: An Introduction to Modern Art.* New York: Brentano's, 1923.

Dreier, Katherine Sophie, and Matta Echaurren. *Duchamp's Glass: "La Mariée mise à nu par ses célibataires, même: An Analytical Reflection.* New York: Société Anonyme, Inc., 1944.

Dreier, Katherine Sophie, James J. Sweeney, and Naum Gabo. *Three Lectures on Modern Art.* New York: Philosophical Library, 1949.

Herbert, Robert. "Introduction." Herbert, Eleanor S. Apter, and Elise K. Kenney, eds. *The Société Anonyme and the Dreier Bequest at Yale University: A Catalogue Raisonné.* New Haven: Yale University Press, 1984.

Saarinen, Aline B. "Propagandist: Katherine Sophie Dreier." *The Proud Possessors: The Lives, Times and Tastes of Some Adventurous American Art Collectors.* New York: Random House, 1958, 238–49.

Société Anonyme (the First Museum of Modern Art, 1920–1944): Selected Publications. New York: Arno Reprints, 1972.

ARTHUR CRAVAN AND MINA LOY

Begot, Jean-Pierre, ed. *Arthur Cravan: Oeuvres, poèmes, articles, lettres.* Paris: Lebovici/Champ Libre, 1987.

Bohn, Willard. "Chasing Butterflies with Arthur Cravan." Rudolf E. Kuenzli, ed. *New York Dada.* New York: Willis Locker & Owens, 1986, 120–23.

Buffet-Picabia, Gabrielle. "Arthur Cravan and American Dada." *transition,* Paris, no. 27 (April–May 1938); reprinted in Robert Motherwell, ed. *The Dada Painters and Poets: An Anthology.* New York: George Wittenborn, 1951, 13–17.

Conover, Roger. "Introduction." *Mina Loy. The Last Lunar Baedeker.* Conover, ed. Highlands, N.C.: Jargon Society, 1982.

————. "Mina Loy's 'Colossus': Arthur Cravan Undressed." Rudolf E. Kuenzli, ed. *New York Dada.* New York: Willis Locker & Owens, 1986, 102–19.

Cravan, Arthur, ed. *Maintenant,* nos. 1 (April 1912) through 4 (March–April 1915); reprinted with an introduction by Maria Lluïsa Borràs. Paris: Jean-Michel Place, 1977.

————. "Oscar Wilde Is Alive!" *The Soil,* I, no. 4 (April 1917), 145–56; no. 5 (July 1917), 195–200.

Galerie 1900–2000. *Arthur Cravan: Poète et Boxeur* (with essays by Roger Conover, Maria Lluïsa Borràs, Jean-Pierre Begot, and Bernard Heidsieck). Paris: Galerie/Terrain Vague, 1992.

"Independents Get Unexpected Thrill." *New York Sun* (20 April 1917), 6.

Kouidis, Virginia M. *Mina Loy: American Modernist Poet.* Baton Rouge: Louisiana State University Press, 1980.

Loy, Mina. "Colossus." Unpublished manuscript.

Collection Mrs. Herbert Bayer, Montecito, California.

"Poet-Pugilist at Artists' Ball." *New York Herald* (21 April 1917), 6.

THE BARONESS ELSA VON FREYTAG-LORINGHOVEN

Anderson, Margaret. *My Thirty Years' War: The Autobiography, Beginnings and Battles to 1930.* New York: Horizon Press, 1969, 177–83.

Barnes, Djuna. "Elsa—Notes." Unpublished manuscript, 1930s. Papers of Djuna Barnes, University of Maryland Archives, College Park.

Biddle, George. *An American Artist's Story.* Boston: Little, Brown, 1939, 137–42.

Churchill, Allen. *The Improper Bohemians: A Recreation of Greenwich Village in Its Heyday.* New York: E. P. Dutton, 1959, 69.

Freytag-Loringhoven, Baroness Elsa von. "Elsa." Unpublished manuscript, c. 1926. Papers of Djuna Barnes, University of Maryland Archives, College Park.

————. *Baroness Elsa.* Paul I. Hjartarson and Douglas O. Spettigue. Ottawa, Canada: Oberon Press, 1992.

Reiss, Robert. " 'My Baroness': Elsa von Freytag-Loringhoven." Rudolf E. Kuenzli, ed. *New York Dada.* New York: Willis Locker & Owens, 1986, 81–101.

Rodker, John. " 'Dada' and Else von Freytag von Loringhoven." *The Little Review,* 7, no. 2 (July–August 1920), 33–36.

Williams, William Carlos. "Sample Prose Piece: The Three Letters." *Contact,* no. 4 (Summer 1921), 10–13.

————. *The Autobiography of William Carlos Williams.* New York: Random House, 1951, 164–65, 168–69.

THE INDEPENDENTS EXHIBITION OF 1917

Bean, Theodora. "Your Country's Art Calls You." *The Morning Telegraph* (15 April 1917), sec. 2, 1.

Buchanan, Charles L. "Art Versus License: Some Impressions of Contemporary American Painting." *The Bookman,* 45 (June 1917), 368–74.

Camfield, William. *Marcel Duchamp: Fountain.* Houston: Fine Art Press/Menil Collection, 1989.

Coady, R. J. "The Indeps." *The Soil,* I, no. 5 (July 1917), 202–10.

Cortissoz, Royal. "The Danger of Mixing Democracy and Art." *New York Tribune* (15 April 1917), part 3, 3.

Dixon, Jane. "An Outsider Explores Two Miles of Independent Art." *New York Sun* (22 April 1917), sec. 4, 11.

Eddy, Frederick W. "News of the Art World." *The New York World* (8 April 1917), editorial sec., 5.

Glackens, L. M. "Exeunt Independent Artists." *New York Tribune* (6 May 1917), part 5, 7.

Glackens, W. J. "The Biggest Art Exhibition in America and, Incidentally, War, Discussed by W. J. Glackens." *The Touchstone,* 1 (June 1917), 164–73, 210.

Gregg, Frederick James. "A New Kind of Art Exhibition." *Vanity Fair* (May 1917), 47.

Henri, Robert. "The 'Big Exhibition,' The Artist and the Public." *The Touchstone,* 1 (June 1917), 174–77, 216.

"His Art Too Crude for Independents." *New York Herald* (14 April 1917), 6.

"Independents' Art Show a Howler." *New York Sun* (10 April 1917), 5.

Kent, Rockwell. "The Big Show." chap. 6, part 2, *It's Me O Lord: The Autobiography of Rockwell Kent.* New York: Dodd, Mead, 1955, 311–18.

Kobbe, Gustav. "What Is It? 'Independent Art.' " *New York Herald* (1 April 1917), sec. 3, 12.

McBride, Henry. "News and Comment in the World of Art." *New York Sun* (8 April 1917), 5.

————. "News and Comment in the World of Art." *New York Sun* (15 April 1917), sec. 5, 12; reprinted in Daniel Catton Rich, ed. *The Flow of Art: Essays and Criticism of Henry McBride.* New York: Atheneum, 1975, 121–25.

————. "News and Comment in the World of Art." *New York Sun* (22 April 1917), sec. 5, 12.

————. "News and Comment in the World of Art." *New York Sun* (13 May 1917), sec. 5, 12; reprinted in Daniel Catton Rich, ed. *The Flow of Art: Essays and Criticism of Henry McBride.* New York: Atheneum, 1975, 125–29.

Marlor, Clark S. *The Society of Independent Artists: Exhibition Record 1917–1944.* Park Ridge, N.J.: Noyes Press, 1984; review by Francis M. Naumann, *The Archives of American Art Journal,* 26, nos. 2/3 (1986), 36–40.

Mather, Frank Jewett, Jr. "The Society of Independent Artists." *The Nation,* 104, no. 2706 (May 10, 1917), 574–75.

Naumann, Francis. " 'The Big Show,' The First Exhibition of the Society of Independent Artists, 1917." Part 1: *Artforum,* 17, no. 6 (February 1979), 34–39; part 2: "The Critics," *Artforum,* 17, no. 8 (April 1979), 49–53.

Nelson, W. H. de B. "Aesthetic Hysteria." *The International Studio,* 61, no. 244 (June 1917), 121–25.

[Pène du Bois, Guy]. "Notes of the Studios and Galleries." *Arts and Decoration,* 7 (May 1917), 371–74.

Simonson, Lee. "The Painters' Ark." *The Seven Arts,* 2 (June 1917), 202–13.

Society of Independent Artists: Catalogue of the First Exhibition. New York: Grand Central Palace, 10 April–6 May 1917.

Stein, Leo. "Introductory to the Independent Show." *The New Republic,* 10 (April 7, 1917), 288–90.

Watson, Forbes. "At the Art Galleries." *The New York Evening Post* (14 April 1917), *Saturday Magazine,* 11, 20.

W[atts], H[arvey]. M. " 'Greatest Ever' in Art Shows." *Philadelphia Public Ledger* (10 April 1917), 5.

Early Articles on Dada in the New York Press: 1920–23

Burke, Kenneth. "Dadaisme Is France's Latest Literary Fad." *New York Tribune* (6 February 1921), sec. 7, 6.

Cheney, Sheldon. "Why Dada?" *Century Magazine*, 104, no. 1 (May 1922), 220–29.

"Dadaists Fight in Paris Theatre." *New York Herald* (8 July 1923).

"Dadaists on Trial as Army Defamers." *New York Times* (22 April 1921), 17.

"The Dadas." *New York Times* (30 March 1919), sec. 3, 1.

"Dada: The Newest Nihilism in the Arts." *Current Opinion*, 68 (May 1920), 685–87.

Drake, William A. "The Life and Deeds of Dada." *Poet Lore*, 33 (December 1922), 497–506.

————. "The Life of Dada." *New York Tribune* (4 November 1923), sec. 9, 17–18.

Goldberg, Isaac. "Dada Putting the Jazz into Modern Verse." *Boston Evening Transcript* (12 January 1921).

"The Importance of Being 'Dada.' " *The International Studio*, 74, no. 296 (November 1921), 63.

"Intolerance at Zurich." *New York Times* (8 June 1919), sec. 3, 1.

Kreymborg, Alfred. "Dada and the Dadas." *Shadowland*, 7, no. 1 (September 1922), 43, 70.

Lozowick, L[ouis]. "The Russian Dadaists." *The Little Review*, 8, no. 3 (September–December 1920), 72–73.

McBride, Henry. "New Dada Review Appears in New York." *New York Herald* (24 April 1921), sec. 3, 11.

————. "Tzara at the Théâtre Michel." *The Dial* (December 1923); reprinted in Daniel Catton Rich, ed. *The Flow of Art: Essays and Criticism of Henry McBride*. New York: Atheneum, 1975, 179–81.

Munson, Gorham B. "A Specimen of Demi-Dadaisme." *The New Republic* (April 18, 1923), 219–20.

"Nothing Is Here: Dada Is Its Name." *American Art News*, 14, no. 25 (April 2, 1921), 1.

O'Sullivan, Vincent. "Dada is Dead." *The Freeman*, 4, no. 100 (8 February 1922), 518–19.

"Paris Notes & News, Dadaists Disappoint, Still Unshaven." *New York Daily Mail* (28 May 1920).

"Pictures in Berlin: The Dada Display." *American Art News*, 18, no. 39 (18 September 1920), 4.

Rex, Margery. " 'Dada' Will Get You if You Don't Watch Out: It Is on the Way Here." *New York Evening Journal* (29 January 1921), 3; reprinted in Rudolf E. Kuenzli, ed. *New York Dada*. Willis Locker & Owens, 1986, 138–42.

————. "Dada Is Busy Again in Paris: Now It's Going to Furnish Some Original Guides." *New York Evening Journal* (24 May 1921).

Ribemont-Dessaignes, G[eorge]. "Dada Painting or the Oil-Eye." *The Little Review*, 9, no. 4 (Autumn–Winter 1923–1924), 10–12.

Schinz, Albert. "Dadaism." *The Bookman*, New York, 55, no. 2 (April 1922), 103–5.

————. "Dadaisme." *Studies in Modern Languages*, Smith College, Northampton, Mass., 5, no. 1 (October 1923), 53–79.

Seabrook, W. B. "Did You Ever See Family Portraits Like These?" *The Saint Louis Star* (24 July 1921).

Smith, Agnes. "Introducing Da Da." *The Morning Telegraph*, 97, no. 121, 1 May 1921, sec. 2.

Tyrrell, Henry. "Dada: The Cheerless Art of Idiocy." *The World Magazine*, New York (12 June 1921), 8, 13; reprinted in Rudolf E. Kuenzli, ed. *New York Dada*. Willis Locker & Owens, 1986, 142–45.

Tzara, Tristan. "Some Memoirs of Dadaism." *Vanity Fair* 18, no. 4 [5] (July 1922), 70, 92, 94.

"What Is Dadaism?" *New York Tribune* (9 July 1918).

Wilson, Edmund, Jr. "The Aesthetic Upheaval in France: The Influence of Jazz in Paris and the Americanization of French Literature and Art." *Vanity Fair* 18, no. 6 [sic] (February 1922), 49, 100.

Dada Magazines

The Blindman. No. 1, New York, April 10, 1917; *The Blind Man*, No. 2, New York, May 1917 (2 nos.). Eds. Marcel Duchamp, Henri-Pierre Roché, Beatrice Wood. Reprint Milan: Mazzotta, 1970.

Broom. Rome, Berlin, New York, 1921–24 (6 vols.). Eds. Harold A. Loeb, Matthew Josephson, Alfred Kreymborg. Reprint New York: Kraus, 1967.

Cabaret Voltaire. Zurich, 1916 (1 no.). Eds. Hugo Ball, Emmy Hennings. Reprints Milan: Mazzotta, 1970; Paris: Jean-Michel Place, 1981.

Camera Work. New York, 1903–17 (50 nos.). Ed. Alfred Stieglitz. Reprint New York: Kraus, 1969.

Contact. New York, 1920–23 (5 nos.). Eds. William Carlos Williams, Robert M. McAlmon. Reprint New York: Kraus, 1967.

Dada. Zurich and Paris, 1917–21 (8 nos.). Ed. Tristan Tzara. Reprints Milan: Mazzotta, 1970; Nice: Centre du XXe siècle, 1976; Paris: Jean-Michel Place, 1981.

Littérature. Paris, 1919–21 (21 nos.); n.s. 1922–24 (14 nos.). Eds. Louis Aragon, André Breton, Philippe Soupault. Reprint Paris: Jean-Michel Place, 1978.

The Little Review. New York, 1914–29 (12 vols.). Ed. Margaret Anderson. Reprint New York: Kraus, 1967.

Manuscripts. New York, 1922–23 (6 nos.). Ed. Paul Rosenfeld.

New York Dada. New York, April 1917 (1 no.). Eds. Marcel Duchamp, Man Ray. Reprint Milan: Mazzotta, 1970.

Others. Grantwood, N.J., New York, Chicago, 1916–19. Ed. Alfred Kreymborg. Reprint New York: Kraus, 1967.

The Ridgefield Gazook. No. 0, Ridgefield, N.J., March 31, 1915 (1 no.). Ed. Man Ray. Reprint Milan: Mazzotta, 1970.

Rogue. New York, 1915–16 (2 vols.). Eds. Allen and Louise Norton.

Rongwrong. New York, Summer 1917 (1 no.). Ed. Marcel Duchamp. Reprint Milan: Mazzotta, 1970.

The Soil. New York, 1916–17 (5 nos.). Ed. Robert Coady.

TNT. New York, 1919 (1 no.). Eds. Henry S. Reynolds, Adolf Wolff, Man Ray.

391. Barcelona, New York, Zurich, Paris, 1917–24 (19 nos.). Ed. Francis Picabia. Reprint Paris: Pierre Belfond/Eric Losfeld, 1960.

291. New York, 1915–16 (12 nos.). Ed. Marius de Zayas. Reprint New York: Arno Press, 1972.

Archives

Austin, Texas: Harry Ransom Humanities Research Center, Carlton Lake Collection, University of Texas (Marcel Duchamp, Man Ray, Henri-Pierre Roché). HRC

Claremont, California: Francis Bacon Library, Francis Bacon Foundation (Walter Conrad Arensberg, Marcel Duchamp). FBL

Milwaukee, Wisconsin: Golda Meir Library, University of Wisconsin (Papers of *The Little Review*: The Baroness Elsa von Freytag-Loringhoven, Marcel Duchamp, Man Ray, Francis Picabia, Tristan Tzara, Joseph Stella). GML

New Haven, Connecticut: Yale Collection of American Literature, Beinecke Rare Book and Manuscript Library, Yale University (Katherine Dreier, Marcel Duchamp, Henry McBride, Man Ray, Francis Picabia, Société Anonyme, Alfred Stieglitz, Ettie and Florine Stettheimer, Marius de Zayas). YCAL

New York, New York: Butler Rare Book and Manuscript Library, Columbia University (Florine Stettheimer, Marius de Zayas; Oral History Program: Holger Cahill, Paul Sachs). BLCU

New York, New York: Manuscript and Archives Division, The New York Public Library, Astor, Lenox and Tilden Foundations (Marcel Duchamp, Walter Pach, Henri-Pierre Roché, John Quinn). NYPL

Paris, France: Bibliothèque Littéraire Jacques Doucet, Universités de Paris (André Breton, Marcel Duchamp, Francis Picabia, Tristan Tzara). BLJD

Philadelphia, Pennsylvania: Department of Modern Art, Philadelphia Museum of Art (Walter Conrad Arensberg, Marcel Duchamp). PMA

Washington, D.C.: Archives of American Art, Smithsonian Institution (George Biddle, Jean Crotti and Suzanne Duchamp, Walter Pach, Beatrice Wood). AAA

Index

Illustrations are designated by *italics*. Birth and death dates are given only for participants in the Arensberg Circle and for the Arensbergs themselves.